CIVIL WAR TIMES ILLUSTRATED

The Civil War

THE COMPACT EDITION

VICKSBURG TO APPOMATTOX

Fighting for Time

The South Besieged

The End of an Era

EDITED BY WILLIAM C. DAVIS AND BELL I. WILEY

UNDER THE DIRECTION OF THE NATIONAL HISTORICAL SOCIETY

WITH A NEW INTRODUCTION BY WILLIAM C. DAVIS

BLACK DOG
& LEVENTHAL
PUBLISHERS
NEW YORK

Copyright © 1998 Black Dog & Leventhal Publishers, Inc.
EDITOR: William C. Davis
SENIOR CONSULTING EDITOR: Bell I. Wiley
PHOTOGRAPHIC CONSULTANTS: William A. Frassanito, Manuel Kean, Lloyd
Ostendorf, Frederick Ray

Originally published in three separate volumes as:
The Image of War 1861–1865, volume Four: Fighting for Time
The Image of War 1861–1865, volume Five: The South Besieged
The Image of War 1861–1865, volume Six: The End of an Era

This edition published by arrangement with Cowles Magazines, Inc.

PUBLISHED BY
Black Dog & Leventhal Publishers
151 W 19th St.
New York, NY 10011

DISTRIBUTED BY
Workman Publishing Company
708 Broadway
New York, NY 10003

Manufactured in the United States of America

ISBN 1-57912-013-X

h g f e d c b a

A previous edition was cataloged as follows:
Library of Congress Cataloging-in-Publication Data
The Civil War times illustrated photographic history of the Civil War / edited by
William C. Davis and Bell I. Wiley; under the direction of the National Historical
Society.
 p. cm.
Originally published in 6 separate volumes: New York: Doubleday, 1981–1983
(The image of war, 1861–1865). Includes indexes.
Contents: [1] Fort Sumter to Gettysburg [2] Vicksburg to Appomattox
ISBN 1-884822-08-8 (hardcover: v. 1). ISBN 1-884822-09-6 (hardcover: v. 2).
1. United States—History—Civil War, 1861–1865—Pictorial Works.
I. Davis, William C., 1946–. II. Wiley, Bell Irvin, 1906–. III. National Historical
Society.
E568.7.C585 1994
973.7'3'022—dc20 94-30567
 CIP

The Editors

EDITOR

William C. Davis

SENIOR CONSULTING EDITOR

Bell I. Wiley

PHOTOGRAPHIC CONSULTANTS

William A. Frassanito
Manuel Kean
Lloyd Ostendorf
Frederick Ray

EDITORIAL ASSISTANTS

Deborah A. Berrier
Karen K. Kennedy
Denise Mummert
James Rietmulder

Contents

INTRODUCTION
William C. Davis
11

Fighting for Time

JEWELS OF THE MISSISSIPPI
VICKSBURG AND PORT HUDSON, INVINCIBLE UNTIL GRANT
Herman Hattaway
16

FOLLOWING THE ARMIES
WHEREVER THEY GO, THE CAMERA FOLLOWS
86

RAIDERS OF THE SEAS
REBEL COMMERCE DESTROYERS TAKE THE WAR AROUND THE WORLD
Norman C. Delaney
134

THE SIEGE OF CHARLESTON

THE CITY THAT FATHERED SECESSION SUFFERS
THE WAR'S LONGEST SIEGE

Rowena Reed

166

CARING FOR THE MEN

HOSPITALS, MEDICINES, DOCTORS, AND DO-GOODERS

George W. Adams

231

THE CAMERA CRAFT: A PORTFOLIO

INNOVATION, INVENTION, AND SOMETIMES ART, SPILL FROM THE LENS

275

WAR ON HORSEBACK

THE DASHING DASH TO "JINE THE CAVALRY"

Dee Brown

301

THE SAILOR'S LIFE

THE ROUTINE, BOREDOM, AND SOMETIME ADVENTURE
OF WEBFOOT REB AND YANK

Harold D. Langley

361

PRISON PENS OF SUFFERING

SIMPLE NAMES LIKE JOHNSON'S ISLAND
AND ANDERSONVILLE COME TO MEAN HELL.

Frank L. Byrne

396

The South Beseiged

THE WAR FOR TENNESSEE

THE ENDLESS, BLOODY BATTLES FOR THE STATE CALLED "VOLUNTEER"

Edwin C. Bearss

455

SQUADRON OF THE SOUTH

OF SHIPS AND SEA AND SUFFOCATING THE CONFEDERACY

Frank J. Merli

539

PARTNERS IN POSTERITY—A PORTFOLIO

HAAS & PEALE AND THEIR INCOMPARABLE RECORD
OF SIEGE IN SOUTH CAROLINA

593

INTO THE WILDERNESS

GRANT AND LEE MEET AT LAST, AND WILL NOT PART

Robert K. Krick

613

THE ATLANTA CAMPAIGN

"HELL HAS BROKE LOOSE IN GEORGIA," AND SHERMAN MAKES IT SO

Richard M. McMurry

680

BACK TO THE VALLEY

SOME OF THE FACES ARE NEW, BUT THE SOUND OF BATTLE
IS THE SAME IN THE SHENANDOAH

Everard H. Smith

743

A CAMPAIGN THAT FAILED

COTTON AND POLITICS AND THE RED RIVER
MAKE STRANGE WAR IN LOUISIANA

Ludwell H. Johnson III

786

THE FORGOTTEN WAR: THE WEST

FROM THE MISSISSIPPI TO THE GOLDEN GATE,
THE CIVIL WAR IS EVERYWHERE

Maurice Melton

818

The End of an Era

THE MODERN ARMY
YEARS OF WAR, OF TRIAL AND ERROR, PRODUCE AT LAST A FIGHTING MACHINE
IN THE SHAPE OF THINGS TO COME
Russell F. Weigley
891

"DAMN THE TORPEDOES!"
SHIPS OF IRON, AND MEN TO MATCH, BATTLE ON AN AUGUST MORNING FOR MOBILE
Charles R. Haberlein, Jr.
962

HOUGHTON AT THE FRONT: A PORTFOLIO
THE LITTLE-KNOWN VERMONT PHOTOGRAPHER G. H. HOUGHTON WENT TO THE WAR
IN 1862 FOR AN UNFORGETTABLE SERIES
998

THE GREAT MARCH
"FROM ATLANTA TO THE SEA" AND ON THROUGH THE CAROLINAS, THE
INDOMITABLE SHERMAN COULD NOT BE STOPPED
John G. Barrett
1022

PETERSBURG BESIEGED
AFTER THREE YEARS THE UNION FINALLY HAS LEE AT BAY, BUT
THE QUARRY GOES TO GROUND AND GRANT CAN ONLY WAIT
Richard J. Sommers
1058

RICHMOND, CITY AND CAPITAL AT WAR
SYMBOL OF THE CONFEDERACY, THE VIRGINIA METROPOLIS
FIGHTS TO THE LAST
Emory M. Thomas
1151

AN END AT LAST
WHEN BLOOD AND BRAVERY AND INDOMITABLE WILL
COULD DO NO MORE, THE SOUTHERN BANNERS WERE FURLED

Louis Manarin

1200

THE "LATE UNPLEASANTNESS"
THE WAR DONE, THERE WAS PEACE TO WAGE, AND BATTLES ANEW
WITH THE HATREDS REMAINING, AND CHALLENGES AHEAD
FOR A NATION REUNITING

William C. Davis

1239

ABBREVIATIONS

1327

THE CONTRIBUTORS

1329

INDEX

1333

Introduction

WILLIAM C. DAVIS

THE ORIGINAL IDEA for this series of books did not spring fully formed from the sleepless night in 1978 that gave it birth. Having been bowled over by encountering the 40,000-image collection of Civil War photographs just donated to the U.S. Army Military History Institute, I thought at first of putting together a four-volume series of books to be drawn exclusively from that single source, the only editorial rationale being to present as much as possible from this truly unique archive. There was no idea of making it a photographic history of the war itself, for there were too many gaps in the Institute's collection, magnificent as it was. Two of three priceless volumes of Confederate images had been stolen years before it all came to Carlisle. Representation of naval subjects, while good, was still spotty. And relatively few of the photographs covered matters like home life, industry, or the conflict west of the Mississippi. No truly comprehensive photographic history of the war as a whole was possible from this single source.

Yet as time wore on and the idea matured, I drifted more and more in the direction of attempting something that would be as all-encompassing as possible—and admitting that there were places and events that the actual cameramen never captured, and that, therefore, would have to go unillustrated. From the uncataloged storage in my mind came recollections of all those photographs that readers of *Civil War Times Illustrated* had told us of over the years. Art director Frederic Ray knew of many more, as did Manuel Kean, Lloyd

Ostendorf, and William A. Frassanito, all of whom I soon engaged as consultants. From sources like these, some of the gaps in the coverage in the Institute's collection began to fill.

Finally it became evident that it would be possible to attempt a comprehensive photographic history. Equally to the point, one was needed. From that early book *Campfire and Battlefield* and its contemporaries, right down to the present in the late 1970's, Civil War photographic histories and books carrying only a few photographs even, had all been plagued by carelessness and benign ignorance. Almost every photograph was assumed to have been taken by Mathew Brady. Literally hundreds of images and portraits were consistently misidentified, the errors passed on from one generation to the next. Even the great work of record in the field, Francis T. Miller's *Photographic History of the Civil War*, published in ten volumes in 1911, either created or perpetuated scores of these errors.

By the time the idea for this series matured, however, serious scholarly study of Civil War photographs as historied documents had made available corrections to most of these old chestnuts, thanks especially to people like Frassanito and Ray. And so here was one more argument for making an attempt at a new comprehensive history. We could offer a whole trove of photographic treasure never before seen, while at the same time identifying correctly for the first time much of what was well known. Moreover, we could accompany it all with text by the nations leading Civil War historians, all of them contributors to *Civil War Times Illustrated*. We could use their text to set the stage for the drama that the photographs themselves would provide.

Still it remained to fill in more of those gaps. In the end it required more than 30,000 miles of travel to over 100 institutions—public and private archives, private collectors, historical societies, even a museum in London, England. While I never again encountered a collection that could rival the Institute's for sheer size, still what I found sometimes left me almost reeling. Confederate photographers were few and very limited in their operations. Not much of their output survived. Other than studio portraits—the bulk of their work—only about 100 outdoor views were known to exist. One day at Tulane University in New Orleans that number increased by half when I stumbled onto nearly 50 new images not even known to the curators. More turned up at the Chicago Historical Society, and at the University of North Carolina there emerged a priceless hoard of nearly a dozen large views by the war's first photographer, the New Orleans Confederate Jay D. Edwards.

Incrementally these supplemental finds were small in numbers, but rich in the depth and coverage they added to the project. A privately owned photo album yielded priceless images of Texas during its Confederate years. The work of a Little Rock, Arkansas artist illuminated more of the war west of the Mississippi. A magnificent album in Alabama produced unknown portraits in uniform of nearly a score of Confederate generals. At the start of each new research trip I felt the same sense of expec-

tation that Columbus must have known before his voyage. It was a close as I will ever come to pioneering.

In the end, we accumulated more than 10,000 prints, which I had to winnow down to about 4,000. That was tough enough. But then I had to write each and every caption, trying to illuminate what the picture showed, correct any old errors, and try not to make new ones. Inevitably, a few crept through, as they must in any creation by man. But what we achieved—and that "we" includes the efforts of two score writers and consultants, and at least that many more collectors, not to mention the one hundred and more archives—is still something of which I feel inordinately proud. I have written or edited a lot of books on the Civil War and Southern history—about 33 at latest count—but none of them have yielded to me the personal satisfaction that I derived from conceiving and seeing through to completion the six-volume series we called *The Image of War,* and now

republished in two volumes as the *Civil War Times Illustrated Photographic History of the Civil War.* More to the point, I genuinely believe that none of my works will last as long as these volumes. More photographic books on the Civil War have been published since, and they will continue to appear. More and more photos themselves continue to come to light, their appearance in part spurred by the interest stimulated by this series. The thrill of discovery can still be felt by those who look long enough and hard enough. But in putting together these books it was given to me to experience a once in a lifetime kind of exhilaration that I sincerely doubt any future photographic historian of the war will get to feel, and on a scale that will be impossible to equal. If my career never produced anything more than that, I would have to count myself as quite extraordinarily blessed.

Any who would share a bit of that thrill have but to start turning these pages.

Powerful batteries like these thirty-pounder Parrots readied a devastating
fire for the final assault when it should come. The besieged Confederates
at Port Hudson were about to feel the weight of their iron.

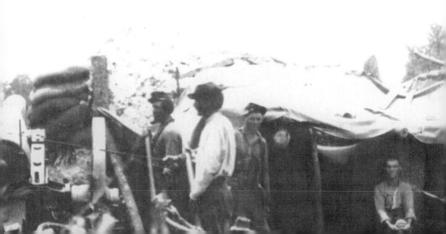

Fighting for Time

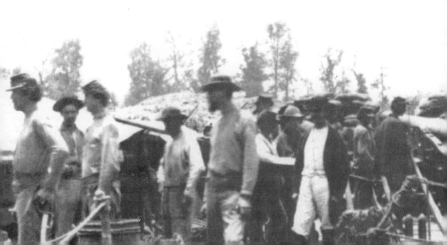

Jewels of the Mississippi

HERMAN HATTAWAY

Vicksburg and Port Hudson, invincible until Grant

FROM THE OUTSET OF WAR, the Union made control of the entire Mississippi River one of its principal aims. By early 1862 it had seized all but a 110-mile stretch, but at Port Hudson, Louisiana, and Vicksburg, Mississippi, the Confederates held tenaciously to two very strong points: one, a port town twenty-five miles north of Baton Rouge; the other, a commercial city at the mouth of the Yazoo River. Port Hudson sat on an almost precipitous bluff where the river made a sharp turn; Vicksburg, called the Gibraltar of the West, seemed impregnable because of its location on high bluffs and rough surrounding terrain.

Surprisingly, though, the Southern high command paid seemingly inadequate attention to the river. The contrasting attitudes of top leaders reflected both in the priority they assigned to the campaign and in the quality of personnel employed. The North unleashed a major effort, directed by two able commanders: U. S. Grant and William T. Sherman. The Confederacy countered with beclouded policies, a theater commander—General Joseph E. Johnston—who was given insufficient guidance and resources, and a field general who proved inadequate: John Clifford Pemberton.

A native of the North, Pemberton had been born in Philadelphia. Because he ultimately failed to hold Vicksburg, many Southerners afterward considered him either a pariah or a deliberate traitor. He was, in truth, an honest and dedicated man, but his job was too big for him.

Yet, ironically, at Port Hudson, a place of equal importance, the quality of leaders was reversed and the Confederates held secure there until after Vicksburg had fallen. Expertly led by the Rebel Major General Franklin Gardner—who relieved W.N.R. Beall on December 28, 1862—the Southerners arrayed their guns in well-conceived clusters, protected by elaborate earthworks. The Federals floundered under poor leadership from a former Speaker of the House of Representatives with presidential ambitions, Major General Nathaniel P. Banks.

In late 1862 the onslaught opened at both ends of the Confederate segment of the river. On November 16 a Federal fleet steamed upriver toward Port Hudson and commenced a brief bombardment of the batteries. That action was bloodless and the boats withdrew, leaving things quiet for almost a month, but on December 13 the war vessels returned. Then on the seventeenth the Yankees reoccupied Baton Rouge, which they had abandoned the previous August. Grant, too, before the

year's end, launched the first of his efforts against Vicksburg, this one culminating in the Battle of Chickasaw Bayou.

Grant had wanted a three-pronged attack, himself to lead troops overland from Memphis, Sherman to head a downriver naval-supported expedition, and Banks to cooperate with a column from Baton Rouge. But Banks refused to work with Grant, and brilliant cavalry raids by the Rebel Major General Earl Van Dorn caused Grant's own thrust from Memphis to be abandoned. Sherman, though, in late December, steamed south with his 33,000 men aboard sixty transports accompanied by seven gunboats.

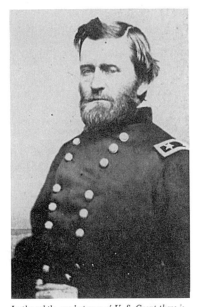

In the subtle, modest eyes of U. S. Grant there is not the look of a man determined not to fail. Yet those eyes were set on Vicksburg in the fall of 1862, and never taken away. He would have his prize if it took a year. In the end, it did.

Pemberton was not personally at Vicksburg initially. The city's inner defenses were overseen by Major General Martin Luther Smith, and the field forces were led by Brigadier General Stephen D. Lee. Ultimately Pemberton concentrated 12,000 men, but in the beginning the Southerners faced Sherman's force with a mere 2,700 outside the city and another 2,400 manning the interior fortifications.

Sherman's armada went down the Mississippi and twelve miles up the Yazoo River to debark. By December 27 terrain, more than planning, had forced two Union brigades into assault positions at Chickasaw Bayou. There Lee set a trap. A morass of mud and water slowed the Federals and forced them to funnel over a log bridge. The Yankees could get only to within 150 yards of the Rebel main line before withering fire forced the attackers to brake and retreat. Losses were 1,776 Union and 207 Confederate.

Sherman planned another attack, but dense fog settled and a torrential rain instilled fear that a flood might drown the entire command; so he withdrew on January 2, 1863. One Union corporal aptly observed that "Sherman or Grant or both had made a bad blunder."

January passed in relative quiet, but on February 2 the Union ram *Queen of the West* ran past the Vicksburg batteries—proving that it could be done. She was struck twelve times, but not seriously. For the next dozen days this vessel wreaked considerable havoc upon both the Mississippi and Red rivers, until she was lost. She illustrated that the Union possessed a tremendous advantage in the struggle for the Mississippi because the Confederacy never managed to develop sufficient naval strength. There had been a brief moment the previous summer, during the short life of the CSS *Arkansas,* when things might have been rendered differently. But the *Arkansas* had been destroyed by the Confederates to prevent her imminent loss to the enemy. That vessel, and a sister ship that was never finished, were the only new Mississippi River gunboats authorized to be built by the Confederate government. The rest of the Southern flotilla consisted of altered wooden steamships.

The Federal Navy conversely possessed a fleet of new boats specifically designed for river warfare. The United States had commissioned seven heavily

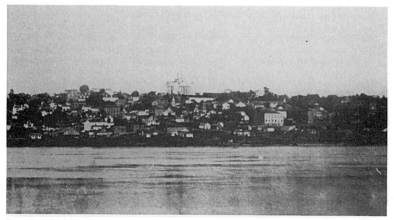

The prize. Vicksburg. The fortress city on the Mississippi. As the Warren County Courthouse dominated the city, so did the city dominate the great river.
(USAMHI)

armed, armored gunboats at St. Louis, each fitted with thirteen large-caliber guns and shielded with oak planking two feet thick on the gun decks. Another vessel, the *Benton,* a converted snag boat, carried sixteen guns and was covered with iron plating. In addition nine Federal rams were built out of old steamers at Cairo, Illinois.

Thus, naval strength proved to be one of the keys to Grant's conduct of his campaign. After Sherman's failure, Grant had the boats bring his army down from Memphis and land it on the Louisiana side, just north of Vicksburg. He immediately set into motion a series of schemes to approach the city from a more desirable direction.

In Grant's canal project, an attempt was made to deflect the waters of the Mississippi from their natural channel so that the naval support could safely bypass the Vicksburg batteries. The diggers dug feverishly but to no avail, while the Confederates remained relatively unconcerned—their engineers having predicted, correctly, that it would come to nothing. A Federal ram was used in an effort to throw water into the canal with its paddle wheel, but without success.

Then followed the hapless Lake Providence ex-

pedition, during which the Union gunboats tried to get into the Red River from above Vicksburg, thereby reaching the precious segment of the Mississippi.

Next came the Yazoo Pass expedition. The Federal Navy moved into Yazoo Pass and tried to get from there into the Yazoo River, via a bayou, but on March 11 were blocked at Fort Pemberton.

Last among the unsuccessful preliminary affairs came complex and fruitless campaigning north of Vicksburg in expeditions on Deer Creek, Steele's Bayou, and Rolling Fork. The Federal gunboats entered bayous north of the Yazoo and tried to maneuver through the narrow, overhung labyrinth of streams.

Grant later asserted that he had only scant hopes that any of these schemes might work. He was saving his major effort for the spring and summer: to have *empty* vessels, shielded by cotton bales, run southward past the Vicksburg batteries while Grant marched overland with the troops.

MEANWHILE, the Port Hudson campaign also continued in momentary stalemate. On March 14 a prodigious naval bombardment revealed that gun-

boats alone could not reduce the batteries. Two vessels did run by, but at great cost. The Confederates fired artillery with deadly accuracy, even at night, because they used special reflectors to flash the light from great bonfires they lit on both banks, and they also beamed a number of railroad locomotive headlights onto the river. The shore gunners could "aim almost as well as if it were day."

Although the bombardment continued nearly every night and sometimes during the day, the defenders found time to engage in occasional fri-

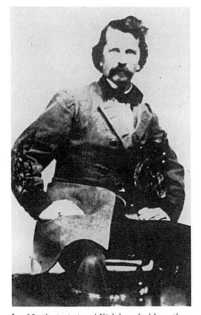

In 1862 the protector of Vicksburg had been the egotistic Major General Earl Van Dorn, a "coxcomb" and "dandy," thought many of his soldiers. The ladies found him attractive, too, until a cuckolded husband killed him on May 7, 1863. (MESERVE COLLECTION, CHICAGO HISTORICAL SOCIETY)

volties. Sometimes they played marbles atop a memorial slab in the nearby cemetery. Or they held footraces for the prize of sleeping on the flat tombs, which, though hard, at least were much drier, and the troops considered them more comfortable, than the damp Louisiana earth.

By mid-April Grant proceeded to force matters to a head at Vicksburg. As a prelude, he employed several diversions. A marauding division under Major General Frederick Steele moved by water from Young's Point to Greenville, Mississippi, and then inland. Colonel Benjamin H. Grierson led 1,000 cavalrymen out of Memphis on a raid that continued all the way into Baton Rouge. Sherman's corps made an elaborate feint from north of Vicksburg, landing at Haynes' Bluff.

On April 16, during the middle of the night, Rear Admiral David D. Porter's fleet ran past the city. Often hit by the Confederate guns, all but one of the boats nevertheless got safely through. They met Grant near Hard Times, west of the river.

On the twenty-ninth the fleet pounded the Rebel gun emplacements across the river and attempted to clear the way for Grant's men to cross. But after six hours, "finding the position too strong," Grant moved his leading force southward to a spot opposite Bruinsburg. Now outnumbering his enemy by more than two to one, Grant was able to cross, push away the Confederates, and force Grand Gulf's evacuation.

Grant pushed one corps rapidly inland toward Port Gibson. A small Confederate force hurried to intercept. Hopelessly outnumbered but aided by the terrain—steep, sharp ridges and gullies covered with thick vines and dense undergrowth—the Southerners fought a plucky defense.

Grant had intended to live off the country, but it was necessary that his forces move rapidly; otherwise they would deplete the immediately available supplies. He quickly realized that he had to reopen supply lines. Organizing this effort delayed him for more than a week while he arranged to run past the Vicksburg batteries an additional 400,000 rations of "hard bread, coffee, sugar, and salt." Ammunition that could not be exposed to fire came by wagon along with additional subsistence stores.

GRANT'S SUCCESS in reaching the east bank below the city caused appropriate alarm in Richmond. Secretary of War James Seddon immedi-

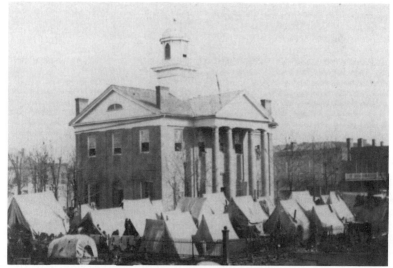

*Van Dorn managed to blunt Grant's first campaign against Vicksburg in
December 1862. The Federals were here in Oxford, Mississippi, camped about
the courthouse and throughout the countryside, when Van Dorn destroyed
Grant's supply base at Holly Springs.* (CHS)

ately diverted 5,000 reinforcements to Mississippi
and soon after ordered Joe Johnston to assemble
3,000 men and go to take charge in person. Sed-
don then renewed previous efforts to secure rein-
forcements from Virginia, but Robert E. Lee effec-
tively resisted the move. Convinced by Lee that the
South should not deplete the Virginia forces, Presi-
dent Jefferson Davis and his war secretary turned
to General Braxton Bragg's army.

The Union hopes for a successful conclusion to
the Vicksburg campaign depended in part upon
Major General William S. Rosecrans's remaining
sufficiently strong and doing at least enough to en-
sure effective limits upon any reinforcements that
Bragg might send to Pemberton. This Rosecrans
accomplished well in his unheralded and under-
rated Tullahoma campaign.

Meanwhile, Grant's opportunity to move into al-
most virgin country vastly simplified his logistics.

He now luckily enjoyed the fruits of a growing sea-
son that was well along in this fertile region where
planters had reduced the cultivation of cotton in
favor of food crops. In addition to fodder, the
countryside abounded in "corn, hogs, cattle, sheep,
and poultry." The Mississippi farms thus relieved
Grant's long and inadequate road communications,
enabling him to "disregard his base and depend
upon the country for meat and even for bread."
This was fortunate, for Grant's line of wagon com-
munications west of the river was tenuous. In the
early spring the "roads" that had gradually
emerged from the flooded lands amounted to little
more than slimy streaks through oozy mud.

Grant's good fortune and good planning in his
supply arrangements extended rearward all the
way to his base. He had been able to abandon the
railroad running north through western Tennessee,
so that all his communications above Vicksburg lay

on the Mississippi River. He thus foiled one of the main Confederate hopes to defeat him. Johnston had expected, as had Van Dorn the previous winter, again to neutralize Grant with cavalry raids upon supply lines.

Grant was further aided by Pemberton's indecisiveness. Initially Pemberton did perceive that Grant's new position "threatens Jackson, and, if successful, cuts Vicksburg off from the east." To stop Grant, Pemberton realized that his forces, scattered from Port Hudson to north of Vicksburg, must be concentrated. Yet after taking the appropriate initial steps, Pemberton almost immediately quailed and ordered the garrison to stay at Port Hudson.

By THE MIDDLE of the second week of May, as Grant's resupplied army began its advance, the Confederates stood tragically divided. Grant thus had the opportunity of "threatening both and striking at either." On May 12 an engagement erupted at Raymond, about fifteen miles from the Mississippi capital. The ensuing contest lasted for several hours, each side sustaining some 500 casualties. Gradually the outnumbered Rebels fell back toward Jackson. At the same time Sherman's men clashed with Southern skirmishers along Fourteen-Mile Creek. These two struggles induced Grant to choose first to deal with the concentration at Jackson.

Grant used one corps as a covering force to hold Pemberton at bay while the other two Federal corps concentrated against Johnston. Outnumbered almost five to one, Johnston began on the fourteenth to withdraw northward, leaving only two brigades to try delaying the Yankees. Brief, one-sided fighting followed, and in the afternoon Grant's men occupied the capital. Now Grant stood astride Vicksburg's landward communications.

Turning next toward Vicksburg and Pemberton's forces, Grant left a minimal guard to his rear in protection against Johnston's increasing army. Relying primarily upon logistic means, Grant destroyed the Pearl River railroad bridge and the road instead in all directions as far as practicable.

Pemberton meanwhile could have placed Grant in a difficult supply situation if he had been able to hold Grant east of the Big Black River. This Pemberton attempted to do, on the sixteenth, by pre-

Meanwhile, Grant had sent William T. Sherman to try to reach Vicksburg by the bayous north of the city. By December 28 Sherman got as far as Chickasaw Bayou, intending to attack the thinly held heights between it and Vicksburg. The next day he struck at Chickasaw Bluffs and suffered a bloody repulse. The Confederates on those commanding heights proved to be stronger than he believed. The defeat ended land operations for the rest of the winter. (USAMHI)

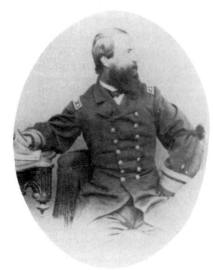

The Navy took the next fire, led by Grant's trusted associate, Acting Rear Admiral David D. Porter, commanding the Mississippi River Squadron. (USAMHI)

cipitating a major engagement at Champion's Hill. A little more than four miles east of Edwards Station, Champion's Hill is a crescent-shaped ridge, about seventy-five feet high. Each of the three roads that led eastward from Edwards Station was covered by one of Pemberton's divisions. The Confederate line stretched out about three miles.

Eventually the Federals attacked from the north and northeast in an attempt to roll up the Confederate left flank. The Southerners responded by moving an entire division in a counterclockwise direction, eventually to form a line of battle somewhat in the shape of the number 7. Pemberton expected the main attack along the vertical, but it actually came from the horizontal above.

As the Yankees moved farther and farther to the west, attempting to turn the Rebel left, Pemberton shifted more men northward. The Confederate line eventually stretched more west to east than north

to south. And so, fearing greater disaster, Pemberton decided to withdraw, ending the contest.

In this costly battle, the bloodiest of the series of conflicts preliminary to the siege of Vicksburg, Federal effectives numbered about 29,000 and they sustained a total of 2,441 casualties; while the Confederate effectives, probably numbering under 20,000, suffered 3,851 casualties. One Union brigade commander ranked the Battle of Champion's Hill among "the most obstinate and murderous conflicts of the war." And Federal Brigadier General Alvin P. Hovey said to an Illinois soldier, "I cannot think of this bloody hill without sadness and pride."

Pemberton fought a holding action the next day for the Big Black River bridges. He hoped to keep a passage open long enough for the division under Major General William W. Loring, hopelessly cut off and lost, to rejoin the main force. The Confederates occupied a line about one mile long, touching the curving river at both ends. Launching an attack, the Federals quickly discovered a vulnerable point. On the Confederate extreme left the previously prepared earthworks had been washed away by a recent overflow of the river. The Northerners easily moved up to this point and thereby were able to roll up the flank. The Southerners broke in disorder and fled to the environs of the city.

ON MAY 18, THEN, the siege of Vicksburg began. Three days later Banks began a siege of Port Hudson, also. After a minor action on the twenty-first, the Battle of Plains Store, and another on the twenty-second, the Federals began building siege lines. Confederate General Gardner spoke prophetically to the men in one of his batteries: "The enemy are coming, but mark you, many a one will get to Hell before he does to Port Hudson."

Banks had his investment completed by the twenty-third, and thereafter it was constant siegecraft. But there was plenty of peripheral action, first at Troth's farm, then at Thompson's Creek, where the Confederates had two war vessels. Both steamers were captured and converted to Federal service. Banks, though, failed to prove himself a particularly capable besieger, and his losses mounted disproportionately high. He already had wasted time, men, and resources aimlessly pursuing all over central Louisiana his strangely chosen per-

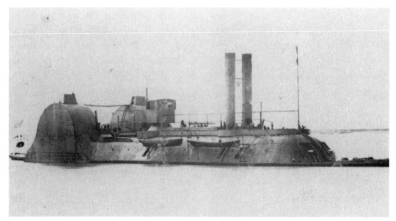

On April 16, 1863, Porter ran part of his fleet, including the newly completed mammoth ironclad Lafayette, *past the Vicksburg batteries in order to support the troop crossings below the city.* (LOUISIANA STATE UNIVERSITY, DEPARTMENT OF ARCHIVES AND MANUSCRIPTS, BATON ROUGE)

sonal objectives. Now he reluctantly acknowledged that he did "not know that anything is left me but to direct my forces against Port Hudson," and he revealed an obtuse courage: he also said he feared that this involved "the probable loss of New Orleans."

Indeed, Banks seemed to pay primary attention not to realistic factors but to his personal appearance. His looks had somewhat impressed Admiral Porter, who wrote of Banks: "Rather theatrical in his style of dress, he wore yellow gauntlets high upon his wrists, looking as clean as if they had just come from the glove-maker; his hat was picturesque, his long boots and spurs were faultless." But at least now Banks was to some degree cooperating with Grant by keeping Gardner's garrison from helping Pemberton.

Grant knew that Pemberton might be tenacious in a conventional siege; they had known each other since the Mexican War, when Pemberton had demonstrated a stoically stubborn streak. So, hoping that a prompt attack might catch the enemy unprepared, Grant tried two assaults. In the first, on May 19, the Federals sustained 1,000 casualties,

a testament to the strength of the Confederate positions. A second assault, quite large, was hurled on May 22. One momentary breakthrough occurred, at a redoubt defending a railroad cut, but counterattacks closed the breach. Losses were heavy: of 45,000 Federals engaged, 3,199 became casualties, while the Confederates lost fewer than 500 men. Grant tried no more assaults, but he felt confident about the prospects of his siege. "The enemy are undoubtedly in our grasp," he wrote on May 24. "The fall of Vicksburg and the capture of most of the garrison can only be a question of time."

BANKS also tried two fruitless assaults upon Port Hudson: on May 27 and on June 14. In the first the Confederates safely held their fire until the Federals were within forty yards of the lines. "We are laying in our rifle pits," one smug Rebel wrote, "awaiting the hated foe. . . . They will catch it, sure. . . ." And catch it they did!

But the vicious episode gave rise to some exaggerated stories concerning the prowess of the Union's black troops, which the North used for propaganda. Fictitiously, the colored troops were

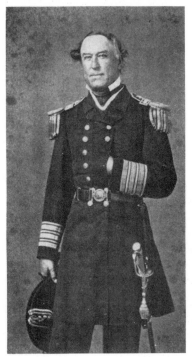

Admiral David G. Farragut brought his fleet from New Orleans up past the Port Hudson batteries to cooperate with his stepbrother Porter and with Grant. (USAMHI)

disciplined, ill-managed, and showed cowardice. Many of them were shot by their own disgusted comrades. One officer wrote, "I have heard before of negroes turning white from fright, and did not believe it; but it is literally true."

The June 14 assault was even more ignominious: the Federals lost 1,805 to a mere 47 Confederate casualties. Why had Banks ordered so reckless a venture? "The people of the North demanded blood, sir," he callously replied. Otherwise the siege dragged on, Gardner's 6,800 men defending well against Banks's 26,000.

The soldiers gave nicknames to the various field-pieces. There were names such as Bounding Bet, whose shells typically ricocheted along the ground, skipping and bounding and finally rolling like a bowling ball; and the Lady Davis, also called the Demoralizer, a 10-inch columbiad that the ammunition-short Rebels loaded with whatever they could find, from flatirons to nails. Sometimes such guns belched "cane knives, railroad spikes, bolts, hatchets, ramrods, nuts, wooden plugs fastened together with cotton, and broken pieces of bayonets."

And all the while the troopers burrowed deeper and deeper into the ground "like moles," seeking cover. The hot sun took a heavy toll too. Some of the men grew delirious, or fell asleep in the heat and died. But the siege continued, while sharpshooters and disease—scurvy and malaria—also took their share of lives. Exploding shells shattered the windows of the Port Hudson church, intermixing millions of glass fragments with the field peas stored there by the Confederate commissary. It became not unusual "to see hungry Confederates spitting out pieces of glass between bites of corn bread."

said to have "engaged in mortal hand-to-hand combat, fighting with bayonets: 'one Negro was observed with a rebel soldier in his grasp, tearing the flesh from his face with his teeth. . . .'" A wildly romanticized illustration appeared in *Harper's Weekly.*

Meanwhile, the Rebels were accused of equally fictitious atrocities: the Mississippians supposedly nailed black troops, while alive, to trees around the bluffs. Actually the blacks under Banks fought poorly (although Negro troops valiantly proved themselves on many other fields). They were badly

BUT IN MISSISSIPPI, Grant simply and masterfully outgeneraled his opponents. After things settled down to a siege, the Rebels could do little about it. With modesty and humor Grant afterward gave much credit to Pemberton by characterizing him as his "best friend." Nevertheless, Pemberton's "help" would have availed the Union little without Grant's energy and perceptiveness. Grant exploited the enemy's weakness by first turning against Pemberton and Vicksburg rather than joining Banks against Port Hudson, which Banks had urged and even Lincoln had thought wise.

After the siege began, Johnston received some

additional troops from Tennessee and South Carolina, but the Union reinforced Grant much more heavily. Union communications along the Mississippi, protected by gunboats, remained completely secure and Grant had only to wait, while enjoying a tactical security, until Pemberton—trapped against the river obstacle—was forced to surrender because of depleted supplies.

From boats on the river and from troops in the encircling lines, the Vicksburg populace and defenders suffered onslaughts against nerve and will. On June 2 one officer living within the besieged city declared that if the attack went on much longer, "a building will have to be arranged for the accommodation of maniacs," because the constant tension was driving people out of their minds. Union gunboats lobbed into the city huge mortar shells that made impact holes seventeen feet deep.

On the field the situation was described by Confederate Corporal Ephraim Anderson: "The enemy continued to prosecute the siege vigorously. From night to night and from day to day a series of works was presented. Secure and strong lines of fortifications appeared. Redoubts, manned by well-practiced sharpshooters, . . . parapets blazing with artillery crowned every knoll and practicable elevation . . . , and oblique lines of entrenchments, finally running into parallels, enabled the untiring foe to work his way slowly but steadily forward."

Another Confederate soldier recalled that "fighting by hand grenades was all that was possible at such close quarters. As the Federals had the hand grenades and we had none, we obtained our supply by using such of theirs as failed to explode, or by catching them as they came over the parapet and hurling them back."

And, as Anderson continued, "It soon became

But these could be costly heroics. Ships were hit, and some were lost in the repeated tauntings of the Confederate river batteries. On March 25 the steam ram Switzerland, *a ship belonging to the Army, went to the bottom. She appears here earlier off Cairo, Illinois, bristling with guns and soldiers.* (CHS)

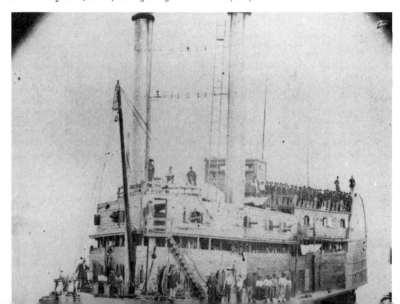

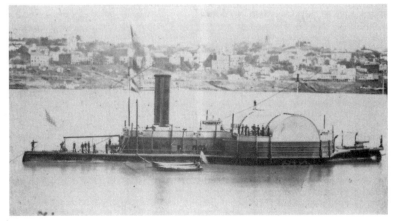

More formidable rams like the Vindicator *survived the passages, and lived to pose one day for the camera with the captured city in the background.*
(PENNSYLVANIA-MOLLUS COLLECTION, WAR LIBRARY AND MUSEUM, PHILADELPHIA)

evident that there was not an abundant supply of rations . . . one day, . . . among the provisions sent up . . . the only supply in the way of bread was made of peas. . . . This 'pea bread' . . . was made of . . . 'cow peas,' . . . a small bean, cultivated quite extensively as provender for animals . . . the idea grew . . . that, if reduced to the form of meal, it would make an admirable . . . bread. . . . But the nature of it was such that it never got done, and the longer it was cooked the harder it became on the outside . . . but, at the same time, it grew relatively softer on the inside, and, upon breaking it, you were sure to find raw pea meal in the center."

Meanwhile, as the city trembled from the bombardments, the people therein gradually reduced their daily meals to one-half and then to one-quarter rations. The Confederate engineer officer S. H. Lockett reported that the men ate "mule meat and rats and young shoots of cane." Dora Miller, one of the entrapped civilians, recalled that during the final days of the siege her servant found rats "hanging dressed in the market." Willie Tunnard, a Confederate enlisted man, wrote that rat

flesh, when fried, had a flavor "fully equal to that of squirrels." One Missouri soldier stoutly held that "if you did not know it, you could hardly tell the difference, when cooked," between mule meat and beef.

At last, after forty-seven days of siege, Pemberton and all but two of his officers agreed that they must surrender on July 4, 1863. The Federal losses amounted to 4,910 during the siege, while the Confederates had suffered casualties amounting to 1,872 before they then capitulated totally. The captives numbered 2,166 officers, 27,230 enlisted men, and 115 civilian employees; all were paroled save for 1 officer and 708 men who preferred to go north as prisoners. The Rebel army also yielded its entire complement of equipage: 172 cannon, large amounts of every ammunition type, and some 60,000 shoulder weapons, many of which were of such superior quality that some Union regiments exchanged their own for those they found stacked by their vanquished enemy.

"ALL WILL SING 'HALLELUJAH!' The heroic city has fallen! Vicksburg *is* ours!" proclaimed a Fed-

eral captain. To have to surrender on the American Independence Day was bitter indeed for the Southerners, but Pemberton had preferred to do it then, believing that he could get better terms. One citizen who had lived for weeks in a hillside cave said, "I wept incessantly, meeting first one group of soldiers and then another, many of them with tears streaming down their faces." For many hours they listened to "hateful tunes" played by the exuberant Yankee bands. The unreconstructed people of Vicksburg did not themselves celebrate the Fourth of July again until during World War II. But they *were* relieved, even if also demoralized, that the awful ordeal was over.

The news that Vicksburg had capitulated was sure to be the last thing needed to bring Port Hudson's surrender too. There was hardly any reason to continue to hold only one Confederate garrison on the Mississippi River. And sure enough, just a few days were all that were required: on July 8 Gardner asked Banks for terms. Port Hudson fell, having cost the Union nearly 10,000 men—dead, wounded, or physically impaired from disease or exposure—compared with the Southern losses of only 871. But now the entire Rebel garrison fell prisoner. And "The Father of Waters," as Lincoln gratefully proclaimed, again flowed "unvexed to the sea."

One mighty vessel after another ran past the batteries. (NAVAL HISTORICAL CENTER, WASHINGTON, D.C.)

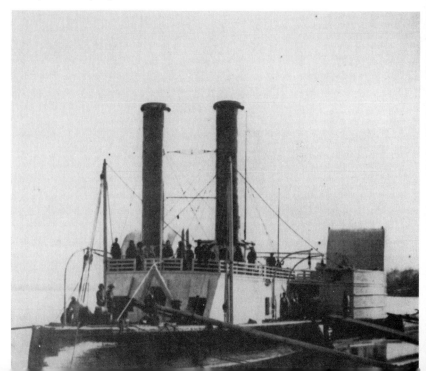

Colonel J. F. Pargoud, a Frenchman by birth, led his 3d Louisiana Cavalry in resisting Federal landings at Young's Point, Louisiana, when Grant began sending his corps into Louisiana to march below Vicksburg. (NATIONAL ARCHIVES, WASHINGTON, D.C.)

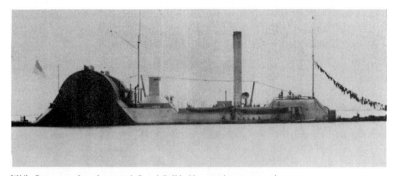

While Grant moved south to attack Grand Gulf in his campaign to approach Vicksburg from the south, Yankee soldiers and sailors made feint attacks north of the city at Haynes' Bluff on the Yazoo. One of the ships involved was the behemoth ironclad Choctaw. (LSU)

The seamen of the Choctaw *eventually battered the Yazoo defenses severely, then later became their enemies' saviors by plucking many Confederates out of the river in fighting at Milliken's Bend.* (LSU)

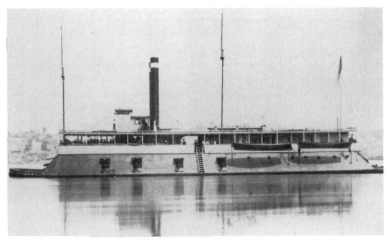

*Then came the attack on Grand Gulf, where Grant recrossed his army below
Vicksburg. Mighty ironclads like the* Louisville, *shown here in front of
Vicksburg, helped batter the Confederates' meager defenses before the crossing.*
(KEAN ARCHIVES, PHILADELPHIA, PA.)

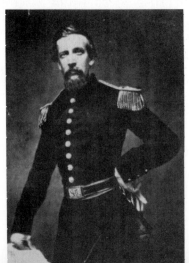

*A first-rate Confederate officer, Brigadier General
John S. Bowen of Georgia, maintained a spirited
defense, resisting first at Grand Gulf, and then
heroically at Port Gibson on May 1. For his efforts
he won promotion, but the ensuing siege of
Vicksburg so destroyed his health that he died a
week after the surrender.* (USAMHI)

As a diversion to assist his movement south of Vicksburg, Grant sent Colonel Benjamin H. Grierson and 1,700 men on a dashing raid into the interior of Mississippi and Louisiana. They rode 800 miles in seventeen days. The raid disrupted Confederate communications and made Grierson a brigadier general, as he appears here. (USAMHI)

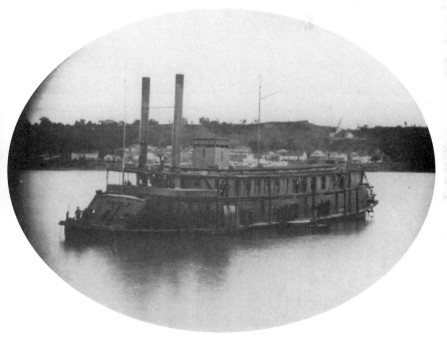

When Grant sent Sherman and 6,000 men on a feint up the Yazoo to Yazoo Pass, ostensibly in the hope of getting around to the eastern side of the city, the little tinclad Rattler served as flagship. She spent the rest of her career as a raider up and down the Mississippi. (NHC)

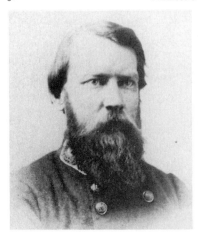

It was at Champion's Hill on May 16 that the Union and Confederate armies finally came together in the first major battle of the campaign. Brigadier General Seth Barton and his brigade held the left of the Southern line, but could not withstand. The rout of Barton threatened the whole Rebel army. (VALENTINE MUSEUM, RICHMOND, VA.)

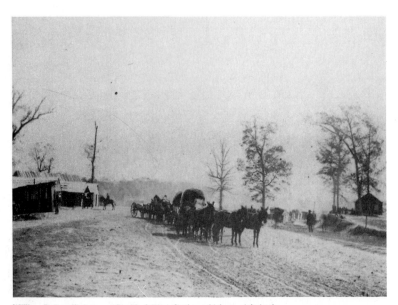

William R. Pywell's image of Big Black River Station, which was right in the center of the Union and Confederate lines. (LIBRARY OF CONGRESS, WASHINGTON, D.C.)

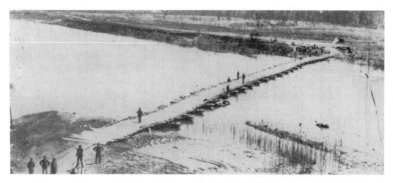

Finally the Confederates crossed the river and burned the bridge behind them.
Grant could not cross until this and other pontoon bridges went up in its place.
This J. M. Moore photograph purports to show Union soldiers in the foreground
and Confederate guards and wagons on the other side, but such is not likely to
be the case. (OLD COURT HOUSE MUSEUM, VICKSBURG, MISS.)

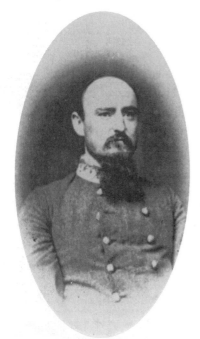

Colonel Hylan B. Lyon and his 8th Kentucky
Cavalry covered the Southern retreat to Vicksburg
after the defeat at Champion's Hill, and then later
escaped from the siege. (USAMHI)

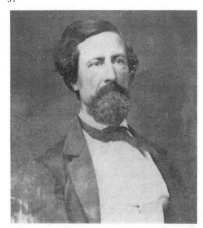

But there was nothing left but a siege for Lieutenant General John C. Pemberton. He was a Pennsylvanian loyal to the Confederacy, and soon felt himself abandoned by his government and his army. He was not a brilliant commander, but few in his situation could have achieved more. (USAMHI)

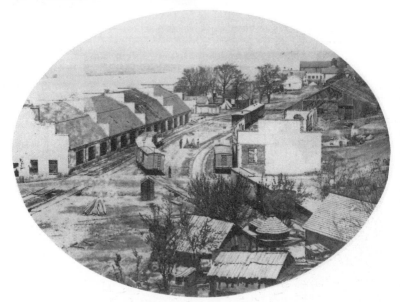

Vicksburg's railroad depot on the Vicksburg & Jackson line. Until Grant cut off the rail link, this was the destination of the supplies the Confederates stockpiled to resist him. (KA)

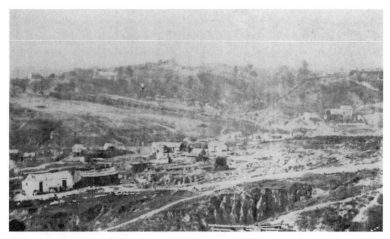

The shantytown just below Vicksburg, as seen by a photographer of the city's Washington Photographic Gallery. Much of this vicinity was virtually swept clean in the advancing fortifications of the besieging Federals. (KA)

Closer to the city the Washington Gallery artist captured a view of an earthwork fortification in the left distance, a flag flying overhead. (KA)

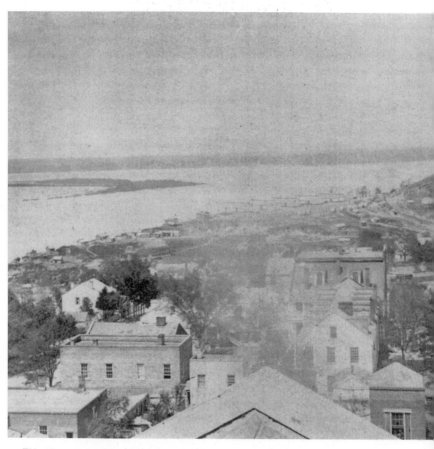

This 1864 panorama of two images offers a wide view of the northeastern portion of Vicksburg, looking toward Fort Hill in the distance. It is seen from the cupola on the Warren County Courthouse. (KA)

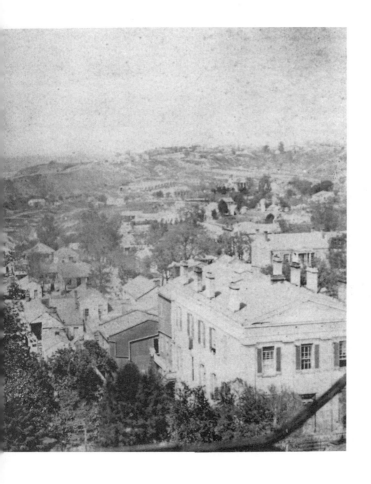

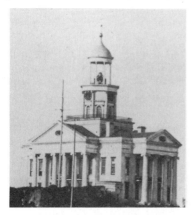

Visible to all, Union and Confederate, was the Warren County Courthouse. At 5:35 one afternoon the Washington cameraman caught the Greek Revival building, which still stands today. Never the scene of fighting itself, the courthouse became in a measure symbolic of the struggle for Vicksburg. (KA)

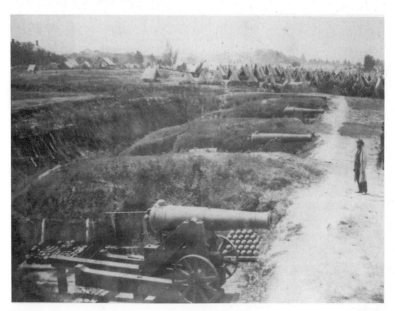

Row after row of heavily emplaced guns were so situated as to be nearly impervious to Union naval gunnery. That in large measure is why Grant had to take the city from the rear, its landside. This image, probably by French & Company of Vicksburg, was made after the city fell. (KA)

The Tuscumbia, *with the USS* Linden—*number 10—in the background, and two of the mortar boats that pounded Vicksburg night and day during the siege.* (NHC)

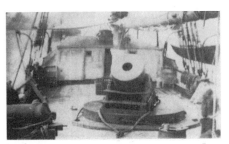

Schooners with mortars mounted on their decks also entered the bombardment; their high arching shells, with fuses sputtering like rockets in the night, provided not only danger but also an element of entertainment for Vicksburg's citizens. They watched the shells and became rather expert in predicting where they would fall. (USAMHI)

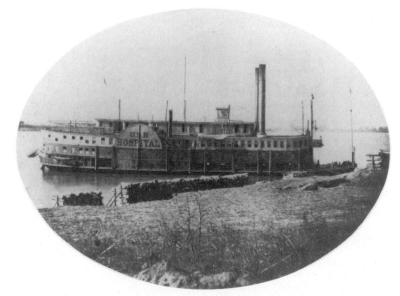

There were other vessels in Grant's combined forces, but none more unique than the Red Rover. *She had been a Confederate troopship at the war's start, then fell to the Yankees with the capture of Island No. 10 in 1862. They converted her into an army hospital ship and later transferred her to the webfoot service, making the* Red Rover *the Navy's first hospital vessel.* (NHC)

The 8th Wisconsin, a fine regiment in its own right, was best known in the army for its eagle mascot, "Old Abe." The bird adopted the regiment, staying with it through most of the war. In battle, said the Badgers, Old Abe went aloft, circling over the fray and screaming at the enemy. When he died after the war, they had him stuffed. A J. M. Moore image. (OCHM)

Only a little more successful in the May 22 attack than Sherman was the corps of Major General James B. McPherson, here seated second from the right among his staff. Behind him is the Balfour house, his headquarters in the weeks after the siege. A young general of remarkable promise, he was already a particular favorite with Grant. (KA)

McPherson's division commanders, men like General John "Blackjack" Logan, got no nearer Vicksburg than did Sherman. (USAMHI)

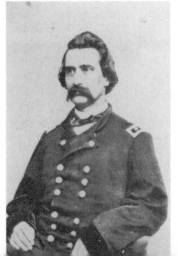

And the division of Brigadier General Marcellus Crocker did not get into the fight at all. (USAMHI)

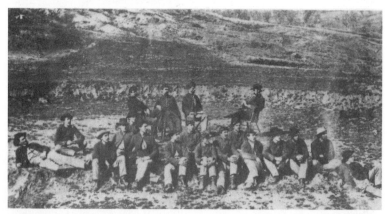

McPherson's signal corpsmen had little to do but watch and pass an occasional message. A French & Company image. (KA)

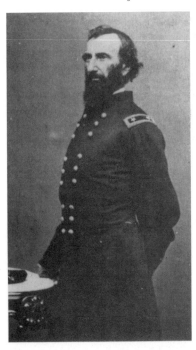

Only the troublesome and boastful Major General John A. McClernand achieved something of a breakthrough, attacking the eastern defenses of the city. (USAMHI)

Tough Western regiments like this one, drawn up for the camera near Vicksburg, pushed their way into, and briefly through, part of the Confederate fortifications to threaten more than half a mile of the Rebel earthworks. A French & Company image of an unidentified Federal regiment. (KA)

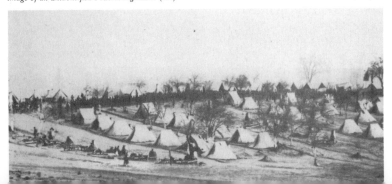

Defending against McClernand's attack was Brigadier General Stephen D. Lee. He had been at Fort Sumter, then Bull Run, but came west to command Vicksburg's artillery for a time before taking charge of a brigade right at the point where McClernand broke through. (GEORGE H. AND KATHERINE M. DAVIS COLLECTION, TULANE UNIVERSITY, NEW ORLEANS, LA.)

Supporting Lee was Waul's Texas Legion, commanded by Colonel Thomas N. Waul. Waul retook the salient captured by the Federals and ended Grant's May 22 penetration. That made siege a certainty and made Waul a brigadier a few months later. (USAMHI)

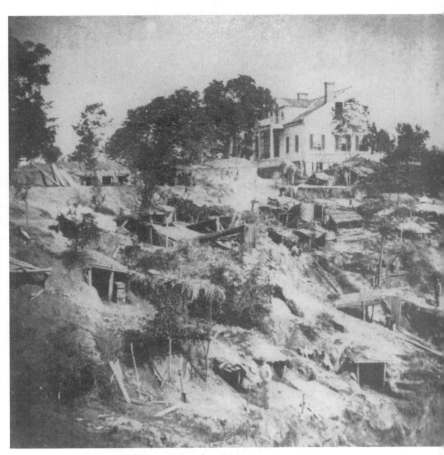

Now came the long waiting, the bombardment, and the hunger and disease of summer: the Siege of Vicksburg. Soldiers and civilians on both sides turned mole, living in dugouts and caves. Here the 45th Illinois bivouacked beside the James Shirley house. The Shirley home, the "White House," stood between the lines and miraculously survived the siege. (OCHM)

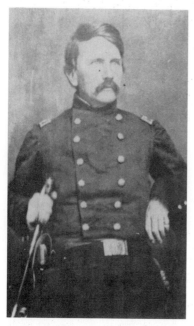

As Grant invested the city, he had to guard against an embryonic army building under Joseph E. Johnston, who was trying desperately to relieve Vicksburg. To protect his flank against Johnston, Grant sent the Missouri politician turned soldier Major General Francis Preston Blair, Jr. (USAMHI)

And to protect Grant from himself—so some said—he relied upon his friend and chief of staff John A. Rawlins, shown here as a brigadier following his promotion in August 1863. Rawlins claimed that he kept Grant from the bottle. (P-M)

The forty-seven days of siege proved a constant test of resolve and stamina, and a test of blood as well. Brigadier General Isham W. Garrott of Alabama sought to relieve the boredom by himself borrowing an infantryman's rifle and going out on the skirmish line to fire at the Yankees on June 17. The escapade cost him his life just days before his brigadier's commission reached him. (VM)

Meanwhile, Grant brought in reinforcements as he slowly built an irresistible iron wall around Vicksburg. From Virginia he was to receive Major General W. F. Smith and his IX Corps, shown here embarking at Aquia Creek in February 1863. In fact, the IX Corps never reached him at Vicksburg in time to participate in the siege. Alexander Gardner made this image. (LC)

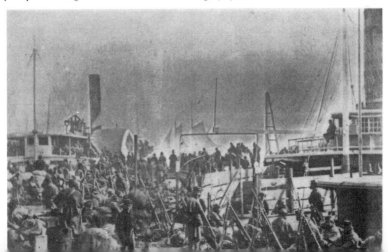

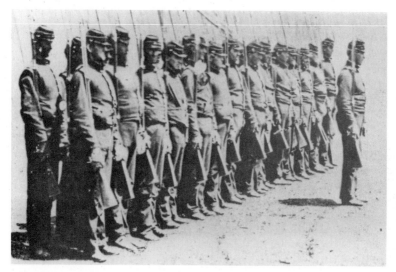

Other reinforcements did arrive, swelling the Union numbers. The 2d Michigan came, its last battle the humiliation at Fredericksburg. They would welcome a victory. (BURTON HISTORICAL COLLECTION, DETROIT PUBLIC LIBRARY)

In June Francis J. Herron, at the time the youngest major general on either side, brought his small division to Grant. One of his brigades was led by Brigadier General William Vandever, shown here seated at left with his staff. On the table before them a saber rests atop a map, perhaps of Vicksburg. (FRED EADS)

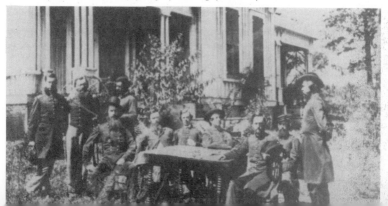

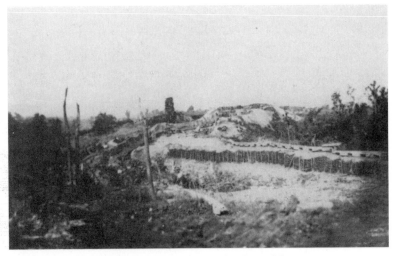

*Closer and closer the advancing earthworks came. Photographers Armstead &
Taylor of Corinth made this image of a section of the lines called the gap, and
behind it an observation post dubbed Coonskin Tower. To the defenders it
became increasingly clear that time was against them.* (CHS)

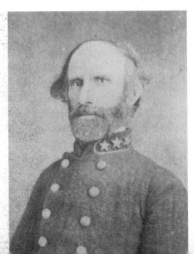

*They held out bravely. Colonel A. W. Reynolds
said that "during these forty-seven days, under the
terrific fire of the enemy's artillery and infantry, the
officers and men of the brigade bore themselves
with constancy and courage. Often half-fed and
ill-clothed, exposed to the burning sun and soaking
rains, they performed their duty cheerfully and
without a murmur."* (USAMHI)

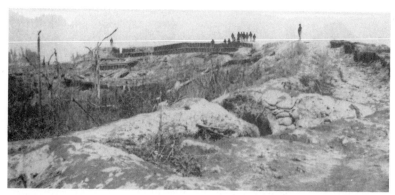

As June came to an end, Grant stepped up his work, launching repeated reconnaissances and small assaults. Here stood Fort Hill, the Confederates' principal earthwork on the river north of the city. On June 25 the Federals attacked and took it. (KA)

By July 3 Pemberton could hold out no more. The next day he surrendered, and jubilant Federals soon occupied the prize they had coveted for so long. At last Yankee soldiers could pose for French in front of the courthouse. (KA)

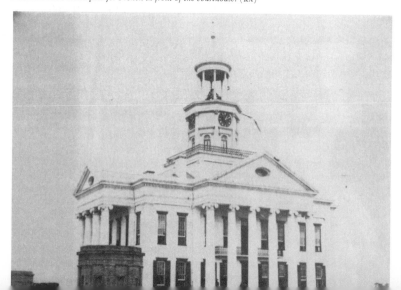

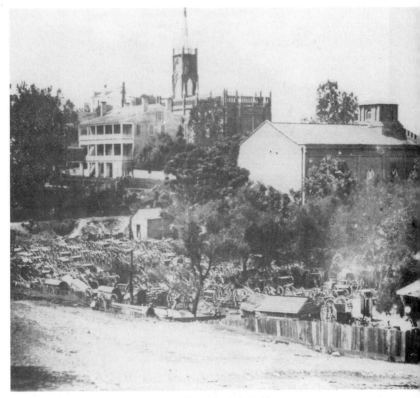

The photographers eagerly recorded the captures. Vacant lots bulged with Confederate artillery seized as spoils of war. Vicksburg's Methodist Church stands at right. The Catholic Church is in the center under the steeple. (KA)

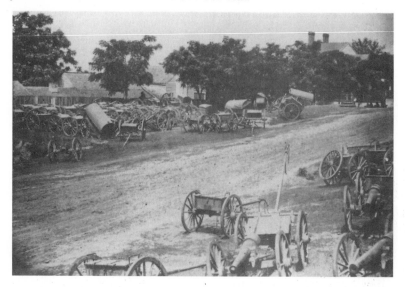

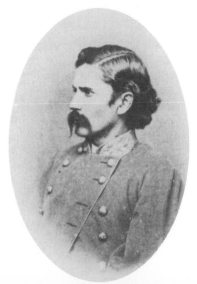

Brigadier General George Cosby, like the other Confederates with Johnston, got only as close as Jackson before learning of Vicksburg's surrender. They withstood a Federal attack on the city for a day before they pulled out, leaving Grant undisputed ruler over central Mississippi. (USAMHI)

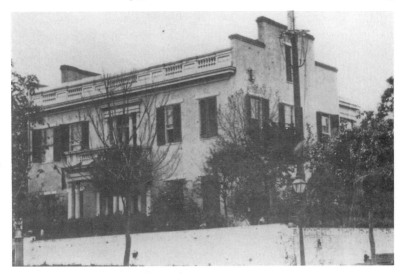

For a time Grant made his headquarters in this Vicksburg house. (USAMHI)

The Signal Corps set up shop in this mansion; their signal wigwag flags hang from the balcony. (USAMHI)

The Quartermaster's people camped behind the city along the old Confederate lines of fortifications. (USAMHI)

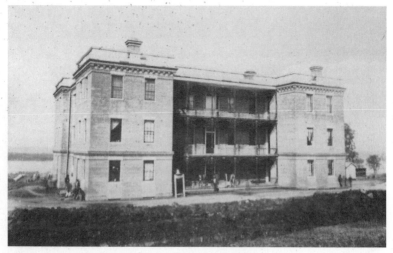

Hospitals, like this U.S. Marine Hospital overlooking the river, appeared everywhere. Unfortunately French blurred his own image in making this picture. (KA)

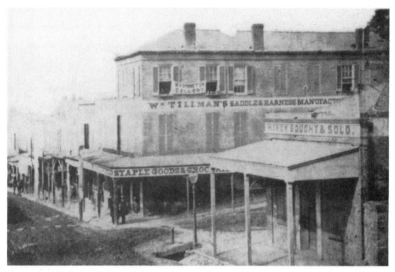

*Among the first to take advantage of the capture were, of course, the
photographers. The Washington Gallery established itself in the third floor of
William Tillman's Saddle & Harness Manufactory.* (USAMHI)

*Everyone wanted a photograph. French found these rugged Westerners in front
of the courthouse.* (KA)

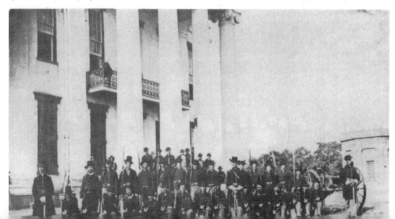

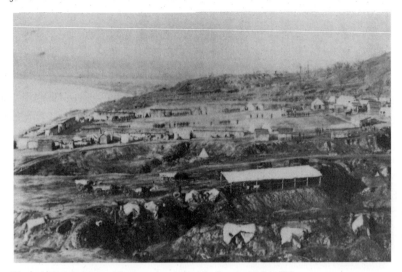

The 20th Mississippi Colored Regiment drew itself up for French with Fort Hill in the background. (KA)

Some regiments stood in front of their tents. (P-M)

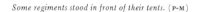

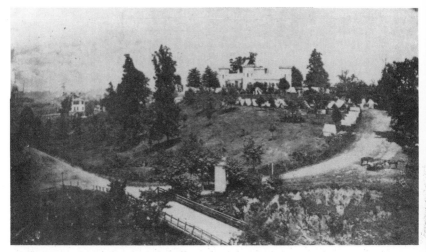

They posed where they camped, as around "The Castle," an unusual home surrounded by a small moat. Armstead & Taylor found it interesting. (OCHM)

Grant soon put his men to work refortifying the river batteries as well as the landside lines, for Vicksburg could always be attacked again by men in gray. He built a formidable battery on the river called Castle Fort. From a height of nearly a thousand feet it mounted fifteen guns. (KA)

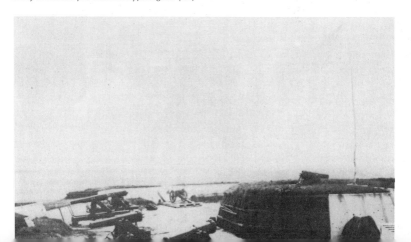

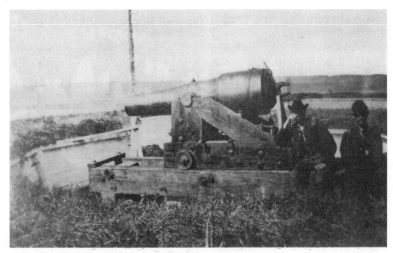

One of those guns was that same 7.44 Blakely used by the Confederates.
(USAMHI)

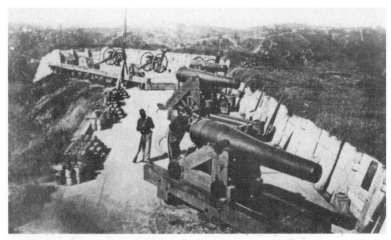

More guns went into Battery Sherman, guarding Vicksburg's rear on the road to Jackson. They would never fire. (USAMHI)

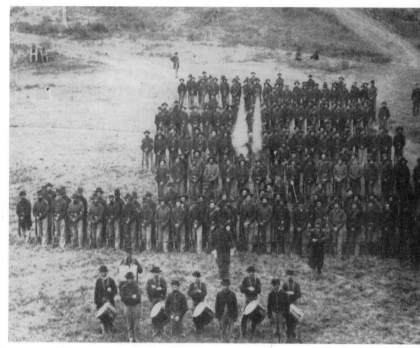

The 17th Illinois Infantry, veterans of the fights at Jackson and Champion's
Hill, and the heavy May assaults on Vicksburg, stayed after the surrender to
garrison the newly won prize. They stand for the camera here early in 1864, the
very picture of the rugged, unkempt, rather unmilitary Western soldier. They
were not much on parade. But they could tear the heart out of the Confederacy.
(NA)

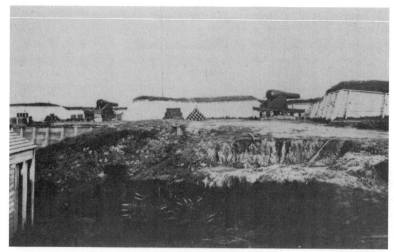

Vicksburg, it seemed, was still a fortress city. Only the armies had changed.
(KA)

*But it was a long river, with more than one Confederate bastion to guard it.
Ships like David G. Farragut's Hartford moved up and down the mighty
waterway between Vicksburg and another fortress, Port Hudson.* (USAMHI)

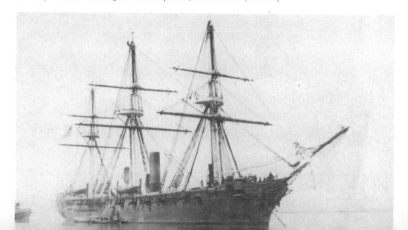

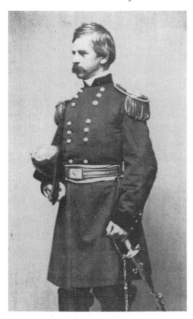

It was intended to be the prize of another politician-turned-soldier, Nathaniel Prentiss Banks of Massachusetts. When the Confederate fortifications finally fell, it would be largely in spite of him. (USAMHI)

Banks commanded from New Orleans and Baton Rouge, staging his operations against Port Hudson from the latter. At the Baton Rouge arsenal his own guns guarded the river below Port Hudson. (LSU)

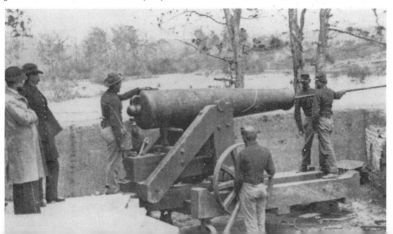

There, overlooking the Mississippi, his army gathered strength, and lost some of it as well. Men of the 52d Massachusetts who died before the campaign could begin. (ILLINOIS STATE HISTORICAL LIBRARY, SPRINGFIELD)

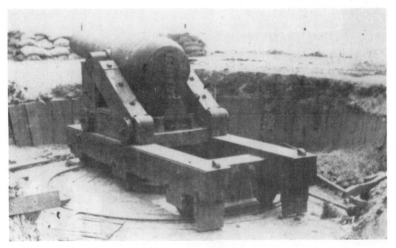

The goal was Port Hudson, itself a village of no significance, but along these steep bluffs the Confederates had placed powerful cannon that commanded the river. An image by the Baton Rouge firm of McPherson & Oliver. Some of the cannon bore names, like the Lady Davis, a 10-inch columbiad. (USAMHI)

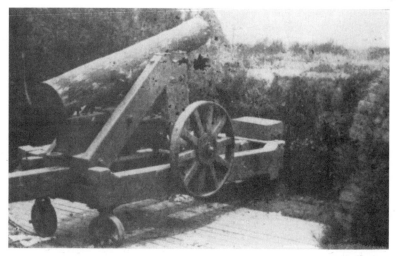

Even a few "Quaker guns," imitation cannon made from logs, could intimidate a Federal ship. From a distance the sham cannon looked like the real thing. (USAMHI)

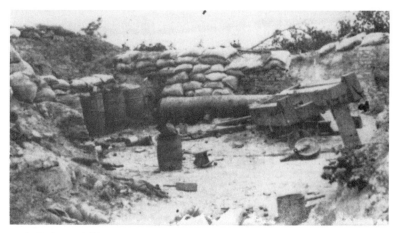

But the Yankee vessels did challenge the batteries from time to time, and they could inflict damage. A well-aimed shot has completely dismounted this Rebel cannon and ruined its siege carriage. (USAMHI)

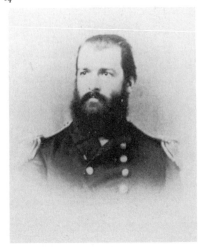

*And so could those shore guns sting. Lieutenant
Commander A. Boyd Cummings steamed his ship
the* Richmond *against Port Hudson on March 18,
1863. It cost him his life.* (USAMHI)

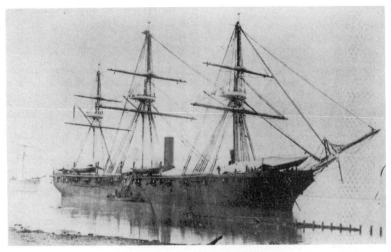

The Richmond *itself, almost a double for the* Hartford, *escaped to fight again.*
(OCHM)

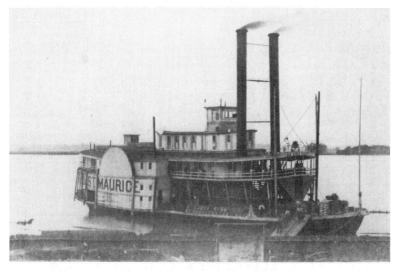

Scores of lesser ships like the "Red River Packet" St. Maurice *did not challenge the batteries as the warships did, but they steamed constantly up and down the river, bringing more troops and more supplies to the besieging Federals. The* St. Maurice *appears here well laden with barrels and sacks of food. Frequently she carried important dispatches to New Orleans as well.* (GLADSTONE COLLECTION)

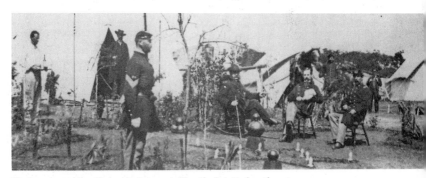

The investment of Port Hudson finally came in May, the first attack on the Confederate works being led by Major General Christopher C. Augur, seated in the rocker at his Baton Rouge headquarters. This image was made by the very capable local photographer A. D. Lytle, whose artistry surpassed that of most of the other cameramen on the Mississippi. (LSU)

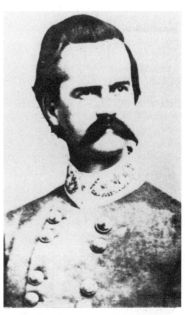

In that May 27 attack, which failed, the 38th Massachusetts occupied this ravine and then held it for the next week in the face of constant Rebel sniping from the trees beyond. In a later assault on June 14, 1863, Federals found themselves trapped by enemy fire for several days and nights. (ISHL)

The first Confederate commander of Port Hudson had been Brigadier General W.N.R. Beall. Later superseded, he remained throughout the siege and, after his capture, was released by the Federals to set up a New York City office for selling captured cotton! (MUSEUM OF THE CONFEDERACY, RICHMOND, VA.)

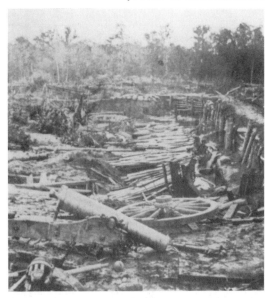

In the big attack of May 27, the Confederates held their ground manfully. This image, taken after the siege, shows one of the most hotly contested points of attack. (USAMHI)

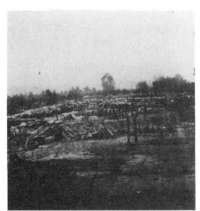

These Rebel earthworks were almost within a stone's throw of the Federal emplacements along the line of trees in the background. It was to be a long and bitter siege for both armies. (USAMHI)

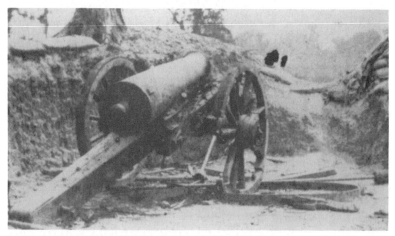

And it would be costly in men and matériel. Yankee fire almost completely dismounted this gun. (USAMHI)

One more shot and it would fall to pieces. (NA)

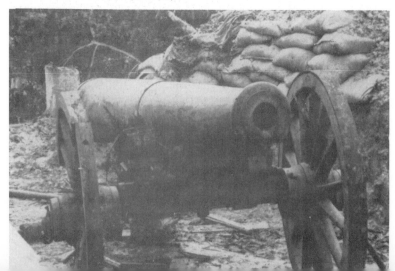

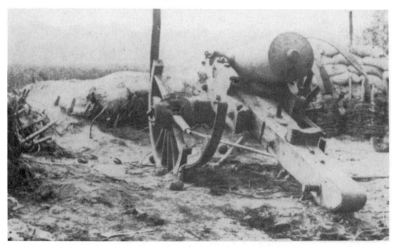

This Rebel cannon seemed to defy gravity by remaining standing. (USAMHI)

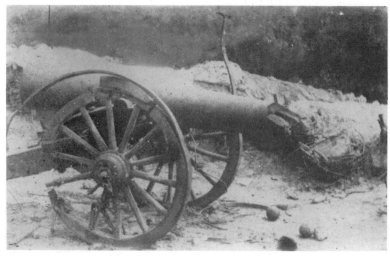

It would never fire again. (OCHM)

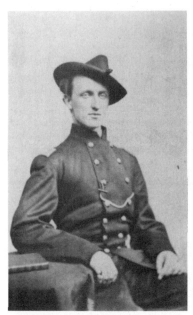

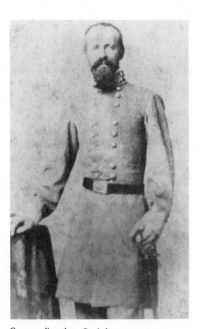

Colonel William F. Bartlett had already lost a leg at Yorktown the year before. In the attack on May 27, he rode his horse straight for the Confederate lines and was hit twice. Ignoring his wounds after he fell, he watched his horse bound for the rear, and commented that the animal "jumped like a rabbit." Bartlett would become a brigadier, and rumors circulated that Confederate officers told their men not to fire at the gallant horseman. (USAMHI)

Commanding those Confederates was a man equally gallant, Major General Franklin Gardner. There was a delicious irony in the fact that Pemberton, defending Vicksburg, was a Pennsylvanian and Gardner a New Yorker. His brother fought with the Union, but Gardner's loyalty to the Confederacy was as undoubted as his ability. (CONFEDERATE MUSEUM, NEW ORLEANS, LA.)

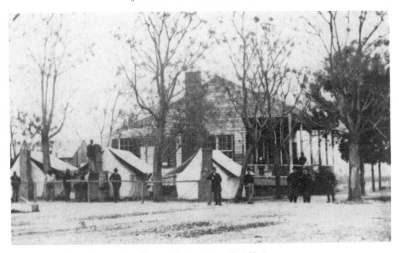

Gardner made his headquarters here just outside the village of Port Hudson. After the garrison fell, it became headquarters for Brigadier General George L. Andrews, who stands in the center, leaning against a post. (USAMHI)

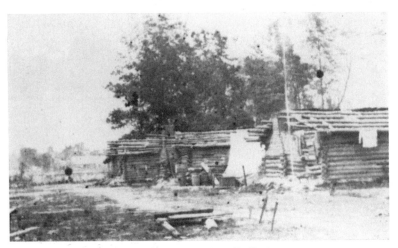

Gardner's soldiers lived as best they could, often in makeshift cabins like these barracks on the edge of the village. (USAMHI)

The Confederates ground their corn into meal in these mill buildings during the siege. But finally the sound of the mill at work drew Federal artillery fire that destroyed it. This and several other images of Port Hudson were gathered by Captain J. C. Palfrey, Banks's chief engineer directing the siege work. (USAMHI)

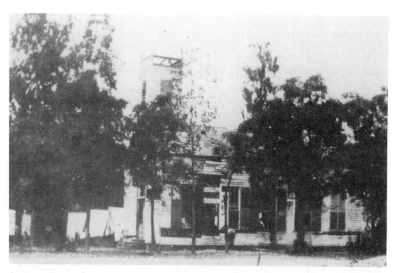

Gardner used this church as a granary for his corn supplies. They dwindled rapidly, and the men resorted to eating rats and other vermin. Gardner, unable to get tobacco, smoked magnolia leaves in his pipe. (ISHL)

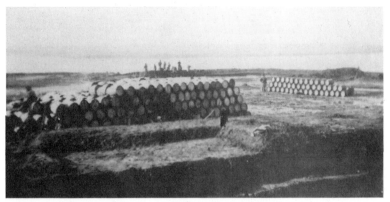

The only supply that the Confederates had in abundance was salt, barrels and barrels of it, along with more barrels of molasses. They left loads of it behind when they surrendered. (CHS)

And on went the siege. Palfrey and his assistants gradually built an ever-tightening grip of saps and earthworks around Port Hudson. They used the materials at hand, trees and cotton bales, as here at the emplacement for Captain Richard Duryea's Battery F, 1st United States Artillery. (USAMHI)

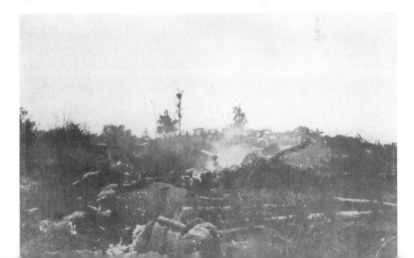

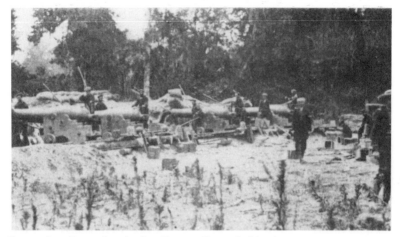

Even guns from ships were brought ashore. Lieutenant Commander Edward Terry brought these 9-inch guns from the Richmond *to make a formidable battery.* (USAMHI)

The 1st Indiana Heavy Artillery built an imposing cotton parapet for its guns, but at least one Hoosier found sufficient free time to devote himself to carving a picture of a house on the trunk of the tree in the left foreground and his company number above it. It was in front of this battery that the Union and Confederate lines came nearest to each other. Soldiers threw messages back and forth. (USAMHI)

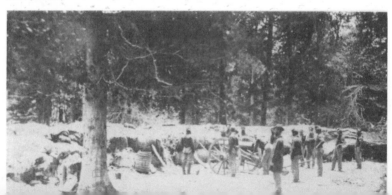

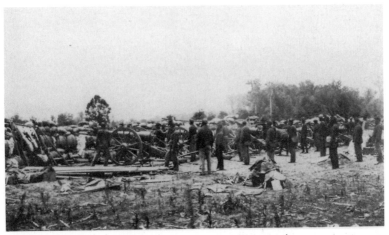

The 18th New York Artillery used cotton bales as well, shielding their mammoth 20-pounder Parrott rifles. (USAMHI)

This image, made after the siege, shows a Confederate line in the foreground and the Federal parallel just beyond it. That is how close together enemy earthworks came in places. (USAMHI)

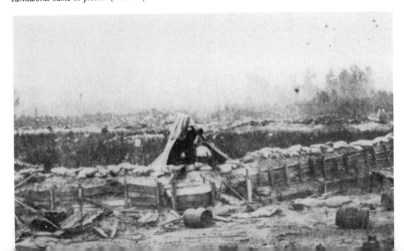

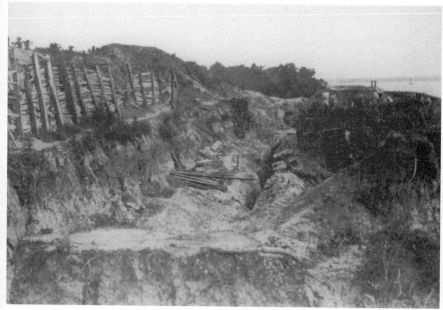

It was Captain James Rundel of the 156th New York who brought photographers McPherson & Oliver to Port Hudson to make these and other scenes of the siege. They captured the look of the Citadel, a major Confederate work on the river. Banks and his people were digging tunnels under the Citadel, intending to blow it apart from underground at the same time the infantry attacked. The surrender came just a day before the scheduled explosion. (ISHL)

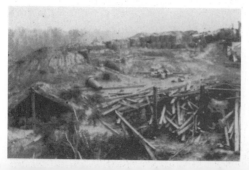

The interior of the Citadel. (USAMHI)

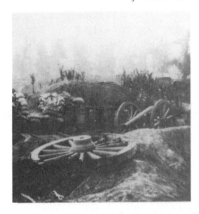

By the time the siege was done, everywhere inside Gardner's lines was a scene of destruction and decay. (USAMHI)

A massive seventeen-gun Union artillery emplacement near the Citadel had dismounted or destroyed several cannon and forced its occupants to burrow into the earth for protection. The Federal artillery position is in the background. (USAMHI)

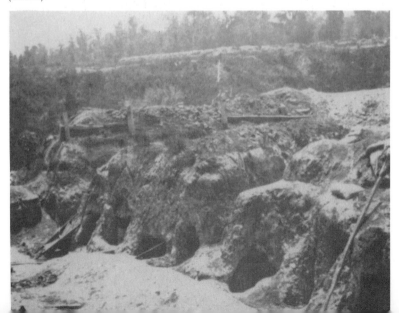

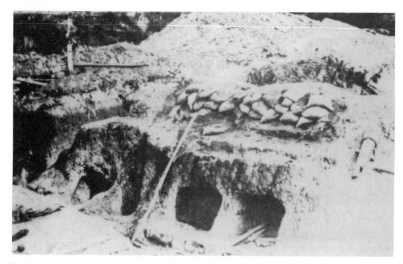

Everywhere there was ruin. (USAMHI)

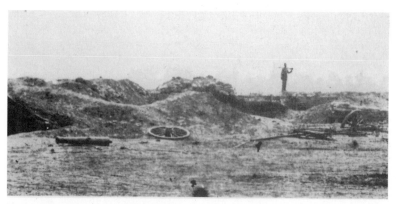

Their works crumbling, their supplies exhausted, their weapons being blown apart, the Confederates could not hold out. (ISHL)

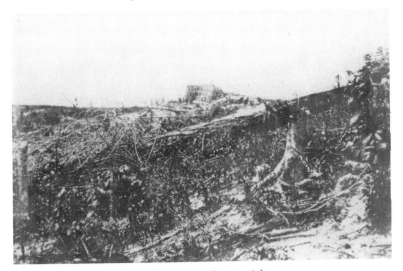

*The Trench Cavalier, a massive trench that ran close to the center of the
Confederate fortifications. To protect it, the Federals built the parapet of
hogsheads in the center, and from behind it, they fired almost directly down and
into the trench.* (USAMHI)

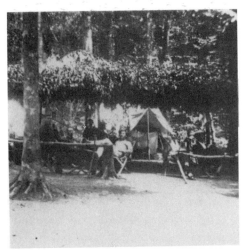

*Brigadier General Cuvier Grover
directed the operations against the
Confederate left, including the
Trench Cavalier, and as June moved
into July, began readying several
mines to explode under the Rebel
works. Here at his headquarters
Grover takes the shade, seen in profile
wearing a hat, fourth from the right.*
(USAMHI)

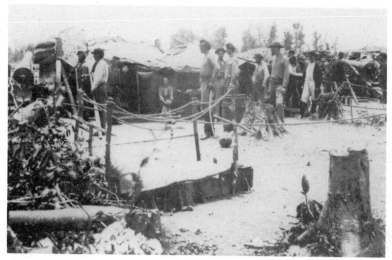

*Powerful batteries like these 30-pounder Parrotts readied a devastating fire for
the final assault when it should come.* (USAMHI)

*Battery A, 1st United States Artillery. Gardner was ringed with cannon wherever
he looked.* (USAMHI)

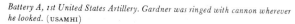

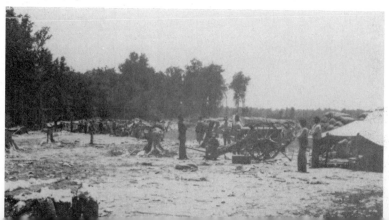

This mine ran under the Citadel. On July 7 Banks expected to detonate it. (USAMHI)

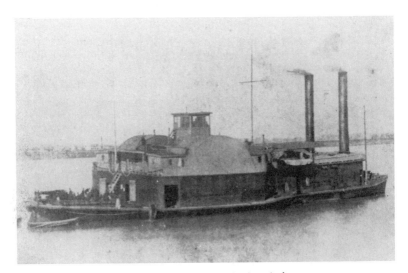

But that morning the General Price, *once a Confederate vessel and now in the Union service, arrived near Port Hudson with the news that Vicksburg had surrendered.* (LSU)

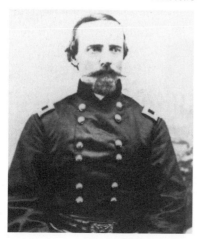

A Yankee colonel wrapped a copy of the message around a stick and threw it into the Confederate works. There was no arguing with it. A heroic defense could do no more. On July 9 General George L. Andrews led the conquering Federals into Port Hudson. (RONN PALM)

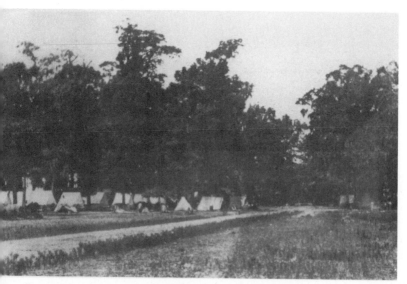

Now the soldiers could rest at last, pitch their tents in the shade of the trees, and try to survive the Deep South summer. (ISHL)

For the tinclad vessels that once braved the batteries of Vicksburg and Port Hudson, ships like the Kenwood, *there was now the routine of patrol duty and an occasional raid. The river was not altogether quiet, but no more fortress batteries on overhead bluffs would threaten Porter's fleets.* (USAMHI)

Once more Vicksburg's waterfront bustled with river commerce, with steamboats like the James Watson *and the* White Cloud *vying for room at the levee.* (USAMHI)

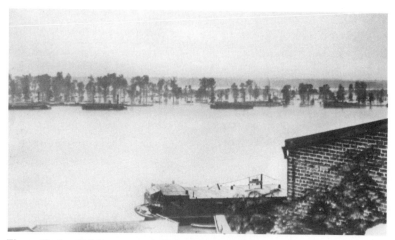

The warships, too, plied the waters, even in times of flood, as here with the river seven feet above her banks in 1865. In the background three tinclads, the powerful city-class gunboat Louisville, *and the old woodclad* Tyler *rest easy on the river they helped to win.* (KA)

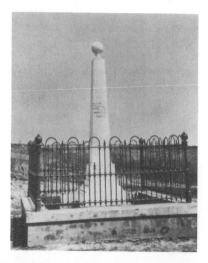

On July 4, 1864, a year to the day after Vicksburg's surrender, Federal soldiers erected a monument on the place where Grant and Pemberton met to make terms. The earthworks are still visible in the distance. With the war not yet done, still the men who fought sensed something greater than themselves about it all, something that needed commemoration. (KA)

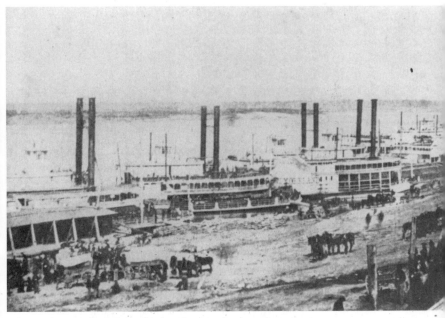

*With Vicksburg safely a Union port, the endless procession of steamboats
carrying the Lincoln soldiers off to new campaigns and victories commenced.
Here early in February, Brigadier General James Tuttle's division, including the
brigade of Brigadier General Joseph Mower, arrives aboard the* Westmoreland
and other boats, bound for Meridian, Mississippi. (THOMAS SWEENEY)

Following the Armies

Wherever they go, the camera follows

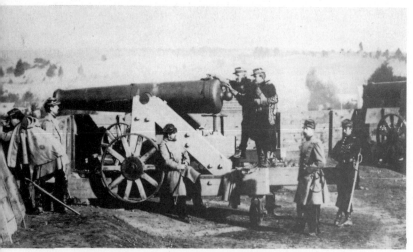

The march leads past the fortifications and the posturing officers like Colonel—later General—Régis De Trobriand, who stands atop the carriage sighting along the cannon's barrel. Just to the right, and standing with him, is General Daniel Butterfield, often erroneously credited with authoring the bugle call "Taps."
(LC)

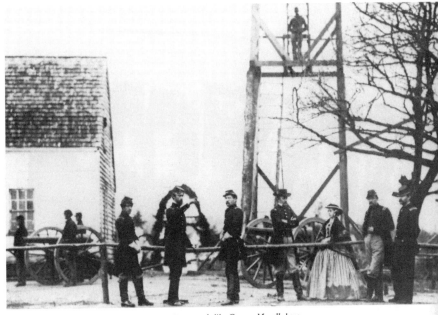

Past signal towers near headquarters, past the generals like George Morell, here pointing toward Confederate lines at Miner's Hill, Virginia. (CHS)

Following the armies, the photographer captured them as they went into formation for the march, as here in this early war image. (LEONARD L. TIMMONS)

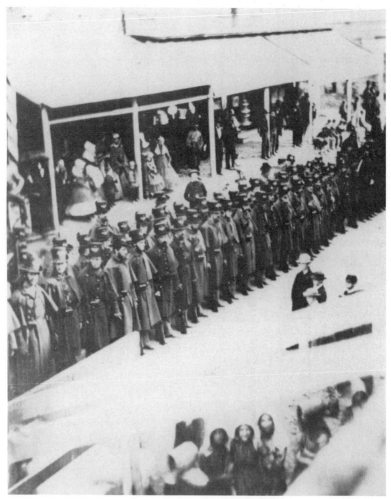

They might be soldiers, but they were young men, too. More than one has his eyes turned toward the huddled young girls in the foreground, while they earnestly try to appear oblivious. It is a game even older than war. (RP)

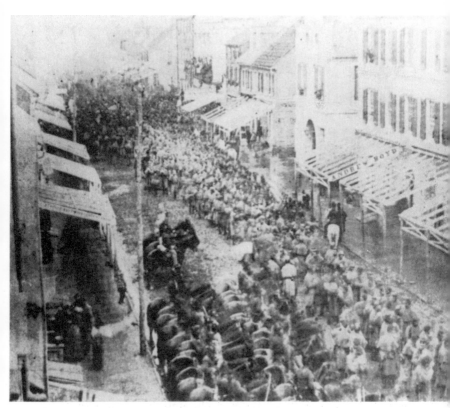

*Wherever the foot soldiers went, the photographer was not far behind. Often
the march led through a nearby town or city. Here Federal regiments stand at
ease after passing onto North Market Street in Frederick, Maryland. The
bunting and the patriotic displays in some windows indicate that this may be a
ceremonial occasion that a photographer captured from J. Rosenstock's
second-floor window.* (BENJAMIN B. ROSENSTOCK)

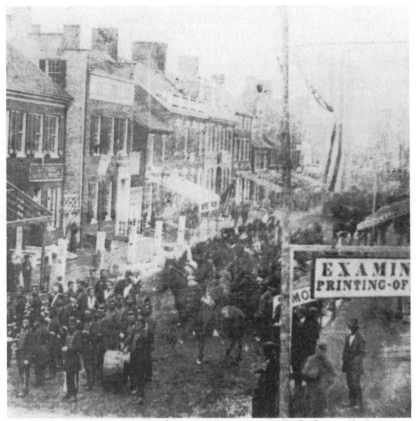

*A band and mounted troops that accompany the column stand in North Market
Street in Frederick, obviously part of a parade. The armies often performed these
ceremonial functions. They built morale at home and in the armies as well.*
(BENJAMIN B. ROSENSTOCK)

But most of the time the march was real. Without the bands and the panoply, the armies marched toward each other, toward fire and battle. Here Federals are camped at the ruins of the bridge at Berlin, Maryland, on the Potomac, in October 1862. They are poised to pursue Lee back into Virginia. (LC)

Army wagons crossing the Union arch of the Washington Aqueduct, where thousands of men and wagons crossed into Virginia. (GLADSTONE COLLECTION)

On the march, James Gardner's image of troopers and pontoon bridge on the Rappahannock, near Fredericksburg, Virginia. (LC)

In the enemy's land new headquarters are established, new scenes for the soldier and the camera. Here the headquarters of the Army of the Potomac near Culpeper, Virginia, in September 1863. Now the army belongs to George G. Meade. (P-M)

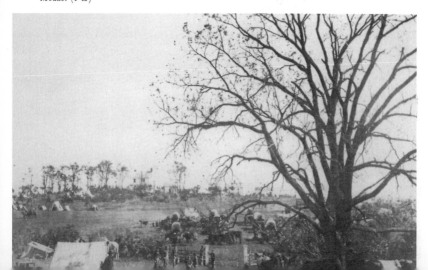

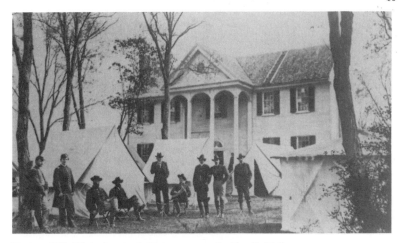

Meade established his headquarters in this house, surrounding himself with these officers who became commonplace faces to the men of the army. (P-M)

Several months later Major General John Sedgwick made this handsome Virginia house his headquarters near Brandy Station, Virginia. Wherever the armies went, the generals made good use of local establishments for official purposes. Sedgwick himself stands third from the right. (USAMHI)

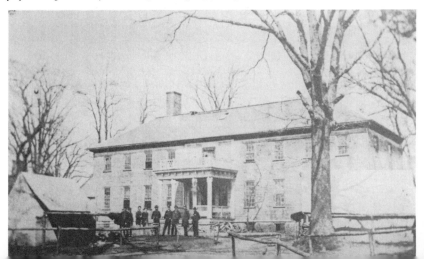

*William Kunstman of Pennsylvania took his camera to Virginia to record
keystone soldiers in the field. The studio may have been primitive, but the artist
posed by it with pride.* (MRS. FREDERIC KNECHT)

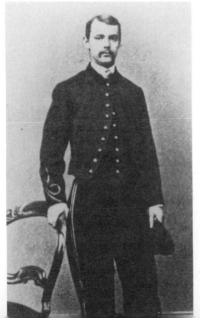

*Relatives of the leaders were familiar sights on the
march. Many served as aides. General Meade's son
George was a captain and aide-de-camp to his
father.* (P-M)

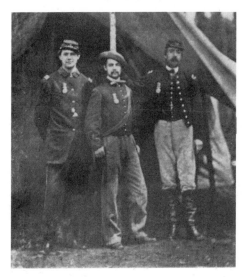

He dressed jauntily and delighted in standing for the camera, as here, at center with two friends. The man at right, Captain F. M. Bache, is another Meade relative. (P-M)

All too familiar on the march, and justly dreaded, was the provost marshal general, Brigadier General Marsena Patrick. A stern man, but with heart, he followed the army, ever vigilant for wrongdoers. (USAMHI)

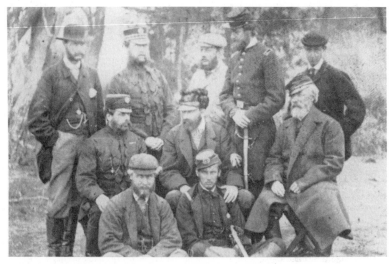

*Familiar, too, were the foreign officers who flocked to the armies to observe for their own curiosity, as well as their governments' information, this American war. Brigadier General Stewart Van Vliet, seated at right, poses for Barnard & Gibson with several British and French officers. (*BRUCE GIMELSON*)*

*Equally colorful, though regarded as far more sinister, were the scouts and guides who led the armies through the South. Those shown here served the Army of the Potomac. Loyal men, renegades, men for hire, all were among their number. Many a soldier mistrusted the true motives of the guides, though most served faithfully. Some became noted in their own right, among them Dan Plue, lying at far left, and Dan Cole, seated at right of center in checked pants. They all looked tough and were. (*USAMHI*)*

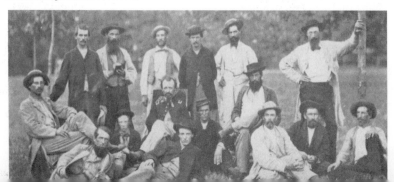

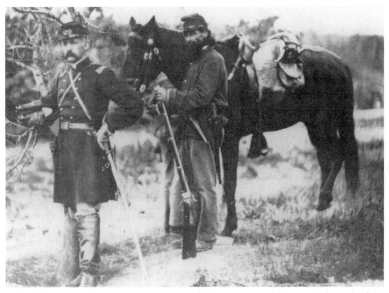

Dashing, though not much admired as a leader, was Colonel Hiram Berdan, of Berdan's Sharpshooters. Surely the most colorful of their number was the man at right, Private Truman Head, known for his marksmanship as California Joe. (VERMONT HISTORICAL SOCIETY, MONTPELIER)

In addition to the civilians who served the armies, the military assigned many of its own as scouts and guides. Taken by the romantic nature of their work, they affected the jaunty attire and pose, pistols in belts, of Sir Walter Scott heroes, but were as a rule less effective than their civilian counterparts. (USAMHI)

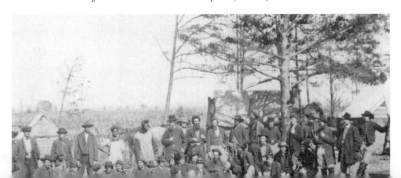

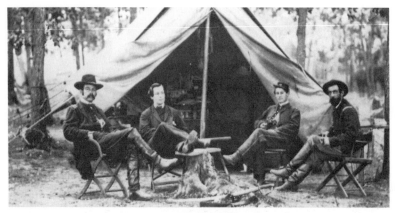

Someone had to manage the efforts of these scouts and spies while on the march.
That was the Secret Service Department, its officers shown here at army
headquarters in the field. Their calm pose belies the often dark business they
directed, the secrets they knew—or thought they knew. Through the pigeonholes
of that desk in their tent passed information that could save or ruin any army.
(USAMHI)

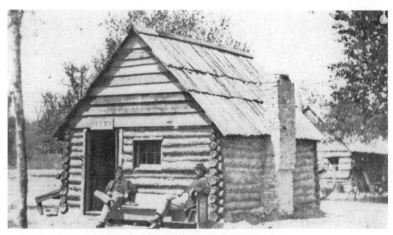

Information for the march was also the work of the Signal Corps. Here a signal
station in Virginia, between Suffolk and Norfolk, in February 1864. An army
traveled in part on its stomach, to be sure, but even more on what it knew.
(USAMHI)

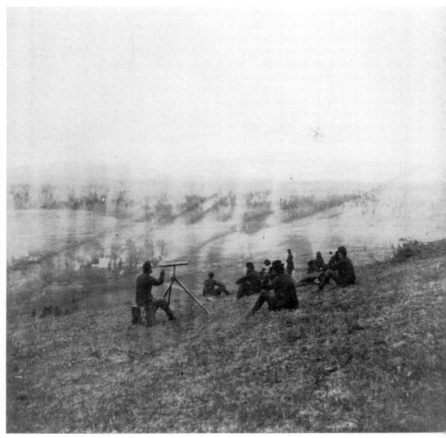

Every hilltop and rise became a potential observation point on the march, for looking ahead and to the flanks for sign of the foe. The ample vistas of the Blue Ridge Mountains and its tributary eminences afforded opportunity to bring out the field glasses and the telescope. (NA)

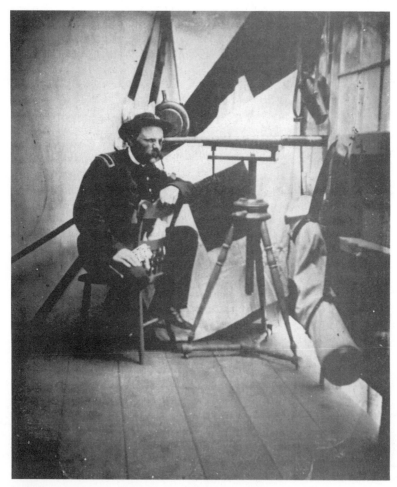

Sometimes more permanent locations allowed more elaborate observations. Here signal flags rest behind the scope and tripod as a signalman peers off into presumably enemy territory. (HERB PECK, JR.)

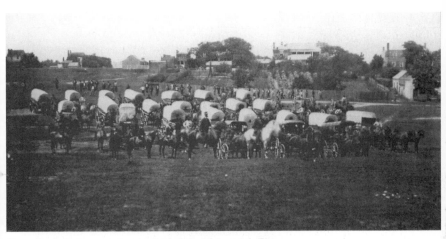

Observations had to be communicated to the armies and their generals. That became the task of the Military Telegraph Corps. Here, at war's end, the men and equipment pose at Richmond in June 1865, their vital work done. (USAMHI)

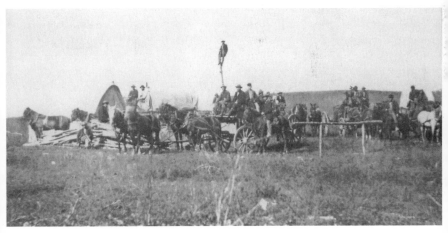

Along the routes of march and in the evening camps, the soldiers became accustomed to seeing the poles go up and the singing wires start their work. (USAMHI)

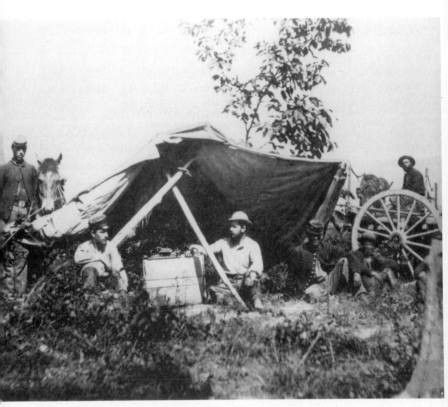

*From advanced positions in the field the telegraphers pounded out their messages
on the portable field keys.* (NA)

Their power came from the battery wagons like this one, which also acted as telegraph stations for communicating with the main army. A soldier marching past knew—or could hope—that he was being helped by the latest information. (NA)

When they moved, the soldiers found other friends in the hardware and ingenuity engineers, the men who used canvas pontoons like this one to bridge Southern streams. A March 1864 image of the 50th New York Engineers at Rappahannock Station. (USAMHI)

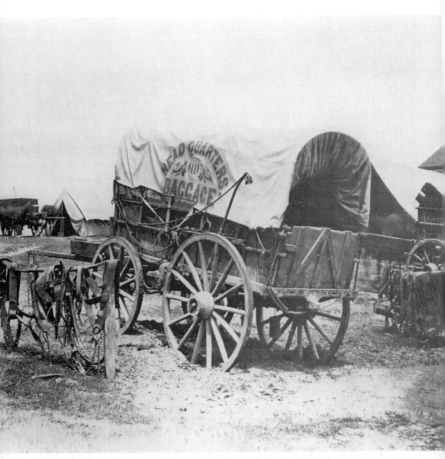

And moving with them was their baggage. Wagons became old friends as they carried the heavier burdens of soldier life. Few became as well known in the Army of the Potomac as this traveled old rambler, U. S. Grant's headquarters wagon. (NA)

The roadside scenes of the march were the same everywhere; only the names on the land changed. A Brady & Company image taken in Virginia in 1864 shows soldiers filling their water cart from a well. (USAMHI)

Other soldiers draw water for their company from the same well. (USAMHI)

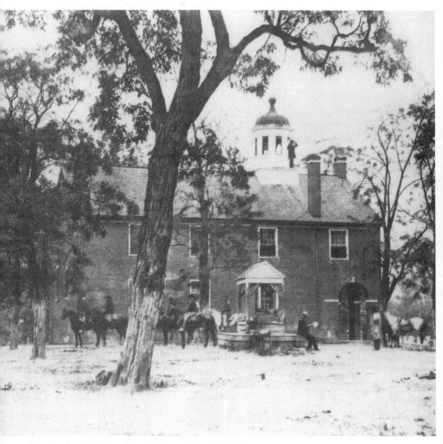

*There is relaxation along the march. Even while a soldier looks out from the
cupola of Fairfax Courthouse in this 1863 image by O'Sullivan, another rests
beside the well to read a newspaper.* (CHS)

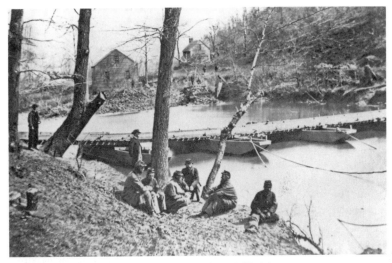

They rest beside their pontoon bridges, here on the Hazel River in Virginia, near Brandy Station in 1863. (USAMHI)

They rest by the roadside. Here Company B, 170th New York, late in the war. Though the image is certainly posed, still it well reflects the activities of a rest from the march. Cards, letter writing and reading, newspapers, cigars, a nap— all were part of the peaceful moments of the march. (USAMHI)

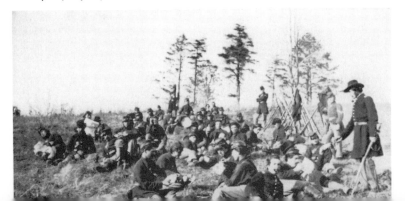

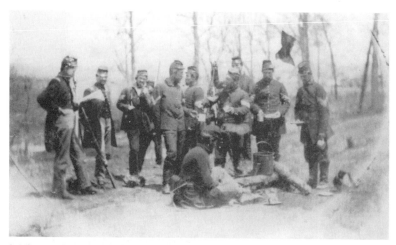

And there was the meal stop, usually right in the road or just beside it. A hasty fire for coffee, a little hardtack from the haversack, perhaps a bit of brandy to flavor the drink, and then a pipe. The soldiers looked forward to these minutes with every step. (RUDOLF K. HAERLE)

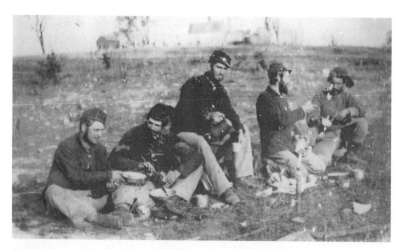

Company K, 11th Rhode Island, pauses in a field for bread and cheese, coffee, and perhaps a spoonful of sugar. (LESLIE D. JENSEN)

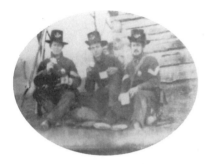

"Today our mess had their ambrotype taken representing us as taking a meal on picket." So wrote Sergeant Jacob Heffelfinger in his diary on January 3, 1862. He sits right. Picket duty, once the army's march ceased for the day, was a necessary precaution against surprise. It afforded rest as well, and a measure of solitude that was usually absent in armies that sometimes numbered over 100,000. (B. N. MILLER)

Solitary, letter in hand, this early war picket rests his "Jeff Davis" hat on a bayonet. Certainly he has two other picket mates, for their rifles show even if they do not. (ROBERT MCDONALD)

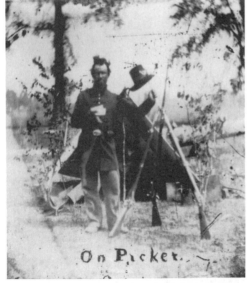

On Picket.

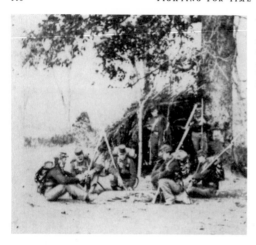

A picket guard at Lewinsville, Virginia, poses at rest for the camera, seemingly unaware of the incongruity of wearing a full field pack while on picket. (CIVIL WAR TIMES ILLUSTRATED COLLECTION, HARRISBURG, PA.)

Finally into camp at the end of the day's march, the soldiers pitched their tents, set their guards, and awaited the night and, sometimes, a few days' rest. A Virginia scene early in the war by Brady & Company. (LC)

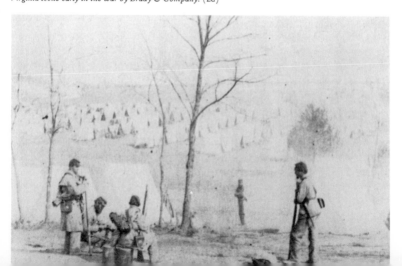

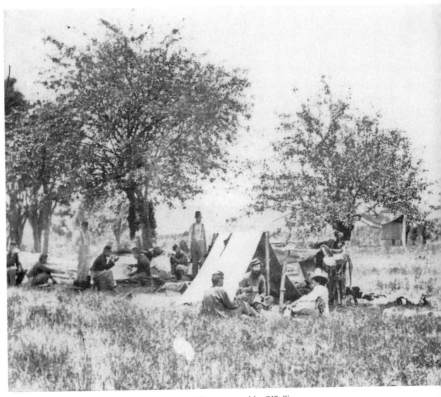

An encampment near Blackburn's Ford on Bull Run, captured by O'Sullivan on July 4, 1862. A bottle or two are in evidence, the meager celebration available on the picket line. (LC)

O'Sullivan captured bathers enjoying a bit of relaxation in the North Anna
River in May 1864. Their clothing hangs at the base of the tree at left, guarded
by three mates who have not braved the stream. (LC)

In the cold season there is snow. A group of officers enjoy sleighing along the
Rappahannock, opposite Fredericksburg, on Washington's Birthday in 1863.
Alexander Gardner caught the scene, which includes the noted battlefield artist
Alfred R. Waud gesturing with his arm just behind the third mule from the
right. (USAMHI)

There was clowning aplenty. Firing mock, or Quaker, guns one minute . . .
(USAMHI)

. . . to posing inside a giant Rodman gun in Battery Rodgers near Washington.
(USAMHI)

And the next minute clowning in human pyramids. Image by Barnard &
Bostwick. (GLADSTONE COLLECTION)

Like tourists in all times, the soldiers with hours to spare left the mark of their passing. Here in Falls Church, Virginia, the church wall becomes a catalog of the Federal regiments that have passed by. (USAMHI)

Several men of the 141st New York left their graffiti as reminders of their visit to Falls Church. They, like the scripture on the wall, are on an Exodus of sorts. (USAMHI)

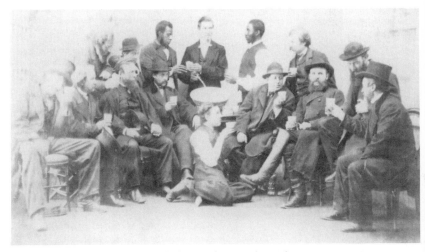

*Traveling with the soldiers is an army in itself, the corps of correspondents and
artists who brought the war to the people back home. Alexander Gardner made
this image on Christmas 1864, showing reporters of the Boston* Herald *and other
papers, as well as the ubiquitous Alfred Waud, seated second from the right.*
(RINHART GALLERIES, INC.)

The field headquarters of the press, chiefly the New York Herald, *was an
ever-present sight, complete with the servant in the left background pouring a
libation for the thirsty correspondents.* (USAMHI)

The artists, too, were well known to the men. Theodore R. Davis sent north depictions of the battle and campaign scenes so familiar to the soldiers. He and his fur-collared jacket were a common sight in the camps and along the march. (LC)

Alfred R. Waud hardly seems to have had time to produce sketches, spending so much of it in front of the camera. Yet he built the finest body of work of any of the battlefield artists, working for the widely read Harper's Weekly. (P-M)

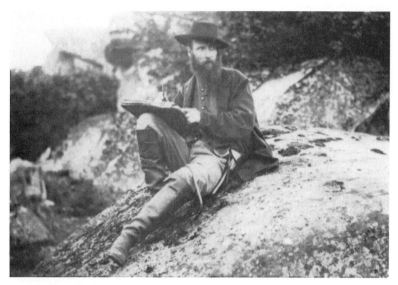

This is how the soldiers knew Waud best, seated on a high place, sketchbook in hand, interpreting them and their war for their families at home and for posterity. O'Sullivan took this photograph of Waud on the Gettysburg battlefield, July 1863. (LC)

The artists and correspondents banded together into an informal "Bohemian Brigade." Here Davis and the noted landscape artist James Walker pose together in Chattanooga, Tennessee, in 1864. (LC)

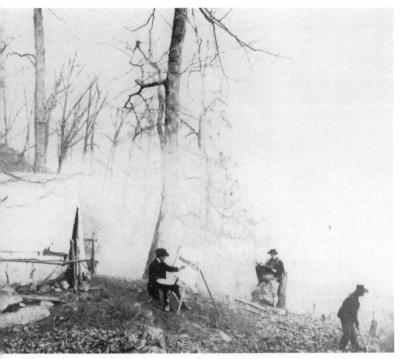

Walker at work, not an unfamiliar sight to the marching armies. Here, on the slopes of Lookout Mountain overlooking Chattanooga, he works on one of his vivid scenes of the battles for this gateway city in Tennessee. Theodore Davis is perched atop the boulder at right. (CHS)

Of course, following along right behind the armies was the photographer. This artist from Pennsylvania apparently traveled with the 47th Pennsylvania, camera in hand, and his chemicals and paraphernalia on the floor and shelf. (DALE S. SNAIR)

The soldiers, like Walker, were always interested in a good view. One of the favorite places was Umbrella Rock on Lookout Mountain. (LC)

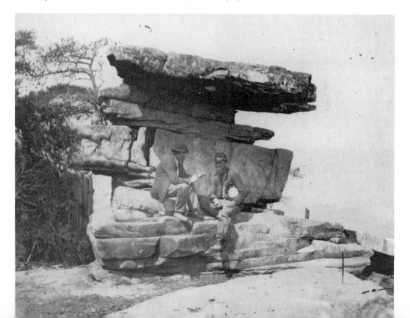

They posed singly with their battle banners.
Sergeant Andrew Geddes, 105th Ohio Inf
(MICHAEL J. MCAFEE)

The officers sat at the edge of Lookout, the
Chattanooga valley below them. (KA)

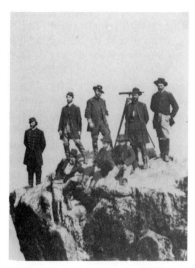

They came in groups to pose for R. M. Linn's camera. A reversed tintype. (RP)

They sat precariously at the rock's very edge, where one poor soldier actually did fall to his death. (TERENCE P. O'LEARY)

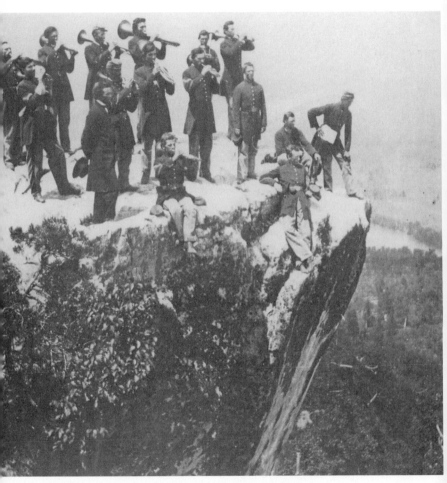

And they came in whole bands, to blow their horns above the Tennessee River.
Perhaps, appropriately, they played a few bars of "Down in the Valley." (STATE
HISTORICAL SOCIETY OF WISCONSIN, MADISON)

The marching armies loved to visit the places of historic as well as scenic significance. Falls Church, where Washington had worshiped, was a favorite. (USAMHI)

The marker commemorating Washington's mother at Fredericksburg caught many passing eyes. (USAMHI)

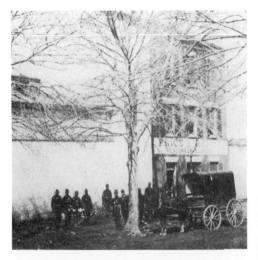

The slave pens of Price, Birch & Co.,
Dealers in Slaves, in Alexandria,
Virginia, were often visited by soldiers
passing through Washington. Some
even posed behind the bars of the
cells. (USAMHI)

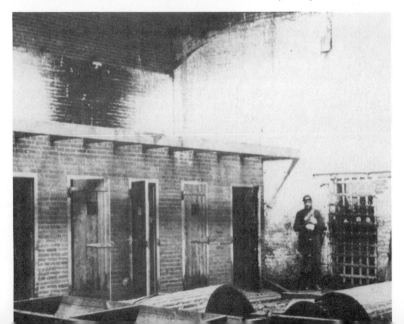

The Marshall House in Alexandria, the scene of the martyrdom of Elmer Ellsworth, the Union's first hero, attracted many a curious farmboy become soldier. (USAMHI)

And the battlefields themselves lured soldiers to visit anew the scenes of their victories and defeats, and fascinated the new recruits who had not yet tasted battle. Blackburn's Ford on Bull Run, in 1862. (USAMHI)

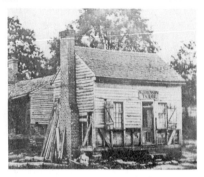

The humble tailor shop of Andrew Johnson in Greeneville, Tennessee. Now Johnson was the loyal governor of Tennessee; he was soon to be Vice-President and, following Lincoln's murder, President. (USAMHI)

The ruins of the stone bridge over Bull Run on the Manassas battlefield. An 1862 image by George N. Barnard. (LC)

The slave quarters on Jefferson Davis's plantation in Mississippi. Alfred Waud made this image in 1866, but it looks much the same as it did in 1863 and later, when Federal soldiers and freedmen thronged the place for souvenirs of the Confederate President. (THE HISTORIC NEW ORLEANS COLLECTION)

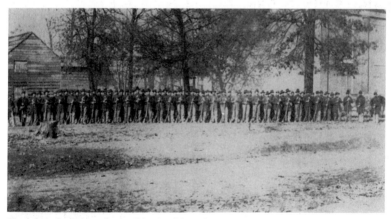

All across the South the armies passed, leaving their mark, witnessing scenes repeated a hundred times over. E company, 47th Illinois, posing in Oxford, Mississippi, in 1863. (CHS)

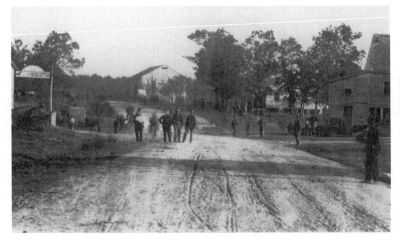

A handful of soldiers at Bailey's Cross Roads, Virginia. (WESTERN RESERVE
HISTORICAL SOCIETY, CLEVELAND, OHIO)

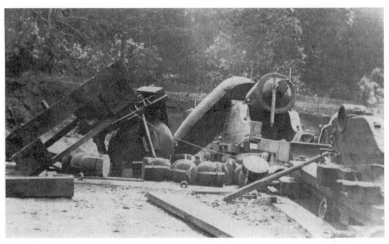

They passed scenes of destruction like these wrecked naval cannon. (AMERICANA
IMAGE GALLERY)

*They saw hapless spies caught at their work and condemned. This man,
Johnson, in the white shirt, prays with a parson as he leans against his coffin
during his final moments of life.* (CHS)

*And they saw men die. Here the photographers Armstead & White of Corinth,
Mississippi, photograph Johnson in death while, rank on rank, Federal
cavalrymen pass before him. Already his blood enriches the soil for which he
died.* (LC)

The armies pass a hundred forgotten cemeteries, like this of the 13th Connecticut near Baton Rouge, Louisiana. Wherever the armies pass, they leave their dead behind. (ISHL)

Their lonely, solitary, fallen comrades, alone and at peace in death. (NA)

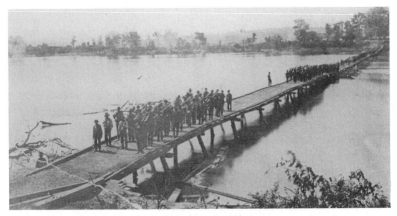

*But always the armies march on. There are rivers to cross, lands to conquer,
battles to fight. Crossing the Green River at Bowling Green, Kentucky, these
Federals are on their way to preserve the Union.* (CHICAGO PUBLIC LIBRARY)

*While these Confederates, men of Lee's army, are stopping only briefly in
Frederick, Maryland, on their 1862 invasion of the North. They are on their way
to Antietam. From his window Rosenstock could observe the sights seen
throughout the war-swept land, hear the marching of the booted and bootless
feet, and witness the passing of the armies.* (BENJAMIN B. ROSENSTOCK)

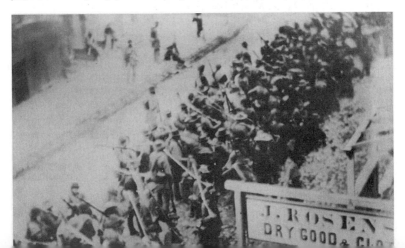

Raiders of the Seas

NORMAN C. DELANEY

Rebel commerce destroyers take the war around the world

THOUGH THE MISSISSIPPI might be "unvexed" after the fall of Vicksburg and Port Hudson, not so the sea it flowed into, for there Confederates carried the American Civil War to distant oceans. In doing so, they seriously disrupted the North's overseas commerce and struck a mortal blow against an already troubled whaling industry. They served to counter the severe injuries inflicted upon the Southern economy by a powerful Northern antagonist. They were the Confederate cruisers —the commerce destroyers.

The authorization by the Confederate Congress on May 10, 1861, for six cruisers to be built in England indicated their awareness that the South was incapable of producing a navy to match that of her enemy. Instead, swift and maneuverable commerce destroyers would be used to strike at the North's vital shipping lanes. Confederate Secretary of the Navy Stephen R. Mallory and other Southern leaders were convinced that recent history was on their side. The United States had played the role of the underdog during both the War of Independence and the War of 1812, yet had scored impressive victories at sea through privateering and cruiser warfare. What Mallory and his supporters failed to recognize, however, was that the successes of cruisers and privateers in the earlier wars had, in

the final outcome, made no difference. In 1861 they were convinced that the policy of commerce destruction would contribute to ultimate victory. The South could benefit from privateers and blockade runners, some of which were government-owned or chartered, and the government would move promptly to obtain the promising cruisers.

The purpose of the Confederate cruisers was threefold. In addition to crippling enemy commerce, they were expected to panic and demoralize the northeastern coastal population and thus divert hundreds of vessels from the Southern blockade. Even a small number of cruisers—steam-powered and propeller-driven—could contribute significantly to victory. The hit-and-run strategy of the cruisers would be supplemented by the use of privateers, ironclads, torpedoes, and submersible or semisubmersible "Davids." To help in these efforts, the Confederacy had experienced naval officers eager to serve. Millions of dollars for acquiring the cruisers were appropriated from cotton sales abroad and from Confederate bonds and treasury notes.

The problems that still faced Mallory and his department appeared insurmountable. The need to obtain ships—by purchasing or by building them—was urgent. But, even if ships could be obtained

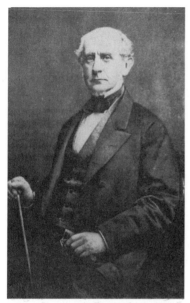

Lincoln's minister to Great Britain, Charles Francis Adams, faced a number of critical problems in keeping the peace between the two great nations, but few were more volatile than the issue of the commerce raiders built or fitted out in Britain for the Confederate Navy. He kept agents everywhere looking for such vessels before they put to sea, and even arranged for photographs to be taken so that the raiders might later be identified. But Adams proved quite unsuccessful in the early years of the war, and one raider after another eluded his grasp. (USAMHI)

hibited from recruiting or taking on military supplies. Those Southerners were naive who believed that the British government would look with favor at the very practice that had been used against them by the United States in earlier wars. In fact, Great Britain in 1856 had, along with other major maritime powers (but not the United States), condemned the practice of warring against commerce.

Confronted with such problems, the South needed a man in England with a background in international law as well as in naval building and technology. The identity and purpose of the cruisers, to be secured through private contractors, would have to be carefully guarded until they were safely at sea and under Confederate control. Commander James D. Bulloch, CSN, became the chief architect of the South's naval procurement program in Europe. The veteran officer, who wrote a book describing his role as Confederate agent, has been compared with Robert E. Lee in the magnitude of his labors on behalf of the Confederacy. Bulloch was responsible for the building of two cruisers, the *Florida* and the *Alabama*, the purchase of the *Shenandoah*, and the construction of the Laird rams. Mallory soon realized that Bulloch was indispensable to his overseas operations. Thus, Bulloch, who longed to return to sea duty and had been promised the captaincy of one of his cruisers, never attained his greatest wish. Although he had successfully brought to the Confederacy early in the war the *Fingal*, with an impressive cargo of military supplies, others would gain renown as captains of "his" *Florida*, *Alabama*, and *Shenandoah*.

Bulloch was successful both in obtaining these ships and in getting them to sea by elaborate subterfuge. Agents and spies employed by the United States minister to Great Britain, Charles Francis Adams, and Thomas H. Dudley, United States consul at Liverpool, were constantly probing for information on the identity and purpose of suspicious vessels under construction. Even photographs and sketches based on descriptions of witnesses were eventually obtained for all the cruisers. Bulloch's *Alabama* was brought to sea as the *Enrica*—all of his cruisers had aliases—only hours before British authorities ordered her detained. Bulloch also devised a method of circumventing Britain's Foreign Enlistment Act by manning, as well as equipping, the cruisers at remote locations. In the case of the *Alabama*, this was done near Terceira in the

overseas, how could they be manned and equipped? Much depended on the policies and attitudes of European powers toward the Confederacy. When Great Britain and France declared their neutrality, Southerners felt disappointed, but they were somewhat encouraged by British and French recognition of the South as a belligerent. The cruisers would be allowed to stop at French ports and those of the British empire but were pro-

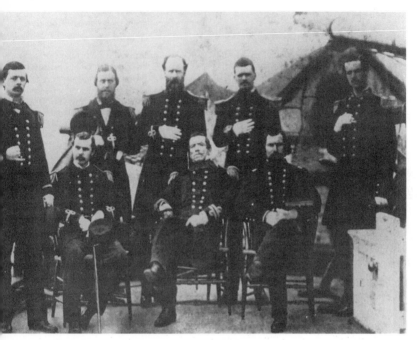

The officers of the first Confederate commerce raider, Sumter. *Commander Raphael Semmes is seated center. The man standing at center behind him is his executive officer, Lieutenant John McI. Kell, who will stay with Semmes throughout most of the war.* (NHC)

Azores. Bulloch brought a second ship from England with arms and additional sailors and transferred them to the *Alabama*. The ship was then officially commissioned and the men enlisted. Those who refused to serve were allowed to return with Bulloch to England. Captain Raphael Semmes, CSN, assigned command of the *Alabama*, made it clear that he wanted only men willing to serve.

Since his cruisers were equipped with auxiliary steam power, Bulloch arranged for a supply tender, the *Agrippina*, carrying coal, to meet the *Alabama* at secretly designated times and locations. But

when this practice proved unreliable and increased the risk of discovery, it was discontinued. Because of the constant danger from enemy warships, cruiser captains needed freedom from any strict schedule. Although given wide discretionary powers, they were under orders to avoid contact with Federal warships and to fight only if escape was impossible.

Raphael Semmes, the most famous of the cruiser captains, commanded both the *Sumter* and the *Alabama*. Semmes was an early advocate of the concept of commerce warfare and helped to convince Mallory of its potential value. Well schooled in in-

And this is the ship that Semmes commanded, the first publication of a remarkably rare image of the CSS Sumter, probably taken in Birkenhead or Liverpool after her conversion to the blockade runner Gibraltar in 1864. In this small, sleek ship, Semmes and his men sent the first shock of terror through Yankee shippers, portending the havoc he would wreak with his next ship, the Alabama. (HENRY E. HUNTINGTON LIBRARY AND ART GALLERY, SAN MARINO, CALIFORNIA)

ternational law during thirty-five years of United States naval service, Semmes's abilities were ideally suited to his assignment. The cruise of the *Sumter* —the South's first cruiser—demonstrated to Confederate officials the possibilities of the cruisers they had already authorized. But the small and frail *Sumter*, although successful in taking seventeen prizes in only six months, had worn out her engines and was in no condition to continue as a cruiser.

A second commerce destroyer launched from the Confederacy soon after war began was far less successful than the *Sumter*. The CSS *Nashville*, commanded by Lieutenant Robert B. Pegram, CSN, operated out of Charleston, South Carolina, and sailed to Southampton, England, in her one brief cruise. With a score of only two prizes, she re-

turned to the Confederacy in February 1862, then served as a blockade runner and a privateer before being sunk by the Federals.

Because cruiser captains could not take their prizes into any Southern port, they disposed of them at sea. American-owned vessels and American-registered cargoes were burned as a matter of course after the removal of all persons on board and the transfer of supplies needed by the Confederates. When American merchant ships were found with cargo belonging to foreign nationals, they were released on ransom bond, documents that stated that the value of the ship would be paid to the Confederacy at the end of the war.

The men engaging in cruiser activities soon became aware that their enemies considered their

The whole issue of the cruisers was a constant sore point between the United States and Great Britain. Gideon Welles and his navy had to spend enormous energies putting powerful ships on patrol virtually all over the Atlantic. The mighty USS Tuscarora *spent all of 1862 and much of the next year cruising the English Channel, the Irish sea, and European waters as far south as Gibraltar, looking for the most dread of all Confederate cruisers . . .* (P-M)

methods beyond the pale of "civilized" warfare. Early in the war President Lincoln declared that individuals so engaged were "pirates" and could expect to be treated as such when captured. However, the Confederates vowed retaliation if such threats were ever carried out, and the issue remained unresolved. Far from regarding themselves as pirates, Semmes and other cruiser captains took pride in what they considered to be their honorable treatment of prisoners. These "detainees," who occasionally included women and children, were ordinarily treated humanely until they were eventually transferred to a neutral ship. When he captured the California-bound mail steamer *Ariel,* which included 150 marines among her 700 passengers, Semmes released the ship on ransom bond and paroled the marines as prisoners of war. Yet Semmes had put sailors from his first prizes in irons as retaliation for the similar treatment of his pay-

master, Henry Myers of the *Sumter,* who had been seized in Morocco and turned over to United States officials.

Semmes, "Old Beeswax" to his men, gained the most fame of the cruiser captains. His obvious zeal in playing the role of destroyer and his undisguised contempt for Yankee—especially New England—captains contributed to Northerners' hatred of him. Semmes's practice of burning prizes at night to lure unsuspecting Good Samaritan captains contrasted sharply with the conduct of Lieutenant William L. Maury, CSN, of the CSS *Georgia,* who once swore that he would rather be court-martialed than "burn the ship of a man who had come on an errand of mercy." Semmes, dour and humorless with friend and foe alike, with piercing eyes, a waxed mustache, and small imperial-style whiskers, better suited the pirate image. United States naval captains David G. Farragut and David D. Porter

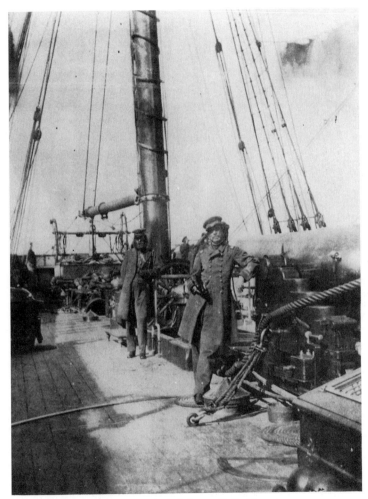

. . . *the CSS* Alabama. *Following his cruise in the* Sumter, *Raphael Semmes took charge of the 290, soon renamed the* Alabama, *in the spring of 1862, and sailed the raider for the next two years. He leans here against a mighty Dahlgren gun, with the trusty Kell standing in the background.* (INTERNATIONAL MUSEUM OF PHOTOGRAPHY, ROCHESTER, N.Y.)

Kell himself took a turn at posing for the camera. The Alabama *was not a neat ship, as evidenced by the clutter on the decks. Semmes regarded many of his seamen with open contempt and despaired of enforcing proper sea discipline.*
(INTERNATIONAL MUSEUM OF PHOTOGRAPHY)

were infuriated by Semmes's sinking the USS *Hatteras,* off Galveston, Texas, in a battle that lasted only thirteen minutes. Such a humiliation was not easily forgotten, even though the *Hatteras*—a former passenger steamer—was a decidedly inferior vessel. Nor could Semmes be forgiven his success in evading his pursuers for so many months at sea.

Semmes's easy victory over the *Hatteras* contributed to his own eventual undoing. Confident that his men could fight and win again, he decided to challenge Captain John A. Winslow, USN, when the powerful USS *Kearsarge* appeared off Cherbourg, France.

The *Alabama* had arrived at Cherbourg on June 11, 1864, after spending twenty-two months at sea. During that time she had covered 75,000 miles and had overhauled almost 300 ships. She had destroyed 55 of these, setting a record unmatched by any other Confederate cruiser. Moreover, a large part of the Northern merchant fleet had by then transferred ownership to foreign flags or had disappeared from the seas entirely. Semmes, soured by his enemy's defamation of him and drained by the demands of months at sea, was about to relinquish his command. He was incensed at those who denounced him as a coward for sailing under false—British and United States—colors and destroying defenseless ships. Semmes preferred to

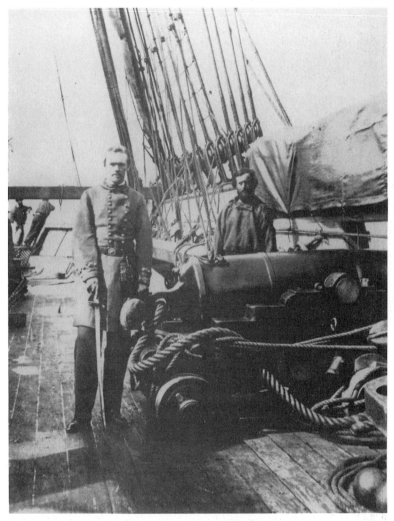

Yet Semmes had good officers for the most part, and none in the Confederate Navy saw more service. The man at left is probably Midshipman E. M. Anderson. (INTERNATIONAL MUSEUM OF PHOTOGRAPHY)

These images of the Alabama *and her officers were either taken at Cape Town, South Africa, or at Luanda, in what is now Angola. Semmes put his vessel into these ports to take on coal, an operation that is taking place while this image of Lieutenants Richard Armstrong and Arthur Sinclair is being exposed. These are the only known photographs of the* Alabama, *and none seem to have survived showing the vessel in its entirety. The only reason these survive is that they were sent ashore along with other valuables before the ship's fateful meeting with the* Kearsarge. (WHALING MUSEUM, NEW BEDFORD, MASS.)

end his career with a dramatic victory, his Confederate flag flying in full view of thousands of spectators. It took Winslow just over an hour to destroy the *Alabama*. Powerful guns in the hands of his well-trained and disciplined crew reduced the *Alabama* to a shattered, sinking hulk. Northerners, exultant over Winslow's victory, nevertheless felt cheated at Semmes's escape to England aboard the yacht *Deerhound*.

Semmes was rewarded by a grateful Congress,

which promoted him to admiral and gave him command of the James River Squadron. However, other Southerners may have shared the personal view of diarist Mary Boykin Chesnut when she wrote: "Admiral Semmes, of whom we have been so proud, is a fool after all. He risked the *Alabama* in a sort of duel of ships, and now he has lowered the flag of the famous *Alabama* to the *Kearsarge*. Forgive who may, I cannot!"

The news of the *Alabama*'s loss came at a low

point for the South. The cruisers provided an important psychological lift for the Southern people. They rejoiced that the South could effectively demonstrate her capacity through the daring exploits of the cruisers. With the *Alabama* gone, the *Florida* remained the only cruiser at sea, and Mallory was eager to acquire others. Two other Confederate naval agents, the renowned oceanographer Commander Matthew Fontaine Maury, CSN, and Commander George T. Sinclair, CSN, went to England to obtain cruisers, but only Maury succeeded in getting his—the *Georgia* and the *Rappahannock* —to sea. However, neither ship was comparable with Bulloch's.

The CSS *Georgia,* under Lieutenant William L. Maury, took only nine prizes during a cruise that began in April 1863 and lasted seven months. She was unsuitable as a cruiser because her iron hull required frequent dry-dockings. Matthew Maury finally secured the CSS *Rappahannock* as her replacement in November 1863. The new ship was no improvement, however. Built in 1857 as the *Victor,* the *Rappahannock* had already been condemned by the British as "rotten and unservicable." After a major overhaul in England, the *Rappahannock* still remained unfit for sea and was brought to Calais for additional repairs. But Emperor Napoleon III was becoming increasingly reluctant to give aid to the apparent loser in the American war. Although he allowed the *Rappahannock* to be dry-docked and repaired, he refused to allow her to leave port.

Sinclair's ship, the *Canton,* designed to be even more formidable than the *Alabama,* presumably would have added much to the success of the cruisers. However, she never got to sea. Receiving irrefutable evidence of the *Canton's* true identity, British authorities seized her for violation of the Foreign Enlistment Act.

Cruiser officers and agents in Great Britain had

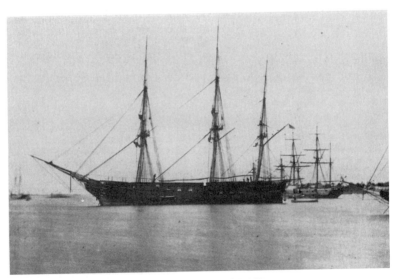

Lincoln's navy sent a small armada of ships after the Alabama. *The* Sabine, *one of the first vessels on the blockade duty, went after her late in 1862. She is shown here in December 1864, off Fort Monroe, Virginia.* (USAMHI)

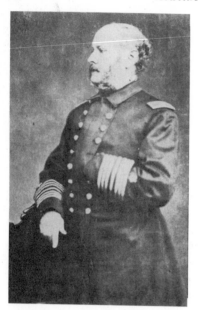

But finally came Captain John A. Winslow, shown here as a commodore. He will be the man to be in the right place at the right time. (USAMHI)

become personae non gratae by the second half of 1863. The British were embarrassed by the successes of the Confederate agents and the circumvention of the neutrality laws. They were further aggravated by the cruiser captains' use of their foreign ports. Earlier in the war, Nassau authorities had detained the *Florida* for alleged violations of British neutrality and the Foreign Enlistment Act. Although the ship was eventually released, similar incidents continued to exacerbate relations between Great Britain and the Confederate States and, especially, the United States. Numerous charges pressed by the United States government after the war resulted in an international tribunal at Geneva, Switzerland, ruling in 1872 that Great Britain was liable for monetary losses caused by the *Flor-*

ida, Alabama, Shenandoah, and their four satellite cruisers. The British government, accepting responsibility for these violations, paid to the United States the $15.5 million indemnity set by the commission.

Whenever a cruiser succeeded in humiliating the Northern colossus by running the blockade or evading Federal pursuers at sea, Southerners rejoiced. Lieutenant John N. Maffitt, CSN—the dashing "Prince of Privateers"—scored such a triumph when, on September 3, 1862, he brought the *Florida* into heavily blockaded Mobile. This was accomplished despite the fact that Maffitt and all but five members of his crew were stricken with yellow fever. Four months later, Maffitt brought the *Florida* to sea again for a cruise similar to that of the *Alabama.* Finally, at Brest, France, Maffitt—still suffering from his illness—was relieved from command by Lieutenant Joseph N. Barney, CSN, who, also because of ill health, was soon replaced by Lieutenant Charles M. Morris, CSN. The *Florida* finally sailed from Brest after delays lasting almost six months.

At sea, Morris continued to add to the *Florida*'s impressive list of captured prizes, which eventually totaled thirty-seven. But, in the harbor of Bahia, Brazil, Morris's luck ran out. On the night of October 7, 1864, Morris and half his crew were ashore when a surprise attack upon the *Florida* was made by Commander Napoleon Collins, USN, of the USS *Wachusett.* This act promptly raised an international storm. Collins had refused to be thwarted at finding his quarry in a presumed safe haven. He considered that he would have been guilty of inexcusable negligence had he let the "pirates" escape him. Collins gave the order, and without warning, the *Wachusett* rammed the *Florida.* The crew were easily subdued and the ship taken. Collins then had the *Florida* tied fast and, ignoring Brazilian shore fire, towed her to sea. Collins's prize and her crew were brought to the United States, where officials realized that the sovereignty of Brazil had been violated. The *Florida* was ordered returned to Brazil, but she sank in what appears to have been a deliberately caused collision with another vessel at Newport News, Virginia. Secretary of State William H. Seward considered her crew to be "enemies of the human race" and regretted their later release. Collins, although court-martialed and ordered dismissed

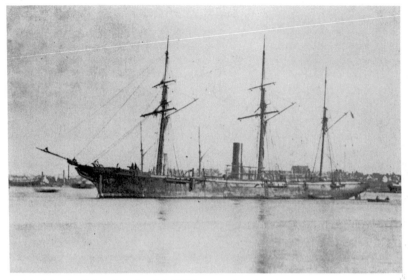

And the deck under his feet will be that of the USS Kearsarge, *shown here at Portsmouth, New Hampshire, just a few months after her appointment with the* Alabama. (GLADSTONE COLLECTION)

from the service, was instead restored to his command by Secretary of the Navy Gideon Welles. Welles agreed with Collins's defense that his action, although illegal, was "for the public good."

Much earlier, Lieutenant Charles W. "Savaz" Read, CSN, with a reputation for "coolness and determination," had been requested by Maffitt to serve under him aboard the *Florida*. During the cruise, Read became intrigued with the idea of converting a suitable prize to a cruiser and commanding her. Maffitt also liked the idea and had the prize *Clarence* armed with a 12-pounder howitzer and turned over to Read, in command of twenty sailors. On his own, Read captured a vessel he preferred to the slow *Clarence*, the bark *Tacony*. He transferred his gun and crew and, after burning the *Clarence*, steered for New England. In the next two weeks Read captured fifteen ships. Among those he destroyed were six Gloucester

fishing boats. Off Portland, Maine, Read captured the schooner *Archer* and again transferred his gun and crew. Only twenty-one men were accomplishing much of what Mallory had hoped his cruisers would achieve. Governor John Andrew of Massachusetts blasted the Navy Department for the "defenseless condition of the coast." Coastal New England residents were in panic, and scores of vessels took refuge in the nearest port. Some forty ships were directly involved in the search for the raiders, although without seriously weakening the blockade.

In his most daring move, Read brought the *Archer* into Portland harbor at night and surprised the crew of the revenue cutter *Caleb Cushing* at anchor. Unable to get away with his prize, Read released his prisoners and set her ablaze. Finally, before they could return to the *Archer*, Read and his men were captured. They were taken to Fort

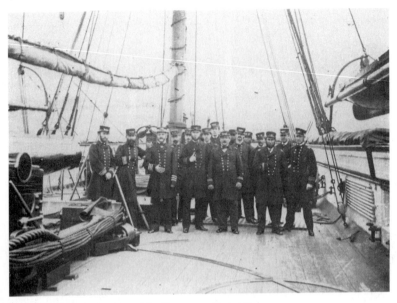

*Winslow, standing third from left, and his officers managed to trap the
Confederate cruiser in the harbor at Cherbourg. Indeed, there was even some
fraternization between the two crews in the neutral port. The local photographer
Rondin came aboard the* Kearsarge *to make this and other images.* (USAMHI)

Warren in Boston harbor, thus ending what has been called "the most brilliant daredevil cruise of the war."

Maffitt was not the only Confederate captain to use a captured prize as a satellite cruiser. Few prizes, however, suited the demands made upon a raider, and captains could ill afford the loss of even a small number of men and guns. Keeping even a minimum crew was a problem that all the captains faced. Some recruits were enlisted from captured prizes, and in some cases men were impressed into Confederate service. Semmes and James I. Waddell were both guilty of this practice, but only as a desperate measure.

Despite his shortage of men, Semmes converted one of his prizes—the bark *Conrad*—into the satellite cruiser *Tuscaloosa*. For six months this vessel, with fifteen men commanded by Lieutenant John Low, CSN, cruised Atlantic shipping lanes until, at Simon's Bay, South Africa, she was seized for alleged violation of Britain's neutrality laws. The *Tuscaloosa* was eventually released, but by then Low and his men had left for England.

The successes of most cruisers encouraged Confederate officials during the summer of 1864 to search for replacements. Two blockade runners, *Atlanta* and *Edith,* both at Wilmington, North Carolina, were converted into the cruisers *Tallahassee* and *Chickamauga.* The CSS *Tallahassee,* although swift and easy to maneuver, nevertheless had two serious drawbacks for a cruiser: exposed boilers and insufficient coal storage space. Her resourceful commander, John Taylor Wood, CSN, a veteran of the ironclad *Virginia* (*Merrimack*),

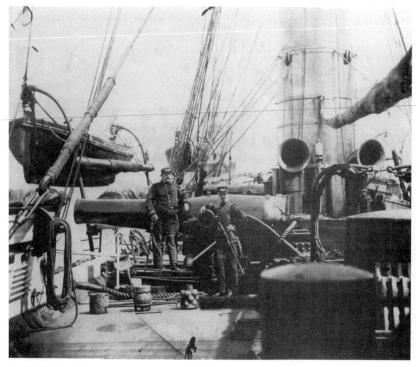

He caught Master J. R. Wheeler and Engineer S. L. Smith leaning on their powerful 11-inch forward pivot gun. (USAMHI)

compensated for these deficiencies by protecting his engines with cotton bales and storing extra coal on deck. He brought the *Tallahassee* through the blockade on August 6, 1864. Wood originally entertained a daring scheme to involve the *Tallahassee* in a surprise night raid into New York harbor to attack its shipping and Navy Yard. Handicapped without a pilot, however, he instead cruised north to Halifax, capturing thirty-three vessels in only a few weeks. Wood's cool official reception at Halifax and the likelihood of his being captured caused him to return to Wilmington. The cruiser was reoutfitted, and as the CSS *Olustee,* under

Lieutenant William H. Ward, CSN, she again ran the blockade. Her cruise was brief—only nine days —but before his return to Wilmington on November 7, Ward had destroyed six prizes.

By the time the CSS *Chickamauga,* commanded by Lieutenant John Wilkinson, CSN, left Wilmington on October 28, 1864, it was impossible for any Confederate cruiser to be welcomed in a foreign port. Unable to secure extra coal, Wilkinson returned to Wilmington after three weeks at sea, having burned four of his five prizes. He was back in time to assist in the final defense of Fort Fisher.

Despite enormous odds, Bulloch, still in En-

The ship's mighty engine would propel her in the impending battle. A postwar view. (USAMHI)

gland, succeeded in obtaining another cruiser, the *Sea King*. Renamed the *Shenandoah*, she was much like the *Alabama* she replaced. Her captain, Lieutenant James I. Waddell, CSN, had no previous cruiser experience, having been waiting assignment in Europe for several months. Once at sea, the *Shenandoah* was manned and equipped in the manner of the earlier cruisers. Near Madeira, on October 19, 1864, the newly commissioned *Shenandoah* began what became the most unusual cruise of any Confederate raider. Waddell's orders were to follow sea lanes missed by the earlier cruisers, especially "the enemy's distant whaling grounds." Outwitting hostile officials at Mel-

bourne, Australia, Waddell managed to stow aboard several seamen from that port, in direct violation of the Foreign Enlistment Act. He then cruised to the North Pacific, reaching the Sea of Okhotsk in late May 1865. Finally, in June, he reached the Bering Sea and the Arctic Ocean. There Waddell found his unsuspecting prey—a considerable portion of the American whaling fleet. When told that Lee had surrendered in April and shown newspapers to prove it, Waddell still refused to believe that the war was over. He set twenty of the whalers ablaze, leaving four to carry away his numerous prisoners. His destruction on June 28, 1865—eleven weeks after Appomattox—

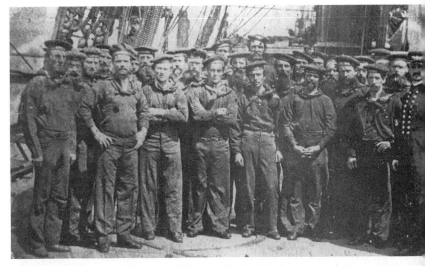

And Kearsarge's *trusty crew would serve her well. They pose, like the others, in June 1864 for Rondin. On June 19 they will destroy the* Alabama. (USAMHI)

was the last hostile act of a Confederate force. Only later, on August 2, when informed of the war's end by a British captain, did Waddell finally accept the reality of defeat. He then decided to sail to England rather than to Australia to surrender. Fearing that he would be branded an outlaw for his last acts of destruction, Waddell disguised his ship as a merchantman and brought her the 17,000 miles to England nonstop. The trip turned into a nightmare. Water and supplies ran short, scurvy developed, and two crewmen died. On November 15, 1865, the *Shenandoah* arrived at Liverpool and Waddell surrendered to amazed British officials. He had brought the cruiser a total of 58,000 miles and had taken thirty-eight prizes, two-thirds of them after the war had ended. Only with Waddell's surrender was the Civil War finally over.

The story of the Confederate cruisers is but one segment of a long and bloody conflict. It involved only a few ships and a few hundred men, most of whom—the ordinary seamen—were not even Southerners. And yet, the cruisers succeeded in de-stroying two hundred Union merchant ships, fishing craft, and whaling vessels, plus cargoes worth millions of dollars. Despite such injury, however, the North's economy was strong enough to endure every blow from the South. The damage inflicted by the cruisers was like bruises on a powerful giant. The cost of such efforts to the South—in terms of all her resources—was exceedingly high. Secretary of the Navy Welles had clearly seen the means of achieving ultimate victory when he refused to weaken the blockade despite outcries by many Northerners that the cruisers be hunted down and destroyed at all costs. For Lincoln and his advisers to have altered their strategy would have provided Southerners with the relief they so desperately needed from the ever-constricting blockade. As it was, a large number of Federal warships spent frustrating months in pursuit of the elusive raiders, and only the men of the USS *Kearsarge* had the satisfaction of actually locating and destroying a cruiser—the CSS *Alabama*—in a dramatic sea battle.

While Semmes terrorized Yankee shipping, other agents like Commander Matthew F. Maury tried to outfit and equip cruisers. Maury, a distinguished oceanographer, succeeded to a small degree. (VM)

Maury got the CSS Rappahannock *ready for sea, only to discover that she was "rotten and unservicable." He took her to France, where a photographer in Calais saw her as she is shown here. The French never let her leave port again. It was a terrible blow to her officers. All they could do was wait and hope. (VM)*

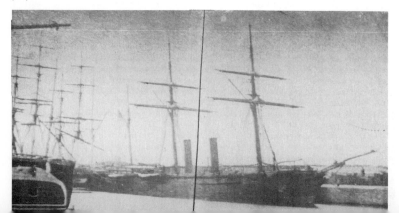

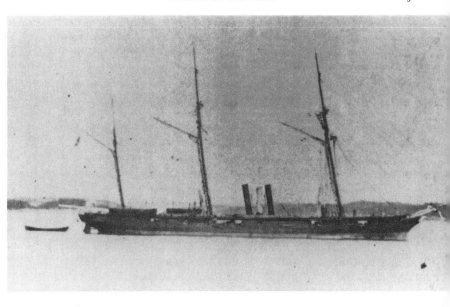

But it did not pass by many others—those fortunate enough to serve aboard the CSS Florida, for instance. Next to the Alabama herself, this ship came to be the most feared and sought on the seas. She appears here photographed at Brest, France, probably in 1863, and was in fact the first foreign-built cruiser to be commissioned. (NHC) Her first captain, Lieutenant John N. Maffitt, was one of the most dashing Rebel seamen and a man of considerably more humor than Semmes. It was he who ran the ship into Mobile, Alabama, for outfitting, thus bringing disgrace on . . .
(WILLIAM A. ALBAUGH COLLECTION)

. . . Commander George H. Preble, who, thanks to events beyond his control, was not able to prevent the Florida from reaching safety. Even Maffitt later testified that Preble did his very best. Preble found himself dismissed from the service temporarily. (USAMHI)

When Maffitt proved too ill to retain his command once the raider returned to European waters, he turned the vessel over to Lieutenant Joseph N. Barney. Yet Barney, too, fell ill and relinquished his command to . . . (WILLIAM A. ALBAUGH COLLECTION)

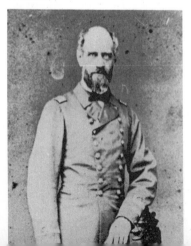

. . . Lieutenant Charles M. Morris. It was he who commanded the Florida for the remainder of her days. (WILLIAM A. ALBAUGH COLLECTION)

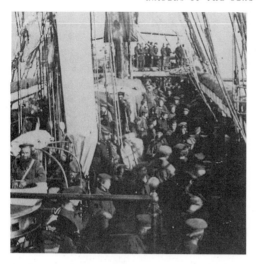

Exciting days they were, too. Several Yankee warships plied the Atlantic seeking the Florida, *ships like the sailing sloop* St. Louis, *shown here at Algeciras, Spain, on December 7, 1863.* (USAMHI)

Often the Yankee hunters encountered checkered voyages without ever coming near the Florida. *The USS* Ticonderoga *ran aground off Brazil, ran out of coal and had to rely on sail, was evicted from Grenada by the colonial governor, and had several of its furnace tubes burst—all in a single cruise after the* Florida. *Battle in the open sea would have been a relief after the frustrating fight with elements, machinery, and bureaucracy.* (GLADSTONE COLLECTION)

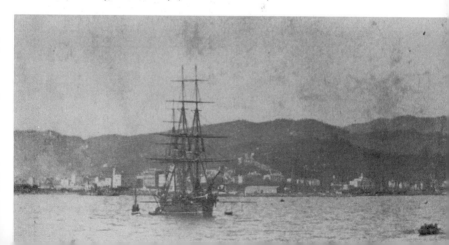

Her quarry continued to elude the St. Louis and other ships for months, just as one prize ship after another fell to the raider. Master Richard S. Floyd of the CSS Florida. *(MC)*

Chief Engineer G. W. Quinn kept the raider's machinery functioning better than on most Confederate ships, and when she put into Brest he posed for the Mage brothers' camera. (MC)

So did his assistant, I. Lake. (MC)

Yet there was better work than standing before a camera. The Florida *stayed at sea as much as possible to visit her damage upon the enemy. When she did put into port, it was only for coaling and provisions. But the French kept her at Brest until February 10, 1864—almost six months after her arrival—before they let her go. Her first stop was Funchal, Madeira, where she anchored to take on coal on February 28. That day or the next a United States official there got a local photographer to make this incredible image of the* Florida, *the large ship in the foreground, her flag sailing bravely in the breeze. The smaller ship in the right*

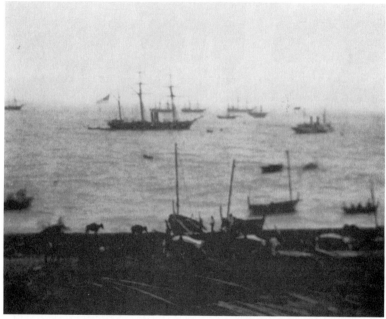

foreground is the Confederate blockade runner Julia. *There are other vessels there as well, and one of them, the large three-masted sailing sloop on the center horizon, is almost certainly the USS* St. Louis, *which had arrived just the day before. This was a neutral port, so the* St. Louis *had to remain at bay until the* Florida *steamed once more into international waters. Yet there is a further irony in this image that captures at once both the hunter and the hunted. For commanding the* St. Louis *was a man with a score to settle, the recently reinstated Commander George H. Preble. This is as close as he ever came to his quarry, however. On February 29 the* Florida *steamed away, while Preble watched helplessly, becalmed. "Oh, for a little steam!" he lamented. Lord Nelson had complained that "the want of frigates" in his squadron would be found engraved on his heart. Poor Preble sadly declared, "I am sure the want of steam will be engraven on mine."* (NA)

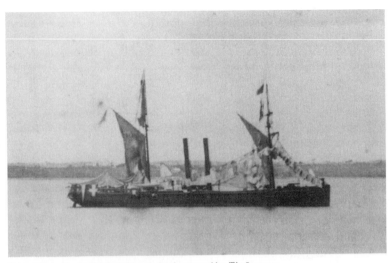

Other ships besides Preble's looked in vain for the great raider. The Saco *was one of them, a hard-luck ship with bad boilers and engine.* (USAMHI)

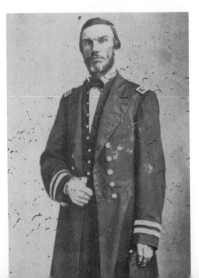

It was Commander Napoleon Collins, shown here as a captain, who finally put an end to the Florida; *yet even he had to resort to questionable means to do it.* (NA)

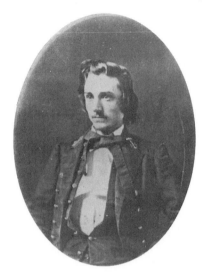

Lieutenant Charles W. Read, once an officer on the Florida, *put his experience to good use when he took command of a prize ship and raided the New England coast in a lightning raid that sent shivers through the Union. He appears here as a midshipman in the old United States Navy.* (NHC)

The Alabama, *like the* Florida, *also gave birth to a second-generation cruiser converted from one of her prizes. Semmes put Lieutenant John Low, seated at left, aboard the* Tuscaloosa *and turned him loose in the Atlantic for a six-month cruise.* (INTERNATIONAL MUSEUM OF PHOTOGRAPHY)

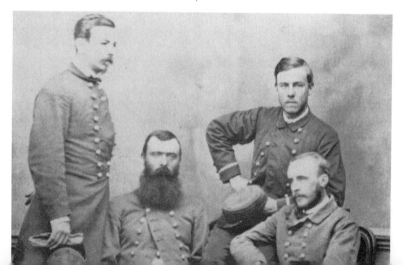

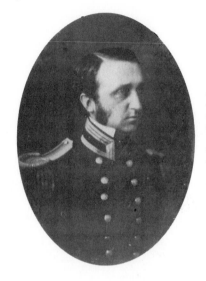

Meanwhile, slowly other ships, sometimes even blockade runners, were converted into makeshift cruisers, two of them in Confederate waters. One became the command of Lieutenant John Taylor Wood, a dashing veteran of the CSS Virginia *and grandson of President Zachary Taylor. President Davis was his uncle. This 1854 portrait by J. H. Whitehurst is believed to be Wood, of whom photographs are rare.* (CHARLES S. SCHWARTZ)

And here is Wood's ship itself, the only known photograph of the CSS Tallahassee, *taken in Halifax in August 1864 when she put in for coal after her lightning raid along the New England coast. The authorities were not accommodating, and Wood had to leave port the next day. This remarkable image, showing some slight damage incurred during the cruise, is published here for the first time.* (MARITIME MUSEUM OF THE ATLANTIC, HALIFAX, N.S.)

Bulloch desperately tried to build and send to sea a new class of commerce raiders to assist the cruisers already at work. They would be a formidable race of warships, iron-sheathed, mounting enormous 300-pounder rifles among other armament, and with awesome iron ramming prows just below the waterline. Such vessels, the Confederates believed, could break the blockade and destroy any ship the Yankees sent against them. They built the first one, eventually named the Stonewall, *in France, but it was well into the winter of 1864–65 before she left French waters at last. She steamed for El Ferrol, Spain, for coal and repairs, and there the photographer found her that March.* (LC)

There, too, the USS Niagara *found the* Stonewall. *The Confederate ship put out to sea on March 24 to give battle, but the Federal vessel feared her powerful armament and retired.* (LC)

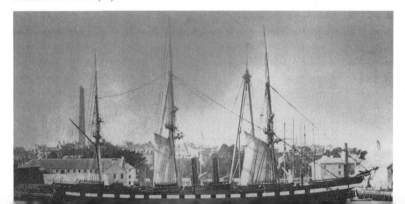

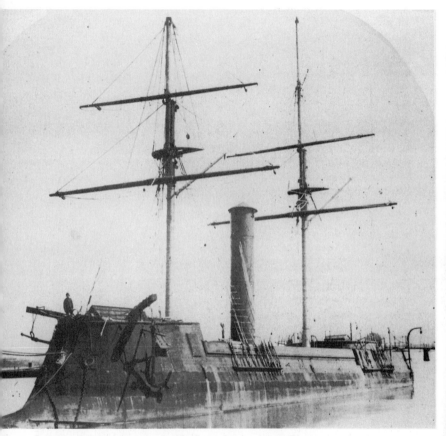

So the Stonewall *steamed on across the Atlantic unmolested, arriving in Havana in May, where she learned of the end of the war.* Stonewall's *commander gave the untested ship to the governor general of Cuba in return for money to pay off his crew, and Cuba in turn presented the ship to the United States.* (NA)

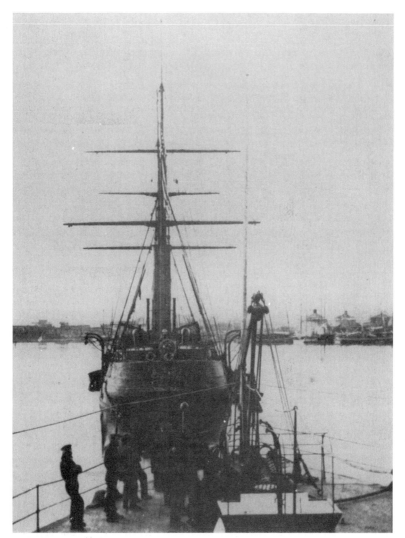

By July 1865 the mighty ram lay off the Washington Navy Yard, a prize of war.
Finally she was sold to Japan, to end her days as the HIJMS Azuma. (NHC)

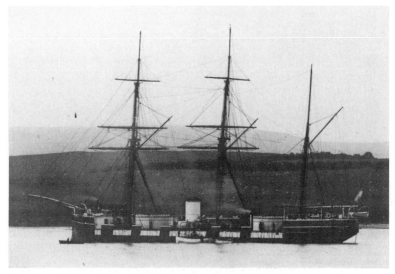

Sister ships to the Stonewall *wound up in the Prussian and other navies, as did the formidable Laird rams, built on Confederate contract at the Laird shipyards at Birkenhead, England. These ships became such an international point of contention between Britain and the Union that finally they were held up by London authorities and never delivered to the South. Instead, these Confederate rams joined Her Majesty's Royal Navy. One of them, HMS* Wivern, *appears here, the turret that mounted her guns clearly evident.* (IMPERIAL WAR MUSEUM, LONDON)

It remained to a Confederate cruiser to fire the last shots of the war. Lieutenant James I. Waddell oversaw the conversion of the British vessel Sea King *into yet another commerce raider. On October 19, 1864, he commissioned her . . .* (NHC)

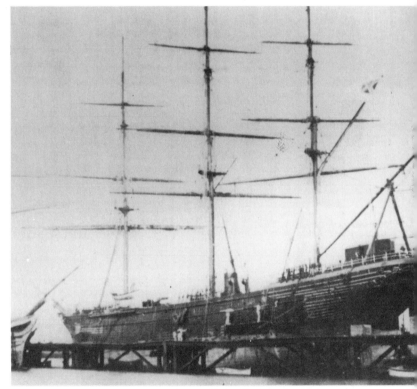

. . . *the CSS* Shenandoah. *She went to a new assignment, Yankee shipping in the Pacific. In her twelve-month cruise she took thirty-eight prize ships, most of them whaling vessels, and thereby nearly put an end to the American whaling industry in the North Pacific. Her last prizes were taken nearly three months after the war had ended. This remarkable image shows the* Shenandoah *in the Williamstown dry dock at Sydney, Australia, in February 1865, just before she sailed into the Bering Sea and the Arctic Ocean, where most of her prizes were taken. Her proud Confederate flag flies overhead.* (NHC)

It was the packet steamer America *that brought the Union the first news of the depredations of the* Shenandoah. (NA)

And when Waddell himself learned of the war's end some months before, he quickly set course for Liverpool, where he gave up his ship. There, to commemorate their cruise, many of his officers, like John T. Mason, posed for Liverpool photographer C. Ferranti. (MC)

Some, like Raphael Semmes, would carry their hatred of the Yankees to their graves. He and Maury met after the war to sit for this image, two old sea dogs of the Confederacy, whose great war and infant nation were, like their ships, now only a memory. (NHC)

The Siege of Charleston

ROWENA REED

The city that fathered secession suffers the war's longest siege

YANKEE RULE OF THE SEA, despite the commerce raiders and the blockade runners, played a large part in the "siege" of Charleston, the longest campaign of the Civil War. Federal attacks on this "cradle of the Confederacy," though erratic, were imaginative and introduced new tactical concepts. Not really a siege, because the city was never invested, the operations in both attack and defense relied upon mass firepower and engineering. The Confederate defense against a superior enemy holding command of the sea was a brilliant achievement, although the Federal failure was due largely to the Lincoln administration's decision to concentrate instead on destroying the main Confederate armies in the field.

Charleston's importance was mainly psychological. There the war began. There the Confederacy would prove worthy of nationhood, or Union hatred of secession would be assuaged. Events there did not decide the issue, but they could have. Loss of Charleston in 1863 might have been more fatal to Southern morale than the fall of Vicksburg. Nevertheless, the Northerners did not, at first, plan to take Charleston and never gave the campaign high priority. It evolved as a by-product of the Federal blockade, itself part of the original "Anaconda Plan" to strangle the Confederacy by shut-

ting off external aid. Established in April 1861, right after the fall of Fort Sumter, the blockade strained the then inadequate Union Navy and required measures for fleet maintenance that led eventually to the siege of Charleston.

Charleston lies between the Ashley and Cooper rivers, on a point of land that juts south into Charleston Harbor itself. Immediately below the city, bounded on the north by the harbor and on the south by the Stono River, sits James Island. It reaches almost down to the Atlantic, separated from the sea only by thin strips of land that run along the ocean face, Folly and Morris islands. The upper tip of Morris Island, called Cummings Point, marks the southern gate into Charleston Harbor. Less than two miles across the harbor mouth lies the northern gate, Fort Moultrie on Sullivan's Island. Between these two gates, lying astride the main channel into the harbor, sits Fort Sumter. A series of forts on James and Sullivan's islands, as well as on Morris Island and in Charleston itself, virtually ringed the harbor with fire.

In the summer of 1861 the Union Blockade Board recommended among other points the seizure of Port Royal, a spacious anchorage midway between Savannah and Charleston, as a station for the blockading squadrons. In early November a

Hilton Head, South Carolina, headquarters of the Department of the South and nerve center for the war-long siege of Charleston. Here men, matériel, and ships came together to mount the longest sustained investment of an enemy during the entire Civil War. (SOUTH CAROLINA HISTORICAL SOCIETY, CHARLESTON, S.C.)

large Union fleet commanded by Flag Officer Samuel F. Du Pont reduced the defenses there and occupied the harbor. With him were 12,000 Northern troops under Brigadier General Thomas W. Sherman, who at once established an army base on nearby Hilton Head Island. The easy capture of Port Royal revealed Confederate weakness and threatened the Southern seaports of Charleston and Savannah.

However, Sherman could not move against any point of real importance because he had insufficient water transportation. Nor was Du Pont willing to cooperate in offensive movements. This leading exponent of the blockade thought Charleston of so little importance that he sank old ships loaded with stone in an attempt to close the channels leading to the city. Major General George B. McClellan wanted Charleston as a base for advancing to Augusta and, eventually, to the vital rail junction at Atlanta. But the Northern general-in-chief became ill in December and was not well until February 1862, by which time his government insisted that all his resources be used against Richmond.

The Confederates took prompt advantage of the Union failure to exploit the lodgment on the southern Atlantic coast. In late November General Robert E. Lee arrived to implement a new system to guard against further Federal movements. Southern policy of siting coastal batteries too far seaward allowed these isolated defenses to be overwhelmed by the superior Union Navy. Lee at once evacuated this peripheral line. Instead, a new line of works was constructed well up the many rivers penetrating that coast to guard vital interior points. With fewer than 14,000 men to garrison Charleston and Savannah, Lee based a mobile defense on the railroad connecting these cities. Detachments stationed along this line could quickly concentrate at any threatened point. Lee's system thus countered Union sea mobility with a greater mobility over a shorter distance by rail. The Confederates also strengthened Charleston's harbor defenses,

"Merchant's Row" at Hilton Head, where sutlers and civilian suppliers did their business with the soldiers and sailors. (SOUTH CAROLINA HISTORICAL SOCIETY)

bridged the Ashley River to improve internal communications, and mounted heavier guns along the city's waterfront. The weakest point in the new system remained the large rivers, like the Edisto, which could lead a sizable enemy force into the rear of Charleston.

Sherman's replacement by Major General David Hunter in April 1862 brought some Union reinforcements and more transportation. Eager to make his reputation by taking Charleston, Hunter persuaded Du Pont to provide some fleet support. In June the Union Navy ascended the Stono River south of James Island, landing a division under Brigadier General Henry W. Benham at Legaré's plantation on the left of the Confederate lines, from which point a good road led into the rear of Fort Johnson on the south side of the harbor. But the road was threatened from the direction of Secessionville and the approach to that town restricted by impassable swamps and an earthen battery, Fort Lamar. Benham's unsuccessful frontal assault on this work resulted in large Union casualties, made worse by the indirect fire of two "cooperating" Federal gunboats, which fell on their own men. Incensed by this fiasco, Hunter absolved

himself by filing charges against Benham for supposedly disobeying orders, and spent the remainder of the year reconnoitering and trying to raise regiments of former slaves from the nearby plantations.

Meanwhile, Assistant Secretary of the Navy Gustavus Fox pressured Du Pont to try a naval descent upon Charleston with ironclads. Fox, who had been involved in the futile effort to relieve Fort Sumter in 1861, was obsessed with capturing this "hotbed of secession" and impressed by the apparent invulnerability of the monitor ironclads. A sailor of the old wooden navy, Du Pont loathed the "ugly" iron monitors with their clanking machinery and thought their two heavy guns too few and too slow for contests with forts. In his judgment, only a combined operation with the army to outflank the harbor defenses via the Stono or the North Edisto could succeed. Unfortunately, Hunter proved incapable of cooperating with anybody, and so an unsupported naval attack was ordered by the government.

Du Pont did not like the look of Charleston, and for good reason. In arranging their batteries, the Confederate engineers under General P.G.T.

Beauregard took maximum advantage of the peculiarly favorable configuration of the harbor to construct a complex of mutually supporting defenses, consisting of three interlocking "circles of fire" that extended from the seaward perimeter to beyond the city. Until September 1863, the outer circle—comprising Battery Beauregard and Fort Moultrie on Sullivan's Island, Fort Sumter, a two-tiered brick-casemated fort on an artificial island flanking the main channel, and Batteries Gregg and Wagner on Morris Island—was by far the strongest. For a distance of two thousand yards, the fire of seventy-six heavy guns could be poured upon the main ship channel; while two thousand yards in front of a rope barrier between Sumter and Moultrie, this fire converged to form a "wall" that the Federal squadron had to pass through to remove the obstructions and gain the inner harbor.

Under threat of relief from Command, Du Pont finally agreed to make the attempt as an "experiment," though in the event he was unwilling to risk his ships by pressing the attack vigorously. On April 7, 1863, a Union squadron comprising seven monitors, the large ironclad frigate *New Ironsides,* and the thinly armored, fixed-turret ship *Keokuk*

steamed up the channel and engaged Fort Sumter at ranges from one to two thousand yards. The contest was brief and still more discouraging than Du Pont had predicted. Five of the seven monitors were damaged. The *Keokuk,* carried closer to the fort by the tide, was riddled and sank the next day. The *Ironsides* became unmanageable and grounded on a shoal farther off, so her powerful broadside of eight heavy guns fired only once. The disparity of fire was tremendous. While the squadron shot off 139 projectiles, Sumter alone fired over 2,000 rounds and Moultrie half again that number.

Thick smoke prevented the admiral from observing that the few shells that did strike Sumter's thin masonry caused extensive injury. Besides, he was not inclined to look. His judgment had been vindicated and the monitor captains, like John Rodgers and Percival Drayton, who had been confident of success, now backed their admiral by telling the Navy Department that these vessels were useless for offensive purposes. In fact, damages to the monitors were not serious and were easily repaired.

Du Pont's reluctance to resume the attack or to

The Port Royal House, comprising a hotel and restaurant, where thousands came and went in the four years of planning and fighting directed at the prize Charleston. (SOUTH CAROLINA HISTORICAL SOCIETY)

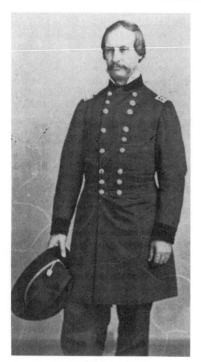

After being briefly commanded by Brigadier General Thomas W. Sherman, the Department of the South, and with it the goal of Charleston, went to the sturdy old politico Major General David Hunter. Here, as everywhere in the war, he failed to distinguish himself. (USAMHI)

support an army landing on Morris or James islands led to his removal from command. His successor was the former chief of Naval Ordnance, John A. Dahlgren. The Union general-in-chief, Henry W. Halleck, disliked the whole idea of joint expeditions. But in June he was persuaded by the Lincoln administration, who badly wanted Charleston as a moral victory, to allow Brigadier General Quincy A. Gillmore to conduct operations against the city in conjunction with the navy. Gill-

more, the North's best engineer, who had earlier demolished Fort Pulaski at Savannah by long-range fire, guaranteed to knock down Fort Sumter, opening the channel for a naval coup de main.

Accordingly, Gillmore, with 10,000 reinforcements, arrived in the Department of the South in June. In early July he conferred with Dahlgren about the plan of attack. Benham's repulse the previous year and the squadron's inability to provide fire support long distances from shore made operations on James Island appear unpromising. It was decided instead to approach via Morris Island because the fleet could cover the landings and protect a Union base there against counterattack. The three-stage joint plan called for the capture of Battery, or Fort, Wagner, followed by the destruction of Fort Sumter from breaching batteries erected on Cummings Point. In the final stage the fleet, using the monitors to suppress Moultrie's fire, would remove the obstructions and run into the harbor.

The first stage went well. While Gillmore's batteries on Folly Island pounded the weak defenses on the southern end of Morris Island, and the monitors lying close offshore took them in reverse, two brigades under Brigadier General Truman Seymour rowed across Lighthouse Inlet and overran these positions on July 10. However, an attempt to storm Wagner the next morning without artillery support was repulsed.

An enclosed earthwork mounting twelve heavy guns and extending completely across Morris Island near its northern end, Wagner was much more formidable than Gillmore had supposed. Its narrow approaches were protected by rifle pits, mines, and a wet ditch. Constructed of fine quartz sand by Colonel D. B. Harris of the Confederate engineers, with its guns in embrasures and its quarters bombproofed, the work was extremely resistant to bombardment. Gillmore, nevertheless, emplaced the siege guns brought for use against Sumter. On July 18 he opened a terrific fire, pounding Wagner for eleven hours with 9,000 heavy projectiles, while the fleet threw 15- and 11-inch shells at close range. Assuming the guns had been disabled and the garrison knocked senseless, Gillmore sent two brigades, led by Colonel Robert G. Shaw and his 54th Massachusetts (colored) troops, to assault the fort. But the defenders, unharmed in the bombproof, retrieved

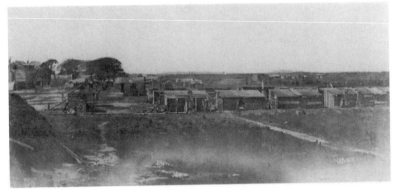

The only engagement fought while Hunter was in command came at Secessionville, where a subordinate attacked without orders and suffered a defeat. Hunter quickly absolved himself of all blame. (NA)

their guns from the sand and repulsed the attack by a storm of grapeshot, canister, and rifle balls, killing and wounding a third of the Union force.

Gillmore now decided to besiege Wagner and built more batteries in the swamps on his left. The ironclads kept down the garrison's fire and guarded the right of the Union lines. By August 8 the siege works were within five hundred yards of the fort. Here progress was stopped by plunging shells from Sumter that were fired over Batteries Wagner and Gregg and fell vertically into the trenches. Gillmore thought it necessary to alter the original plan and destroy Sumter first at long range. In a massive precision bombardment lasting fifteen days, Sumter's gorge wall was practically destroyed. Struck in front and reverse, the rest of the upper casemates fell into rubble. When the firing stopped, only a small section of the northeastern wall remained standing and only one gun, in the western face, was serviceable.

Gillmore tried another expedient to end the campaign quickly. With great exertion and skill, Federal engineers built a heavy emplacement on pilings in the marsh between Morris and James islands. Here they mounted an 8-inch rifled cannon that, at thirty-five degrees elevation with a large powder charge, could throw 200-pound shells five

miles into Charleston. When Beauregard refused an ultimatum to surrender the city, the Federals fired this "Swamp Angel" thirty-six times before the gun burst. Fifteen projectiles struck the city, causing some material damage, but no one was killed and the psychological effect was negligible. In the autumn the bombardment was resumed, this time with rifles and mortars firing explosive and incendiary shells. Although damage to buildings was extensive enough to cause civilian evacuation of the lower town, casualties were light. Confederate authorities were believed to have sent Union prisoners of war to be housed under fire in Charleston, to discourage this cannonade. In retaliation, Southern prisoners were kept on Morris Island under the fire of Confederate harbor batteries. Eventually, this futile practice was stopped and the prisoners were exchanged.

Elimination of the plunging fire on the approaches allowed Gillmore to resume the siege of Battery Wagner. By September 7 the trenches had been pushed so close that Wagner's guns were useless. Their stout resistance having won time to strengthen the inner defenses, the Confederates abandoned Morris Island.

Thinking that Sumter had been evacuated also, Dahlgren sent a party of 500 sailors and marines to occupy it the following night. Again the defenders

Regiments like the 104th Pennsylvania took heavy losses for nothing at Secessionville, though Captain John M. Laughlin survived to pose with his model of a seacoast rifle. (RP)

Another who survived, and happily so, was Albert Ordway, a lieutenant of the 24th Massachusetts. After the war he will become one of the most prominent collectors and preservers of war photographs and compiler of many of the major collections extant. (NA)

were prepared. The first boats had barely landed under the eastern faces when all the guns on Sullivan's and James islands, along with the Confederate harbor ironclad *Chicora,* opened on them. Bullets and chucks of masonry crashed down from the walls. Within an hour, 125 Federals were prisoners, while the remaining boats beat a hasty retreat. Because of a command dispute with the navy, an army assault force assembled at Cummings Point remained inactive. The boat attack was the climax of Union operations against Charleston. Having accomplished the army's objective by knocking Fort Sumter pretty thoroughly to pieces, Gillmore expected the navy to take the initiative.

Dahlgren recognized his responsibility for the final stage of the joint plan, but he was disconcerted by the limited results of the bombardment and the Union occupation of Morris Island. The Confederate transfer of Sumter's artillery to the inner defenses eliminated the cross fire on the channel, but the obstructions had to be removed by small boats under full fire from the batteries on Sullivan's Island. Nor was Sumter entirely useless for channel defense. Before the boat attack, the 1st South Carolina Artillery, which had so stubbornly defended the fort, was relieved by the Charleston Battalion of infantry under Major Stephen Elliott, who immediately prepared against another landing. Parts of the shattered work were heavily revetted with earth, sandbags, palmetto logs, and pieces of masonry to afford bombproofs for massing troops to repel assaults. On the exterior slopes, the Confederates placed chevaux-de-frise and wire entanglements as deterrents against surprise. Because a terrific fire could be poured upon Sumter from the increasingly powerful Federal batteries erected on Cummings Point, these obstacles had to be taken up before dawn each day and replaced after sunset.

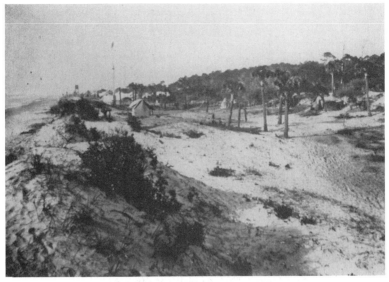

Yank and Reb did not meet in battle again until April 10, 1863, when skirmishing on Folly Island finally gave the Union a foothold on the very door to Charleston. The Stars and Stripes went up . . . (USAMHI)

. . . and so did the tents of the troops. Uncle Sam had come to stay. (USAMHI)

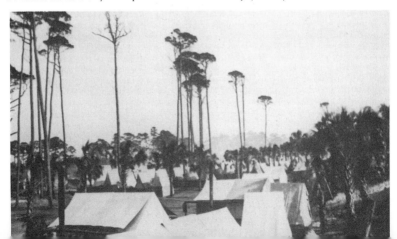

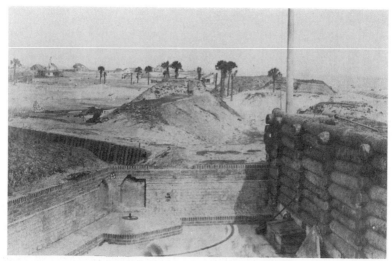

But they would stay a long time before the prize was won. Charleston was ringed with a formidable array of forts besides Sumter out in the harbor. Most daunting of all was Fort Moultrie, which dated back to the Revolution. A combination of earthworks, masonry, and palmetto logs, it controlled the main channel into Charleston Harbor. (NA)

Elliott intended more than mere defense of a ruined post. Three weeks after assuming command, he suggested to Brigadier General Thomas Jordan, Beauregard's chief of staff, the remounting of some guns on the northeastern face. Four of the lower casemates, shielded by the southeastern wall against reverse fire from Morris Island, were further strengthened in the rear by mounds of log-reinforced earth. Three heavy guns mounted in these emplacements crossed their fire just ahead of the obstructions with the fire from Fort Moultrie. Thus, by late October, the ironclads were again exposed to damage in approaching close enough to cover the removal of these obstacles. Barring another night assault, which neither Union commander considered practicable, the solution appeared to be the complete destruction of the fort.

The second bombardment of Sumter opened on October 26 and continued day and night until December 6. Although heavier than the first and con-

ducted at much closer range, it proved less destructive because of the already battered condition of the masonry and the vigorous exertions of the garrison in adding large quantities of more resistant material. Gillmore's aim was to blow away enough of the southern faces to expose the northern channel faces to his batteries. Unlike direct fire, which caused the material to fall inside the fort, forming a convenient ramp for the defenders to mount the walls, reverse fire threw the debris outside, creating an escalade slope for assault parties.

Despite fairly heavy casualties to the garrison, the bombardment was unsuccessful. While the southern faces were considerably reduced, the three-gun battery remained intact. The 15-inch monitor projectiles, fired over the eastern angle, were far more destructive than the fire of the land batteries—so much so that, at one time, the only remaining magazine, in Sumter's southwestern angle, was seriously threatened.

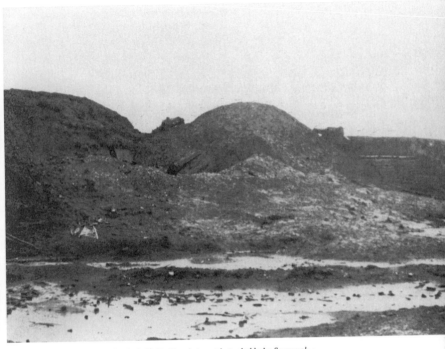

In this previously unpublished April 1865 photograph, probably by Savannah artist J. T. Reading, Moultrie's strength is still evident despite the destruction. Gun after gun faced any who dared test its mettle. (AMERICANA IMAGE GALLERY)

But Dahlgren was aware only of his own difficulties. The monitors had been in almost constant service since July and needed overhaul. Many leaked badly. Accumulated minor injuries to their turrets and plating added to their unfitness for action, while the crews were decimated by sickness and exhaustion resulting from the extreme heat inside these vessels. The fleet's inability to sustain its fire more than a few hours a day for a few weeks gave the Confederates time to repair damages. The new monitors scheduled to join Dahlgren for an attempted breakthrough to the city in December were delayed by construction problems, so the navy could do little more than strengthen the blockade.

The second great bombardment having failed to open a way to Charleston, Gillmore asked for a different command. In May 1864 he was called north for operations in Virginia. His successor was Major General John G. Foster, another engineer familiar with the Charleston harbor. Although his instructions were simply to defend ground already held, Foster naturally hoped to accomplish more than his predecessors. The same demands of the Virginia campaign that reduced the Federal forces

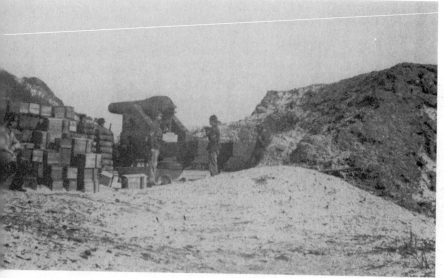

Reading catches a 10-inch Brooke gun as it stares out to sea, its store of ammunition still ready. Such guns visited a terrible destruction on the Union fleets that tried to penetrate the harbor. (AMERICANA IMAGE GALLERY)

to about 15,000 men reduced Confederate numbers to barely 5,000 to guard their extensive lines.

Foster first planned to seize Sullivan's Island as the quickest way to open the channel. However, Dahlgren refused to cover landings on the north side. In September 1863 the *Weehawken,* while aground under enemy gunfire, had sustained damages that contributed to her foundering two months later. In November the *Lehigh,* grounded near Cummings Point, was pounded by Fort Moultrie before being hauled off. The admiral considered the treacherous shoals off Sullivan's Island more hazardous than the forts.

Foster next designed a three-phase operation to turn the Southern lines and capture Fort Johnson. On July 2, 5,000 men under Brigadier General J. P. Hatch landed on John's Island and the southern tip of James Island. As expected, the outnumbered defenders withdrew most of the garrison from

Johnson, setting the stage for the second phase. That night, 500 men attempted to surprise the fort by water. The plan was excellent, but everything went wrong. The departure from Cummings Point was delayed by the tide, the pilot lost the narrow channel in the dark, and many boats grounded. It was near daylight before the leading boats landed near the fort, by which time the garrison was alert; 5 officers and 135 Federal soldiers were taken prisoner, while the remaining boats, retreating without orders, came under fire from Battery Cheves on the eastern shore of James Island. The third phase, an expedition to cut the Charleston & Savannah Railroad, was stopped before it reached its objective. On James and John's islands, Confederate counterattacks led to withdrawal of Union forces.

The Federals turned again to Fort Sumter. While conducting sporadic bombardments, Foster searched for some technique to overcome the stub-

born defenders. With aid from the navy, he prepared to float torpedoes and barges containing explosives against the fort, but conditions were never favorable enough to try these devices. Another idea, reflecting Foster's frustration, was to build large row galleys with elevated platforms to storm the walls. Specifications for such ancient contraptions, sent to General Halleck, were rejected with the laconic comment that Foster was to remain on the defensive.

No further initiatives were taken against Charleston until late November, when there were several more unsuccessful attempts against the railroad in conjunction with Major General William T. Sherman's march through Georgia. The fall of Savannah on December 21 and Sherman's advance into South Carolina sealed the fate of Charleston. On February 17, 1865, after sinking their vessels, spiking their guns, and setting fire to many buildings, the Confederates evacuated the city and its defenses under the noses of the Federals, who were then attempting to outflank them via the Stono and Bull's Bay.

And so the siege ended. For twenty-two months Charleston's harbor outposts held against an ironclad fleet and a superior army. While geography, aided by Confederate tenacity and skill, favored the defense, the Federals often failed to press their attacks. Too much reliance was placed on the physical and moral impact of bombardment. Union Army leadership changed too often, and the troops were not the best. The monitors, designed for brief ship-to-ship engagements, held up badly during extended service against shore batteries, and the admirals were too reluctant to risk ships in an all-out push to the city. Finally, the strategic priorities of the Northern high command lay elsewhere. Yet at one time the Charleston campaign was the only Civil War action seriously studied in Europe. It remains one of the war's most interesting chapters.

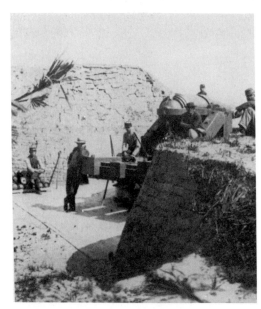

Here, in April 1865 in Battery Marion in Fort Moultrie, a 7-inch Brooke seacoast gun attracts the attention of men whom it once held at bay. (USAMHI)

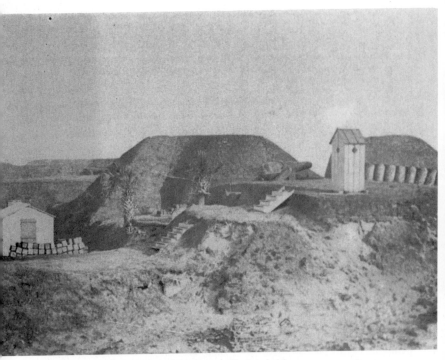

Indeed, this is the single most photographed cannon in Charleston's defenses.
The photographers shot it from all angles, and with it the two palmettos
incongruously decorating the emplacement. Reading's view. (AMERICANA IMAGE
GALLERY)

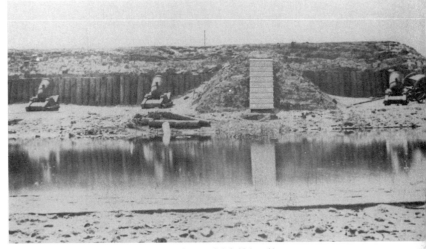

Elsewhere in Moultrie mighty mortars poised ready to send their high-arching shells against any attacker. A previously unpublished 1865 Reading image.
(AMERICANA IMAGE GALLERY)

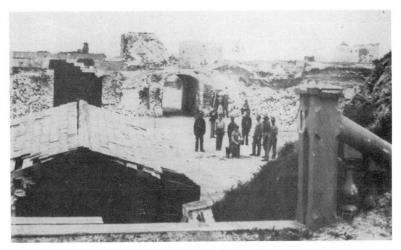

The much-battered remains of the fort at war's end gave testimony to its strength and near impregnability to attack. (USAMHI)

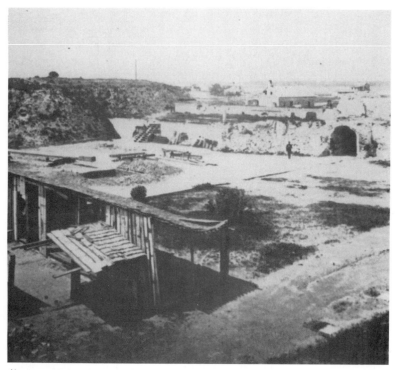

After years of Federal siege, Moultrie could boast stairways that went nowhere.
(USAMHI)

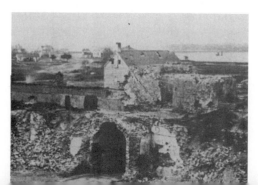

Sally ports in walls that no longer stood; yet the bastion never fell in combat. (USAMHI)

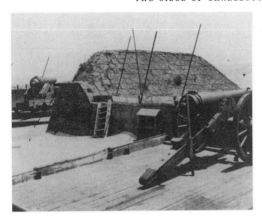

To be sure, there were other fortifications on Sullivan's Island, like Fort Marshall on the island's northern tip. (USAMHI)

But none could match Moultrie. It took four years to see the Stars and Stripes float over it once more. (USAMHI)

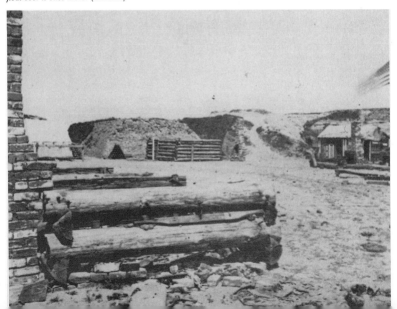

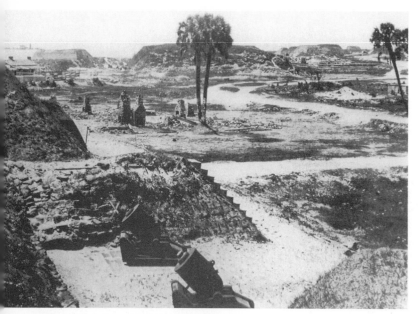

Four years earlier a Yankee ironclad could pause with safety beside the battered yet formidable fortress. (CHS)

After the failure of the April 1863 naval attack, Quincy Gillmore, hero of Fort Pulaski, gained a foothold on Morris Island, south of Charleston, and began working his way toward the city. (WRHS)

His first obstacle was Fort Wagner, the Confederate earthwork whose parapet cut completely across the northern end of the island. It had to be taken. (USAMHI)

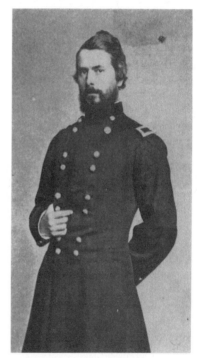

Gillmore gave the job to Brigadier General Truman Seymour, a veteran of the Confederate bombardment of Fort Sumter two years earlier. The attack was doomed to failure, and Seymour himself took a terrible wound that put him out of the war for half a year. (USAMHI)

Doomed as well was Colonel Robert G. Shaw, the twenty-five-year-old leader of the 54th Massachusetts, a colored regiment that took a leading part in the battle. He was killed on Wagner's parapet, and angry Confederates buried him beneath the bodies of his fallen Negro soldiers in a common grave. (USAMHI)

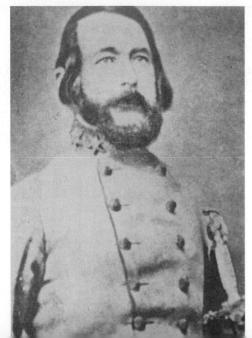

The immediate commander of the defense of Wagner was Brigadier General William B. Taliaferro, a veteran of the Virginia campaigns and one who had served well under Stonewall Jackson. This previously unpublished portrait shows him as colonel of the 23d Virginia. (CWTI)

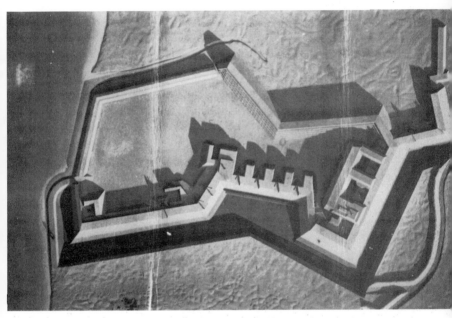

It took over two months before the Rebels finally abandoned Fort Wagner, and by that time Gillmore had thoroughly studied and mapped it. Indeed, he even prepared a model, which was photographed and sent to Washington. (NA)

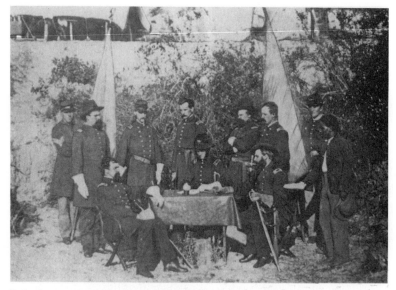

During those two months regiments like the 39th Illinois waited for the next attack and posed for photographers Haas & Peale. (USAMHI)

The bands played to drive away the summer heat. (USAMHI)

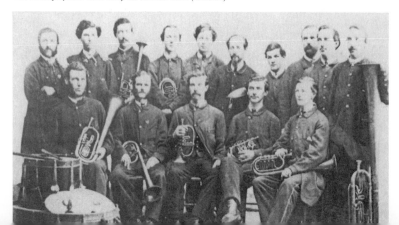

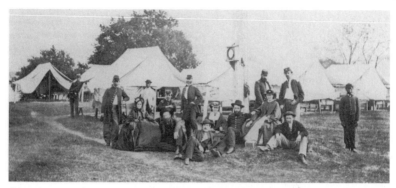

*A few wives came to brighten the lonely wait for the 1st United States Artillery,
and Samuel Cooley came to capture the scene.* (NA)

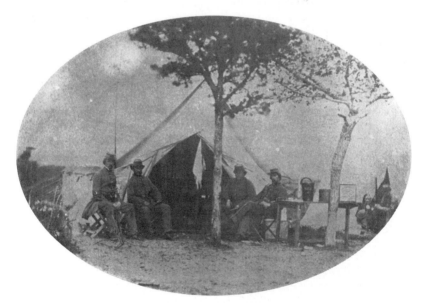

*Across the island, behind the works at Battery Wagner, the Confederates also
waited and posed for the photographers. This is a rare group shot of
Confederates, the 25th South Carolina, formerly Charleston's own Washington
Light Infantry.* (WASHINGTON LIGHT INFANTRY)

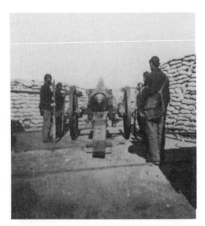

Meanwhile, unwilling to be idle until Wagner fell, Gillmore planted batteries on Morris Island and began shelling Fort Sumter. Here a 4.2-inch Parrott rifle on a siege carriage fired from the second Swamp Angel battery, the first one having been dismounted when the gun itself exploded. (USAMHI)

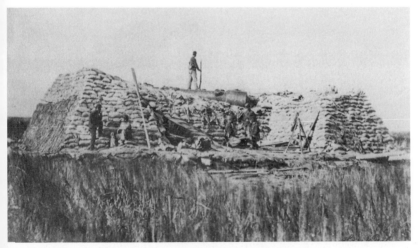

Haas & Peale's photograph of the first Swamp Angel after it burst while firing, destroying its carriage and flinging itself up on the sandbag embrasure. (USAMHI)

*But the Federals had to get close to Charleston first before big guns would work,
and the Confederates had other ideas. The city was a symbol of their cause.*
(NEW-YORK HISTORICAL SOCIETY)

*They would defend it to the last. Here, at top center, is The Citadel, the military
school that trained many young Confederate officers.* (NYHS)

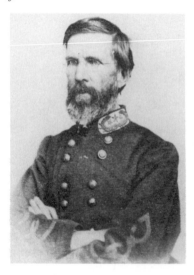

Major General Jeremy F. Gilmer, chief of the
Confederate Engineer Bureau, actually designed
some of the city's more formidable defenses.
(USAMHI)

There were many who would volunteer to help
defend their city, even once-prominent politicos
like William Porcher Miles, now a volunteer aide
to Beauregard. (LSU)

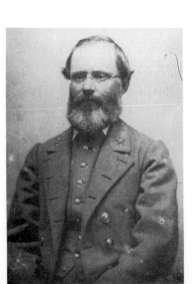

And others, like Colonel D. B. Harris, actually put
Gilmer's plans into practice. (VM)

And they erected formidable defenses. Here we see the King Street Battery, its grass-covered earth mounds almost giving it the appearance of a city park. (NA)

White Point Gardens, at the foot of the East Battery, an image taken in 1865. Out of almost every backyard grew a gun emplacement. (NA)

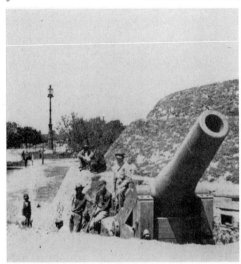

The Point Battery, its guns, like the city lampposts, often illuminating the night sky over Charleston. (USAMHI)

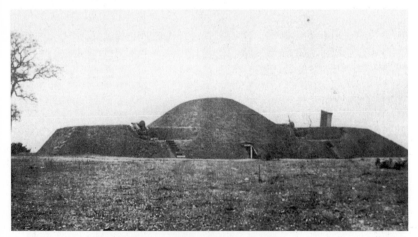

One of many batteries along the city's waterfront, its own "bombproof" magazine built into the earth beneath it. Probably taken by J. T. Reading.
(AMERICANA IMAGE GALLERY)

The wharves had their own batteries.
(USAMHI)

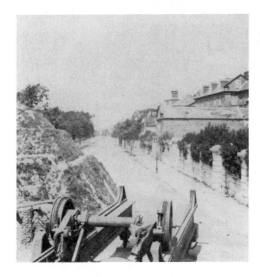

In time, Gillmore's guns managed to arch their shells into the city.
(USAMHI)

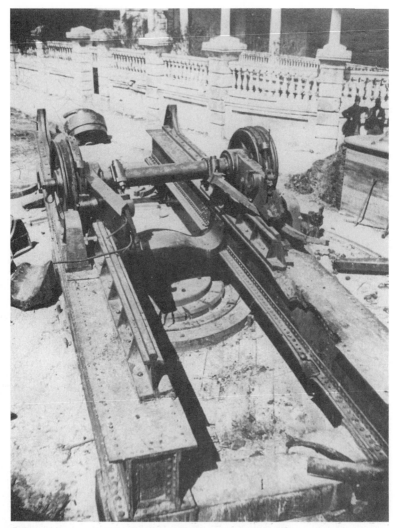

So did the other cannon in places like the South Battery, where this was all that remained of a 600-pound Blakely gun. A mighty engine of war was nothing but scrap. (NA)

The tranquil view along the East Battery waterfront belied the noise and turmoil of Charleston under siege. (USAMHI)

But the scars of the bombardment were there. (NA)

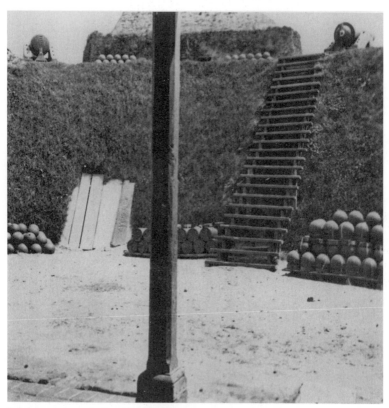

And always more guns, in places like Castle Pinckney. (NYHS)

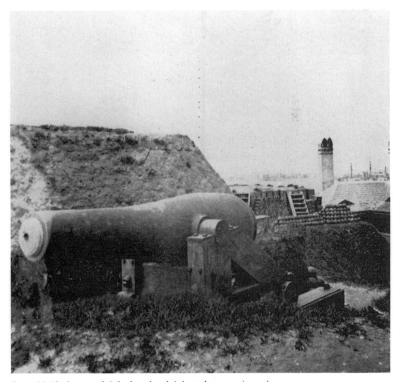

Guns with Charleston at their back, and to their front the enemy. (NYHS)

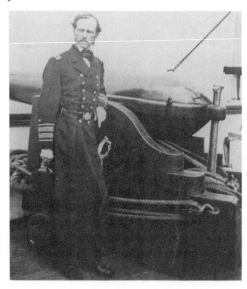

After the failure of the April 1863 attack on Charleston, a new naval commander, Rear Admiral John A. Dahlgren, arrived on the scene. He renewed the attacks on the city and its forts from the water, and assisted in the final capture of Fort Wagner. (USAMHI)

The attacks of that summer proved harder on the Passaic than on the Confederates. Cooley's assistant E. W. Sinclair made this image, showing some of the turret dents suffered by the ship. (SOUTH CAROLINA HISTORICAL SOCIETY)

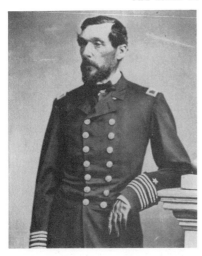

Percival Drayton commanded the Passaic *that summer and came out of the experience with little enough respect for the wisdom of sending ironclads against fortresses.* (NA)

The Passaic *had its smokestack nearly demolished. Here it rests at the Bay Point shops along with other wreckage.* (USAMHI)

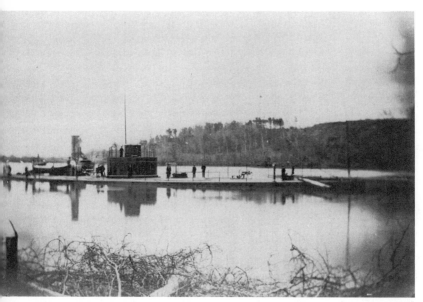

The USS Lehigh *joined with the other monitors in Dahlgren's bombardments. It, too, boasted a dent or two when it was later ordered to the James River for service in Virginia, as shown here.* (USAMHI)

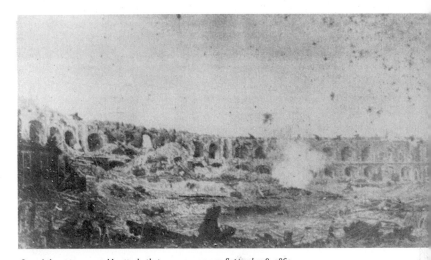

One of the most memorable attacks that summer came on September 8, 1863, valued chiefly because Confederate photographer George S. Cook made a rare excursion from his studio and took his camera to Fort Sumter. There, during a bombardment from Dahlgren's fleet, he made a series of magnificent images graphically depicting Sumter and its occupants under siege. Despite poor conditions, he had just set up for a view of the parade ground when a shell believed to come from the Weehawken exploded just as he exposed a plate. The result was this badly deteriorated image, probably retouched on the original by Cook himself, which also shows a group of Confederates standing and sitting at left. (USAMHI)

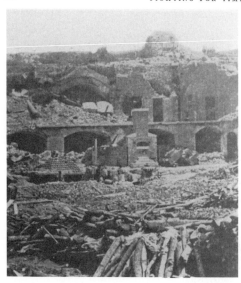

A view of the shot furnace, and behind it the officers' quarters, now mere caves amid the dust and ruin. (USAMHI)

Another view of the shot furnace; defenders pose jauntily for Cook atop it. (SOUTH CAROLINIANA LIBRARY)

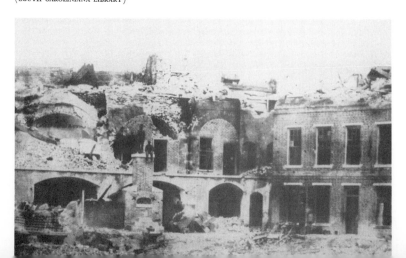

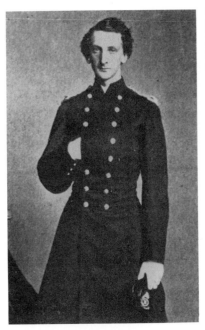

In the early hours of September 9 Dahlgren sent parties of volunteers on a daring attempt to land at Sumter in the dark and take it by assault. It failed, and all were captured, including Marine Lieutenant Robert L. Meade, nephew of General George G. Meade. (P-M)

Cook took his camera to the parapet, braving enemy fire, to capture this view of three Yankee ironclads firing at Fort Moultrie. It was late in the morning of September 8; the men aboard the Weehawken had just finished their breakfasts when they opened fire on Sumter. As Dahlgren later reported, "Some movement in Sumter seemed to draw attention from the Weehawken." That movement was Cook setting his camera on the parapet. Just after he got this view, the Confederate commander ordered him off, angry that he had drawn enemy fire. The identities of the ships cannot be ascertained with certainty, but the one at the extreme right is probably the New Ironsides. (USAMHI)

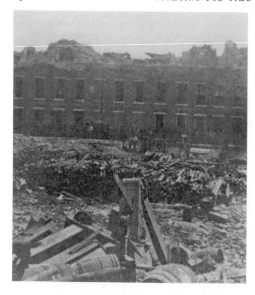

The parade ground now crowded with rubble, wood, and shattered supplies. There is little attempt to maintain a sense of order, though the defenders still line up against the wall for the camera, their uniforms now anything they can find to wear. (USAMHI)

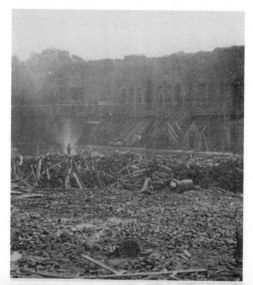

They cook their meals out in the open over smoking fires, when the enemy's shells are not exploding on the parade ground. (USAMHI)

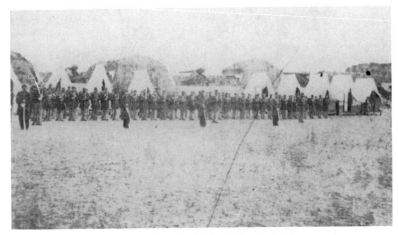

At last Battery Wagner fell, and the new Federal garrison could pose at a dress parade before the parapet that had cost them so dearly in lives. (ROBERT J. YOUNGER)

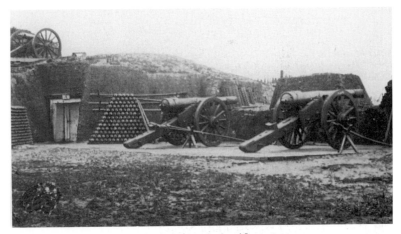

These heavy Parrott rifles had as their single task the reduction of Sumter to a useless ruin. They very nearly succeeded. (USAMHI)

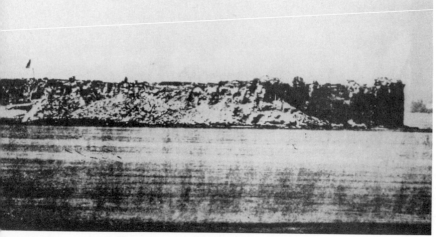

On August 23, 1863, Gillmore had this photograph of Fort Sumter made from a position near the northern tip of Morris Island. For seven days his guns had been firing at the fort, and the shelling continued for another six hours after this was taken. More than half of the 5,009 shells fired at Sumter found their target. He sent a sketch based on the photo to Washington to show the damage done. (USAMHI)

Eleven weeks later Gillmore had another image made. "I keep up a slow fire on the ruins of Fort Sumter night and day," he reported when he sent in another sketch. The damage done in the previous weeks is obvious. (USAMHI)

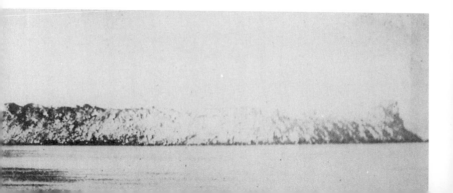

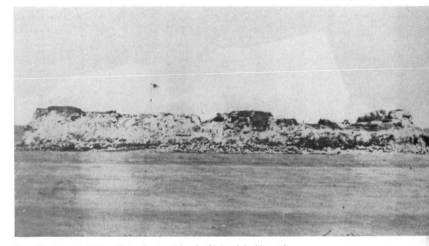

Some time later, probably on December 11, 1863, the third and final image in the series revealed the further destruction of the fort. It holds barely the shadow of the shape of the August before; yet the Confederate banner still floats jauntily overhead in this previously unpublished image. (AMERICANA IMAGE GALLERY)

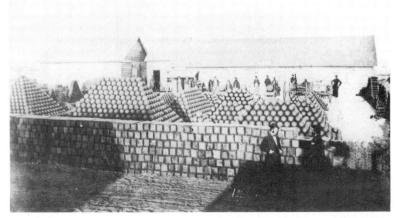

Cooley's November 1864 image of the Morris Island ordnance yard, through which passed the tons of iron hurled at Sumter. (USAMHI)

From the mammoth ordnance yard at Hilton Head came the heavy guns that battered the defenders. (NA)

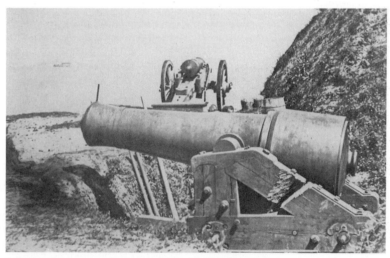

Gradually Yankee might inevitably wore down the Confederates in Charleston. On July 3, 1864, the bluecoats attacked Fort Johnson and failed. They tried again a week later, only to be driven from James Island altogether for a time. Sumter lies in the distance. (KA)

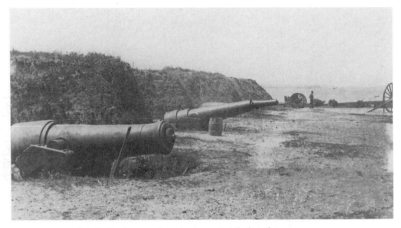

Later in the war, when the Confederates themselves evacuated the fort, they hacked away at the wooden gun carriages to make them unsafe for firing. (NA)

Another joint Army-Navy attack on Charleston came on September 9, 1864, with more new soldiers and more new ironclads, like the USS Mahopac. (USAMHI)

The Confederates held out as best they could, still posing jauntily for the very few photographers who came to see them. These men, probably of Company I, Palmetto Battery, Charleston Light Artillery, pose before their position at Fort Pemberton on the Stono River. The gentleman with arms folded standing before the banner may be their captain, J. R. Bowden. (USAMHI)

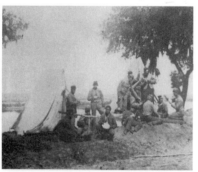

Quarters were not quite what they had been in 1861, but the artillerists could still relax beneath a tree for a game of cards. Of course, there were still slaves to chop wood and wash dishes. (USAMHI)

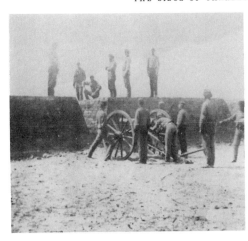

And there was plenty of time for artillery practice, or at least posing for the camera. (USAMHI)

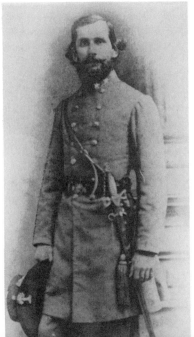

Indeed, in the indolent days of besiegement, some Rebels grew rather lax. An inspector complained that Colonel Fitz William McMaster's 17th South Carolina had defective discipline, bad ammunition, a messy adjutant's office, and "camp very dirty." Poor McMaster was tried and relieved from duty for six months. (PETER COPELAND)

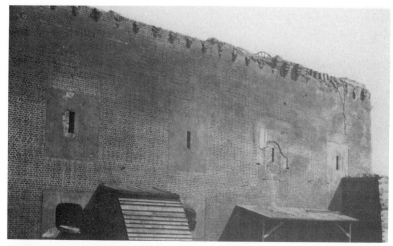

Yet still Charleston held on, and symbolizing it all, Fort Sumter. As 1864 wore on into 1865, it ceased to offer any distinguishable shape. Only one wall, not directly facing any of the Federal land batteries, preserved its form. (NA)

The rest looked like a rocky hillside, guarded from assault at the summit by makeshift portable chevaux-de-frise. Even as early as late 1863, Gillmore believed that he could take the fort by assault but that it was not worth the cost. (NA)

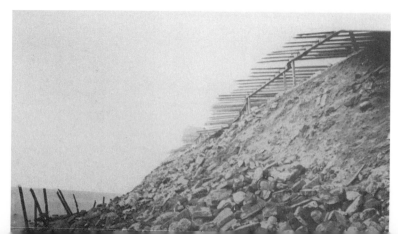

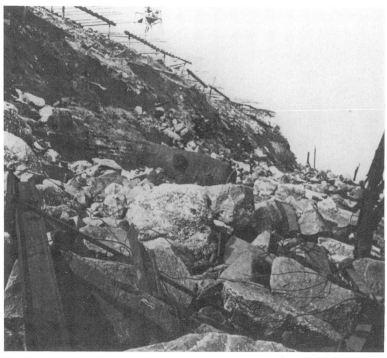

The stakes and the telegraph wire entanglements would cost too many men.
(NYHS)

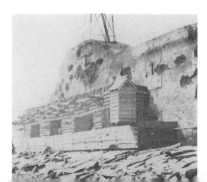

The bombardments forced the defenders to resort to palmetto barricades to patch the gaping holes blasted in the walls. (USAMHI)

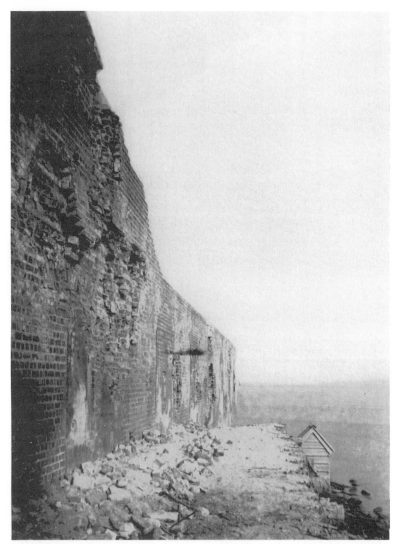

It looked like an abandoned medieval ruin. (NA)

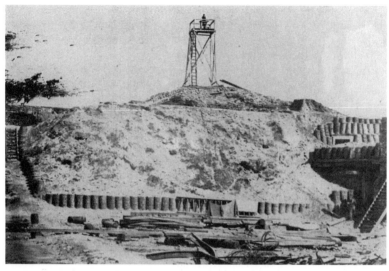

The only life visible was often the sentinel in the oft-repaired watchtower. His view was chiefly one of desolation, as was photographer Reading's. (AMERICANA IMAGE GALLERY)

To contain the gradually crumbling masonry and give some kind of order to the fort's walls, the Confederates reinforced them with earth and rubble-filled baskets, which offered an odd contrast to the lonely chimneys rising, and sometimes barrel-capped, from the barracks. (AMERICANA IMAGE GALLERY)

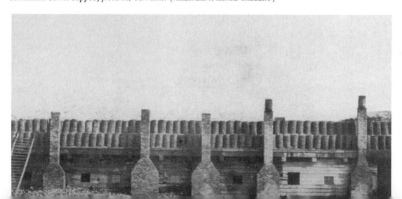

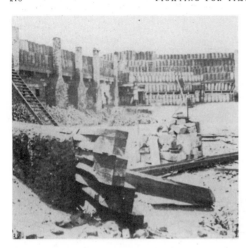

These were the officers' quarters, such as they were, really little more than a jumble of palmettos, baskets, and dirt. (USAMHI)

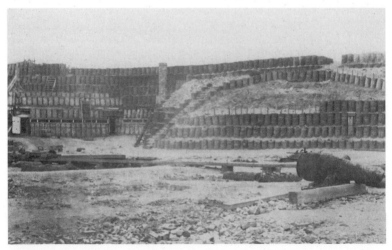

So rutted and rubbled was the parade ground that boardwalks had to be laid for running guns and wheelbarrows back and forth. (NA)

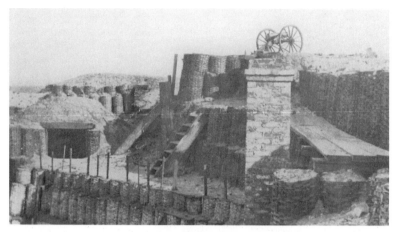

Yet they held out, their signal gun defiant on the battered parapet. (AMERICANA IMAGE GALLERY)

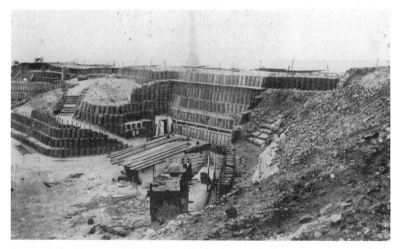

It was a mingling of textures—the baskets, the rubble, the wire strung on the parapet, the stakes jutting out. The fieldpieces seem almost out of place. (LOUISIANA HISTORICAL ASSOCIATION, SPECIAL COLLECTIONS DIVISION, TULANE UNIVERSITY LIBRARY, NEW ORLEANS)

As Sumter fell, so Charleston had inevitably to fall as well. A beautiful city had been much laid waste. Here sat Secession Hall, where in 1860 the state seceded. (USAMHI)

Here, already being rebuilt in this 1865 view, stands the Circular Church, Secession Hall's neighbor. (USAMHI)

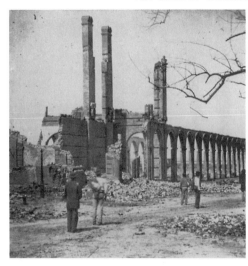

The Northeastern Railroad Depot lay in ruins. (LC)

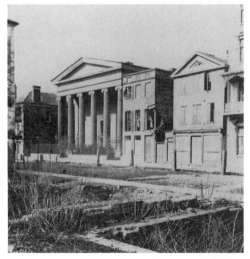

Hibernian Hall came through the siege relatively secure. (USAMHI)

The Mills House Hotel, once home to P.G.T. Beauregard until enemy shells began striking it, showed the effects of the bombardment. (NYHS)

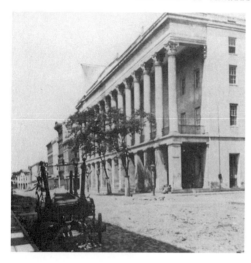

The Charleston Hotel managed to survive the Yankee shot and shell, only to fall victim to the wrecking ball a century later in 1960. Sometimes a city can face greater enemies than warfare. (USAMHI)

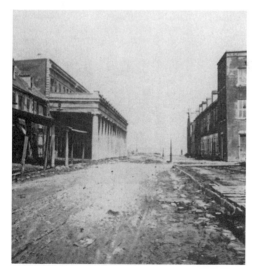

Yet portions of Charleston looked wasted, like the Vendue Range. Once it bustled. (USAMHI)

Meeting Street, with Saint Michael's in the distance. The Confederates painted it black to present less of a target to Federal gunners. The great mound of earth scooped from the street may be a defensive work, or the signs of reconstruction. (NA)

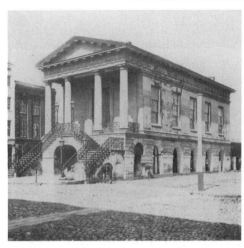

Charleston's old Market House happily missed the rain of iron during the siege; yet it would take time before it again echoed the calls of the vendors on market day. (USAMHI)

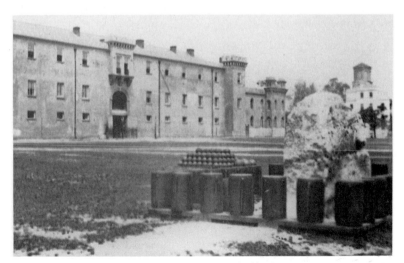

At The Citadel, in the city's heart, no more officers would be trained for the Confederate States of America, but it would soon begin schooling young men again for distinguished military careers under the banner of the Union. (NYHS)

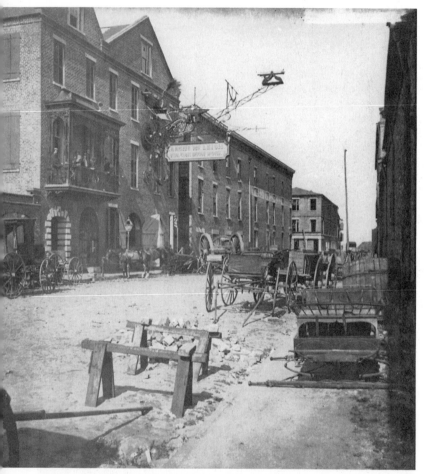

*Amid the scenes of destruction, there were also signs of renewed life. Mr.
McLeish's Vulcan Iron Works was able proudly to proclaim its presence in a
sign and a bracket obviously ornamented with a few war "surplus" items like an
anchor, a signal gun, and an anvil-like locomotive spring.* (LC)

*There was much to clean up after the surrender. Here the wreckage of some
Yankee ordnance, probably remnants of the first Swamp Angel that exploded.*
(LC)

*Charleston's arsenal bulged with tons of unexpended ammunition and torpedoes,
or "infernal machines," plus floating mines. Someone obligingly arranged and
marked them for the camera.* (USAMHI)

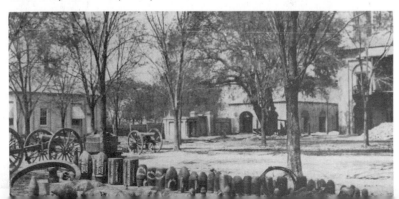

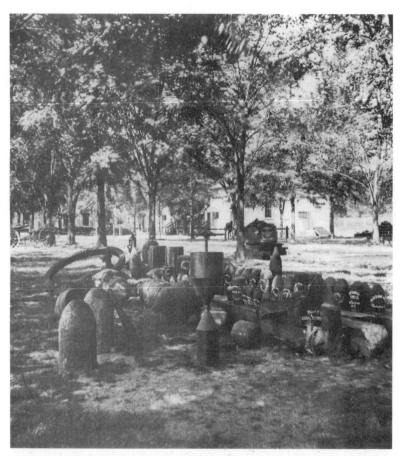

*Most of these will wind up as souvenirs and museum pieces. For now they rest
under the taunting gaze of Yankee bunting draped in the trees.* (LC)

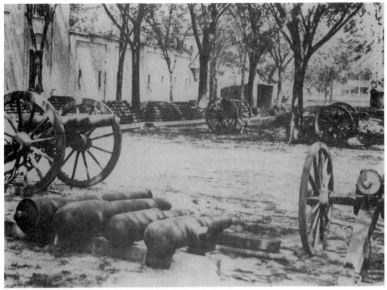

These Blakely guns will never again send hostile shots at fellow Americans.
(NYHS)

*Americans like these men, Brigadier General John Hatch and his staff. Hatch,
seated in the chair, came to Charleston to command the occupation forces.*
(USAMHI)

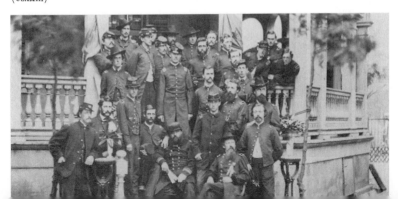

*His soldiers soon became a common sight, troops like these, caught by
photographer W. E. James of Brooklyn.* (T. SCOTT SANDERS)

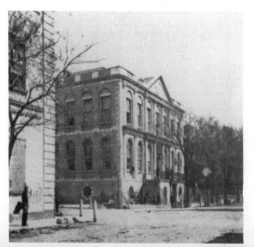

*The City Hall teemed with
bluecoated soldiers.* (USAMHI)

They stood sentry before Hatch's headquarters. (USAMHI)

All that remained of the four-year siege of Charleston were the broken guns and the carriages and rubble beneath the Union flag flying over Fort Johnson. (USAMHI)

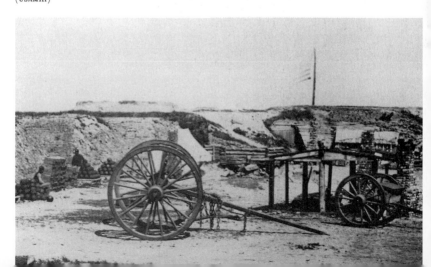

*Ships once again came and went
without fear to Vanderhoff's Wharf.*
(USAMHI)

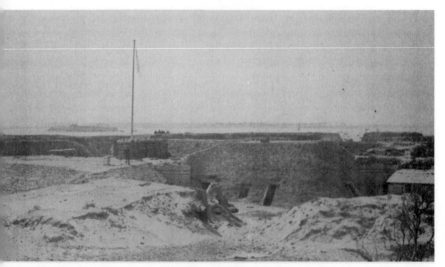

*And out in the harbor, beyond a now silent Fort Moultrie, the brooding hulk of
battered but unbeaten Fort Sumter, defiant to the end.* (AMERICANA IMAGE
GALLERY)

Caring for the Men

GEORGE W. ADAMS

Hospitals, medicines, doctors, and do-gooders

WHEN THE WAR BEGAN, the United States Army medical staff consisted of only the surgeon general, thirty surgeons, and eighty-three assistant surgeons. Of these, twenty-four resigned to "go South," and three other assistant surgeons were promptly dropped for "disloyalty." Thus the medical corps began its war service with only eighty-seven men. When the war ended in 1865, more than eleven thousand doctors had served or were serving, many of these as acting assistant surgeons, uncommissioned and working under contract, often on a part-time basis. They could wear uniforms if they wished and were usually restricted to general hospitals away from the fighting front.

The Confederate Army began by taking the several state militias into service, each regiment equipped with a surgeon and an assistant surgeon, appointed by the state governors. The Confederate Medical Department started with the appointment on May 4 of Daniel De Leon, one of three resigned United States surgeons, as acting surgeon general. After a few weeks he was replaced by another acting surgeon general, who on July 1, 1861, was succeeded by Samuel Preston Moore. He took the rank of colonel and stayed on duty until the collapse of the Confederacy.

Dr. Moore, originally a Charlestonian, had served twenty-seven years in the United States Army. He has been described as brusque and autocratic, a martinet. He was also very hard-working and determined, and he was progressive in his military-medical thinking. Dissatisfied with the quality of many of the surgeons of the state troops, he insisted that to hold a Confederate commission, every medical officer must pass examinations set by one of his examining boards. He disliked filthy camps and hospitals. He believed in "pavilion" hospitals—long, wooden buildings with ample ventilation and sufficient bed space for eighty to one hundred patients. Moore, with the compliance of the Confederate Congress and President Jefferson Davis, began the construction of many such hospitals when field activities demonstrated that the casualties would be high and the war long. Dr. Moore maintained a cooperative relationship with Congress, successive secretaries of war, and President Davis, always subject to the availability of funds from the Confederate Treasury.

In that era of "heroic dosing" Moore foresaw shortages in drugs, surgical instruments, and hospital supplies. He established laboratories for drug manufacture and took prompt steps to purchase needed supplies from Europe. In the course of time, capture of Union warehouses and hospitals

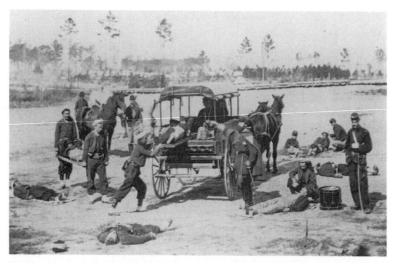

*For those unfortunate enough to take an enemy bullet, a piece of shell, or a saber
or bayonet wound, this is how the Civil War medical experience often began.
These Zouave soldiers are practicing an ambulance drill in Virginia, probably in
1864. The real thing would not have looked so peaceful—or so organized. In
battle the officer gesturing into the ambulance would more likely be dodging
bullets rather than preening for the camera.* (USAMHI)

played an increasing role in the Confederate sup-
ply. As an additional precaution he procured and
distributed widely a book on native herbs and
other plants that grew wild in the South and were
believed to possess curative qualities. As a result,
despite frequent shortages of some drugs, the Con-
federate record was a good one.

Meanwhile, in the old Union, Surgeon General
Thomas Lawson, an octogenarian, obligingly died
only weeks after Fort Sumter. He was replaced by
Clement A. Finley, the sexagenarian senior surgeon
who had served since 1818 and was thoroughly
imbued with Lawson's parsimonious values. Law-
son had wanted to keep the Army Medical Depart-
ment much as it had been throughout his career,
which meant that the eighty-seven surviving
members of the medical corps had not had the kind
of experience that would be needed in a major

war. Yet now they were the senior surgeons of a
rapidly expanding army.

Fortunately, immediately after the outbreak of
war there was a swarming of humanitarians of
both sexes who wanted to be of help to the citizen
soldiers. Among the most clamorous was the
Women's Central Association for Relief, of New
York, all of whose officers were men. Soon there
was a strong demand for the creation of a United
States sanitary commission, patterned on the Brit-
ish Sanitary Commission, which had been formed
to clean up the filth of the Crimean War. The ten-
tative United States commission elected officers;
the two most important were the president, Henry
W. Bellows, a prominent Unitarian minister, and
the executive secretary, Frederick Law Olmsted,
superintendent of Central Park. The commission
asked for official recognition by the War Depart-

ment, stating that its purpose was to "advise and assist" that department.

Surgeon General Finley, just beginning his incumbency, had no desire for a sanitary commission, but when that body promised to confine its activities to the volunteer regiments and to leave the regular army alone, he withdrew his objections. Secretary of War Simon Cameron then named a commission of twelve members, of whom three were army doctors.

The United States Sanitary Commission quickly extended itself to 2,500 communities throughout the North, the Chicago branch being especially proficient. The St. Louis people accomplished great things but insisted on remaining independent under the name of the Western Sanitary Commission. The women of the local branches kept busy making bandages, scraping lint, and sending culi-

nary delicacies to army hospitals. The national organization maintained a traveling outpost with the Army of the Potomac to speed sanitary supplies to the field hospitals of that army. In 1862 and again in 1864 the commission provided and manned hospital ships to evacuate Army of the Potomac sick and wounded to general hospitals as far from the front as New York City.

Early in the war, and later when it seemed appropriate, the commission persuaded highly respected doctors to write pamphlets on sanitation and hygiene. These were widely circulated among both medical and line officers. Although often erroneous, these pamphlets presented the best thought of that prebacteriological era and did some good where surgeons could persuade their colonels to take the advice. In the absence of any medical inspectors, the commission induced a number of es-

A folding stretcher used for transporting the wounded from the field to the hospitals and ambulances. (KA)

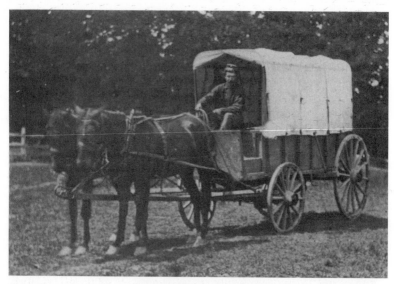

The ambulance wagons came in a wide variety; many were nothing more specialized for the service than simple flat-bottomed boxes. For a man with a painful wound, a trip of any distance in one of these could be excruciating, even deadly. (MINNESOTA HISTORICAL SOCIETY, ST. PAUL)

teemed doctors to examine recruit camps and to report on cleanliness and on the professional adequacy of surgeons to hold their commissions.

Although the Southerners had some local and state relief organizations, they enjoyed nothing similar to the Sanitary Commission in scope or efficiency; yet in the effects of camp disease and unsanitary conditions, the Confederacy and the Union shared common experiences indeed. The two armies had similar experiences as their forces were being trained, usually in an instruction camp as a gathering place for the troops of each state. Medical officers did not know how to requisition drugs and medical supplies. Commissaries did not know how to requisition rations. It has been said that "the Americans are a warlike but unmilitary people," and the first months of the Civil War proved the adage. Too many men, when entering the army after a lifetime of being cared for by mothers and wives, had a tendency to "go native" —to ignore washing themselves or their clothing and, worst of all, to ignore all regulations about camp sanitation. Each company was supposed to have a sink, a trench eight feet deep and two feet wide, onto which six inches of earth were to be put each evening. Some regiments, at first, dug no sinks. In other cases the men, disgusted by the sights and odors around the sinks, went off into open spaces around the edge of the camp. The infestation of flies that followed was inevitable, as were the diseases and bacteria they spread to the men and their rations.

Soon long lines of soldiers began coming to sick call with complaints of loose bowels accompanied by various kinds and varying degrees of internal discomfort. The medical officer would make a slapdash diagnosis of diarrhea or dysentery and prescribe an astringent. He usually ascribed this

sickness to the eating of bad or badly cooked food. Union Army surgeons were to come to use the term "diarrhea-dysentery," lumping all the cases together as one disease. In fact, in many cases it was only a symptom of tuberculosis or malaria, though amoebic and bacillary dysentery—introduced into the South by slaves brought from Africa—was certainly present as well. It caused enormous sickness and many deaths. The Union Army alone blamed the disease for 50,000 deaths, a sum larger than that ascribed to "killed in action." It was even more lethal in the Confederate Army.

The diets of both armies did not help and were deplorably high in calories and low in vitamins. Fruits and fresh vegetables were notable by their absence, and especially so when the army was in the field. The food part of the ration was fresh or preserved beef, salt pork, navy beans, coffee, and hardtack—large, thick crackers, usually stale and often inhabited by weevils. When troops were not fighting, many created funds to buy fruits and vegetables in the open market. More often they foraged in the countryside, with fresh food a valuable part of the booty. In late 1864, when Major General W. T. Sherman made foraging his official policy on his march from Atlanta to Savannah, his army was never healthier. As the war went on, Confederate soldiers were increasingly asked to subsist on field corn and peas. And the preparation of the food was as bad as the food itself, hasty, undercooked, and almost always fried.

No wonder, then, that at sick call, shortly after reveille, many men who claimed to be sick were marched by the first sergeant to the regimental hospital, usually a wall tent. There the assistant surgeon examined them, then assigned some to cots in the hospital tent, instructed others to be sick in quarters, and restored a few to light duty or to full duty. The less sick and slightly wounded would be expected to nurse, clean, and feed the patients and to see to the disposal of bedpans and urinals.

In the event of an engagement, the assistant surgeon and one or more detailed men, laden with

These were the men who transported the wounded to the field hospitals. This was the camp of the chief ambulance officer of the IX Corps, in front of Petersburg, Virginia, in August 1864. (LC)

lint, bandages, opium pills and morphine, whiskey and brandy, would establish an "advance" or dressing station just beyond musket fire from the battle. Stretcher-bearers went forward to find the wounded and, if the latter could not walk, to carry them to the dressing station. The assistant surgeon gave the wounded man a stout drink of liquor, expecting it to counteract shock, and then perhaps gave him an opium pill or dust or rubbed morphine into the wound. Later in the war the advantages of a syringe to inject morphine became apparent. The assistant surgeon examined the wound, with special attention to staunching or diminishing bleeding. After removing foreign bodies, he packed the wound with lint, bandaged it, and applied a splint if it seemed advisable. The walking wounded then started for the field hospital, officially the regiment hospital tent, although in 1862 and onward there was an increasing tendency to take over a farmhouse, school, or church if such was available. The recumbent went by ambulances, if there were any, for the ride to the field hospital, usually anywhere from three to five miles from enemy artillery and sometimes much farther.

There, lying on clumps of hay or bare ground, the wounded awaited their turn on the operating table. There was usually little shouting, groaning, or clamor because the wounded were quieted by shock and the combination of liquor and opiate. It was an eerie scene, with a mounting pile of amputated limbs, perhaps five feet high, the surgeon and the assistant surgeon—after a few months both Union and Confederate authorities decided that two assistant surgeons were necessary in a regiment —cutting, sawing, making repairs, and tying ligatures on arteries. The scene was especially awesome at night, with the surgeons working by candlelight on an assignment that might sometimes go on for three or four days with hardly a respite. And there was always the smell of gore.

The surgeons tried to ignore both the slightly wounded and the mortally wounded in the interest

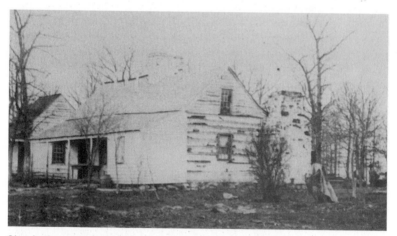

Often the places where the wagons delivered the wounded were as makeshift as the ambulances. The battlefield hospitals and surgeries were usually little more than someone's house, appropriated for the moment. The image shows Mrs. Stevens's house near Centreville. Here Federal wounded from two Bull Run battles were treated. (USAMHI)

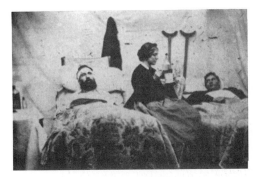

Here nurse Anne Bell poses with two of her patients, probably in Nashville, Tennessee, in the latter part of the war. In fact, photographs actually showing nurses at bedsides are extremely rare. (USAMHI)

of saving as many lives as possible. This meant special attention to arm and leg wounds. Union statistics showed that 71 percent of all gunshot wounds were in the extremities, probably because of fighting from cover behind trees and breastworks. Wounds of the head, neck, chest, and abdomen were most likely to be mortal, so the amputation cases went first on the operating table. The bullet or piece of shell had to be removed, often with the operator using his fingers for a probe. Between the extensive damage done by the Minié bullets used to inflict wounds, and the haste and frequent ignorance in treating them, amputation was all too often the "treatment" prescribed.

Everything about the operation was septic. The surgeon operated in a blood- and often pus-stained coat. He might hold his lancet in his mouth. If he dropped an instrument or sponge, he picked it up, rinsed it in cold water, and continued work. When loose pieces of bone and tissue had been removed, the wound would be packed with moist lint or raw cotton, unsterilized, and bandaged with wet, unsterilized bandages. The bandages were to be kept wet, the patient was to be kept as quiet as possible, and he was to be given small but frequent doses of whiskey and possibly quinine. This was a supportive regime.

The urgency of operating during the primary period—the first twenty-four hours—was to avoid the irritative period, when infection showed itself. The surgeon seldom had to wait more than three or four days for "laudable pus" to appear. This was believed to be the lining of the wound, being

expelled so that clean tissue could replace it and the wound could heal. In the rare cases when no pus appeared, it was called "healing by first intention" and was a complete mystery. Actually the pus was the sign that *Staphylococcus aureus* had invaded and was destroying tissue.

As to technique, the amputating surgeons had a choice of the "flap" operation or the "circular," both quite old. The former was quicker but enlarged the wound; the latter, when properly done, opened up a small area to infection. By the end of the war a small majority preferred the flap. The frequency of amputations was much questioned at the time. Yet, considering the condition of the patients, the difficulties of transportation, and the septic condition of the hospitals, amputations probably saved lives rather than limbs.

Men wounded in the abdomen by gunshot frequently died of peritonitis if they had not already bled to death from serious arterial injuries. Wounds of the head and the neck were frequently mortal. Some surgeons in both armies experimented for a while in sealing chest wounds. They would plug the wound with collodion, relieving the dreadful dyspnea—breathlessness—of the patient, but sealing in such infections as entered with the bullet. These cases were likely to be mortal, but the operator seldom knew because the patient was soon evacuated to a general hospital. As for the frightful-looking sabers and bayonets, they inflicted barely 2 percent of the wounds, most of which usually healed.

Surgical fevers disheartened the doctors. Four or

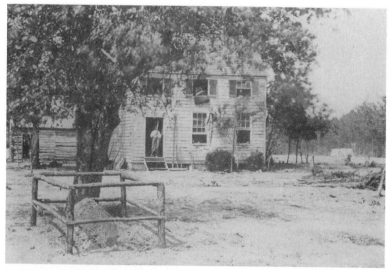

*A rude frame house on the Fair Oaks battlefield, used by Hooker's division in
1862. This James F. Gibson image shows eloquently the awful proximity of
the battlefield hospital to death.* (CHS)

five days after a wound operation, the patient
would be recovering well, producing copious pus.
Then suddenly the pus stopped, the wound dried,
and the patient ran a terrific fever. Despite drugs,
the patient would very likely be dead in three or
four days. The diagnosis was blood poisoning. Ery-
sipelas also affected both armies. With a case mor-
tality of 40 percent, it received serious attention. It
was recognized by a characteristic rash, and it was
thought by some to be airborne, with the result
that both Unionists and Confederates took steps to
isolate erysipelas patients in separated tents or
wards. The surgeons were in the dark as to how to
treat this affliction, but it was noted that if iodine
was painted on the edges of a wound, its further
extension was stopped.

Civil War surgeons had not only iodine but
carbolic acid as well, and a long list of "disin-
fectants" such as bichloride of mercury, sodium
hypochlorite, and other agents. The trouble was
that the wound was allowed to become a raging in-

ferno before disinfectants were tried. However, one
of the good features of Civil War surgery was that
anesthetics were almost always used in operations
or the dressing of painful wounds. It was practi-
cally universal in the Union, and despite mythol-
ogy, anesthetics were very seldom unavailable in
the Confederacy. The almost universal favorite was
chloroform, probably because ether's explosive
quality made it dangerous at a field hospital oper-
ating table, where there was always the possibility
of enemy gunfire.

With the coming of the big battles of 1862, both
armies more or less simultaneously evolved larger
and better field hospitals. First, regimental hospi-
tals clustered together as brigade hospitals with
some differentiation of duty for the various medical
officers and with the chief surgeon of the brigade
in charge. Soon brigade hospitals clustered into di-
vision hospitals, and by 1864 in most field armies
there were corps hospitals. There the best surgeons
would operate; one surgeon would be in charge of

most unfit soldiers were detailed, which often meant that, not being good fighters, they were little better as medical assistants. Often in the first year of the war they got drunk on medicinal liquor and ignored their wounded comrades in order to hide themselves from enemy fire.

Such improved organization was copied or approximated in the other field armies despite loud opposition from the Quartermaster Corps, which wanted to keep control of ambulances and drivers, and from some field commanders, of whom Major General Don Carlos Buell of the Army of the Ohio was notable for noncooperation.

In general, the Union forces in the West were spared battlefield relief scandals by the fact that

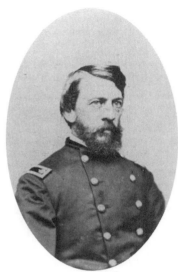

The man who gave form and reason to the management and treatment of wounded on the battlefield was Major Jonathan Letterman, medical director of the Army of the Potomac. He reorganized the field hospital system and instituted mobile hospitals and ambulance service so effectively that his plan has served as a model ever since. (P-M)

The Confederates enjoyed their share of effective physicians as well. Dr. Samuel Stout served as medical director of the Army of Tennessee, with the rank of major. Besides coping with casualties and camp disease, the Confederate surgeon faced an added enemy—shortage of almost every vital medication. (NA)

records, another of drugs, another of supplies, and yet another would direct and treat the sick and lightly wounded who were the nurses.

In time for Antietam, the Army of the Potomac, under its medical director Jonathan Letterman, developed the Letterman Ambulance Plan. In this system the ambulances of a division moved together, under a mounted line sergeant, with two stretcher-bearers and one driver per ambulance, to collect the wounded from the field, bring them to the dressing stations, and then take them to the field hospital. It was a vast improvement over the earlier "system," wherein bandsmen in the Union command, and men randomly specified in the Confederacy, were simply appointed to drive the ambulances and carry the litters. Frequently the

Women, too, served officially in the medical service, though in very small numbers. Dr. Mary Edwards Walker was commissioned assistant surgeon, the first woman to hold a commission in the United States Army. She was later awarded the Medal of Honor for her work. (LLOYD OSTENDORF COLLECTION)

confusion. The state boats, especially those from Ohio and Indiana, were so persistent in their "raiding" the evacuation hospitals for Buckeyes and Hoosiers that General Grant had to forbid their removing any patients.

After losing control of their rivers, the Confederates made considerable use of railroads in evacuating men from field hospitals to general hospitals. They had no special hospital cars and felt fortunate when they could use passenger rather than freight cars. They became adept at maintaining dressing and supply stations where wounds could be tended and the patients fed. The Union Army, too, increasingly used railroads for evacuating men north. After the Battle of Chattanooga, a real hospital train was regularly used to move the sick and wounded from Chattanooga to Louisville. Some of the cars were equipped with two tiers of bunks, suspended on hard-rubber tugs. At the ends of such cars would be a room for supplies and food preparation. The locomotive assigned to this train was painted scarlet, and at night a string of three red lanterns burned on the front. Confederate cavalrymen never bothered this train.

The truth was that the military commanders, both Confederate and Union, hated to see fighting soldiers separated from the army; the fear was they would never return. The South was well aware it was fighting a much larger people. The Union generals were well aware that as the invaders, on the offensive, they needed a majority of the men on the battlefield. They also realized that the deeper they penetrated the South, the greater the number of men needed to garrison important points and to guard ever-longer supply lines. And so there was never an actual separately enlisted and separately trained hospital corps in either army.

When Edwin M. Stanton took over as Lincoln's Secretary of War early in 1862, he realized that Dr. Finley, now a brevet brigadier general, would have to be replaced as surgeon general. Taking the advice of the Sanitary Commission, he appointed William A. Hammond, then a junior assistant surgeon. A Marylander, Hammond had served eleven years as an assistant surgeon before he resigned and became a professor in the University of Maryland Medical School. He was to accomplish many good things and to make many good suggestions during the fourteen months he served as surgeon general. It was obvious to him and to his supporters in the

major battles were fought on the banks of rivers, whence wounded and sick could be evacuated by riverboats to Mound City, Illinois, St. Louis, and other cities with general hospitals in the safety and secure supply of the North. After the relatively prompt fall of Memphis, that city became the site of several general hospitals. The evacuating boats, however, might be maintained by individual states or by the United States Sanitary Commission or the Western Sanitary Commission, which led to

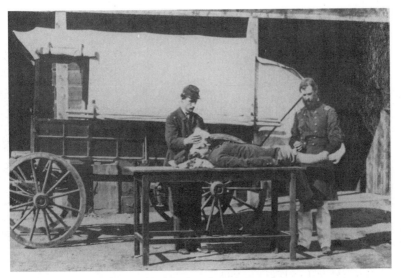

Alas, for many a wounded soldier organization and supply were not enough. Arrayed against the twin enemies of enormous, destructive enemy bullets and woeful ignorance of antiseptics, the soldier who was hit in arm or leg stood little chance of keeping the limb. Amputation became a dreadfully commonplace "treatment." Here is a posed scene on an amputating table. This fortunate soldier is only shamming, as the assistant pretends to administer anesthetic and the surgeon holds knife in hand. (LO)

Sanitary Commission that the army needed a group of medical inspectors, chosen for merit and possessing enough rank to give orders to hospital commanders. It was obvious that the makeshift general hospitals—hotels, warehouses, schools, churches—should be rapidly replaced by pavilion hospitals designed for their function. It was obvious that corps and division hospitals should become official and that something like the Letterman Ambulance Plan should be extended throughout the army. It was obvious that the quartermaster should not be able to remove ambulances nor line officers be able to remove experienced attendants from the medical field details.

Eager to educate his department in the best ideas of the time, General Hammond wrote a full-length textbook on military hygiene. He brought about the writing of Joseph J. Woodward's admirable *The Hospital Steward's Manual.* He gave every encouragement to the many medical societies that had sprung up in the army, ordering that interesting scientific specimens should be forwarded to Washington for inclusion in an Army Medical Museum. He began the collection of what has become the world's largest medical library.

Finley and Hammond secured Congressional authority to augment the regular Army Medical Department by several hundred men, first called brigade surgeons, later surgeons of volunteers, a group that contained unusually prestigious doctors. They were used chiefly as staff assistants. As for the increase in regimental surgeons and assistant sur-

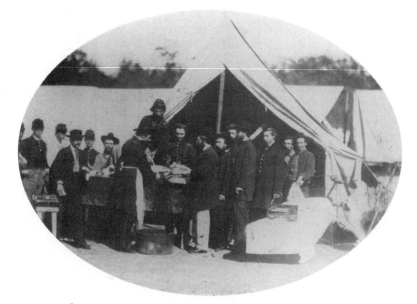

*In contrast, what appears to be a genuine amputation scene became an occasion
for posing. Taken at Camp Letterman at Gettysburg in August 1863, it shows
clearly the bloodstain on the tablecloth and the open wound on the patient's
shoulder. As several assistants stand by with the anesthesia and other materials,
the surgeon has the good sense to put an apron over his uniform. It was a messy
business—with or without the camera.* (PEARL KORN)

geons, the Medical Department was to have little
say. Higher authority had found it desirable to in-
crease the army by a persistent raising of new regi-
ments rather than by filling up the depleted ranks
of the old ones. This maintained the state gover-
nors in their unfortunate practices of selecting and
commissioning the surgeons and assistant surgeons.
The surgeon general could only attempt to reject
unfit professionals by extensive use of reexamina-
tions and "plucking" boards.

General Hammond felt frustrated. Secretary
Stanton leaned heavily on General Henry Halleck
for military advice, and this usually supported the
ideas of the old regular army medics who were
jealous of Hammond, the interloper who had been

promoted over their heads from captain to briga-
dier general. In addition, Hammond won the en-
mity of a large proportion of the American medical
profession through his banning of the two mer-
curials, calomel and tartar emetic, from the army
drug table. He may have been correct in his idea
that these drugs were being overused, but this
seemingly arrogant action lost him the sympathy of
many medical colleagues.

As a result, Hammond was effectively replaced
by Joseph K. Barnes, of the surgeon general's
office, in September 1863. It was almost a year be-
fore a court-martial of docile surgeons, although
finding him "not guilty" on other counts, did vote
Hammond guilty of "conduct unbecoming an

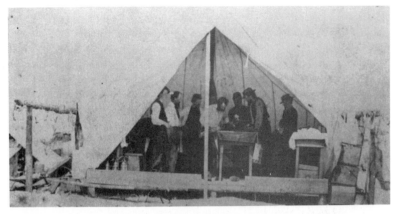

At Morris Island, South Carolina, photographers Haas & Peale captured this image of an operation taking place in July 1863. The very informal attire and lack of posturing on the part of the surgeons may indicate that this is a genuine treatment under way. The patient's shoes lie at the foot of the table, while his own stockinged left foot is just visible on the table's top right. The man in the shadows at the back of the table appears to hold a white cloth or cotton, probably soaked with chloroform, over the patient's face. The absence of tourniquets, sponges, blood basins, and saws and knives suggests that this is not an amputation scene but, more likely, treatment of a broken leg, since the surgeon, in his shirtsleeves and leaning over the table, appears to hold a splint or some other apparatus. The surgeon, incidentally, is Dr. John J. Craven, medical director of the Department of the South, the physician who later attended to Jefferson Davis when he was imprisoned after the war. (USAMHI)

officer and a gentleman." He had to leave the army.

Even where successful, Hammond was only partially so. After the medical inspector bill passed, Secretary Stanton decreed that half the inspectors were to be "political" appointees. When the ambulance corps bill of 1864 became law, what was essentially the Letterman Ambulance Plan was extended to all the armies. The Army Medical Department was to have the privilege of choosing the enlisted men to be put on ambulance and stretcher-bearer detail, and they could not be withdrawn, but there was still no ambulance corps per se.

Confederate Medical Department organization

was very much what Surgeon General Moore thought it should be. Congress gave him a considerable body of medical inspectors and hospital inspectors, the former operating within the field armies and the latter in the general hospitals of each state, with the medical director of each state responsible for its hospitals. There was some debate with the quartermaster general about ambulances, but this was generally over the lack of them. Farm wagons most often constituted the ambulances of the Confederacy. Although Moore had much the same "arrogant" personality traits as did Hammond, he usually obtained prompt obedience to orders rather than conflict.

Both armies experimented with "special" hospi-

Of this image there can be no doubt. This is no pretended photograph. Eight or nine legs lie where they were stacked after being removed from their owners. The amount of flesh and bone cut away from men in this war can literally be measured in tons. (STANLEY B. BURNS, M.D. AND "THE BURNS ARCHIVE")

tals, with admission limited to patients with the same disorders. The Confederates established several venereal hospitals and some ophthalmic hospitals. The Unionists began a venereal hospital at Nashville and the famed neurological hospital, Turner's Lane, at Philadelphia, where W. W. Keen is believed by some to have founded neurology in America.

In contrast, a "general" hospital did not limit its admissions. The sick and the wounded were evacuated to general hospitals so that empty beds could be made available in field installations when a new rush of wounded was expected. Buildings adapted for use as general hospitals were usually considered unsatisfactory because of the inadequate plumbing, the bad ventilation, and the "crowd poisoning" and "mephfluvia" which that generation thought bred and spread disease. Moore and Hammond believed a large building program of pavilion hospitals in 1862 was the answer. To the best of their abilities both sides carried this out, and followed it by still bigger construction programs in 1863 and 1864. The Union pavilions were longer than their Confederate counterparts. Some were as long as 120 feet, with a width of 14 or 15 feet, with a longitudinal ventilator along the 12- to 14-foot roof. This, along with floor ventilation, made the patients too cold and was later closed by wooden slats.

At the inner end, each pavilion, North and South, had toilets, sometimes flush and sometimes seats over a sloping zinc trough in which water was supposed to run continuously. Reports show that often the water supply was insufficient and that toilets were flushed only after many usings.

Frequently the pavilions were built as though they were spokes spreading from a hub. The buildings at the hub were operating rooms, kitchens, offices, pharmacies and supplies, "dead house," ice house, and other services. The grounds were usually joined by a wooden roadway on which food could be hauled or the wash taken up and delivered by a steam-powered vehicle.

The staff, aside from the medical officers and hospital stewards, was mostly made up of the convalescents. They were frequently weak and weary, often snappish and irritable. They did not like the dirty work they performed. They wanted to go home. The surgeon-in-charge, as the hospital commander was titled, was often in a dilemma. If he returned the patient to his regiment too soon, the man might relapse or die on the road to his unit. If he tried to hold on to the man too long, he might be forcibly returned to his regiment; and if he prevailed upon an inspector to give a medical discharge, he would be losing an attendant who had learned something about his work, and would be forced to rely on a new man who knew nothing. Union and Confederate surgeons-in-charge faced the same problem, although occasionally in Southern hospitals there were hired blacks of both sexes. These people were considered only marginally successful. Some attempts in the North to use cheap male labor as hospital attendants proved unsatisfactory, the men being undisciplined, a "saucy lot" who even stole from the patients.

The brilliant results of Florence Nightingale in cleaning up the Crimean hospitals had been widely noted, with the result that early on it was decided that a corps of female nurses should be added to the army, with Dorothea Dix their superintendent. Miss Dix was widely known as a reformer of jails and as the "founder" of several state mental hospitals. Devoted and hard working, she was disorganized, unyielding in controversy, and deeply in the grip of Victorian ideals of propriety. Allowed to choose the nurses and to set the rules, she announced that her appointees must be at least thirty and plain in appearance, and must always dress in plain, drab dresses and never wear bright-colored ribbons. They could not associate with either surgeons or patients socially, and they must always insist upon their rights as the senior attendants in the wards.

It was not long before outraged surgeons virtually went to war with Miss Dix's nurses, frustrating them, insulting them, trying to drive them from the hospitals. These were strong-minded middle-class American women, accustomed to ruling within the home and to receiving the respectful attention of their husbands and male acquaintances. For the most part they had no nursing training. The surgeons complained that they often substituted their own nostrums for the drugs prescribed and that they sometimes were loud and interfering when attempting to prevent amputations.

As time passed, younger and less self-righteous nurses began to appear in the army, furnished by the Western Sanitary Commission or some other relief agency. Some surgeons learned to suppress

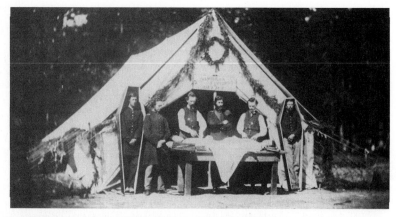

And another certainty of field hospital medicine was that some would die. At Camp Letterman Dr. Chamberlain and Dr. Lyford established their embalming business, with plenty of clientele awaiting their services. The two gentlemen in the coffins, however, will be spared their knives for the moment. They are posing, having been standing, very much alive, in some other images.
(PEARL KORN)

their male-chauvinist behavior. In September 1863, the War Department approved a new nurse policy that, although ostensibly a victory for Miss Dix, really defeated her. Under this edict, hospital commanders could send away Dix-appointed nurses but were forced to accept Dix-appointed replacements unless the surgeon general authorized the appointment of someone the surgeon-in-charge preferred. The surgeon general was always willing.

In fact, the female nurses were much liked by the patients and were not so much nurses as mother-substitutes. They wrote letters for their "boys," read to them, decorated the wards with handsome garlands, and sometimes sang. Both armies used small contingents of Catholic nuns in certain general hospitals. They came from the Sisters of Charity, the Sisters of St. Joseph, the Sisters of Mercy, and the Sisters of the Holy Cross. Having been teachers, some lacked previous hospital experience, but surgeons liked them because they had been bred to discipline. The patients liked them too, but called them all Sisters of Charity.

Hospital food improved perceptively when women matrons took over the supervision of kitchens. These women came from various sources, many supplied by the United States Christian Commission, a large organization that donated delicacies to hospitals but considered the saving of souls, by passing out religious tracts, its principal mission.

Because of the great fame of Clara Barton, and some women like her, an impression prevailed that women functioned in hospitals in the field. This was seldom the case. Miss Barton might best be described as a one-woman relief agency. However, the strong-minded but winning "Mother" Mary Ann Bickerdyke became so popular that in 1864 General W. T. Sherman officially appointed her to his own corps hospital.

Women could be found serving in various ways in Confederate hospitals, too, but the bulk of them were hired black cooks and washerwomen. In the conservative South there was a widespread feeling that a military hospital was no place for a lady.

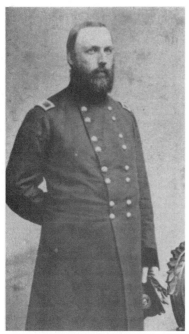

The United States Army Medical Department was in dismal condition when the war began, and it fell to Surgeon General Brigadier General William A. Hammond to put it in order. Impatient with politics and vested interests, he attempted to institute reform by cutting through all opponents. He proved highly effective—and was just as disliked. Before the war was done, he sat in front of a court-martial and heard himself dismissed from the service. Yet the improvements he made saved lives and helped modernize army medicine. (KA)

Women as well revolutionized medical care, and none more so than Dorothea Dix. Prominent before the war in reform movements for the indigent, she became superintendent of nurses for the Union, organizing the small army of ladies who went to the hospitals and the front to care for the men. (USAMHI)

Only in Richmond were there significant numbers of women working in the city's many hospitals.

Richmond was indeed the hospital center of the Confederacy, with twenty hospitals in 1864 after many of the makeshift type had been closed and replaced by pavilion structures. The queen of them was Chimborazo, which had beds for 8,000 men and was often called the largest hospital on the continent. It was organized into four divisions, each with thirty pavilions. There were also five soup houses, five ice houses, "Russian" baths, a 10,000-loaf per day bakery, and a 400-keg brewery. On an adjacent farm the hospital grew food and grazed three hundred cows and several hundred goats. Almost as amazing was Jackson Hospital, which could care for 6,000 patients in similar ways. Elsewhere than Richmond, general hospitals were neither so large nor so grand, but there were many of which the Confederates were proud. By

late 1864 there was a total of 154 hospitals, most located close to the southern Atlantic coast. They began to close down, often because of enemy action, early in 1865.

Washington and its environs was the natural hospital center of the Union Army because of its proximity to major battlefields. This proved unfortunate because the city had always been considered a sickly place, chiefly because of the large open canal that stretched across town and into which much sewage was dumped. Also, the metropolitan community had many standing pools in which anopheles mosquitoes bred. The intestinal disease and malarial rate of the hospitals were a natural result.

At the end of 1861 Washington had only 2,000 general hospital beds. The great slaughters of the Peninsular campaign, with the Second Battle of Bull Run immediately after, followed shortly by Antietam, flooded the hospitals of the Washington area and Baltimore and Philadelphia as well. Adaptation went so far as converting the halls of the Pension Office, with cots among the exhibitions, the Georgetown jail, and the House and Senate in the Capitol. From August 31 to the end of 1862, 56,050 cases were treated in Washington. Many of these adaptations were closed in 1863, replaced by modern pavilion hospitals. At the end of 1864 the city contained sixteen hospitals, many of them large and fine. There were seven at nearby Alex-

andria and one each at Georgetown and Point Lookout, Maryland. Outstanding was Harewood, said to resemble an English nobleman's estate, with professionally landscaped grounds, flower gardens, and a large vegetable garden. Its building consisted of fifteen large pavilions with appropriate service buildings and some tents.

The Western showpiece was Jefferson Hospital at Jeffersonville, Indiana, just across the river from Louisville. Built in the winter of 1863–64 with 2,000 beds, later increased to 2,600, at war's end it had plans for 5,000 beds. Its most interesting architectural feature was a circular corridor 2,000 feet long from which projected twenty-four pavilions, each 175 feet long.

By the last year of the war there were 204 Union general hospitals with beds for 136,894 patients. This proved to be the maximum. In February 1865 the United States began closing down its hospitals.

The many men and women, North and South, who served in the hospital and sanitary services during the war were justly proud of their achievements. The morbidity and mortality rates of both armies showed marked improvement over those of other nineteenth-century wars, particularly America's last conflict, the war with Mexico. In that war 90 percent of the deaths were from nonbattle causes. In contrast, in the Civil War some 600,000 soldiers died, but in the Union Army 30.5

The system of general hospitals established by Hammond and others soon spread across the country. Usually they were placed near enough to the front that wounded and ailing men did not have to travel all the way back to the North for care. The Army of the Potomac's general hospital in 1864–65 stood at its City Point, Virginia, supply base. (USAMHI)

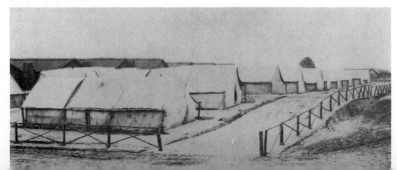

percent of them died in or from battle, and in the Confederate Army the percentage ran to 36.4. Clearly, the physicians and sanitarians had held down the disease mortalities to levels that their generation considered more than reasonable. Better, they made some few halting strides in treatment and medication, and considerable leaps in the organization of dealing with masses of wounded and ailing soldiers. It was a ghastly business for doctors and patients alike; yet without the medicos in blue and gray, much of the young manhood of America at midcentury might not have survived for the work of rebuilding.

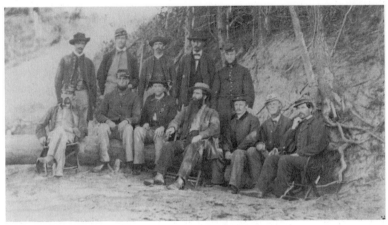

Well-trained corps of surgeons and assistants staffed the general hospitals, often making up for whatever their formal training might have lacked by an abundance of on-the-job training. The image shows a group of surgeons of the Army of the Potomac near Petersburg, Virginia, in October 1864. (USAMHI)

Hospital stewards of the IX Corps near Petersburg, November 1864. (USAMHI)

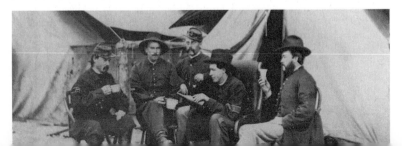

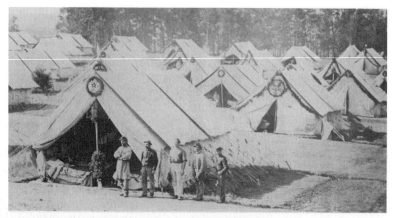

Camp Letterman General Hospital at Gettysburg, taken by the Tysons during the summer of 1863. That the tents were crowded is evident by the side-by-side placement of beds in the tent in the foreground. (THE OAKLAND MUSEUM, OAKLAND, CALIF.)

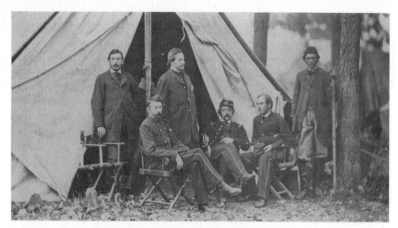

Surgeon Jonathan Letterman sits at left with his assistants in November 1862. Much of the credit for the field hospital system belongs to him. Exhausted after his labors caring for the wounded at Antietam, he retired to a Maryland home for a rest and there met the woman he later married. Behind the impassive face in the image sits a man already in love. (USAMHI)

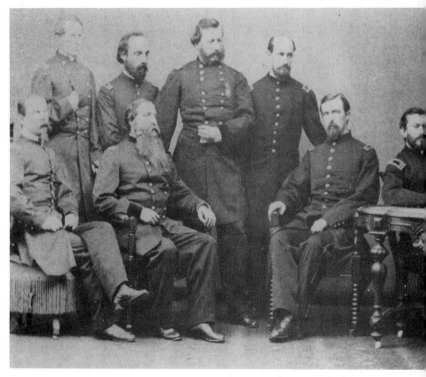

The Army replaced the dismissed Surgeon General Hammond with Brigadier General Joseph K. Barnes, a man of less vision than his predecessor. Barnes profited from Hammond's innovations and continued them, winning for himself and his staff considerable acclaim. A major general at war's end, he stands in the center here with members of his staff, among them Brigadier General Charles H. Crane, seated second from left; Joseph J. Woodward, seated far right; and Edward Curtis, standing far right. It was Barnes who was present at Abraham Lincoln's death, overseeing his care. Woodward and Curtis later performed the autopsy. (NATIONAL LIBRARY OF MEDICINE, BETHESDA, MD.)

The enemy received—or was supposed to receive—the same humane treatment given to friends in these hospitals. A sizable number of wounded Confederates populated Camp Letterman at Gettysburg. The crutches and the empty sleeves give testimony to their sacrifice for their cause. This view is believed to have been taken by P. S. Weaver. (USAMHI)

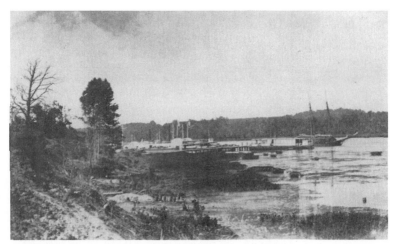

Sometimes the wounded went by steamer, like the medical supply ship Planter, *shown here in the Appomattox River in September 1864.* (USAMHI)

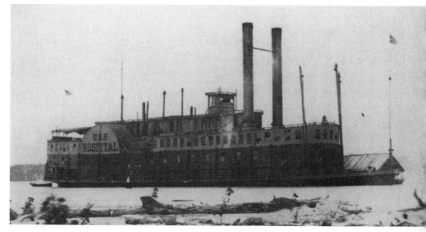

In the West the wounded generally went up the Mississippi by riverboat, some aboard an innovation, the hospital ship. Here the USS Red Rover, *the Army's very first hospital ship, ties up with an ice barge on the Mississippi. She had been a Confederate troopship until captured at Island No. 10 in 1862 and converted into a hospital.* (NHC)

Smaller state and private relief associations also did their part. Here ladies of the Michigan and Pennsylvania Relief Association minister to some wounded and ailing soldiers in a Brady & Company image. (ROBERT J. YOUNGER)

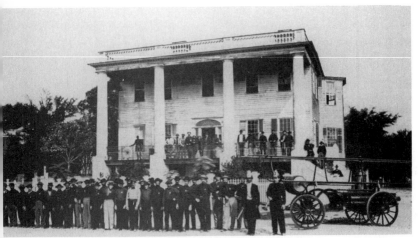

*Whether taken north or south, the wounded found much better care for their
recovery and convalescence at the permanently established hospitals. In
Beaufort, South Carolina, that could mean going to Hospital No. 15, shown here
with a local fire brigade posed in front.* (NA)

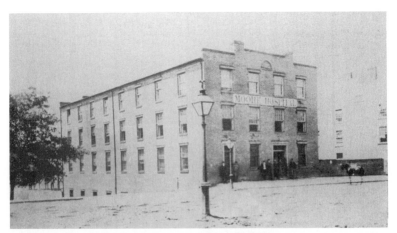

*Many Confederate hospitals were makeshift at first, usually confiscated tobacco
warehouses like this one in Richmond at Twenty-sixth Street and Main.* (VM)

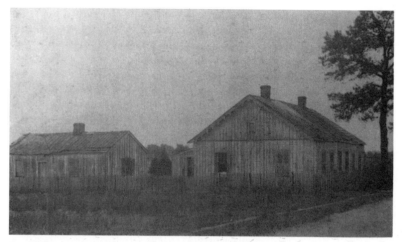

Near Richmond, Surgeon General Samuel Moore built a few hospitals, all of them scantily equipped, drafty in winter, and woefully lacking in sanitation. The roofs of the hospital buildings at Camp Winder, for instance, were in desperate need of repair by the end of the war. (VM)

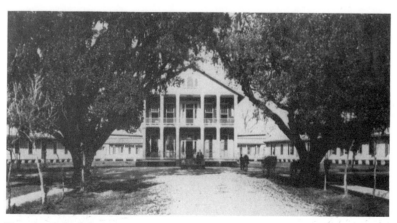

The conquering Federals established their hospitals all across the South. They set up Sedgwick Hospital in Louisiana, shown here, turned houses into hospitals, and arranged medical facilities for ex-slaves. (NA)

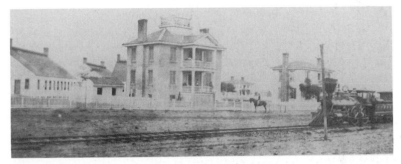

They established small complexes of buildings for treatment and care, as at
Morehead City, North Carolina. (CHS)

Indeed, some onetime Confederate cities became virtual hospital communities.
In Memphis a score of buildings were appropriated for patients. The building of
W. G. Mepham and Bro., grocers, became an officers' hospital, complete with
exultant Yankees atop the roof. (CHARLES H. BOURNSTINE)

The Jefferson Block Building became Jefferson Hospital. No need to change the name for patriotic reasons here. (CHARLES H. BOURNSTINE)

The Yankees established even better facilities back on conquered land and at the major military installations. Chesapeake General Hospital at Fort Monroe, Virginia, looked more like a resort. (USAMHI)

At Jeffersonville, Indiana, Hammond built Camp Holt, with row upon row of neat wards. (INDIANA HISTORICAL SOCIETY LIBRARY, INDIANAPOLIS)

In Cincinnati the Marine Hospital catered not to marines but to the members of the infantry unit known as the Mississippi Marine Brigade. (NA)

In the larger cities of the North even more elaborate and extensive facilities emerged. At Broad and Cherry streets in Philadelphia this General Hospital appeared. (LO)

In the military posts and forts of New York, hospitals for invalids and convalescents were organized, such as the Fort Schuyler Hospital, shown here on July 27, 1864. (USAMHI)

*Alexandria, Virginia, near Washington, burgeoned with such infirmaries. This
handsome Italianate house on Wolf Street became a general hospital.* (USAMHI)

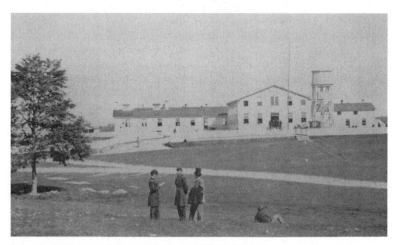

*Washington itself was ringed with hospitals. Harewood Hospital, shown here,
was one of the largest.* (USAMHI)

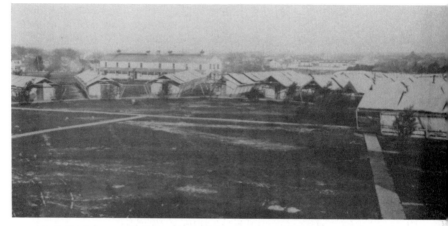

Lincoln Hospital was a makeshift arrangement of canvas over frame stretchers.
(USAMHI)

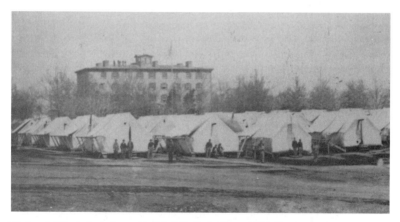

The large building in the background is, in fact, the block of homes built in the 1850s by Stephen A. Douglas, John C. Breckinridge—now a Confederate general—and Henry M. Rice. It was called Douglas Row before the war and is now the Douglas Hospital, with a nearby tented adjunct. Just after the surrender, General U. S. Grant will come to live for a time in what had been Breckinridge's home. (USAMHI)

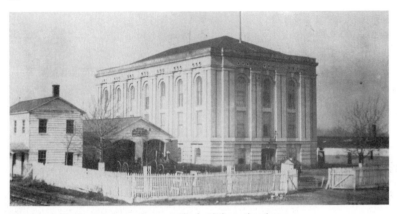

Downtown in Washington's Armory Square another hospital occupies a former public building. Next door sits the United States Steam Fire Brigade, its modern equipment on display in the yard and its canvas hoses drying in the sun on the sidewalk at left. (USAMHI)

These three leg amputees posed together after each lost a leg in the fighting in Georgia. (GLADSTONE COLLECTION)

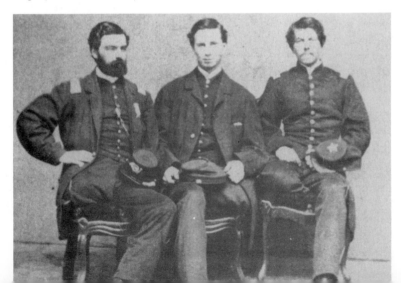

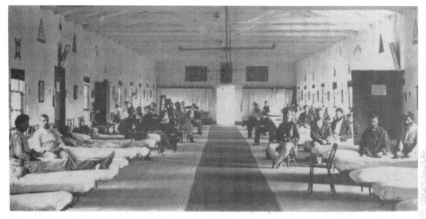

Armory Square was far more open and pleasant, with military insignia on the walls, the word "Excelsior" over one door, and an inspirational poster at the end of the ward. "The true characteristic of a perfect warrior," it reads, "should be fear of God, love of country, respect for the laws, preference of honor to lawlessness, and to life itself." (USAMHI)

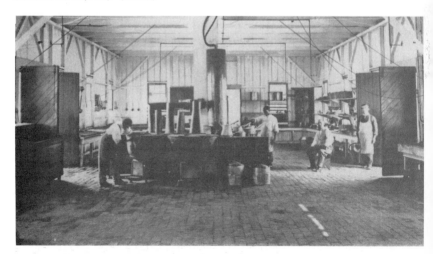

Hospital food, then as later, was always the object of derision, and worse when it was army hospital food. The kitchen at Soldiers' Rest, Alexandria, did the best it could, but institutional food has never been the best. (USAMHI)

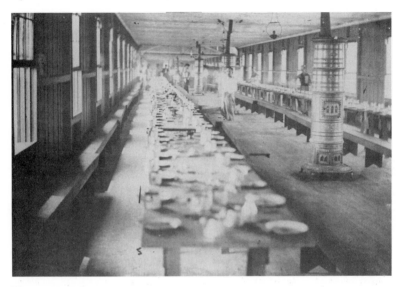

The mess room at Harewood Hospital. (LC)

*Holidays were the best times. Here, in Armory Square General Hospital, soldiers
and nurses probably celebrate either July 4 or the end of the war.* (LC)

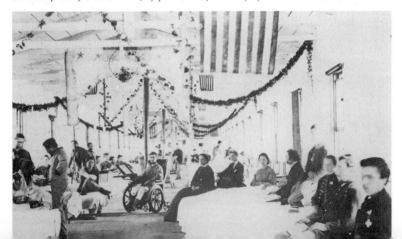

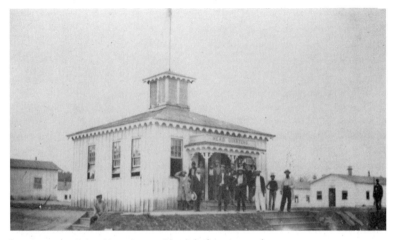

Once the men were released from the general hospitals, there was cause for celebration as well. Many went to the convalescent camps, where there was greater freedom yet sufficient medical care available to get them through to full recovery. This one was in Alexandria, Virginia. (USAMHI)

Quartermaster Ansel L. Snow, seated at center, poses with staff and patients at the Alexandria camp. (RP)

The camp provided entertainment for them with a band. (GLADSTONE COLLECTION)

The Women's Central Association of Relief worked out of New York City's Cooper Union in assisting the United States Sanitary Commission. These ladies appear in their association's main office. Not content only to wait, they also served. (MUSEUM OF THE CITY OF NEW YORK)

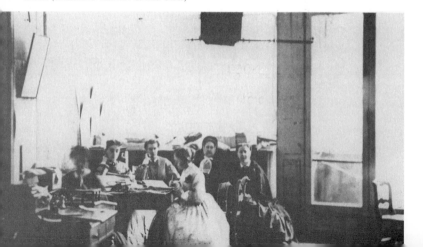

*Avid organizers like Clara Barton raised money to buy and send medical supplies
to the front, as well as to minister to the soldiers' spiritual needs. Barton's
operation eventually became the American Red Cross some years after the war.*
(AMERICAN RED CROSS)

*Members of the commission like these, including Major General John A. Dix,
organized and operated sanitary fairs in the North to raise funds for their
mission.* (NA)

*The Sanitary Commission made its
headquarters in Washington on F
Street, serving both the Army and the
Navy.* (USAMHI)

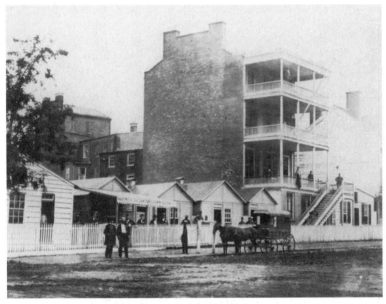

The Sanitary Commission operated homes for sick soldiers like this one in Washington, their Lodge for Invalid Soldiers. (AMERICAN RED CROSS)

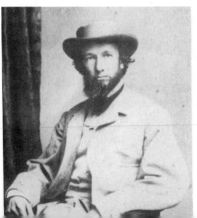

The Sanitary Commission placed its agents with all the armies, but chiefly concentrated on the eastern commands. The Reverend Fred N. Knap served as a special field agent, doing pioneer work in caring for the soldier, work that later became the model for some of the functions of the Red Cross. (AMERICAN RED CROSS)

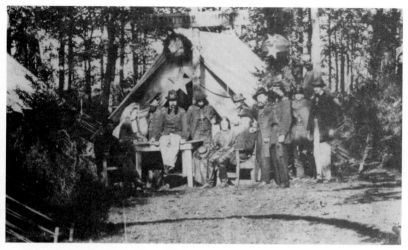

*Here is a Sanitary Commission tent at Camp Letterman, Gettysburg,
photographed by the Tysons in August 1863. The surgeons, nurses, and
humanitarians frequently made common cause to better the condition of the
wounded.* (USAMHI)

*In the more permanently established camps, the commission built, at its own
expense, rest homes for recuperating soldiers. Here at Camp Nelson, Kentucky,
sits one such Soldiers' Home. This one even boasted of a fountain in the center of
its inner courtyard, thanks to the ample reservoir at the top of the hill.* (WRHS)

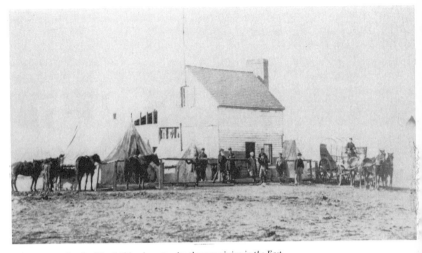

In late 1863 and early 1864 field headquarters for the commission in the East was near Brandy Station. The rather ubiquitous gentleman in the center with the long gray beard appears in many Sanitary Commission photos taken throughout the war, particularly at Camp Letterman. He is a Dr. Winslow, one of the commission's more ardent leaders. (P-M)

In the field near Petersburg, Virginia, in 1864, a Sanitary Commission office somewhere behind the lines. (LC)

Members of the Sanitary Commission with one of their wagons and with their own flag fluttering in the breeze. Members of the commission went to Geneva, Switzerland, in 1864 to explain their work to the International Humanitarian Convention meeting there. When a treaty calling for basic humanitarian care of soldiers in wartime was negotiated, several provisions reflected the work of the United States Sanitary Commission. (AMERICAN RED CROSS)

The Confederacy, too, sprouted innumerable relief associations, but they, as always, suffered terribly from want of supply, as did the Confederate Medical Department. Surgeon General Samuel Preston Moore did as much as could be expected, even introducing a few innovations of his own, but his cause was a losing one, as was the South's. (VM)

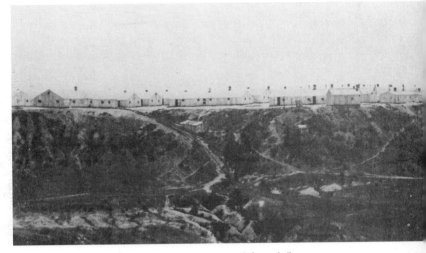

The famous Chimborazo Hospital, one of the largest military hospitals, was built by Moore in Richmond. It could hold thousands of wounded at a time and drew its nurses from the cream of Richmond society. But good care and good intentions could not reverse one of the immutable laws of war: Men die. (LC)

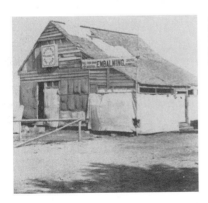

And when they died, they faced either a hasty burial or, for those more fortunate, embalming before their bodies were shipped back to their families. Dr. Bunnell boasted that his cadavers were "free from odor or infection." (USAMHI)

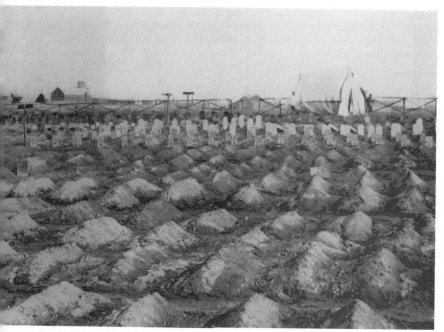

Embalmed or not, the fallen dead's last appointment was with the earth, either in the family plot at home or among other comrades, as here at City Point, Virginia. To be sure, Civil War surgery and medicine saved thousands of lives and made considerable advances in treatment. But they were halting advances, made over the rutted and hillocky road of tens of thousands of graves. (NA)

The Camera Craft

Innovation, invention, and sometimes art, spill from the lens

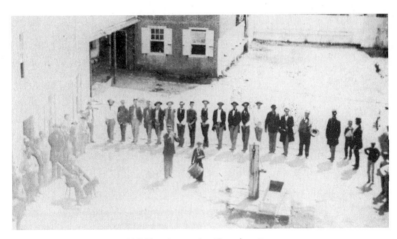

Perhaps because so many of the Civil War photographers themselves sprang from the common people, they often showed a peculiarly apt talent for posing and capturing lowly Americans in distinctly informal scenes. Witness this unusual view of an unidentified muster of recruits or militia. Instead of posing on the village green, they stood in the backyard or side lot of a public house. The men themselves are variously dressed, at least two of them in portions of uniforms, and one self-important gentleman sits in an armchair with his best gun and dog beside him. That is how Americans went to war. (GLADSTONE COLLECTION)

The photographers saw something in the melding of men and war machines with the American landscape. A simple Virginia river crossing at Jericho Mills, on the North Anna, attracted Timothy O'Sullivan. (LC)

So did the Merchant's Cotton Mill at Petersburg, Virginia, the tin roof of the house from which the photographer made the scene intruding into the scene and creating a bizarre contrast to the view beyond. (LC)

Some of the images were simply beautiful in every detail. Johnson's Mill at Petersburg. (NA)

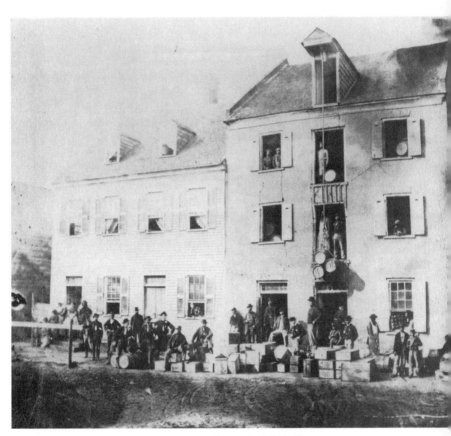

A Federal photographer at New Berne, North Carolina—probably J. Dowling—managed to create almost a genre scene out of men and barrels and boxes and a quartermaster's depot. The barrels contain potatoes, the boxes hardtack, or "army bread." A cook's helper displays fresh bread out a window. (USAMHI)

Not only in groups but singly as well the photographers used soldiers to people their glass and paper canvases. A solitary horseman near Welford's Ford on Virginia's Hazel River seems untouched by a war that the photo does not even imagine. (USAMHI)

Soldiers fishing on the Potomac, with the Georgetown aqueduct in the distance and a ferry passing by, offered a compelling scene of peace and calm. (NLM)

Repose offered the most eloquent subject for the lens, and the Civil War soldiers gave the cameramen ample opportunity to catch them at rest. A photographer found these Federals lounging by a pontoon bridge at Deep Bottom on the James River in 1864. (NA)

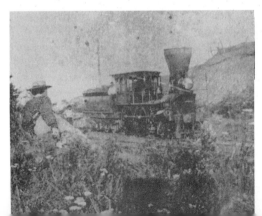

A fading yet still evocative image of one of O'Sullivan's assistants in homespun, lying in a field of wild flowers beside the track of the Orange & Alexandria Railroad. The locomotive fits the scene, the almost pastoral view interrupted only by the jagged earthworks that have spoiled the hillside beyond. (USAMHI)

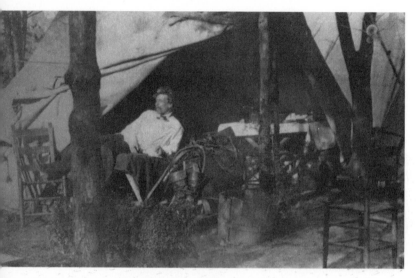

Lieutenant Thompson at Chattanooga. Nothing seems unnatural. Even the chair and wooden tub seem to grow out of the ground. (KA)

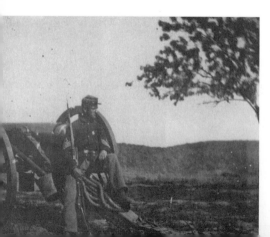

A sergeant of the 22d New York State Militia sat on a gun carriage, and a Brady assistant at Harpers Ferry found it irresistible. (USAMHI)

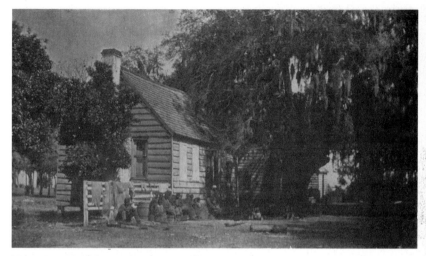

A Henry P. Moore view on the Elliott plantation at Hilton Head arranged lights and darks into a vivid portrait of freed blacks in front of the former slave quarters. The moss-laden tree at right almost weeps. (USAMHI)

The living and the dead at Blandford Church near Petersburg, Virginia. (USAMHI)

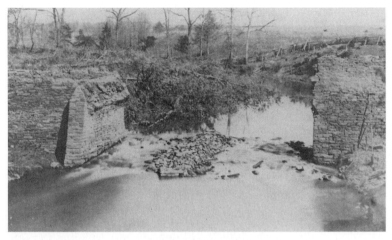

The onetime scenes of carnage often provided a chance for a special view.
George Barnard and James Gibson worked together to capture the ruins of the
stone bridge that once crossed Bull Run on the Manassas battlefield. The
textures and contrasts give ample evidence of the far from primitive effects
possible with the camera of the 1860s and the imaginative eye of the
photographer. (USAMHI)

Timothy O'Sullivan's view of Quarles Mill on the North Anna. Almost unseen is
the single nude soldier, crouching on a rock at the edge of the stream. (USAMHI)

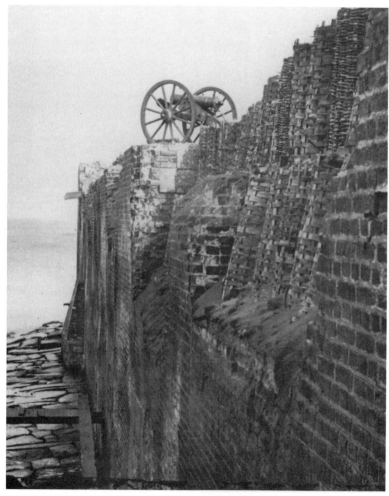

*A magnificent patchwork of patterns made up the outer wall of Fort Sumter in
1865, when George N. Barnard took his camera to Charleston. The regular
rhythm of the bricks, interrupted by the latticework of the earth-filled
gabions—all drop down to a random system of flagstone at the base. Barnard's
work was always superb.* (LC)

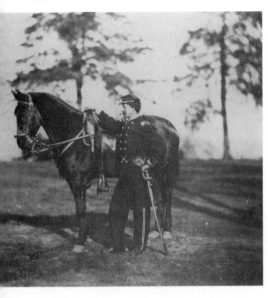

Even in the more conventional modes of photography the artists experimented. The simple portrait underwent great changes. Lieutenant Colonel O. H. Hart, adjutant of the Federal III Corps, stood with his mount at Brandy Station, Virginia, in February 1864 to offer a lensman a striking pose. (USAMHI)

Generals, of course, loved to pose, and none more so than the self-important George B. McClellan. He smiled for the camera . . . (USAMHI)

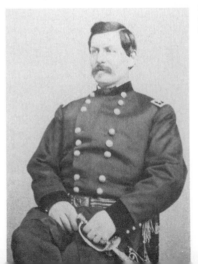

. . . struck a pensive mood . . . (USAMHI)

. . . and even offered his back in a decidedly experimental pose. (MJM)

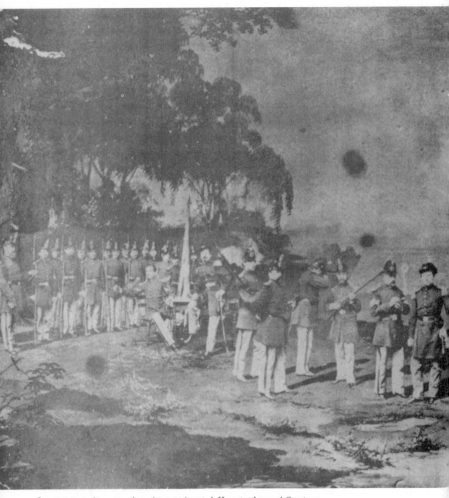

*In group portraiture, too, the artists experimented. Here stand men of Company
B of the 6th New York National Guard, taken in 1863. Yet it is not a group
photograph. Rather, several smaller group images have been blended together
onto a painted background to present an almost surreal scene.* (STANLEY
LEVITT)

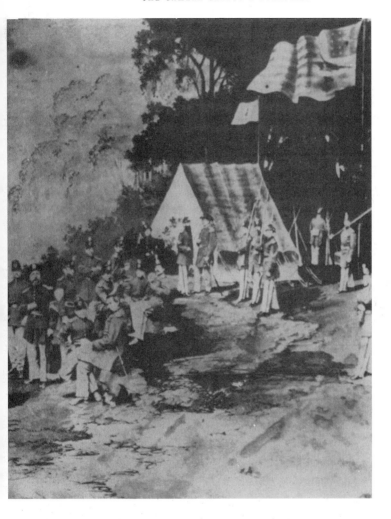

*If photographer B. Shunk can be believed, he even managed to make this 1863
image of Harpers Ferry by moonlight. The scene, however, appears too well lit
for a night view, unless Shunk exposed his plate for a very long time indeed.*
(USAMHI)

The innovation took a backseat to grandeur, however, whenever the armies and their photographers came to a place where the landscape demanded undivided attention. Nowhere in the country did the vista command more awe than at Chattanooga. The city fell to the Federals for good in late 1863, but the cameramen became its permanent captors. Lookout Mountain beckoned to them and would not be denied. Here on its summit, above the clouds of mist that often filled the Lookout and Tennessee valleys, the cameras recorded scenes of magnificent scope and beauty. (USAMHI)

R. M. Linn, who established his Gallery Point Lookout on the mountain crest, became a practiced artist in recording the grandeur of the valley, the river, and Chattanooga. (KA)

*Thousands came to stand at the precipice, the Tennessee River snaking across
the land hundreds of feet below.* (NA)

*The brilliant George N. Barnard came to Chattanooga to record its scenic
environs. Lookout Mountain intrigued him, yet he sought more than mere views
from its heights. He found greater scenes in lesser places.* (USAMHI)

There were tiny ponds and waterfalls everywhere. (USAMHI)

Nearby scenes like Estill Springs, Tennessee . . . (USAMHI)

Perhaps most lovely was Lu-La Lake. "The waters of this Indian mirror are as pure and clear as possible," Barnard said. The same could be said for his magnificent photograph of the lake. (USAMHI)

The Civil War photographer may have been at his best, however, when he caught a still-life scene such as these vessels on the wharf at Alexandria, Virginia. The image has a peaceful morning air to it, as though the dawn mists have not yet cleared. (USAMHI)

*Here is a wedding of images of Fort Carroll, near Giesboro Point in the District
of Columbia. A magnificent panorama of the cavalry stables in winter, it offers
the look of a country genre painting in still life. Pickets, wheels, branches, and
the long stable buildings standing against the snow present a remarkable portrait.
The two separate views are here jointed together and published for the first time.*
(WRHS)

Nothing so moved the cameraman as the solitary sentry on his lonely vigil. This Union enlisted man seems more shadow than substance, more a hole in the winter picture than a part of it. Rarely in the history of war photography has a cameraman achieved a more eloquent image. Like so many of the thousands of views made during the Civil War, the timeless quality and lasting impact of scenes like this attest to the craftsmanship of the photographers of the blue and the gray. (NA)

War on Horseback

DEE BROWN

The dashing dash to "jine the cavalry"

IN A WAR with so much horror, on the field and in the hospitals, there was a desperate need for romance, for glamour. The cavalry was the glamour arm—handsome young men in flowing motion on graceful steeds, embellished with colorful costumes of capes, jackets, plumed hats, knee boots, and fancy spurs. At least it was that way in the beginning. Also in the early weeks of the Civil War, the cavalry on both sides was compact, slow-moving, heavily accoutred, usually operating with the infantry. Experience brought striking changes, first in the Confederate cavalry, considerably later in the Union. After a few battles in conjunction with the infantry, the horse soldiers began cutting loose from their bases to destroy enemy communications and supplies. They burned bridges and stores, ripped out telegraph lines, and raided far behind the lines in attempts to keep the enemy so busy that he could apply only a part of his potential when battle was joined.

Before the war, professional cavalrymen maintained that two years were required to produce a seasoned trooper, a precept that proved to be more applicable to the North than to the South. For the first two years of conflict the exploits of Jeb Stuart and John Mosby in the East and the daring raids of Nathan Bedford Forrest and John Hunt Morgan in the West far outshone their Union opposites.

One reason given for the early superiority of Confederate cavalry was that in the South the lack of good highways had forced Southerners to travel by horseback from boyhood, while in the North a generation had been riding in wheeled vehicles. Although there may have been some truth in this, rural young men in the North were also horsemen by necessity, but unlike many of the Southern beaux sabreurs, they had to bear the tedious burden of caring for their animals after plowing behind them all day. Young Northerners who knew horses seemed to have little desire to assume the responsibility of taking them to war, and instead joined the infantry. In the South also, long before the war, young men organized themselves into mounted militia companies, often with romantic names. Although these may have been more social than military, the men learned how to drill, ride daringly, and charge with the saber.

Southern cavalry horses were also superior to Northern horses, largely because of the Southern penchant for racing. Almost every Southern town had its track, and the sport developed a superior

*"Boots and saddles." "To horse and away." The eternal lure of the
horse-mounted soldier, the dash and romance of it all, captured the imagination
of Americans at war, North and South, as no other image. "Draw sabers," this
erect bugler blows, his own blade beginning to leave its scabbard. There are
gallant charges to come, and more than enough glory for all.* (ROBERT
MCDONALD)

stock of blooded fleet-footed animals. In the North,
muscular and slow-moving draft horses were the
preferred breeds.

At the war's beginning there were only six regi-
ments of United States cavalry, dragoons and
mounted riflemen, and a considerable number of
their officers resigned to serve with the Confed-
eracy. In the opinion of the United States Army's
commanding general, Winfield Scott, improve-
ments in weapons had outmoded cavalry. He was
inclined, therefore, to limit the number of cavalry
regiments for prosecution of the war, and when
Lincoln made his first call for volunteers, only one
additional regiment of cavalry was authorized.

After George McClellan took command of the

Union Army late in August 1861, the policy was
quickly reversed. McClellan named George Stone-
man chief of cavalry, and by year's end eighty-
two Union volunteer cavalry regiments were in the
process of enrollment and outfitting. Most of them
were short of proper weapons, trained riders, and
good mounts.

One might suppose that McClellan, who wrote
the Army's cavalry regulations and developed a
saddle that was standard equipment for half a cen-
tury, would have handled his horsed soldiers with
dash and imagination. Instead, he attached them
to infantry divisions, scattering them throughout
the Army where they were too often misused by as-
signment to escort and messenger service. Not until

the summer of 1863, when a vast cavalry depot was established at Giesboro Point, did the Union Army have the horse power to challenge the Confederacy's mounted units. Located within the District of Columbia across the eastern branch of the Potomac (Anacostia River), Giesboro was the energy source for the great Union cavalry operations of the last two years of war.

Until that time, however, Confederate cavalry was dominant—a dashing, disruptive, and disconcerting force that kept many a Union commander off balance during the early months of war. In the first major battle, at Bull Run on July 21, 1861, the pattern for Southern cavalry leaders was set by James Ewell Brown "Jeb" Stuart. During the early afternoon of that day, as General Irvin McDowell's advancing Union Army was being brought to a halt by General Thomas Jackson "standing like a stone wall," Stuart led his 1st Virginia Cav-

alry into the fight. When a column of New York Zouaves tried to stop the Virginians, Stuart sent his Black Horse troop charging in with flashing sabers and rattling carbines. Stuart's horsemen may not have changed the outcome that day, but they certainly added to the terror of the fleeing soldiers in blue.

A West Point graduate in 1854 and a six-year veteran of Indian fighting on the western frontier, Jeb Stuart at twenty-eight was the right man in the right place to create the perfect image of romantic cavalier. He was handsome, he was daring, and he dressed the part—wide-brimmed hat worn at an angle and decorated with an ostrich feather and a gold star, a flowing cape, scarlet-lined jacket, yellow sash around his waist, long gauntlets, golden spurs, and a rose always in his buttonhole.

Two months after Bull Run, Stuart was a brigadier general with five more regiments under his

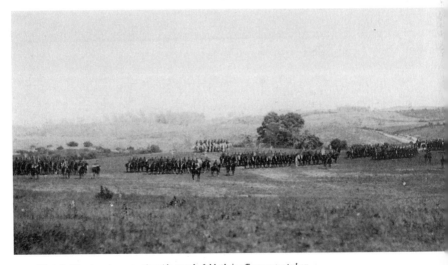

Massed with sabers drawn on the wide parade field, their officers mounted on white chargers in the distance, a Federal cavalry regiment presents all the spectacle of a mode of warfare that was already almost outdated by the 1860s. Here the 13th New York is on inspection at Prospect Hill, Virginia, in July 1865. (LC)

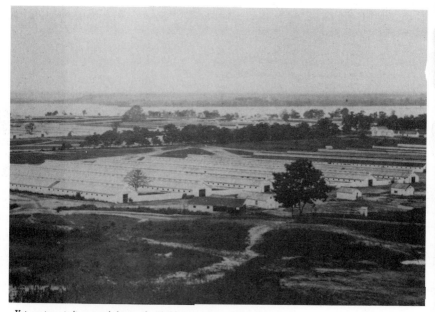

Yet, contrary to its romantic image, the Civil War cavalry was, like every other branch of the service in this very organized war, more organization and administration than dash and glamour. Massive cavalry depots like this one at Camp Stoneman, Giesboro Point, outside Washington, were necessary to house and train the mounts for the armies. (USAMHI)

command, and he soon added a battery of horse artillery commanded by John Pelham. After a winter of relative inactivity by both armies, Stuart's cavalry brigade left Manassas Junction to join in the defense of Richmond, which was threatened by McClellan's growing forces on the Virginia peninsula. Events moved rapidly for the Confederates that spring, with former cavalryman Robert E. Lee replacing the wounded Joe Johnston as commander of the armies in northern Virginia.

Early in June 1862, Lee sent Stuart on a reconnaissance mission that turned into a spectacular ride around the entire invading army of McClellan. With 1,200 of his finest horsemen, Stuart reached the South Anna River on the first day, then turned to the southeast along the Federal flank. After two small skirmishes Stuart made a daring decision to circle the rear of McClellan's army. To cross the Chickahominy, his men had to rebuild a bridge before they could start their return along McClellan's left flank. All the while they were busily capturing and burning supply trains, wrecking railroads, and destroying communications. Ironically, Stuart's opposite cavalry commander in McClellan's army was his father-in-law, Philip St. George Cooke, and at one point the two men were in firing distance of each other.

On June 14 Stuart transferred command to

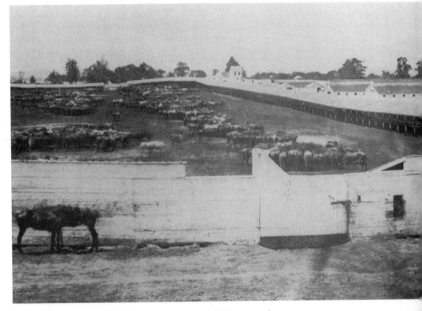

Indeed, so great was the demand for animals to pass through this mammoth depot that unscrupulous speculators soon did a thriving business in selling spavined and blind horses to the government. (USAMHI)

Fitzhugh Lee and dashed on ahead to Richmond to inform his commander of weaknesses in McClellan's defenses. Using this information, General Lee ordered Stonewall Jackson to attack the Union Army's rear and flank, as part of the Seven Days Battles, after which McClellan abandoned his long-planned assault on Richmond and withdrew to Harrison's Landing on the James River.

In the West, meanwhile, an entirely different breed of Confederate cavalry leader was attracting much attention. When the war began, Nathan Bedford Forrest, a forty-year-old cotton planter and livestock trader, enlisted as a private at Memphis, Tennessee. In a matter of days his superiors authorized Forrest to raise a battalion of cavalry, and by August 1861 he was in command of several

companies of volunteers, many of whom he armed and mounted with his own resources. In a way, Forrest was as theatrical in appearance as Stuart— tall, lithe, finely cut features, swarthy complexion, iron-gray hair, and piercing eyes. Although he lacked the cultured background and military training of Stuart, he was not the illiterate country bumpkin he was sometimes depicted, and his language was the common usage of most Westerners of his time. As for his military prowess, Sherman called him "that devil Forrest," and Grant considered him "about the ablest general in the South."

In November 1861 Forrest was raiding as far north as Kentucky. In February 1862 he was at Fort Donelson when the Confederate commanders there decided to surrender to Grant, but instead of

surrendering with them, Forrest galloped his men out in a flight to Nashville. In the general retreat from that city, Forrest's cavalry formed a protective rear guard. By early summer he was raiding northward again, capturing Murfreesboro, Tennessee, and its Federal garrison. On October 20 he suffered one of his rare repulses in a skirmish along the Gallatin Pike near Nashville, but later that year he was cutting Grant's communications and harassing his supply lines in western Tennessee.

Also in 1862 another Southern cavalryman began operations in the West. John Hunt Morgan was the cavalier type, a product of the Kentucky Bluegrass, soft-spoken, handsome, a devotee of horses and racing. Long before the war he organized a fashionable militia company, the Lexington Rifles, and around this company late in 1861 he organized the famed 2d Kentucky Cavalry Regiment. Among his recruits was an accomplished

telegrapher, George Ellsworth, whose intercepted and faked telegrams became a specialty of Morgan's many cavalry raids. After the fall of Fort Donelson, the Kentuckians withdrew to a Tennessee base, using it for frequent strikes into their home state.

Morgan chose July 4, 1862, to start his first Kentucky raid in force, riding a thousand miles in three weeks, skirmishing, capturing supplies, and recruiting men and horses. Three months later he returned to Kentucky again, this time with Braxton Bragg's army, easily capturing his hometown of Lexington and its Union garrison. Morgan never forgave Bragg for retreating after the Battle of Perryville and abandoning Kentucky to the Federals. On December 21 Morgan left his winter base in Tennessee for a Christmas raid, his most significant accomplishment being the destruction of a vital railroad bridge at Muldraugh's Hill, Kentucky, an

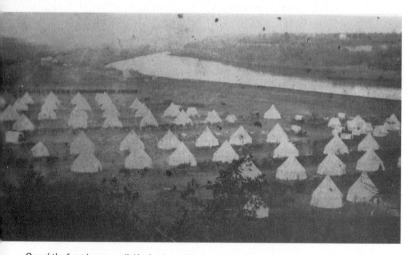

One of the finest images available showing a Union cavalry training camp. This is Camp Hunter, on the Illinois River, near Ottawa. It was made in the fall of 1861 and shows the 4th Illinois Cavalry in training. The regiment's horses are lined up along the rows of tents, while the men are standing in formation in the distance. It is a rare cavalry outfit that three years from now will be able to boast of a plush encampment like this. (KEN BAUMANN)

And in the end organization paid off here at Giesboro and throughout the Union mounted war effort. (KA)

act that halted shipments of supplies to Union forces to the south.

While Bragg's army was retreating from Kentucky, another rising Confederate cavalryman, Joe Wheeler, began appearing in official dispatches. Wheeler was only five feet four and in his midtwenties, but he was a West Pointer. Although he lacked the color and élan of his rivals, Wheeler soon won the nickname "Fighting Joe" and the rank of major general.

Back in the East late in 1862, Jeb Stuart led about 1,800 of his horsemen in a wild three-day dash north into Pennsylvania, wrecking railroads and seizing horses and military equipment. On his return he completed another circuit of McClellan's army, which was still positioned along the upper Potomac after the Battle of Antietam.

During that battle a Union cavalry leader provided some evidence of the forthcoming power of Northern cavalry. He was Alfred Pleasonton, late of the 2d Dragoons, who at the outbreak of war had traveled by horseback from Utah to Washington to offer his services to the Union. Soon he would be in command of a reorganized Federal cavalry corps.

Then came springtime of 1863, midpoint of the Civil War, the year of fullest flowering for the soldiers on horseback, the year of maturation for Union cavalry. By this time both sides had found through experience what weapons and accoutrements best suited them, the methods of fighting that were most successful. The Southerners learned to travel light and live off the country; indeed, the Confederate Congress authorized ranger units that were encouraged to roam independently, raiding

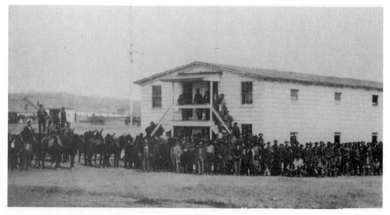

*It took hundreds of warehouses bulging with supplies and thousands of men like
these, soldiers and civilians, to keep the system running. Here is the mess house at
one of the government stables in Washington at war's end.* (USAMHI)

Union bases and supply trains for loot to sustain
themselves. In northern Virginia, John S. Mosby
was the most notable of the ranger leaders. In the
West, M. Jeff Thompson was typical of the irregu-
lars who fought in the border states. Thompson
sometimes moved his troops on horseback, some-
times in dugout canoes.

Although most cavalrymen favored sabers at the
beginning of the war, their use declined in favor of
the carbine and the pistol. Records show that fewer
than a thousand saber wounds were treated in Fed-
eral hospitals during four years of combat. Cavalry
commanders also quickly learned to use their
horses for swift mobility rather than for direct at-
tacks, bringing their men close to the enemy and
dismounting them for combat, with one man in
each set of four acting as horse holder.

By 1863 several models of breech-loading car-
bines were available in quantity for Federal cav-
alrymen, although opinions differed as to the
qualities of the different models. With the new
Blakeslee cartridge box known as the Quickloader,
a trooper could fire a dozen aimed shots a minute.
Yet there were many Southerners, such as Basil
Duke of Morgan's cavalry, who were arguing until

long after the war in favor of their old-fashioned
Enfields and Springfields, which they claimed were
more accurate and of longer range than the newer
Spencer or Sharp's carbines.

Among the extraordinary feats of cavalrymen on
both sides during 1863 was Forrest's interception
and capture of Colonel Abel Streight's entire regi-
ment, John Morgan's great raid across the Ohio
River into Indiana and Ohio, and Stuart's contro-
versial raid just before Gettysburg, when he
inflicted considerable damage upon his enemy but
failed to inform Lee of his actions. On the Federal
side, in the West Benjamin Grierson, a former
music teacher, demonstrated that Yankee cavalry
could raid as daringly and as deep behind the lines
as Confederates. In a seventeen-day march through
the heart of Mississippi, Grierson also demon-
strated the value of cavalry in attacking vital sup-
ply lines and in drawing off enemy forces from the
main battle area, in his case Vicksburg.

Soon after Major General Joseph Hooker took
command of the Army of the Potomac early in
1863, he consolidated his forty cavalry regiments
into three divisions. For the first time the Union
Army had a mobile strike force that could out-

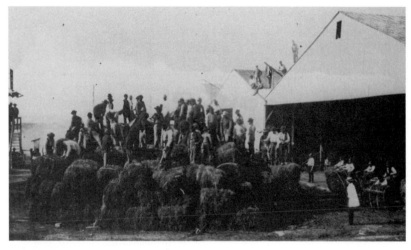

Mountains of fodder and grass passed through the Army of the Potomac's hay department to keep the animals fed. (NA)

number the Confederates. A new breed of young, aggressive leaders was also coming to the fore with the cavalry corps—notably Hugh Judson Kilpatrick, John Buford, and George Custer.

A preview of what was in store for the free-roaming Confederate horsemen occurred on March 17 when Brigadier General William W. Averell challenged Fitzhugh Lee's Confederate brigade at Kelly's Ford on the Rappahannock. What formerly would have been an easy skirmish for the Virginia horsemen turned into a fierce engagement. Averell's men retired from the field, but not until they inflicted double the casualties they received. Among the dead was the Confederate hero of Fredericksburg, "the gallant John Pelham."

The real test came at Brandy Station on June 9. As customary, Jeb Stuart's cavalry was to serve as a screen for Lee's army, which was preparing to invade the North, a march that would culminate in the Battle of Gettysburg. The Confederate cavalry was at its peak, five brigades led by such tested veterans as William E. "Grumble" Jones, Fitzhugh Lee, William H. "Rooney" Lee, and a rising briga-

dier from South Carolina, Wade Hampton. While waiting for General Lee to move out of Culpeper, Stuart decided to put on a grand review. The various squadrons performed at their glittering best before an audience of beautiful women, various civilian and military officials, as well as a number of distant watchers from Alfred Pleasonton's Union cavalry corps.

General Hooker's balloon observers had reported unusual activity along the Rappahannock, and Pleasonton was ordered to investigate. Among his officers were Buford, Kilpatrick, David McMurtrie Gregg, Alfred Duffie, and George Custer, who was then a captain.

After a careful reconnaissance, Pleasonton decided to attack Stuart by crossing one column at Beverly Ford and another at Kelly's Ford. In numbers the opponents were about equal, 10,000 horsemen in blue and 10,000 in gray. The lead units of blue columns crossed the Rappahannock at four o'clock in the morning and caught most of the Confederate camps by surprise. Some Confederates hastily retreated, some formed defense lines, some

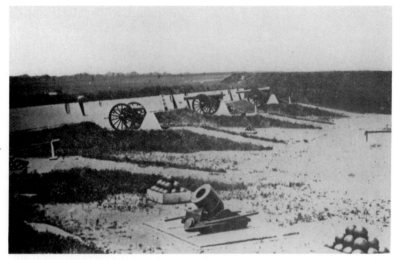

Fortifications like Fort Carroll had to be built just to guard all the accumulated matériel that supported the cavalry. Long gone were the days when a few hotspurs leaped upon their horses and that was the cavalry. (USAMHI)

charged their attackers half-dressed and riding bareback. At Fleetwood, just east of Brandy Station, Stuart was finally able to concentrate his forces, and it was here that the greatest cavalry battle of the war was fought. By this time, delays and communication failures had collapsed command organization on both sides so that regiments, battalions, squadrons, and individuals charged and countercharged in clouds of smoke and dust. As this was cavalry against cavalry at close quarters, many a long-unused saber came into play. After three hours of combat, both sides were completely exhausted, and many men were unhorsed from the wild fighting. With the arrival of Confederate infantry, the Union regiments began withdrawing across the Rappahannock. Estimates vary as to the number of casualties, but it is safe to say that about 500 men on each side were out of combat at the end of the battle.

Brandy Station was not only the greatest cavalry battle of the war; it was the turning point for Fed-

eral cavalry. "Up to that time confessedly inferior to the Southern horsemen, they gained on this day that confidence in themselves and in their commanders which enabled them to contest so fiercely the subsequent battlefields." The man who said that was not a Union cavalryman but one of Jeb Stuart's own adjutants.

Succeeding events were portentous for Confederate horsemen. In July John Morgan's raiders disintegrated during their flight across Ohio; on the twenty-sixth Morgan was captured and imprisoned. In September, after Bedford Forrest clashed with General Bragg over the conduct of the Battle of Chickamauga, he was ordered to turn his troopers over to General Wheeler. In official disgrace, but still a hero in the Western Confederacy, Forrest returned to Mississippi to recruit a new mounted command. But the Southern cavalrymen could not yet be counted out. John Mosby's rangers were very much in action in northern Virginia. Joe Wheeler made a daring circuit of Gen-

eral William Rosecrans's Army of the Cumberland, and in October Stuart gave Kilpatrick and Custer a good scare at Buckland Mills.

As springtime of 1864 approached, with the war seemingly sunk into stalemate, Union cavalry leaders planned a daring raid into Richmond. It was a three-pronged affair, with Kilpatrick leading one column, Custer leading a diversionary attack on Stuart's camp near Charlottesville, and twenty-one-year-old Ulric Dahlgren (who had lost a leg at Gettysburg) supporting Kilpatrick with a third force. Because of bad timing, the main assault failed. Dahlgren lost his life, Kilpatrick retreated with considerable losses, and only Custer came off well by surprising Stuart's winter bivouac and destroying supplies and capturing horses.

In March Lincoln brought U. S. Grant east to command all Union armies. In early April Grant exiled Pleasonton to the West after informing Lin-

coln that he was bringing "the very best man in the army" to head the Union cavalry. He was Philip Henry Sheridan, and his arrival signaled the end for Confederate cavalry power in Virginia.

A further blow to the Confederacy's mounted forces occurred on May 11 when Sheridan brought 10,000 of his troopers within a few miles of Richmond, threatening the capital and destroying large quantities of Lee's already dwindling supplies. In an effort to save Richmond, Jeb Stuart attacked with his 4,500 horsemen. A charge led by Custer drove the Confederates back, and while rallying his men, Stuart was mortally wounded.

In the West, however, the indomitable Forrest with his new command continued an unceasing harassment of the Federals. He led a month-long expedition through Tennessee and Kentucky, capturing Union City, Tennessee, on March 24. On April 12 he captured Fort Pillow, Tennessee, an

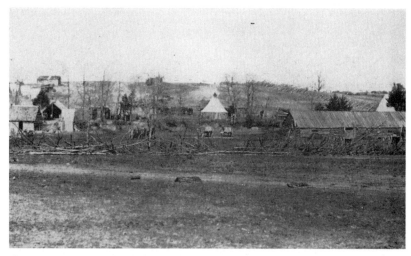

When not on the march, the horsemen lived and looked much like any other soldiers. Their camps, like this one of the 2d Massachusetts Cavalry at Vienna, Virginia, in 1864 sat lightly fortified by felled trees and branches, with only the long, crude stable buildings betraying the fact that horsemen lived here.
(USAMHI)

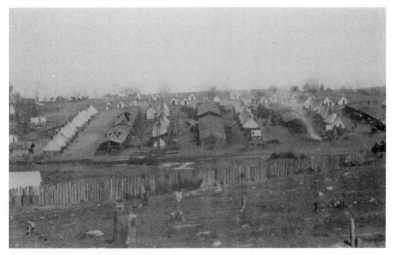

The officers stayed in their little winterized tents near the top of the hill, while the enlisted men shared the larger tents between the stables, man and horse often living in uncomfortable proximity. (USAMHI)

action that is still controversial, some charging that his men massacred black and white soldiers after they surrendered. At Brice's Cross Roads, Mississippi, on June 10, outnumbered more than two to one, Forrest defeated General Samuel Sturgis and sent the Federal column in a panic retreat to Memphis. In August Forrest came close to capturing the Union commanders in Memphis with a daring Sunday morning raid that caught them by surprise. "Old Bedford" closed out the year by assembling a navy of sorts. After capturing two gunboats and two transports, he combined the naval armament with his shore artillery and shelled everything in sight along the Tennessee River.

Confederate cavalrymen seemed to have a talent for attacking gunboats from their saddles. During Fighting Joe Wheeler's January raid in 1863, his cavalrymen captured a gunboat and three transports on the Cumberland River. On June 24, 1864, Brigadier General Jo Shelby and his audacious Missourians fought three United States

steamers on the White River in Arkansas, capturing and destroying the USS *Queen City.*

In the late autumn of that year Shelby joined Major General Sterling Price's expedition into Missouri, the final futile effort to recover that state for the Confederacy. At Westport they felt the sting of Federal cavalry led by none other than the recently deposed commander from Virginia, Alfred Pleasonton. When Price ordered a withdrawal, Pleasonton pursued, but after two heavy engagements the Union commander pulled his troopers away, allowing the beaten Confederates to escape.

Pleasonton's replacement in Virginia, the long-armed and short-legged Phil Sheridan, most likely would have shattered Price's cavalry. In the Shenandoah Valley he and Custer were racking up victories and devastating the Eastern Confederacy's breadbasket. On October 19 Sheridan made his famous twenty-mile ride from Winchester to turn the tide of battle against Jubal Early's infantry at Cedar Creek.

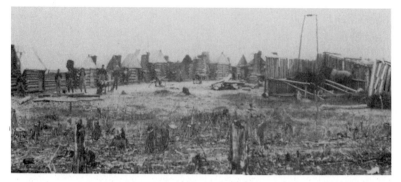

The 3d Pennsylvania Cavalry built its own small village at the headquarters of the Army of the Potomac in the winter of 1864–65. (USAMHI)

By this time other Federal cavalrymen had driven deep into the South. George Stoneman and James H. Wilson were operating in northern Georgia, and Judson Kilpatrick joined Sherman for the march from Atlanta to the sea. Kilpatrick tangled twice with Joe Wheeler's decimated command, but he had so little trouble on the march that he grew careless of security. In South Carolina, March 9, 1865, Wade Hampton's troopers almost captured him in bed, and he was forced to flee without his trousers.

In the meantime, John Morgan had been killed on September 4, 1864, in Tennessee, and on December 13 Stoneman defeated the remnants of his old command. Many units of the once superbly mounted Southern cavalrymen were now reduced to fighting on foot. Wade Hampton and Joe Wheeler were no match for Kilpatrick's powerful cavalry in the Battle of Bentonville in mid-March, 1865. On March 29 Fitzhugh Lee was beginning his last stand in the Appomattox campaign. On April 7 Bedford Forrest fought his last skirmish with Wilson's cavalry in Alabama.

And then on April 8, when the battered survivors of Lee's cavalry units prepared for one final charge near Appomattox, they found themselves facing a solid mass of blue-clad infantrymen, 24,000 strong. The long war practically ended there, and significantly it was a horse soldier in blue who dashed forward under a truce flag to demand immediate and unconditional surrender. The demand was not granted. George Custer had to wait for his commander, General Grant, who on the following day accepted it from General Lee.

And the elegant 13th New York did even better at Prospect Hill. (USAMHI)

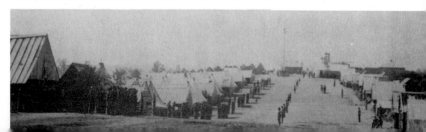

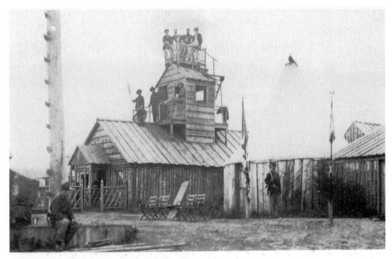

They could even boast of rapid communications thanks to their signal station. It was the look of permanence about some of these perennial camp soldiers that often led the weary and cynical infantryman to wonder if anyone "ever saw a dead cavalryman." (USAMHI)

The horsemen often relaxed in some pleasant grove near headquarters, in this case General Alfred Pleasonton's headquarters at Castle Murray, near Auburn, Virginia, in November 1863. (USAMHI)

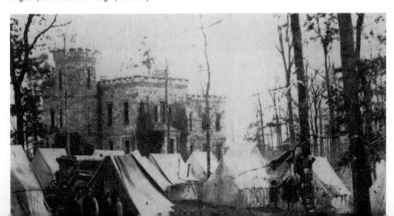

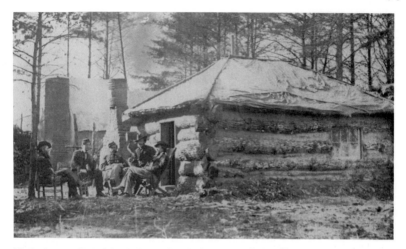

The headquarters life had the air of home about it, of permanence in a world that was rapidly changing. Officers of the 1st Brigade Horse Artillery at Brandy Station, Virginia, in February 1863. (USAMHI)

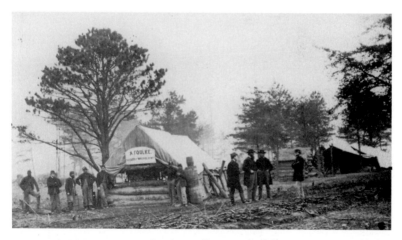

Cavalrymen and their constant companions, horse artillerymen, enjoyed the occasional comforts and stimulants of the brigade sutler, in this case the enterprising A. Foulke, who kept himself well fortified in his log store. (USAMHI)

The officers often imported their comforts. Here Major Granger of the 7th Michigan Cavalry entertains friends and family at his quarters. (KARL ROMMEL)

Brigade and regimental bands often took the boredom out of the long fall afternoons at camp. Here at Auburn, Virginia, in October 1863, General Pleasonton sits in the center of the group at left, with Brigadier General Judson Kilpatrick to his immediate right. (LC)

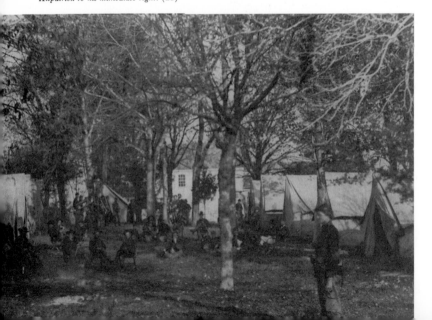

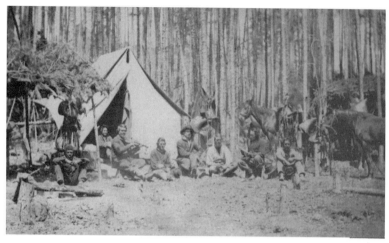

*The horsemen brought their own fiddles to liven the camps, as did these
cavalrymen in Georgia.* (MISSOURI HISTORICAL SOCIETY)

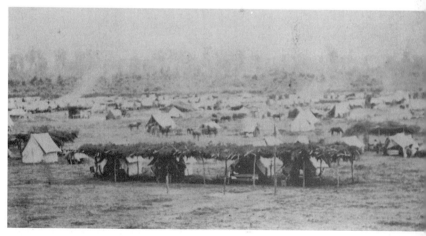

*Farther to the south the picture was the same, only hotter. Men like these Federal
cavalrymen at Baton Rouge, Louisiana, built extensive makeshift awnings to
protect them from the merciless sun. An A. D. Lytle photograph.* (LSU)

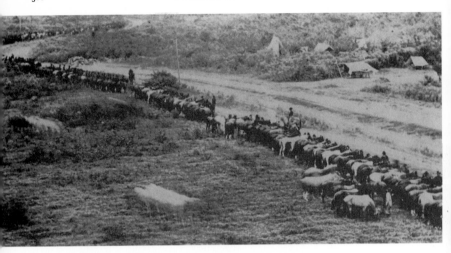

*Exercise at parade and mounting often served only to make a hot day in the
Deep South steamier yet. The weather put more cavalrymen out of action than
did bullets and sabers. This Lytle image, as well as other photographs, have long
been erroneously identified as being taken for the Confederate secret service; but
in fact no evidence exists to support the claim, and the photos have no real
military intelligence value at all. They show only the seemingly endless round of
toil and boredom. (LSU)*

*Two Federal officers, Lieutenants Wright and Ford, languish before their tent at
Westover Landing, Virginia, in August 1862, obviously in the warm part of the
summer, as evidenced by the fans and the mosquito netting over the cot. But
they are still fully dressed in their heavy woolen uniforms for the camera. (LC)*

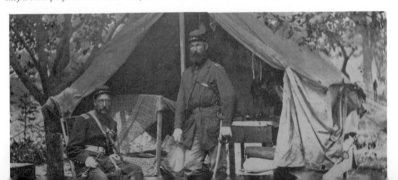

More sensible was Lieutenant Colonel S. W. Owen of the 3d Pennsylvania. At Westover Landing in August 1862 he ignored the camera and opted for a bottle and a nap. (USAMHI)

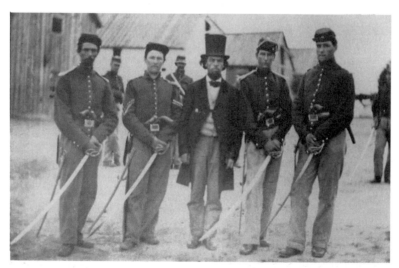

Everyone posed, like these Ohio cavalrymen with their uncomfortable civilian friend. (JAMES C. FRASCA)

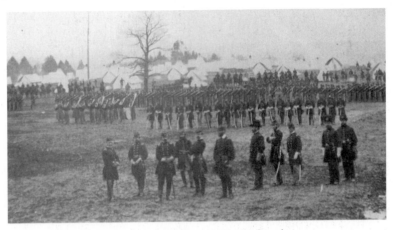

And like the entire resplendent 7th New York Cavalry, with Brigadier General I. N. Palmer standing third from the left in front of them. (WRHS)

Even foreigners were caught by the romanticism of the cavalryman. A Frenchman, Louis Rilliet de Cansdourt, "jined the cavalry" and served much of the war at the Cavalry Depot in St. Louis, Missouri. It all made for a grand pose. (CHRIS NELSON)

Some of those who sat for the cameras were undeniably cavaliers, the last of an age-old tradition of gallantry ahorse. None filled the role better than General James Ewell Brown ("Jeb") Stuart—bold, fearless, dashing, the peerless Southern cavalier. (VM)

Stuart lost not only a battle at Kelly's Ford but irreplaceable people like the dashing young horse artilleryman Major John Pelham, the "gallant." The whole army sorrowed at the boy captain's death, and it marked the end of Stuart's undisputed preeminence. (VM)

It was Stuart who established the tradition of Confederate invincibility in the mounted arm— until he met up with Brigadier General William W. Averell, shown here as a colonel at Kelly's Ford. (RP)

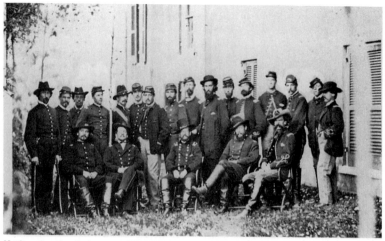

Not long thereafter the horsemen of blue and gray met yet again in the greatest cavalry battle of the war. Commanding the cavalry of the Army of the Potomac was General Pleasonton, seated here at center and surrounded by his staff at Warrenton, Virginia, a few months later. (USAMHI)

With Pleasonton, mounted at right, in the fight was a young captain and aide, George A. Custer, mounted here at left, a dandy frequently more resplendent than his commanders. He would be heard from in this war. (USAMHI)

B. H. Gault of Company H, 8th Pennsylvania
Cavalry, seems all hat and gloves in a uniform
distinctly more tailored than the average horse
soldier's garb. (CHRIS NELSON)

Men like this lancer, who followed Rush, finally
officially managed to lay down their lances in
1863. It gave them a step up from the Middle
Ages. (DALE S. SNAIR)

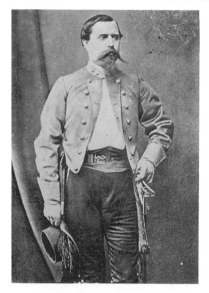

But nothing could take away the cavalier spirit of
the horseman, not even defeat at Brandy Station.
Men like the giant Heros Von Borke, a Prussian
who came to ride with Stuart for the adventure of
it, could still find it all a lark. (VM)

Facing Stuart in the summer of 1863 was Brigadier General George Stoneman,
here seated at right with members of his staff and with General H. M. Naglee
sitting next to him. Though a good officer, Stoneman was replaced by
Pleasonton in time for Gettysburg. (P-M)

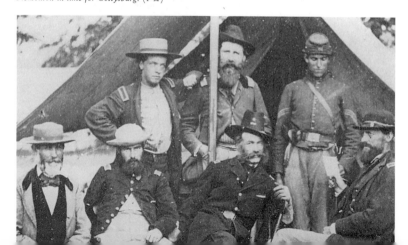

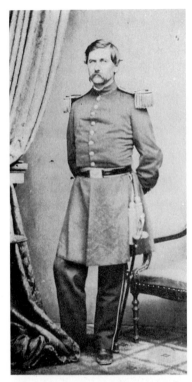

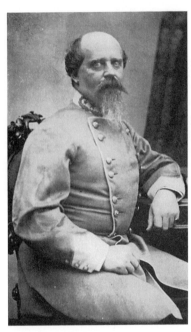

Brigadier General Beverly H. Robertson was there, one of the few Confederate cavalrymen with Lee, since Stuart was off on an inconsequential raid that cost Lee dearly. (LC)

At Gettysburg it was a cavalryman who brought on the opening of the battle and first realized that this was a good place for the Federals to meet Lee. Brigadier General John Buford, shown here as a captain in 1861, held the line long enough for Meade to begin sending his legions forward. (USAMHI)

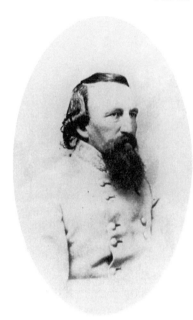

And the fighting continued, as did the dying. Just one day after Yellow Tavern, Brigadier General James B. Gordon took a mortal wound while battling Sheridan. These Confederate cavalry generals placed themselves in the thick of the fighting and all too often paid for bravery with death. (USAMHI)

They met their match in the ruthless, relentless Sheridan. When he came to Virginia in the spring of 1864, fresh from victories in the West, he brought bulldog determination and a jugular instinct. He also captained a host of very competent subordinates. Henry E. Davies sits at left, David M. Gregg next to him, with James H. Wilson and Alfred T. A. Torbert on the ground looking at a map while Sheridan gazes past them. Behind Sheridan sits the youthful yet most talented Wesley Merritt, just beginning one of the most distinguished military careers in the army's history. (LC)

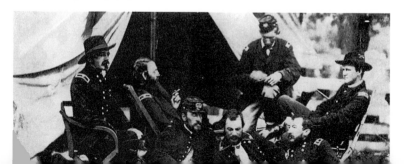

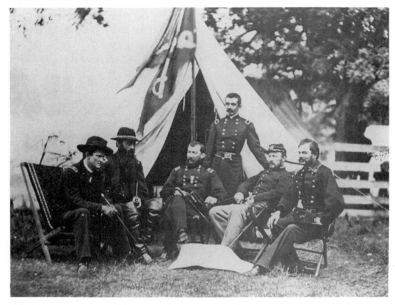

Sheridan and his generals loved to fight—and to pose. (USAMHI)

Torbert, in particular, proved something of a dandy, here seated at center with his staff. (USAMHI)

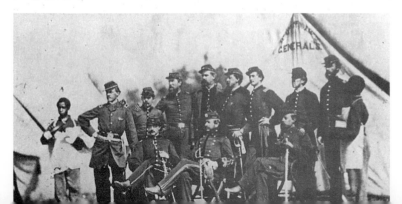

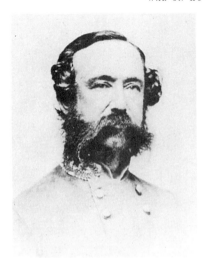

Meanwhile, east of the Blue Ridge Stuart was replaced by another dashing giant, General Wade Hampton of South Carolina, a cavalier who, in a firefight at Gettysburg, declined to shoot at a Yankee cavalryman until the opponent had unjammed his rifle and was able to return fire. (NYHS)

Fighting with Hampton were men who had gone through a lot by the time 1865 approached. General Matthew C. Butler lost a foot at Brandy Station yet stayed with the cavalry to lead one of Hampton's divisions. In 1898, in the war with Spain, he took a commission as a major general in the United States Army and traded his gray for blue. (USAMHI)

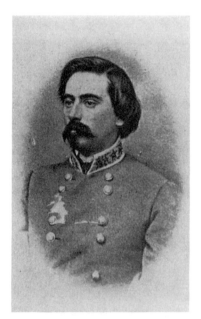

Of course, there were two cavalry wars, just as there were two of the other armies, eastern and western. The men who rode in the Deep South and the West were often of a different stripe, leaner, harder, more pragmatic. To be sure, there were the beaux sabreurs like General Pierce Manning Butler Young. A major general at twenty-eight, he led cavalry that resisted Sherman's 1865 advance through the Carolinas. (USAMHI)

One of Wheeler's more competent subordinates was Major General John A. Wharton of Texas. The combativeness of these hotbloods outlived the war all too often. Indeed, on April 6, 1865, while the Confederacy was still gasping for survival, Wharton slapped a colonel in the face during an argument, and the colonel promptly killed him. (USAMHI)

More temperate was Colonel Charles C. Crews, a Georgian who fought with Wheeler right to the end of the war, later claiming that he had been made a general. (USAMHI)

These Confederates in the West and Deep South faced Federals of equal fiber and dash, none more so than Colonel John T. Wilder of the 17th Indiana Cavalry. His regiment carried Spencer repeating carbines, and on June 24, 1863, at Hoover's Gap, Tennessee, they did deadly work against Confederates armed with single-shot weapons. (ELI LILLY AND COMPANY)

Men of the 5th Ohio Cavalry, who rode across the South with Sherman in 1864, hard men, men of the West. (RP)

Lieutenant General Stephen D. Lee, one of the few Lees not related to Robert E. Lee, commanded Confederate cavalry in Mississippi and Alabama in 1863 and 1864. Already a veteran of Bull Run, Antietam, and Vicksburg, he was still just thirty years old. All the horsemen were young. (LC).

General Frank Armstrong was certainly young, a brigadier at twenty-seven and one of Lee and Wheeler's most trusted subordinates. (CM)

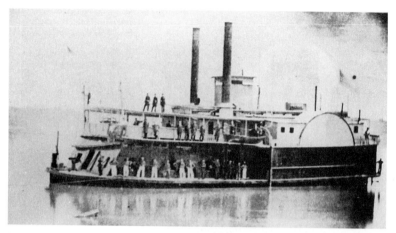

In large part because of their youth and impetuosity, these Rebel riders thought to do things not done before by cavalry. For one thing, they stalked and attacked ships! On June 24, 1864, two Confederate cavalry regiments attacked the USS Queen City *in the White River, off Clarendon, Arkansas, disabled her paddle wheel, forced her to surrender, and then blew her to bits.* (USAMHI)

Another Yankee ship, the Silver Cloud, *exacted a measure of revenge in Tennessee by helping drive away from Fort Pillow another daring Rebel raider . . .* (LC)

. . . Lieutenant General Nathan Bedford Forrest, perhaps the most storied Confederate cavalryman of them all, and probably the best. (TU)

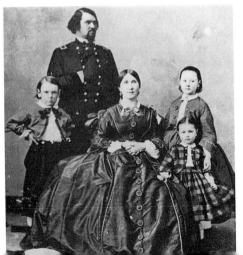

For a time Forrest and his men had the good fortune to face distinctly inferior Yankee commanders, among them Samuel D. Sturgis, shown here with his family. At Brice's Cross Roads, Mississippi, Forrest gave him such a decisive defeat that Sturgis was virtually shelved for the balance of the war. (NYHS)

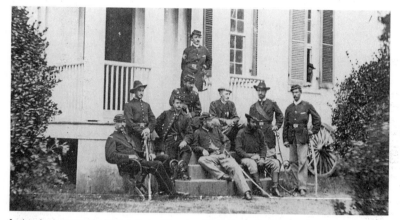

*In time, however, good leaders came to face Forrest and Wheeler, among them
the boy general James Wilson, a favorite of Grant's. Sherman made him his
chief of cavalry, and eventually he led 17,000 troopers. In 1865 he finally
overwhelmed Forrest and led a triumphant raid through the Deep South, in the
process capturing Jefferson Davis.* (USAMHI)

*Meanwhile, in the East Sheridan and his generals, including Wesley Merritt at
left, George Crook in the center, and James W. Forsyth standing between Crook
and Custer, laid waste the Shenandoah and then helped Grant trap Lee.* (LC)

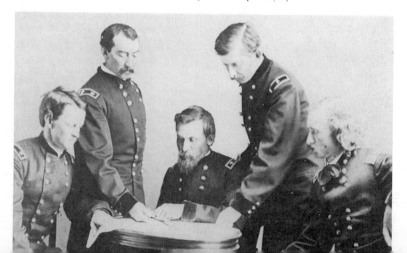

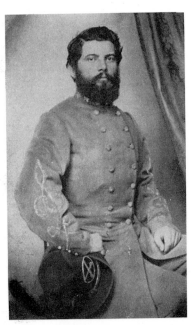

On April 1, 1865, at Five Forks Lee's cavalry let him down. General Thomas L. Rosser held a fish bake, not expecting any activity that day. (MRS. THOMAS R. COCHRAN, JR.)

In attendance were, among others, Lee's nephew General Fitzhugh Lee. (USAMHI)

Robert E. Lee's son, Major General W.H.F. Lee, the youngest man of that rank in the army, led his cavalry creditably in the fighting but could not withstand Sheridan's might. (USAMHI)

At Five Forks and beyond, well-trained and well-supplied units like the 1st United States Cavalry were simply irresistible. Bravery alone could no longer withstand superior might and equal dash. (USAMHI)

Though for some a little glory still remained even after Appomattox, and for others even stranger fates. General George A. Custer, to whom Sheridan gave much of the credit for cornering Lee and his army. He had just eleven years to live. (USAMHI)

Yet throughout the mounted war, it was often lesser men who captured the most attention—and imagination—of the people North and South. They inspired more terror as well. Guerrillas, partisans, raiders, bushwhackers—what they were called depended on who did the calling. They were men like Colonel Alexander M. Shannon, shown here as a captain in the 8th Texas Cavalry, Terry's Texas Rangers. He served General John B. Hood as chief of scouts and became his partner in the insurance business after the war.
(MICHAEL SHANNON)

*The scout Dr. Hale on the left and
"Tinker Dan" Beatty on the right.
These Union guerrillas, like men of
both sides, often operated under
assumed names. They seemed to
gravitate toward colorful sobriquets.*
(USAMHI)

*And they gravitated toward destruction. The Confederate raiders particularly
left their mark behind Yankee lines. Here they have taken up rails on the
Orange & Alexandria Railroad near Bristoe Station, Virginia, then bent them in
the heat of fires from their own ties. A Timothy O'Sullivan image.* (LC)

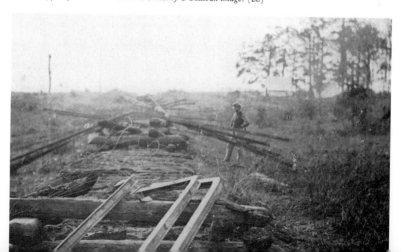

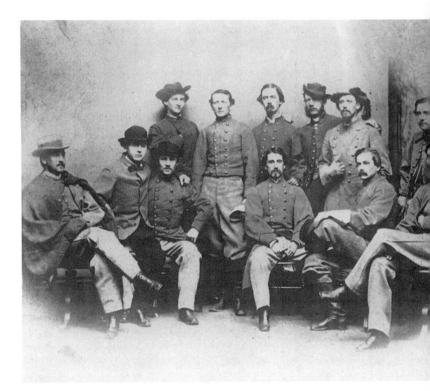

In Virginia, raids like this were as often as not the work of the 43d Battalion of Virginia Cavalry, led by their dashing commander, John Singleton Mosby, standing second from the left among his officers. These partisan rangers were men of daring. (MARYLAND HISTORICAL SOCIETY)

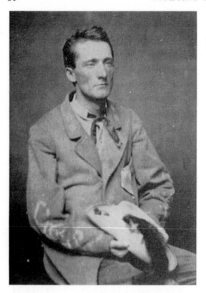

Indeed, led by Mosby, shown here as a lieutenant colonel in 1864, the partisans so dominated a four-county region in northeastern Virginia that it came to be called Mosby's Confederacy. (USAMHI)

In West Virginia the mounted raiders virtually ruled the countryside. Federal outposts like this one at New Creek, West Virginia, could not stop them. (CHS)

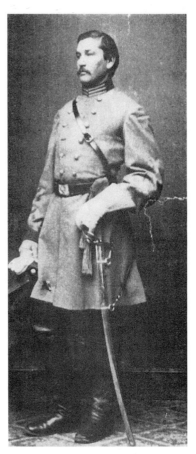

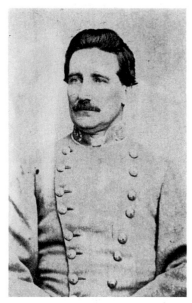

Men of higher rank, and more regular service, occasionally proved to be effective raiders, none more so than Brigadier General John D. Imboden. In 1863 and 1864 his raiding helped materially in protecting the Shenandoah and visiting damage upon the enemy at places like . . . (USAMHI)

All the Yankees could do was to hinder the guerrillas whenever possible, which was not often. For there were other talented men besides Mosby riding against them. Captain Harry Gilmor led a small but effective, and sometimes unruly, command. He will be relieved in 1864 for a time when his men stop a train and rob the civilian passengers. (USAMHI)

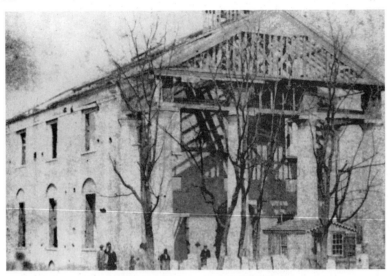

. . . *Charles Town, West Virginia. Here Imboden attacked a Yankee outpost.*
The Federals barricaded themselves in the courthouse, the same building where
old John Brown went to trial. They knocked loopholes in the walls to fire from,
but Imboden captured them just the same, leaving the building in near ruin.
(LO)

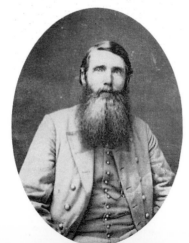

Captain John H. McNeill was even more effective
in western Virginia. Until his death in a skirmish,
he raided continually, his most dashing exploit
being the capture of . . . (USAMHI)

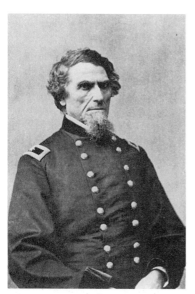

. . . Brigadier General Benjamin F. Kelley
and . . . (USAMHI)

. . . Brigadier General George Crook at
Cumberland, Maryland, on February 21, 1865.
McNeill stole into town in Union uniform and
woke the sleeping generals. (KA)

Albert G. Jenkins lost his life at Cloyd's Mountain,
Virginia, in 1864, but not before achieving an
enviable reputation as a cavalry raider, on one
occasion riding five hundred miles into western
Virginia and on into Ohio. As part of Lee's
vanguard, in 1863 he occupied and held for
several hours Mechanicsburg, Pennsylvania, the
northernmost Union town officially captured and
occupied by Confederate forces. (USAMHI)

A host of lesser-known Confederates, men like
Colonel John S. Green of the 6th Virginia Cavalry,
followed Jenkins, Imboden, and "Grumble" Jones
and the other raiders. (WRHS)

And following them were raw and rugged men like this one, armed with an 1855 pistol carbine, two pistols, and the set jaw of determination. (RP)

The Yankees, too, had their raiders, though few were as effective as their opponents. General Hugh Judson Kilpatrick was one, shown here standing in the center, with his staff and his wife on the left, at Stevensburg, Virginia, in March 1864. Just which side suffered more damage from him is debatable. His own men came to call him "Kill-cavalry" for the way he wore them down and wasted them and their horses. Sherman called him a "hell of a damned fool." (USAMHI)

Kilpatrick, with Colonel Ulric Dahlgren, the son of Admiral John Dahlgren, led a controversial raid on Richmond that failed but did some damage. Kilpatrick raided and destroyed this mill on the James River and Kanawha Canal. (LC)

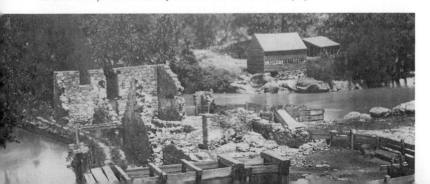

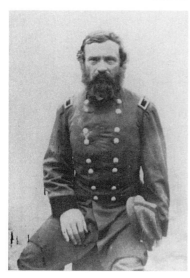

Another somewhat successful Yankee raider was Brigadier General August V. Kautz. He participated in the capture of John Hunt Morgan and his command in 1863, and the next year joined James H. Wilson in the celebrated but only partially successful ride behind Lee's lines at Petersburg, Virginia, a ride that nearly saw both of them captured. (USAMHI)

It was here in Baton Rouge that the most famous of all Union raiders, Colonel Benjamin Grierson, found safety after a daring ride and hairbreadth escape. During Grant's final campaign on Vicksburg, Grierson provided diversion leading his command south through Mississippi and Louisiana. A. D. Lytle's photograph. (LSU)

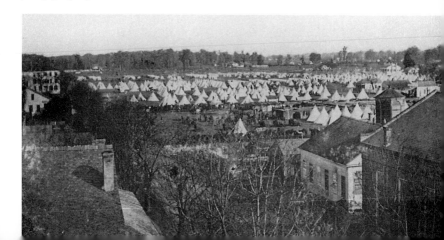

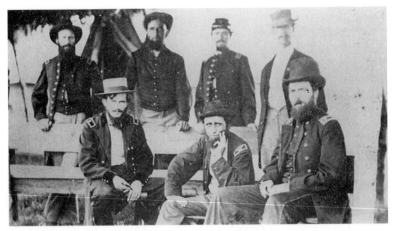

Federal cavalrymen like Brigadier General Albert Lee, seated at left, oversaw sporadic raiding into the enemy interior from bases in Baton Rouge and New Orleans as the war went on. (LSU)

And when they did not raid, they sat out the hot, humid summer days at their landscaped and well-appointed quarters. (LSU)

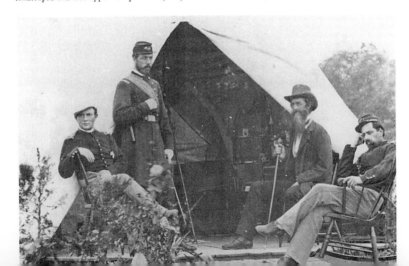

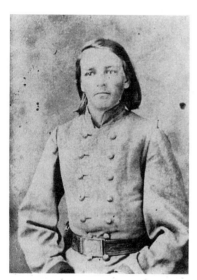

*These western raiders were colorful men, men with
names like "Doc Rayburn." Captain Howel A.
Rayburn led his small command of raiders in the
desperate border warfare in Arkansas and
Missouri. His opponents called him and his men
banditti. (*CONFEDERATE CALENDAR WORKS*)*

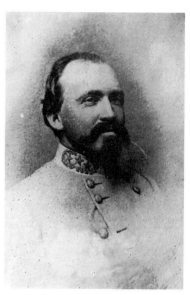

*But of all Confederate raiders surely the most
dashing and the most notorious must be Brigadier
General John Hunt Morgan. His raids into
Kentucky and the North electrified the Union high
command and made him a hero in the South.
(*VM*)*

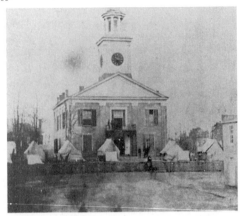

Yet, like all partisans, Morgan could
get out of control, and his men, so
accustomed to destruction and
plunder, could go too far. They did
at Mount Sterling, Kentucky, in June
1864. They captured the Federal
garrison that had been bivouacked
here around the courthouse . . .
(USAMHI)

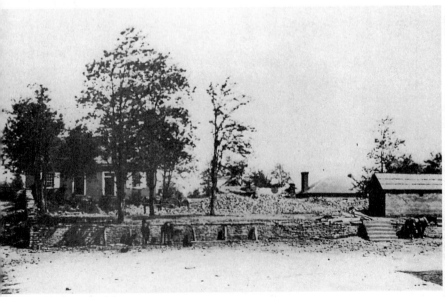

. . . and then destroyed the building and robbed the local bank. Morgan
never gave a satisfactory explanation, and died just a few months later. (CHS)

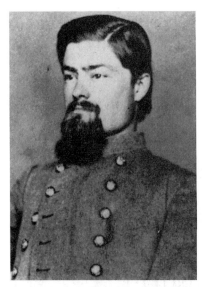

Perhaps the best of Morgan's men—and, in fact, a better overall commander than Morgan himself, was the dashing Basil W. Duke. He took over at Morgan's death and after the war proved to be one of the premier writers about the Confederate partisan service. (CWTI)

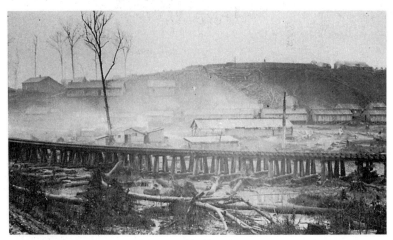

The damage these Rebel raiders could do was considerable, as here at Johnsonville, Tennessee. (LC)

Supply depots like Johnsonville were favorite targets of the partisans, for they could inflict maximum damage without encountering large bodies of enemy soldiers. (LC)

And they liked railroad bridges. They burned nicely and took a long time to rebuild. This one, spanning the Holston River at Strawberry Plains, Tennessee, was destroyed four times by Rebel raiders. (LC)

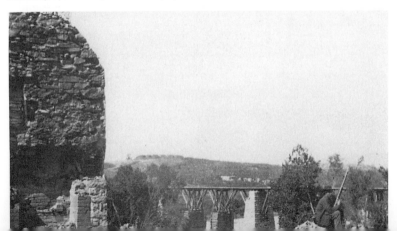

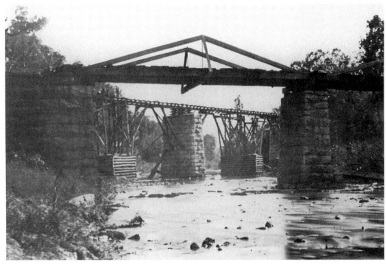

In eastern Tennessee especially, railroad bridges as a matter of course began to take on the look of makeshift. Here is the bridge across Platt Creek, twelve miles above Knoxville. (LC)

To protect the bridges and roadbeds from the raiders, the Federals built blockhouses like this one on the line of the Tennessee & Alabama. (USAMHI)

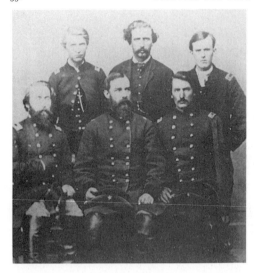

To combat the guerrilla depredations in Tennessee and elsewhere, in 1864 Brigadier General Alvan C. Gillem, seated center, took the field. He finally managed to kill Morgan . . . (USAMHI)

. . . but the Union could never stop the work of the raiders. Throughout the war-torn country scenes of road gangs repairing damaged track, like this one after a raid near Murfreesboro, Tennessee, remained commonplace. The work of the Union and the Confederate cavalries went on until the end. (LC)

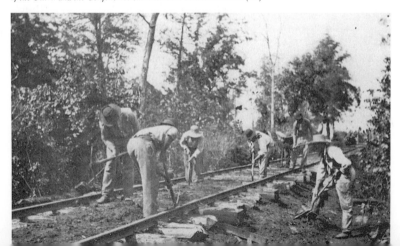

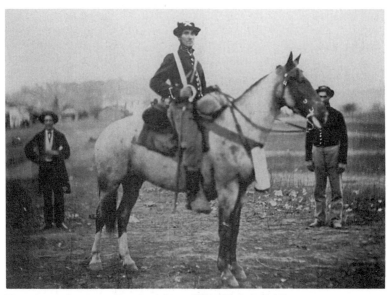

They rode with sabers drawn. Shown here is Private William Harding, 5th Ohio Cavalry. (ROBERT MCDONALD)

Pistols in their belts. (ROBERT MCDONALD)

And some with servants to hold their horses. Here is Major Granger of the 7th Michigan. (KARL ROMMEL)

Young . . . (RP)

. . . and fiercely determined . . . (RP)

. . . they rode forward, toward the enemy and glory. (ROBERT MCDONALD)

The Sailor's Life

HAROLD D. LANGLEY

The routine, boredom, and sometime adventure of webfoot Reb and Yank

CAVALRYMEN were not the only warriors who went into battle as passengers, though they were far more plentiful than their "webfoot" counterparts. Throughout the Civil War the navies of both the North and the South suffered from a shortage of manpower. On both sides the demands of the armies were so persistent that there were never enough sailors, especially experienced men, to complete the crews of all the ships in service. This proved particularly true in the South, where the pool of available seamen was very small under the best of circumstances. Stephen Mallory, the Secretary of the Navy, got the Confederate Congress to pass a law in 1863 whereby any man serving in the army who volunteered for the navy was to be transferred. Mallory claimed that hundreds of men volunteered, but that their military commanders would not release them. In the North, trained seamen were diverted into the army by enlistment bonuses, by local competition to fill regiments, by a desire to try something different, and by the draft. Sometimes it became necessary in both the North and the South to divert soldiers into naval duty. Usually the soldiers were not too pleased by the assignment. Some became disciplinary problems or deserted, but a number adjusted to the demands of the war and gave a good account of themselves.

One part of the Confederate Navy, at least, had no difficulty in attracting men: the ships *Alabama, Florida, Shenandoah,* and other famous commerce raiders. The commanders of such ships completed their manpower needs by drawing on the crews of the vessels they captured. The Confederates paid high wages and in gold. Those factors and the prospect of being a prisoner made a crucial difference. But the result was that a high percentage of the crews of these famous ships were foreigners.

In the South a young man wishing to join the navy had to have the consent of his parent or guardian if he was under twenty-one years of age. His counterpart in the North needed parental consent if he was under eighteen. No one under the age of thirteen was to be enlisted in the North, or under fourteen in the South. Height requirements for the Union Navy were at least five feet eight inches; those for the Confederacy were four feet eight inches. At the other end of the spectrum, no inexperienced man was to be enlisted in the Union Navy if he was over thirty-three years of age unless he had a trade. If he had a trade, thirty-eight was the age limit. In the South an inexperienced man with a trade could join if he was between twenty-five and thirty-five. Inexperienced men without

trades were shipped as landsmen or coal heavers. Free blacks could enlist in the Confederate Navy if they had the special permission of the Navy Department or the local squadron commander. Slaves were enlisted with the consent of their owners, and some of them served as officers' servants as well as coal heavers and pilots. Before the war the United States Navy had tried to restrict the number of black men in the ranks to one-twentieth of the crew. During the Civil War, however, the chronic shortages of men led Secretary of the Navy Gideon Welles to suggest to the commander of the South Atlantic Blockading Squadron that he open recruiting stations ashore for the enlistment of blacks or contrabands. As a result of this and other activities, the Union Navy had a high percentage of blacks in the lower ranks. The normal pay scales in both navies ranged from $12 a month for landsmen and other inexperienced hands to $14 a month for ordinary seamen and $18 a month for seamen. Boys were rated as third, second, or first class in ascending order according to their knowledge and physical ability. Third-class boys were paid $7 a month, second class $8, and first class $9.

In both the North and the South it was customary to send the newly recruited men to a receiving ship. These were usually old frigates or other sail-powered ships that were stationed at navy yards in the North and functioned as floating dormitories. In the South old merchant ships were used at Richmond and at other major Southern

"All hands on deck!" Or perhaps it is another call that the mate blows on his whistlelike pipe. Whatever it is, the Civil War sailor—like his mates in the armies—can look forward to another day of work and play, tedium and excitement. It is the lot of the webfoot men of blue and gray. (LC)

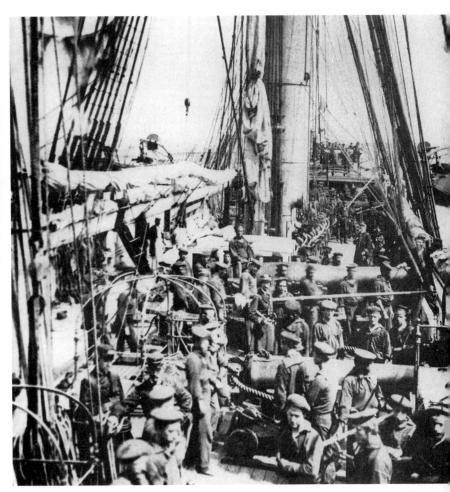

At the mate's call, hundreds of sailors rush to their posts aboard massive steam frigates like this one. Decks crowded, the crews at their guns, a marine detachment standing at attention in their white crossbelts, another of Lincoln's warships is ready to meet the enemy. (WAR MEMORIAL MUSEUM OF VIRGINIA)

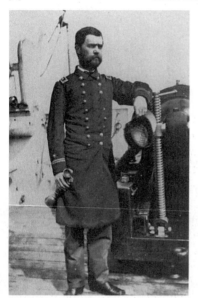

They will answer to the officer of the deck, his speaking trumpet ready to bark orders that send sails flying or steam puffing from the stack. (USAMHI)

sails, rigging, boats, and cutlasses, as well as the procedures for repelling boarders. The manpower demands of the Union and the Confederate navies meant that the amount of time a recruit was on a receiving ship ranged from a few days to a few weeks. Anything not learned on the receiving ship had to be learned in the hard school of active service. Periodically the commander of the receiving ship would receive orders to send a certain number of men to a vessel preparing for active service, or as replacements for a ship that had lost men through death, illness, or desertion.

Once a man reported to a ship in the regular service, he was assigned to various stations at the guns, on deck, in the tops, in a boat, at a mess, and in a hammock. Each had a number to be remembered. So, on a man-of-war, a given recruit or veteran might define his niche in the following way: He belonged to the starboard watch, was stationed in the top of the mizzenmast; he belonged to the third division of the battery, attached to gun number eight, where he was the first loader. In the event of a need to board an enemy vessel, he was the second boarder in his division. When it was necessary to loose or to furl sails, his post was at the starboard yardarm of the mizzen topgallant yard. In reefing sails his position was on the port yardarm of the mizzen topsail yard. When tacking or wearing the ship, his place was at the lee main brace. If the anchor was being raised, his duty was at the capstan. In a boat he pulled the bow oar of the captain's gig. Until all these assignments became second nature to him, the recruit might forget his numbers and have to refresh his memory by consulting the station bill, where everyone's position was recorded.

On gunboats and monitors all the duties associated with masts, rigging, and yards were eliminated, of course. These ships were also much smaller than a steam frigate or some of the merchant vessels converted to warships. But on these smaller ships there were still quarters, guns, and decks to be kept clean, and there were still watches to be kept. On all coal-burning vessels it was a constant problem to keep the ship and the guns clean. The actual work of coaling a ship left black dust everywhere. About the time that the dust was under control, it was time to recoal.

Any man with experience in the merchant service found life on a warship quite different, at least

ports. A recruit arriving on board a receiving ship reported to the officer of the deck. His name and other details went into the ship's books, and he was sent forward. Usually he received only the clothing needed for immediate service. In the North no civilian clothing was allowed, though shortages of uniforms later in the war sometimes made it necessary to modify this rule in the South. When the recruit arrived at the forward part of the receiving ship, he was given a number for his hammock and another for his clothes bag and was assigned to a mess.

While on board a receiving ship the recruit learned the rudiments of navy life. He learned how to address and to respect his officers, petty officers, and shipmates. Much time was spent in various kinds of drills, such as learning to handle

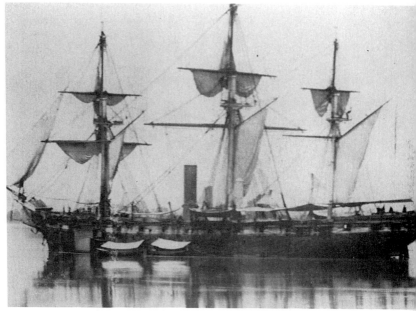

It was mostly work in the duty hours aboard ship. Supplies had to be brought aboard in small boats, decks washed, and the ship's sides painted, as evidenced by the lighter patch near the bow of this warship anchored off Baton Rouge. An A. D. Lytle photograph. (LSU)

at times. In the merchant service, for example, when raising the anchor, the men at the capstan might sing a sea chantey. In the Navy this and other tasks were performed in silence lest some order from an officer not be heard. Loud talking by the men while on watch was frowned upon for the same reason. In warships of both the Union and the Confederacy, the shipboard routines were performed to the sound of shouted orders, boatswain's pipes, or a drum, depending on the situation covered.

Joining the crew of a warship was apt to be quite a memorable experience for the recruit. Here he found himself among a wide variety of men. There were some older, weatherbeaten types who had been at sea for many years. In contrast to these were the young men of seventeen, eighteen, or younger, away from home for the first time. There were foreigners, including some not many months removed from their old environments in Europe. There were black men, including many who had recently left the slave status. Also caught up in such groups was an occasional North American Indian, or a Pacific islander. In a very real sense a man-of-war was the world in miniature, especially on Union ships. Crews of Confederate gunboats and other vessels that defended Southern harbors, inlets, and rivers were apt to be more homogeneous, especially early in the war.

For the Northern recruit particularly, adapta-

The steam vessels, great and small, had to take aboard coal to fill their bunkers.
Here the monitor Canonicus *is coaling in the James River in the summer of*
1864. (USAMHI)

tion to the cross section of humanity that comprised the crew was often difficult. Their early weeks and months in the Navy might be marked by personality clashes, accusations and counteraccusations, and fights. Marines and officers had the duty of stopping any affrays. The man who struck the first blow might find himself confined to the brig, in irons and on a diet of bread and water for twenty-four hours, as a warning not to persist in such conduct. A man who was wronged by another soon learned to settle his score indirectly rather than by fighting. His tormentor might find the rope of his hammock cut while he was asleep, or have a belaying pin dropped on his toes, or become the victim of other "accidents."

In the Union and the Confederate navies it was the specific duty of the commanding officer to see to it that ordinary seamen, landsmen, and boys were instructed in steering, in heaving the lead to determine the depth of the water, in knotting and splicing ropes, in rowing, in the use of the palm and needle to do sewing, and in bending and reefing sails. Mastery of these duties was necessary if the recruit hoped to qualify for promotion to seaman or to become a petty officer. Coal heavers with any intelligence at all could master the requirements necessary to become a fireman. In addition, the men were continually drilled in exercising the guns, in handling small arms and boats, and in using the boat howitzer. Anything not learned on the receiving ship was thoroughly learned on a ship in regular service. In the Confederacy, whenever the needs of war made it necessary to transfer from one ship to another, the men had to have additional training because no two ships had engines or guns that were exactly the same.

In both navies the daily routine was somewhat the same, depending on the size of the ship, the preferences of the captain, the season of the year,

The engines needed maintenance. The image shows the works of a smaller steam vessel, its engine from the Morgan Iron Works, built in 1861 and sporting steam gauges from the Cosmopolitan Company. It all gleams, even the oiling cans in the brass basket at right. (WRHS)

and the needs of the moment. Sailors might begin their day as early as 4 A.M. if the ship had to be thoroughly cleaned or was scheduled to be coaled in the morning. Otherwise, a typical day might have gone as follows:

At 5 A.M. the marine bugler sounded reveille. The master-at-arms, or one of his corporals, and the boatswain's mate from the current watch ran around the berth deck shouting at the sleeping men and slapping hammocks. The men were ordered to get up and to lash up their hammocks and bedding into a tight, round bundle. These were then carried up to the spar, or upper, deck. Here the hammocks were stored uniformly behind heavy rope nets,

called nettings, along the bulwarks. Storing the hammocks here gave some small additional protection from gunshots and from wood splinters dislodged by cannon fire. The nettings also provided a barrier against boarders. In theory, a well-trained crew was supposed to rise, lash their hammocks, and deliver them to the spar deck in seven minutes. In practice, it may have taken that long to get some men out of their hammocks.

About 5:07 A.M. the crew got out sand, brooms, holystones, and buckets and washed down the decks. Usually the berth deck was scrubbed with saltwater, and the spar deck was holystoned by teams of men working under the direction of a

The engines came from many makers, this one manufactured by the Allaire Works, but basically they looked and operated the same. This one, aboard the steamer Fulton, *also gleams, the signal bell overhead polished and reflecting the light from the hatchway. It was hot work for the seamen trapped below deck with the puffing monsters.* (USAMHI)

boatswain's mate. In addition to the decks, the brass fittings and other bright work were polished. Metal tracks on which the gun carriages turned were burnished. The guns themselves were cleaned. On ships that carried sails, the rigging, halyards (ropes for hoisting yards or sails), and blocks were checked and maintained as necessary. Once the ship was cleaned, the sailors might fill the buckets with saltwater to wash themselves and to shave, if they so desired.

In a man-of-war, boys assembled at the port gangway at 7:30 A.M. for inspection by the master-at-arms. The boys were expected to have clean faces and hands, hair combed, and clothes clean and tidy. Their pants were supposed to be rolled up. After the inspection, each boy was expected to climb to the top of the masthead and come down. Each boy did his best to get up and down first. Sometimes the last boy down had to climb up and down again. The theory behind this routine was that it made the boys agile and gave them a good appetite for breakfast.

At 8 A.M. the boatswain piped breakfast. Cleaning equipment was put away and buckets were returned to their racks. Each man reported to his respective mess, which consisted of from eight to fourteen men. Members of a gun crew, coal heavers and firemen, and topmen would have their own messes, often determined by the watch to which they belonged. Marines and petty officers messed separately, and the boys were distributed among the messes. Each member of the mess took his turn as the orderly or cook, though sometimes one person would be hired by his messmates to do the job on a permanent basis. It was the job of the orderly to unlock the mess chest and take out the tableware and cooking utensils, as well as the food allotted to the mess each week by the ship's cook or by the paymaster. The individual kept track of his own knife, fork, spoon, and mug. For breakfast each man was served one pint of coffee without milk, as well as a piece of salt junk, or hard, salted beef. After breakfast the dishes were cleaned and returned to the mess chest.

Then, at 9:30 A.M. came the call to quarters. Guns were inspected to see that they were properly secured and ready for any emergency throughout the day. Once this was done, the men relaxed at their stations by writing letters, reading newspapers or books, or dozing.

Noon was the fixed time for lunch, so at that hour the men reported to their messes. Now they had a piece of beef or pork, vegetables, and coffee. Cheese might enhance the meal from time to time. On blockade duty there were opportunities to acquire fresh provisions from the shore areas, and these broke the monotony of the average meal served at sea.

The crews of the Confederate cruisers usually ate well as a result of their captures of merchant vessels, but for the rest of the Confederate Navy, items like cheese, butter, and raisins, while technically a part of the ration, were never available. Tea and coffee could be obtained from blockade runners, but at a great cost. Even so, the Confederate Navy usually ate better than the Army. One and one-quarter pounds of salted beef, pork, or bacon was issued to each man every day. As late as 1864 the men of the James River Squadron got meat three times a week.

After lunch the men might return to the stations they had left, or portions of the afternoon might be

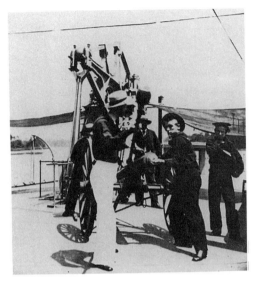

Yet there was hot work above as well, and none more tiring than the endless gun drill, particularly endless for a crew that could not meet the time set by its captain or hit its marks. Whether aboard smaller ships like the little USS Hunchback . . .
(USAMHI)

filled by various kinds of drills. Blockade duty proved so monotonous most of the time that commanders had to exercise their ingenuity to keep the men occupied. Training sequences were not the same on any two successive days; thus there was no predicting what would come next on the agenda. As Charles K. Mervine, a boy attached to a blockading squadron ship, wrote in 1863: "The life of a sailor is not one of a real and regular work, his hours of rest may not be uniform but they are more or less regulated. The details of a program [*sic*] of any day on shipboard cannot be as fixed as in other forms of labor, yet its original outlines are the same day after day."

At 4 P.M. a light evening meal was served by the various messes. In this and the other meals, the timing was related to the watch sequence of four hours on and four hours off. Mealtimes were when the watch was relieved. From a nutritional point of view, there were objections to this format because in a twenty-four-hour sequence all the meals were crowded into less than eight hours. Since the noon meal was the main meal, men who stood watch at midnight or in the early hours of the morning might be quite hungry.

On blockade duty individual captains could alter the watch routine by splitting the period from 4 P.M. to 8 P.M. into two 2-hour watch segments called dogwatches. This meant that there would be seven watches instead of six in a twenty-four-hour period. If this was done, no watch would have to take the midnight to 4 A.M. shift for two nights in succession. An alternative was to divide the crew into three watches so that each man would be on duty for four hours and off for eight. Still other captains went so far as to use quarter watches, or one-fourth of the working hands, or half of each watch. In this system the watch would be divided into first and second parts, which would constitute the quarter watch. There were, however, those who believed that the use of quarter watches was unwise in dangerous waters.

The watch procedure was also used in coaling the ship. Such work might begin with the port watch and function in a prearranged order. Coaling might begin about 7 A.M. for the Union ships

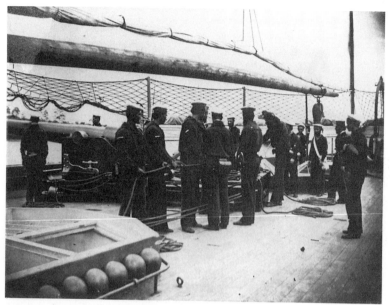

. . . or on bigger ones like the Mendota, *the routine was much the same. Only the size of the guns differed. When the men worked the guns on these ships, they wore swords and pistols at their belts. This massive pivot gun is ready to fire. The crew is standing clear, men are ready to haul on the ropes that will pull it back forward after its recoil, and the sailor directly behind the gun carriage holds one hand aloft to signal clear while with the other he grasps the lanyard that will fire the piece. More shot for the next round lie waiting in the shot rack.* (USAMHI)

on blockade and be finished by noon, if the crew really worked at it. If they did not, and the work continued into the heat of the afternoon, the process could take as much as twelve hours. Because everything depended upon the time of arrival of the coal ship, there was no consistent time for the operation to begin. If the process began in the late afternoon, it might continue all night.

At 5:30 P.M. the sound of the drum called men to their quarters. Once again guns and stations were inspected to see that everything was ready for the night. This was especially important, for the

hours of darkness were the times when the blockade runners were most active. Once the inspection was finished, the boatswain's pipe announced that the hammocks could be removed from the nettings and prepared for sleeping. Then came the period of relaxation for all who were not on watch. The men might write or read letters, or read newspapers and books. At this time and in other free periods during the day they repaired their clothing. Dominoes was a popular pastime. Cards were strictly forbidden. Gambling was also outlawed but went on covertly. It could range from simple

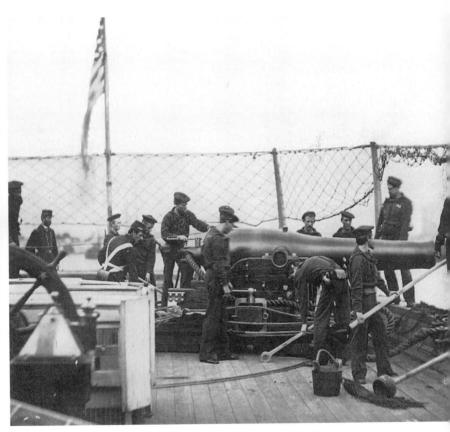

The scene is the same aboard the USS Miami. The gun crew are armed with .36 caliber Navy pistols and cutlasses. A seaman stands ready to swab out the bore with a brush soaked in water from the bucket. Two other seamen and a marine hold the great long wrenches that will help reset the gun after firing. Another man holds the elevating screw at the breech, and the man at far left holds the lanyard. Everyone is ready to defend that flag. (NHC)

games of calling odds and evens, matching money, or bets associated with daily activities, such as how long it would take them to overhaul another ship, to more formal games with dice.

At idle times in the afternoon or evening the men might also listen to music if they were fortunate enough to have a banjo or fiddle player on board. A larger ship might have some semblance of

The routine was the same on the monitors, both inside the turret and with the deck guns outside. They loaded and stood ready . . . (NA)

. . . and stood ready and stood clear to fire. Shown here are men of the Lehigh. (USAMHI)

a band. On many vessels minstrel shows or theatricals were staged in the early evening, written and produced by the men themselves. Black crew members performed in minstrel shows along with their white comrades. On ironclads and monitors, of course, space was much more limited, and therefore so was the range of entertainment. In this as in every war, mail from home and from loved ones was looked forward to with great anticipation.

The daily scrubbing the ship received tended to keep the lower decks somewhat damp. This, combined with the daily humidity on the Southern stations, especially in the summer, made for a generally stuffy atmosphere. On monitors and gunboats the heat of the engines warmed the metal plating and the decks. There was also the smell of burning coal and sometimes of sulfur. The men tried to enjoy the fresh air as long as possible before retiring, for during the night the atmosphere on the berth deck sometimes became so oppressive that they had to congregate around the hatches for a breath of air.

Those who wished to smoke went to the forward part of the ship. Cigars and pipes were lit by a taper from a whale oil lamp and carefully extinguished. Hand-rolled cigarettes had been introduced into the United States from Turkey in the late 1850s but did not become popular until many years after the war. Friction matches were strictly forbidden on ships because of the danger of fire, and no uncovered light was allowed in any storeroom or in the hold. Lamps were carefully chosen to avoid any that used explosive oils for fuel.

On some ships it was a common practice to allow time after dinner for general horseplay, tomfoolery, and skylarking as a means of relieving tension. Other captains thought that tension was relieved by scheduled boxing matches in the afternoon. On more sedate ships the hours after dinner were the time for a quiet smoke, for telling or listening to a yarn, or for writing and reading.

Problems relating to the abuse of alcohol were common on all ships and in all ranks. The enlisted man's daily ration of grog, or one gill of whiskey mixed with water, was abolished by act of Congress in September 1862. In the Confederate Navy the enlisted men were entitled to one gill of spirits or a half pint of wine per day. This continued throughout the war, though a man could receive money in lieu of the spirit ration if he chose. Originally this compensation was set at four cents a day, but it rose to twenty cents a day by the final years of the war. The Congress gave the Union sailor an additional five cents a day in lieu of the spirit ration. In both the Union and Confederate navies there were constant efforts to smuggle liquor on board ships, and some of these plans proved successful. Private vessels that sold food to the Union ships on blockade sometimes sold liquor in tins described as oysters or canned meats. Despite such ingenuity, the supply never matched the demand. When a man was discovered drinking or drunk, the usual practice was to place him in irons in the brig. On some ships drunks had saltwater pumped on them until they sobered up.

For the Union ships on blockade duty, tattoo normally sounded at 8 P.M. This was the signal for the men to go to their sleeping quarters and retire. Lights and fires were put out and there was to be no noise. Elsewhere the usual rule was that when the sun set at or after 6 P.M., the tattoo was beaten at 9. When the sun set before 6, tattoo was at 8. For the men of the Union blockading squadrons, going to bed was often accompanied by the latent fear that the ship might be the victim of a torpedo attack before morning. This was especially true after the Confederate submarine *David* succeeded in sinking the U.S. steam frigate *Housatonic*. Sleep might also be interrupted by reports of a blockade runner entering or leaving a harbor. At such times the ship sprang to life as it pursued or overtook a potential prize.

As the control of the Union Navy over the rivers and coastal waters of the Confederacy increased, the opportunities for appropriate Southern countermeasures decreased. Hopes placed in the submarine *David* or the ironclad *Albemarle* as a means of weakening the blockade were soon dashed. Overseas the famous Confederate cruiser *Alabama* went down in a fight with the Union cruiser *Kearsarge* in June 1864. Time was running out for the Confederate Navy.

For the men of the Union Navy the biggest problem was boredom. Despite daily activities of scrubbing, painting, drilling, target practice, entertainments, and the duties directly related to war, time passed slowly. Changing stations, taking on coal and supplies, entering and leaving harbors all added a bit of novelty to a day. But the men

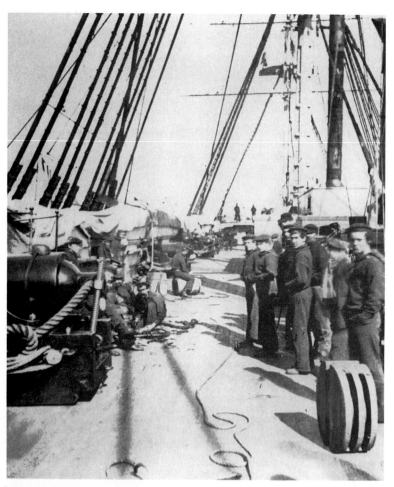

Besides the gun practice, a thousand daily chores kept the sailors busy in the long months of blockade and cruising duty. On the gun deck of the USS New Hampshire *barrels are rebound, blocks taken down and refitted, and endless miles of cables spliced, trimmed, and repaired.* (P-M)

eagerly looked forward to short periods of liberty when their ship was at some Union-controlled port in the South, or was being repaired or overhauled in the North. Any time ashore was an occasion for the pursuit of liquor, women, or both. Men returned from such ventures drunk and often with venereal disease. Fevers and diseases common to the region also took some toll of both Union and Confederate sailors. In battle men could be killed in a horrible fashion by being scalded with steam from shattered engines. Even peaceful steaming on a river could become a hazardous affair when a Confederate sniper opened fire. Shore leave could also be dangerous if a man ventured too far inland or away from Union-held territory. Yet virtually any distraction was a welcome change from the boredom of blockade duty.

Sometimes a man slipped into deep despair over his daily duty. One naval surgeon called this condition land sickness. Those afflicted with it had a terrible urge to smell the earth and to breathe air far removed from the ocean. Sometimes a change of scene and some days ashore solved the problem, but for others the brief change did no good. For such men discouragement and despondency led to real illnesses, and they had to be sent home. It was boredom, and all the other aspects of life in the blockading squadrons, that led a former paymaster's clerk to write that "there was no duty performed during the whole war, in either the land or sea service, that was attended with so much toil, exposure and peril as this duty compelled." All the ship-to-ship fighting put together totaled little more than one week of battle out of four years of war. For the Yankee and Rebel seamen it was indeed a war of watch and wait as they sat imprisoned on their ships.

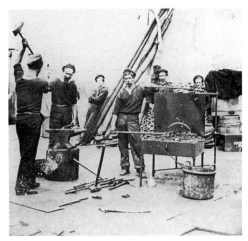

There was iron to replace and repair. Ships like the monitor Saugus *carried portable forges, complete with bellows, to turn white-hot iron into ship's parts. Photographer Egbert G. Fowx's trunk of chemicals and makeshift darkroom are visible in the background.* (USAMHI)

Cooks and stewards like these aboard the Fulton *earned their share of obloquy for the wares they produced, trying to turn salt pork, beef, and hard peas with weevils into fit meals.* (USAMHI)

And someone had to watch the ship's accounts. That was the purser. Often regarded as dishonest, and almost always thought a bore, the poor purser stood in low repute. When Herman Melville shipped aboard a United States man-of-war in the 1840s, he found that the ship's purser was only useful in a conversation "by occasional allusions to the rule of three." Purser McManus of the Fulton. (USAMHI)

Of course, the men had to be paid, and that called for the paymaster, this one shown aboard the New Hampshire. (USAMHI)

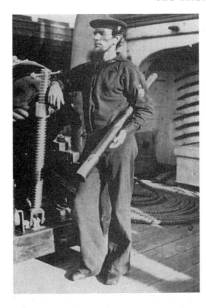

The quartermaster of the New Hampshire. *His lot was the navigation of the ship.* (P-M)

Constant vigilance was the business of everyone, on duty or off. Shown here is the lookout station aboard the Vermont *while she stood blockade duty off Charleston.* (P-M)

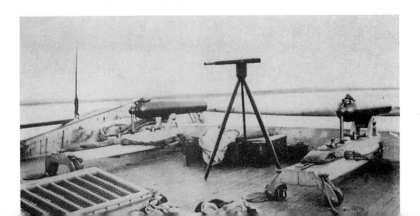

Of course there were lesser, more personal chores to fill the odd hours. Everyone, from captain to private seaman, had dirty laundry to wash and hang for drying. The USS Sangamon. *(LC)*

There were the quiet moments for the officers, resting against their mammoth guns as they plied the Virginia rivers. Shown here are officers of the Mendota. *One of them has thoughtfully posed a cartridge bag and cutlass on the cannon's screw. (NA)*

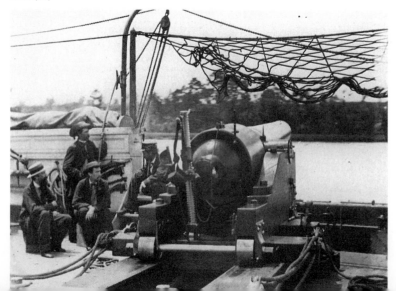

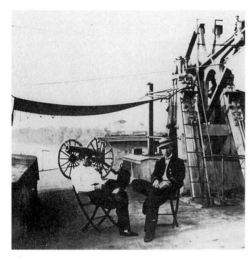

A book and the shade of an awning made an afternoon aboard the Hunchback *pass quietly enough.* (USAMHI)

The awninged gun deck of a larger warship kept these officers out of the sun to enjoy their pipes. (USAMHI)

Those fortunate enough to serve aboard passenger steamers pressed into service could enjoy the interior of their ships, such as the saloons like this one aboard the Delaware. *War did not have to be uncomfortable all the time.* (WRHS)

Some, like the fellow at right, even managed to step into their carpet slippers from time to time. (USAMHI)

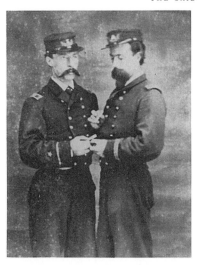

There were quiet moments for friends to exchange what appear to be cigarettes . . . (GLADSTONE COLLECTION)

. . . or just to lounge on the deck amid the peaceful paraphernalia of war. (LC)

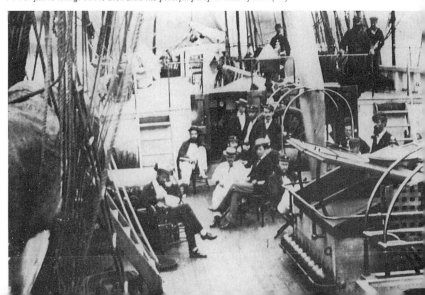

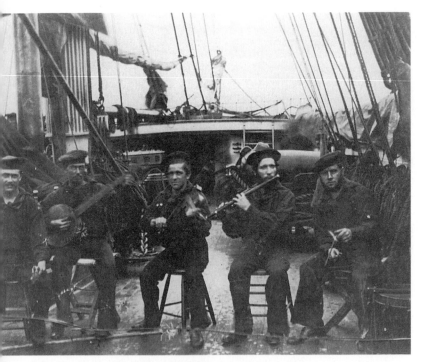

The sailors, North and South, like the soldiers, turned to music for relaxation, though their songs traditionally ran more to the bawdy than did those of their compatriots in the armies. Minstrels aboard the Wabash, *off Hilton Head.* (USAMHI)

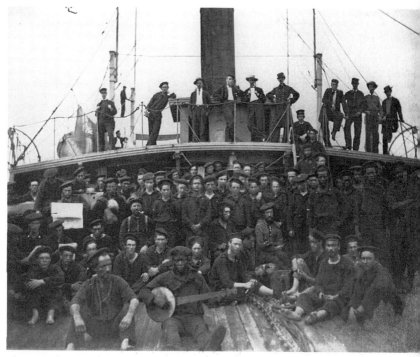

More players aboard the Hunchback, *this time a colored seaman entertaining shipmates. Some smoke, some read, one sailor at left holds a ship's dog, and others peel apples or potatoes. The ship's complement of Negro sailors pose as well, though they stay together and somewhat apart from the rest of the crew. Equality came closer in the navy, but not that close.* (NA)

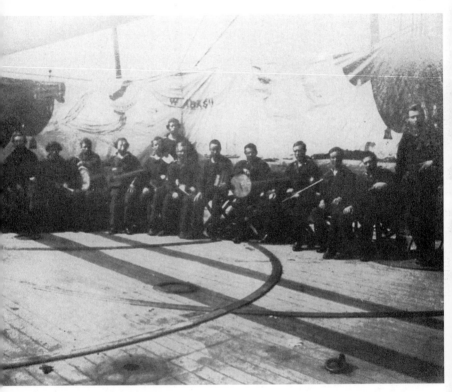

Yet more minstrels aboard the Wabash, *performing before a painted awning
proclaiming their ship and its battles.* (NHC)

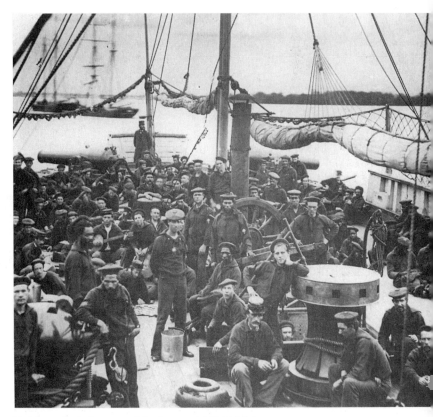

The full panoply of sailors at ease. Colored seamen at right patch their worn garments. A game of checkers in the center is played on a fabric board. Acey-deucey, the sailor's backgammon, flourishes elsewhere. And all around is quiet and calm, a peaceful day on the water. If photographs of Confederate sailors were to be found, they would look much the same. (NA)

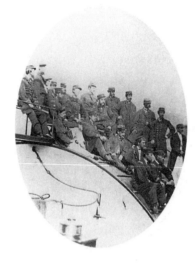

Of course, the officers could pose on a somewhat higher plane, including perched atop the paddle box. (HENRY DEEKS)

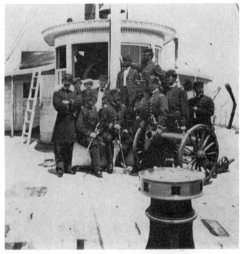

Or in front of the wheelhouse of the USS Philadelphia, off Charleston. (USAMHI)

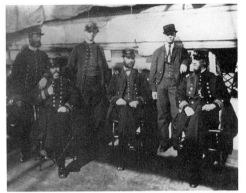

Or on the gun deck, or wherever they wanted, for that matter. (DOUGLAS DOUGHTY)

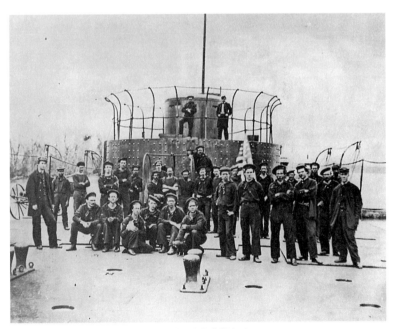

Usually when the photographer came, as here aboard the Lehigh, *the common seamen stood by themselves.* (KA)

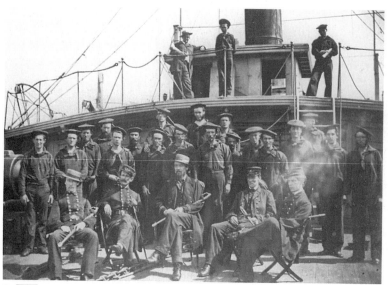

Sometimes, particularly on the smaller ships, the officers condescended to pose with them, as on the Agawam. (USAMHI)

And often the men posed by themselves, like this tired old sea dog next to a 100-pounder Parrott rifle. He looks more like the Ancient Mariner than a sailor aboard the Pawnee. (CWTI)

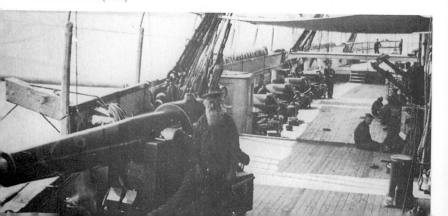

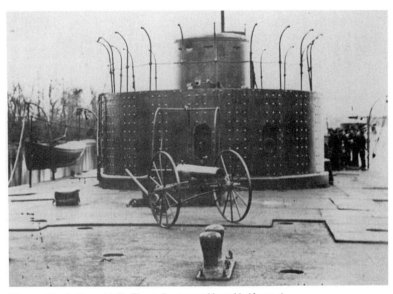

There was time for fun and frolic. The smaller men would crawl inside one of the large bore cannon on the Lehigh, *as in the center, to peer out of the turret.* (USAMHI)

When not relaxing or clowning, almost every man thought of home, of someone he left behind. Sailors, like soldiers, carried photographs of loved ones with them. Lieutenant John McI. Kell of the Alabama *carried this image of his wife, Blanche, with him as he and Raphael Semmes terrorized Yankee shipping. Two of the three children would die during the war, and their father would not learn of it until months afterward. There was the hardship that the soldier in the field did not share. Isolated for months at sea, the webfoot was cut off from all news of home and family. It has ever been so in the annals of the sea.* (MUNROE D'ANTIGNAC)

Some, like Marine Frank L. Church, managed to find photographers who could work tricks for them. Here Church tickles his own ear with a feather while he poses at sleeping, a remarkably adept trick photograph for the time. (CHURCH FAMILY COLLECTION)

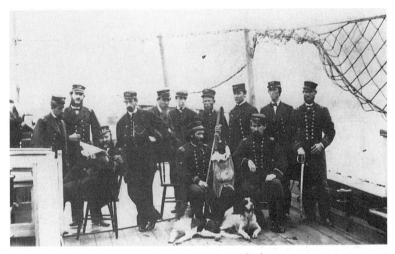

To cheer the homesick, there were excursions ashore. Besides carousing in port, the sailor could take his fowling piece and hunting dogs ashore to bag game, which added a welcome variety to the shipboard menu. Men of the USS Miami. (USAMHI)

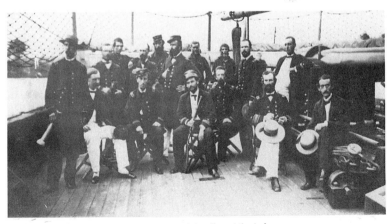

Another would-be hunter aboard the Mendota, *and the officer of the deck standing with trumpet ready.* (USAMHI)

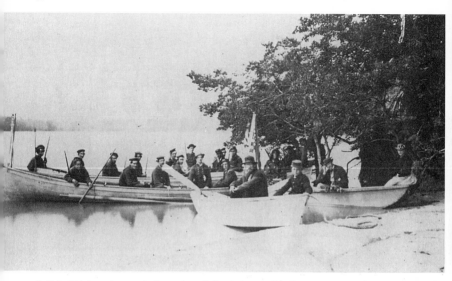

In their ship's boats they rowed ashore to hunt, frolic, picnic, or, as here, to visit with the ladies and local civilians. Anything could pass the time. (USAMHI)

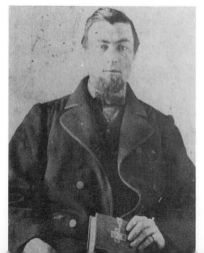

And on the Lord's Day they met at ship's service, their souls guarded by men like Chaplain James Goffee of the Confederate ship Tacony, *the Good Book in hand.* (WILLIAM A. ALBAUGH)

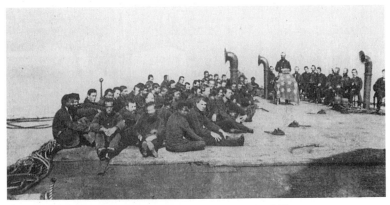

Aboard the monitor Passaic *off Port Royal, South Carolina, photographer E. W. Sinclair caught the ship's men and officers at divine services.* (NA)

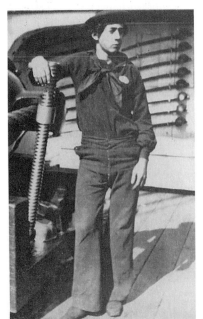

They were young, for the most part, hardy, able, willing, as men of the sea have always been. The boatswain's mate of the New Hampshire. (P-M)

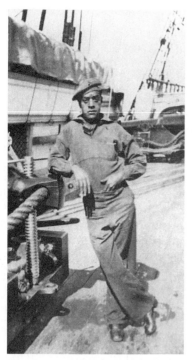

Some of them, in a war that brought revolutions in many places, were colored, with the seasoned air of the old salt. (USAMHI)

Some were no more than boys, boys made men by war. A powder monkey aboard the New Hampshire. (LC)

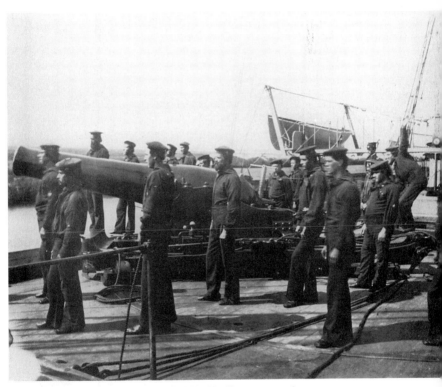

For all of them, as for these men of the USS Unadilla, *life at sea went on from day to day, in and out of danger, marked by their sense of purpose, by their comradeship, and at day's end by the firing of the evening gun.* (WRHS)

Prison Pens of Suffering

FRANK L. BYRNE

Simple names like Johnson's Island and Andersonville
come to mean hell

OF COURSE, there were prisons in this war far more onerous than the decks of a ship. The prisons of the Civil War in some ways were part of a long tradition and yet, like so much else about the great conflict, they overwhelmed precedents. In previous modern wars, nations had held relatively limited numbers of captives, usually confining enlisted men while putting fewer restrictions on paroled officers. While each war had produced complaints about the mistreatment of prisoners, the duration of their imprisonment had often been shortened by exchange. But in the Civil War, with the Confederacy's independence unrecognized, the two sides found it especially difficult to agree upon terms of exchange, and hence they perforce established long-term prisons. Just as Civil War armies grew beyond the imaginations of antebellum Americans, so the prisons bulged, presenting unexpected problems. The nineteenth-century officials who dealt with them, frequently drawing upon eighteenth-century precedents, unwittingly provided a preview of twentieth-century horrors.

The Confederates were first to have to deal with large numbers of prisoners. Even before the firing on Fort Sumter, they had forced the surrender of the United States regulars stationed in Texas, paroling the officers and eventually holding the enlisted men in temporary camps. Following their victory at Bull Run, the Southerners had to provide for over 1,000 prisoners sent back to their capital, which almost by chance became their main prison depot. The officer in charge of the Richmond prisoners was Brigadier General John H. Winder. A West Point graduate, the sixty-one-year-old Winder had long served the United States before resigning his commission. He had the respect of President Jefferson Davis, whom he had known of old, and at first he favorably impressed many others among both his friends and foes. But, while he was capable of kindness, especially to those who flattered him, he was also a rigid disciplinarian who became increasingly obsessed with matters of security. At the end of 1861, he became commander of the Confederate capital and quickly antagonized its citizens with his harsh rule. Civilians and prisoners both came to dislike Winder and his staff, dominated heavily by fellow Marylanders and particularly by members of his family.

To house the increasing number of prisoners at Richmond, Winder used several warehouses. One, which became known as Castle Thunder, was used mainly for political prisoners and other Confederate offenders. As in the provost prisons of the North, treatment there was especially stern. In

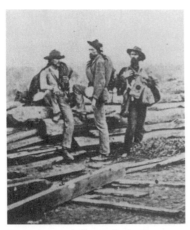

The first step on the long road to imprisonment. Three rawboned Confederates captured in the fighting at Gettysburg await their trip to a Yankee prison. For them the war is over for now, but a greater war, one with boredom and sickness, lies ahead. (USAMHI)

All they took with them were the clothes—often rags—on their backs. Two Confederates captured near Norfolk, Virginia, late in 1864. (USAMHI)

1862 Winder requisitioned a warehouse occupied by a ship chandlery and grocery company, Libby & Sen. While unfurnished, the building did have running water and primitive toilets. Its inmates, being out of the weather, were better off than the men whom Winder encamped in and out of tents on Belle Isle in the James River. But, because the Libby warehouse soon became a facility for officers who wrote a disproportionate share of the accounts of prison life, it became one of the Confederacy's more notorious prisons. Especially well known was the escape through a tunnel of 109 prisoners in 1864. Libby also housed the headquarters of the prisons in Richmond, at which all new prisoners were registered, and therefore most Yankee captives recalled that they had been in "The Libby." Many, however, were soon sent to be imprisoned elsewhere in such diverse accommodations as a factory in Salisbury, North Carolina, a fort called Castle Pinckney at Charleston, South Carolina, a paper mill in Tuscaloosa, Alabama, and the parish prison at New Orleans. Winder continued to exercise control over prisoners outside Richmond, but without the title that would have put him at the head of a clearly defined prison system.

Meanwhile, the United States government was improvising more systematically. In the fall of 1861 the Federals designated Colonel William H. Hoffman, an officer on parole after the Texas surrender, as commissary general of prisoners. Only a few years younger than Winder, Hoffman also was a graduate of the United States Military Academy and a veteran soldier. In the prewar army, he had learned to manage small garrisons economically

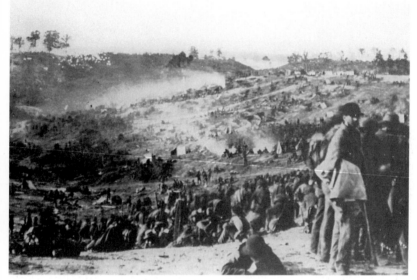

The place was Belle Plain, Virginia, and the Rebels thronged the little valley, clutching their few possessions. (NA)

and in strict accordance with regulations. Like Winder, he was now faced with the prospect of controlling numbers of men far greater than at any time in his previous experience. If security was Winder's obsession, economy was Hoffman's. Each warden's inmates would suffer in consequence.

Hoffman's initial assignment was to locate and build a central prison. The North, like the South, had begun the war with assorted facilities. Among them was the quondam temporary capitol building in Washington, which, as the Old Capitol Prison, ultimately became the principal jail for political prisoners and other civilians. Also pressed into use were the forts at the Atlantic ports, including McHenry at Baltimore, Delaware below Philadelphia, Lafayette and Columbus at New York, and Warren at Boston. In the West the army took over a former medical college at St. Louis, which became the Gratiot Street Prison. When it over-

flowed, prisoners began to be kept at the Illinois State Prison at Alton. Hoffman hoped to supersede this hodgepodge with one secure prison.

After inspecting several islands in Lake Erie, Hoffman decided upon Johnson's Island as the site for his prison. A small spot of land in the bay near Sandusky, Ohio, Johnson's Island had the advantages of being a mile from the mainland and free of civilian inhabitants. On it, Hoffman built a high-fenced camp guarded further by fortifications. For housing he erected one- and two-story barracks. Prisoners found the resortlike location pleasant enough in the first summers of the war, but when winter winds whipped in across the frozen bay, they shivered, and poets among them wrote sentimental verses longing for the sunny South. In 1864 Johnson's Island was the target of an unsuccessful attempt to free their compatriots by Confederates based in Canada. Throughout the

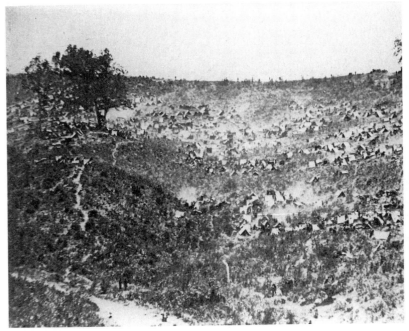

Standing at intervals along the rim of the prison camp, sentries appear against the sky in this image of the Belle Plain encampment. Most of the prisoners are sleeping under tents for the last time. (USAMHI)

war, despite Hoffman's original intent that it be the main depot for all Rebel prisoners, the island held mostly Confederate officers.

The inadequacy of Hoffman's initial planning became apparent early in 1862. With the capture of Fort Donelson, thousands of prisoners fell into Northern hands. More space was needed for them than the old veteran had imagined. Hastily he turned to the camps that had been created to train Union volunteers. Located at state capitals or in principal cities, they had good railroad connections, an important consideration in transporting and feeding the growing horde. Several were on state fairgrounds with converted prewar buildings; all had additional barracks and tents. With the addition of board fences and walkways for guards, the training camps in whole or part became prisons. During the middle of the war, Camp Butler near Springfield, Illinois, and Camp Randall at Madison, Wisconsin, were temporarily so used. Of more lasting significance was Camp Douglas in Chicago. Undrained, it quickly became so filthy, according to a Union relief agency, as "to drive a sanitarian to despair." Yet Quartermaster General Montgomery C. Meigs rejected as an extravagance Hoffman's proposal to build a sewer. Not until

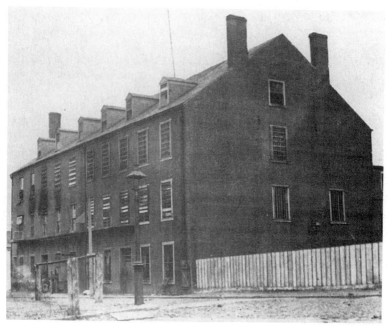

*In the early days of the war the next stop for these captured unfortunates was
usually a makeshift prison ill-suited for their accommodation. In Richmond and
the Confederacy most often that meant a warehouse like this one, soon to be
known as Castle Thunder.* (USAMHI)

after the death rate reached 10 percent a month
early in 1863 would Douglas get its draining. Also
important were Camp Morton at Indianapolis and
Camp Chase at Columbus. The Ohio camp also
became a major depot for civilian prisoners, espe-
cially inhabitants of the border slave states. In
these Northern prisons, as well as in those of the
South, the guards were mostly a random selection
of recruits, veterans recuperating from battle, and
home guard units. An exception was Johnson's Is-
land with a unit expressly recruited for the duty
and first known as the Hoffman Battalion, later
part of the 128th Ohio.

The buildup of prisoners in the pens of both bel-

ligerents came to a temporary end in July 1862
with the signing of an agreement, or cartel, regu-
lating exchanges. Under it, prisoners were to be
released on parole within days of their capture and
sent across the lines at Aiken's Landing, on the
James River, in the East and Vicksburg in the
West. Hence the prison populations shrank dra-
matically. Soon the South was using mainly Libby
and other Richmond buildings to hold the tran-
sient prisoners of war and Salisbury for a few hun-
dred civilian captives. In the North, Hoffman was
able to concentrate most of his prisoners of war at
Johnson's Island, Camp Chase, and Alton. Several
former prisons, together with Camp Parole at An-

Castle Thunder was also the new home of those Southern citizens deemed "disloyal" or dangerous, for it has to be remembered that both North and South faced not only enemies from without but also from within. (USAMHI)

napolis, Maryland, now housed paroled Union soldiers awaiting formal exchange.

For reasons legal and practical, the cartel's operation was soon suspended. The belligerents, after firing off charges of atrocious acts, used threats to withhold prisoners as part of the consequent ritual of retaliation and counterretaliation. The officials who supervised the exchange, Union General Ethan Allen Hitchcock and Confederate Colonel Robert Ould, also quibbled endlessly over the execution of the cartel. Under these pressures the system collapsed, with the regular release of officers ceasing in May 1863 and that of enlisted men two months later. Subsequent attempts to reopen exchange broke down over Ould's refusal to treat as prisoners of war black soldiers who had been slaves in the seceded states. Indeed, Confederate Secretary of War James A. Seddon doubted "whether the exchange of negroes at all for our soldiers will be tolerated. As to the white officers serving with negro troops," he added with ominous import, "we ought never to be inconvenienced with such prisoners." By 1864 the new Union generalissimo, Ulysses S. Grant, added to the legal arguments the contention that it was more humane not to release Confederates who would rejoin their army. "If we commence a system of exchange which liberates all prisoners taken," according to Grant, "we will have to fight on until the whole South is exterminated. If we hold those caught they amount to no more than dead men." Unfortunately for many captives on both sides, Grant's metaphor became literally true as they again accumulated in prisons —this time perhaps for the duration of the war.

Northern and Southern reactions to the challenge of the prisons that were again filling differed significantly. Hoffman immediately supplemented the prisons still open by reactivating the closed camps. He also ordered the building of additional barracks at several of them. By the end of 1863 he had established two entirely new prisons: a fenced group of barracks at Rock Island, Illinois, and a tented camp at Point Lookout, Maryland. The latter, located on a sandy peninsula where the Potomac entered Chesapeake Bay, was convenient to the battlefields in the East and therefore became the largest Union prison, once containing almost 20,000 men. For better control, Hoffman expanded his previous attempts to segregate Confederate officers and enlisted men. Most officers were kept at Johnson's Island or in part of Fort Delaware, while some officers thought to require special security were sent to Fort Warren. The officers of Confederate Raider John Hunt Morgan suffered the special humiliation of being placed in state penitentiaries in Pennsylvania and Ohio—relieved by a spectacular escape from the latter by Morgan and others. In all the Northern prisons, congestion produced problems of feeding, housing, and medical care.

The deterioration of conditions in the South was worse, in part because of a reaction to the problem that was almost a nonresponse. The Confederates hoped that somehow their negotiators could induce the resumption of exchange, which would bring back to them the now greater number of Rebels in Yankee hands. They had no wish to provide facilities for the long-term incarceration of their ene-

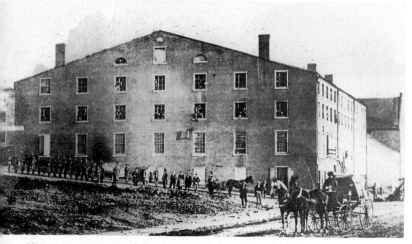

Many of these ersatz Southern prisons became infamous in their own time, and none more so than the onetime warehouse and ship chandlery of Libby & Son. This remarkable, previously unpublished image of Libby Prison was made by Richmond photographer Charles Rees in 1862. Already the windows, now barred, are jammed with Union prisoners struggling to see what is happening outside. Lined up in front stands the assembled prison guard. No one will ever overpower them, but the resourceful Yankees will make at least one bold escape by turning moles. (CHS)

mies. Therefore, though they confined some of the accumulating prisoners in tobacco warehouses at Danville, Virginia, they allowed most to crowd into the existing Richmond warehouse prisons and into the camp on Belle Isle. Since the Confederate capital was also the center for supplying large armies and a considerable civilian population, a food shortage quickly developed. The Union authorities, receiving reports of hunger among their men in Rebel hands, retaliated in 1864 with reductions in the rations given to Confederates in the North.

Yet shortages and deliberate withholding of rations were not alone responsible for the emaciation and deaths of so many prisoners. Men receiving the full ration of either side might have been less hungry, but they were likely to get sick if they long subsisted exclusively on the bread and meat that

were its principal ingredients. Such was the frequent fate of free soldiers when sieges or other circumstances cut off access to vegetables and fruit. Most of the time, prisoners were allowed to buy such supplements from sutlers and others—salvation for many officers but scant help for usually less affluent enlisted men. For the latter in the North, Hoffman authorized buying vegetables with prison funds raised by withholding part of the regular rations. But, with his rigid economy, he tended to order vegetables only after scurvy had actually begun its deadly work. Southerners furnished vegetables even less frequently. As their Union captives sickened, many could no longer digest the rough corn bread. Thus it was less an absolute absence of food than dysentery and diarrhea that killed the bulk of those who died in the South from 1863 to

Through this door into the so-called fireplace Federals, led by Colonel Thomas Rose, worked daily in 1864 to dig a tunnel through the underside of the building and out under Richmond's Twentieth Street. In the daring escapade 109 Yankees escaped into the city streets; 2 of them drowned trying to swim the James River, and 48 more, including Rose himself, were recaptured. But 59 made good their escape, among them Colonel Abel D. Streight. This image was made years after the war, when Libby was moved as a war museum to the Chicago World's Columbian Exposition in 1892–93. (CHS)

1865 and turned so many of the survivors into living skeletons.

To relieve the food shortage at Richmond, the Confederates decided to remove most of the prisoners. A further incentive was the Rebels' fear that the prisoners would give aid to any Union attack on Richmond—a fear that impelled them to plant a gunpowder mine under Libby early in 1864 in order to intimidate its officer inmates and keep them from revolting. General Winder sent two relatives to locate and build a prison in southern Georgia. At Andersonville they erected a stockade of timber. Designed originally to hold 10,000 men, it enclosed sixteen acres. At the end of February

The rooms in Libby were named by their inhabitants for the battles in which they were captured. Here is the Chickamauga Room on the first floor. (CHS)

1864, even before the fence was finished, rail shipments of prisoners from Richmond began arriving. They found no shelter, and in improvising huts, tents, and burrows they created a disorderly chaos impossible to keep clean. Captain Henry Wirz, the officer nominally in charge of the prison interior, in any event lacked the ability to do much about the worsening conditions. Ill-tempered and profane, ridiculed for his foreign accent, Wirz became the focus of the prisoners' unhappiness and ultimately the target of their hatred. One of his few popular acts was to cooperate with an attempt by prisoners to stop crime, which ended in the trial and public hanging of six prisoners stigmatized as "raiders."

In June 1864, General Winder came to take command of the entire post at Andersonville. Characteristically he centered his attention almost wholly on security rather than on the prisoners'

physical condition. He worried not only about an uprising from within the prison but also about the ineffectiveness of the guards and the disloyalty of nearby civilians. In his fear, he even angrily barred local women from bringing vegetables to the scurvy-ridden captives. While prisoners sickened and starved, bartered and robbed, prayed and killed, the Confederates kept watch from the walls of this corral for human beings, occasionally shooting someone who crossed the "deadline." One visitor photographed the grim enclosure. Enlarging it by ten acres did not keep up with the Confederate government's shipments. By late summer almost 33,000 men were in Andersonville; the graves of 13,000 of them memorialized one of the war's greatest horrors.

While a few officers were temporarily at Andersonville, the Confederates moved most of them

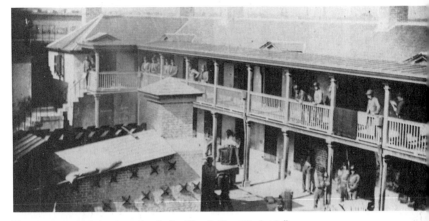

The Confederates farther to the south took a lot of boys in blue at the first Bull Run fight, and they sent many to Charleston's Castle Pinckney. There was a camaraderie between prisoners and guards here. The guards could lounge in their barracks . . . (USAMHI)

. . . or pose with the prisoners themselves. The Yankees were restricted to the fort's interior parade ground and to casemate dungeons they dubbed Hotel de Zouave and other sobriquets. The guards simply watched them from above. (USAMHI)

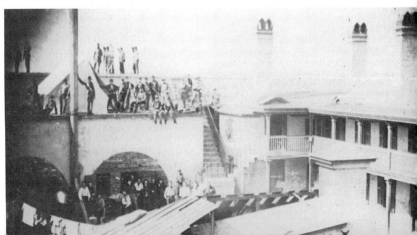

At the war's start the Federals, too, went about the prison business in a halting fashion. Colonel, later brigadier general, William Hoffman took the post of commissary general of prisoners and quickly began trying to find accommodations for the Confederates that would fit within the parsimonious budget he set himself. He stands here at right in an image taken in April 1865.
(USAMHI)

While the South proceeded with the uncoordinated expansion of its prisons, the North continued the more planned enlargement of its system. Besides ordering the construction of new barracks at existing posts, Hoffman in 1864 had a fence erected around a camp originally used for Union recruits at Elmira, New York, and early in 1865 he briefly opened a similar facility at Hart's Island, also in the Empire State. The former, used for enlisted men, became the worst Union prison. This was partly because of Hoffman's stress on economy. He and Quartermaster General Meigs repeatedly instructed that barracks be built cheaply. While it was true that Hoffman also ordered flimsy buildings for the Union guards, the Rebel prisoners with their worn clothing, few blankets, and limited fuel suffered more intensely, sickened, and often died. At Elmira, as at Camp Douglas earlier, the Federal authorities were reluctant to spend money to drain the camp. Only after the submission of precise calculations of the gallonage of sewage daily being added to the pond at Elmira did Hoffman belatedly authorize a minor expenditure for materials for a sewer constructed by the prisoners. Besides its pestilential conditions, Elmira suffered from inept administration and several ignorant and brutal surgeons. Unsurprisingly, about a fourth of its some 12,000 prisoners remained in its National Cemetery.

At all Union prisons, a policy of retaliation worsened conditions from mid-1864 to early 1865. Proposing to treat Confederate prisoners as he believed their government treated its captives, Hoffman ordered rations reduced, sutlers' stocks restricted (with sale of food including vegetables often forbidden), and receipt of packages from friends severely limited. The outcome was malnutrition, including more scurvy, and actual hunger. Indeed, at several prisons the inmates organized to hunt and eat rats. In early 1865 the Federal authorities again allowed the sale of extra food and both sides permitted one another to send clothing to prisoners, but this was belated relief. General Hoffman, as he had been brevetted in 1864, finally returned to the United States Treasury the then enormous sum of over $1.8 million, representing more than half the total of the prison funds accumulated by deduction from rations. It represented the unacknowledged price of many prisoners' lives.

While often suffering, inmates of Northern and

from Libby to a separate fenced stockade at Macon, Georgia. Not all were able to build shelter, but conditions were generally better than at Andersonville. Prisoners captured farther west were often sent after late 1863 to a former Confederate training camp at Cahaba, Alabama. There a fence enclosed a half-ruined warehouse, which became a depot for enlisted men. It would be less well known than other prisons because so many of its survivors died immediately after release in the explosion of the riverboat *Sultana*. Even more obscure were the several Confederate prison camps beyond the Mississippi. The most important of these was the stockade called Camp Ford at Tyler, Texas. Though isolated and primitive, Camp Ford was healthier than most prisons.

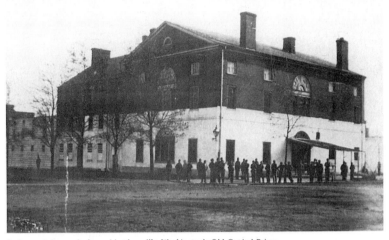

Early war prisoners he housed in places like Washington's Old Capitol Prison. Once the temporary capitol of the United States, now it housed its enemies, including political prisoners. (USAMHI)

Southern prisons also had lighter moments. They played cards and otherwise gambled, read books and newspapers, wrote diaries and letters, and conducted classes, theatrical performances, and religious meetings. When extra food was available, some ran eating places or brewed beer. Many made jewelry out of bones and scrap material as souvenirs for loved ones or for sale to guards and civilian visitors. The latter were so curious that they could often be seen at guard posts. At Elmira, entrepreneurs actually built a tower near the walls from which anyone willing to pay could gape at or photograph the prison. Other photographers, mainly in Northern prisons, made portraits for a price within the walls. Since both sides used little of the prisoners' labor, most inmates spent much of the time between roll calls and meals in idleness. Inevitably their main topic of conversation was the prospect of obtaining freedom. A few tried to escape; most awaited release.

The Confederate pens in Georgia first disgorged their miserable hordes but not to freedom. Instead, concern about Sherman's invading force caused the

Southern leaders to search for safer holding places for the prisoners, who were their only hope of obtaining the release of their own men confined by the Yankees. In the late summer of 1864, the Rebels began to remove the enlisted men from Andersonville and the officers from Macon. After keeping part of them at a temporary camp in Savannah, they moved thousands of the enlisted men to a stockade near Millen, Georgia, which Winder boasted was the world's largest prison. Sherman's March to the Sea quickly ended that dubious distinction, and most of its inmates were shuttled circuitously over the South's collapsing rail system back to Andersonville.

Other prisoners originally at Andersonville and Macon had been sent to Charleston, South Carolina. There the officers were housed at an old hospital that, like most of the city, was in range of Union siege guns. Believing that the Confederates had deliberately put prisoners under fire, the Federal commander sent to Fort Delaware for 600 Southern officer prisoners, whom he confined in a stockade also exposed to artillery bombardment on

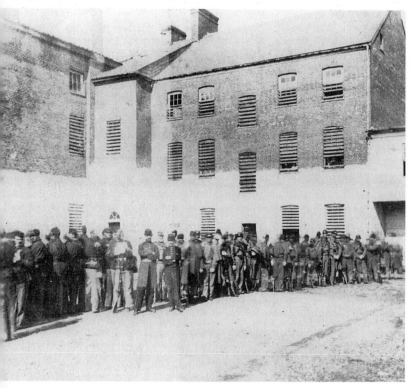

They could peek out through their slatted windows while the prison guard posed below. (AMERICANA IMAGE GALLERY)

Morris Island near Charleston. The Confederates then moved their officer prisoners inland to camps at Columbia and the enlisted men to a new prison near Florence, South Carolina. The latter, chosen as usual because of its convenience to railroad transportation, was a stockade outside of which was built up an earthwork. Once again the prisoners were left to improvise quarters while attempting to survive on even scanter rations.

After the disruption of the Confederate prisons in the Deep South, captives had again accumulated at Richmond, mainly on Belle Isle. Unable to feed or shelter them adequately, the Confederate government sent a few to Danville and abruptly decided to ship the rest to Salisbury, North Carolina. The old fenced camp there had since 1862 held only a few hundred men, mostly deserters and political prisoners. In October 1864, with almost no warning, the Richmond authorities simply dumped some 7,500 men into the pen, with no stream to supply adequate water or carry off sewage. While there were a few huts and tents and an old factory building, many of the prisoners had to dig holes in the earth to escape the North Carolina winter. In their desperation some of the prisoners unsuccessfully made one of the few attempts at a mass outbreak. In less than five months, over a third of a total of 10,000 Salisbury prisoners perished. The proportionate casualties rivaled Andersonville's, but the number of prisoners and hence the total losses were fewer.

At this penultimate moment in the war, the Confederate government responded to the chaotic condition of its prisons by creating a central authority. In November 1864, General Winder finally became commissary general of prisons, responsible for all facilities east of the Mississippi. He spent much of his brief tenure in office attempting to cope with the inexorable advance of Sherman's men and vainly seeking prison locations permanently safe from attack. Old and exhausted, he died in February 1865 at the Florence prison—followed to his grave by the rejoicing of his embittered captives.

At about the same time, the log jam blocking exchange suddenly gave way. The belligerents had exchanged several thousand sick prisoners in the previous fall and public pressure had mounted to free the rest. Though the Confederates had released some black soldiers who had not previously been Confederate slaves, the issue of the status of ex-slaves still remained. Nonetheless, with the war almost over, Grant decided to agree to a general exchange. At City Point, Virginia, and Wilmington, North Carolina, thousands crossed the lines while fighting continued nearby. With the collapse and surrender of the Confederacy, the remainder of the prisoners on both sides went home and the unhappy camps closed forever. Within them had died over 56,000 men, about 1 in 7 of the Civil War's nonbattle deaths.

Subsequently, the United States sought evidence to blame high Confederate officials for conditions in their prisons and actually tried several subordinates. Only one, Wirz of Andersonville, went to the gallows after the semblance of a trial, whose result was a foregone conclusion. With the stupendous horror of Andersonville as their principal example, former Union prisoners for years wrote books accusing the Confederates of deliberately and cruelly plotting to cause the death of helpless captives. As tempers cooled, defenders of the South were able to get a hearing for the contention that much of the suffering in the South was the result of wartime shortages, while on the other hand the North had with premeditation worsened conditions through its attempts at retaliation. During the Civil War Centennial, those anxious to heal at last the old wounds argued that in fact both sides had done about as well as could have been expected, and that the deaths of prisoners had resulted in large part from the practical limitations of the time and from the war itself. And yet this interpretation is only a little more satisfactory than the earlier explanations. It does not, for example, account for the great differences in conditions and casualties between specific camps and in general between the camps for officers and those for enlisted men. Even in a nineteenth-century civil war, prisons might have been much less fatal. Perhaps a former Confederate and prisoner could be given the last word. As he looked back, Henry Kyd Douglas thought that ill treatment had been exaggerated and that intentional cruelty had been the exception. He concluded, however, that ". . . there were hardships and suffering among prisoners on both sides from neglect, incompetency, and indifference."

It should hardly have been surprising. North and South had fought a war brought about by "neglect, incompetency, and indifference."

*And occasionally the camera went inside for an image of a particularly
interesting or important tenant, in this case Mrs. Rose O'Neal Greenhow,
Confederate spy, here being visited by her daughter.* (LC)

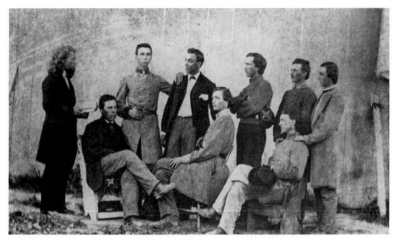

Hoffman, like the Confederates, used existing fortresses to house prisoners until he could construct a proper—and cheap—prison. Most infamous of all was Fort Delaware, near Philadelphia. J. L. Gihon took his camera there on July 6, 1864, to capture this unpublished image of several Confederates from Texas, Missouri, Florida, Virginia, Tennessee, and Arkansas. Fort Delaware proved to have one of the highest mortality rates of any Civil War prison. (TERENCE P. O'LEARY)

The fort on Governor's Island, New York, became a prison. (NA)

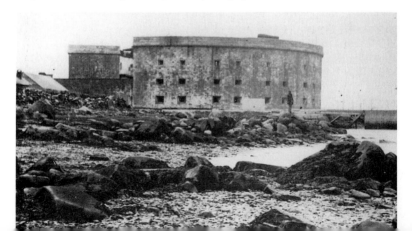

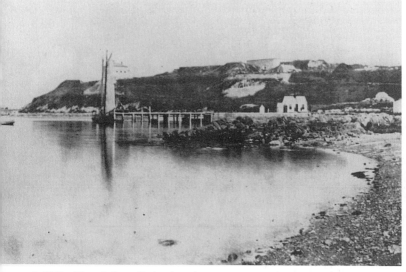

As did Fort Warren in Boston Harbor. (NYHS)

Indeed, Fort Warren became a favorite spot for a particular kind of prisoner, the blockade runner and the Confederate naval officer. They, in turn, enjoyed a particularly elegant parade ground for their exercise, with Boston in the distance. (NYHS)

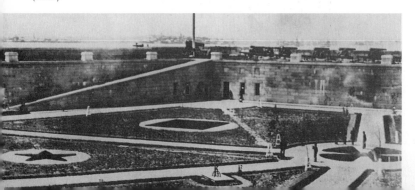

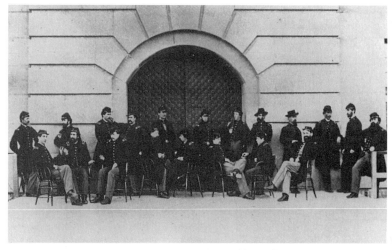

The officers who ran the place, like most of these Massachusetts soldiers, took pride in their appearance and their charge. Certainly Bostonians believed their regiments to be a cut above the rest in the army, and their prison must be the same. (NYHS)

And so it was only fitting that their prisoners be no ordinary sort. Here sat some of the crème de la crème of the Confederate Navy. (NYHS)

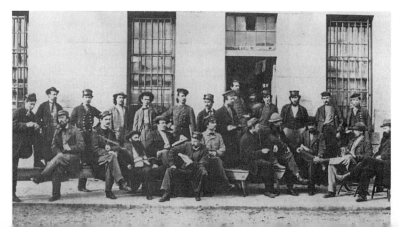

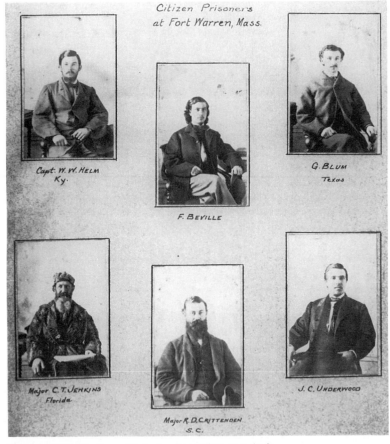

Citizen Prisoners at Fort Warren, Mass.

Capt. W. W. HELM
Ky.

F. BEVILLE

G. BLUM
Texas

Major C. T. JENKINS
Florida

Major R. D. CRITTENDEN
S. C.

J. C. UNDERWOOD

Here some of the better citizens of the South, suspected of treason or simply disliked by the ruling powers in Washington, spent part of the war. Major Jenkins of Florida appears to have brought the better part of his wardrobe with him. (RINHART GALLERIES, INC.)

Among their lodgers was Commander William A. Webb, once in command of the dreaded Confederate ironclad Atlanta. (WILLIAM A. ALBAUGH)

The need for a more efficient system for housing prisoners led Colonel Hoffman to lay out a new Federal prison strictly for war prisoners. He placed it on Johnson's Island in Lake Erie. Here the barracks went up, all of them commanded by the guns of Fort Hill. The Ohio shoreline is visible in the distance. (USAMHI)

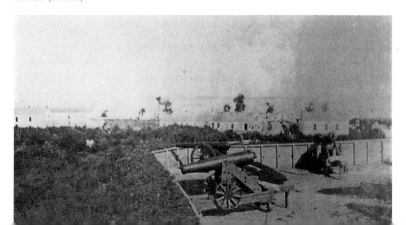

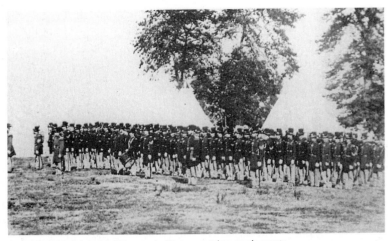

Four companies of the 128th Ohio, organized to serve as prison guards, soon to be called Hoffman's Battalion; here Company A stands in formation on Johnson's Island. (USAMHI)

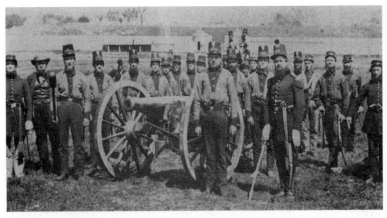

In time the island acquired its own artillery command as well, the Ohio National Guard 8th Light Artillery. Part of the stockade surrounding the prison can be seen in the background. (BURTON J. AUSTIN)

Sandusky, Ohio, in the background, looked out upon an island teeming with underfed and ill-clothed Southerners. (USAMHI)

When even Johnson's Island could not accommodate the flow of prisoners, Hoffman turned to onetime Yankee training camps and fairgrounds. Camp Douglas, in Chicago, became a major prison, one of the most popular with photographers. Here a considerable group of Confederates sit for the camera, with what appears to be a fire hydrant in the foreground. (CHS)

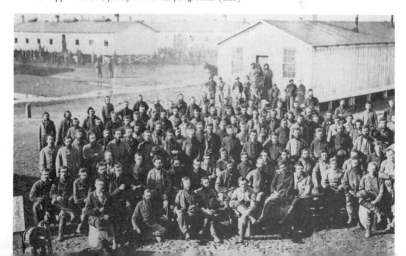

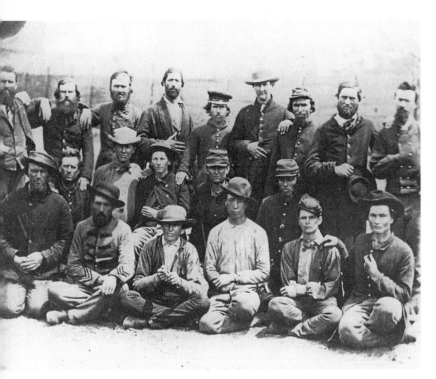

They posed in smaller groups as well. (DAVID R. O'REILLY)

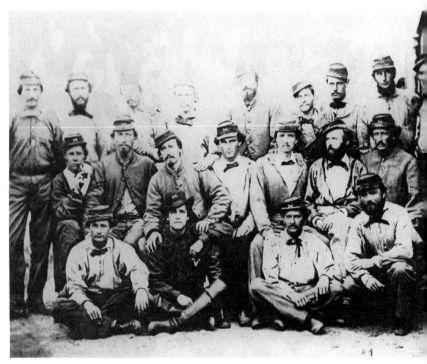

They posed seated and standing. (DAVID R. O'REILLY)

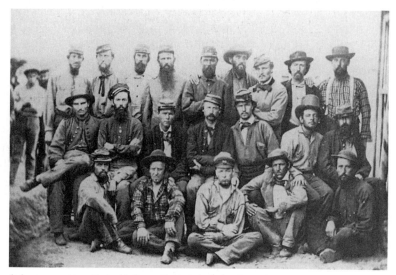

And some even apparently stood in line, waiting to be in the next image. (DAVID
R. O'REILLY)

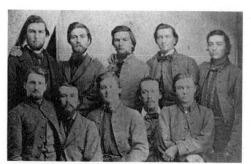

*Chicago photographer D. F.
Brandon set up a modest studio in
the prison to make images such as
this pose of ten Kentuckians captured
from the command of Raider John
Hunt Morgan.* (DAVID R. O'REILLY)

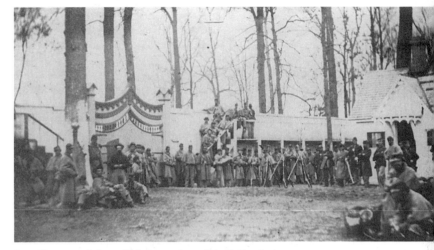

Camp Morton, near Indianapolis, Indiana, took on a distinctly Victorian aspect, complete with gingerbread trim on the buildings. Here the entrance appears in this series of images, most of them previously unpublished. (UNIVERSITY OF GEORGIA LIBRARY, ATHENS)

Headquarters Row at Camp Morton could almost have been a small-town street anywhere in the Midwest. (UNIVERSITY OF GEORGIA LIBRARY, ATHENS)

This post even had a drum and bugle corps. (UNIVERSITY OF GEORGIA LIBRARY, ATHENS)

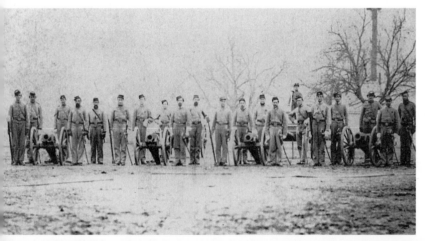

And its own artillery company. (UNIVERSITY OF GEORGIA LIBRARY, ATHENS)

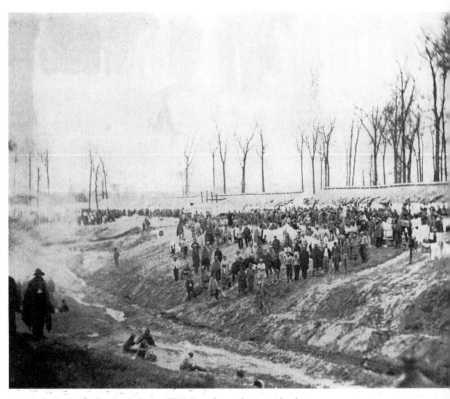

And, of course, thousands of prisoners. Their barracks ran along a creek, where they also washed their clothes. In the winter they had little to keep out the cold but their army blankets. Hundreds became ill with diseases and died, one of them being Private Josiah S. Davis of the 45th Virginia. His great-great-grandson is the editor of The Image of War. (UNIVERSITY OF GEORGIA LIBRARY, ATHENS)

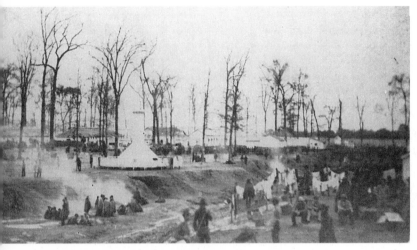

*At least Camp Morton did provide a modest attempt at sanitary facilities,
unlike so many other prisons. Instead of locating the latrine, or sinks, right in the
creek that supplied drinking water, the camp provided the large white latrine in
the center of the picture. Still, it was too close to the water, encouraging diseases
like the "debility" and dysentery.* (UNIVERSITY OF GEORGIA LIBRARY, ATHENS)

*Although a cold and lonely place, Camp Morton and its inmates fared far
better than those in other places. Camp Morton would never become an
infamous name like Fort Delaware or Andersonville.* (UNIVERSITY OF GEORGIA
LIBRARY, ATHENS)

When the rank and file were ready for exchange, the ceremony was a little less formal. Here several hundred Confederate prisoners stand gathered, awaiting their exchange at Cox's Landing on the James River. (USAMHI)

Another heavily used exchange point, before the prisoner exchange system was stopped, was Aiken's Landing on the James, here being patrolled by the double-turreted Yankee monitor Onondaga. (MHS)

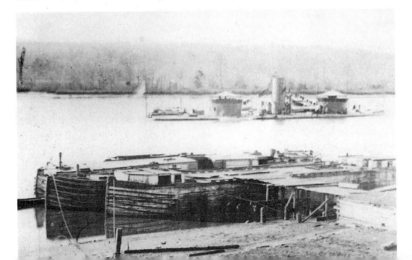

Another Rees view of Libby. The commandant stands between the two men in the foreground, hand on his lapel. (VM)

Buildings like this Petersburg, Virginia, warehouse became temporary prisons.
(LC)

The yards once thronged with prisoners, and in the winter the cold wind blew through the bars and broken windows. (LC)

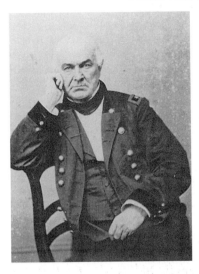

In charge of the Federal exchange was Major General Ethan Allen Hitchcock, one of the oldest officers in the service. He was sixty-four when appointed to command the exchange system, and proved contentious to the point that he helped the exchange program break down. An 1865 image by Brady & Company. (KA)

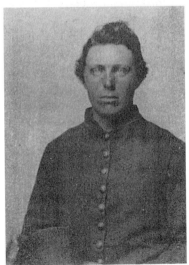

And so life in the prisons went on, and the numbers began to swell again. A few places enjoyed having their own resident photographers, among them Point Lookout, Maryland. Here Stanley J. Morrow, of the 7th Wisconsin, spent some time recording the scenes of the prison—and his own portrait. (W. H. OVER MUSEUM, UNIVERSITY OF SOUTH DAKOTA, VERMILLION)

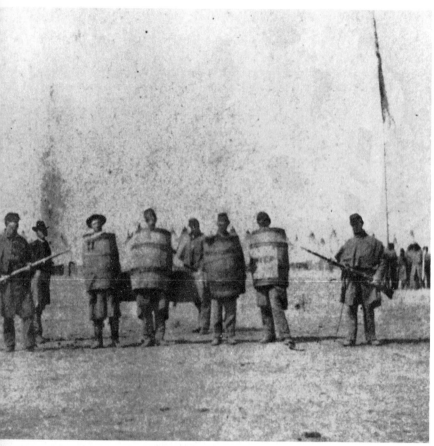

Morrow caught the scene of escaped prisoners returned and placed in barrels as
punishment. One or two of these men may even be Federals, guards perhaps
guilty of some infraction. One of them wears a sign proclaiming "THIEF."
(W. H. OVER MUSEUM)

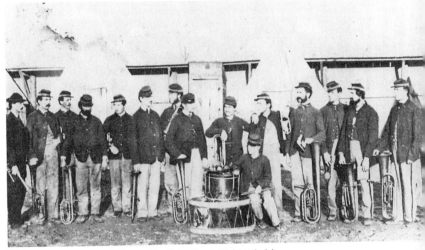

The Point Lookout band, with Morrow himself standing eighth from the left. Whether they were for the entertainment of the guards or the prisoners is uncertain. (W. H. OVER MUSEUM)

The officers in command of Point Lookout, including Brigadier General James Barnes, commandant, standing seventh from the left. (W. H. OVER MUSEUM)

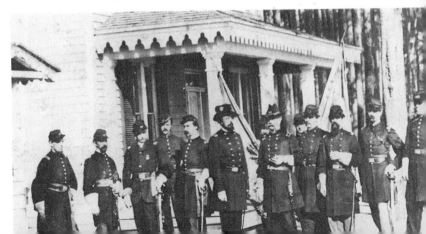

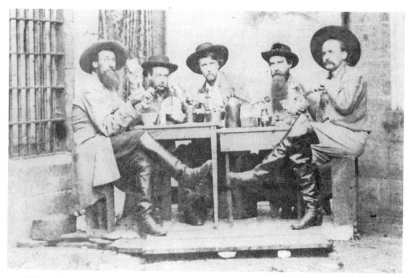

Others who were captured with Morgan were put in state prisons, like these Kentuckians in the Western Penitentiary in Pennsylvania's Allegheny City. They dubbed the photo Happy Family. (RP)

In the South, buildings like this one in Danville, Virginia, became notorious. A postwar image. (USAMHI)

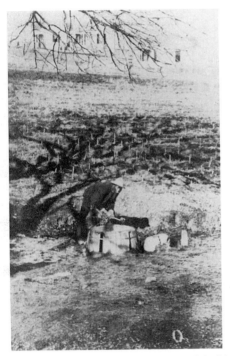

Their water in Danville came from this spring, and their spiritual sustenance from the Reverend George W. Dame. (USAMHI)

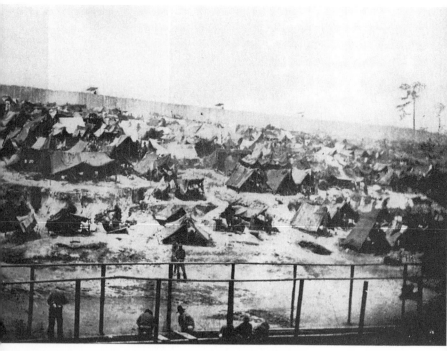

But nothing North or South could match in notoriety the place in Georgia first called Camp Sumter. Soon it was known to all as Andersonville. On August 17, 1864, Southern photographer A. J. Riddle took his camera to record this panoramic scene of the southern part of the compound. There were almost 33,000 prisoners confined within its twenty-six acres, all under the watchful—and sometimes cruel—eyes of the sentries atop the stockade.
(USAMHI)

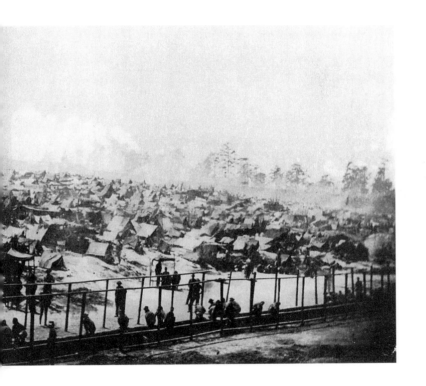

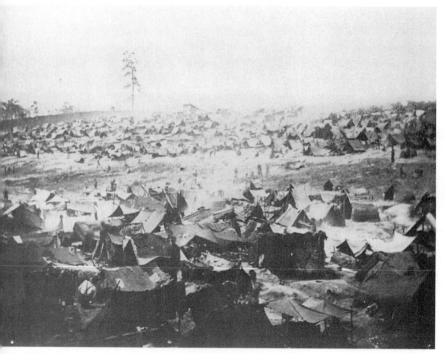

*The northwest view of the stockade, again by Riddle. The death rate that
summer went well over 100 per day; yet there was little intentional mistreatment
of prisoners. They enjoyed almost the same substandard diet as their guards.
There were simply too many, crowded and with poor sanitation, kept by a
Confederacy that did not have the resources to feed them. And that was quite
bad enough.* (USAMHI)

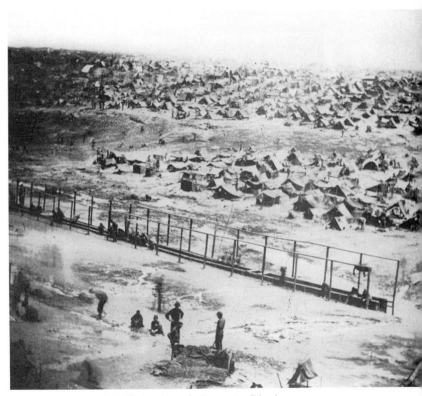

Another view from the stockade. The long sinks, or latrines, run parallel and next to the stream that provided drinking water. With dysentery rampant, it is no wonder the latrine is constantly crowded. (USAMHI)

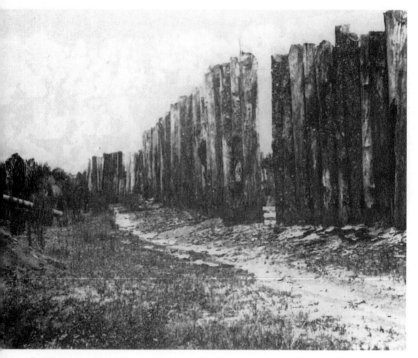

Even in the years after the war, the place has not lost its menace. The Confederates abandoned the camp in the days before the war's end. Some time later Fernandina, Florida, photographers Engle & Furlong came to record the crumbling place of horror. The gateway to the stockade . . . (NA)

. . . the road leading from the railroad station to the camp, the long road trod by more than 13,000 who never walked back . . . (NA)

. . . the southeast stockade, the bakeries at right . . . (NA)

. . . and the crumbling stockade itself. Only echoes linger to tell of the misery of
the place, as in almost all Civil War prisons. (NA)

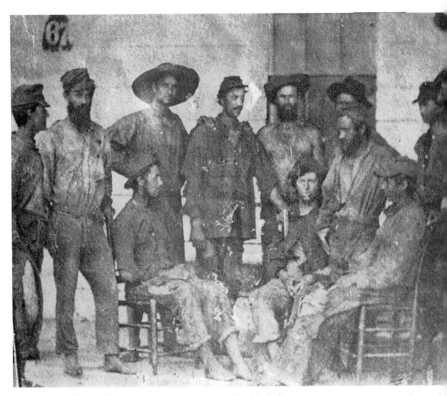

Federal soldiers who were captured in the West were retained in the less crowded western prisons, like these men of the 19th Iowa. They are shown here in New Orleans immediately after their release from Camp Ford at Tyler, Texas. Rags and tatters were the uniform of all prisoners. (LC)

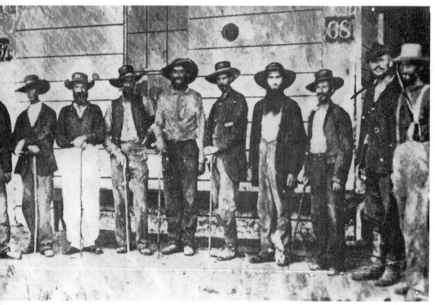

The officers of the 19th Iowa looked little better at the time of their release. (LC)

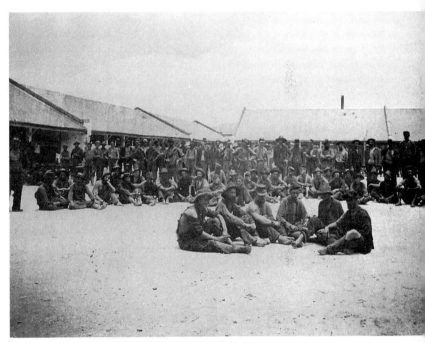

But tatters or no, they were more than happy to be on their way home.
(USAMHI)

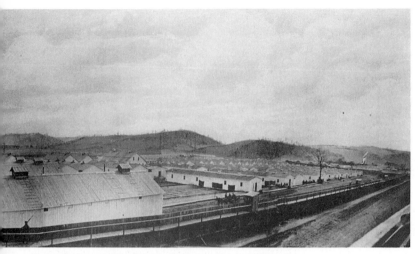

Meanwhile, the work of housing the unfortunate continued. At Elmira, New York, General Hoffman built yet another camp, forty acres inside a stockade that ran alongside the aptly named Hoffman Street. The prisoners inside proved to be a curiosity for local photographers like J. E. Larkin, who made this 1864 image, and for the citizens of the surrounding area. (LC)

The civilians were allowed to mount the stockade and look in upon the Confederates inside, here lined up for a roll call of ration issue. Some even made a business of selling goods over the wall to prisoners with money. (MC)

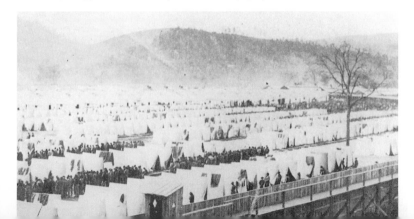

Sightseers in the South could take a look, too, both at Union prisoners and at Confederates, as here in Beaufort, South Carolina, where an Episcopal church has been turned into a prison by the conquering Yankees. The tent at right is the prison hospital. (WRHS)

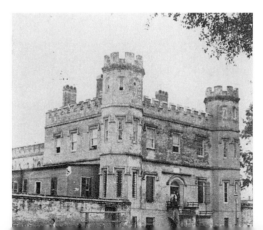

And the armies had to use even the local city jails, as here in Savannah, where quite a few Federals were accommodated during the war. (USAMHI)

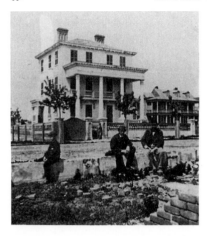

From time to time the men in prison did have to face the threat of being used in the political and military battle between North and South. When it was reported that Confederate authorities in Charleston had placed Union officers in this house on Broad Street, directly in the line of fire from the bombarding Federals, . . . (USAMHI)

. . . the Yankees retaliated by erecting this stockade on Morris Island and populating it with 600 Confederate officer prisoners, right in the line of Southern fire. Both sides backed away from the confrontation before any casualties were suffered. (LC)

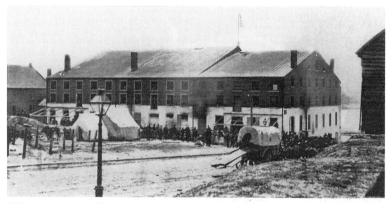

With the war over, a fascination erupted in the North. People wanted to see these infamous places they had read about for four years. Libby Prison became the single most photographed building in the former Confederacy. (USAMHI)

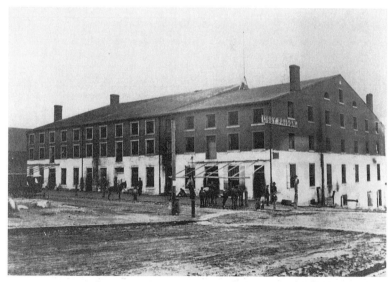

The photographers took it from every angle. (NA)

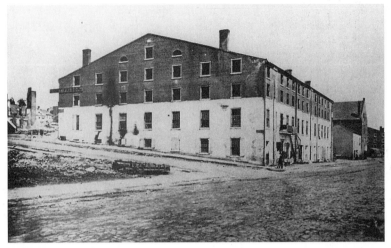

A place that had to be remembered. (VM)

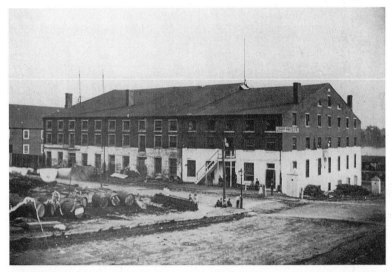

They even gave it a new sign, not that anyone needed reminding. (USAMHI)

Certainly the soldiers, finally released after their time in Libby and the other prisons North and South, needed no reminding. They packed their few prison belongings, donned their tattered uniforms, and went home. Lieutenant William May of 23d Connecticut, after his release from Camp Ford at Tyler, Texas. May edited a prisoners' newspaper, The Old Flag, *for fellow inmates at Camp Ford.* (RP)

And for thousands more there was nothing to remember. They were past their suffering, their war. All that remained for them, as for these hundreds in rank on rank at Andersonville, was to be remembered. (USAMHI)

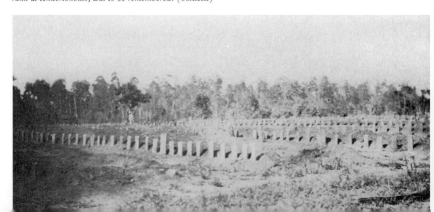

The South Besieged

The flagging South's blood, men who could not be spared. Prisoners captured in Virginia in 1864 can do nothing more for their country now, and can only stare at the camera for posterity. Lean and weathered, worn and starved like their infant nation, their war is done.

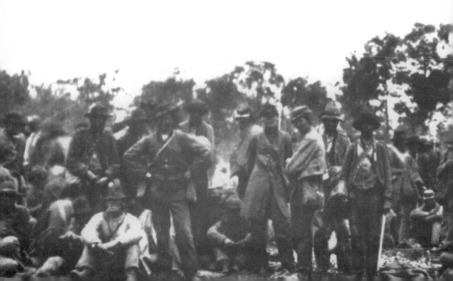

The South Besieged

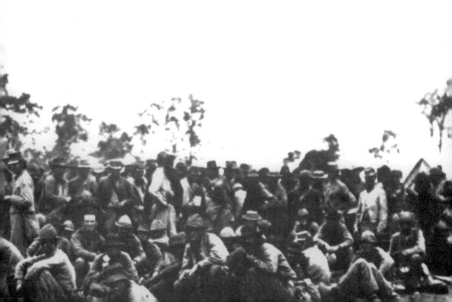

The War for Tennessee

EDWIN C. BEARSS

The endless, bloody battles for the state called "Volunteer"

CIVIL WAR PHOTOGRAPHERS recorded the soldiers and scenes of the sweeping military operations that dashed Confederate expectation in America's heartland and shattered a mighty Southern army. During the six months following the struggle at Stones River, December 31, 1862–January 2, 1863, Union Major General William S. Rosecrans' Army of the Cumberland regrouped and built up strength in and around Murfreesboro in Middle Tennessee, 30 miles southeast of Nashville. Confederate General Braxton Bragg's Army of Tennessee fortified a line covering Duck River barring the direct route to Chattanooga.

Geography and the "iron horse" dictated that Chattanooga, with only 2,545 people in 1860, play a key role in the Civil War. The town was on the south bank of the Tennessee, where the great river knifed its way through a mountain barrier. Possession of Chattanooga, "Gateway to the deep South," was vital to the Confederacy, and a strategic necessity Union leaders could not ignore.

Railroads focused the armies' attention on Chattanooga. It was the terminus of major railroads leading northeast to Knoxville and Richmond, southeast to Atlanta, and northwest to Nashville and Louisville. At Stevenson, Alabama, 40 miles to

the southwest, the railroad to Memphis joined the tracks of the Nashville & Chattanooga.

On June 24, 1863, Rosecrans, in response to goading from Washington, took the offensive. There ensued, on the part of the Federals, a brilliantly planned and executed ten-day campaign. After stubborn but brief fights at Hoover's and Liberty Gaps, the bluecoated columns forged ahead. Satisfied that his Middle Tennessee position had become untenable, Bragg determined to abandon the region. Rosecrans' soldiers entered Tullahoma on July 1, capturing a few prisoners, and the Confederates retreated across the Cumberland Plateau and took position behind the Tennessee River. Rosecrans now called a halt, sent his troops into camp, and began stockpiling supplies for a thrust across the Tennessee and on to Chattanooga.

By mid-August, Rosecrans resumed the offensive. His army had regrouped, and ripening corn promised forage for his thousands of horses and mules. His immediate goal was Chattanooga. As in the Tullahoma Campaign, Rosecrans hoped to maneuver the Confederates out of their stronghold by hard marches and an indirect approach.

General Bragg, pending arrival of reinforcements, massed his army in and around Chat-

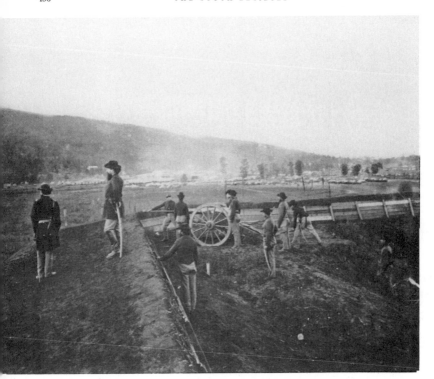

*Mr. Lincoln's army was on the move in Tennessee. In a brilliant campaign,
Rosecrans had feinted Bragg out of Tennessee's heartland. Now he prepared to
drive him into Georgia, and here at Stevenson, Alabama, the right of the
advancing Federals established Redoubt Harker to guard rail supply lines.* (U.S.
ARMY MILITARY HISTORY INSTITUTE)

tanooga. Yankee artillery, north of the Tennessee,
opened fire on the town, and Bragg, to counter this
threat, recalled most of his troops guarding the
downstream crossings. Rosecrans took advantage of
Bragg's miscalculations, and divisions crossed and
bridged the Tennessee. Pressing rapidly forward
after what Rosecrans believed to be a broken and
dispirited foe, the XIV and XX Corps entered
mountainous northwest Georgia. Thus by Septem-

ber 10 some 45 miles of rugged country separated
the wings of Rosecrans' army.

Meanwhile, General Bragg had been reinforced.
Major General Simon B. Buckner's 8,000-man
corps joined him, and 11,500 troops arrived from
central Mississippi. On September 6, Bragg had
evacuated Chattanooga and massed his army near
La Fayette, 26 miles to the south.

Bragg now moved to take advantage of Rose-

Here around the Stevenson railroad depot the Yankees built up their supplies for the campaign to come. Mountains of boxes of "army bread" and row after row of salt beef and pork barrels wait on the siding. (BEHRINGER-CRAWFORD MUSEUM, COVINGTON, KENTUCKY)

crans' blunder and defeat the Federals in detail. On September 10 he moved to crush Major General George Thomas' advance—Major General James S. Negley's division of the XIV Corps in McLemore's Cove. Plans were frustrated by the inaction of the principal subordinates involved, Lieutenant General Daniel H. Hill and Major General Thomas C. Hindman, and Thomas pulled back. Bragg then turned to assail Major General Thomas Crittenden. Again, a senior corps commander failed and Bragg's plans misfired.

Rosecrans now realized that his army was imperiled. Thomas' XIV Corps and Major General A. M. McCook's XX Corps were recalled and ordered to join Crittenden at Lee & Gordon's Mills, 12 miles south of Chattanooga. Nightfall on September 17 found Rosecrans' infantry corps within supporting distance: Crittenden's at Lee & Gordon's Mills, Thomas' nearby, McCook's in McLemore's Cove, and Gordon Granger's Reserve Corps, called up from near Bridgeport, Alabama, in position at Rossville, guarding the road into Chattanooga.

General Bragg, fuming over his subordinates' failures, marched his columns northward on the east side of Chickamauga Creek. He planned to cross the Chickamauga north of Lee & Gordon's Mills, block the road to Chattanooga, and turn on

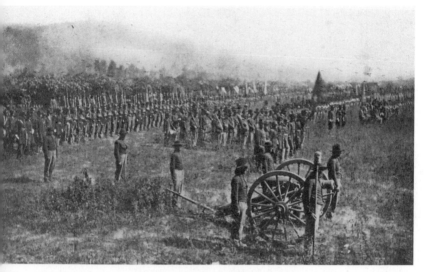

A magnificent image of an unidentified Federal regiment drawn up for the camera near Stevenson. Hard-bitten Westerners like these would take the war to the enemy wherever they found him. (BEHRINGER-CRAWFORD MUSEUM, COVINGTON, KENTUCKY)

and either crush Crittenden's XXI Corps or hurl it back on Thomas. By mauling Rosecrans' left, Bragg could reoccupy Chattanooga and possibly destroy the Union Army before it recrossed the Tennessee.

On September 18 three brigades of Lieutenant General James Longstreet's corps detrained at nearby Ringgold. These Army of Northern Virginia veterans, vanguard of a famed corps, had left Virginia nine days before. The Confederacy had employed its interior position and warworn railroads to give Bragg a numerical advantage in the impending struggle.

One of Longstreet's brigades reinforced Brigadier General Bushrod R. Johnson's division as it pressed toward Reed's Bridge. Johnson's column, in Bragg's plan, was to cross the Chickamauga at this bridge and wheel left. Other Confederate divisions and corps, in turn, were to cross at upstream bridges and fords, their movements facilitated by Johnson's advance.

Union cavalry and mounted infantry, guarding the crossings, engaged the Confederates. Alexander's Bridge, upstream from Reed's, was broken down by the horse soldiers, and Major General W. H. T. Walker's corps, advancing on Johnson's left, was compelled to proceed to a downstream ford, where it crossed and reinforced Johnson. The Federals pulled back. By daybreak on the 19th, all of Bragg's army, 66,000 strong, except three divisions, was west of Chickamauga Creek.

General Rosecrans took advantage of time bought by his mounted troops to redeploy his 58,000-man army to counter Bragg's threat to the Union left. Thomas' corps was called up during the night, and two of his divisions took position on Crittenden's left, covering the roads leading to Reed's and Alexander's bridges.

On September 9, 1863, Rosecrans also obtained a valuable prize well north of Bragg. Cumberland Gap fell to Federals, thus closing that passage to the enemy and giving the Yankees a back door into eastern Tennessee. (LINCOLN MEMORIAL UNIVERSITY)

Early on September 19, General Thomas sent Brigadier General John M. Brannan to reconnoiter the Confederate forces that had crossed the Chickamauga. Feeling their way ahead, the Federals, as they neared Jay's Mill, clashed with Brigadier General Nathan B. Forrest's dismounted cavalry, screening Bragg's right. The Yanks pushed Forrest's people and their supporting infantry back. The Confederates brought up reinforcements, Walker's corps, and the Federals, in turn, recoiled.

As the day progressed, Bragg and Rosecrans continued to call up and commit fresh units. By midafternoon savage combat raged along a three-mile front. Around 2:30 the Confederates began advancing successfully. By 4 P.M. the situation looked bleak for the Army of the Cumberland. Bragg's Confederates, if allowed to exploit this success, were in position to block the Dry Valley road —Rosecrans' only remaining link with Chattanooga. Desperately, the Federals held on.

Although darkness closed in, close combat flared for several more hours before the firing and shouting ceased. During the night General Longstreet arrived from Ringgold with two fresh brigades.

George N. Barnard's image of the pass in Raccoon Mountain near Whiteside, Georgia. An important trestle bridge of the Memphis & Chattanooga Railroad passed through here, and both Confederates and Federals vied for it. These blockhouses are only part of its defenses. (USAMHI)

Bragg then reorganized his army into two wings preparatory to resuming the attack. Lieutenant General Leonidas Polk was to command the right wing and Longstreet the left.

Bragg called for resumption of the battle at daybreak on Sunday, September 20. Major General John C. Breckinridge's division on the right was to open the attack, which would be taken up by successive divisions to his left. Misunderstood orders and difficulties in effecting dispositions resulted in several hours delay. It was 9:30 before Breckinridge advanced, and as he did his brigades gained ground and threatened to envelop Thomas' left. A Union counterattack blunted and threw back Breckinridge's grim fighters, mortally wounding one of President Lincoln's Confederate brothers-in-law, Brigadier General Ben Hardin Helm.

Patrick R. Cleburne's division now struck, closing on the Union breastworks. His brigades were mauled as General Thomas called up more reinforcements. After two and a half hours of savage fighting, Polk's wing, having frittered its energy in futile piecemeal attacks on Thomas' barricaded line, recoiled.

It was now 11:15, and Longstreet massed a three-division column under hard-hitting Major General John B. Hood opposite Rosecrans' center. Through a misunderstanding, Rosecrans had just

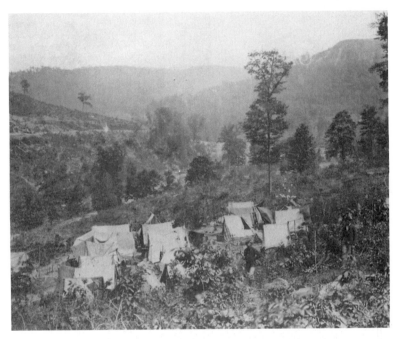

Barnard's camera also caught some of the men who manned those defenses.
(WESTERN RESERVE HISTORICAL SOCIETY)

then created a huge hole in his own line opposite Longstreet.

Longstreet's thunderbolt now struck, his column surging through the gap that had opened in the Union line because of Rosecrans' blunder. It shattered their foe. Whole divisions fled the field. Among the dead was the brilliant and beloved Brigadier General William H. Lytle. Rosecrans, McCook, and Crittenden, caught up in the panic, abandoned the field. The right wing of the Union Army, except Colonel John T. Wilder's brigade, which advanced and battered one of Hindman's brigades, was in wild retreat.

General Thomas did not panic. He pulled back and re-formed his right along the crest of Snodgrass

Hill. Unwilling to bypass Thomas, Longstreet's troops repeatedly charged up the slopes only to be repulsed. They next moved to envelop Thomas' right and were succeeding when General Granger, marching to the sound of the guns, arrived with two reserve brigades on Snodgrass Hill. Attacking, Granger hurled the Confederates back.

Undaunted, Longstreet returned to the attack, vainly committing his reserve, General William Preston's division. About 4 P.M., Polk's wing resumed battering Thomas' left, and at dusk Thomas withdrew most of his troops to Rossville Gap. On that grim Sunday afternoon Thomas saved the Army of the Cumberland and earned the *nom de guerre* "The Rock of Chickamauga."

They were all commanded by the smiling Major General William S. Rosecrans, "Old Rosey," whose prospects in the campaign ahead took a decidedly less rosy turn. (USAMHI)

Losses in the battle, the war's bloodiest two-day fight, which the Confederates won but failed to follow up, were staggering. Bragg listed 2,312 dead, 14,674 wounded, and 1,468 missing. Rosecrans reported 1,657 dead, 9,756 wounded, and 4,757 missing.

On the night of September 21, 1863, the defeated Union Army was back in Chattanooga. Here, between Confederates in front and natural obstacles to the rear, it was trapped. Bragg's troops advanced and invested the Union forces, occupying Missionary Ridge, Chattanooga Valley, Lookout Mountain, and Lookout Valley.

News of Rosecrans' defeat at Chickamauga had far-reaching repercussions. Two corps, the XI and the XII, were detached from the Army of the Potomac, placed under Major General Joseph Hooker, and rushed west as fast as the railroads could move them. Four divisions were detached from Major General Ulysses S. Grant's Army of the Tennessee, then based at Vicksburg, and sent up the Mississippi by steamboats to Memphis. These units were led by Major General William T. Sherman.

Then Grant, overall commander in the theater, relieved Rosecrans, elevating General Thomas to command the Department and Army of the Cumberland. Grant promptly learned something of Thomas' character. Replying to a telegram from Grant to hold Chattanooga at all hazards, Thomas answered, "We will hold the town till we starve."

The most immediate task facing Grant and Thomas was supplying Chattanooga. Rosecrans began work on a route using the Tennessee River, and now they completed it. While mechanics built the steamboat *Chattanooga*, and other vessels were repaired for service, the generals went about taking and holding Lookout Valley, vital to their supply route. It took secrecy and desperate fighting at Wauhatchie, but by November 1 the route was open. The "cracker line" they called it, bringing vital supplies from the railhead at Bridgeport, Alabama, up the river to Kelley's Ferry aboard the *Chattanooga* and several other ships like her, and then overland to Chattanooga.

Grant now confronted the enemy in his front. But Bragg immediately blundered by allowing Longstreet to take his corps on an ill-advised campaign into East Tennessee toward Knoxville. Learning of this, Grant began to plan an attack on the remaining Confederates.

Early on November 23, to confirm the reports of deserters and spies that two divisions of Buckner's corps were en route to East Tennessee to reinforce Longstreet, Grant directed Thomas to make a forced reconnaissance of the Rebel lines. The Army of the Cumberland—Granger's corps on the left and John N. Palmer's on the right—moved out at 2 P.M., as if on parade, and formed lines of battle in view of watching Confederates. Taking up the advance, the Federals drove in Bragg's pickets and routed the Rebels from a line of rifle pits, capturing more than 200. On the afternoon of the 24th, Sherman's army moved out from its bridgehead in three columns. They overpowered several outposts and, by four o'clock, occupied the north end of Missionary Ridge.

To hinder Rosecrans' advance, the Confederates had destroyed the Howe Turn bridge over the Tennessee River at Bridgeport. Engineers are building a temporary bridge to span the stream. (MINNESOTA HISTORICAL SOCIETY)

Meanwhile, at 4 A.M. on the 24th, General Hooker put his three divisions in motion. While his pioneers bridged Lookout Creek, Hooker sent Geary's division, reinforced by Brigadier General Walter C. Whitaker's brigade, upstream to cross at Wauhatchie. Screened by a morning fog, Geary's people forded the creek and swept down the slope overlooking the right bank, routing Confederate pickets. Covered by this movement, Hooker's main column bridged and crossed the stream. Supported by enfilading fire of cannon emplaced on Moccasin Point, Hooker's divisions forged ahead, driving a

Confederate brigade around the face of Lookout Mountain to the Cravens farm. Though ordered to halt and re-form, Geary, seeing he had the Rebels on the run, pushed ahead until checked by Confederate reinforcements posted behind breastworks beyond the Cravens house. By 2 P.M. the fog had thickened and it was impossible for the combatants to see more than a few yards. This, along with an ammunition shortage, caused Hooker to halt and consolidate his gains. The "Battle Above the Clouds" had ended in a Union success.

During the night of the 24th the Confederates

The commander of those Confederates, General Braxton Bragg, was on the verge of winning the most shattering triumph in the career of Southern arms.
(VALENTINE MUSEUM)

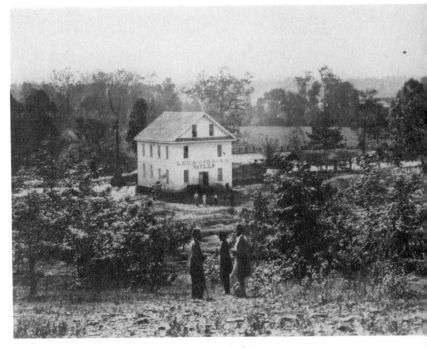

*He would win that victory along the banks of Chickamauga Creek in
northwestern Georgia. Some of the first skirmishing prior to the battle took place
near Lee & Gordon's Mills on the creek.* (LIBRARY OF CONGRESS)

withdrew from Lookout Mountain and reported to
Bragg on Missionary Ridge. Next morning, a pa-
trol from the 8th Kentucky scrambled up the
mountain and at sunrise, the fog having lifted, un-
furled the U.S. flag from the point, to the cheers of
bluecoated onlookers.

Grant's November 25 program called for Sher-
man to assail Tunnel Hill, at the north end of Mis-
sionary Ridge, at daylight; Hooker to march at the
same hour on the road to Rossville, storm Rossville
Gap, and threaten Bragg's left and rear; and
Thomas to hold his ground until Hooker and Sher-
man had accomplished their missions.

Sherman began his attack as scheduled. Strong
battle lines advanced and occupied a wooded crest
within 80 yards of rifle pits held by Cleburne's divi-
sion. A savage fight ensued. The outnumbered
Confederates held firm and stood tall in the face of
Sherman's blows. About 2 P.M. two of Sherman's
brigades effected a lodgment on the slope of Tun-
nel Hill but were counterattacked and driven back
in disorder.

Hooker was also in trouble, not with the foe, but
with Chattanooga Creek. Reaching that stream at
10 A.M., he found the bridge destroyed and the
Rossville road obstructed by retreating Confed-

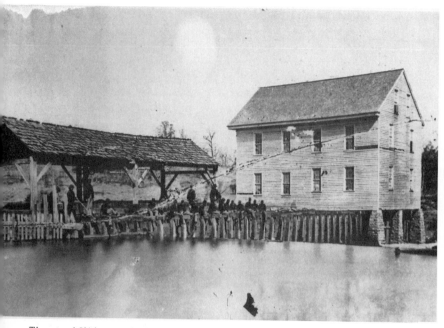

The water of Chickamauga Creek would soon be stained with the blood of thousands as the battle commenced. Scores of dead floated peacefully past Lee & Gordon's. (NATIONAL ARCHIVES)

erates. Hooker lost three hours crossing his lead division, which then advanced and seized Rossville Gap. His other divisions followed, and, deploying them in line, Hooker pushed ahead.

Grant, at his Orchard Knob command post, knew that Sherman had been rebuffed at Tunnel Hill and that Hooker had been delayed. To assist Sherman, Grant told Thomas to send his four center divisions to carry the Confederate rifle pits at the foot of Missionary Ridge and there halt and await further instructions. At 3:30 P.M. signal guns on Orchard Knob boomed, and the divisions, covered by a powerful skirmish line, swept forward. The Federals, though subjected to a storm of shot and shell from Confederate batteries emplaced on

the commanding heights, routed the Rebels from the rifle pits. After a brief halt and without orders to continue, first one regiment and then others scrambled to its feet and surged up the ridge. They followed so hard on the heels of the Confederates fleeing the rifle pits that the Rebels posted in the works on the crest at many points hesitated to fire for fear of hitting their comrades. Units from Major General Philip H. Sheridan's division reached the crest first, routing Confederate soldiers from their breastworks near Bragg's headquarters. Regiments from the other three divisions ripped the line at other points, and the brigades holding Bragg's center panicked. Many prisoners and cannon were captured. Though the Confederate cen-

ter was shattered, Lieutenant General William J. Hardee's corps, on the right, grimly held its ground till dark and then retired with Cleburne's division, successfully screening the army's retreat to winter camp at Dalton, Georgia.

Coincident with the November 25 orders for pursuit of Bragg's defeated Army of Tennessee, Grant directed Thomas to send General Granger with 20,000 men to the relief of the force led by Major General Ambrose Burnside, then besieged in Knoxville. In late summer of 1863, Burnside, at the head of the Army of the Ohio, had advanced from bases in central Kentucky. Bypassing heavily fortified Cumberland Gap, Burnside's troops entered Knoxville on September 2. On September 9 the 2,100 Confederates under Brigadier General John W. Frazer, left to "wither on the vine" at Cumberland Gap, laid down their arms.

Burnside was expected to join Rosecrans near Chattanooga, but he moved slowly, and Rosecrans' defeat at Chickamauga doomed plans for a rendezvous of the two armies. Then, in early October, 1,500 Southern horsemen led by Brigadier General John S. Williams, advancing from Jonesboro, came down the road paralleling the railroad to the vicinity of Bulls Gap. Burnside reinforced his men in that quarter, and, on October 10, at Blue Springs mauled Williams' column and drove it back into southwestern Virginia.

Following the Battle of Wauhatchie, General Bragg had divided his army, sending Longstreet and his corps, reinforced by four brigades of Wheeler's cavalry, to assail Burnside and recapture Knoxville. Longstreet's 10,000 infantry and artillery were shuttled by rail from the Chattanooga area to Sweetwater. General Joseph Wheeler and his cavalry, 5,000 strong, were to cut Burnside's communications and seize high ground at Knoxville. Longstreet, with Lafayette McLaws' and Micah Jenkins' infantry divisions and E. Porter Alexander's reinforced artillery battalion, would cross the Tennessee and make a direct approach on Knoxville.

Wheeler failed. Meanwhile, Longstreet's columns had crossed the Tennessee on November 13 and 14. Spearheaded by a strong vanguard, the Rebels vigorously pushed ahead in a vain effort to force Burnside to fight before he could mass his forces within the Knoxville fortifications. To gain time and enable Burnside's infantry and artillery to

The bulk of the real battle will be fought on the right, where Lieutenant General Leonidas Polk commands Bragg's right wing. The bishop-turned-general will repeatedly disappoint Bragg, as he does almost everyone except his old friend Jefferson Davis. An unpublished portrait. (COURTESY OF TED YEATMAN)

strengthen their earthworks, Brigadier General William P. Sanders and his horse soldiers engaged and delayed the Confederate vanguard. With 700 men, he manned and stubbornly held a position covering the Loudon road, about a mile outside the perimeter. The bluecoats held the Rebels until midafternoon on the 18th, when the roadblock was smashed by the South Carolina brigade and Sanders mortally wounded.

Next morning, the Confederates appeared in force. Longstreet, ignoring the need for haste, invested the city, and his soldiers began digging in. "The earthworks on each side seemed to grow like

It was chiefly divisions of the corps of Lieutenant General Daniel H. Hill of North Carolina that set the scene for the Confederate victory. It was his attacks on Rosecrans' left wing that forced the Federal to weaken his center. (VM)

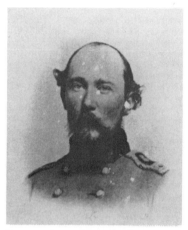

It came at a heavy price. Leading his brigade in one of Hill's attacks, Brigadier General Ben Hardin Helm of Kentucky fell, mortally wounded. He was the brother-in-law of President Abraham Lincoln. (USAMHI)

magic," recalled one soldier. Sharpshooters banged away, and several successful sorties buoyed the defenders' morale.

On the night of the 23rd, Longstreet received a message from General Bragg stating that if it was practicable to defeat Burnside it must be done immediately. The sector selected by Longstreet's chief engineer to be assailed was shielded by Fort Sanders. Longstreet scheduled the attack for sunrise on the 25th, but, on being apprised of the approach of two infantry brigades sent by Bragg as reinforcements, he postponed the assault to await

their arrival. With these troops came Brigadier General Danville Leadbetter, an officer of engineers, presumably familiar with the area. Leadbetter's advent resulted in a new reconnaissance and vacillation on the part of Confederate leaders and, as Porter Alexander recalled, "cost us three as valuable days as the sun every shone upon."

Meanwhile, Longstreet had changed his battle plan. Instead of jumping off at sunrise and being preceded by a savage bombardment by Alexander's massed artillery of Fort Sanders, a surprise thrust by four infantry brigades was programmed. The night of November 28–29 was miserable. Temperatures went below freezing and it misted. At 10 P.M. Confederate skirmishers advanced, captured or drove in the enemy pickets, and took possession of abandoned rifle pits within 150 yards of the fort.

The firing alerted the Federals, particularly the 440 soldiers garrisoning Fort Sanders, and the works to the strongpoint's right and left. Cannoneers manning the 12 guns emplaced behind the fort's embrasured parapets stood by their pieces

and, during the remaining hours of darkness, fired harassing charges of canister.

At dawn Confederate signal guns barked; several of Alexander's batteries roared into action briefly; and in two columns McLaws' veterans scrambled to their feet and rushed forward. As they neared the van encountered a nasty surprise, telegraph wire entanglements stretched a few inches above ground and secured to stumps and stakes. Though this obstacle was soon passed, it disordered the ranks and caused wild rumors to circulate among supporting units as to impenetrable barriers and a slaughter of the attackers.

From inside the fort and adjoining rifle pits grim Union soldiers blazed away at the oncoming mass with rifle muskets and cannoneers got off several charges of canister. The Confederates rushed on and crowded into the ditch fronting Fort Sanders' northwest bastion. The men lacked scaling ladders, and the parapet slope was frozen and slippery. Soldiers shot through embrasures, causing the Yanks to keep their heads down and to slacken their fire. This enabled some of the Confederates to claw their way up the icy slope and plant three battle flags on the parapet. Men seeking to reach and rally on the colors were killed or captured, and one of the standard bearers was dragged into the fort by the neck.

Confederates milling in the ditch now found themselves under a deadly flank fire of musketry and canister, as well as shells rolled into the moat as hand grenades. To advance or retreat was equally hazardous, and a number of soldiers began to wave their handkerchiefs. Many of their comrades, however, pulled back slowly at first, but the retreat quickly became disordered and rapid. As McLaws' men withdrew, one of Jenkins' brigades, though Longstreet sought to have it stopped, rushed the fort. Striking the ditch east of the scene of McLaws' repulse, this brigade suffered a similar fate. The assaulting columns were rallied by their officers under cover of the Rebel works, some 600 yards in front of Fort Sanders, and rolls were called. The charges had cost the Confederates 813 casualties: 129 killed, 458 wounded, and 226 missing. Union losses in Fort Sanders were about a score.

Plans for a new and better-organized attack were discussed, but before it could be launched dispatches were received confirming rumors of

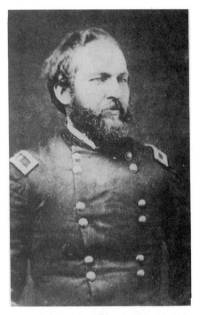

In the confusion behind Rosecrans' lines, his chief of staff, Brigadier General James A. Garfield, was too busy to write an order for his commander. Rosecrans dictated it to another, and inadvertently it cost him the battle. Garfield, however, would win promotion for Chickamauga and eventually become President. (USAMHI)

Bragg's defeat and retreat beyond Ringgold and ordering Longstreet to end the siege and reinforce Bragg.

Preparations were accordingly made to withdraw the troops and, as soon as it was dark, begin the march south. But, after meeting with his generals and being apprised that General Sherman was en route to Knoxville with a powerful column, Longstreet determined to hold his ground in front of Burnside and compel Sherman to continue his march. Longstreet held firm until December 3, when he learned that Sherman's vanguard was

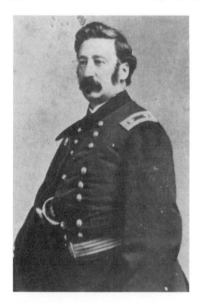

There was confusion enough in the Federal army without bungled orders. Major General James S. Negley unaccountably wandered away from the battle line with most of his division and did not heed orders to return. He would never command again, though he claimed for the rest of his days that his disgrace had been engineered by jealous West Point trained officers who despised a man never educated at the Military Academy.
(COURTESY OF RONN PALM)

A man who obeyed orders to the letter, however, was Major General Thomas J. Wood. Rosecrans' dictated order told him to move to the left, and Wood obeyed, even though it left a massive hole in the Union line just as . . . (USAMHI)

within a day's march. During the night the trains started rolling northeastward. Longstreet's troops followed as soon as it was dark on the 4th, retreating to Rogersville. Sherman entered Knoxville on the 6th to be welcomed by General Burnside and his troops, victors in the 16-day siege. The soldiers soon went into winter quarters, and the year's campaigning in Middle and East Tennessee ended.

ONE YEAR LATER, in November 1864, Middle Tennessee again became a focal point in the struggle.

General John B. Hood, in the weeks following his evacuation of Atlanta, had succeeded in securing President Jefferson Davis' approval of a plan fated to lead his army deep into Tennessee. Boldly crossing the Chattahoochee, Hood lunged at the Western & Atlantic, the single-track railroad over which General Sherman supplied his "army group." Sherman, detaching a corps to hold Atlanta, hounded Hood's columns across the ridges and hollows of northwest Georgia and into Alabama. Despairing of overtaking and bringing Hood to battle,

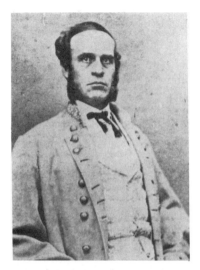

*Major General Bushrod R. Johnson and his
division spearheaded the attack of a Confederate
corps aimed precisely at the gap. Johnson, a native
of Ohio, was yet one of the most able generals in
the Southern service.* (COURTESY OF WILLIAM A.
ALBAUGH)

*Some of the attacking soldiers in that Confederate
assault were hardly more than children, like this
youngster of the 9th Mississippi.* (COURTESY OF
PAUL DE HAAN)

Sherman was delighted to learn, on November 8,
that General Grant had approved Sherman's pro-
posal to return to Atlanta, where preparations
would be completed for evacuation of that city and
the "March to the Sea."

When Hood failed to turn and follow the Union
columns on their return to Atlanta, Sherman
directed Major General John M. Schofield and his
XXIII Corps to join Thomas in Middle Tennes-
see. Schofield soon reached Nashville by rail, and
part of his corps rushed westward to bolster troops
routed from the Johnsonville supply depot by now
Major General Nathan B. Forrest's cavalry.
Schofield, accompanied by two divisions of his
corps, traveled to Pulaski, where, as senior officer,
he took command of the troops assembled there to
oppose Hood's advance.

Also ordered to join Thomas were Major Gen-
eral Andrew J. Smith and his three divisions that
had helped smash the Confederates at Westport,
near the Kansas border, on October 21–23. Low
water on the western rivers delayed the transfer of
Smith's "ten wandering tribes of Israel," and the
vanguard did not disembark at Nashville until No-
vember 30.

General Hood had sought to cross the Tennessee
River at Decatur, Alabama, but an aroused de-
fense by the garrison frustrated his plans. Hood
then pushed on to Tuscumbia, where by the end of
October his men crossed the river and occupied
Florence.

On Monday, November 21, Hood put the
50,000-man Army of Tennessee in motion. Screened
by Forrest's cavalry, the three infantry corps
traveled different roads. Vital days had been lost,
and the weather was frightful. There were contin-
uous snow, sleet, and ice storms.

Apprised of the Confederate advance, General

Yet others were experienced and battle-hardened veterans, like Brigadier General John Gregg of Alabama, shown here in an unpublished portrait. He led his brigade into the attack right behind Johnson, taking a wound for his effort. (COURTESY OF LAWRENCE T. JONES)

and two divisions of his corps and the army's artillery to entertain Schofield in front of the Columbia bridgehead, Hood, at daybreak on the 29th, began crossing Duck River via a pontoon bridge positioned at a ford uncovered by Forrest's surge. Several of Forrest's brigades spearheaded the Confederate thrust toward Spring Hill, a village on the Columbia pike, eight miles north of Columbia. If the Rebels blocked the road Schofield's army would be confronted by a disastrous situation. By a hair's breadth, they failed. Schofield, informed that he was outflanked, held Spring Hill long enough to get his army marching safely toward Franklin.

The Confederates, the night being very dark, did little to impede the Union retrograde, though Schofield's columns marched by in view of Hood's campfires.

Except for several dashes by Forrest's cavalry, Schofield's 14-mile retreat to Franklin was not disturbed. General Jacob D. Cox's division was first to reach Franklin on a cold last day of November, and Cox established his command post at Fountain

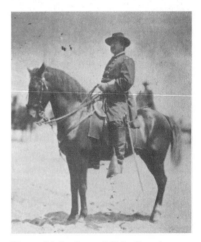

The attack isolated most of Major General Alexander McCook's XX Corps, and McCook himself, with two of his divisions, fled the battlefield in rout. He never led troops again in the war, and in 1866 was serving as a lowly captain. (USAMHI)

Schofield sent his supplies to the rear and evacuated Pulaski. Union infantry reached Columbia on the 24th, in time to reinforce the cavalry and check a dash by Forrest's horse soldiers. Some 48 hours elapsed before all of Hood's infantry arrived in front of Columbia, and by then Schofield had perfected his dispositions for defense of the Duck River crossings.

Hood, seeing that a frontal assault on the Duck River bridgehead could be suicidal, sought to slip across the river and outflank Schofield. On the 28th, Forrest's cavalry hammered backward Thomas' cavalry, who retired toward Franklin, uncovering the Columbia pike.

Leaving Lieutenant General Stephen D. Lee

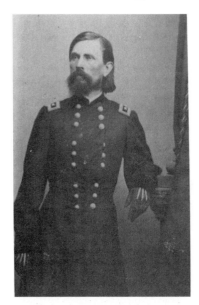

Major General Thomas L. Crittenden fared no better. The Confederate attack shattered one of his divisions and cut him off from the other two. He joined McCook and Rosecrans in following the rout and never held important command again. (WRHS)

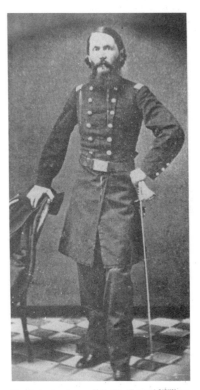

B. Carter's house. The brick dwelling fronted on the west side of the Columbia pike south of town. Schofield arrived and told Cox to deploy the XXIII Corps' two divisions to hold a bridgehead south of Franklin and shield the army as it crossed to the north of the Big Harpeth River on two improvised bridges. Combat veterans all, the soldiers needed no encouragement as they strengthened the earthworks erected some year and a half earlier. More divisions arrived, including General James H. Wilson's cavalry.

An angry and bitter Confederate Army marched north following the Spring Hill fiasco. General Hood was in a foul humor, convinced that failures by subordinates had permitted the Federals to es-

Yet there were heroes. Brigadier General William H. Lytle of Ohio was best known then and later as a poet. Here at Chickamauga his division was just moving to the left when the Confederate attack struck. To protect the moving columns of Federals, he turned his brigade back to meet the attack and try to stall it. One brigade faced more than a division of the enemy. In the desperate fight, Lytle was hit by four bullets and died soon thereafter. The Confederates who later found him placed a guard over the body to prevent its being robbed, and gave him an honored burial. That night many Confederates sadly recited the lines of Lytle's most famous poem, Antony and Cleopatra. *It began, "I am dying, Egypt, dying." (USAMHI)*

*It was good ground for a battle, and even after the Confederate breakthrough,
the remnants of the Federal army could hold out on hills like this.* (NA)

cape a frightful mauling. He was determined to
make a final effort to destroy Schofield's army be-
fore it gained the security afforded by the Nashville
defenses. Hood called for a frontal attack.

It was 4 P.M. when the Rebel battle lines, flags
unfurled, stepped out. Few Civil War combat
scenes were as free of obstructions to the view. As
15 brigades swept forward at quick step, Union
troops posted behind the perimeter anxiously
waited. Cleburne's and Brown's people momen-
tarily recoiled when they hit George D. Wagner's
advance division, and then stormed ahead. Wag-
ner's brigades broke and bolted for the rear. Con-
federates raised a shout, "Let's go into the works

with them," and the race was on. A number
of Cleburne's and Brown's men entered the works
to the left and right of the pike hard on the heels
of panic-stricken bluecoats.

Colonel Emerson Opdycke hurled his brigade
into the breach. Reinforced by two of Cox's regi-
ments, Opdycke's men, in furious fighting center-
ing about the Carter house and gin, drove back the
Confederates. General Cleburne was among those
killed in this savage fighting.

The Rebels attacked with reckless abandon.
Brigadier General John Adams led his brigade,
and, jumping his horse over a ditch, his steed was
killed astride a parapet, and the general pitched

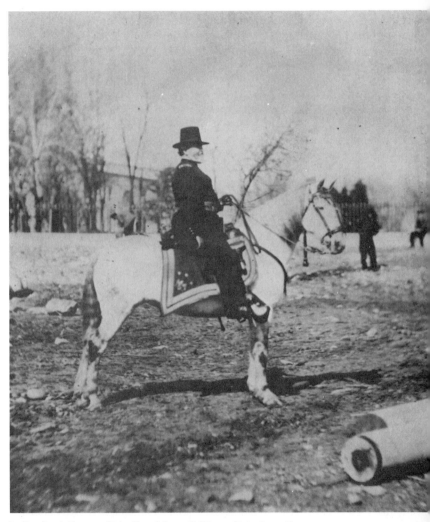

Leading those holdouts was Major General George H. Thomas. Today he would become the "Rock of Chickamauga," valiantly fighting on while nearly surrounded in order to cover the withdrawal of the rest of the army. (LC)

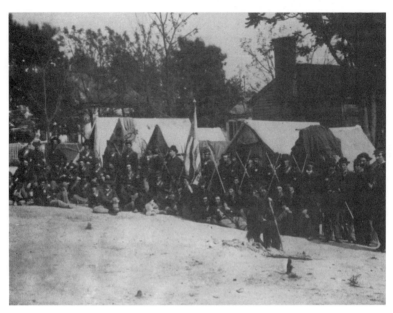

*Regiments like the 44th Indiana, cut off from their brigades, wandered to
Thomas' aid as he built a hasty defense against the ceaseless enemy attacks.*
(WRHS)

headlong among the defenders, mortally wounded.
Brown's division assailed the Union center in con-
cert with Cleburne's and grimly clung to a toehold
in the ditch fronting the works. Here, Brigadier
General Otho F. Strahl stood directing the fire of
his men. And here he fell. As darkness, which came
quickly, closed in, the combatants, separated by lit-
tle more than the parapet, banged away, aiming at
the flash of the enemy's rifle muskets. Brown had
been wounded; two of the division's four brigade
commanders, Strahl and States Rights Gist were
dead; George W. Gordon had been captured; and
John C. Carter was mortally wounded. Battered
but still victorious, the Federals withdrew at 11
P.M. when threatened yet again by Forrest on the
flank.

The Confederate charge at Franklin, pressed
with a savage ferocity, left the field strewn with
dead and wounded. Losses among the Rebel leaders
were staggering. General Hood reported 6,300 ca-
sualties. Five generals were killed, six wounded,
one mortally, and one captured. Union losses were
189 killed, 1,033 wounded, and 1,104 missing, of
whom more than a thousand were in Wagner's two
unnecessarily exposed brigades.

Schofield's tired but confident army reached
Nashville on the morning of December 1, where it
merged with the forces General Thomas was mass-
ing. General A. J. Smith had finally arrived from
the Kansas-Missouri border with his three divi-
sions, about 12,000 strong. Major General James
B. Steedman had rushed up from Chattanooga by

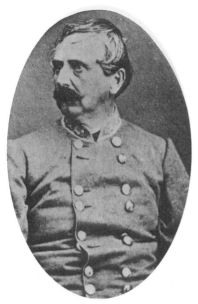

So heavily did the Confederates batter the Yankees that William Preston's division was not even needed until late in the day. He delivered the last major attack on Thomas, with fearful casualties. The general would later be appointed Confederate minister to Mexico. (DEPARTMENT OF ARCHIVES AND MANUSCRIPTS, LOUISIANA STATE UNIVERSITY)

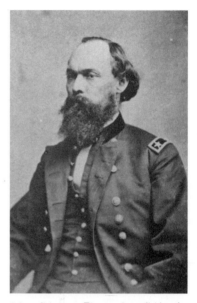

At last relief came to Thomas when a division of Major General Gordon Granger's Reserve Corps arrived in time to help repulse Preston. (USAMHI)

rail, bringing two brigades of blacks and a provisional division of casuals organized from soldiers belonging to Sherman's army group, who had returned from leave too late to participate in the March to the Sea. Most of Steedman's 5,200 officers and men reached Nashville on the evening of the 1st. But one train, having been delayed, was attacked on the 2nd by Forrest's cavalry five miles southeast of Nashville. The locomotive and cars were captured and destroyed. Most of the soldiers, however, cut their way through to Nashville.

Protecting the approaches to Nashville, a vital

Union supply base and communications center since February 1862, were a formidable belt of fortifications. These included redoubts, redans, lunettes, and star forts sited on knobs and hills commanding the roads entering the city from the region south of the Cumberland. These strongpoints were connected by rifle pits.

Thomas positioned his rapidly increasing army in the defenses, while General Hood, despite the Franklin mauling, boldly closed on the southern approaches to Nashville. His reasons for doing so have been challenged, but Hood, however, was a confident man and undoubtedly hoped that a blunder on Thomas' part might yet give the desperate Confederates a victory.

As he closed in on Nashville, Hood deployed S. D. Lee's corps in the center, across the Franklin

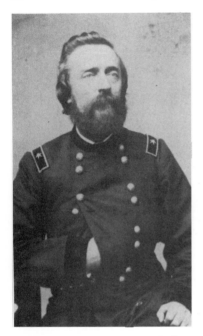

Leading the first brigade to arrive was Brigadier General Walter C. Whitaker, who marched "to the sound of the guns." (COURTESY OF BARBARA CHEATLY)

tially successful, their absence gave the Federals an opportunity. General Grant and the Lincoln administration urged Thomas to take the offensive. On December 2, Grant telegraphed from City Point, Virginia, advising Thomas to attack Hood immediately. Thomas, desirous of boosting the strength of Wilson's mounted arm, which had experienced difficulty coping with Forrest, decided to wait several days. But, on the 8th, the weather, which had been fair with moderate temperatures for more than a week, changed. Sleet and snow blanketed the area, all but paralyzing both armies. Thomas and his generals determined to wait for a thaw before moving out. His situation was not appreciated by Grant and the Administration, and, on the 13th, Major General John A. Logan was ordered to proceed from Washington to Nashville for the purpose of replacing Thomas. Grant, himself, was preparing to leave the nation's capital for Middle Tennessee when apprised of the successes scored by Thomas' troops on December 15. This news caused Grant to cancel the orders relieving Thomas and to return to City Point.

On the morning of the 15th, the snow and ice having melted, Thomas' troops moved out. A thick fog hid their march, but the mud slowed their deployment. Thomas' plan called for a feint against Hood's right, to be followed by a powerful thrust designed to envelop the Confederate left.

Advancing via the Murfreesboro pike, Steedman with two brigades, one of them black, attacked Hood's right—Cheatham's corps—between the railroad and pike. Steedman's demonstration focused Hood's attention on this sector. Spearheaded by Wilson's cavalry corps, A. J. Smith's powerful columns trudged out the Charlotte and Harding pikes and assailed Confederate forces guarding Hood's left. Chalmers' outnumbered Rebel horse soldiers were brushed aside and a supporting brigade of infantry mauled. In the fighting, as the battle lines wheeled southeastward, Wilson's cavalry to the right and Smith's infantry on the left, the Federals stormed Redoubts Nos. 4 and 5. Smith's divisions next approached a stone wall paralleling the Hillsboro pike and defended by men of Stewart's corps. Coincidentally, Schofield's XXIII Corps, which had supported the attack on Hood's left, took position on Smith's right.

Meanwhile, General Thomas Wood had committed his IV Corps to Smith's left. At 1 P.M. one

pike, A. P. Stewart's corps formed on the left, holding the Granny White and Hillsboro pikes, and Cheatham's corps to the right, its flank anchored near the railroad and Murfreesboro pike. One of Forrest's divisions, James R. Chalmers', was detached and guarded the several miles of countryside between Stewart's left and the Cumberland River. Forrest, with the rest of his corps, to effect a partial investment of Thomas' army, swept through the counties to the southeast and guarded the army's right.

Now Hood weakened his army by sending Forrest and William B. Bate's infantry division to harass Thomas' rail communications. Though par-

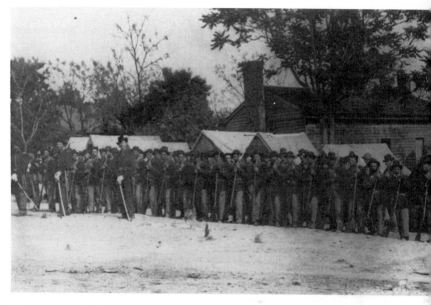

*Before their successful withdrawal, the last Federal volley fired by Thomas'
troops came from the 9th Indiana. Men of Company A pose here. Perhaps their
most illustrious private was young Ambrose Bierce, who would later become one
of America's most popular essayists and humorists.* (NA)

of Wood's brigades had carried Montgomery Hill,
a Rebel outpost midway between the lines in his
sector. Wood's battle formations then closed on the
rifle pits held by Stewart's people to the right and
east of the stone wall. The Confederate line at this
point formed a right angle. Assailed by Wood's
men coming in from the north and Smith's from
the west, Stewart's grim fighters were routed from
the salient. Simultaneously, Schofield crossed the
Hillsboro pike on a broad front.

Hood, his left shattered, hastened to occupy and
hold a new and shorter front. Too late, Hood rec-
ognized the folly of the overconfidence that had led
him to extend his lines in the presence of an enemy
possessing superior numbers. Orders were sent re-
calling Forrest, but it would be many hours before

he could rejoin the army. Sixteen cannon and
1,200 prisoners had been captured, Hood's main
line of resistance broken, and his divisions rolled
back two miles.

General Thomas met with his corps com-
manders that evening and made plans for a contin-
uation of the offensive. The night and morning of
the 16th were spent by the Federals adjusting their
lines and perfecting connections between units.

Then Union skirmishers advanced and found
the foe either strongly entrenched or posted behind
stone walls. Wood directed the fire of his artillery
against Peach Orchard Hill, while Smith's and
Schofield's cannoneers swept Shy's Hill with a
deadly crossfire. Wilson's cavalry, having dis-
mounted, pushed back Chalmers' outnumbered

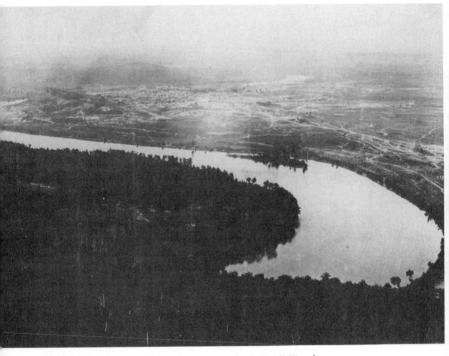

Rosecrans retreated to Chattanooga, and there began to fortify himself. Viewed here from Lookout Mountain, the city appears nearly a year later, with Moccasin Point in the Tennessee River in the foreground. Here for nearly two months the Federals sat and waited. (USAMHI)

division. About 3 P.M., while Union artillery pounded the Shy's Hill salient and Wilson's cavalry threatened to sweep Chalmers from the field and turn Hood's left, Wood and Steedman attacked Peach Orchard Hill. Covered by a host of skirmishers, four brigades ascended the slopes. Some of the Yanks gained the Rebel rifle pits, only to be dislodged by a slashing counterstroke by S. D. Lee's troops. The Union brigades recoiled, suffering heavy casualties, including one brigade commander and a number of officers.

Four o'clock was approaching and darkness would soon put a stop to the day's fighting. In the hollow fronting Shy's Hill, Brigadier General John McArthur of Smith's corps had massed one of his brigades. Coincidentally, Wilson's dismounted cavalry continued to gain ground, outflanking Govan's brigade, forcing back Chalmers, and threatening to envelop Cheatham's left. McArthur's brigade now stormed the steep slopes of Shy's Hill. In a short but desperate struggle, the bluecoats routed the Southerners from the rifle pits. Among the slain

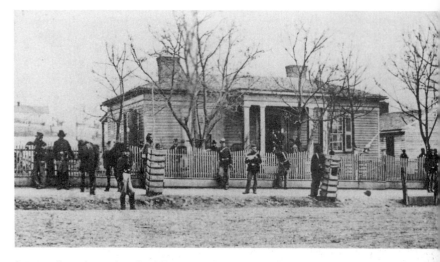

Rosecrans, disgraced, was to be replaced. Now commanding the Army of the Cumberland would be Thomas, his headquarters here in Chattanooga. (USAMHI)

was Colonel William M. Shy, of the 20th Tennessee, who gave his name to the hill. Shy's Hill was the key to Hood's position. Cheatham had no reserves to plug the breakthrough. Schofield's corps and Wilson's cavalry and other units of Smith's corps drove ahead. Abandoning their artillery, the Confederates posted west of Granny White pike fled.

As night fell, a drenching rain set in, adding to the confusion, darkness, and misery. Thomas ordered Wood to pursue by the Franklin pike and Wilson via the Granny White pike. Few, if any, Confederates retreated by the latter because of the proximity of Wilson's people. Hurriedly organized and defended roadblocks in the Brentwood Hills gaps and at Hollow Tree Gap, four miles north of Franklin, enabled a few dedicated units to delay Wilson's horse soldiers long enough for the shattered army to cross the Big Harpeth. At Columbia, Forrest rendezvoused with Hood's columns and with his cavalry, and five infantry brigades covered the army's retreat to the Tennessee River. Hood

crossed the Tennessee at Bainbridge, Alabama, on December 26 and 27, the campaign done.

Hood had played hell with the Army of Tennessee. A number of units would fight again in North Carolina and others in the defense of Mobile, but the once proud army had been destroyed as a feared fighting machine. Hood had lost the confidence of his officers and men, so, at his request, he was relieved of command by President Davis.

Thomas listed his losses in the decisive two-day Battle of Nashville as 387 killed, 2,562 wounded, and 112 missing. Hood failed to file a return of his casualties, but Thomas' provost marshal listed the number of prisoners captured and deserters received in November and December as more than 13,000. In addition, 72 cannon and 3,000 stands of arms were captured by the Federals. It was an altogether bloody and decisively fitting end to the fight for Tennessee, scene of some of the bloodiest and most decisive combat of the Civil War.

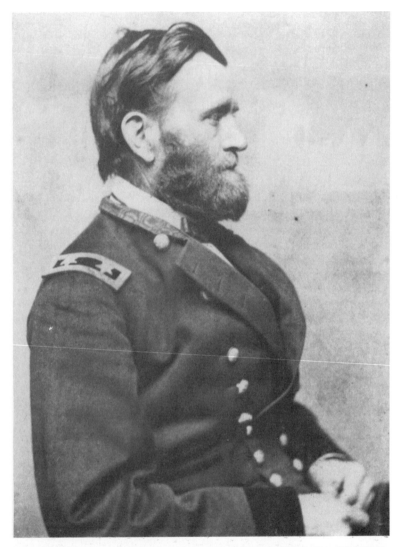

And on October 23, 1863, the new overall commander in the theater arrived, Major General U. S. Grant. This image was made in Nashville around this time by T. F. Saltsman. (COURTESY OF WILLIAM C. DAVIS)

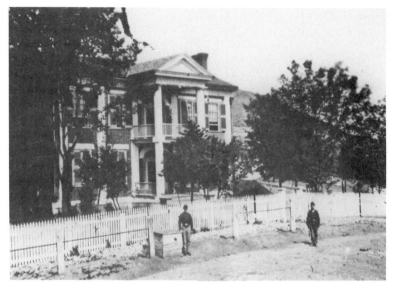

With Grant's arrival there was no question that the siege would be broken. He would not sit and wait here in his headquarters for long. (NA)

Reinforcements came in, among them Major General William T. Sherman with two corps. He made his headquarters here. (NA)

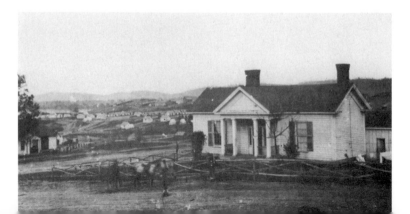

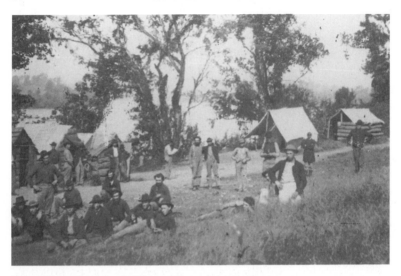

George N. Barnard's photograph of Union soldiers camped at Monument Garden near Chattanooga shows some of the hard-boned Westerners who will fight their way out of Chattanooga. (LC)

Grant's first chore was to break the strangling hold that Bragg had on his supplies. The "cracker line" is what they called the circuitous route by which Grant re-established his supply. It depended upon the Tennessee River. (USAMHI)

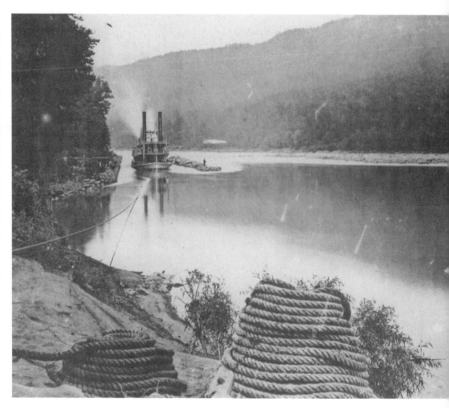

Supply steamers like the Missionary *sometimes had to be towed through the shallows as they went upstream.* (NA)

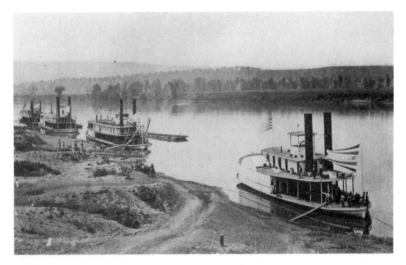

But still they came to tie up at the banks and disgorge their precious cargo.
(USAMHI)

They came, like the Chickamauga, *loaded with barrels of salt pork.* (NA)

Or like the Chattanooga, *piled high with sacks of grain.* (MHS)

There was usually a cannon aboard, and sometimes even a woman, as here on the Wauhatchie. (LC)

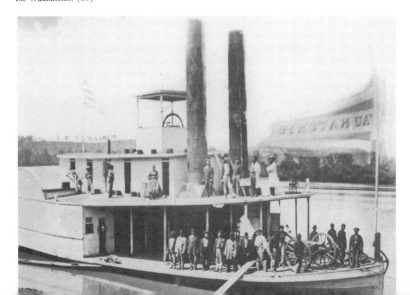

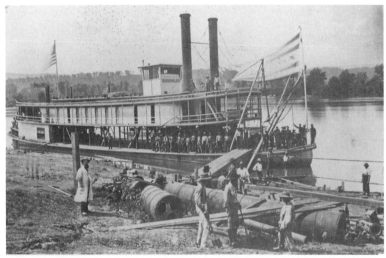

And here the Missionary *stands empty but for firewood, ready to return for more. The boiler parts in the foreground give evidence that the Federals had to be prepared for makeshift repairs and spare parts for these vital vessels.* (USAMHI)

Then they were off on the return voyage to get more of the food and material that kept Chattanooga supplied during the siege. Soldiers and civilians were there to watch them go, and to look anxiously for the next steamer. (NA)

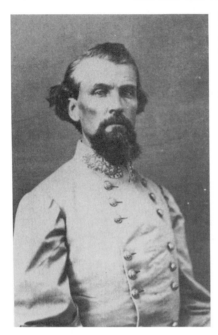

It was a tenuous lifeline, always in danger of attacks from Confederate raiders, particularly cavalry led by intrepid soldiers like General Nathan Bedford Forrest. He so loathed Braxton Bragg that he called him "a damned scoundrel" and declared that "if you were any part of a man I would slap your jaws." (USAMHI)

To protect against men like Forrest, Grant had gunboats such as the USS Peosta *patrolling the Tennessee, sometimes convoying the supply ships.* (USAMHI)

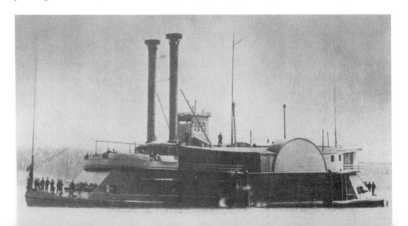

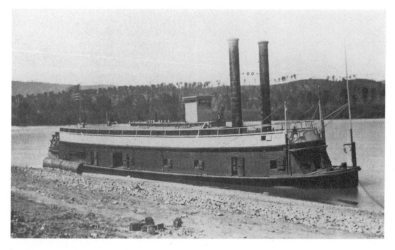

Some months after the siege, special gunboats would be commissioned to continue this duty after the armies had left Chattanooga. Here at her moorings sits the USS General Grant. *(USAMHI)*

Long a landmark in Chattanooga, this old Indian mound became a military office during the siege. "Visitors are requested to register their names at the office," reads the sign at the foot of the steps. (NA)

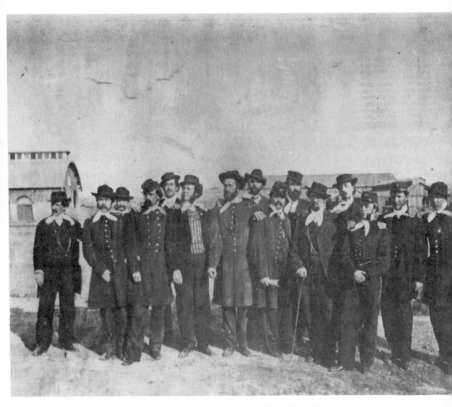

Life during the siege was at first a hardship for the scantily provisioned Federals, and then, once the "cracker line" was operating, the enemy became boredom. Here a jaunty band of neckerchiefed officers pose at the Western & Atlantic Railroad terminal. (COURTESY OF JOSEPH H. BERGERON)

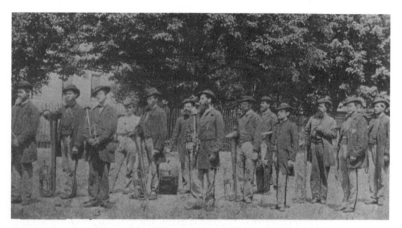

*Their musicians relieved what they could of the doldrums. Here the regimental
band of the 4th Minnesota, taken at Huntsville, Alabama, soon after the siege.*
(MHS)

*And as soon as the supplies could get in, the "robbers' rows" and sutlers' shops
appeared to relieve the soldiers of their pay. They were barely more than shacks
behind their facades.* (USAMHI)

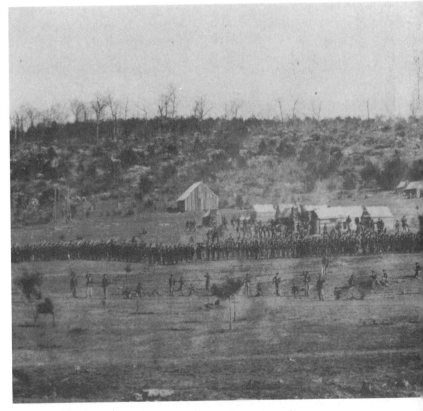

There was drill aplenty to keep the men in shape. Here several companies stand in double ranks during skirmish drill, their skirmishers and sharpshooters thrown forward as if on the advance. There would be plenty of this work for them before long. (USAMHI)

That work would come when Grant decided to take Lookout Mountain. Up these steep and rugged slopes some Federals had to climb and fight on November 24. (MHS)

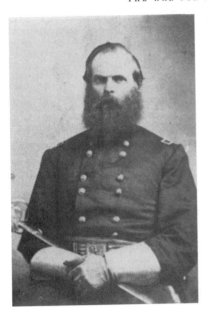

It was bloody and costly fighting. Brigadier General John W. Geary led a division that included his own son. In the battle just west of Lookout, in "Wauhatchie's bloody glen," his son was killed while his father was driving the Confederates off the mountain. (USAMHI)

In command of the attack on Lookout Mountain was a veteran of the Virginia campaigns, Major General Joseph Hooker. Here he stands with his staff with Lookout in the background. Hooker stands at the right, a head taller than the rest, while just behind him, looking away, is General Daniel Butterfield, often erroneously credited with composing "Taps." (USAMHI)

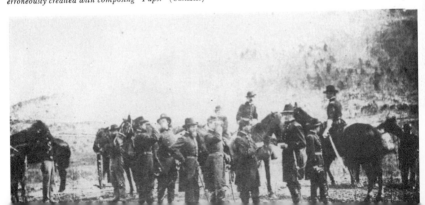

Hooker proudly sits atop his conquest, Point Lookout on the mountain's summit. (USAMHI)

Photographer R. M. Linn captured this view of the Confederate defenses and quarters atop Lookout Mountain. Fortunately, the Federals did not have to attack these directly, but moved around them. (COURTESY OF T. SCOTT SANDERS)

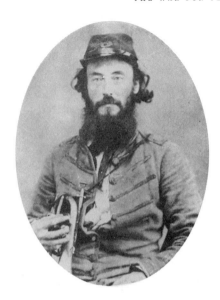

It was a fight in a dense fog much of the time, and some orders could be transmitted only by bugle call. A Confederate cornetist. (COURTESY OF CLYDE E. NOBLE)

The Lookout House on Lookout Mountain, high over the slopes overlooking Chattanooga and the battle that raged for the summit. A lone Federal sentry now stands vigil at its base. (MHS)

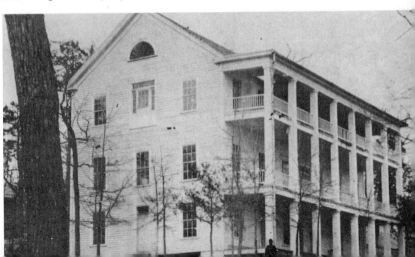

The day before the assault on Lookout, Grant sent Thomas forward to take Orchard Knob, the bald rise of ground seen between the two trees. George N. Barnard made this image from the crest of Missionary Ridge, providing the viewer with precisely the view that Bragg's Confederates had as they watched Thomas advance to take the knob. Two days later, from this same vantage, the Confederates watched in awe as the Army of the Cumberland swept across the intervening ground and up the slopes to the very spot where Barnard placed his camera. (USAMHI)

Here Barnard captured the view in reverse. The camera is now on Orchard Knob, and this is what Thomas' Federals saw as they began their assault up Missionary Ridge. (WRHS)

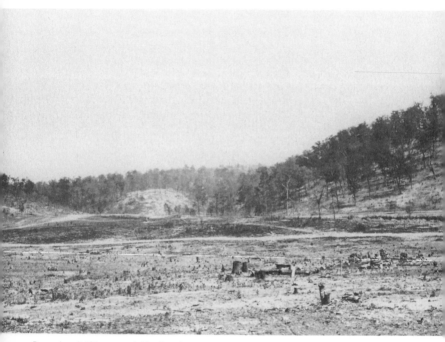

Barnard made this panoramic blending of images at Rossville Gap, the southern end of Missionary Ridge. Here Hooker attacked the left wing of the Confederate line, rushing past the John Ross house at the right and up the slope at left onto the ridge. (BOTH USAMHI)

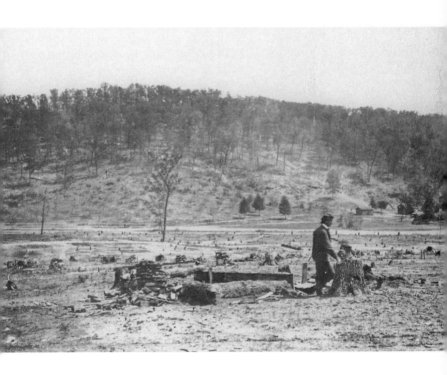

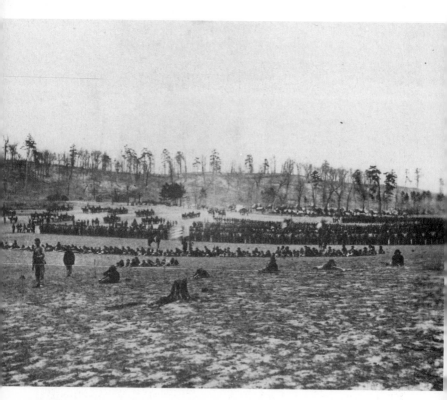

*Men of Gordon Granger's IV Corps practice forming for an assault,
sharpshooters and skirmishers in front, artillery in place to give support fire, and
the infantry drawn up in wave after wave of double-ranked soldiers. There may
be as many as two full brigades in this remarkable image, made at Blue Springs,
Tennessee. Granger's corps, including these men, struck at the very center of the
Confederate line on Missionary Ridge.* (USAMHI)

It was lean and tough Westerners like these who swept up the ridge to drive
Bragg's Confederates from the summit. An unidentified regiment. (RP)

In Barnard's view of part of the main run of Missionary Ridge, the lines of
Confederate defenses are faintly visible at the crest. Thomas' army marching in
full view up that slope unnerved many Southerners and helped lead to the rout
that followed. (USAMHI)

Another part of the five-mile line of summit that Bragg tried to defend. His army was so thinly spread that there was only one man for every seven or eight feet in places. (USAMHI)

Yet the men that he had were good ones. Men like the Washington Artillery of New Orleans, shown here in an unpublished image made in New Orleans in 1861. The officer seated is probably Colonel James B. Walton. (CONFEDERATE MUSEUM, NEW ORLEANS)

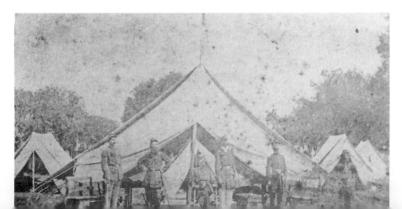

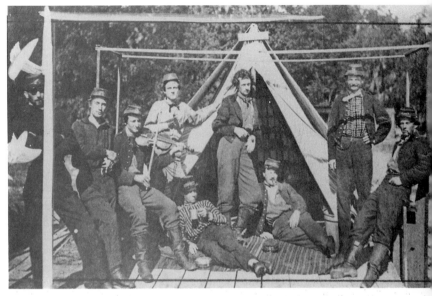

The men Walton led were hardy Louisianians like these, photographed in 1861 by J. W. Petty of New Orleans. The lines drawn on the image were probably made by designers in 1911 when they defaced the original photo in using it in Francis T. Miller's Photographic History of the Civil War. (USAMHI)

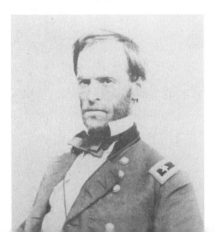

At the northern end of Missionary Ridge another attack was under way while Thomas and Hooker assaulted the center and southern ends. Here General William T. Sherman struck. (USAMHI)

Barnard captured the rugged and difficult terrain over which Sherman had to advance. The crest of Missionary Ridge runs off on the left, while in the distance rises Lookout Mountain. (USAMHI)

Assisting Sherman in his attack were artillerymen such as these, men of Battery B, 1st Illinois, the Chicago Light Artillery. They appear here at war's outset, at Bird's Point, Missouri, in May 1861. They will be battle-seasoned by the time they shell Bragg. (CHICAGO HISTORICAL SOCIETY)

Sherman's objective was Tunnel Hill, where the Chattanooga & Cleveland Railroad passed through this tunnel in Missionary. (NA)

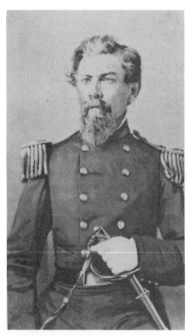

Opposing Sherman was Lieutenant General William J. Hardee. When the rest of the Confederate line on Missionary gave way to Thomas and Hooker, still he held out for a time, covering the retreat. Bragg never had a better subordinate. A heavily retouched prewar portrait taken when Hardee was in United States service. (CIVIL WAR TIMES ILLUSTRATED COLLECTION)

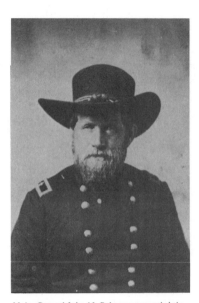

Major General John M. Palmer commanded the XIV Corps in the November 25 attack, virtually covering the entire battle line. One of his divisions held Thomas' right, another was the center division in the attack up Missionary, and yet a third of Palmer's divisions was with Sherman at Tunnel Hill. (CWTI)

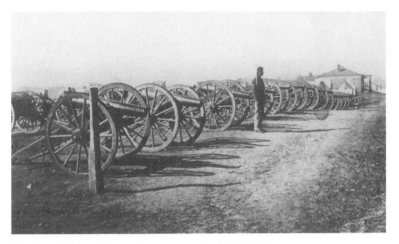

When the Confederates fled in rout from Missionary Ridge, they left behind them not only a signal Federal victory but also forty-two pieces of artillery. Here some 19 of the captured guns stand in line for the conqueror's camera. (USAMHI)

After the victory there was rest for a time, and a sense of revenge for the humiliation of Chickamauga. Federal generals like Brigadier John H. King established their headquarters in comfortable surroundings such as this Italianate masterpiece on Lookout Mountain. (COURTESY OF TERENCE P. O'LEARY)

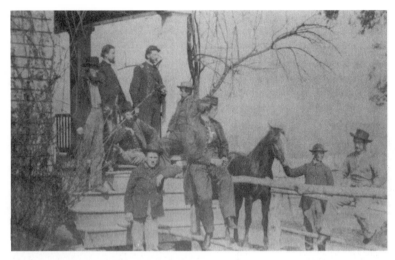

There was time to lounge and relax once again. (TPO)

Once again they could sight-see, here at Saddle Rock, for instance. "By sitting on this rock under a hot sun," they joked, "you can get a 'Saddle Rock Roast.'" (TPO)

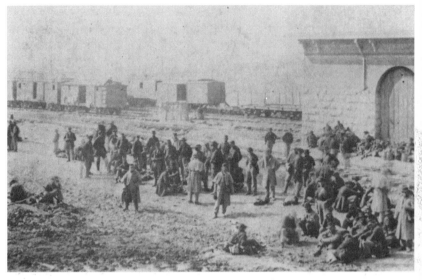

And in Chattanooga now the trains could come and go freely once more, taking men home for furloughs and bringing more back to continue the drive into the Confederacy. (MHS)

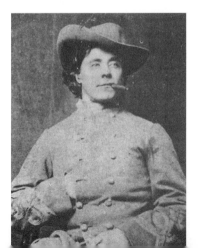

Though Grant did not pursue Bragg into Georgia after Missionary Ridge, the Federals did begin even then gathering information for the next campaign in the spring. Out of Chattanooga they sent W. J. Lawton, an intrepid Federal scout who often traveled in the uniform of a Confederate colonel, as he is seen here. In mid-December he penetrated deep into the Confederate lines, learning that after their defeat the Southerners were "low-spirited and demoralized and said they had lost all hope of ever gaining their independence." (USAMHI)

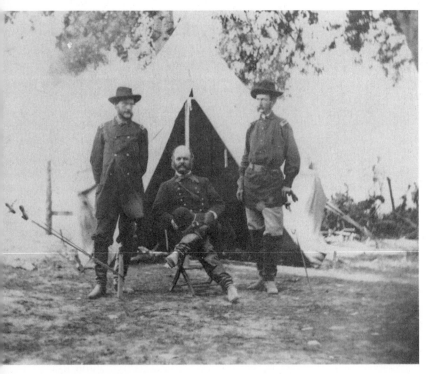

Even while the Chattanooga operations were under way, there was another campaign brewing in Tennessee, and it, like Chattanooga, brought another former commander from Virginia. Hooker fought for Lookout Mountain, and Major General Ambrose Burnside, the loser at Fredericksburg, defended Knoxville. Here he poses, seated, with his former chief of staff, Major General John G. Parke, standing at left. (COURTESY OF BRUCE GIMELSON)

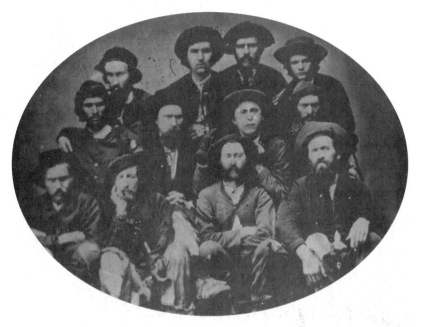

Burnside occupied Knoxville in September, freeing much of eastern Tennessee and allowing thousands of pro-Union Tennesseeans like these refugees to return home. These men were photographed in Knoxville just after their return, and the tattered condition of their clothing testifies to the hardships of their exile. (NA)

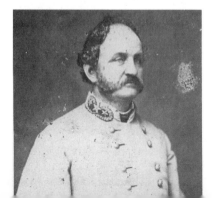

Soon after Burnside took Knoxville, Confederate Brigadier General John S. Williams came out of southwest Virginia to harass the Federals. (VM)

*Williams fought with elements of Parke's IX Corps here at Blue Springs in
October, but was forced back, ending any threat to Burnside for several weeks.
Here portions of Parke's corps are encamped, protecting Knoxville's northeastern
flank.* (LC)

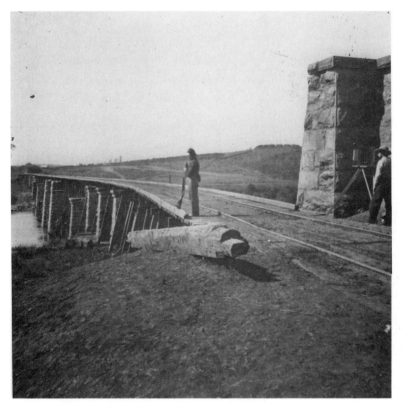

*George N. Barnard's view of the bridge of the East Tennessee & Virginia
Railroad crossing the Holston River at Strawberry Plains. It was a major
approach to Knoxville and well guarded, as the earthwork fort on the hill attests.
One of Barnard's assistants—perhaps it is Barnard himself—stands behind an
instrument at right.* (LC)

*This panoramic view, blending two images, shows Knoxville as it appeared
during the siege. It is taken from Fort Byington, west of the city, and looks across
it. The Holston flows past at right, with Fort Stanley rising above the river at the
south end. At the left center rise two hills containing important defensive works,
Fort Huntington Smith at the left and Fort Hill to its right in the distance.*
(BOTH NA)

Knoxville appears here in the spring of 1864, looking much the same as during its siege. Taken from the heights below Fort Stanley, this view looks north across the Holston. The Knoxville jail is at left. (LC)

Looking farther to the west, the camera shows the jail at right and, at far left, the University of Tennessee building. In the distant background just to its right is Fort Sanders. (LC)

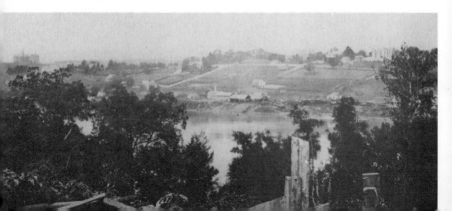

Another view of the university, this image made at the time of the siege. (USAMHI)

One of the defensive ditches on the perimeter of Fort Sanders, the Union bastion that withstood Longstreet's desperate assault. The university stands in the distance. (LC)

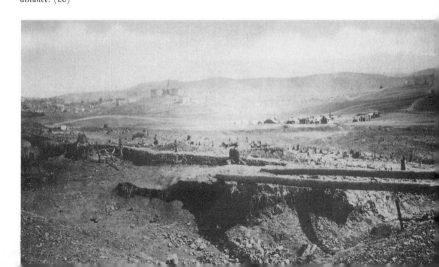

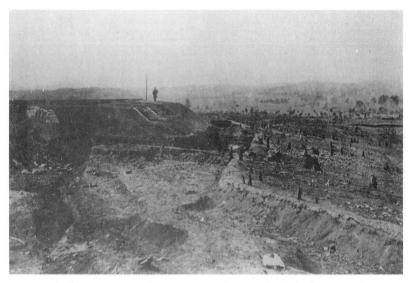

Fort Sanders not long after the siege. A lone soldier stands now where thousands struggled. (LC)

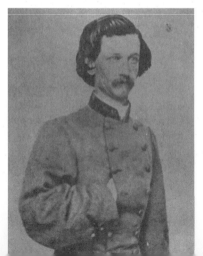

The Confederate chief of ordnance in the Knoxville siege was Lieutenant Peyton T. Manning, but for advice on the best use of his artillery, General Longstreet was more apt to turn to his devoted subordinate . . . (PRIVATE COLLECTION)

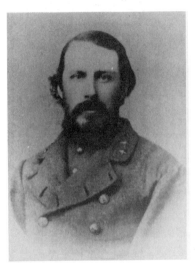

. . . Colonel E. Porter Alexander, chief of artillery. Through the entire campaign he lost only four guns, thrown into the Holston during the retreat. (TULANE UNIVERSITY LIBRARY, NEW ORLEANS)

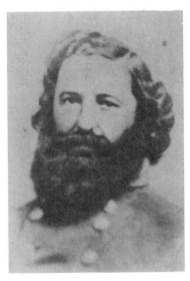

Less successful was Major General Lafayette McLaws, one of Longstreet's division commanders. His commander severely censured him for failing to take Fort Sanders, even though McLaws had fought well at Chickamauga. This portrait of McLaws was taken in Augusta, Georgia, in September 1863 during a brief stop in the trip from Virginia to join Bragg at Chickamauga. (TU)

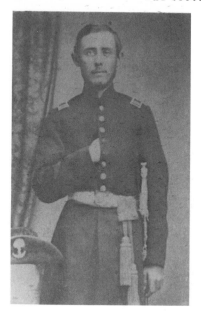

One of the first to die in the siege of
Knoxville, Major William M. Gist of the
15th South Carolina was instantly killed on
November 19 as he prepared to lead his
regiment in a charge. A Federal
sharpshooter's aim was true, and a fine
Confederate officer lay dead. (MUSEUM OF
THE CONFEDERACY)

Silent Fort Sanders after the siege was done. Burnside's chief engineer, Brigadier
General Orlando M. Poe, sits at left, facing Lieutenant Colonel Orville E.
Babcock, chief engineer of the IX Corps. The success at Knoxville was largely
due to their efforts. (USAMHI)

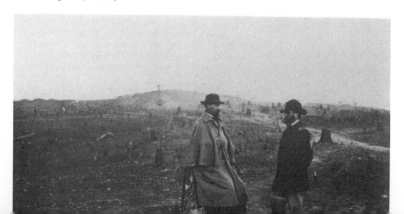

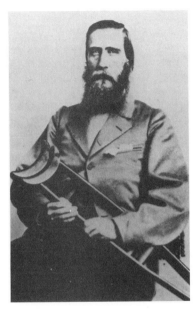

Tennessee was relatively quiet for almost a year, until November 1864 when one last Confederate invasion came out of Georgia. General John Bell Hood planned to leave Sherman behind in Georgia and meet and defeat Thomas and his army around Nashville. Then he could invade Kentucky. It was a bold plan, but boldness was in the character of the one-legged general, shown here around the end of the war. (CHS)

Hood and the Federals met first around the little town of Franklin, shown here in an early postwar image. (USAMHI)

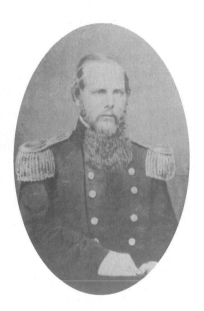

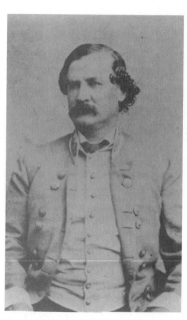

Commanding the three Union divisions in the fight at Franklin was Major General John M. Schofield, just thirty-three years old. Many years later he would recommend that the United States acquire Pearl Harbor in Hawaii. Schofield Barracks, near Pearl Harbor, is named for him. (USAMHI)

Hood's attacks at Franklin were brutal, costly to both sides, and in the end he almost wore out his army. Major General Benjamin F. Cheatham, often accused of drunkenness by Bragg, led one of Hood's corps. He was already under severe censure by Hood for allowing Schofield to retreat to fortified Franklin. (CHS)

Cheatham led his corps in an assault up the Columbia Pike against Federals placed behind the stone wall in the center of the photograph. (USAMHI)

Then the Confederates came up against Schofield's main line, part of it on the Carter farm, just in front of this gin house. (USAMHI)

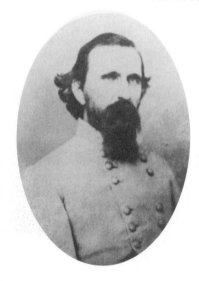

Brigadier General John C. Brown led his division in attacks on the Carter farm until seriously wounded. (CHS)

Half of Schofield's small army was the IV Corps, commanded by Major General David S. Stanley, seated second from the right. Nathan Kimball, seated at right, led the division that held Schofield's far right. General Thomas J. Wood, of Chickamauga fame, seated second from the left, stayed in reserve in the rear. The other generals are: seated at left, Samuel Beatty; standing, left to right, Ferdinand Van Derveer, Washington L. Elliott, Luther P. Bradley, and Emerson Opdycke. All except Van Derveer were in the battle. (USAMHI)

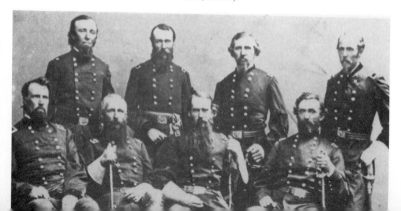

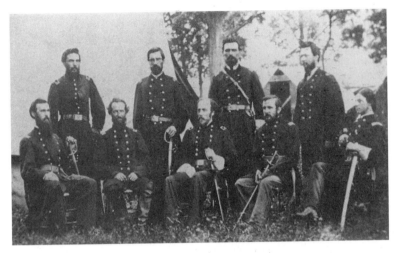

Opdycke, in particular, was outstanding. His brigade spent thirty minutes bitterly defending a gap that had opened in Schofield's line near the Carter house. He sits in the center here with his regimental commanders. The young officer at far right is only nineteen years old and already lieutenant colonel of the 24th Wisconsin and a Medal of Honor winner. He is Arthur MacArthur, future father of General Douglas MacArthur. (USAMHI)

Some of the bitterest fighting of the war rages around the Carter house, and it tells in the casualties. (USAMHI)

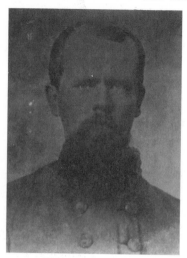

Colonel George A. Smith of the 1st Confederate Georgia Infantry was killed. (VM)

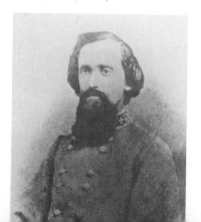

Brigadier General Otho F. Strahl was killed handing guns to his men. "Keep on firing" were his dying words. (USAMHI)

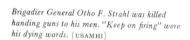

Brigadier General States Rights Gist, like Strahl, led a brigade in Brown's division. He was killed instantly in the attack. (USAMHI)

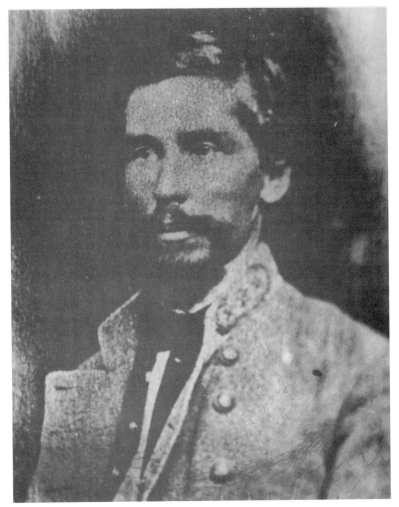

The cost to Hood's high command was devastating. Besides Strahl and Gist, Generals Hiram Granbury and John Adams were killed, and John C. Carter mortally wounded. But surely the most telling loss of all was the death of the premier division commander in the Army, Major General Patrick R. Cleburne. His was a loss that could never be replaced. (VM)

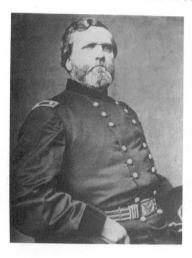

While Schofield battled Hood at Franklin, General Thomas readied the defenses of Tennessee's capital . . . (USAMHI)

. . . Nashville. George N. Barnard made this image several months after the Battle of Nashville, but it still reveals Federal soldiers encamped on the state house grounds. (KEAN ARCHIVES, PHILADELPHIA)

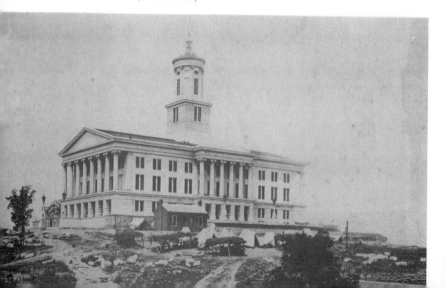

The state house in Nashville, with the Nashville & Chattanooga Railroad in the foreground. (NA)

The view looking west from the capitol. The log breastworks hastily erected on the capitol building are still in evidence, with loopholes for firing. They were not used, but give evidence of Thomas' determination to hold every inch of ground. (USAMHI)

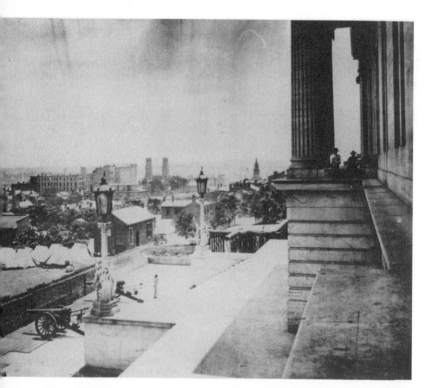

Looking south from the capitol across the city. Cannon and earthworks still surround the building. (CWTI)

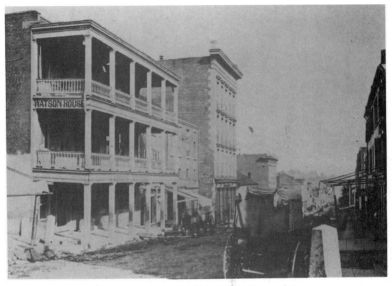

Market Street, off the public square, in downtown Nashville. (USAMHI)

*With Hood weakened after Franklin, Grant ordered Thomas to leave his
defenses and attack him. But Thomas would not do so until his cavalry was
properly mounted. Mounts were always a problem for the cavalry. Here in
Nashville, mechanics and smiths work at shoeing horses and keeping wagons in
running order.* (USAMHI)

It presented a deceptively peaceful picture prior to the fury that was released when Thomas finally did attack on December 15. (USAMHI)

The next day, December 16, while the battle raged south of Nashville, soldiers left in the outer defenses of the city listened to and watched what they could of the battle. (MHS)

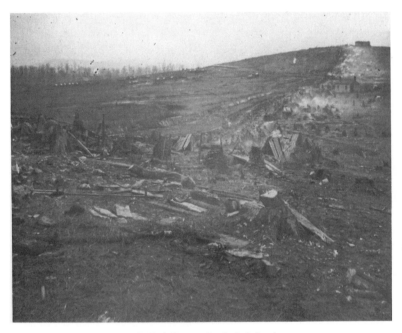

George Barnard captured much of the Nashville scene that day including, here, another view along the outer defense perimeter. Somewhere in the distance Hood's army was being virtually destroyed. (LC)

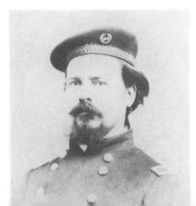

It was Brigadier General John McArthur's division that attacked and routed Hood's left flank on the first day of fighting. Hood never recovered, and McArthur won another star. (LC)

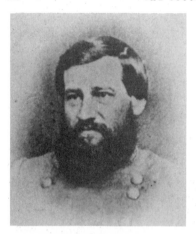

Lieutenant General Stephen D. Lee had missed the debacle at Franklin, but reached Nashville in time to command the corps holding the right of Hood's deteriorating line. His was the last Confederate command to hold its position as Thomas continued his attacks. (USAMHI)

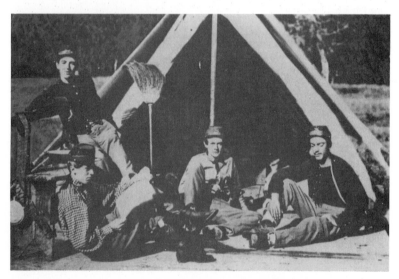

Brave Confederates like these enlisted men of the Washington Artillery were no match for the greater numbers and fresh troops under Thomas. When New Orleans artist J. W. Petty photographed them in 1861, they were jaunty. After Nashville, they and their army were devastated. (USAMHI)

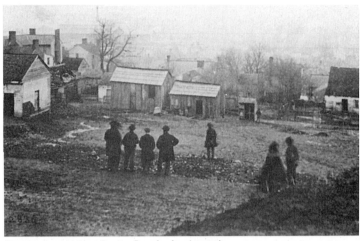

Everyone was a spectator on those two December days. (USAMHI)

Federal Fort Negley, south of Nashville. Hood never got close enough to attack it. (CHS)

Another view of Fort Negley, its gun embrasures glaring, like a smile with missing teeth, toward the Confederates. (USAMHI)

A casemate inside Fort Negley. The light is gleaming on a gun tube inside the ironclad casemate, but the gun will never fire. With the repulse and destruction of Hood, the last threat to Tennessee is at an end. For three years North and South bitterly contested the Volunteer State. Now at last it is decided, and with it rests much of the fate of the Confederacy. (USAMHI)

Squadron of the South

FRANK J. MERLI

Of ships and sea and suffocating the Confederacy

WHEN PRESIDENT ABRAHAM LINCOLN announced his intent to blockade the Confederate coast, he set on foot a host of problems for his Administration. For one thing, he violated a fundamental maxim of the American view of naval war —that there be no paper blockades. From the days of the Founding Fathers, Americans had insisted that in order for a blockade to be recognized in law it had to be maintained by forces sufficient to prevent entrance to and exit from the ports under blockade. However, in April 1861 the Union Navy simply did not possess enough ships to seal off the 3,500-mile shoreline of the South.

Of course, the President asserted his intent to post a competent force "so as to prevent entrance and exit of vessels from the ports aforesaid." But obviously, with only eight warships in home waters at war's outset, that was bold talk. And before the North could build or buy the ships that would demonstrate its determination to close the South to foreign trade, the European powers would monitor the blockade and assess its impact on their interests.

In the opening weeks of the war—about the time foreign officials started sorting out their responses to conditions in America—a talented Washington naval administrator began devising means to subdue the South by way of its vulnerable seacoasts. Alexander Dallas Bache, great-grandson of Benjamin Franklin, promoter par excellence of technological and scientific innovation, superintendent of the coastal geographic survey, and a supremely gifted political infighter, saw and grasped an opportunity to merge his interests with those of the navy and the nation.

Bache's suggestion for a naval planning board to develop a comprehensive strategy for implementing the blockade therefore found a sympathetic hearing, especially after John C. Frémont, a prominent Republican then in London, warned of "very active" and well-financed Confederate efforts to buy up large numbers of steamers in British shipyards. Secretary of the Navy Gideon Welles and his assistant Gustavus V. Fox remembered the proposal for a centralized naval coordinating committee and set about establishing it. Fortunately, they had at their disposal a number of talented men for the task. In addition to Bache, the Strategy Board, as it came to be called, consisted of Commander Charles H. Davis, Major John C. Barnard, representing the Army Corps of Engineers, and Captain Samuel F. Du Pont, a capable, if sometimes controversial, naval officer who acted as the board's president. Less than a month after its inception, it had pre-

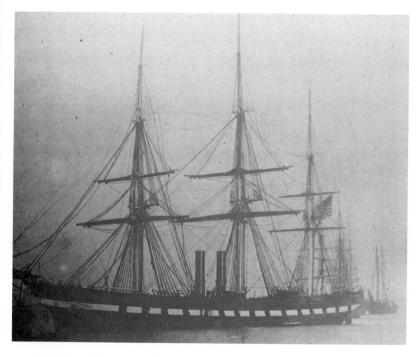

As with the origins of the North Atlantic Blockading Squadron, its Southern counterpart had to depend at war's start upon ships already in service, and often of checkered careers. The USS Niagara, *shown here in September 1863 at Boston, was the steam frigate that helped lay the first transatlantic cable. In 1860 she carried Japan's first diplomatic mission to the United States, then returned to America in April 1861 to find civil war. Immediately she went on the blockade.* (LC)

pared a number of important reports, suggesting division of the Southern coastline into four commands, the North Atlantic, South Atlantic, East and West Gulf Squadrons. The navy must seize a base in each, which, besides providing convenient supply and repair facilities for the fleets would also discourage European intervention for the South. They must show Europe that they could control their coastline.

In the autumn of 1861, as Captain Du Pont began massing his Federal armada for its assault on Port Royal, South Carolina, and began assembling and deploying the forces that would become the South Atlantic Blockading Squadron, the chief of Confederate naval procurement in Europe, Captain James D. Bulloch, started planning a challenge to that squadron. Bulloch decided to buy a ship, stock it with much-needed war material, and

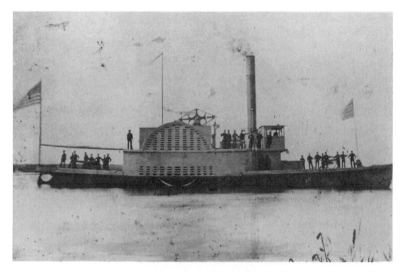

Warships were not available in abundance to begin Mr. Lincoln's stranglehold on the Southern coastline. This wooden side-wheel tugboat, USS O. M. Pettit, was purchased by the Navy at the war's start and sent south. She appears here in 1862 off Hilton Head, South Carolina. (USAMHI)

run it through the blockade. He set about that task with the flair and skill that marked all he did—and he succeeded brilliantly. The *Fingal* was loaded in Scotland, Bulloch and other passengers did not board until after she cleared customs, and after a slow passage the *Fingal* reached Bermuda on November 2. Now she prepared for the final, most perilous steps in the journey to the American coast.

Meanwhile, Union countermeasures began to yield results. On the same day that newly promoted Rear-Admiral Du Pont issued his General Order No. 1 to the commanding officers of the blockading vessels under his command, on October 24, 1861, Secretary of the Navy Welles sent him a warning that the *Fingal* was coming, loaded with supplies for the rebellion. Further, Welles had learned that a Confederate firm in London had purchased the vessel, making her "in reality a Confederate ship." That made her fair game.

After circumventing efforts of the American consul at Bermuda to deplete his crew and deprive him of coal, Bulloch set out for the southern coast on the afternoon of November 7. At a deck conference Bulloch took the men into his confidence, explained his mission, and asked for volunteers. To the question "Will you go?" he received unanimous assent. He then explained his intention to defend the ship against the Savannah blockaders. In the event of an encounter with a blockader, Bulloch intended to take control of the ship and fight it. Would the crew help? Again, to a man, they answered, "Yes."

After settling affairs with the deckhands, Bulloch looked to the most important preparation for a successful dash past the blockaders, the steam engine. As Bulloch explained his plan, Chief Engineer McNair told him that "he had been putting aside a few tons of the nicest and cleanest coal," that if

Ships that accompanied the first offensives directed at the Confederate coast then stayed on post to do blockade duty. The USS Unadilla *was with the Federal fleet that attacked and occupied Beaufort, South Carolina, in November 1861. Thereafter she patrolled those waters, her hearty crew denied another real fight until war's end.* (USAMHI)

Bulloch could arrange for him to clean his flues and fireboxes, the engines might be made to drive the ship, overloaded as she was, at 11 knots for a brief period.

The last night out, soon after midnight, "as nice a fog as any reasonable blockade-runner could have wanted" enveloped the ship, and under its protection the *Fingal* edged toward land, so as to be inshore of patrol boats. With lights out, engines silent, nerves taut, the crew waited for daybreak. Suddenly, an eerie wail, a sound like an "unearthly steam whistle" threatened to reveal their presence to every Federal vessel for miles around. Then it came again. The offending chanticleer, that bird of

morning, did not greet the sun, for it met quick and violent death at the hands of an irate sailor.

At daybreak all was in readiness for the final dash into the harbor. The engineer's preparations proved their worth, as the engines now propelled the ship northward at a steady 11 knots. Even the elements helped, for the fog moved out to sea, forming a curtain between the shore and any patrol boats in the vicinity. Soon the *Fingal* sighted the massive brick walls of Fort Pulaski, crossed the bar, hoisted the Confederate flag, and acknowledged the waving hats and inaudible cheers of the men lining the parapets of that ill-fated fort. Then, close to safety, the *Fingal* ignominiously ran

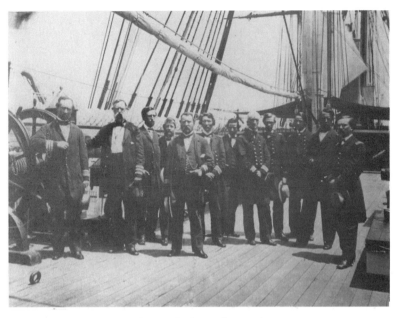

The first commander of the South Atlantic Blockading Squadron upon its creation on September 18, 1861, was Rear Admiral Samuel F. I. Du Pont, standing second from the left aboard his flagship USS Wabash in 1863. He enjoyed a notable career during the Mexican War, then began the Civil War by planning and executing the attack on Port Royal and Hilton Head. (USAMHI)

aground. Some hours later, with the help of a rising tide and local tugs, the *Fingal* completed her voyage upriver to Savannah at 4 P.M., November 12, 1861. She brought with her, by Bulloch's estimate, the greatest military cargo ever imported into the Confederacy. Bulloch himself modestly noted that probably "no single ship ever took into the Confederacy a cargo so entirely composed of military and naval supplies." In this, as in so much else connected with his Civil War career, he makes a reliable witness, though his contribution to the Confederate cause is vastly underrated all too often.

The original Confederate plan called for Bulloch

to stock the *Fingal* with cotton for the credit of the Navy Department abroad and to "return to Europe with her to carry out the further purposes of the government there." But from about November 25, 1861, until February 5—when Bulloch returned to Europe by an alternative route—it proved impossible for the *Fingal* to slip past the blockaders of the Union Squadrons.

During his enforced idleness at Savannah, Bulloch studied the strength and movements of units of the South Atlantic Squadron and assessed Confederate defenses and possibilities of keeping the port open to foreign commerce. His starkly professional reports make grim reading. At the Wassaw

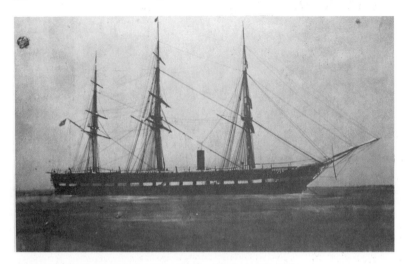

Du Pont's mighty ship, the Wabash, *taken in Port Royal Harbor in 1863, from
the deck of the monitor USS* Weehawken. *Ironically, the only known image of
the* Weehawken *that survives is the stanchion and rope that appears in the lower
left of this image.* (USAMHI)

outlet Union forces consisted of anywhere from
four to seven ships, "frequently as many as eleven";
the enemy seemed fully informed of the *Fingal's*
position and of Southern plans to get her out to
sea: "Unless there be some changes in the politi-
cal relations of the United States with the courts of
Europe, I consider the port of Savannah as com-
pletely closed to commerce for an indefinite time.
There are . . . five ships-of-war at the entrance to
the Romerly Marsh, a force too powerful for the
simple blockade of the *Fingal,* and this assembling
of the enemy's fleet can only be regarded as prelim-
inary to an attack in force upon the city."

But of all of Bulloch's commentaries on condi-
tions in Savannah and of his attempts to get the
Fingal out past enemy blockaders, one has a partic-
ular poignancy. On November 25, 1861, Bulloch
told Secretary of the Navy Stephen R. Mallory:

I have the honour to report that the steam-
ship *Fingal* has been discharged, and now lies

in the Savannah River ready to receive
freight. . . . I cannot refrain from urging the
necessity of getting the ship off without delay.
Yesterday five of the enemy's gunboats stood
cautiously in, and after throwing a number of
shells upon and over Tybee Island, a force
was landed without opposition. This morning
the Federal flag is flying from the lighthouse,
and they will doubtless soon have a battery
upon the point of the island. The only egress
left for the *Fingal* is through Warsaw [*sic*]
Inlet, and it can scarcely be supposed that the
enemy will permit it to remain open many
days.

Perhaps his pressing concern for getting the *Fin-
gal* back to England and for resuming the vital
tasks assigned to him by the Navy Department
prevented the usually astute Bulloch from assessing
the larger significance of that Federal flag on Tybee
Island's lighthouse.

From the USS *Savannah,* at anchor off Tybee Bar at 1 P.M. on November 25, Commander J. S. Missroon reported to Flag Officer Du Pont that at 3 P.M. the previous evening Commander John Rodgers "hoisted the flag of the Union on the martello tower and light-house . . . [on Tybee Island]." Du Pont lost no time in conveying this good news to his superiors in Washington. "I have," he told Welles, "the honor to inform the Department that the flag of the United States is flying over the territory of the State of Georgia. . . . I am happy now to have it in my power to inform the Department that the *Flag,* the *Augusta,* and the *Pocahontas* are at anchor in the harbor abreast of Tybee beacon and light, and that the *Savannah* has been ordered to take the same position. The abandonment of Tybee Island on which there is a strong martello tower, with a battery at its base, is due to the terror inspired by the bombardment of Forts Walker and Beauregard, and is a direct fruit of the victory of the 7th." Then Du Pont added a strategic prediction of some importance: "By the fall of Tybee Island, the reduction of Fort Pulaski, which is within easy mortar distance, becomes only a question of time."

Given the supposed impregnability of the massive masonry walls of Pulaski, few, especially among the local Southern military commanders, would have agreed with that assessment. But in early 1862 steps were already under way to reduce the sentinel of Savannah.

In its first report of July 5, 1861, the Strategy Board had called for the capture of "a convenient coal depot on the southern extremity of the line of Atlantic blockades, and . . . if this coal depot were suitably selected it might be used not only as a depot for coal, but as a depot of provisions and common stores, as a harbor of refuge, and as a general rendezvous, or headquarters, for that part of the coast." The place selected by the board for these functions was Fernandina, roughly on the Florida-Georgia border. In addition to the many advantages Fernandina offered as a supply depot, its possession would afford Union forces considerable opportunities to cut off rail and water trade with other parts of the South—it would, in short, serve much the same function at the southern terminus of the blockade that Port Royal and Hampton Roads served in the North. It would give the Squadron effective control over the Georgia coast.

An unpublished portrait of a black seaman aboard the Wabash. *Hundreds of Negroes served in the Union Navy and aboard the blockading ships.*
(PAUL DE HAAN)

"And," as the board noted, "the naval power that commands the coast of Georgia will command the State of Georgia."

Although Du Pont wished to commence the Fernandina offensive as soon as the Port Royal operation was completed about mid-November 1861, a number of factors combined to delay the start of that operation until early in 1862. Toward the end of 1861 the naval and military commanders, Du Pont and Brigadier General Thomas W. Sherman, had agreed "to some kind of offensive against Savannah," but the ambitious undertaking, requiring logistical resources (especially supplies of coal) and coordination of command facilities not then available, proved "too intricate and hazardous," and it had to be curtailed. As a sort of compromise, the navy set out for Florida, and the army set about preparing for the task of reducing Fort Pulaski, a major obstacle to control of the en-

*Commander C. R. P. Rodgers was captain of the
Wabash while Du Pont flew his flag in that ship,
commanding it in the attack on Port Royal. In the
later siege of Fort Pulaski, Rodgers led the naval
force that fought on land in the trenches, and in
1863 took the helm of the ironclad New
Ironsides.* (USAMHI)

*Fort Pulaski was the next major move for the
Southern squadron, but first there was extensive
preparatory work. Ships like the Coast Guard
schooner* Arago *did hydrographic work along the
shore and in the channels, making some 60,000
casts of the lead in sounding over 300 miles of
coastline. Only armed with this knowledge could
Du Pont's ships brave the Confederate shores and
inlets.* (USAMHI)

trances to Savannah. While Sherman set his plans
in motion, Du Pont assembled his armada for the
assault on what would become the southern depot
of the South Atlantic Squadron.

The long-awaited attack on Fernandina when it
came proved an anticlimax. On March 4, Du Pont
reported himself in complete possession of the ob-
jectives of his mission, having achieved that goal
merely by defending his forces against "a few scat-
tered musket shots . . . from the town." Du Pont's
report of the expedition to Secretary Welles con-
tains a capsule comment on the affair that would
be difficult to improve upon: "We captured Port
Royal, but Fernandina and Fort Clinch have been

given to us." If he knew the reason for the "gift"
he did not mention it in his report.

After the loss of Port Royal, General Robert E.
Lee and other Confederate leaders had reluctantly
concluded that the defense of the Atlantic seaboard
was impracticable and beyond the capabilities of
military and naval forces of the South. Except in a
few special cases, as, for example, Charleston, Con-
federate forces would withdraw inland, out of
range of Union naval bombardment. In early Feb-
ruary 1862, General Lee wrote to General James
M. Trapier, commander of the Florida military
district, that Fernandina might have to be aban-
doned unless sufficient guns could be found to
command the entrance to the Cumberland Sound,
"the back door" to the island. By February 24 the
Confederate high command realized that no guns
could be supplied to the Cumberland forts, and

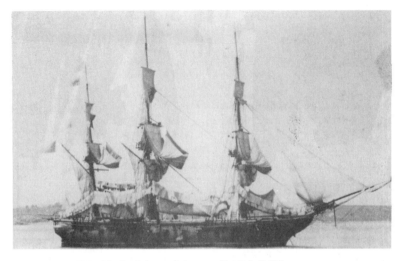

The first goal was Tybee Island, which controlled access to Fort Pulaski. Ships like the USS Savannah . . . (USAMHI)

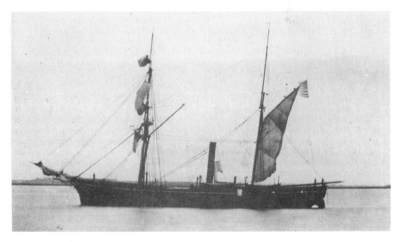

. . . and the steam sloop Pocahontas *mustered for the November 24, 1861, attack.* (USAMHI)

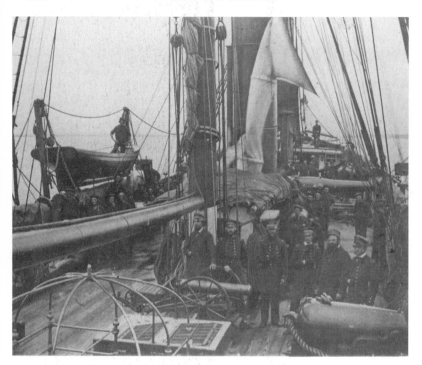

The officers of the Pocahontas *. . . .* (USAMHI)

Trapier was authorized to evacuate his defenses. The logic of Southern strategy, not overpowering Union strength, gave Du Pont control of the South Atlantic Coast at no cost. The navy subsequently played only a minor, token role in the later attack on Fort Pulaski, which was predominantly an army operation. Federal troops had occupied Tybee Island, about a mile from the fort, in late 1861, and by early April 1862 they had constructed eleven batteries, including ten 9-inch Columbiads, heavy rifled guns, and emplacements of 13-inch mortar.

Although the attack on Fort Pulaski did not lead to the surrender of Savannah, it did demonstrate another lesson of "modern" war—that walls, however massive and well constructed, could not withstand the pounding of heavy rifled cannons, especially those equipped "with these wonderful projectiles which we now possess," as one Union gunner summed up the encounter. In fact, so poorly defended was the fort that it took Federal forces a mere 30 hours and about 5,275 shots on April 10–11 before the Confederate commander, twenty-six-year-old Colonel Charles H. Olmstead, surrendered. But he raised the white flag only after the fort's flagpole, flying the Stars and Bars, had been shot away three times and the fort's magazine stood exposed to the danger of imminent explosion

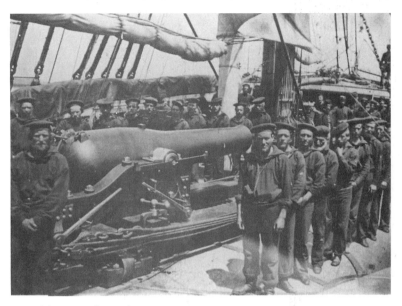

. . . and the men . . . (USAMHI)

from enemy fire. His seven and one-half-foot thick walls crumbled under Yankee bombardment.

A reporter for a local newspaper visited the shattered fort soon after its surrender and left this account: ". . . all the parapet guns were dismounted. . . . Every casemate gun, except one, [was] dismounted and the casemate walls breached in almost every instance to the top of the arch —say between five and six feet in width. The moat outside was so filled with brick and mortar that one could have passed over dry-shod. . . . The parapet walls on the Tybee side were all gone, in many places to the level of the earth. . . . The protection to the magazine in the northwest angle of the fort had all been shot away; the entire corner of the magazine next to the passageway was shot off, and the powder exposed, while three shots had actually penetrated the chamber."

The role of the South Atlantic Blockading Squadron was limited and of minor significance.

For a time the naval component of the expedition camped on the beach, without being allowed into combat, for all the guns had been manned. Then, after an insubordinate colonel had been relieved of his command and his German troops refused to fight without him, the sailors of Du Pont replaced them and served with distinction. The naval battery, firing three 30-pound Parrott rifled guns and one 24-pound James rifle, proved to be one of the two deadliest components of the Union attack. Commander C. R. P. Rodgers later reported that his rifled guns bore "into the brick face of the wall like augurs," while the columbiads were "striking like trip hammers and breaking off great masses of masonry which had been cut loose by the rifles." The general in command recognized the services of the Navy by including Naval Lieutenant John Irwin in the party that accepted the Confederate surrender of the fort.

This left the *Fingal* trapped in Savannah, and

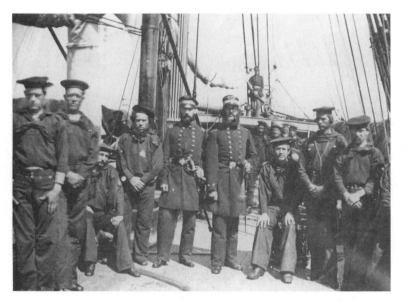

. . . and the boat's crew of the ship's cutter were all ready for the attack on . . .
(USAMHI)

now that presented the Confederate defenders with a glorious opportunity to augment their naval forces. In the spring of 1862 the vessel was turned over to a local shipyard for conversion into an ironclad. In time the blockade runner *Fingal* became the ironclad CSS *Atlanta,* and her story is very much part of the adventures of the South Atlantic Blockading Squadron.

First, the ship was cut down to her deck, which was slightly widened and overlayed with a thick layer of timber and iron. "A casemate was built, the sides and ends inclining at an angle of about 30°." The sides and ends of the casemate were covered with about four inches of iron plate, secured to a backing of three inches of oak over 15 inches of pine. She was armed with two 7-inch rifled guns on bow and stern pivots, and two 6-inch rifled guns in broadside.

As soon as the ship was completed, a public

clamor "to do something" with so magnificent a weapon arose, and the public political pressure prevailed over the calmer, more prudent plans of the naval authorities charged with the defense of the city. "Although the [city] council considered the Confederate armorclad to be competent to almost any achievement," Tattnall knew better. His experience with the *Virginia,* plus his knowledge of the *Atlanta*'s deficiencies, convinced him that she would not stand a chance. "I considered the *Atlanta* no match for the monitor class of vessel at close quarters, and in shoal waters particularly." Despite his considerable misgivings about the wisdom of trying to run past the Union guardships, Tattnall agreed to make the attempt. But Union reinforcements of the outlets with the new class monitor *Passaic* stymied Southern plans, at least for the moment.

After several shake-ups in the Savannah naval

. . . Tybee Island. They took it without opposition, thus gaining a foothold at the mouth of the Savannah River and a perfect base for the attack on Fort Pulaski, which defended the city. (USAMHI)

command, Mallory found a man anxious for action. The new commander, William A. Webb, had a reputation with fellow seamen as "a very reckless young officer," one who received his appointment primarily because "he would at once do something." His plans included, among other things, to "raise the blockade between here and Charleston, attack Port Royal, and then blockade Fort Pulaski"—all this without assistance, if need be!

Union intelligence about the maneuvers and plans of the *Atlanta* were "uncanny." When, on the night of June 16, she attempted to surprise the Union forces, a lookout on the monitor *Weehawken* spotted her approach and sounded the alarm at 4:10 A.M. Captain John Rodgers, commander

of the Union monitor, was a member of one of America's most illustrious naval families and an experienced officer in his own right, with a reputation for courage and audacity. He commanded an experienced crew that knew its business, cleared for action, and took their ship downstream ready for any contingency, though they and their captain were a bit puzzled by the opening gambit in this game.

Upon entering the Wilmington River, Webb had sighted his quarry, and in his enthusiasm to attack he left the narrow channel and ran aground, a perfect target for the gunners on the *Weehawken*.

Approaching the grounded ship to a range of about 300 yards, Rodgers opened fire with his 11-

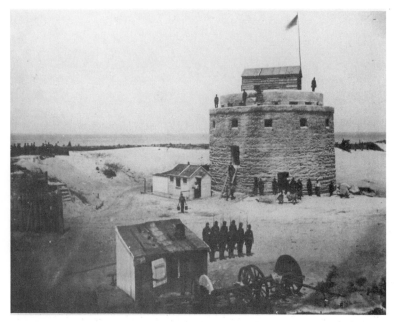

It was a place that had been defended before, 304 years before to be exact. The Spaniards erected this martello tower on Tybee in 1557. No longer are there halberds and burnished breastplates, but the soldiers are much the same, like the tower itself, eternal. (USAMHI)

and 15-inch Dahlgrens, and four out of five shells fell with devastating impact on the near-helpless Southern ship. One shot wounded as many as 40 or 50 men. Other shots disabled guns, shot away the pilot house; and Webb's immobility and list prevented him from bringing any of his own guns into effective play. He fired some seven shots, none of them effective. Fifteen minutes of battle—if it can be called that—convinced Webb that he had no choice but to surrender.

Rodgers got a vote of confidence from Congress and a promotion to commodore; the Navy Department believed that its faith in the new monitor class had been vindicated at the bar of history; and Admiral Du Pont could turn over command of the

South Atlantic Blockading Squadron to Admiral John A. Dahlgren with a measure of contentment, that, while sweet, did not quite erase the bitterness of his failure to capture the cradle of the Confederacy at Charleston, South Carolina.

From the beginning of the war, Charleston, South Carolina, "the cradle of the Confederacy" and "the hotbed of secession," had possessed a peculiar fascination for Union military and naval planners. Consequently, Washington devoted more resources and time to the subjugation of the city than its military importance justified. However splendid the city might be as a symbol of Confederate defiance, it had no war industries of importance, and its comparatively inadequate rail net-

work with the rest of the South deprived it of any great utility as a way station for blockade-runners.

Yet, Federal naval administrators, especially Assistant Secretary of the Navy Gustavus V. Fox, regarded capture of the city as "the ultimate propaganda prize" for the United States Navy; further, capture of the city would enhance the department's reputation and demonstrate its worth by "attaining a spectacular psychological victory," and in addition a Union victory at the heart of rebeldom would mute press and congressional criticism of the department and confirm the Administration's faith in the invincibility of the newer class of monitors, then coming off the stocks of northern naval yards.

Du Pont wished a carefully prepared and coordinated attack on the city, not because it had any military value, but because failure at so prominent a place might have disastrous domestic and international repercussions. Impressed by some of the technological improvements in Union ships and guns, Du Pont nonetheless retained substantial reservations about the plans outlined to him by his superiors. More important, he was made to believe that the Navy was expected to take the city: he had "to recognize that this operation was of no consequence to the Army" and no troop reinforcements could be expected for the raw recruits that had been sent to the region. And Du Pont made an important mistake: he never fully convinced his superiors that in fact "he was fundamentally opposed to the *method* of attack" rather than to merely this or that tactical aspect of the plan.

At noon on April 7, 1863, Du Pont ordered his offensive, with the *Weehawken* in the van, pushing a raft to clear mines and torpedoes from the column's line of approach. The Confederates had not only heavily obstructed the channels but they had marked them with range finders, which greatly increased the accuracy of the fire with which they were able to rake the Union ships as they advanced into range. The *Weehawken*, for example, engaged the enemy for some 40 minutes, sustaining over 50 hits, and as she disengaged she was taking water through a shot hole in her deck. The *Passaic* was hit about 30 times; *Patapsco* became a kind of sitting duck for the Confederate gunners in Forts Moultrie and Sumter and sustained nearly 50 hits; *New Ironsides* escaped certain destruction when an

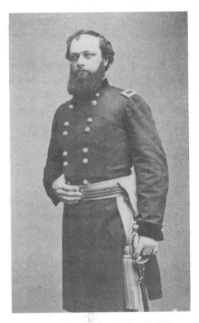

Now came Brigadier General Quincy A. Gillmore, and with him came a plan. He placed heavy batteries of rifled cannon on Tybee Island, and from there would bombard Fort Pulaski into submission. It was the first time that rifles were used against masonry, and the results were devastating. (USAMHI)

electric torpedo with a ton of gun powder miraculously failed to go off. The last ironclad in line, the *Keokuk*, spent 30 minutes under the undivided attention of the guns of the Confederates, sustaining some 90 hits, many of which lodged below the waterline. Calm weather allowed her to stay afloat overnight, but the next day a roughening of the sea sent her to her grave, but not before the captain and 15 survivors were able to save themselves.

The severe battering that his ironclads had sustained led Du Pont to call off the attack, and though he originally expected to resume it the next

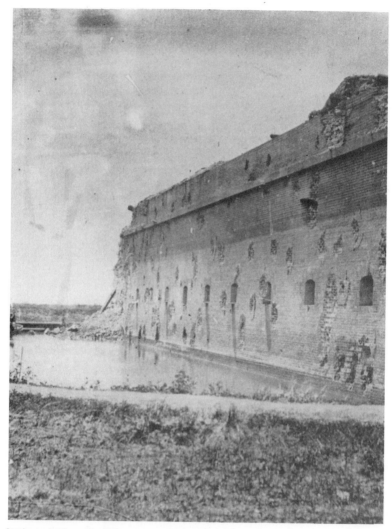

Starting on April 10, 1862, Gillmore began to pulverize Fort Pulaski. Shell after shell burrowed into the brick face of the bastion. (USAMHI)

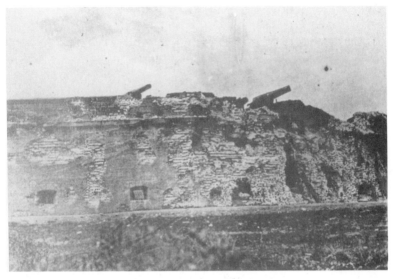

By the end of the day very few Rebel cannon still stood ready to continue the fight. (USAMHI)

day, the reports of his captains changed his mind. As he told Welles, "I was fully convinced that a renewal of the attack could not result in the capture of Charleston, but would, in all probability, end in the destruction of a portion of the ironclad fleet and might leave several of them sunk within reach of the enemy. I therefore determined not to renew the attack, for in my judgement it might have converted a failure into a disaster."

Perhaps Du Pont anticipated some of the northern response to the repulse of his forces, for on April 8 he wrote to Henry Winter Davis and let some of his bitterness show. He told Davis, "Of course, I am ready for the howl—but I never was calmer in my life and never more happy that, where I thought a disaster imminent, I have only had a failure." In letter after letter Du Pont bitterly complained of the monitor mania of his superiors in Washington and of the greed of those civil contractors who pressed the Navy for immediate

use of a weapon of unproven effectiveness. In an outburst of anger he once told Davis that "eight musical boxes from Germany off Ft. [Sumter] would have brought about the same effect upon the rebel cause."

Public and departmental dissatisfaction with the results at Charleston led to a shake-up in the naval chain of command. On June 3, 1863, Secretary Welles informed Du Pont that because of his opposition to a renewal of the attack on Charleston the department was relieving him of his command of the South Atlantic Blockading Squadron. The new commander, Andrew Foote, an officer admired by Du Pont, despite the former's advocacy of monitors, unfortunately died before he could assume his new command. His replacement was, from Du Pont's point of view, a less happy one. Admiral John Dahlgren had long intrigued for command of the South Atlantic Squadron, and in his quest he had the advantage of being a favorite of President

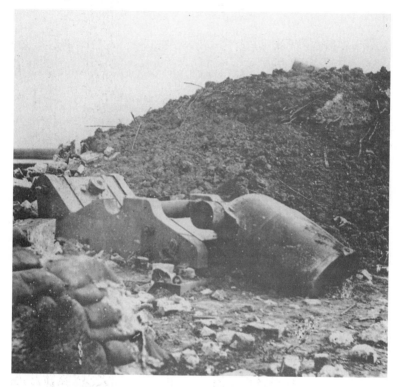

More were out of action, like this mortar caught by photographer Timothy O'Sullivan, who made most of the Fort Pulaski views taken that April. (LC)

Lincoln, who much appreciated the loyal support that Dahlgren had tendered in the uncertain early days of the war. In his new post, the armchair admiral hoped to add seagoing laurels to his impressive record of some 20 years as chief of the Bureau of Ordnance. Earlier Du Pont had told another correspondent that "Dahlgren [had been] made an admiral, in part for a gun which is a greater failure than the monitor which carries it."

Dahlgren's repeated attacks on Charleston in the

months that followed his appointment fared no better than had Du Pont's, and resulted in greater loss of life and material. Dahlgren launched a series of well-organized but vain attacks on the city but could make no substantial progress in reducing it into submission. It has been estimated that in the course of the Union attacks in a few days of the summer of 1863 over 5,000 Federal shells, weighing well over a half million pounds, had rained down on the defenders of Charleston—and still

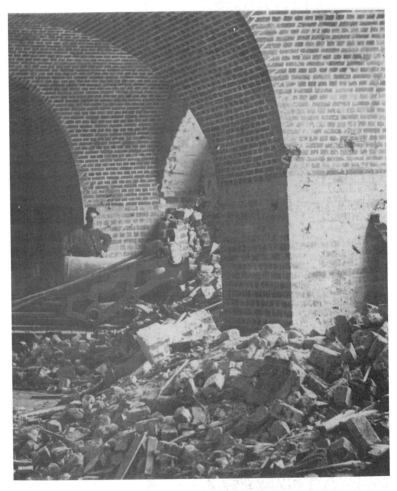

Inside the casemates was a shambles, the rubble so choking the embrasures that even functioning guns could not be reloaded. (LC)

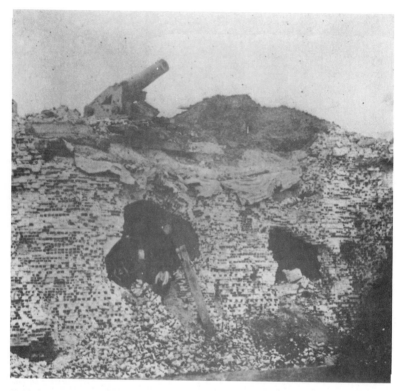

The next day Gillmore resumed his bombardment against weakening resistance.
These two gaping holes appeared in the wall, leaving the fort vulnerable to an
assault at any time. Its commander had little choice but to surrender.
(NEW-YORK HISTORICAL SOCIETY)

they held out; it is also said that the Union bombardment of Sumter on September 1–2, 1863, was one of the heaviest ever recorded in the annals of war up until that time. Yet the beleaguered city continued to hold out against the best the Union could throw at it, and when the end came, it did not come from the sea.

It is extremely difficult to judge with any precision the impact that the blockading squadrons had

on the defeat of the South. The need for secrecy and the danger of capture led to the falsification and destruction of records; the intricacies of international law and the ramifications of British neutrality regulations led to some really imaginative efforts at subterfuge and disguise. Nor is it always possible to unravel the complicated skein of secrecy that the Confederacy wove to cover its operations.

Most important, blockaders had to contend with

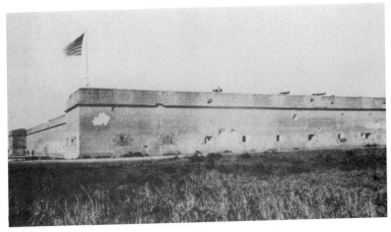

In time the industrious Yankee engineers and workmen rebuilt Pulaski into a powerful link in the blockade chain that constricted Savannah. (CHS)

By 1863 the Federals had built up a mighty arsenal and restored much of the fallen masonry, making Pulaski again one of the more attractive casemated forts on the Atlantic coast. (USAMHI)

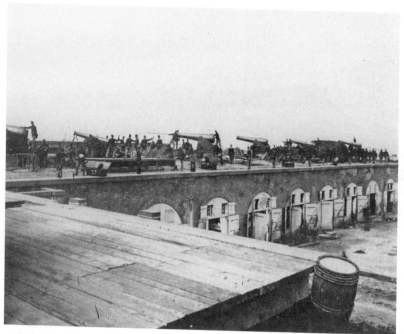

The 3d Rhode Island Heavy Artillery came to man the mighty seacoast guns that faced Savannah and the ocean. (USAMHI)

the greed of those who saw golden opportunities in evading it. "Moreover, once the blockade was in effect, the inflated prices that provisions and war supplies commanded in the Confederacy made it profitable for British shipbuilders to construct fast vessels designed exclusively for blockade-running," and most of these benefited from the technological improvement that steam gave the runner over the blockader. The ports of the South seemed a cornucopia of profit, and even as late as 1864 it is estimated that as many as two of every three ships eluded the most vigilant blockaders. One careful assessment of the efficiency of the blockade of the Carolina ports from 1861 to 1865 estimates that of

the more than 2,000 attempts to breach the blockade about 85 percent were successful.

No one has ever calculated the profits of foreigners who entered the Confederate trade. Successful captains cleared £1,000 on a round trip from Nassau to Wilmington, and their crews were proportionately well paid. It is reported that one ship earned nearly £85,000 for about three weeks work; and conservative estimates say that profits of £30,000 on each leg of a journey into and out of the Confederacy were not uncommon. It is well known that throughout the war profits remained high, with one Liverpool firm reported to have cleared over £4 million in the trade. Unfortu-

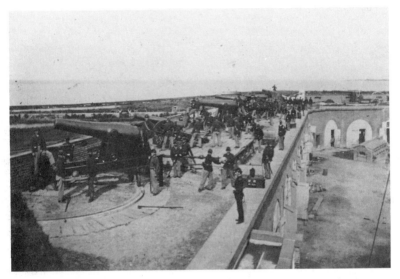

The giant smoothbores dwarf a smaller siege gun as the Rhode Islanders go at their gun practice. Two men at front left strain under the weight of a projectile while others pass a powder cartridge from the open chest. (USAMHI)

nately, most of these profits accrued to middleman profiteers, for it was late in the war before the Confederate Navy Department established its own system of supply under government sponsorship—and by that time it was too late to have much of an impact on the course of the war.

But the blockade may have cost Lincoln more than it was worth, for it tied up warships that might have been more effective elsewhere. America's greatest naval historian, Alfred Thayer Mahan, reflected upon the naval lessons of the Civil War, and in an all too infrequently quoted passage he observed, "But as the Southern coast, from its extent and many inlets, might have been a source of strength, so, from those very characteristics, it became a fruitful source of injury. The great story of the opening of the Mississippi is but the most striking illustration of an action that was going on incessantly all over the South. At every breach of the sea frontier, warships were entering.

The streams that had carried the wealth and supported the trade of the seceding States turned against them, and admitted their enemies to their hearts. Dismay, insecurity, paralysis, prevailed in regions that might, under happier auspices, have kept a nation alive through the most exhausting war. Never did seapower play a greater or more decisive part than in the contest which determined that the course of the world's history would be modified by the existence of one great nation, instead of several rival states, in the North American continent."

Possibly the blockade was a waster of resources and opportunities. Certainly the lessons of history are wasted if we recount the story of the South Atlantic Blockading Squadron without asking whether the Federal ships engaged in that duty could have struck a more decisive blow if they had abandoned the coasts for the rivers.

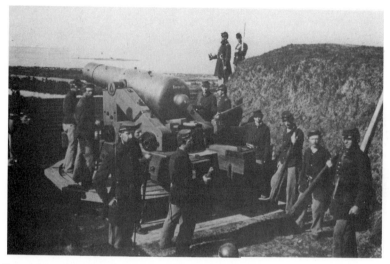

Some of their guns they named for popular generals and, like "Burnside," the not so popular. His fellow Rhode Islanders here were perhaps more forgiving than others in the North. (USAMHI)

Governor William Sprague found this namesake at the southwest corner of Pulaski's parapet, commanding a scene that inspired confidence in Union might. (USAMHI)

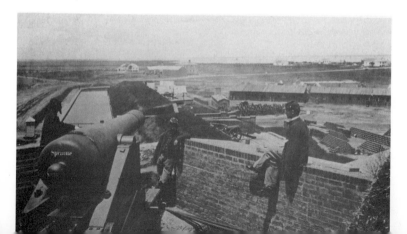

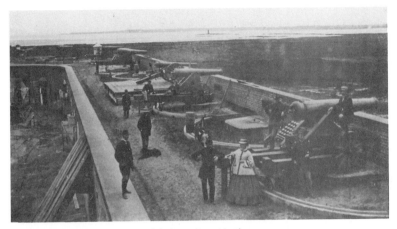

Officers of the 48th New York garrisoned the fort and posed for the camera along with their colonel, W. B. Barton, standing with his wife. Beyond them lay the mouth of the Savannah River and, in the distance, Tybee Island. (USAMHI)

Inside, on the parade ground, the band of the 48th New York and, on dress parade . . . (USAMHI)

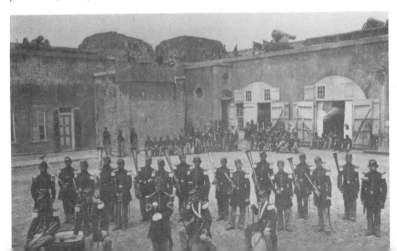

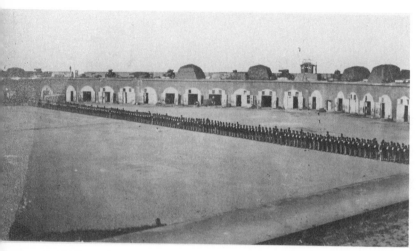

. . . the 48th New York itself, complete with seldom seen white gloves. (USAMHI)

But always in the distance, just ten miles away to the northwest, lay Savannah, and Fort Pulaski must be, like the sentinel, ever vigilant. (USAMHI)

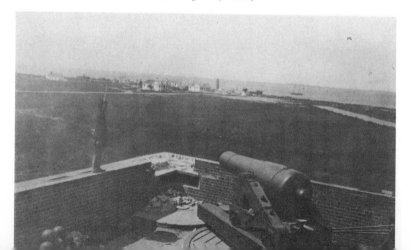

For the sea-based elements of the Southern squadron, there was much more to blockade duty than looking for runners. Army generals like Benjamin F. Butler might live in the plush cabins of their headquarters boats like the transport Ben DeCord *. . .* (USAMHI)

. . . but the Navy men had constant work to do. Maintaining the fleet in those Southern waters required extensive on-site facilities, like the machine and carpenters' shops in Station Creek, near Port Royal. (USAMHI)

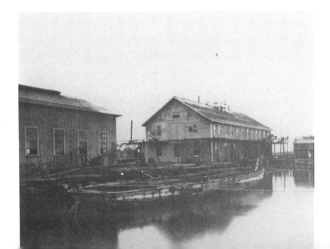

Machine shops at Bay Point performed repairs, such as replacing the smoke stack of the monitor Passaic *after it was severely damaged in the April 7, 1863, attack on Charleston.* (USAMHI)

Most of the fleet repairing took place at this floating shop in Machine-Shop Creek, near Port Royal, where two old whaling ships, Edward *and* India, *were converted for the purpose.* (USAMHI)

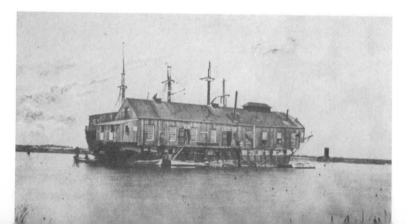

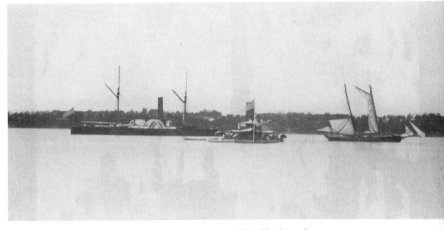

A constant flow of ships passed into and out of Port Royal, ships like the monitor at center, the transport at left, and James Gordon Bennett's yacht Rebecca *at right.* (USAMHI)

Old ships of the line like the Vermont, *too aged for active service, came south to act as receiving and store ships.* (NAVAL HISTORICAL CENTER)

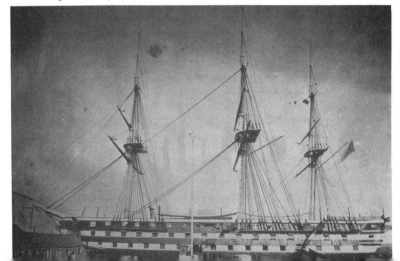

Captain John Rodgers, standing fourth from left in the center group,
commanded the Vermont *at Port Royal and chafed that her massive array of*
guns remained silent. (USAMHI)

For officers who had trained for active service, their—perhaps their only—war
seemed to be merely one of watch and wait. Even the ship's dog seems bored
with the blockade service. (USAMHI)

But certainly some were not bored. Poor Commander George Preble, standing center at the Philadelphia Navy Yard in this early postwar image, was dismissed from the service in 1862 for allowing a Confederate cruiser to run the blockade into Mobile, but then was restored to his rank and sent to Port Royal. He commanded the coal depot for a time, and near the end of the war actually led a "fleet brigade" in fighting on shore. (USAMHI)

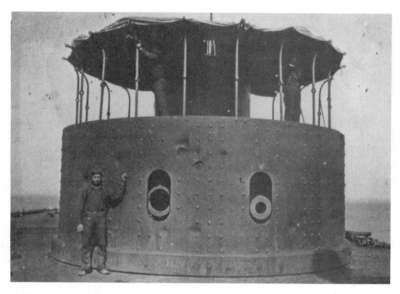

Real action came to the squadron in 1863, as blockaders, enemy ironclads, and attacks on Charleston kept the fleets busy. On April 7, Du Pont, against his better judgment, attacked Charleston and saw his ironclad fleet severely battered. Ships like the Passaic *visibly displayed their damage.* (USAMHI)

The officers even posed beside their dented turret. (NA)

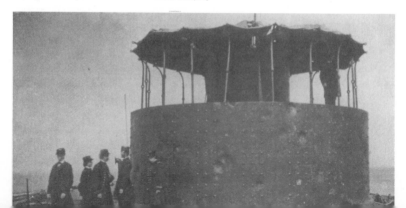

The USS Nahant *took 36 hits on its turret, which was completely disabled during the fighting. She appears here shortly afterward in Machine-Shop Creek, with the floating machine shops barely visible in the distant background to the left. The powerful 15-inch Dahlgren and 11-inch Dahlgren smoothbores peering out of the turret were useless to her in the attack.* (USAMHI)

Yet the Nahant *was revenged a bit. She joined the* Weehawken *in June 1863, with Captain John Rodgers now commanding the latter.* (USAMHI)

The two of them passed the Frying Pan Shoals Lightship and steamed to Wassaw Sound. The Nahant *is the monitor in the right background.* (USAMHI)

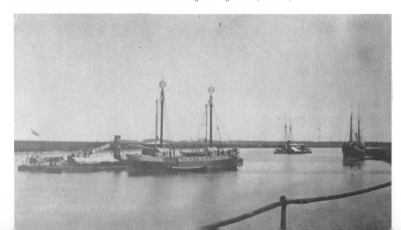

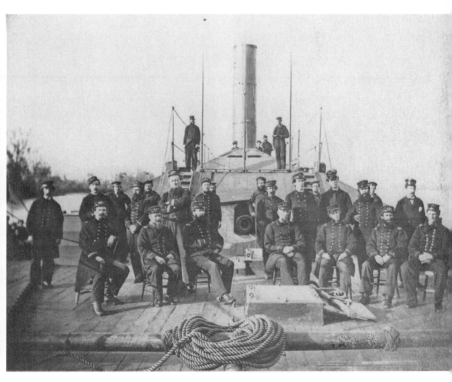

Together they battled and captured the formidable Confederate ironclad Atlanta, *shown here after she was converted to Federal service and sent to the James River in Virginia.* (NA)

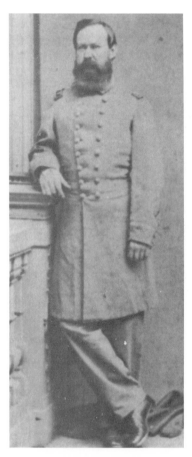

So did Lieutenant George H. Arledge. (WA)

Captain W. A. Webb was the Atlanta's *luckless commander. He spent the next several months in Fort Warren Prison.* (MC)

And 1st Assistant Engineer W. J. Morell. (WA)

And Gunner T. B. Travers. (WA)

And poor Midshipman J. Peters. (WA)

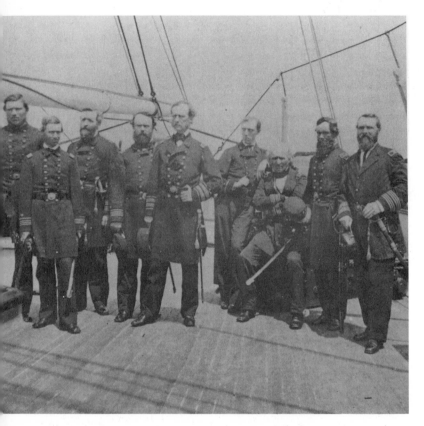

And soon after the capture of the Atlanta *there came a new face to the South Atlantic Blockading Squadron, Rear Admiral John A. Dahlgren, shown here at center with his staff aboard his flagship, the USS* Pawnee. (NHC)

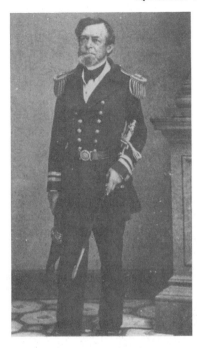

When it was first decided to replace the hapless Du Pont, Washington opted for a naval hero from the West, Admiral Andrew Hull Foote, who relinquished his command of the Mississippi flotilla after the successes at Forts Henry and Donelson and Island No. 10 due to a wound. On June 4, 1863, he received orders to relieve Du Pont, but three weeks later, before he could assume command, he died. (CWTI)

Once again the crews and their guns readied for an attack. The after 10-inch Dahlgren smoothbore aboard the Wabash, *the gun designed by the new squadron commander. (USAMHI)*

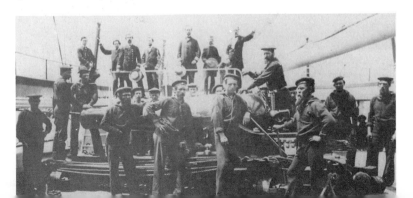

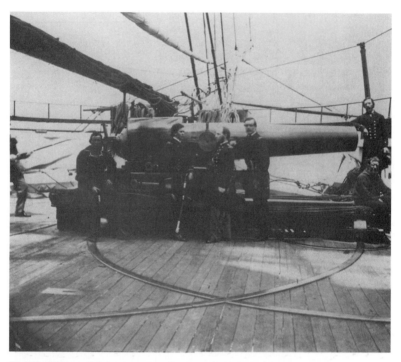

The Wabash's *forward pivot gun, a mammoth 200-pound rifle. Captain H. B. Lowrey, commanding the ship's Marine contingent, stands bearded in the center, while one of his Marines brandishes a much smaller rifle at the far left.* (USAMHI)

Another great Dahlgren aboard the Wabash, *dubbed the "Truth Seeker."* (USAMHI)

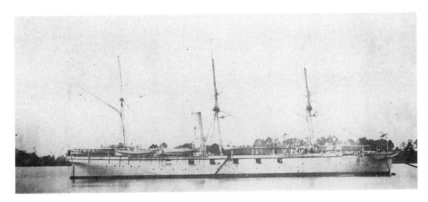

The USS Pawnee, *ready for battle.* (NA)

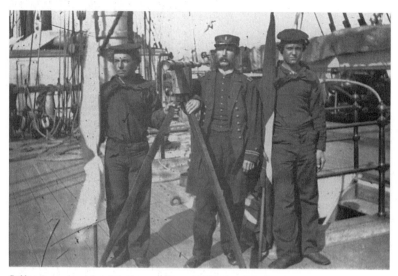

Dahlgren's signalmen aboard the Pawnee *will transmit his orders to the fleet during the impending attack on Charleston.* (LC)

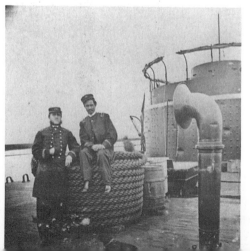

Yet Dahlgren's attacks are no more successful than Du Pont's. The monitor Patapsco's *turret shows the beating it takes.* (USAMHI)

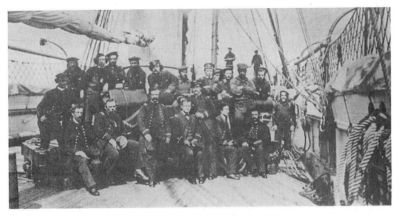

The USS Dai Ching *is no more successful, though later in the year she will go on to capture a blockade-runner before being ordered to Florida.* (USAMHI)

But for the Dai Ching *the war will end on February 3, 1865, when she goes down off Savannah.* (USAMHI)

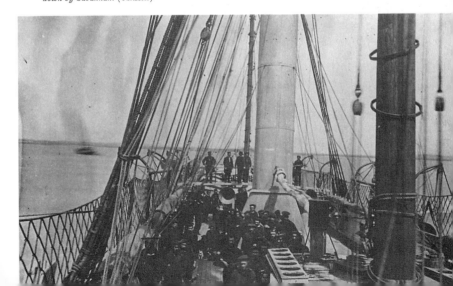

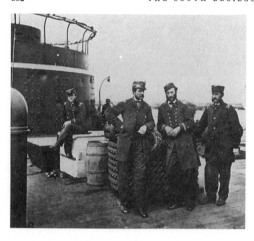

Again in September, Dahlgren sends his monitors against Fort Sumter, and again without success. For the Patapsco there are only more dents in the turret. (USAMHI)

Dahlgren himself went aboard the Montauk for his September bombardment, but its most famous passenger would come nineteen months later, when the body of John Wilkes Booth was brought here briefly before its burial. Here, too, some of the other conspirators in the Lincoln murder were imprisoned. (DAM, LSU)

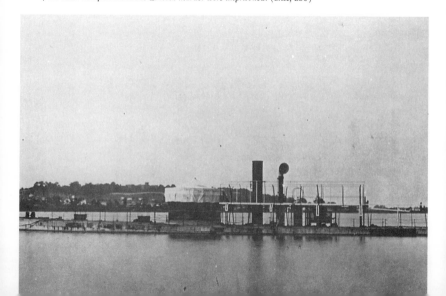

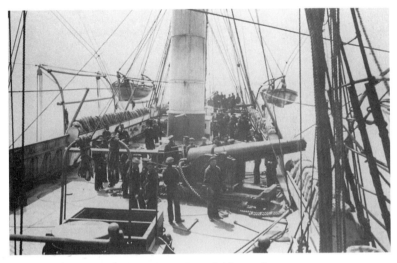

After the attacks of the summer of 1863, the squadron settled down to the routine of hunting blockade-runners, and effectively at that. The USS Nipsic *captured the runner* Julia *on June 27, 1864.* (USAMHI)

The fragile runners could not hope to match powerful guns aboard gunboats like the Nipsic. *If they were unable to get away, they surrendered without a fight.* (USAMHI)

Sometimes even lightly armed transport ships like the Arago *managed to effect a capture or two.* (USAMHI)

The Arago, *shown in this Samuel A. Cooley view, took part in the celebrated capture of the runner* Emma, *loaded with cotton, turpentine, and resin.* (NA)

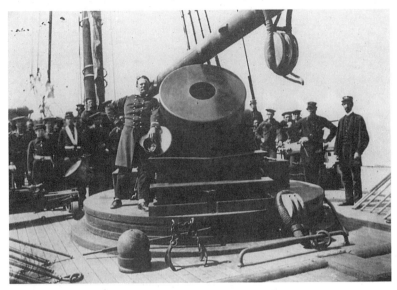

The mortar schooner USS Para *lent a hand in taking the* Emma, *though this mighty mortar, "Old Abe," was not called on in the fight, for there was no fight.* (USAMHI)

Gentlemen like this blockade-runner captain, posing calmly with a Confederate banner in Havana, were the wary quarry. (HP)

And their ships were the coveted prizes. Frequently they ran them aground rather than surrender, only to see the vessels battered by the waves. Here, on Morris Island, near Charleston, lie the remains of the Ruby. (USAMHI)

And here the wreck of the blockade runner Colt, *near Sullivan's Island, in 1865. It was a sad end for these greyhounds of the sea.* (USAMHI)

The squadron extended down to Florida as well, and there Commander John R. Goldsborough patrolled in his USS Florida, *helping in the 1862 capture of Fernandina.* (USAMHI)

While for others the age-old game of wait went on. The old ship of the line Alabama *was laid down in 1819, but was never launched until April 23, 1864, forty-five years later! She hit the water with a change in name, now the USS* New Hampshire, *and went south to Dahlgren.* (USAMHI)

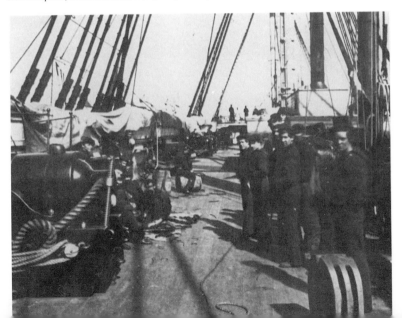

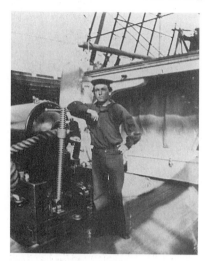

There her crew would not see action but simply relieve the Vermont *as a stores and depot ship. It was an ignominious end for these mighty ships of oak.* (USAMHI)

And so the work went on. Work done by a hundred forgotten vessels and thousands of unsung men. Little armed transports like the Nelly Baker *did their share.* (NA)

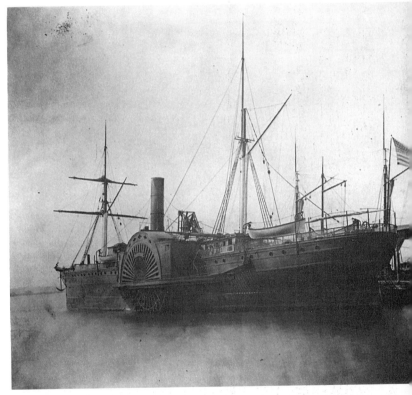

So did the giant transports like the Cahawba, *shown here in June 1864, probably in Hampton Roads.* (USAMHI)

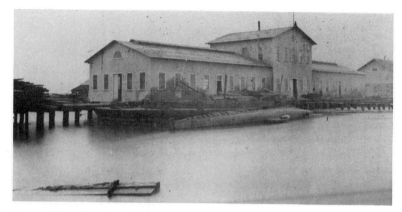

There was little the Confederates could send against them except their innovative but ineffective little "Davids," the cigar-shaped torpedo boats that Southerners hoped might sink a few of the Goliaths strangling their ports. One rests here at the Bay Point machine shop, captured by the Federals and photographed by Cooley. (WRHS)

While the "Davids" were not too successful, the Confederate submarine CSS H. L. Hunley managed to sink the USS Housatonic in Charleston Harbor before she went down herself in mysterious circumstances. The USS Canandaigua shown here swooped in to pick up the survivors from the first ship in history to be sunk by a submarine. (GLADSTONE COLLECTION)

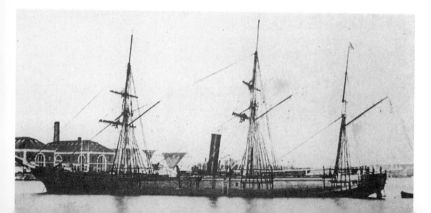

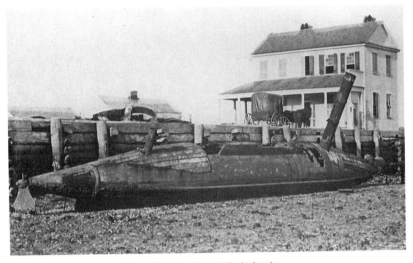

Another "David" appears, beached near Charleston, its propeller broken, its torpedo spar extending from its nose. They were makeshift vessels, little better than coffins. (NA)

And at war's end they seemed everywhere along Charleston's waterfront. (NA)

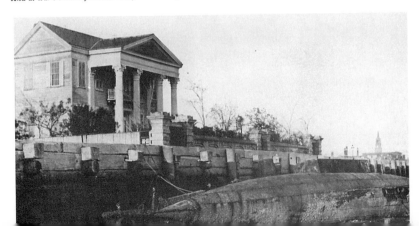

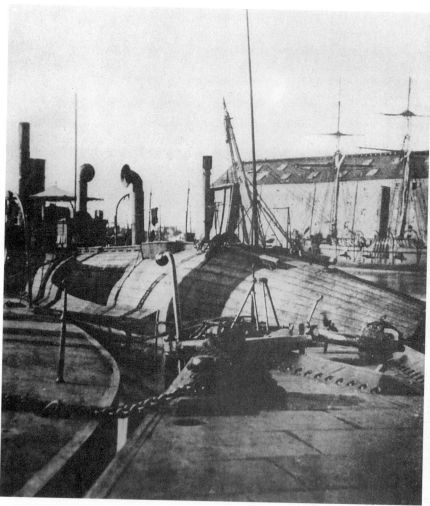

*Even in Washington's navy yard they were to be seen tied up next to Yankee
monitors. They were the last tangible evidence of the vain efforts of the
Confederacy to combat the power of the South Atlantic Blockading Squadron.*
(NHC)

Partners in Posterity

A PORTFOLIO

Haas & Peale and their incomparable record
of siege in South Carolina

IN 1863, AS FEDERAL MINIONS sought relentlessly to take Charleston, their major obstacle was Fort Sumter and the ring of earthwork forts built around the South Carolina city. In a chapter in Volume IV of this series, *Fighting for Time,* the story of the Siege of Charleston was told. However, there were a pair of photographers there who told much of the story themselves in images far better than words. They were Haas & Peale of Morris Island and Hilton Head. Their 1863 images depicting General Quincy Gillmore's efforts to take Charleston represent almost the total corpus of their Civil War work. Except for a few portraits and random images, Haas & Peale seem to appear in Civil War photography with their arrival at Morris Island, and then disappear again when they have done. Little more is known of them.

Yet if any artists of the war can rest securely knowing that their fame depends upon a single series of images, then surely Haas & Peale have safely made for themselves a niche in posterity with their Charleston views. They are somewhat unique in Civil War photography. Mathew Brady, Alexander Gardner, Samuel Cooley, and others attempted to create and market series of images showing battle and campaign scenes, yet they offered them to the public only in oversized "imperial" prints too unwieldy for casual collecting, stereo views that required a stereo viewer, or else in the small *carte-de-visite* format that offered little detail for large outdoor scenes. Haas & Peale, however, created a series of over 40 serially numbered views around Charleston in a medium-sized format that offered the advantages of size, chiefly quality, without the disadvantages attendant to the oversize prints.

Alas, it remained for others to gain public acceptance of this new photographic style in the years after the war when the cabinet photograph enjoyed its vogue. But though their innovation did not last, still the work of Haas & Peale has lasted, a reminder of perhaps the most accomplished photographic partnership of the war.

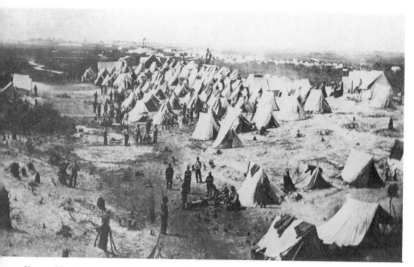

Here on Morris Island, spread out toward the horizon, sprawls the camp of the 9th Maine Infantry. (USAMHI)

They made a virtual tent city, huddled along the shoreline to catch the ocean breezes in the hot, humid summer. (USAMHI)

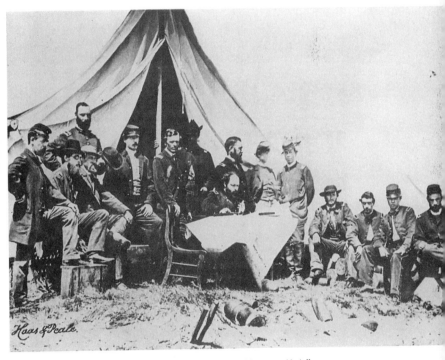

Undaunted by the heat, General Gillmore and his staff posed in reasonably full uniform for the partners. Gillmore sits at center striking a contemplative pose as he ponders an enormous map captioned "Charleston, South Carolina." Arrayed here and there are a variety of shells and solid projectiles to lend a suitable warlike atmosphere. (USAMHI)

*Still, Gillmore, too, could seek some relief from the sun and heat in his tent
headquarters on Folly Island.* (USAMHI)

*There was less relief for the men manning the siege guns that pounded Fort
Sumter and the other Charleston forts, however. Here are three 100-pounder
Parrott rifles in Battery Rosecrans, all trained on Sumter.* (HUGH LOOMIS
COLLECTION, KA)

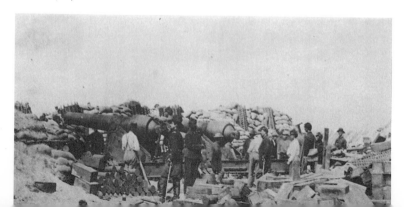

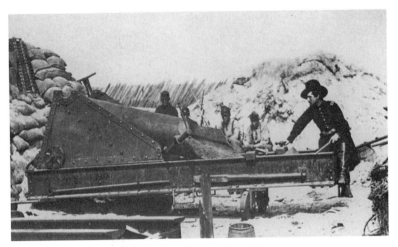

Things do not always go as planned, including cannon shells. One of those 100-pounders had a shell burst before it cleared the muzzle, creating a considerable curiosity for men and officers of the battery. (USAMHI)

An equal curiosity were men from the webfoot service doing shore gun duty. This naval battery of two 80-pounder Whitworth rifles threw its shells, too, at Fort Sumter. Just so no one would forget where they came from, the naval deck carriage of the rifle at right carries the legend "Rear Admiral S. F. Du Pont, Port Royal, S.C." It also carries a pair of boots and some laundry drying in the sun. (USAMHI)

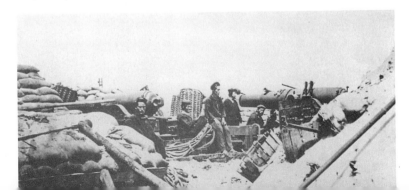

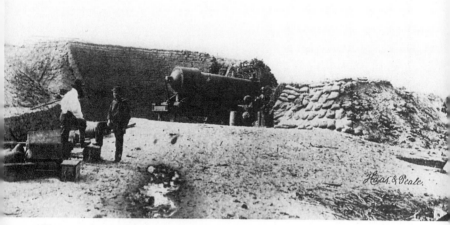

The mammoth 300-pounder Parrott rifle in Battery Strong. (NYHS)

In some places Gillmore built his batteries on artificial islands made of pilings driven into the swamps, or else on little more than built-up sand spits. Here in Battery Hays sat one such gun emplacement, this one for an 8-inch Parrott rifle that is, at the moment, dismounted. (CHS)

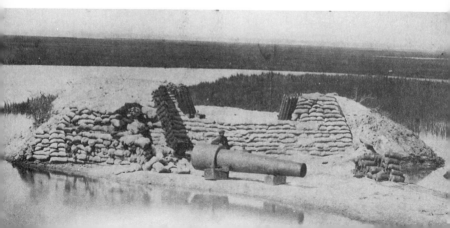

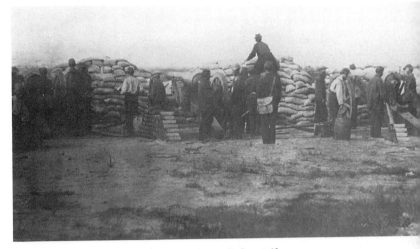

The rest of the guns in Battery Hays, however, these 30-pounder Parrott rifles, are more than ready to do service in the bombardment of Confederate Fort Wagner at the end of Morris Island. (SOUTH CAROLINA HISTORICAL SOCIETY, CHARLESTON)

This 300-pounder Parrott in Battery Brown got a bit carried away. (USAMHI)

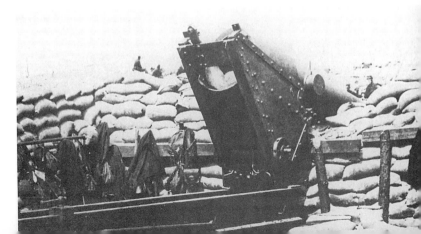

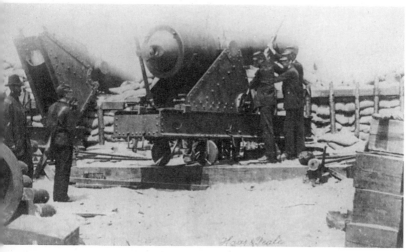

Its neighbor manages to seem coolly indifferent. (NYHS)

Gillmore peppered Fort Sumter with everything, including these 10-inch siege mortars in Battery Reynolds, here aimed at Fort Wagner. One of the mortar shells can be seen dangling between the two soldiers at extreme left. (NYHS)

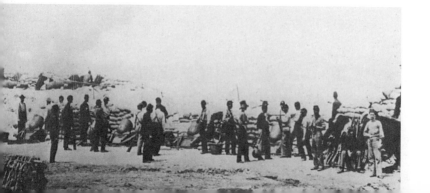

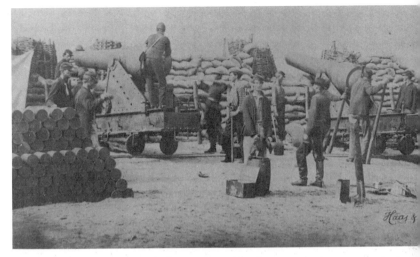

These two 100-pounder Parrotts in Battery Meade are attempting to blast a breach in the masonry walls of Sumter. All that they and their fellow batteries will succeed in doing, in fact, is in reducing the fort to a shapeless mound of rubble that will never surrender. (SOUTH CAROLINA HISTORICAL SOCIETY)

Here at the headquarters of the field officer of the trenches, almost anything might be found, stretchers, beer bottles, spare shells, even an "infernal machine," a torpedo or mine. (HUGH LOOMIS COLLECTION, KA)

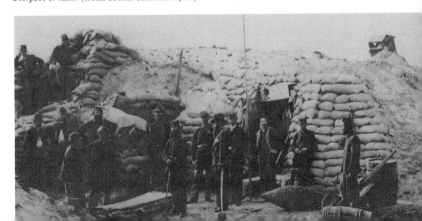

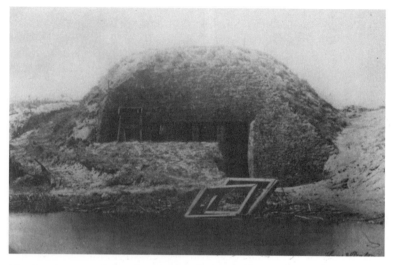

The telegraph operator, relaying orders and messages back and forth, really needed protection, and here in this bombproof he got it. (NYHS)

Everywhere those who did not live in tents went underground. Here in Fort Wagner, after its fall to Gillmore's army, Federals occupied the bombproofs once used by the Confederates. Earth and sand were happily neutral in this war—they would shield blue and gray alike. (USAMHI)

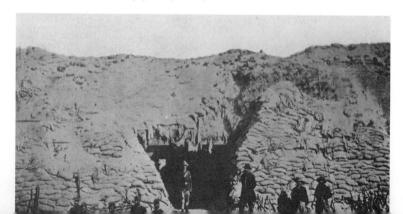

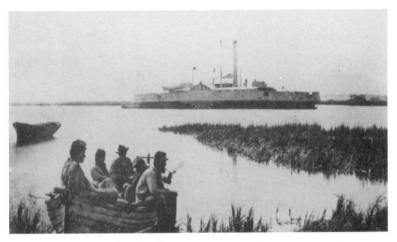

Life in the lens of Haas and Peale was a little better for the men at sea, even those serving aboard converted Staten Island ferry boats like the Commodore McDonough. *At least they could move a bit now and then, steam up to within range of one of the forts, throw a few shells, and then put back out to sea where the breezes cooled the guns and the men.* (USAMHI)

The gunboats could not count on navigational assistance from the Charleston lighthouse on Morris Island. In 1863 this is all that was left of it. (USAMHI)

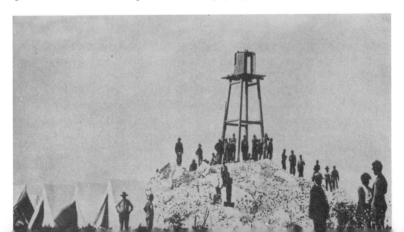

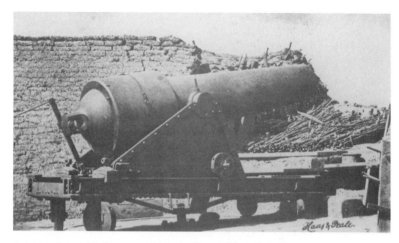

And this is all that is left of a 300-pounder Parrott after a shell burst just inside the muzzle. Yet this gun could still be fired, and was. (USAMHI)

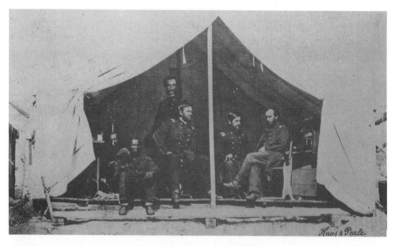

When not digging or firing, it was a siege of boredom for Gillmore's little army. These regimental officers had plenty of time to pose for Haas & Peale. (USAMHI)

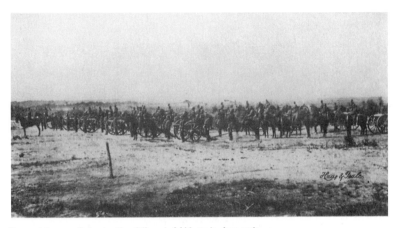

Now and then, mostly for practice, Gillmore's field batteries drew up in formation, looking formidable, but utterly ineffectual against Sumter's walls or against Fort Wagner's earthworks and bombproofs. Battery B, 1st U.S. Artillery. (USAMHI)

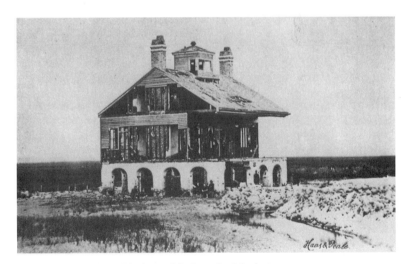

The Beacon House on Morris Island was sufficiently ventilated that heat no longer appeared to be a problem. (USAMHI)

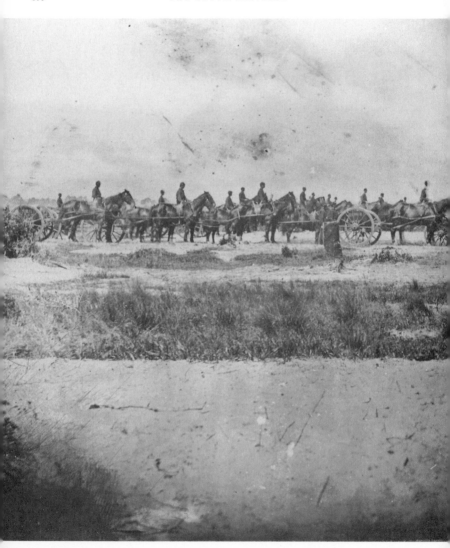

It could get awfully hot out there under the sun. (LC)

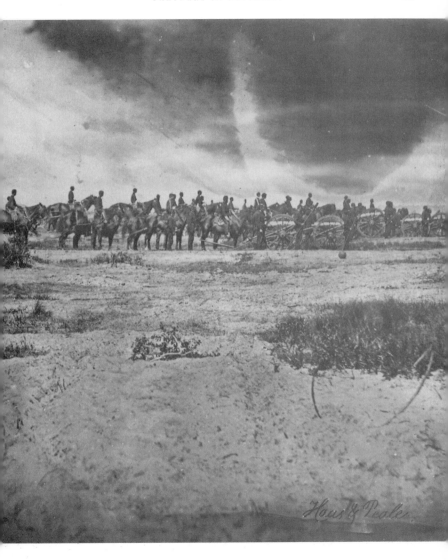

Haas & Peale.

*But the heat and boredom got to a few, including this unfortunate fellow. He
bears a sign proclaiming his offense: "THIEF. This Man, Benj. Ditcher, 55th
Mass. Vol's, Stole Money From a Wounded FRIEND." Ditcher had his head
shaved, his hands bound behind him, and was paraded through the camp by a
guard carrying their rifles upside down and musicians playing the "Rogue's
March." Ditcher, like the rest of the 55th Massachusetts, was a Negro, and his
"wounded friend" was almost certainly injured in the skirmishing on Folly
Island.* (CHS)

An orderly delivers a message for the camera on Folly Island. The colonel receiving it is duly formal for the occasion, but the men in the neighboring tent seem unimpressed by the ceremony. (CHS)

Meanwhile the work of reducing Sumter went on, as did Haas & Peale's work of capturing it with their camera. Battery Kirby, with its two 8-inch seacoast mortars. (USAMHI)

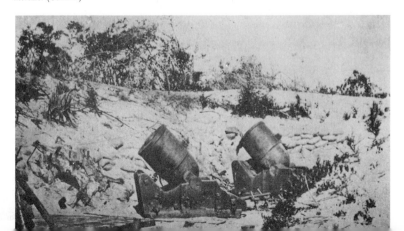

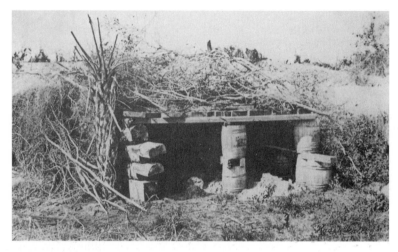

One of the "splinter-proofs" to protect gunners from flying chunks of wood and debris as Confederate shells sporadically returned fire. (USAMHI)

In the seemingly endless siege work against Fort Wagner, Gillmore, ever the engineer, created miles of trenches and siege works, pushing parallels ever closer to Wagner. The workmen pushed this rolling sap ahead of them, dug behind it, and thus inched their way toward the fort. (SOUTH CAROLINA HISTORICAL SOCIETY)

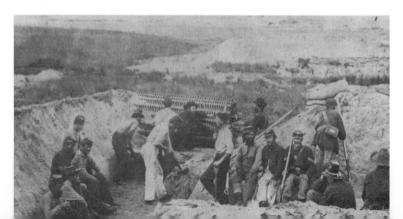

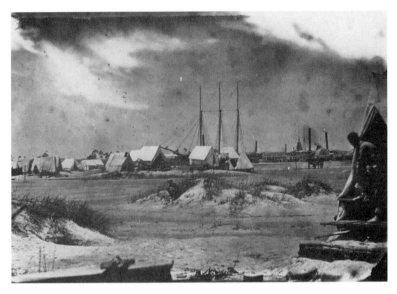

Meanwhile, the tent city grew ever larger, and the buildup of supplies never stopped. Gillmore was intent upon victory. (LC)

Haas & Peale were intent upon capturing it all on their glass plates. (LC)

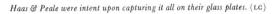

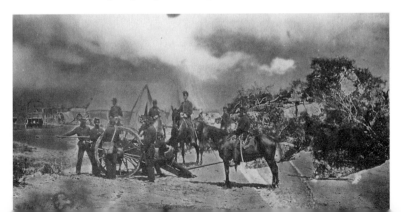

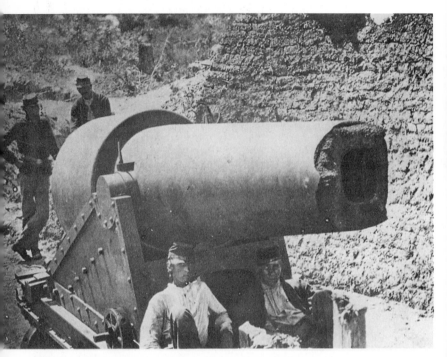

And the irrepressible common soldiers on Morris Island were simply intent upon finding a shady spot wherever they could, even in the shadow of one of their wounded but still dangerous monsters. (USAMHI)

Into the Wilderness

ROBERT K. KRICK

Grant and Lee meet at last, and will not part

BRANDY STATION and Stevensburg and Culpeper had seen some bitter fighting before the war reached 1864. The locale seemed to attract cavalry forces and mounted charges. In the spring of 1864, however, the whole width and breadth of Culpeper County seemed to be carpeted with Northern canvas. The mighty Federal host was commanded by George G. Meade, but it was to be accompanied on its operations by the general-in-chief of all the Northern armies, U. S. Grant.

On May 4, Grant and Meade launched their long-suffering Army of the Potomac across the Rapidan River into dangerous country. Pontoon bridges carried seasoned veterans and frightened youngsters alike into the Wilderness of Spotsylvania. The river crossings at Germanna Ford and Ely's Ford were historic ones. Lafayette had been here two generations before; this same army had crossed these same fords to disaster just one year and five days earlier.

The Wilderness was a dank and unlovely piece of country, about 70 square miles in extent. Its tangled brush and confusing ravines had enfolded and bemused Joe Hooker's army during 1863's Chancellorsville Campaign. The 1864 edition of the same Federal force might be mired in the same morass, and the Confederate Army of Northern Virginia was just the agency to collaborate with the Wilderness in the undertaking.

R. E. Lee had reunited his army in the month before the Wilderness fighting opened. His I Corps had been on an ill-starred winter campaign in Tennessee, suffering through James Longstreet's failure as an independent strategist. General officers languishing in arrest and deteriorating morale in the ranks gave evidence of the change in the old reliable body. When Lee reviewed the returning corps near Gordonsville, the atmosphere was electric. A hard-nosed brigadier, not given to outbursts of emotion, wrote, "The General reins up his horse, & bares his good gray head, & looks at us & we shout & cry & wave our battle flags & look at him again. . . . The effect was that of a military sacrament."

Federal columns thrusting through the Wilderness on May 5 were threatened from the west by two separate Confederate corps moving on the Orange Turnpike and the Orange Plank Road. The battle was fought along those two corridors. Dense intervening Wilderness segregated the two fights into bitter enclaves, all but independent of each other. Richard S. Ewell's II Corps and the Union V Corps contested the Turnpike. Fighting raged with particular ferocity around a small clearing

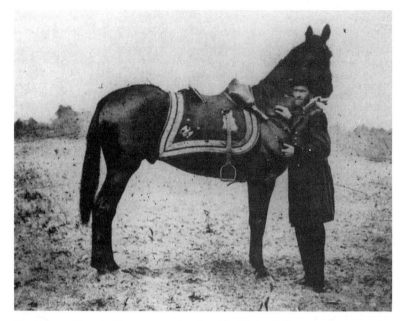

The quiet general from the West, come east to face the undefeatable Lee. U. S. Grant was a lieutenant general, the only man of such rank in the Union Army, and now he commanded all of Lincoln's forces in the field. Grant, with his horse Cincinnati, in early June 1864. (NA)

known as Saunder's Field or Palmer's Field. The Turnpike bisected the field and a shallow wash ran perpendicular to the road. A Union battery in the clearing was repeatedly taken and retaken. Infantrymen from both armies sought shelter in the draw. Both sides entrenched with desperate enthusiasm.

Muzzle flashes in the woods ignited leaves, the fire spread to brush and trees, and soon the wounded were burning to death. The sound of cartridge boxes exploding could be heard over the crackling of flames. Federal wounded who could be reached were carried back to surgical stations beyond the Lacy house, "Ellwood," where Stonewall Jackson's arm had been buried twelve months

earlier. There were also Federal hospitals farther east toward Wilderness Church and other landmarks from the Chancellorsville Campaign. Skeletons of the unburied dead from that earlier fight were macabre prophets, watching the wounded thousands streaming back.

The costly stalemate achieved during May 5 along the Turnpike was duplicated two miles to the south, along the Plank Road. George W. Getty's division of the U.S. VI Corps stood strong around the intersection of the Plank and Brock roads. The Confederate III Corps followed A. P. Hill up to the fringe of the key intersection and threatened to make it their own, thus isolating the sizable Northern force which had advanced farther

south—and setting the stage for destroying the stranded Federals. But the balance of affairs swung away from A. P. Hill and by the end of the day his forces were in dire straits. Hancock's II Corps had pushed the Confederates to the point of breaking when darkness halted operations. One third of Lee's army had not yet reached the field—the I Corps—and its arrival during the night was the only way to forestall disaster.

Grant had spent the 5th near the intersection of the Turnpike with the road from Germanna Ford. He had directed most of the VI Corps under John Sedgwick to strengthen the right flank, above the Turnpike. The troops had moved obliquely into the fray, turning off the Germanna Road near Mrs. Spotswood's house and heading southwest on what was known as the Culpeper Mine Road.

Throughout the 6th of May, Ewell's Confederates and the troops of Sedgwick and Warren struggled inconclusively along the Turnpike. The fragmented gains and losses in the woods yielded a frightful casualty count but no real tactical advantages. John B. Gordon alertly discovered a golden opportunity to turn the Federal right and destroy it; the potential rewards were dazzling. Corps commander Ewell, of the striking personality and the fatal irresolution, equivocated. Not until R. E. Lee arrived in the area during the evening could Gordon get approval to pluck his prize. Gathering darkness constricted the opportunity, but Gordon had little trouble in catching several hundred prisoners—two Union brigadiers among them. The Georgian always believed, using some fragile but persuasive hypothesis, that the lost opportunity was among the greatest that ever slipped through Southern fingers.

Meanwhile, the separate battle along the Plank Road on May 6 had caromed from the brink of Confederate disaster to the brink of Northern disaster and then settled comfortably near a neutral,

He would station himself with the Army of the Potomac and send it into the Wilderness to find Lee and never let him go. Here Grant sits in June 1864, at Cold Harbor, after the Wilderness Campaign is over. Seated beside him is his chief of staff, Brigadier General John A. Rawlins. Standing is Major Theodore S. Bowers. (CHS)

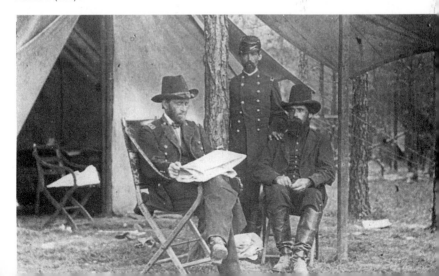

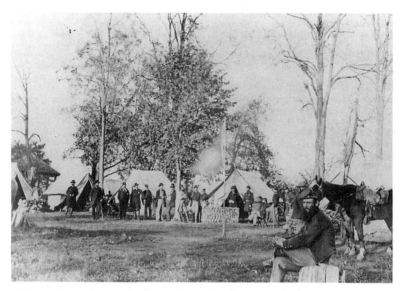

All through that winter and early spring of 1864 the Army of the Potomac
prepared itself for the drive into the Wilderness. Part of the army was stationed
around Culpeper, Virginia, including the brigade of Brigadier General
Alexander S. Webb, standing, hand on sword, in front of his tent. His brigade
was almost wiped out by Pickett's Charge at Gettysburg, and in the coming
campaign Webb will nearly lose his life. An A. J. Russell image. (USAMHI)

if bloody, equilibrium. Hancock threw his II Corps into a solid attack early in the morning, exploiting the success he had won the previous evening. Longstreet's corps was not in line, despite Lee's expectations. The Southerners were driven in disorder along the Plank Road all the way back to a small clearing where stood the house and orchard of a widow named Tapp. Lee's army faced disaster. Veteran units, overwhelmed, ran "like a flock of geese."

In this extremity, the first of Longstreet's arriving men filtered into the clearing. Lee's desperation showed through his usually calm mein as he tried to lead the reinforcements into action. They turned his horse back forcibly and promised to restore the situation. The episode was the first of four "Lee to

the rear" incidents during a seven-day period. The Federal initiative was blunted, then turned back. Lee grasped the initiative for his own. A flanking movement down an unfinished railroad grade (the same that had figured prominently at Chancellorsville) rolled up the Federal lines "like a wet blanket," in the words of Hancock. At the height of the Confederate surge, Longstreet and General Micah Jenkins were shot down by the mistaken fire of advancing Confederates. In the aftermath, momentum dissipated and the Confederates were obliged to accept a result which forestalled Southern disaster but did not inflict a thorough defeat on the enemy. Longstreet's wounds were thought to be mortal but he recovered and returned to duty in October; Jenkins died during the afternoon.

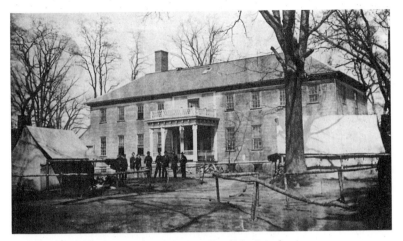

Nearby, just north of Brandy Station, sat the VI Corps. Here Major General John Sedgwick made his headquarters in the home of Dr. Welford. Sedgwick himself stands third from the right. He will not survive the campaign. (WAR LIBRARY AND MUSEUM, MOLLUS-PENNSYLVANIA, PHILADELPHIA)

The Northern army had come across the Rapidan nearly 120,000 strong. Lee was able to counter with about 65,000 men of all arms. That lopsided arithmetic actually grossly understates the case, because the Southern barrel was scraped to its bottom and the Northern barrel was virtually without bottom. Two days of bloodshed in the Wilderness had cost Grant perhaps 18,000 readily replaceable pieces of his army. It had cost Lee less than half that many irreplaceable troops. (Numbers and losses verities—always subject to divergent interpretations—are especially elusive in the 1864 spring campaigns.) Precedent clearly showed Grant the route back across the Rapidan. But the general-in-chief had his eye set on some ghastly and inexorable logic based in the simplest forms of arithmetic—addition and subtraction. On the night of the 7th he prodded the Army of the Potomac into a lunge to the southeast, where there would be unquestioned opportunity to destroy more of the dwindling crop of Southern boys who stood between the North and victory.

Grant's move was toward Spotsylvania Court House, an unobtrusive country settlement composed of three churches and a hotel and a store and a few county buildings. Lee's men raced Grant's for the place, starting long before any other ranking Confederates had deduced what was afoot. Lee's prescience won the race for his side by a matter of seconds. The Federals slogged southeastward along the Brock Road. Southern cavalry resisted the advance from each hedgerow and wood line. Near Todd's Tavern there was a violent clash with Federal cavalry, which was otherwise notably ineffective during this move.

While tired Federal infantry fought and stumbled down the Brock Road, the Confederate I Corps marched most of the night along a parallel route farther west. Richard H. Anderson had had command of the corps since Longstreet's wounding, and he got a very early start. On the morning of May 8, advance elements of Anderson's command were within a mile of the key intersection, which was near a farm called Laurel Hill. Alarms

All around Brandy Station the tents of the waiting Federals sat through the winter. The men were anxious for another chance at "Bobby Lee." (P-M)

reached them, and they rushed forward just in time to hurl back the first Federal infantry to approach the intersection.

The Union troops were members of Warren's V Corps. The men had been fighting or marching, with little or no rest, for five days. As more of them came up, someone set the bands to playing as faint encouragement, and more assaults were attempted, with the same fatal results. A Confederate officer riding along the lines spied his little brother, an artillerist just through his first action, sheltered behind a dead horse. The boy jumped to his feet, flushed with his newfound valor, and called incongruously across the deadly field, "Bubba, Bubba, I wasn't scared a bit—not a bit!"

Federal reinforcements stumbled into line and Confederate reinforcements arrived opposite them.

Both sides entrenched quickly and deeply. After darkness fell on May 8, the Southern line was stretched to the northeast in a great salient angle which came to be known as "The Mule Shoe" because of its shape. The next morning, as the lines were being consolidated, a Confederate sharpshooter firing from very long range killed John Sedgwick. The corps commander had been purposely standing under fire to encourage his men, saying, "They couldn't hit an elephant at this distance."

On May 10, brilliant young Emory Upton, of New York, led an attack against the Confederate salient's western shoulder. He had recognized the opportunity, sold the plan to his superiors, and executed the attack with skill. The absence of promised support kept the fruits of success beyond

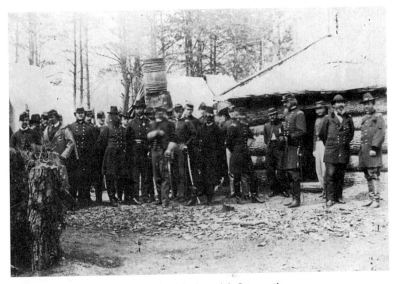

Anxious, too, was the immediate commander of the Army of the Potomac, the only man in the army who had ever beaten Lee, Major General George Gordon Meade. Here he stands, fourth from the right, with some of his officers, among them Sedgwick—second from the right—and Brigadier General A. T. A. Torbert, far right, who commands a division of cavalry that will protect Meade's flank in the advance. (P-M)

reach, but when the Federals were driven back they took along a substantial number of prisoners.

Grant may have concluded that the time was ripe to take Lee head on; or perhaps he decided that that had always been the solution which earlier Federal leaders had missed; or perhaps his ghastly arithmetic suggested that any sort of fighting was going to do the job, and tactical niceties therefore verged on irrelevance. In any event, the successful frontal assault by Upton began a month of frontal assaults in which tens of thousands of Federals were shot with relative ease by sheltered Confederates.

Two days after Upton's temporary success, the Army of the Potomac went right over the top of the Confederates' Mule Shoe earthworks and

raised havoc with Lee's entire position. An early morning assault by the Federal II Corps under Hancock shattered the nose of the salient and pushed into the heart of the Southern lines. Near the McCoull house the advance was blunted. Desperate counterattacks pushed the Federals back to the tip of the salient and then the fight deteriorated into a brutal brawl at arm's length for some 20 hours. Only earthworks separated the ragged lines as they fought in the rain and mud and blood. Quite early in the struggle a 20-inch-thick oak tree toppled to the ground, having been chewed off by the incessant streams of balls flying in such profusion that the hard wood was gnawed as thoroughly as though by beavers. When Confederate survivors stumbled back to a new line across the base of the

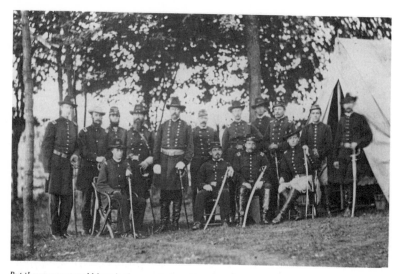

But there were some old faces in the army that would not be going, and one of them that Meade would not miss was Major General William H. French. Here he stands, fifth from the left, among officers of his III Corps. Meade blamed French for the failure to bag Lee the previous November, and shed no tears when the III was reorganized out of existence and French himself mustered out of active service. (USAMHI)

salient, their abandoned works had more than justified the *nom de guerre* "The Bloody Angle."

The logistics which controlled the will of generals had dictated a change of base to Grant. His lifeline was shifted from his right rear at Culpeper to his left rear by way of Fredericksburg to the Potomac River at Belle Plain landing. The success of the early morning attack on the salient on May 12 was traceable in part to a coincidence resulting from Grant's change of base. Lee received word of the activity in that direction and for once his uncanny perception of enemy intentions failed him. He feared a major enemy move to the southeast (which eventually came on May 21), and weakened his front line in preparation for a countermove of his own. That fringe benefit was unknown to Grant, but the logistical merits were large. The maritime might of the North steamed to Belle

Plain and made it into an overnight city. Confederate prisoners and Federal wounded were funneled out through the landing; recruits and war material and horses passed them en route to the front.

The grisly night of May 12 also brought terrible news to Lee from Richmond. J. E. B. Stuart had been harrying Federal raiders, who were being led toward Richmond by Philip Sheridan. On May 11 a severe cavalry fight had taken place at Yellow Tavern, just north of the capital. Promising young North Carolina Brigadier James B. Gordon had been killed and Stuart himself had suffered a mortal wound. He died in Richmond during the evening of the 12th, while distraught friends and colleagues sang "Rock of Ages" at his request.

Back at Spotsylvania, Grant had Meade moving his army steadily around to its left flank. Warren's

V Corps, which had started the battle on the right, moved around to the far left and set up headquarters at the Francis Beverly house, not far from the Court House. Every day there was fighting of varying intensity; sometimes it was localized, sometimes it spread along the lines, but always there was fighting. On May 18, Grant ordered Meade to move against the strongly fortified Confederate main line. Defending artillery so thoroughly swept the attackers that many Confederate infantrymen hardly noticed the whole affair. Meade wrote disgustedly to his wife that finally "even Grant found it useless to knock our heads against a brick wall."

On May 19, Lee sent most of his II Corps, under Ewell, to swing up behind the abandoned Bloody Angle and probe the right rear of the new Federal alignment. The result was an intense struggle around the Harris farm. The Confederates played havoc with some green heavy-artillery regiments, which fought with admirable tenacity, although only recently converted to infantry service. In the confusion many Federal units fired on one another. A disgusted quartermaster watched "Kitching's brigade firing at the enemy; then Tyler's men fired into his; up came Birney's division and fired into Tyler's; while the artillery fired at the whole damned lot." In the final analysis, Ewell had more than he could handle and fell back in confusion under cover of some horse artillery which happened along. The newly blooded Federal heavy artillerists buried their own dead and the Confederate dead around the Harris house and the nearby home of Widow Alsop. Black troops of Ambrose Burnside's IX Corps played a small role in this affair; it was their first action with the Army of the Potomac.

When the armies moved away from Spotsyl-

Finally came May 4, 1864, the great day. Grant ordered the army to move, and the once-teeming winter camps were deserted. James Gardner caught this scene near Brandy Station shortly before the army moved out. (LC)

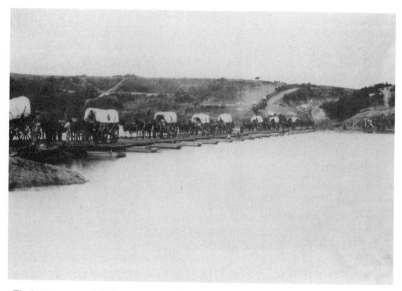

The first to cross was the V Corps, its wagon train seen here rolling over a bridge at Germanna Ford on the Rapidan. Timothy O'Sullivan photo. (USAMHI)

vania on May 21 they left behind the bloodiest ground in North America. The campaigns in the vicinity from 1862 to 1864 had resulted in more than 100,000 casualties. Grant's route took him past Massaponax Baptist Church in the eastern fringe of Spotsylvania County. A Federal surgeon riding past the church noticed the generals and their entourage seated in the yard of the church on pews. He also watched the ungainly snout of a camera poking out of an upstairs church window recording the high command at deliberations as the Army of the Potomac was being spurred southward on May 21, 1864. The new movement prompted another change of base by the Federals, this time to Port Royal on the Rappahannock River. Grant luxuriated in the flexibility which Union naval prowess gave him.

For two days the armies raced for an advantage, then for five days (May 23–27) they fought and

maneuvered along the North Anna River. There were four main river crossing points from west to east: Jericho Mills, Quarles Mills, Ox Ford, and at the Chesterfield Bridge. The commanding heights of the north bank of the river overlooked the south bank and its river flats at all of these points except Ox Ford. Lee skillfully anchored his line at Ox Ford, where the terrain made it all but impossible for the Federals to force a crossing. He then fortified a strong line running away from the river in two lines, covering the absolutely vital rail facilities at Hanover Junction. The line formed an inverted "V," with its apex at Ox Ford.

The Army of the Potomac laid pontoons at the other three crossing points and pushed across in strength. The heaviest skirmishing was in the vicinity of Jericho Mills. Lee pulled his units back into the entrenched line and contemplated a superb opportunity to hurt Grant. The Confederate grip on

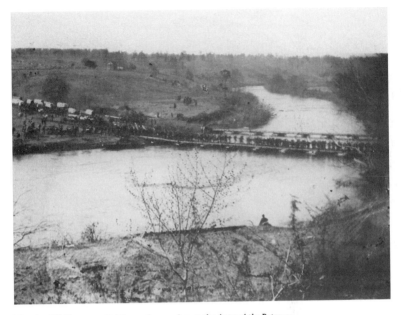

Timothy O'Sullivan recorded the ensuing crossings as the Army of the Potomac supplied the campaign that would drive Lee to cover. Soldiers of the VI Corps cross on pontoon bridges over the Rappahannock at Fredericksburg later in May. (LC)

Ox Ford meant that Lee could move his troops to either side of his line for an attack on a Federal fragment; Federals rallying to the point of attack from the other end of the line would be forced to trek in a huge half circle and cross the river twice. The opportunity was an exciting one, but the prospects for execution revealed the state of Lee's army. Not only was mighty Stonewall gone, but also A. P. Hill was not meeting Lee's needs, Ewell was freshly relieved of his command, and the army could not be put to the task with the verve that had made it famous.

Lee himself was suffering physically during the week and was unable to personally carry the command load at the corps level, although that was to

be his lot for much of the remainder of his army's existence. Grant got away from North Anna unscathed. If he noticed the shadows that had been held from his path, and had some understanding of his good fortune, he must have seen reason for optimism; the Army of Northern Virginia had lost its power to assume the offensive, and the most egregious Federal blunders would yield no more than temporary embarrassment.

The next move to the southeast took the Army of the Potomac from the North Anna to the Pamunkey River and beyond to Totopotomoy Creek. The Union columns poured across the Pamunkey at and near Hanovertown. Grant moved his supply base again, down to the White House on the

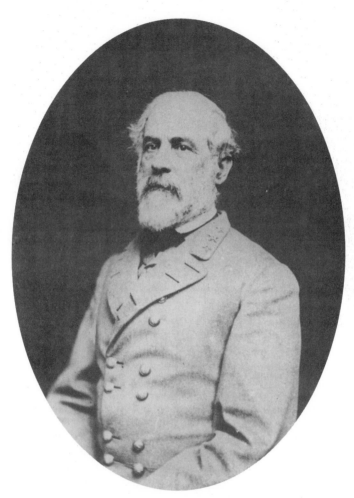

Awaiting them all was the man who had been the nemesis of so many Federals before them, General Robert E. Lee. There is a deceptive peacefulness about his visage in this image by Richmond photographers Vannerson and Jones. He will be ready for Grant and Meade. (CHS)

*He will meet them first here, along the Orange Turnpike, four miles west of the
Wilderness Church. This is Palmer's Field, and just visible at the base of the
trees in the background are the hasty entrenchments behind which Lee awaits
Warren. Photo taken late in 1865 or early 1866.* (USAMHI)

Pamunkey. The house and estate had been owned
by General W. H. F. Lee before the war and had
connections with Lee's Custis and Washington an-
cestors. An earlier Federal occupation, during the
1862 Richmond operations, had left the house in
ashes. Now it was to serve as the port of entry for
another onset.

During the last five days of May there was
heavy localized fighting but no widespread action.
Through it all, Lee maintained a tenuous grip on
the irreplaceable Virginia Central Railroad, barely
west of his positions. There was a sharp cavalry
fight north of Totopotomoy Creek on the 29th at
Haw's Shop and another south of the creek at Old
Church the next day. Also on the 30th the Confed-

erates sent John Pegram's excellent brigade for-
ward in an attack near Bethesda Church. Division
commander Stephen D. Ramseur was widely
blamed for the disastrous result of this attack.
James B. Terrill of the 13th Virginia was killed;
the Confederate Congress confirmed his nomina-
tion as brigadier general the next day.

The last meeting of the armies north of the
James came at Cold Harbor. During the last night
of May both armies completed the gradual slide to
the southeast which had been leading to a cross-
roads called Cold Harbor. A few days short of two
years earlier, Lee had fought on this same ground
his first major battle as commander of the Army of
Northern Virginia, driving McClellan from his po-

Charging against these log breastworks, Warren is unsuccessful. His men are caught in a deadly crossfire. An early postwar image. (USAMHI)

sition in the Battle of Gaines' Mill. Fitzhugh Lee's cavalry attempted to hold the Cold Harbor crossroads for the Confederates on May 31 but Alfred Torbert's Federal troopers forced Lee away. William F. "Baldy" Smith's XVIII Corps was coming along to help, having been transferred to this front from the scene of the ineffectual operations being bungled by Ben Butler below the James.

The dispute between Fitz Lee and Torbert served as a foundation on which both armies eventually built a network of fortifications. A good opening was lost to the Confederates on the morning of June 1 as a result of some inexperienced leadership and some well-handled Federal Spencer carbines. Late on the 1st, a determined Union assault won some ground from Lee, but at heavy cost. Grant planned a massive attack for June 2 but the delayed arrival of Hancock's II Corps

resulted in a postponement until the next morning. Opportunistic Southern initiatives on each flank captured some prisoners during the day; among the Confederate dead was competent, seasoned brigade commander George P. Doles, a thirty-four-year-old Georgian.

About 4:30 on the morning of June 3, Grant sent the Army of the Potomac forward in a massive frontal assault which has since come to symbolize the nadir of generalship. The II, VI, and XVIII Corps attacked in directions which left their flanks exposed to vicious enfilade fire as well as head-on punishment. Within a few minutes the attacks had been beaten down, although many of the Northern survivors stubbornly held their ground near the Confederate lines and began to protect themselves with earthworks. The flames and smoke from Southern weapons hid their enemies

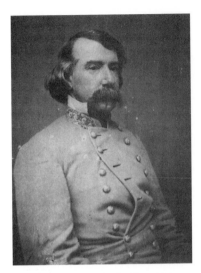

One of the defenders is Brigadier General John Marshall Jones, who leads his brigade in defense of those breastworks. During one of Warren's desperate assaults, Jones sat on his horse gazing at the approaching enemy when a bullet ended his life. (VM)

from the stunned Federals hugging the ground. The roar, they were certain, exceeded the musketry of any other battlefield, even without the artillery thunder. More than 7,000 Union troops had been shot within a few minutes. Four days later Grant requested a truce to tend to the survivors; for ten days the armies lay within 100 yards of each other. The heat and stench and flies and sharpshooters vied for attention. Trench warfare was becoming a way of life. The disgruntled chief of staff of the Federal VI Corps declared that Cold Harbor "was the dreary, dismal, bloody, ineffective close of the . . . campaign . . . and corresponded in all its essential features with what had preceded it."

While the armies glowered across the lines around Cold Harbor, events elsewhere in the state affected them. Union General David Hunter's predations in the Shenandoah Valley demanded Lee's

attention. On June 13, Jubal Early led the Confederate II Corps away from Richmond toward Lynchburg. Lee was also obliged to weaken his army by detaching Wade Hampton, with two divisions of cavalry, in order to contain a Federal cavalry force raiding under Philip Sheridan. Below the James, Union forces under Benjamin Butler posed a threat to Richmond and Petersburg and the crucial rail net around those cities. On June 9 a scratch force defended Petersburg by the barest margin against Federal cavalry under August V. Kautz.

The same day that Early marched away toward the Valley, Lee discovered that Grant was moving away from Cold Harbor. In the tangled countryside between the Chickahominy and the James, Lee lost track of his adversary and Grant took advantage of the terrain to outmaneuver the Confederate commander. By June 16 almost all of the Army of the Potomac was across the James River, having crossed on a pontoon bridge of great length and marvelous engineering. From the 15th through the 18th, Petersburg was held by P. G. T. Beauregard against increasingly heavy masses of attackers. Beauregard knew what was happening and pleaded for reinforcements from Lee, but Lee was slow to respond, in part because Beauregard was habitually importunate.

An almost unbelievable series of accidents and failures kept the overwhelming Federal force from taking Petersburg when it was ripe for the taking. Odds ranging up toward ten-to-one were frittered away. The frustrated commander of the Army of the Potomac finally issued peremptory orders for an assault by each corps, regardless of supports which just could not quite be coordinated. When it was made, the precious opportunity had slipped away, and veteran Confederates had arrived to man the earthworks and destroy the attackers. Eager but unseasoned heavy artillerists-turned-infantrymen (the same who had stood so firmly at the Harris farm a month before) continued the attacks. Veterans tried to stop them with "Lie down, you damn fools, you can't take them forts." The damn fools lost more men in one regiment that day than any other Union regiment lost in any battle through the entire war! Grant had suffered about 12,000 casualties while failing to get into Petersburg. It would cost many more, and almost a year of trying, before the town finally fell.

Behind these defenses, the Confederates could withstand everything Warren hurled at them. It was to be a foretaste of the bitter, often inconclusive fighting of the Wilderness. Taken within months of the end of the war. (USAMHI)

During that day's fight on May 5, Warren made his headquarters in the Lacy House, seen in the far distance in this view taken from the Wilderness Tavern. The battle line lay just another mile over the hill. (USAMHI)

Still farther behind the line, though still taking its name from this tangled mass of woods and thickets, stood the Wilderness Church, itself almost lost among the trees. (USAMHI)

Many died that first day, among them Brigadier General Alexander Hays, shown here at his headquarters near Brandy Station. He stands tenth from the right, hand on hip. (COURTESY OF LLOYD OSTENDORF)

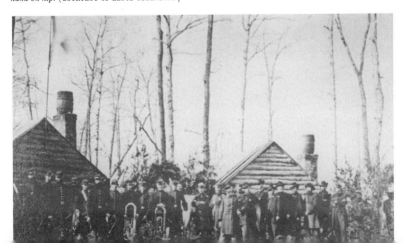

Viewed from the Orange Turnpike, the Wilderness Church nestles at left in the trees, with the Hawkins farm on the right. This was some of the only cleared ground in the vicinity of the battlefield. (NA)

The rest looked like this, these grinning skulls now as much a part of the Wilderness as the leaves and underbrush. (USAMHI)

On their way to the battle line, Warren's men and the others to follow came down the Germanna Plank Road to Wilderness Tavern, then marched straight down the Orange Turnpike, shown here running off to the horizon. The tavern stands at left. (USAMHI)

Sedgwick followed Warren into the battle with the Confederate defenses, his leading division belonging to Major General Horatio G. Wright. Wright, standing in the center beneath the peak of his tent, displays the VI Corps banner behind him. He seems almost to be smiling, and others definitely are. When this photo was made in June 1864 at Cold Harbor, Confederate shell fire was occasionally coming their way, and while the camera was laboriously being adjusted, one wag in the scene commented that he could "Wish a shell would hit the machine." The officers were still smiling when the exposure was made. (USAMHI)

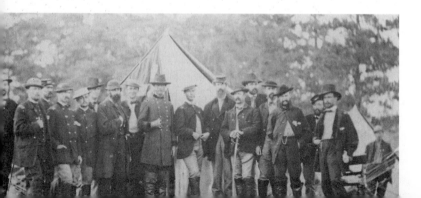

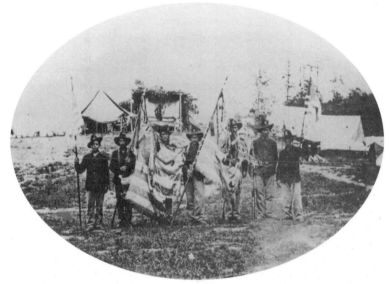

The 56th Massachusetts and the 36th Massachusetts were both repulsed in a bloody assault the afternoon of May 6. At war's end their regimental colors were little better than rags. (USAMHI)

And some of the regiments that fought here were little better. Company I of the 57th Massachusetts went into the fighting on May 6 numbering 86 men. Several weeks later, these nine men, commanded by Sergeant R. K. Williams at right, were all that was left. (USAMHI)

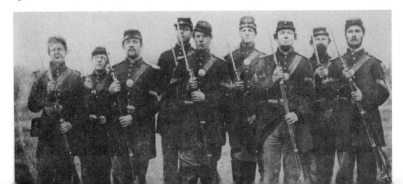

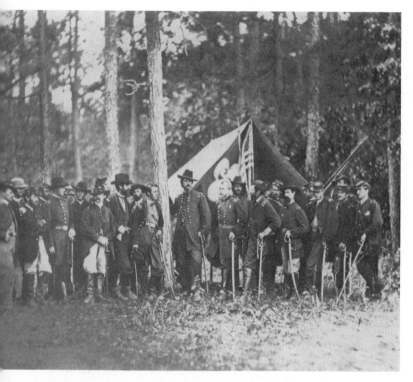

*Commanding Meade's II Corps was Major General Winfield Scott Hancock,
seen here with his generals and staff. Leaning in front of the tree is Brigadier
General Francis Barlow, who began the war as a private. Just to the right of the
tree stands Hancock, and next to him is Major General David B. Birney. As the
fighting left the Wilderness and moved on to Spotsylvania, Birney and Barlow
won glory by capturing over 3,000 Confederates. In the front row next to Birney
is Brigadier General John Gibbon.* (USAMHI)

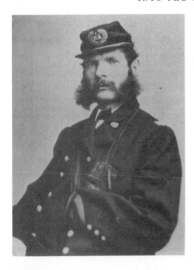

Colonel Samuel S. Carroll led one of Gibbon's brigades in the Spotsylvania fighting until a wound put him out of action. He won a brigadier's star for his conduct, but spent months recuperating, as shown here. (P-M)

The terrain in the Spotsylvania fighting was not any better than the Wilderness, tangled woods filled with Confederate rifle pits and log breastworks. (USAMHI)

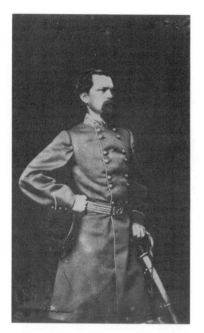

Some, like the brilliant Confederate Brigadier General John B. Gordon, continued to win laurels as the campaign progressed. (VM)

Some, like Brigadier General James S. Wadsworth, were left behind, dead in the Wilderness. A Brady & Company photo, probably made in 1862 when Wadsworth was military governor of the District of Columbia. (ROBERT J. YOUNGER)

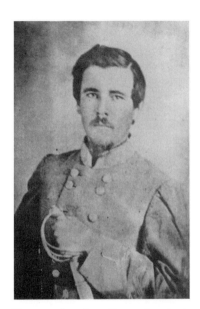

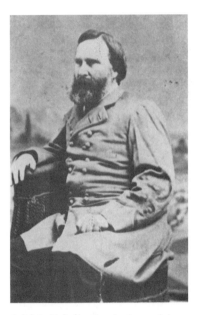

There were others who would not see Spotsylvania either. Caught in the accidental fire of his own Confederates, the popular and talented young South Carolina Brigadier Micah Jenkins took a bullet in the brain on May 6. In his delirium he urged his men forward, forward. (CHS)

And shot with Jenkins, though only wounded, was the commander of Lee's I Corps, his old war horse, Lieutenant General James Longstreet, back in Virginia after his ill-fated Knoxville Campaign. The wound put him out of the war for months. Probably an early postwar portrait, taken in New Orleans. (WA)

This is the view that Jenkins and Longstreet were not there to see. Timothy O'Sullivan's image was taken near Spotsylvania Court House. In the foreground are baggage wagons attached to the headquarters of the V Corps, Army of the Potomac. (LC)

Spotsylvania Court House itself, like so many of the places visited by these warring armies, was a simple country village until war made its name terrible. (USAMHI)

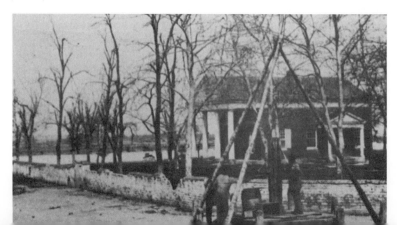

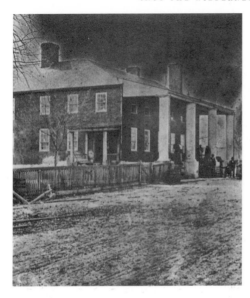

The Spotsylvania Hotel, near the Court House, in a late 1865 view. (USAMHI)

Opposite the hotel was so-called "Cash Corner." (USAMHI)

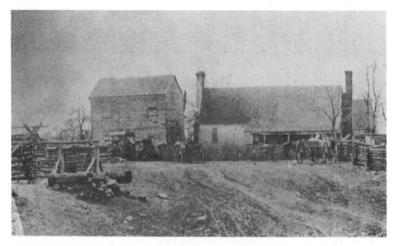

That same day, in the attempt to reach and hold Spotsylvania Court House before Lee could arrive, the Federals sent Brigadier General David McM. Gregg and his Second Cavalry Division on a reconnaissance that was stopped by the arrival of most of Lee's army. Gregg is seated at right. (USAMHI)

Some of the first fighting in the Spotsylvania operations took place here at Todd's Tavern at the junction of the Brock, Catharpin, and Piney Branch roads. Grant tried to use those roads to get around Lee but could not. (USAMHI)

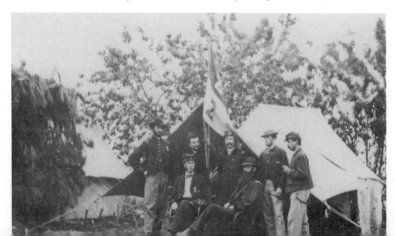

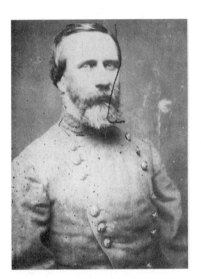

The first Confederate to arrive on the scene at Spotsylvania was Major General Richard H. Anderson, now risen to replace the wounded Longstreet. Just in time he stopped the Federal drive for the Court House. (VM)

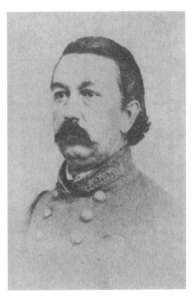

Leading one of Anderson's divisions was Major General Charles W. Field. After the war he took service in the army of the Khedive of Egypt. (USAMHI)

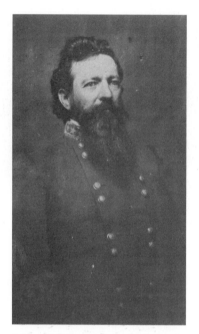

Fighting with him was Brigadier General Harry T. Hays, who received a desperate wound that left him convalescent for much of the rest of the war. (VM)

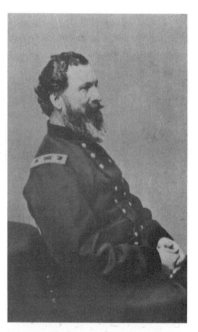

On May 9, Grant suffered a major loss when Major General John Sedgwick, commanding his VI Corps, was killed by a Confederate sharpshooter. "They couldn't hit an elephant at this distance," he calmly boasted just before the marksman's bullet brought him down. (USAMHI)

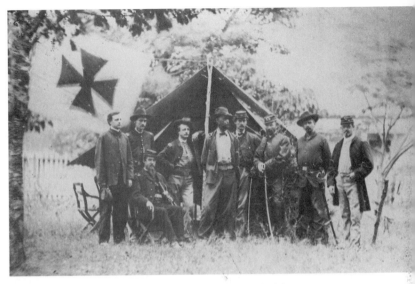

The next day, May 10, the desperate and bloody assaults that characterized the Spotsylvania fighting commenced. Warren's V Corps spearheaded much of it. His Second Division commander, Brigadier General Charles Griffin, is seen standing just right of the tent pole. There were few better soldiers in the army. (USAMHI)

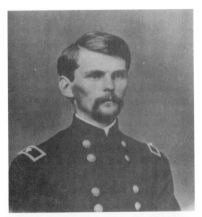

Most brilliant of all was the attack led by Colonel Emory Upton, shown here wearing the brigadier's stars that his assault on "The Bloody Angle" won. He was just twenty-four. (NA)

It was some of the most desperate fighting anywhere in the war. Hardly a tree in the vicinity came through it without some memento such as this Confederate shell, found near the position of the 7th Rhode Island. (USAMHI)

Desperately, Confederates like this private, Da Hicks of Virginia, sought to drive Upton ba (AMERICANA IMAGE GALLERY)

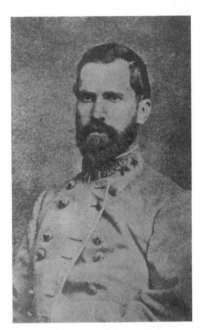

Two days later Grant ordered an even more massive attack where Upton's had almost succeeded. It was in an area called "The Mule Shoe," and here it was that Birney and Barlow overran the Confederates and captured several thousand. Reinforcements rushed to "The Mule Shoe," among them Brigadier General Abner Perrin. "I shall come out of this fight a live major general or a dead brigadier," he supposedly declared. He came out a dead brigadier. (P-M)

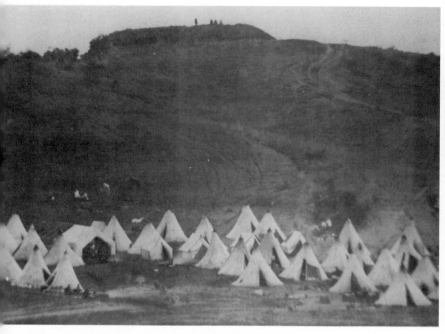

While the Spotsylvania fighting continued on into the middle of May, Grant constantly built up his supplies for the overland campaign through his supply base at Belle Plain, on the Potomac. Once it had belonged to the Confederates, and their earthworks could still be seen on the hill above the landing. (WRHS)

But in May 1864 it belonged to the Union, and it teemed with men and wagons. A Brady & Company image taken probably on May 16, 1864. (USAMHI)

Most of the supplies came ashore on the lower wharf. (USAMHI)

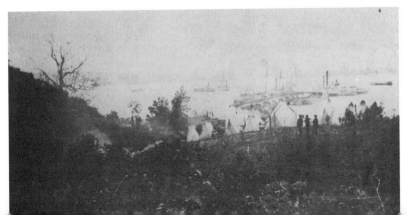

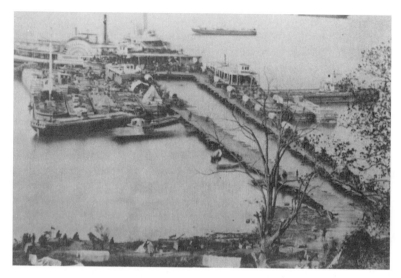

It saw the constant comings and goings of supply steamers as the wagons lined up on the wharf to take on their burdens. (USAMHI)

And then they were off on their way to the Army. (USAMHI)

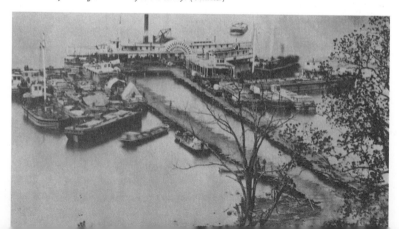

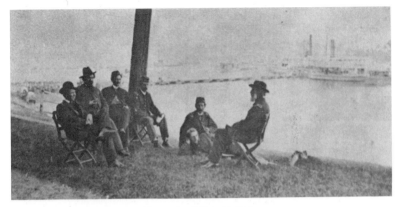

Brigadier General James J. Abercrombie, seated at right, had just taken command at Belle Plain on May 12 and was still new to it when this and other Belle Plain images were taken. He was one of the oldest officers on active service, born in 1798. He will later be relieved of command at Grant's next supply base when he appears to be "bewildered and lost." (KA)

A. J. Russell's view of the upper wharf at Belle Plain, just the day after engineers built it. Already a barge awaits unloading. (LC)

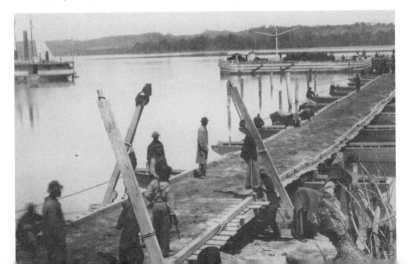

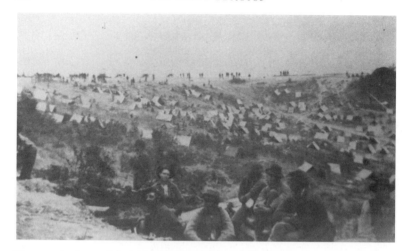

*There was more than supply to contend with. For one thing, Grant was taking
thousands of prisoners in the Spotsylvania fighting. Here a host of them wait at
Belle Plain for transportation to prison camps in the North.* (WRHS)

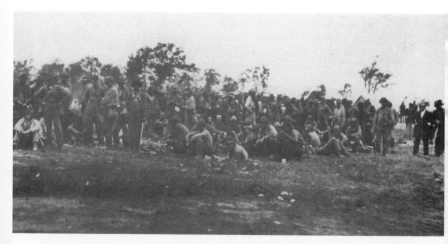

*In the days ahead, Grant would take even more Confederates, many of them
lean and tattered.* (RINHART GALLERIES, INC.)

Then there were the wounded, like these stretched on the Marye House lawn in Fredericksburg. (USAMHI)

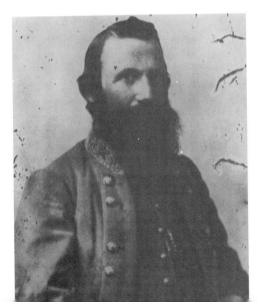

There would be more wounded and dead to come. One of the severest blows to Lee came at Yellow Tavern on May 11, when his beloved—if erratic—cavalry chief, Jeb Stuart, was mortally wounded. He was, perhaps, the last of the cavaliers. (VM)

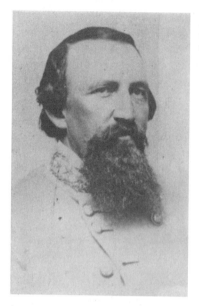

While Stuart was dying, another bold cavalryman, Brigadier General James B. Gordon, took his own mortal wound. Slowly, Grant was bleeding Lee to death. Portrait by Vannerson and Jones of Richmond. (VM)

Many were already dead. Here at the Francis Beverly house mounds of earth may testify to the field burials. (WRHS)

The dead seemed uncountable. A Confederate who fell in the attack of May 19, when Lee tried vainly to probe Grant's right flank. (USAMHI)

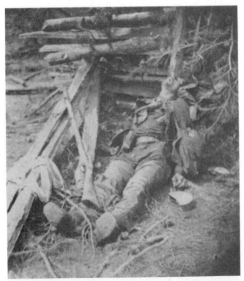

Another dead Southerner, with nothing before him now but burial, and probably in an unidentified grave. (USAMHI)

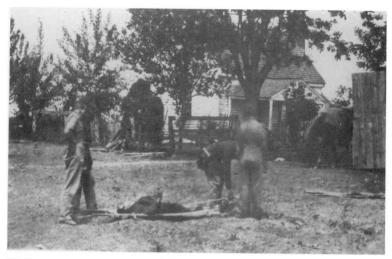

*O'Sullivan captured the scenes of burial with his camera in May, after the
fighting near the Alsop house. As the dead man clutches at the air in rigor, at
least one of the burial detail appears to be wearing a mask. The stench would be
terrible if the men were not interred quickly.* (LC)

*The dead Confederates lay lined up for O'Sullivan's camera in rows. There were
always onlookers to stare in macabre wonder at the face of death.* (USAMHI)

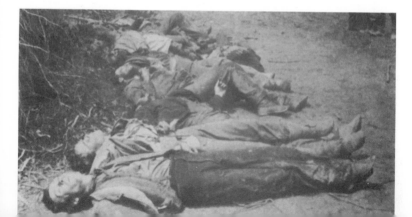

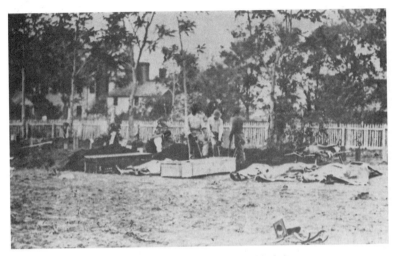

Back in Fredericksburg, artists photographed the interment of Federal dead. At least they would get caskets—rude though they were—and headboards. When there was more time later, they could be removed to permanent plots. A lens from Russell's equipment lies in the foreground. (USAMHI)

In May 1864, when Brady & Company made these images, every blanket in Fredericksburg seemed to have feet. (USAMHI)

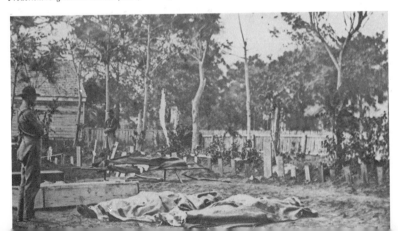

*Meanwhile, the campaign wore on, as Grant continued to try to get around
Lee's flank. As the armies marched, Grant made his temporary headquarters on
May 21 at Massaponax Church.* (USAMHI)

Here he had aides pull pews out of the church so he could hold an open-air council of war. Happily, a photographer positioned his camera in one of the church's windows and recorded what followed. Grant sits on the pew at upper left, directly in front of the two trees. His cigar is in his mouth. Just left of him is probably his aide and brother-in-law, Colonel Frederick Dent. To the right of Grant sit Charles A. Dana, Assistant Secretary of War, and Chief of Staff Rawlins. General Meade sits at the upper end of the pew at far left. Next to him is an aide, and then sits Lieutenant Colonel Adam Badeau, Grant's military secretary, and then probably Grant's aide, Lieutenant Colonel Horace Porter. The man standing inside the circle of pews at right appears to be reading something aloud, to which Grant is listening. The blur in the background is caused by a constant flow of supply wagons moving to keep pace with the army. (USAMHI)

Grant has moved now and is leaning over the pew at left talking with Meade as they both look at a map. (USAMHI)

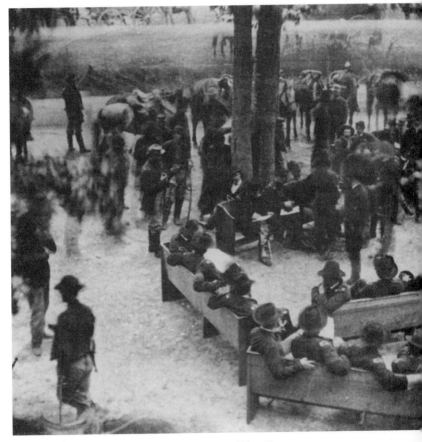

And now Grant is seated once more, writing out an order that will keep his army constantly on the move against Lee. (USAMHI)

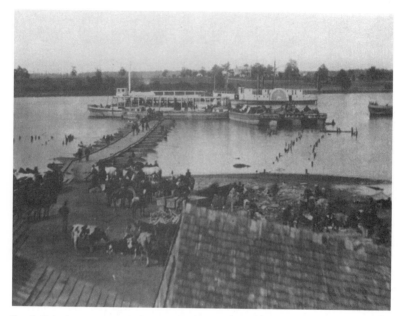

Now the Federal commander changed his supply base from Belle Plain to Port Royal on the Rappahannock River. As his army advanced, Grant was able to make his supply bases advance with him, continuing the endless flow of succor to the marching Federals. (USAMHI)

To help protect his Rappahannock River supply base, Grant also enjoyed the cooperation of the Navy. Here the USS Yankee *poses on the river on May 19.* (USAMHI)

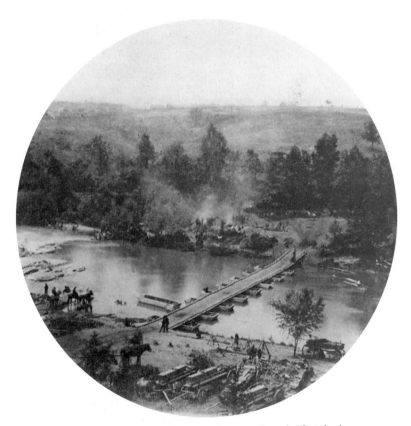

By May 23, Grant was on the North Anna River, 20 miles south of Spotsylvania, and Lee was waiting on the other side. That day Warren's V Corps began crossing here at Jericho Mill. This is what they saw ahead of them. (USAMHI)

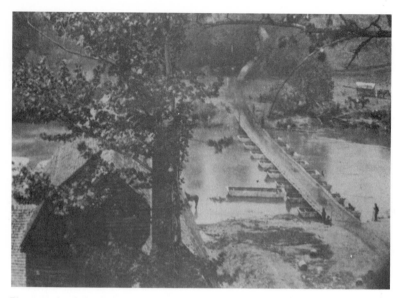

There was only a shallow ford at first, but Warren quickly threw a pontoon bridge over to facilitate the passage of his wagons and artillery. (USAMHI)

The men who drove away the Confederate pickets at the ford were men like this Pennsylvania "bucktail," Private Samuel Royer of Company C, 149th Pennsylvania. Every man in the regiment wore a bucktail in his cap. Royer barely lived out the war, dying June 19, 1865, from the effects of a war wound. (TPO)

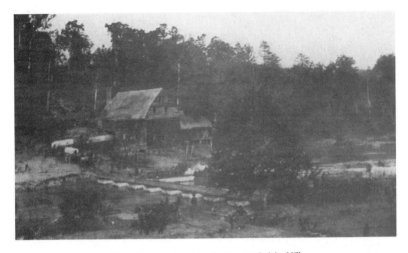

Warren's V Corps ammunition train crosses the bridge the day after Jericho Mill was taken. (USAMHI)

And here the 50th New York Engineers work at cutting a wagon road out of the tangled underbrush to make way for Warren's wagons. Every arm of the Army worked in coordination toward the common goal. (USAMHI)

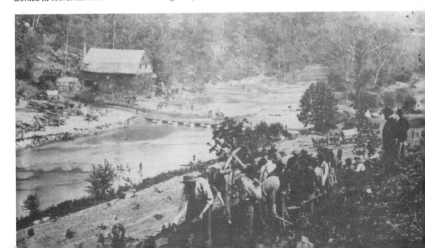

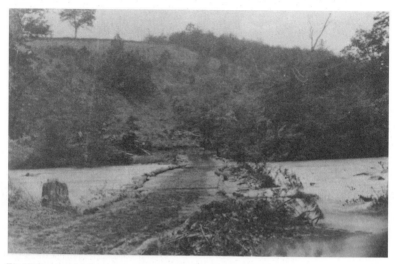

The IX Corps crossed downstream at Quarles Mills, first attacking and overrunning Confederate works at the top of the hill. Then came another bridge, and thousands more Yankees were one river deeper into Virginia. (USAMHI)

Meanwhile, on May 23, as Warren crossed at Jericho, Hancock and his II Corps attacked the redoubt shown on the horizon that guarded the Chesterfield Bridge over the North Anna. They took the redoubt and swept over the bridge. O'Sullivan made this image only a few days later. (USAMHI)

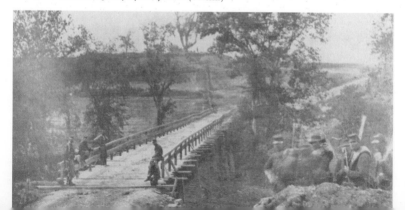

And he took his camera inside the redoubt to capture the view of Yankee cavalry crossing over the bridge toward Hancock's camps in the distance. (LC)

The Federals soon settled into abandoned enemy works like this, where they could protect their important crossings over the North Anna. (USAMHI)

Yet another destroyed bridge, this one on the North Anna. (USAMHI)

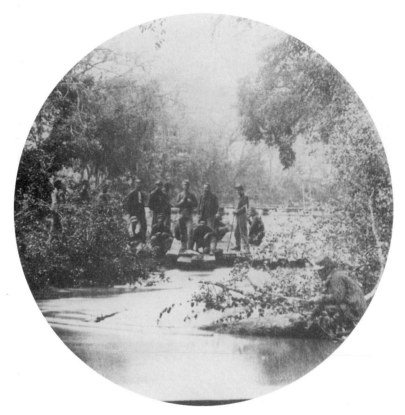

All along the North Anna pontoon bridges sprang up to maintain the flow of foot and wagon traffic that sustained Grant's advance. This one was built by II Corps engineers, downstream from Chesterfield Bridge. (USAMHI)

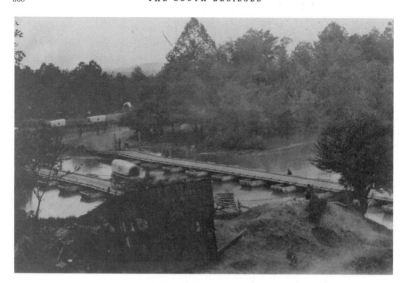

But when Lee confronted Grant on the North Anna, the Federals simply pulled back and moved southeast once more, then crossed once again, this time over the Pamunkey River at Hanovertown Ferry. Lee was ready for him once more. (USAMHI)

Meanwhile, Grant once again shifted his supply base, this time from Port Royal on the Rappahannock to White House Landing on the Pamunkey, 15 miles downriver from Hanovertown Ferry. The first troops to arrive found only "inadequate means of landing." Yet by the time this image was made in June, White House was a busily functioning port. (WRHS)

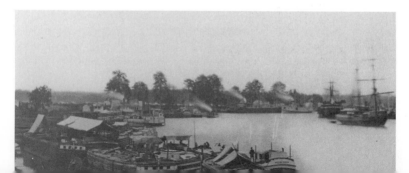

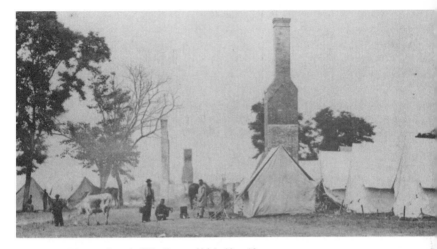

The landing took its name from the White House, which by May 1864 was nothing but lonely chimneys. The man in the felt hat with the beard may be David B. Woodbury, Brady's photographer. (KA)

Here it was that General Abercrombie became bewildered and had to be removed. For his soldiers, however, it was just one more supply base to keep Grant moving. (USAMHI)

And Grant never stopped moving. Here at Old Church, on May 30, Federals skirmished with Lee as Grant's cavalry protected his left flank in the advance. Here a cavalry detail stops outside the Old Church Hotel on June 4. (USAMHI)

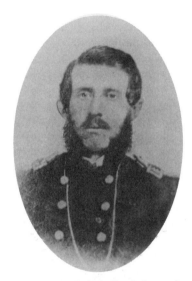

That same day, at Bethesda Church, Grant and Lee began the fighting that would culminate a few days after in the Battle of Cold Harbor. Colonel James B. Terrill was killed leading one of Lee's regiments near Bethesda. He died without knowing that his promotion to brigadier would be official the next day. Ironically, too, his brother William had been a general in the Union Army, and he, too, fell in battle. (USAMHI)

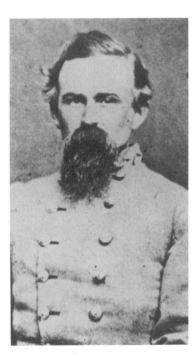

On June 2 the fighting around Bethesda claimed another promising young leader, Brigadier General George P. Doles of Georgia. (MC)

Men like these officers of Doles' 4th Georgia had to look to a new commander. They found him in . . . (COURTESY OF STEVE MULLINAX)

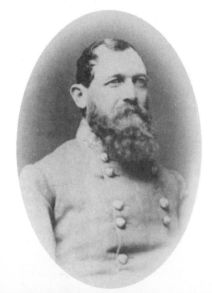

. . . Colonel Philip Cook of the 4th Georgia. Months later he became a brigadier general, as pictured here. (USAMHI)

By June 2, Grant was nearing Cold Harbor. He pushed aside cavalry protection commanded by Robert E. Lee's nephew, General Fitzhugh Lee. (USAMHI)

Soon the Federals were advancing toward the swampy woodlands like this that bordered the Chickahominy River. Lee was waiting for them. (CHS)

And that led, on June 3, to the dreadful battle of Cold Harbor. Photographer J. Reekie's April 1865 image of part of the Confederate works that stopped Grant's disastrous attacks. (CHS)

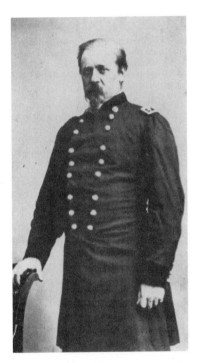

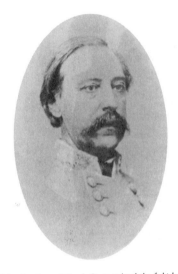

Brigadier General Goode Bryan missed the fight by just a few hours, his failing health forcing him to turn over his brigade to a senior colonel. A few months later he would have to resign his commission. (USAMHI)

Major General William F. Smith with his XVIII Corps had recently arrived, via White House Landing, in time to take part in the attack. His corps, like the others engaged, was dreadfully battered, and he never forgave Meade for sending him into battle at Cold Harbor. (USAMHI)

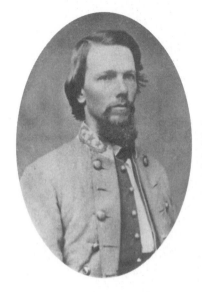

But Confederates like Brigadier General Evander McI. Law were in perfect health and anxious to deliver death to Grant's attacking Federals. Law himself was wounded in repulsing the enemy's charges. (USAMHI)

The men in those assaults were soldiers like these zouaves of the 114th Pennsylvania, here captured by O'Sullivan's camera. They were part of the headquarters guard of the Army of the Potomac, however, and spent more time at parade than in real fighting. (TPO)

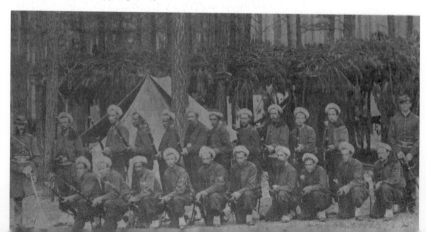

Not so the 8th Michigan. With drummers like Robert H. Hendershot of Company B, these Wolverines were in the thick of the bloody fight. (TPO)

What stopped them were Confederate divisions led by men like Major General Henry Heth, said to be the only general that Lee addressed by his given name. (NA)

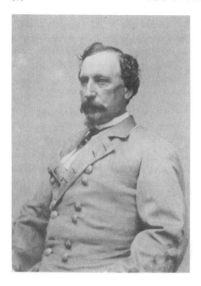

Brigadier General Joseph Finegan of Florida had just arrived from his home state with a brigade in time to help stem Grant's assault. Few Floridians got the chance to serve with the fabled Army of Northern Virginia. (WRHS)

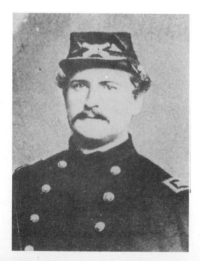

One of the hundreds who fell in attacking works held by the Confederates was Colonel Peter A. Porter of the 8th New York Heavy Artillery. He died on the field that June 3, killed fighting troops led by his own cousin and childhood playmate General John C. Breckinridge. (USAMHI)

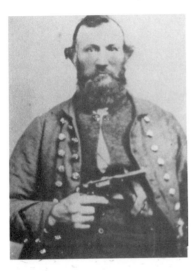

His foolhardy attack at Cold Harbor failed, Grant sent his cavalry on a raid into the heart of Virginia to distract Lee. Confederate cavalry followed, excepting the division of Lee's son, Brigadier General William H. F. Lee. One of "Rooney" Lee's troopers was this man of the 10th Virginia Cavalry, Private Benjamin Franklin Lincoln. His second cousin Abraham was President of the United States. (COURTESY OF DALE SNAIR)

Undeterred, Grant would continue looking for a way to trap Lee and end the war in Virginia. It would not come for another year, but he would never stop trying. Grant stands here at his headquarters at Cold Harbor in early June surrounded by his staff. Colonel Rawlins sits at far left. Brigadier General John G. Barnard, chief engineer of the Union armies at center, hands in lap, and standing just to the right of him is Grant's old friend and military secretary, Lieutenant Colonel Ely S. Parker, a full-blooded Seneca Indian. Parker will be with Grant nine months from now at Appomattox to see the end and to transcribe the terms of surrender. But for both of them, that was still far in the unseen future. (USAMHI)

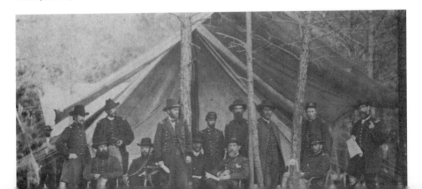

The Atlanta Campaign

RICHARD M. McMURRY

"Hell has broke loose in Georgia," and Sherman makes it so

IT WAS A LONG WAY from the Wilderness to where the western armies of the Union stood poised along the Tennessee and Mississippi rivers preparing for the summer's campaign into the Confederacy's industrial and agricultural heartland in Georgia and Alabama. Three years of warfare had set the stage for the struggle that, more than any other, would determine the outcome of the war.

The Federals who were to assail the Southern heartland were led by Major General William T. Sherman, a forty-four-year-old, red-headed, red-whiskered, hot-tempered native of Ohio. Sherman commanded the Military Division of the Mississippi, embracing all Northern forces between the Appalachian Mountains and the Mississippi River. For the 1864 campaign he assembled three armies. The Army of the Cumberland (60,000 men) was led by Major General George H. Thomas, a Virginian who had remained loyal to the Union. Major General James B. McPherson, a handsome young Ohioan, led the Army of the Tennessee (25,000 men). The 15,000-man Army of the Ohio was commanded by Major General John M. Schofield, a native of New York.

The Confederate heartland was defended by General Joseph E. Johnston's Army of Tennessee, based at Dalton, Georgia, 30 miles below Chattanooga. Johnston was a Virginian, in his late fifties, whose Civil War career was marred by a bitter personal feud with Confederate President Jefferson Davis. By late 1863, Johnston believed that his greatest enemy was the President; Davis was convinced that Johnston could not be trusted with an army. Pride prevented Johnston from resigning; public pressure forced Davis to keep the popular general in command. Johnston's army numbered about 55,000 and was organized into two infantry corps and a cavalry corps. Lieutenant General William J. Hardee, a grumpy Georgian, commanded one infantry corps; Lieutenant General John Bell Hood, a young Kentuckian turned Texan, led the other. The cavalry was under Major General Joseph Wheeler, a young irresponsible Georgian.

During the winter Johnston and the Confederate authorities debated strategy for 1864. The government wanted to drive the Federals from Tennessee. Johnston, convinced that his army was too weak to advance, preferred to select a strong position, fight a defensive battle, and, if successful, move forward against a defeated enemy. This difference could not be resolved, and the Confederates began the campaign with no clear plan.

The Federals, by contrast, had unified their command under Lieutenant General Ulysses S. Grant, who wanted to use the North's full power by having all Union armies advance simultaneously. While he attacked Lee in Virginia, Grant planned for Sherman to move against Johnston while another force captured Mobile and invaded Alabama, thus extending Federal control to a line running along the Chattahoochee River and on to Montgomery and Mobile. Owing to political factors, the campaign against Mobile was abandoned, and Sherman's drive into Georgia became the Union's major 1864 offensive in the West.

Sherman's forces were based in Chattanooga—a city that had been captured by the Federals in late 1863 and the uppermost point on the Tennessee River from which a railroad ran into the heart of the Confederacy. That railroad, the Western & Atlantic, led southeast some 120 miles to Atlanta. Geography and the railroad meant that the campaign would take place in Georgia.

Atlanta, meeting place of four railroads, site of major industrial establishments, hospitals, government and military offices, and the key to control of the West, had come into being as a railroad terminus in the early 1840s. Other railroads were built to link up with the original line, and the city grew to a population of 10,000 in 1860. The influx of refugees, military personnel, and government employees doubled that figure by 1864.

The Federals had many advantages in the campaign. Most important, Sherman and Grant trusted each other and worked together with the support of their government in pursuit of their objective. Johnston's differences with Davis made it impossible for the Confederates to cooperate or even to communicate. Also, Sherman was a more thorough, better-organized, more resourceful, and more flexible leader than Johnston, and he commanded Federal forces in Kentucky, Tennessee, Georgia, Alabama, and Mississippi. There was no overall Confederate commander in the West. Sherman could strike into Alabama against the railroads that supplied Johnston's army, while Johnston could do no more than urge local commanders in Alabama to act. Sherman had, in Thomas and McPherson, chief subordinates of high caliber; Johnston's chief lieutenants, like Johnston himself, were at best mediocre generals. The inability of the Southerners to agree upon a plan, and Johnston's

reluctance to take risks and assume responsibility lest he be criticized by Davis, meant that the Federals would have the initiative and determine the character and tempo of the campaign. Finally, Sherman's forces outnumbered Johnston's about 1.5 to 1 when the campaign opened. Although there was no difference in the quality of men in the opposing armies, Sherman's greater strength gave him another advantage. Circumstances so favored the Federals that only leadership of the highest quality could give the Southerners even a hope of victory.

Rocky Face Ridge, a steep height west of Dalton, runs from north to south. Johnston put his army on that ridge and across Crow Valley, north of Dalton. He believed that Sherman would attack

Come spring of 1864, it was time for hell to break loose in Georgia. The man to unleash it knew a lot about making war hell, Major General William Tecumseh Sherman. (USAMHI)

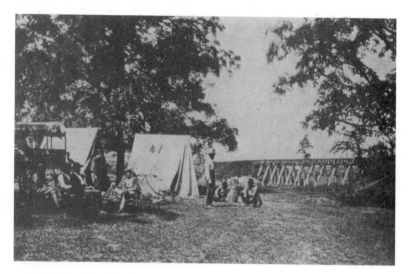

Through that winter of 1863–64, while waiting for the next campaign, the men of Sherman's armies waited at places like Wauhatchie Bridge, guarding his supply lines as he built up his readiness to strike. (USAMHI)

this strong position and was confident that the Confederates could repulse any assault.

Sherman, too alert to fall into such a trap, planned to demonstrate against Johnston's position and swing McPherson's army around to the southwest to the railroad that supplied the Confederates at Dalton. Once the Western & Atlantic was broken, Johnston would have to retreat. Originally Sherman planned to move McPherson toward Rome, Georgia, 35 miles southwest of Dalton, to threaten Johnston's railroad. Because McPherson's army did not attain its expected strength, Sherman decided to send him only to Snake Creek Gap, an opening through Rocky Face Ridge about 12 miles below Dalton. A few miles east of the gap was Resaca, where the railroad crossed the Oostenaula River.

Sherman's plan worked almost perfectly. Johnston, confident in his Dalton fortifications, was deceived by the demonstrations that Thomas and

Schofield staged there in early May. The area to the Confederate left was ignored, and when McPherson reached Snake Creek Gap on May 8 he found it unguarded.

On May 9, McPherson cautiously pushed toward the railroad. Surprised to find numerous Confederates in the area, he drew back to the gap. Johnston had stationed a small force at Resaca to guard the bridge, and by the 9th those men had been joined by advance elements of a 15,000-man force from Mississippi and Alabama that the government had ordered to reinforce Johnston. This force, a third infantry corps, was commanded by Lieutenant General Leonidas Polk, the corpulent Episcopal Bishop of Louisiana who had left military service in 1827. He had resumed his career in 1861 to aid the Confederacy.

Although McPherson had not achieved all for which Sherman had hoped, he had given the Federals a great strategic advantage, and Sherman fol-

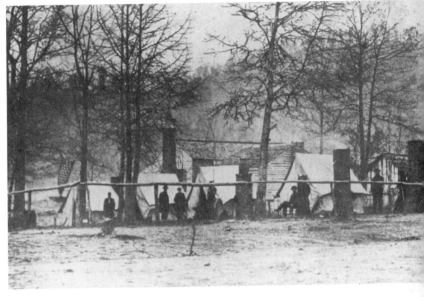

The XV Corps camped around Scottsboro, Alabama, and here its commander,
Major General John A. Palmer, made his headquarters. (USAMHI)

lowed up on his opportunity by shifting Thomas and Schofield to Snake Creek Gap. By nightfall on May 12 only a small detachment of Federals remained in the Dalton area.

Johnston, who had the shorter distance to cover and the use of the railroad, did not abandon Dalton until the night of May 12–13. The Confederates deployed in the rough terrain north and west of Resaca, holding a line that began at the Oostenaula and curved around to rest its right on the Conasauga River. Hood's corps held the right of this line; Hardee's the center; Polk's the left.

On the 13th, Sherman moved against Resaca, his force fanning out, to form a line paralleling that of the Confederates. The first day of the Battle of Resaca was spent in skirmishing. On the 14th, Sherman struck the right center of Johnston's line but was hurled back with heavy loss. Hood lashed

out at Sherman's extreme left, and only reinforcements prevented a Confederate victory. Other local attacks took place on the 15th, but Sherman, realizing that such fighting would accomplish little, sent a detachment down the Oostenaula to Lay's Ferry, where it crossed the river and threatened Johnston's railroad. During the night of May 15–16 the Confederate leader crossed the river and marched southward, seeking terrain for the defensive battle he wanted to fight.

The opening days of the campaign set the pattern for what followed. Sherman had demonstrated that he could plan complicated operations and the logistical details necessary to support them. When it proved impossible to execute his original plans, he had quickly adapted to new situations. He had held the initiative, and he had used his superior numbers to pin down and outflank the Rebels. He

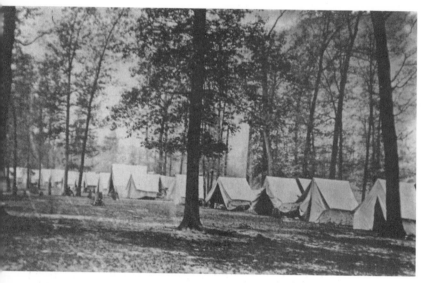

Major General George H. Thomas, the man who had become the "Rock of Chickamauga" back in September 1863, now led the Army of the Cumberland, and here on May 5, 1864, at Ringgold, Georgia, he made his headquarters, readying for the campaign that would shatter the lower South. (USAMHI)

had not, however, pushed aggressively after the Confederates. Johnston had remained passive and twice was maneuvered out of his chosen position. He had neglected Snake Creek Gap and had not defended the south bank of the Oostenaula. In less than two weeks he had abandoned the region north of the Oostenaula (including Rome, an important industrial town) and fallen back into a more open area where Sherman's superior numbers would give the Federals an even greater advantage.

Over the next several days Johnston moved south toward the Etowah River. On May 19 he made an unsuccessful effort to concentrate against a detached part of Sherman's force near Cassville, and that evening he was forced to retreat across the Etowah when his position at Cassville proved vulnerable to artillery. The Rebels took up a strong position about Allatoona Pass. Sherman, after se-

curing his hold north of the river, allowed his men a few days' rest.

On May 23, Sherman crossed the Etowah in open country west of Allatoona. His objective was the small town of Dallas, 14 miles south of the river, from which he could move east to the railroad or southeast toward the Chattahoochee River. "The Etowah," Sherman wrote, "is the Rubicon of Georgia. We are now all in motion like a vast hive of bees and expect to swarm along the Chattahoochee in a few days."

As Sherman's armies closed on Dallas on May 25, they found Confederates posted at New Hope Church, northeast of the town. Overruling his subordinates who believed a strong Rebel force to be in their front, Sherman ordered an attack. The resulting battle of New Hope Church was a victory for Hood's Confederates, who repulsed the North-

erners with ease. Two days later another Union attack was defeated at Pickett's Mill, northeast of New Hope Church.

Both sides concentrated along the Dallas-New Hope Church-Pickett's Mill line, and for over a week deadly skirmish warfare went on in the heavy woods. The soldiers were made even more uncomfortable by the torrential rains that began on May 25 and continued with but few letups for a month.

Unable to defeat Johnston and experiencing difficulty supplying his men over muddy roads, Sherman began to work his way east, shifting troops from his right to his left. By early June the Northerners had regained the railroad near Acworth. Sherman had again outmaneuvered Johnston and bypassed the Allatoona hills.

By June 10, Sherman had received rein-forcements, repaired his railroad, rested his men, and was ready to advance. Johnston, meanwhile, had occupied the hills north of Marietta. Over the next several days Sherman's forces pushed Johnston back to a line running along Kennesaw Mountain and off to the south. On June 14, Polk was killed by Federal artillery fire. Major General William W. Loring took temporary command of his corps.

When the Federals encountered the new Rebel position, Sherman began extending to the southwest to outflank it. Rain and mud slowed movements and hampered efforts to supply units distant from the railroad, but the Federal right slowly stretched southward. Johnston extended his left in an effort to hold his line. By June 22 the armies were strung out along a line that began north of

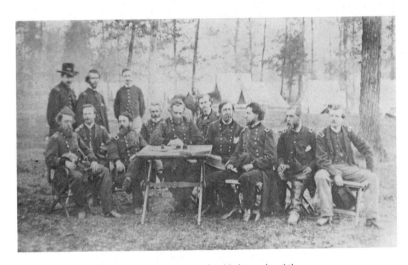

And here on May 5 or 6 sat several of Thomas' generals, with the opening of the campaign less than 48 hours in the future. Seated at far left is Brigadier General Jefferson C. Davis, and next to him, with legs crossed, is Brigadier General John M. Brannan, Thomas' chief of artillery. The man writing at the table is Brigadier General Richard W. Johnson. Seated next to him, hat in lap, is Brigadier General John H. King, and Brigadier General William D. Whipple, army chief of staff. Each will see his share of fighting in the days ahead, and Johnson will be severely wounded. (USAMHI)

Ringgold seemed a peaceful enough place in this image, believed to have been taken in 1865 by George N. Barnard. (WRHS)

Marietta, swung to the west and then south to a point several miles southwest of the town near Olley's Creek. Skirmishing, artillery fire, and sometimes large-scale assaults raged along this line.

In late June, when the rains ceased, Sherman changed his tactics. Believing that Johnston's long line would be weak, the Northern leader determined to assault. He planned to attack at three places—the southwestern end of Kennesaw Mountain, Cheatham's Hill west of Marietta, and along Olley's Creek. If the Federals could break through to the railroad, a large part of Johnston's army might be cut off and destroyed.

Sherman attacked on the morning of June 27. After heavy artillery fire, Northern infantry gallantly rushed against the fortifications on Kennesaw and at Cheatham's Hill. Although some Yankees reached the Confederate lines, the Southerners were able to repulse the attacks, inflicting heavy loss on the assaulting forces. Only along

Olley's Creek, where Schofield's men managed to gain a position on the south bank, could Sherman claim success.

Schofield's advance gave Sherman a position from which to slice eastward to the railroad or south to the Chattahoochee. A few days after the failure of his attack Sherman began to shift troops to his right, forcing Johnston to choose between giving up the Kennesaw line or being cut off from Atlanta.

Johnston, expecting such a maneuver and believing that he could stretch his army no farther, had begun a new line at Smyrna, four miles below Marietta. On the night of July 2–3 he moved to the Smyrna line. Advancing Federals confronted Johnston's new position late on the afternoon of July 3. After a day of skirmishing, Sherman's right threatened Johnston's communications with Atlanta, and during the night of July 4–5 the Southerners fell back to the north bank of the

Not so Buzzard Roost, Georgia. Here on May 8–9, Sherman first met and began to press the Confederate defenses. As Barnard's photo shows so well, even where no major battle was fought, still the passing of the armies left a considerable mess in its wake. (USAMHI)

Chattahoochee where they occupied a heavily fortified position.

Realizing that the Rebel line was too strong to be attacked, Sherman sent his cavalry to capture Roswell, 16 miles upriver, and planned to attempt a crossing above Johnston's fortifications. On July 8, while Johnston was distracted by demonstrations downstream, Schofield's men crossed the river, using pontoon boats and the ruins of a dam. By nightfall the Yankees were securely dug in on the south bank. Johnston, during the night of July 9–10, crossed the Chattahoochee and went into position along Peachtree Creek, a few miles from Atlanta. For a week Sherman rested his men and planned his next move.

Johnston had not kept the government informed of the progress of the campaign, and his long retreat had displeased Confederate officials. The authorities were especially worried because it would be possible for the Federals to use the Chattahoochee as a moat while they wrecked Alabama's virtually undefended industrial area. Sherman's presence on the Chattahoochee, even if he advanced no farther into Georgia, would assure Federal success in the campaign and cripple the Confederacy's ability to wage war. If Johnston abandoned Atlanta, the blow to the Confederacy would be devastating. Criticism of Johnston mounted, and Davis, as early as July 12, began to consider replacing him with a commander who could be counted on to fight for Atlanta. On the 17th the President, with great reluctance, named Hood to command the Army.

Most historians have been critical of Davis, but their criticism stems more from a knowledge of what happened after Johnston was removed than

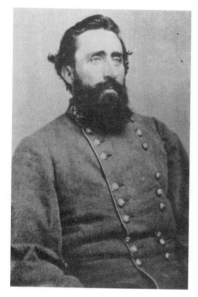

It was Major General William B. Bate who held those Confederate works against Sherman's first tentative stabs. He could not hold for long before the Yankee horde. (USAMHI)

alistic choices: Hardee and Hood (the III Corps commander, Lieutenant General Alexander P. Stewart, had but recently been named as the permanent replacement for Polk). Hardee, like Johnston, was on bad personal terms with important government officials, had declined to take permanent command of the Army in December 1863, and, it was reported to Davis, had supported Johnston's policy of falling back into Georgia. These factors made Hood the choice by default.

Other factors were also involved. Hood was a bold officer who had led many successful attacks on the enemy. He seems to have worked to undermine Johnston by informing Davis' military adviser, General Braxton Bragg, that Johnston had missed many chances to strike a blow against Sherman. Hook's crippled condition—he had lost a leg and the use of an arm in earlier battles—might have caused Davis some hesitation, but, wounds and all, Hood was the best, indeed the only, alternative to Johnston in mid-July 1864.

WHEN HOOD ASSUMED COMMAND on the morning of July 18, he faced a desperate situation. Sherman was north and east of Atlanta. Thomas' army, with its right on the Chattahoochee, was a hinge on which Schofield and McPherson were swinging to the east to reach the Georgia Railroad, Hood's direct link to the Carolinas and Virginia.

As Thomas' men came down into the valley of Peachtree Creek north of Atlanta, a gap opened in the Federal line. Hood saw a chance to attack the isolated Federal right, and he planned to concentrate the corps of Hardee and Stewart to assail Thomas while his old corps, under Major General Benjamin F. Cheatham, and the cavalry defended Atlanta against Schofield and McPherson. Hood worked through the night of July 19–20 to position his army for this battle.

On the 20th, Hood found the Federals east of Atlanta advancing more rapidly than he had anticipated, and he had to strengthen his eastern flank. The confusion caused by this redeployment delayed the attack. When Hardee and Stewart advanced, they found that Thomas' men had built fortifications. Thus what Hood had intended as a quick blow against an unprepared force became an assault on a strong position. The Confederates, fighting bravely, were repulsed in the Battle of Peachtree Creek.

from an evaluation of the decision itself. Davis faced two different but related questions in July 1864. First, he had to decide if Johnston should be relieved from command. All evidence available to the President indicated that Johnston had mismanaged the campaign and that he would make no real effort to hold Atlanta. Johnston seemed to have no appreciation of the city's logistical, economic, political, or psychological importance. If the Confederacy was to survive, Atlanta must be held and Sherman pushed away from the Southern heartland. Nothing indicated that Johnston had the will, ability, or even intention of trying to do so.

If Johnston were removed, who should replace him? Time dictated that a new commander come from the army at Atlanta. There were only two re-

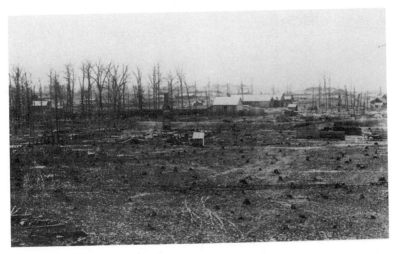

Sherman drove for Resaca, Georgia, a tiny hamlet that held the key to the Confederate rear. This image shows Rebel earthworks in the right distance.
(USAMHI)

On July 21, Hood's attention was drawn to the east side of the city. McPherson had advanced along the Georgia Railroad through Decatur to the outskirts of Atlanta. Hood decided to send Hardee's corps south and around to the east to roll up the left of the Federal line and drive it back onto the center and right. That night Hardee's men set off on their march. The roads were narrow and crowded, and the march was slow. Not until early afternoon was Hardee ready to attack. Meanwhile, the advance of the Northern armies had contracted the Federal lines and crowded part of McPherson's army out of place. McPherson ordered these displaced men to his extreme left. Thus, by accident, reinforcements were sent to the point where the attack fell.

Hardee's men struck a line of battle rather than an undefended flank. The resulting Battle of Atlanta raged through the afternoon of July 22, as Hardee's troops, joined by units from the Atlanta defenses, assaulted the Union position. In bitter fighting the Southerners temporarily overran part of the Yankee position, captured several guns and hundreds of prisoners, and killed McPherson. The Confederates, however, were unable to break the Northern line and at night drew back, leaving the Yankees in the position they had held when the battle opened.

By July 26, Sherman had decided upon his next effort. He would extend his army to the west and south of Atlanta to cut Hood's remaining railroads. The Atlanta & West Point Railroad and the Macon & Western ran southwest to East Point, where they forked, the Atlanta & West Point going southwest and the Macon & Western into central Georgia. If the Federals broke those lines, Hood could not hold Atlanta.

Major General Oliver Otis Howard, a native of Maine, had been selected to replace McPherson, and Sherman transferred Howard's Army of the Tennessee from the Federal left to the right. By the afternoon of July 27, Howard's men were west of Atlanta, pushing southward against slight opposition.

With seasoned veterans like the 33d New Jersey, Sherman fought the Battle for Resaca on May 14–15. (TPO)

Hood, learning of Sherman's movement, sent his old corps, now led by Lieutenant General Stephen D. Lee, supported by Stewart's corps, west from Atlanta on July 28. Hood hoped that Lee would block the Federals, and then, on the following day, Hood would move around their right to attack the rear of the position they had taken confronting Lee.

Lee, finding the Yankees near Ezra Church, attempted to drive them away. He launched a series of sharp, but uncoordinated, assaults on the Northerners, who had hastily built works from logs and church benches. Stewart, coming to Lee's support, joined the attacks. The resulting battle lasted through the afternoon and ended with the Northerners secure in their new position. Hood abandoned his plans for flank attack on July 29.

In his first ten days of command, Hood had thrice lashed out at the Federals. Although none of the battles had fulfilled Hood's expectations, he had demonstrated that he would strike whenever he thought it advantageous to do so. Sherman's movements became more cautious, and as July ended, many Confederates took hope in the belief that Hood's hard fighting had at last stopped the enemy, who seemed always to outflank the Southerners.

THERE WAS NO LARGE-SCALE FIGHTING in the Atlanta area for a month after Ezra Church. Sherman cautiously extended to the southwest, and Hood constructed a parallel line of works covering the railroad. Federal artillery damaged Atlanta but could not drive out the Rebel troops. Both sides resorted to the use of cavalry. Sherman launched several mounted raids against the railroads below Atlanta, hoping to cut Hood's supply line. Although the Federal horsemen inflicted some damage, they were unable to break the rail lines beyond repair.

Hood, on August 10, launched a counterraid, sending Wheeler, with about 4,500 men, to cut the

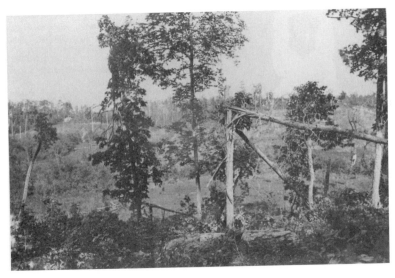

Over rugged, fence-strewn ground like this the armies struggled. (USAMHI)

Barnard's photograph shows the Confederate rifle pits dug out in the foreground by Joseph E. Johnston's Army of Tennessee. (USAMHI)

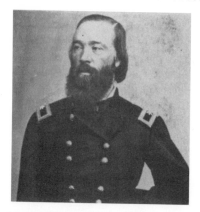

Brigadier General Thomas Sweeney, a troublesome Irishman from County Cork, commanded a division of the XVI Corps in the fight at Resaca. A career fighter, he lost his arm at Churubusco in the Mexican War, and a few years hence will lead an "army" of Fenians in an abortive invasion of Canada. (USAMHI)

railroad that supplied Sherman. Although Wheeler interrupted operations on the Western & Atlantic, the line was too well protected for the Rebel horsemen to break it thoroughly. Instead of returning to Hood, Wheeler began a raid into East Tennessee, a foolish venture that damaged Hood at a crucial time in the campaign.

In late August, with Wheeler out of the picture, Sherman again attempted to oust Hood from Atlanta. Realizing that only infantry could wreck the Rebels' railroads, the Federal commander, on August 25, began his movement. He sent part of the Army of the Cumberland to hold the Chattahoochee bridges and the railroad while the remainder of his force marched far to the south and west. On August 28, Howard's Army of the Tennessee reached the Atlanta & West Point Railroad at Fairburn, 13 miles southwest of East Point. All that afternoon and through the 29th, Sherman's men so thoroughly destroyed the railroad that only the Macon & Western could supply the Rebels at Atlanta.

Meanwhile, many Confederates had interpreted

Sherman's disappearance as a retreat brought on by Wheeler's raid. For a few days optimism reigned among the Southerners. "The scales have turned in favor of the South," wrote an Arkansian, "and the Abolitionists are moving to the rear."

When the Rebels learned of Sherman's presence on the West Point Railroad, they realized that his next objective would be the Macon & Western. Hood, however, without cavalry to ascertain the enemy's strength and intentions, seems to have believed that the force below Atlanta was only a raiding party. He did not realize the magnitude of the disaster moving toward the Macon & Western when, on August 30, he ordered Hardee to take two corps (Hardee's own and Lee's) to Jonesboro (14 miles southeast of East Point) to protect the railroad.

On August 30 the Northerners crossed the Flint River and entrenched on the eastern bank. During the night Hardee moved to Jonesboro, where, on the morning of August 31, the Confederates deployed west of the town. That afternoon Hardee assaulted the Federals. The attack was fierce but uncoordinated, and it failed. With more Yankees closing on the town, Hardee drew back and deployed to make a last defense of the railroad. Hood, still not realizing what was happening, concluded that Sherman was going to attack Atlanta from the south. He ordered Hardee to return Lee's corps to Atlanta, leaving only one corps to face the main Union force at Jonesboro.

On September 1 the Northerners fell upon Hardee. Late in the afternoon the Confederate line gave way, and Hardee retreated to the south. Sherman's hold on Hood's last railroad was unbreakable. The Battle of Jonesboro sealed the fate of Atlanta. With the railroad gone, Hood had to give up the city. During the night of September 1–2 the Southerners destroyed what they could not carry away and marched via a circuitous route to join Hardee.

The campaign that began in the north Georgia mountains four months earlier was over. The war would last another nine months, but the capture of Atlanta was a tangible victory demonstrating that the Federals could reach the heart of the South. Hood would go north that fall to meet overwhelming defeat at Nashville in December, while Sherman, leaving Atlanta a burned wreck, marched across Georgia to the sea.

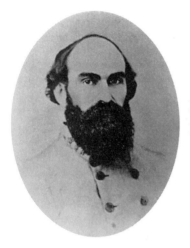

Helping defend the little railroad town was Confederate Brigadier General William F. Tucker. He survived a desperate wound here that put him out of the war for good, but in 1881 an assassin's bullet cut him down. (VM)

Despite every effort to hold the position, the Confederates had to pull out of Resaca, leaving the village and their defenses to Sherman's victorious Federals. It would be repeated many times in this campaign. (USAMHI)

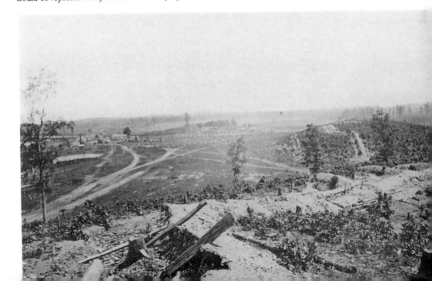

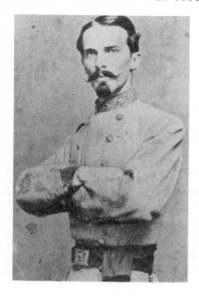

Brigadier General Randall L. Gibson covered the Southern retreat from Resaca. (LSU)

Behind them the Confederates left the battlefield to the victors, and their hastily buried dead to the soil. Rude boards mark the resting spots of those who died in the fight. A Barnard image. (WRHS)

On the armies went, through Kingston. Here for two days they fought before moving on. Barnard followed them in 1865 with his camera. (USAMHI)

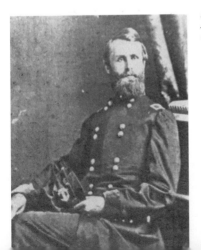

Brigadier General Jacob D. Cox led a division of the XXIII Corps in that fighting. He ordered one of his brigades to find and destroy the . . . (USAMHI)

. . . . *Mark Cooper Iron Works, outside Cartersville. The factory had supplied arms to the Confederacy, but after Cox's raid it was left a ruin. A postwar image.* (GEORGIA DEPARTMENT OF ARCHIVES AND HISTORY)

Finally, Sherman pushed Johnston back across the Etowah River here at Etowah Bridge. Barnard's image shows the fortifications erected by the Confederates to guard the bridge, as well as the beginning of structural supports being erected to keep the Western & Atlantic Railroad crossing operable. (LC)

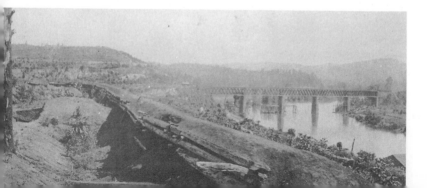

Already, off in the distance down the Western & Atlantic line, Barnard's camera looks toward the next goal, Allatoona Pass. (USAMHI)

Allatoona itself, nestled in the pass, would not see a battle. (USAMHI)

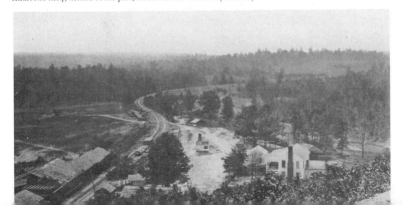

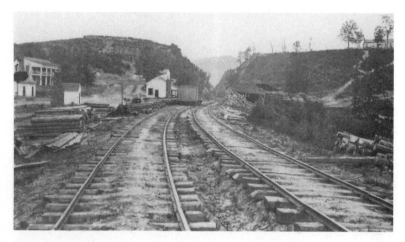

Rather than face fortifications like the earthwork atop the ridge at left, Sherman moved around Johnston and forced the Confederates to pull out of Allatoona. Yet finally the armies would meet in deadly battle at . . . (USAMHI)

. . . New Hope Church. Here for nearly two weeks in late May and early June 1864 the armies glowered at each other from positions like these Confederate works. Barnard captured much of it in the summer of 1865. (LC)

Amid all the trees and brush and entanglements, it was like fighting in a briar patch. (USAMHI)

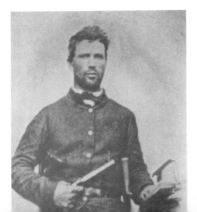

Rebels like Uriah Crawford of the 54th Virginia, one of very few Old Dominion units with Johnston's army, were heartily glad to move away from New Hope Church. Alas, for Crawford, he would be captured just two weeks later. (COURTESY OF DELBERT CRAWFORD)

Johnston pulled back to a line along Pine Mountain on June 4, and here skirmishing continued for several days. (LC)

A casualty of that skirmishing was Lieutenant General Leonidas Polk. On June 14 a Federal cannon ball struck him in the chest and he died instantly. He had been an Episcopal bishop, and then a corps commander for the Confederacy. In this remarkable unpublished, and badly faded, portrait he stands wearing the loose pleated uniform blouse that was popular with many generals in the Army of Tennessee. (MC)

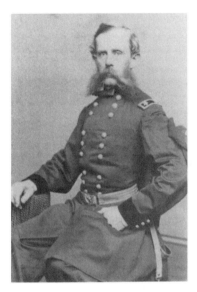

It was Brigadier General Absalom Baird's division of the XIV Corps that was skirmishing at Pine Mountain that day. He appears here in 1865, at war's end, wearing mourning crepe for the murdered Lincoln. (KA)

Pine Mountain was only a stop, however, before a bigger and more deadly fight at Kennesaw Mountain. Here, as Barnard's image shows, the armies turned farmers' fences and fields into places of battle. (USAMHI)

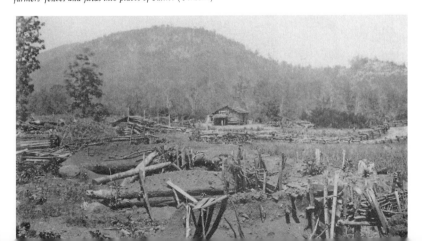

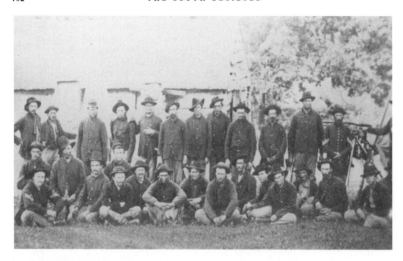

It was the greatest fighting yet in the campaign, and the men of the 125th Ohio led the skirmishers in Sherman's attack. The losses were dreadful. This regiment alone suffered 43 casualties just acting as skirmishers. (USAMHI)

There were casualties on both sides, though. Brigadier General Lucius E. Polk, nephew of the slain Leonidas, was put out of the war by a desperate wound at Kennesaw. (USAMHI)

Yet it was Sherman who suffered the most. Placed behind works like these shown in Barnard's image, the Confederates delivered deadly fire into the attacking Federals. Sherman had to admit defeat. (WRHS)

So did his chief of artillery, Brigadier General William F. Barry. "The nature of military operations in a country like ours is peculiar," he claimed, and unfavorable to artillery. The dense cover forced the guns to work out in the open, exposed, but still they did good work. It cost them. Three division chiefs of artillery were killed in the fighting. (COURTESY OF EUGENE WOODDELL)

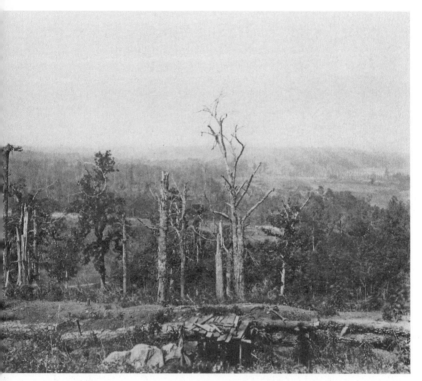

The view from behind Johnston's rifle pits on Kennesaw tells the whole story of the dreadful ground over which Sherman had to attack. The broken and battered trees tell the story of the fight's ferocity. (USAMHI)

For fiery Brigadier General Francis M. Cockrell
of Missouri, Kennesaw was a tough fight in which
his men faced the Federals for an hour within
thirty paces of each other. His skirmishers could
hear the Yankees, hiding behind rocks, giving the
order to "fix bayonets" for the charge. Some of
Cockrell's men fired more than sixty times.
(GOELET-BUNCOMBE COLLECTION, SOUTHERN
HISTORICAL COLLECTION)

Despite the victory at Kennesaw, Johnston had to fall back once more as the
enemy threatened to get around his flank. Now the Confederates withdrew to the
Chattahoochee River, getting ever closer to Atlanta. When Johnston destroyed
the bridges in his path, Sherman at once started rebuilding them with lightning
speed. (USAMHI)

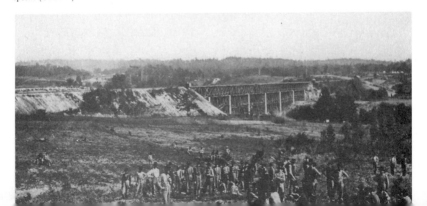

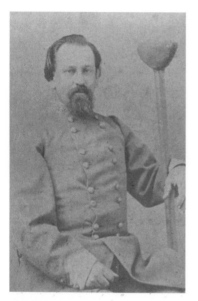

After the fight at Kennesaw, most of the combat for several days was on the fringes of the armies, at places like Vining's Station. There, on July 4, Brigadier General Alfred J. Vaughan, Jr., had his leg blown off by a Federal shell. He appears here months later, near the end of the war, with the crutch that was his companion for the rest of his life. (HP)

Finally, Richmond would stand no more of Johnston's retreats. By July 17, Sherman had pushed to within a few miles of Atlanta. Johnston was replaced by an audacious, sad-eyed fighter from Kentucky, General John Bell Hood. He would do no better than Johnston, and at greater cost. (MC)

This portrait is believed to be of Hood's chief of staff, Brigadier General Francis A. Shoup, a native of Indiana. He would have to cope with all the paper work of running an army, for Hood had no patience for it. (ERNEST HAYWOOD COLLECTION, SHC)

Just three days after taking command, Hood attacked Thomas at Peachtree Creek, proving himself once more to be a vicious fighter, if an unwise one. It was Thomas who emerged the victor, with Atlanta now threatened with encirclement. Barnard's photo shows the graves of those who died on the field. (USAMHI)

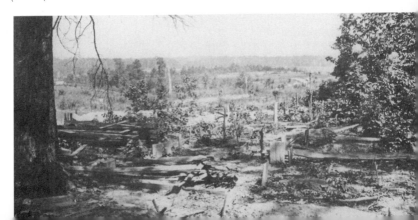

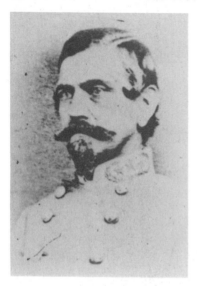

Brigadier General James Cantey was absent from his brigade with ill health, but his men led the Confederate attack that for a time stunned Thomas at Peachtree Creek. (CHS)

While the armies began the final battle for Atlanta on July 22, Brigadier General George Stoneman, seated at right, led his cavalry corps on a raid that hoped to capture the notorious prison at Andersonville and free its inmates. Instead, five days later, Stoneman was himself captured. (MICHAEL HAMMERSON)

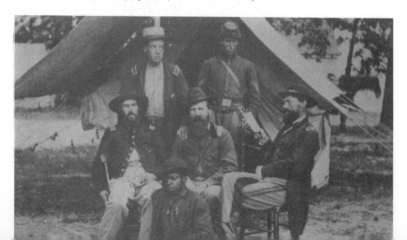

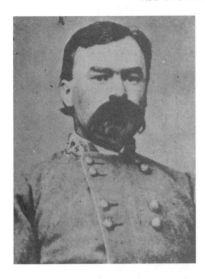

It was Confederate cavalry led by able officers like Brigadier General William H. Jackson that disrupted Stoneman's plans. (NA)

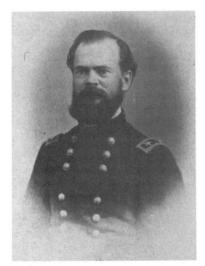

Meanwhile, men were dying for Atlanta. In the first day of fighting, Major General James B. McPherson became the only Union Army commander of the war to die in battle. His men saw him ride off to a threatened point during a Confederate attack. A few minutes later his riderless horse returned. (USAMHI)

He fell and died here, among the cannon balls and the macabre, grinning skull of a dead horse. Sherman particularly mourned the loss of one of the most beloved young generals in the service. (GDAH)

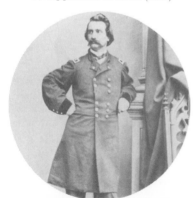

At McPherson's death, command of his army went for a time to one of the most able civilians-turned-soldier of the war, Major General John A. Logan of Illinois. The only trouble was, he was not West Point trained. (USAMHI)

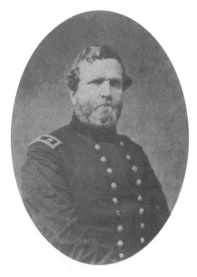

Sherman consulted with Major General George H. Thomas, commanding the Army of the Cumberland, and between them they agreed that permanent command of McPherson's army should go to a professional. Thus . . . (COURTESY OF WANDA WRIGHT)

. . . Major General Oliver O. Howard took over from Logan. (LC)

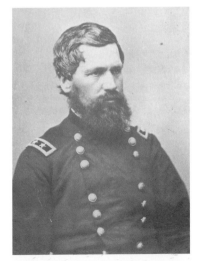

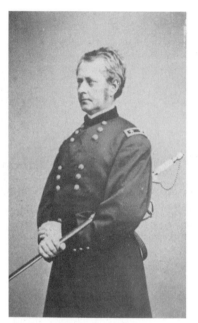

That incensed Howard's senior officer, Major General Joseph Hooker, the "Fighting Joe" who lost a major battle at Chancellorsville the year before. Unwilling to serve under his inferior in seniority, Hooker asked to be relieved. For him it was the end of the war. (USAMHI)

With Hooker's departure, command of his XX Corps went for a time to Brigadier General Alpheus S. Williams, a grizzled old fighter and veteran of the battles in Virginia, shown here with his daughter. Thus did the death of McPherson shift commands throughout his army for a time. (USAMHI)

Meanwhile, for several days after the battle of July 22 the armies watched each other across the lines. Barnard was able to get his camera into some of the abandoned defenses in the summer of 1865. (USAMHI)

He and his instrument could survey some of the scenes of the bloody day's fight.
(LC)

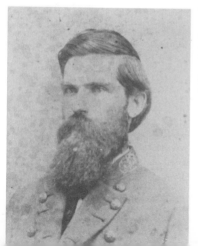

Then came the rugged July 28 battle at Ezra Church, Hood's last hope to keep from being driven back into the city. Brigadier General D. H. Reynolds led two Confederate brigades in Hood's attack, intended to keep Sherman from encircling him. A bold officer, born in Ohio, Reynolds fought for five hours in heavy fire before being called back. He suffered 40 percent losses. (MC)

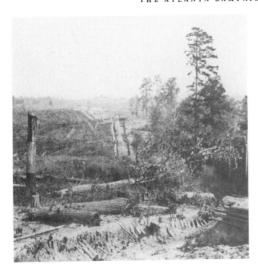

The defenses were well prepared. All around Atlanta ran ditches and rifle pits, with fences, sharpened stakes in the ground . . . (USAMHI)

. . . fortified hilltops . . . (USAMHI)

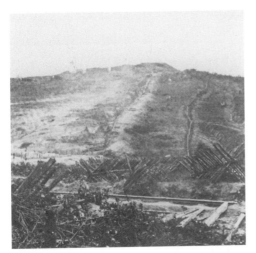

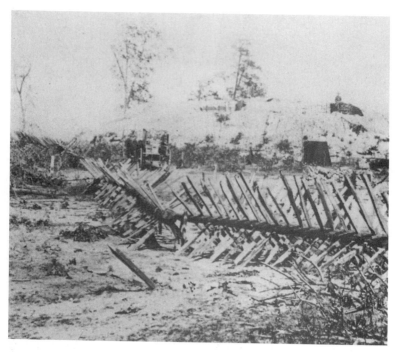

. . . and makeshift obstructions everywhere. (RJY)

Sherman's attackers would have to march across hell to get to the city this way. (USAMHI)

East of the city the Confederates even piled brush on the slopes leading up to their rifle pits. (WRHS)

After the fall of Atlanta, Barnard turned his camera toward the successive waves of vicious obstructions near the Chattanooga railroad line. (GDAH)

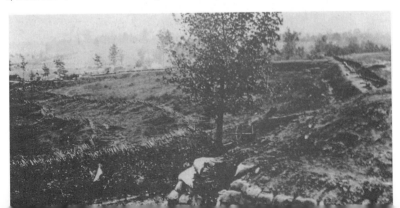

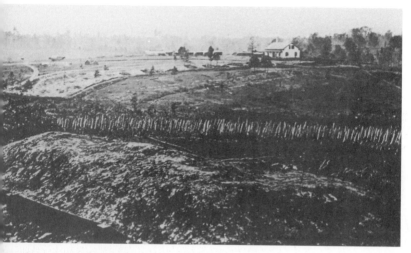

Wherever the camera looked, the environs of Atlanta bristled with trenches and rifle pits and stakes in the ground. (GDAH)

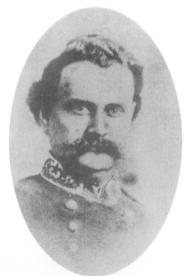

It had been the luckless task of Brigadier General Marcus J. Wright to command the District of Atlanta for a time, but before the Federals closed in finally he was sent off to Macon in the center of the state. Before long, the front might be there as well. (M. J. WRIGHT COLLECTION, SHC)

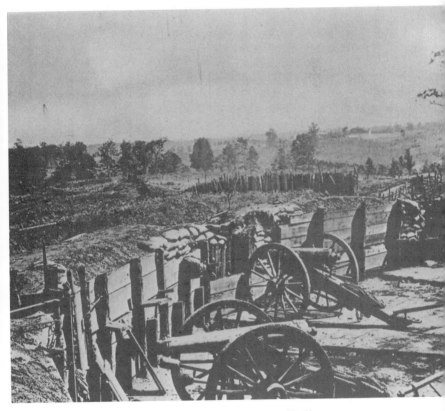

Meanwhile, the Confederates who stayed behind sat in their defenses—like this one—and glowered at the enemy. (GDAH)

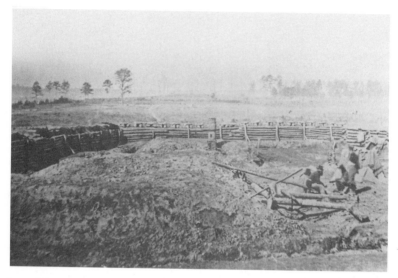

It was all they could do, while Sherman slowly encircled them. (USAMHI)

Just two days before the Ezra Church fight, Brigadier General John M. Corse, seated second from the right, took command of the Second Division of the XVI Corps. His division led the way in the flanking movement by which Sherman hoped at last to cut Hood off from retreat. Seated with Corse are the other officers of his division, Brigadier General Richard Rowett, at left, McPherson's old adjutant, General William T. Clark next, and at far right Brigadier General E. W. Rice. This image, made in May 1865, shows all of them at higher grades than they were during the Atlanta Campaign. (USAMHI)

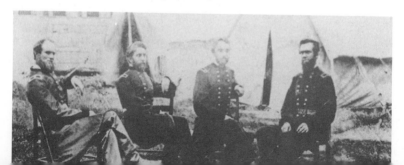

This was the prize they sought. Atlanta in 1864. A Barnard image. (LC)

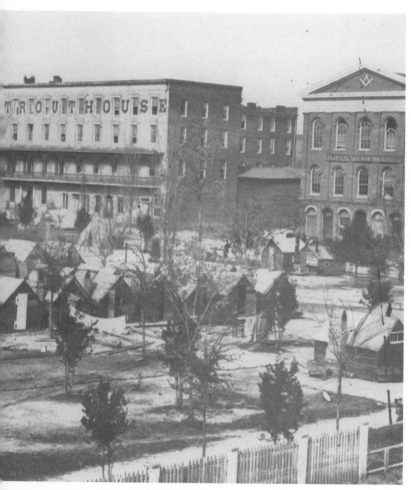

In the center of the city, not far from the Western & Atlantic depot, stood the Trout House, one of Atlanta's better-known hotels. (LC)

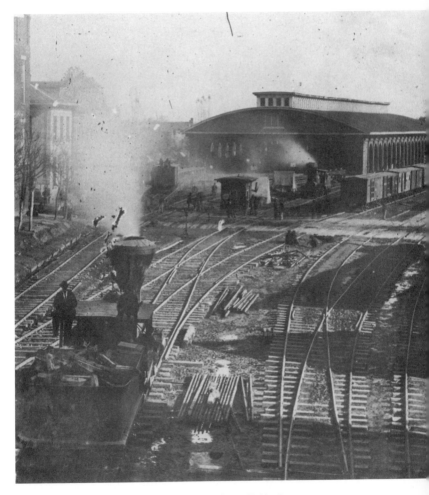

Symbolic of Atlanta, however, was the "car shed" of the Western & Atlantic depot. It was through this depot that Hood's lifeline ran, for Atlanta was the rail communication center of the deep South. (LC)

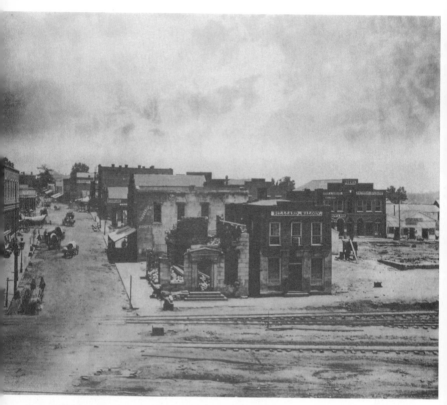

Barnard did some of the best work of his career once Sherman took Atlanta.
This scene, not far from the depot, is one of his most brilliant. (LC)

The Potter house showed to Barnard's camera some of the terrible effects of Federal fire during the bombardment of Hood's defenses. (LC)

The poor Potters' backyard became a major position in the defensive perimeter around the city. It could almost be a scene from the 1914–18 war in Europe. (LC)

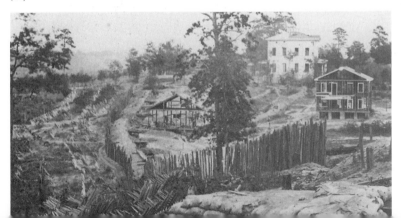

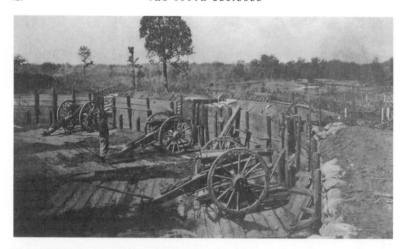

When finally Sherman took Atlanta in September, he found there more and more evidences of the defensive strength of the place. It was no wonder that he wisely chose to drive Hood out by encircling him rather than attacking. Kennesaw Mountain had been a costly lesson, but well learned. (LC)

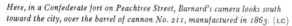

Here, in a Confederate fort on Peachtree Street, Barnard's camera looks south toward the city, over the barrel of cannon No. 211, manufactured in 1863. (LC)

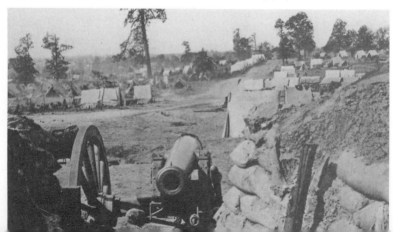

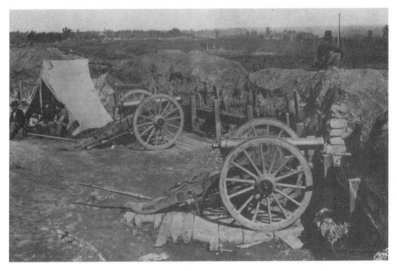

*Where once hundreds of Rebels stood ready to fight, now a lone sentry sits atop
the earthworks looking off toward his old lines.* (LC)

*The thought of having to charge across that no-man's-land of entanglements,
under unrestricted fire from the enemy, sobered even the most hardened of
Sherman's men. They were delighted that he used strategy instead of force.* (LC)

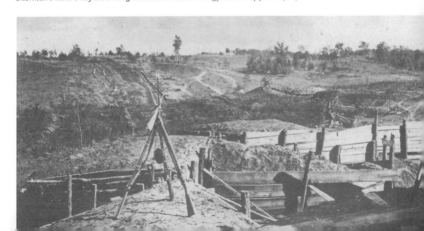

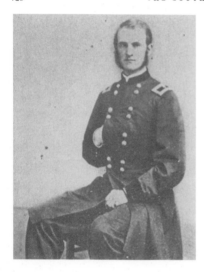

By the end of August, Sherman was ready. Brigadier General Thomas E. G. Ransom temporarily led the XVI Corps as the Federals sealed off Hood's last rail link at Jonesboro. (CHICAGO PUBLIC LIBRARY)

Brigadier General Jefferson C. Davis, seated at left, led his corps in the heaviest of the fighting at Jonesboro, yet was so impressed with the valor of the Kentucky Confederate troops opposing him that he personally looked to the welfare of those he captured. He sits in his tent here with Lieutenant Colonel A. C. McClurg. (LC)

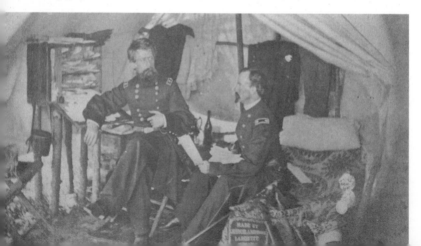

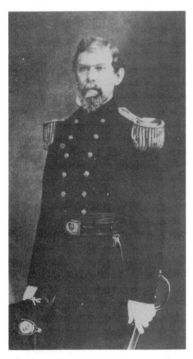

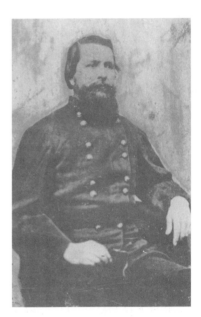

It was bitterly hot fighting. Some Confederate brigades ceased to exist after Jonesboro. Brigadier General Zachariah C. Deas led a brigade in the front line of the initially successful attack. (LC)

Lieutenant General William J. Hardee commanded Hood's unsuccessful attack at Jonesboro. He had to drive Sherman back, or else Atlanta would have to be evacuated. (CHS)

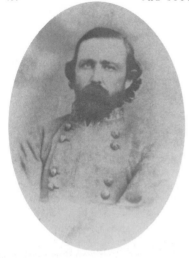

Brigadier General George Maney commanded a division in the battle but managed to make someone in the army high command angry, for he was relieved of his command within minutes of the end of the battle. (MC)

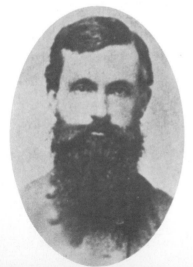

For Brigadier General Daniel C. Govan of Arkansas, Jonesboro was his last battle for quite a while. Captured, he would not return to the service for several months. (USAMHI)

Even with their victory at Jonesboro, the Federals suffered their share as well. Private Henry Cordes of the 18th United States Infantry, seated at right, was part of the 65 percent losses suffered by his regiment. Poor Cordes took a gunshot wound in the left arm and had his limb amputated on the field. (TPO)

The 9th Indiana took part in the chase after Hood's evacuating army. On September 2 they caught up with him near Lovejoy's Station, but the Confederates successfully withdrew deeper into Georgia. It was effectively the end of the Atlanta Campaign. (NA)

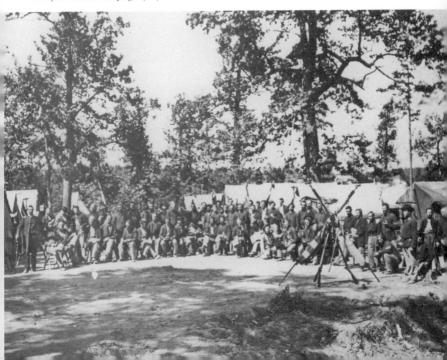

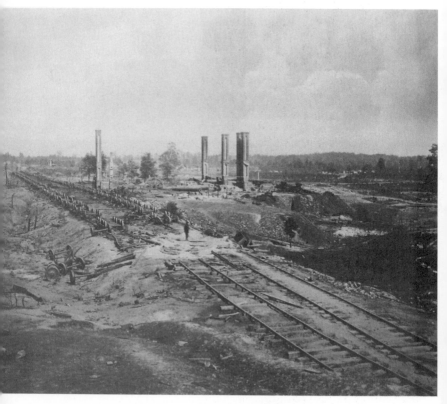

Now Sherman could survey what he had conquered, assisted by Barnard's ubiquitous camera. Here on the Georgia Central tracks they found the remains of Hood's ordnance train, destroyed to prevent capture. It was a scene of perfect desolation. (KA)

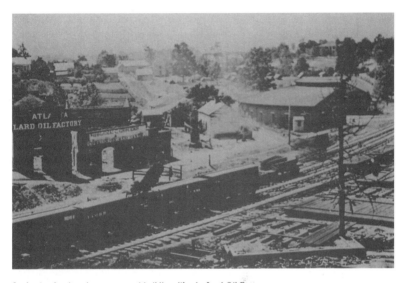

In the city they found more cars and buildings like the Lard Oil Factory destroyed by Hood's retreating Confederates. (GDAH)

But most of the city proper survived both the fighting and the withdrawal, and in time the grounds around city hall sprouted Yankee winter quarters. (RJY)

Here was the encampment of the 2d Massachusetts. (USAMHI)

And here was the conqueror, William T. Sherman, astride his charger in the works he fought so long to take. "Atlanta is ours, and fairly won," he wired to Washington. (USAMHI)

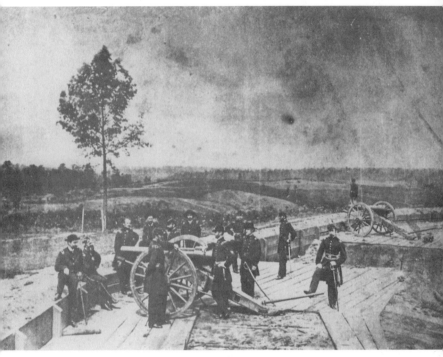

Here, probably in the position of Battery K, 5th U.S. Artillery, in Fort No. 7, Sherman and his staff and generals could pose proudly. They are, from left to right: Major L. M. Dayton, aide; Lieutenant Colonel E. D. Kittoe, medical director; Colonel A. Beckwith, commissary; Colonel Orlando M. Poe, chief engineer; Brigadier General William F. Barry, chief of artillery; Colonel W. Warner; Colonel T. G. Baylor, chief of ordnance; Sherman; Captain G. W. Nichols; Colonel C. Ewing, inspector general; an unidentified major; and Captain J. E. Marshall. (USAMHI)

Now the once-Confederate works became revitalized forts in the Federal defensive line around Atlanta. Once Confederate Fort No. 7, this is now Yankee Fort No. 7 and looks off toward No. 8. (GDAH)

And Fort No. 8 looks back to No. 7. (GDAH)

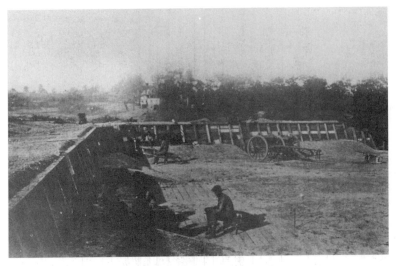

Once the building in the background was Hood's headquarters. Now it looks quietly onto Fort No. 10, with guns removed and work parties with shovels enhancing its strength. (USAMHI)

And more work for the men laboring in Fort No. 12, part of a largely new line of defenses. (GDAH)

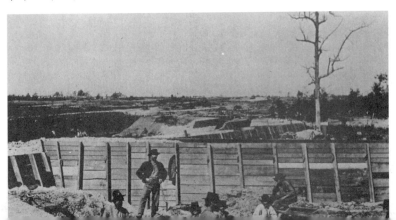

Far more sophisticated than the Confederate lines around the city, the Federal defensive perimeter would never be tested but stood as a monument to Colonel Poe's capability and the soldiers' hard work. (USAMHI)

Fort No. 19, with Atlanta in the background, protected the Georgia Central line, precautions against a Confederate counteroffensive that never came. (USAMHI)

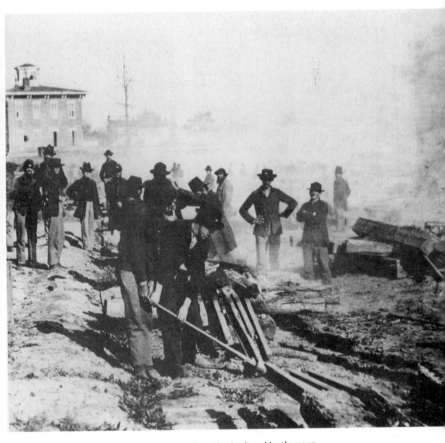

Before too long it came time for Sherman to leave the city, bound for the sea on his march through Georgia. He could leave nothing useful behind, should the enemy strike for Atlanta. And so the work of destroying began. Here soldiers heat railroad rails before bending them out of shape. Some called the final product "Sherman's hairpins." (LC)

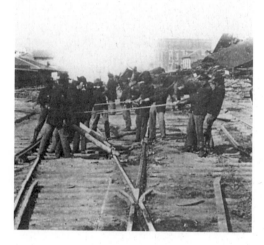

With the ruins of the car shed in the right background, more Yankees lift track from the ties. (USAMHI)

Rails heat over fires and boiler parts and other locomotive pieces await their own fate as Sherman destroyed Atlanta as a rail center. (LC)

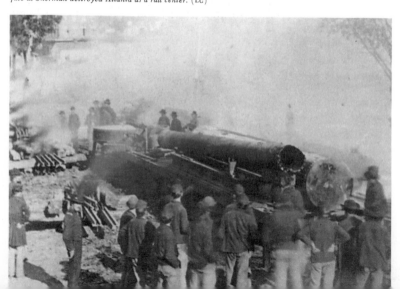

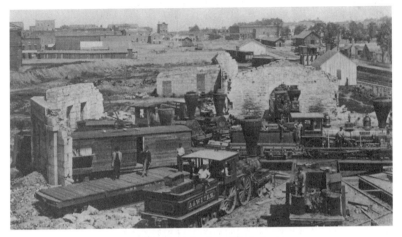

Barnard caught the scene as the roundhouse was reduced to rubble. (LC)

Sherman's wagons prepare for the march toward Savannah while the car shed and track beside it live out their last hours before destruction. With one campaign successfully done, the man who made war hell was off for another one. (CHS)

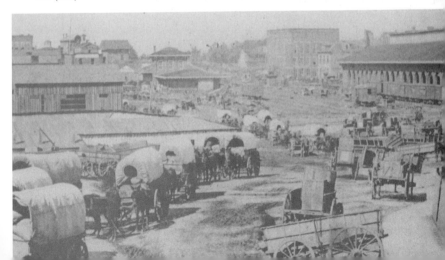

Behind him he left a conquered Atlanta, and at the city's court house, the flag of the old Union flew once more. Color Sergeant Johnson, of the 2d Massachusetts, stands with his banner on the court house steps in September 1864. (MICHAEL J. HAMMERSON)

Back to the Valley

EVERARD H. SMITH

Some of the faces are new, but the sound of battle
is the same in the Shenandoah

IN 1864 THE SHENANDOAH VALLEY of Virginia again became the scene of major military action, while the Wilderness and Georgia echoed from the guns. Once more, reprising the now-familiar theme, a Rebel army muscled confidently into western Maryland and southern Pennsylvania, spreading havoc as it went. Momentarily—as cannon rumbled at Fort Stevens, near Washington, D.C.—it appeared that the very course of the war might be suddenly reversed, and no less an observer than the London *Times* was moved to conclude, "The Confederacy as an enemy is more formidable than ever."

Yet 1864 was not 1862, and the Confederate successes of midsummer proved only transitory. Northern superiority in numbers and resources, combined with a destructive new philosophy of warfare, soon broke the Southern hold on the Valley, and in the process reduced much of that beautiful vale to a smoldering ruin. The Shenandoah became, in fact, a microcosm of the final summer of the Civil War: here, as elsewhere, by the end of the year the Confederacy tottered on the verge of final defeat.

Matters began in April when Major General Franz Sigel, the local Union commander, persuaded Ulysses S. Grant to add a diversionary Valley offensive to his plans for the Old Dominion. A small, wizened German expatriate, Sigel was an officer passionately devoted to the Northern cause but regarded by his men as something of an albatross because of his political connections and foreign background. His strategy, however, was sound: a two-pronged attack on the town of Staunton, with one column, directed by himself, to advance from Harpers Ferry and the other to be led by Brigadier General George Crook from West Virginia.

Unhappily for Sigel, his opponents treated him as the greater threat, and on May 15 they concentrated most of their available forces against him at the Battle of New Market. The Southern ranks included the cadets of the Virginia Military Institute, whose youngest member was barely fifteen. The Rebels also had a superior leader, the charismatic Major General John C. Breckinridge, former U.S. Vice President and veteran corps commander—"that soldierly man," as one of his subordinates remembered him, "mounted magnificently . . . and riding like a Cid." Sigel was driven from the field in rout, provoking Chief of Staff Henry W. Halleck to comment sarcastically, "He will do nothing but run. He never did anything else."

Under heavy political pressure from Washing-

The pivotal spot for all operations in the Shenandoah Valley was Harpers Ferry, northern gateway. Here the Shenandoah flowed into the Potomac, and here, too, the Baltimore & Ohio crossed on its way west. The Harpers Ferry Arsenal and Armory, now mere shells of gutted buildings, stand across the river. (USAMHI)

ton, Grant quickly replaced Sigel with a new commander, Major General David Hunter. The little German had been no paragon, but his replacement was worse. Sixty-one years old, stocky, with thinning black hair and long Hungarian mustaches, Hunter was an intensely bigoted man whose mind had been dominated by abolitionism. He harbored vindictive feelings toward all Southerners, and his brief stay in the Valley unleashed many passions which had previously been suppressed.

Hunter's swift resumption of the offensive caught Valley defenders by surprise, and the early stages of his campaign were marked by considerable success. A small Rebel army under Brigadier General William E. "Grumble" Jones entrenched at Piedmont in a last-ditch effort to save Staunton, but was soundly defeated on June 5. Next day the Union Army entered the town, and shortly afterward it was joined by General Crook, completing the Federal juncture.

Now Hunter had to plan the next phase of the advance, and he guessed disastrously. Ignoring Grant's sensible suggestion to transport his united army east of the Blue Ridge, then follow the railroad south from Charlottesville to Lynchburg, he elected instead to take the army all the way up the Valley to Buchanan before curling in on Lynchburg from the west. As far as it went, the plan of attack was a good one, enabling him to destroy another important railroad, the Virginia & Tennessee. But it also lengthened his march and gave his opponents adequate time to reinforce the town.

As he progressed, it became increasingly evident that Hunter intended to scourge the Valley with fire as well as the sword. In alleged retaliation for harassment by Rebel partisans such as Lieutenant Colonel John S. Mosby, the homes of numerous Southern sympathizers were put to the torch. Some suspected, however, that the general enjoyed his self-proclaimed role as basilisk. "Frequently, when

Troop trains bringing men from the west passed through Harpers Ferry regularly when the Union controlled the town. These are probably Ohioans, resting on flatcars before continuing their journey, while a train laden with supplies approaches from the left. (SPECIAL COLLECTIONS, U.S. MILITARY ACADEMY LIBRARY)

we passed near houses, women would come running out, begging for protection," noted General Crook. "His invariable answer would be, 'Go away! Go away, or I will burn your house!'" Ultimately such acts of retribution had little impact on the guerrillas, but they set in motion a cycle of violence which gradually escalated as the campaign progressed, affecting both Yankees and Confederates and culminating in the devastation which left much of the lower Valley a scorched plain.

By June 12, Hunter's slow but insistent advance had become so alarming that the Confederate high command could no longer ignore it. To Robert E. Lee, whose continuing defense of Richmond rested largely on his ability to maintain the railroad network around it, Lynchburg was a transportation

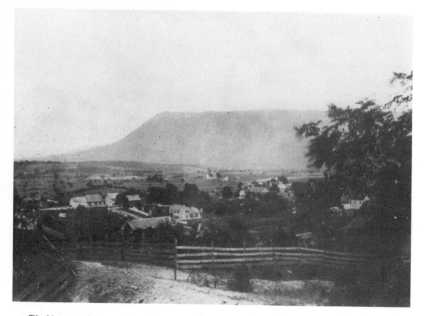

The Massanutten Mountain broods over the Valley itself, the object of Stonewall Jackson's first great campaigns, and now, in 1864, the scene of yet more bitter fighting. This image was probably made shortly after the war, and shows part of the village of Strasburg. (USAMHI)

hub as vital as Petersburg. Only by detaching part of his own command could he deal with the threat. Hence that evening the II Corps of the Army of Northern Virginia, Lieutenant General Jubal A. Early commanding, departed Richmond for the Valley. Making a virtue of necessity, Lee instructed Early to dispose of Hunter first, then either return to Richmond or effect a Maryland invasion of his own.

Lee could scarcely have chosen a more able, or controversial, lieutenant to execute his orders. "Old Jube," a Valley native, was forty-seven, grizzled, and stoop-shouldered. Afield he affected the dingiest of uniforms, which he covered with an enormous linen duster and surmounted with a white slouch hat and incongruous ostrich plume—withal, as one reporter carefully observed, "a person who would be singled out in a crowd." A man of firm opinions, he inspired similar judgments among his associates, who praised his audacity but criticized his sarcasm and abrasiveness.

A forced march brought the II Corps to Lynchburg just as Hunter's vanguard arrived from the opposite direction. Demoralized by the unexpected turn of events, and unable to retreat back north without being cut off, Hunter immediately withdrew into West Virginia. In so doing he saved his army but took it out of the war for the next three weeks, leaving the Shenandoah completely unprotected.

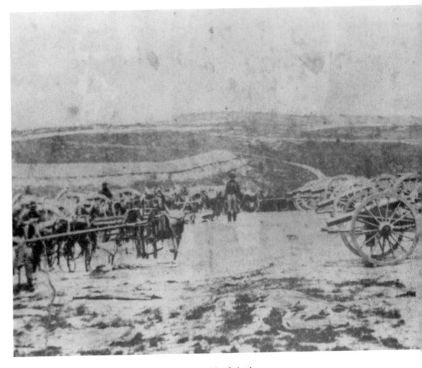

Since Stonewall's campaign, there had been only one real battle in the Shenandoah, here at Winchester on June 14–15, 1863. This faded image is believed to have been taken in the so-called Milroy's Fort soon after the fight, and perhaps shows some of the 23 cannon captured from the routed Federal General Robert Milroy's army. (WINCHESTER-FREDERICK COUNTY HISTORICAL SOCIETY)

Of this strategic opportunity Old Jube promptly took full advantage. His army surged down the Valley in a series of marches which invoked the spirit of Stonewall Jackson's old "foot cavalry." After fording the Potomac on July 6, the gray columns circled eastward along a trajectory that directly threatened both Baltimore and Washington, D.C.

This sudden reversal of Federal fortunes precipitated a crisis in the Union chain of command which came appallingly close to costing the United States its capital. Isolated at Petersburg, Grant had no solution to the situation other than the suggestion that his chief of staff should handle the matter. Henry W. Halleck, who was at heart little more than a petulant Washington bureaucrat, and

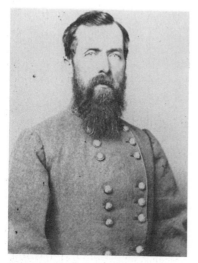

For months thereafter, the Valley was rather quiet, but affairs in southwest Virginia soon threatened. The Confederate commander, Major General Samuel Jones, was not up to the difficult command, and, in February 1864, Richmond replaced him with . . . (VM)

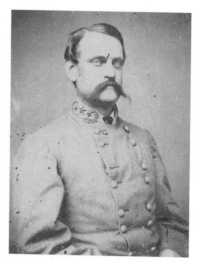

. . . Major General John C. Breckinridge. The youngest Vice President in American history, he had run against Lincoln for the presidency in 1860. Now he was a Confederate officer, charged not only with defending southwest Virginia but also the Valley if it were invaded. (VM)

had besides a fine track record for avoiding responsibility, declined action unless his superior initiated it. So nothing was done. Meantime, subordinates pleaded for instructions, refugees thronged the roads leading east and south, and Early calmly occupied Frederick, Maryland, on July 9, exacting a "contribution" of $200,000 from the unhappy town fathers.

Fortunately for the North, one officer possessed sufficient courage to act in the absence of orders. From Baltimore the Rebel invasion had been watched with mounting concern by Major General Lew Wallace, an Ohio political general with the sad eyes of a basset hound and a romantically literary turn of mind. Gathering a greatly outnumbered force at the Monocacy River, Wallace contested Early's passage on the 9th. The forlorn hope ended in defeat, but it delayed the Southern

advance for a crucial 12 hours. While the battle was in progress, Grant emerged from his lethargy long enough to dispatch portions of the VI and XIX Corps from Petersburg to Washington. Had Wallace not made his stubborn stand, the commanding general later conceded, Early "might have entered the capital before the arrival of the reinforcements I had sent."

Such an upset was just beyond the pugnacious Rebel leader's grasp, though the might-have-beens remained to haunt Southern apologists thenceforth. The Confederate army reached Washington's northern defense perimeter two days after the Battle of Monocacy. But Early, intimidated by the formidable earthworks he faced, confined his activities to a show of strength, and within hours Grant's veterans had arrived to ensure the safety of the

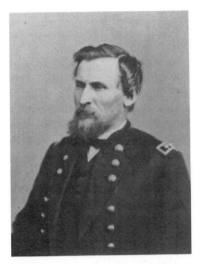

*In May threats came from all over. Union
Brigadier General George Crook swooped into
southwest Virginia from West Virginia and met
part of Breckinridge's command at Cloyd's
Mountain.* (WRHS)

*Breckinridge was not at the battle. Instead,
commanding the small Confederate army there
was Brigadier General Albert Jenkins. In the battle
on May 9, 1864, he lost the fight, his arm, and,
within a few days, his life.* (NA)

city. The following afternoon Abraham Lincoln
visited Fort Stevens, where, to the consternation of
Major General Horatio G. Wright, commanding
the VI Corps, he casually climbed to the parapet
to view the battlefield. Only feet from the Presi-
dent an army doctor collapsed, wounded by a
sniper. Swallowing his diffidence, Wright firmly or-
dered his Commander-in-Chief off the wall (aided,
it is alleged, by the youthful Captain Oliver Wen-
dell Holmes, Jr., who shouted unthinkingly at the
tall figure, "Get down, you fool!").

The raid on Washington proved the Confed-
erate high-water mark of the summer. When word
arrived that Hunter was finally struggling out of
the West Virginia wilderness, Early slipped away
from the capital unimpeded and regained the shel-
tering Blue Ridge walls. Still the Confederates were
not quite ready to surrender their hard-won initia-
tive. An abortive effort by Hunter to secure the

lower Valley ended in near disaster on July 24
when the Rebels pounced on Crook's command at
Kernstown. Then, six days later, Early determined
to strike back at those who had brought devasta-
tion to western Virginia and, in the process, to
teach the North a lesson which it would not soon
forget.

On the morning of July 30 two mounted bri-
gades under Brigadier General John McCausland
entered Chambersburg, Pennsylvania, bearing with
them a demand similar to that visited upon Fred-
erick earlier in the month: pay a ransom of
$500,000 in currency ($100,000 in specie) or face
destruction. Unwilling to believe the threat, the
townspeople declined to raise the money—where-
upon McCausland ordered the entire town fired.

Meanwhile, Breckinridge watched another Federal thrust, south into the Valley. His eyes were the partisan rangers and cavalry scouting all through the Shenandoah, among the most effective being the command of Lieutenant Colonel John Singleton Mosby, the "Gray Ghost of the Confederacy." He appears here near war's end as a full colonel. (VM)

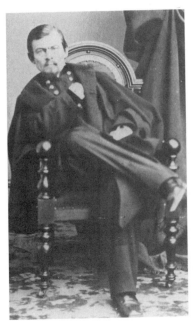

The Yankee army he watched was commanded by Major General Franz Sigel, a man of no military ability but potent political influence. His soldiers proudly declared, being largely Germans themselves, that they "fights mit Sigel." (USAMHI)

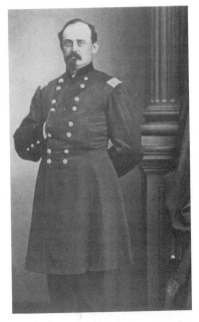

Sigel's army was filled with men no more able than himself, men like Brigadier General Jeremiah Sullivan, commanding his infantry. Toward the end of the war he would be relieved of command because no superior wanted him. (USAMHI)

Four hundred buildings, more than half of them homes, were destroyed. As the conflagration raged, some troopers engaged in drunken pillage while others helped residents save their possessions. "The burning of Chambersburg was generally condemned by our regiment *at first*," admitted a cavalryman, "but when reason had time to regain her seat I believe that they all thought as I thought at first: that it was justice, and justice tempered with mercy. . . . Now everyone knows that the conciliatory policy has failed—utterly failed—and we are driven *nolens volens* to the opposite mode of procedure."

Clearly, attitudes were hardening on both sides, and this fact was apparent in the momentous change in Union leadership which Grant announced two days after the Chambersburg raid. To Major General Philip H. Sheridan, the new commander, went orders "to put himself south of the enemy and follow him to the death." Presaging future events, the general-in-chief also outlined a specific objective for the campaign: "Such as cannot be consumed, destroy," a sentiment expressed with equal cogency in Sheridan's oft-quoted remark that a crow flying over the Valley would have to carry its own rations.

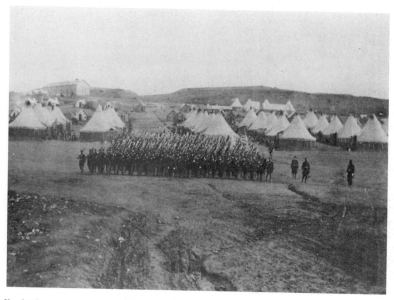

Yet they led good troops, veteran regiments like the 34th Massachusetts, shown here in 1862 outside Alexandria, Virginia. (USAMHI)

"Restless, full of the combative quality, not politic in language, somewhat reticent, half stubborn and fond of hazard enterprises . . . he was the embodiment of heroism, dash, and impulse." Thus Grant described Phil Sheridan, the five-foot-five, black-haired, bullet-headed son of Irish immigrants from County Caven. Despite tactical abilities that were never more than modest, Sheridan had won prominence as one of the hardest-fighting generals in the Army of the Potomac. For his forthcoming operations he possessed an army that eventually included seven infantry and three cavalry divisions, plus substantial artillery. His opponent's command mustered no more than five divisions of infantry and two of cavalry, in addition to one brigade of artillery. In terms of manpower the Northern superiority was even more pronounced, probably on the order of two-to-one.

Reflecting his superiors' concern that further Confederate successes would endanger Lincoln in the fall elections, Sheridan proceeded cautiously at first. However, when he finally moved on September 19 against the Southern position at Winchester, just west of Opequon Creek, his juggernaut rolled forward with irresistible momentum. Combined infantry and cavalry assaults smashed the Confederate left flank; Early was sent, in Sheridan's own expressive phrase, "whirling through Winchester." Battered but still defiant, the gray forces entrenched 20 miles farther south at Fisher's Hill, near Strasburg. Here, three days later, Sheridan attacked again, once more outflanking the Confederate left.

Grant now counseled his subordinate, as he had Hunter, to occupy the Valley as far south as Staunton and then move eastward toward Charlottesville. But Sheridan resisted, citing logistical difficulties and the dangers of partisan bedevilment. Instead he argued that the ravaging of the lower

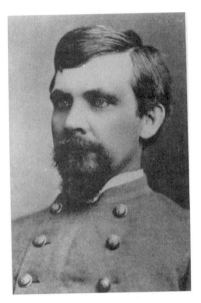

Rushing to meet and stop Sigel, Breckinridge enlisted the aid of the Corps of Cadets of Lexington's Virginia Military Institute. Lieutenant Colonel Scott Ship led the boys, some no more than fourteen, in the battle that followed. (NEW MARKET BATTLEFIELD PARK)

Cadet William Nelson, at nineteen, was among the oldest in the corps who fought at New Market. (VM)

Shenandoah should remain his primary goal. Accordingly, he sent out raiding parties to destroy as much of the recent harvest as possible. The rest of the army began digging in at Cedar Creek for an indefinite stay. To clear up the details of his strategy, the War Department ordered him to Washington for a brief conference on October 16. For the summons which took him from the front at this critical moment, Sheridan was of course not to blame. Nevertheless, his defensive arrangements at Cedar Creek were open to criticism, for he left his army indifferently posted, its left flank resting unsupported above a defile at the foot of Massanutten Mountain.

Out of the foggy dawn on October 19 rose the spine-chilling wail of the "Rebel Yell" as Old Jube struck the Federal left end-on with the full strength of four divisions. Totally surprised, the Union Army reeled backward along the Valley turnpike for four miles. Sheridan, who learned of the attack just as he was returning from Winchester, spurred furiously toward the battlefield, 14 miles away. En route he passed thousands of fleeing soldiers who turned with a cheer to follow him as he shouted, "About-face, boys! We're going back to our camps! We're going to lick them out of their boots!" In a

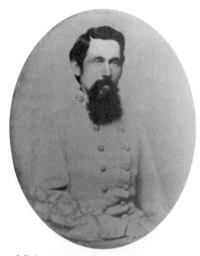

*A distinguished yet little known Confederate officer
who led one of Breckinridge's brigades at New
Market was Brigadier General Gabriel C.
Wharton, himself a VMI graduate.* (LC)

famous poem published shortly after the battle,
T. Buchanan Read exaggerated by half the dis-
tance Sheridan's ride covered (and with it the
endurance of his charger, Rienzi), but accurately
depicted its psychological impact:

He dashed down the line, 'mid a storm of huzzas,
And the wave of retreat checked its course there,
 because
The sight of the master compelled it to pause.
With foam and with dust the black charger
 was gray;
By the flash of his eye, and his red nostril's play,
He seemed to the whole great army to say:
"I have brought you Sheridan all the way
 From Winchester down to save the day."

By way of anticlimax, when Sheridan arrived he
discovered that General Wright had already stabi-
lized the front. Whether Early himself neglected
to press the attack, or whether his men simply

*There were distinguished men in Sigel's army, and
Captain Henry A. DuPont of Delaware was one of
them. Though he did not arrive on the field in
time for the battle, he did save the rout of Sigel's
army from becoming a complete disaster. Years
later he would sponsor legislation to rebuild VMI
after the ravages of the war.* (ELEUTHERIAN MILLS
HISTORICAL LIBRARY)

stopped to plunder the enemy's camps, the impetus of the Southern offensive gradually slowed. The inevitable Northern counterattack precipitated a rout unprecedented even by Valley standards. With dogged tenacity, Early once again assembled his forces farther south, but the final Confederate bid for mastery in the Shenandoah had failed.

Affairs well in hand, Sheridan's men resumed the task of despoliation, their success illustrated by the grim record of the property which they seized or destroyed: 1,200 barns; 71 flour mills; 8 saw-mills; 7 furnaces; 4 tanneries; 3 saltpeter works; 1 woolen mill; 1 powder mill; 1 railroad depot; 1,165 pounds of cotton yarn; 974 miles of rail; 15,000 swine; 12,000 sheep; 10,918 cattle; 3,772 horses; 545 mules; 250 calves; 435,802 bushels of wheat; 77,176 bushels of corn; 20,397 tons of hay; 500 tons of fodder; 450 tons of straw; 12,000 pounds of bacon; 10,000 pounds of tobacco; and 874 barrels of flour. These depredations did not affect the upper Valley, where Early still lurked. Even so, between Staunton and the Potomac they were thorough indeed. Thousands of refugees moved north, and a full year after the war a British traveler found the region standing as desolate as a moor.

While the plundering was under way, Rebel guerrillas continued to plague the invaders, at one point even spiriting General Crook off into captivity. For a while it appeared that the North had a solution to this problem too. Six of Mosby's men were hanged at Front Royal by Brigadier General George A. Custer, a brash young cavalry commander already displaying signs of the faulty judgment which would cost him his life on the Little Big Horn. But anyone could play this game, and after Mosby retaliated in kind both sides mercifully halted the executions. A final stage in the escalation of violence was thereby avoided—yet here in Virginia, as well as elsewhere in the South, rapid progress had been made toward the dreadful 20th century concept of total war.

Sheridan's operations concluded in February 1865, when he overwhelmed the last remnants of Confederate strength at Waynesboro and then rejoined Grant at Petersburg. To contemporaries his campaign was one of the signal accomplishments of the Civil War, and it figured prominently in postbellum song and story. It is true that, in the harsh light of historical retrospection, his exploits

Immediately after the Confederate victory at New Market, Richmond sent Colonel Edwin G. Lee, shown here as a brigadier later in the war, to assume command at Staunton and recruit more troops for the defense of the Valley. It was obvious that the Yankees would come again. (CHS)

fall short of epic proportions. Less than half the Valley suffered from his scorched-earth tactics. Moreover, by nullifying Grant's repeated orders to resume the offensive east of the Blue Ridge, he may well have lost a golden opportunity to end the war six months before Appomattox. All this being said, however, the incompleteness of his victory probably did not matter. To his credit, he achieved more than any Union leader before him, for he demolished an important symbol of Southern invincibility. In so doing, he also removed one of the few remaining props upon which rested the fate of the Confederate nation.

In fact, they came within two weeks, led now by a
general just as incompetent as Sigel, Major
General David Hunter. His destruction of private
property, including VMI, would make his name
reviled in Virginia. (WRHS)

His adjutant, Colonel David Hunter Strother, was
much better liked, and better known by his pen
name "Porte Crayon." He drew sketches of army
life that were widely published in the North.
(USAMHI)

To stop Hunter, Richmond assigned one of Lee's premier fighters, Lieutenant General Jubal A. Early of the II Corps. Cranky, cantankerous, a confirmed bachelor who offended many, still he was more than Hunter's match. (VM)

Hunter was turned back, and with him his chief of cavalry, Major General Julius Stahel, a Hungarian who won the Medal of Honor for his bravery in the Battle of Piedmont in June. (USAMHI)

Less distinguished was the service of Colonel August Moor of the 28th Ohio. Within weeks of Piedmont, he would be out of the service. (USAMHI)

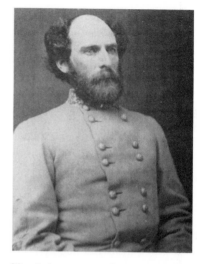

When Early came to the Valley, he brought with him several officers of high merit. He would need them, for barely had he driven Hunter out before he launched his July raid on Washington itself. Confederate cavalry led by Brigadier General Robert Ransom was the vanguard. (USAMHI)

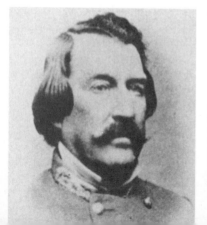

Serving with the Confederate infantry in the raid, and at the Battle of Monocacy, Maryland, which delayed Early, was perhaps the biggest general of the war, Brigadier William R. Peck of Tennessee. He stood six feet six inches tall and won commendation for his bravery in the battle. (USAMHI)

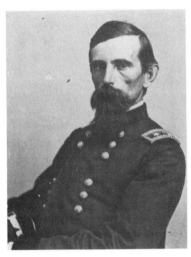

The real hero of Monocacy, however, was a Yankee, Major General Lew Wallace. With inferior numbers, still he managed to stall Early long enough for vital reinforcements to reach Washington and prevent its capture. Years after the war he would write his great book, Ben Hur. (USAMHI)

Early got as close as Fort Stevens, only a few miles outside the capital. On this ground he fought his hesitating battle that ended the raid. Had he pushed, he might still have broken through despite . . . (MHS)

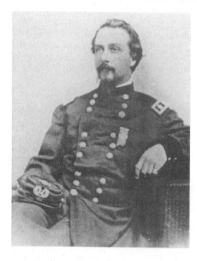

. . . last-minute reinforcements from Grant's army at Petersburg, among them Brigadier General Frank Wheaton and his division of the VI Corps. Ironically, Wheaton's wife was the daughter of the Confederacy's highest ranking general, Samuel Cooper. (P-M)

This house near Fort Stevens shows the effects of Early's artillery fire during the fighting. (USAMHI)

It was as close as the ravages of war came to the District of Columbia, and quite close enough for President Lincoln, who was in Fort Stevens during part of the firing. (USAMHI)

For a few hours Confederates even occupied the home of Breckinridge's cousin and old friend, Montgomery Blair, at Silver Spring, Maryland. Breckinridge saved the house from looting. (USAMHI)

Nevertheless, later on Confederate stragglers would vandalize the home of Blair, Lincoln's postmaster general. (USAMHI)

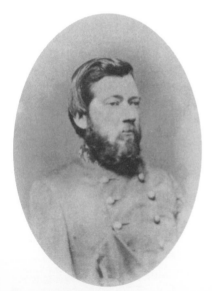

Early, too, took losses, among them the personable young Brigadier General Robert D. Lilley. Back in Virginia, near Winchester, he was so severely wounded that he lost his right arm. Here his empty sleeve is pinned to his blouse. (USAMHI)

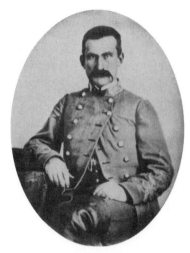

Early did not forget the depredations of Hunter in the Valley. In retaliation, he sent Brigadier General John McCausland to demand a payment of half a million dollars from Chambersburg, Pennsylvania. When the town could not produce it, McCausland gave . . . (COURTESY OF ALEXANDER MCCAUSLAND)

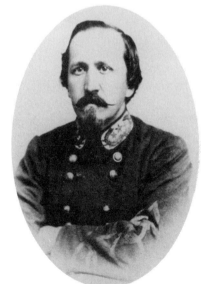

. . . Brigadier General Bradley T. Johnson orders to burn the town. (USAMHI)

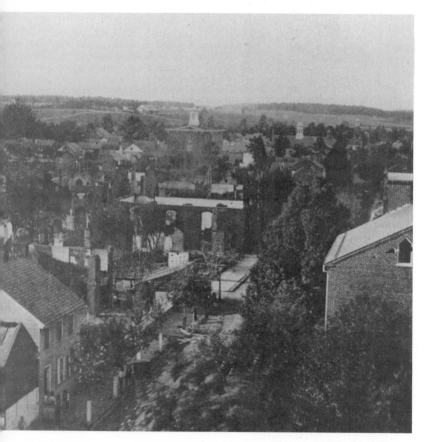

Johnson applied the torch, and Chambersburg burned. Local photographers, the Zacharias brothers, recorded the aftermath. (MHS)

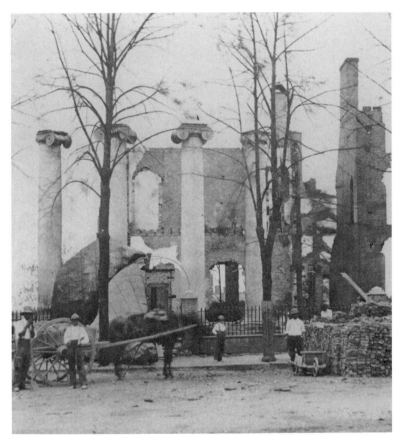

All that was left of the Bank of Chambersburg. (MHS)

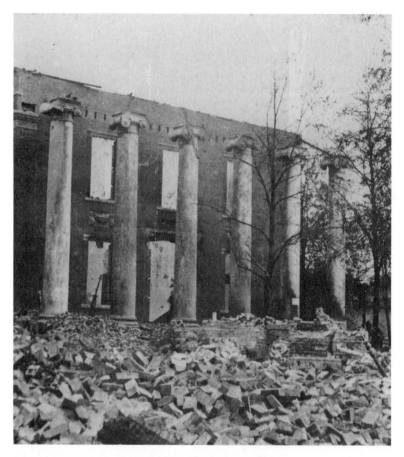

*The skeleton of the Franklin County court house. Chambersburg would
eventually receive compensation from Washington for its loss—in the 1970s!*
(MHS)

But in 1864 there was nothing to assuage the loss. Yankees called it barbarism. Confederates called it revenge. (COURTESY OF MAURICE MAROTTE)

Early's successes in the Shenandoah forced Washington to stop sending political hacks to oppose him. Instead, Grant sent one of his most trusted lieutenants, the ruthless Major General Philip H. Sheridan, small, combative, merciless. He stands at front, fifth from the left, among his staff in 1864. (USAMHI)

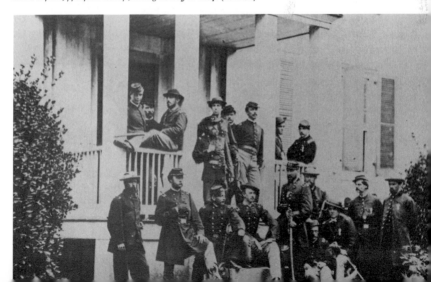

Through August and into September, Early and Sheridan feinted at each other. Then on September 19 the Federals attacked, pushing across Opequon Creek and moving toward Winchester. A postwar view of the creek. (USAMHI)

With Early falling back before them, Sheridan's divisions drove toward the Valley pike, shown here looking south toward Winchester. (USAMHI)

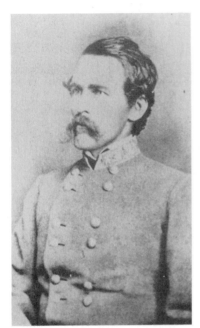

In bitter fighting, one of the best young officers of the Confederate Army, Brigadier General Robert E. Rodes, was killed in action, his division being taken by another promising young officer . . . (USAMHI)

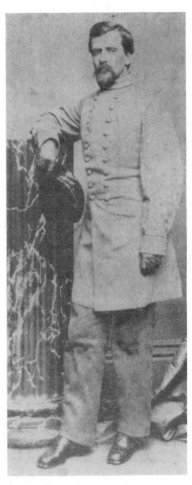

. . . Brigadier General John Pegram. (COURTESY OF W. HAYS PARKS)

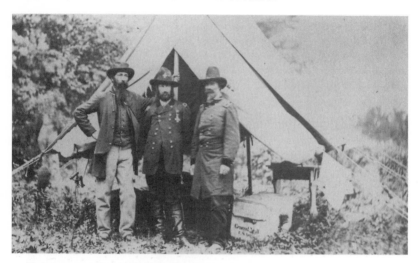

Yankees, too, started to fall. Brigadier General David A. Russell, who had helped save Washington in July, fell leading a brigade when a shell fragment pierced his heart. He stands at left, with Generals T. H. Neill in the center, and John H. Martindale at right. (USAMHI)

Before long the Confederates were pushed back into Winchester itself, desperately holding out against Sheridan's attacks. An 1885 view, with Milroy's Fort visible on the crest in the distance. (USAMHI)

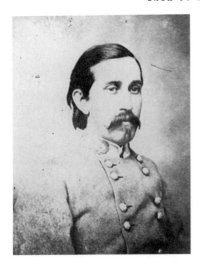

Brigadier General R. D. Johnston led his brigade with particular bravery in trying to stem the Yankee tide, but Sheridan was too powerful, and Early too scattered. (VM)

From this spot in Milroy's Fort civilians looked out and watched the battle for Winchester as it raged off in the distance. (USAMHI)

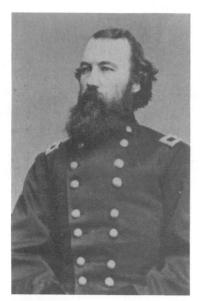

Brigadier General James McIntosh and his cavalry brigade had helped open the battle. For four hours that morning he held a position against Early's infantry. In the end his battling cost McIntosh a severe wound and a leg. (USAMHI)

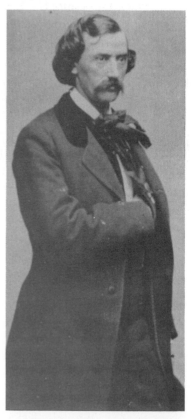

For Colonel James Mulligan, it cost more than that. Wounded while leading his brigade, he was captured by the Confederates and died a few days later. (NA)

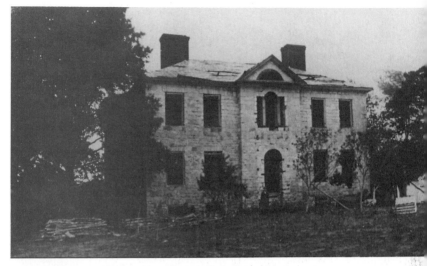

Around the already ruined Hackwood house the contending armies raged as Sheridan pressed ever closer to Winchester. (USAMHI)

Here, late in the afternoon, elements of Sheridan's XIX Corps poised before the final attack that drove Early out of Winchester. A postwar image. (USAMHI)

What put Early's army to flight out of Winchester was the final attack of the day, led by Brigadier General Wesley Merritt. An unpublished image believed to be of the youthful and talented cavalry officer. (COURTESY OF THOMAS SWEENEY)

Colonel Rutherford B. Hayes won a reputation for himself at Fisher's Hill, and after the war his record helped win him a term in the White House. (P-M)

The armies met next at Fisher's Hill on September 22. Southwest of Strasburg, Fisher's Hill proved to be another Confederate stampede, as Sheridan's attack drove Early from his position on the crest in the center background. Many a Confederate was buried in the little cemetery at left. An 1885 view. (USAMHI)

Viewed from the crest of Fisher's Hill, the Federal positions are off in the distance. By getting around his flank, Sheridan forced Early to retreat and almost cut off escape but for the stubborn rearguard stand of Confederate cavalrymen . . . (USAMHI)

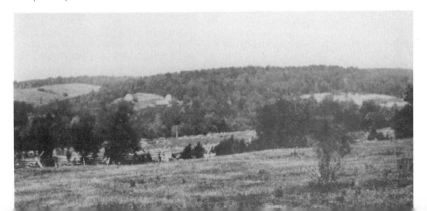

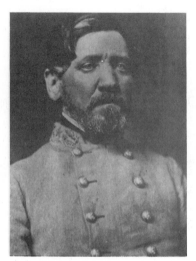

. . . *Brigadier General W. C. Wickham, who*
outwitted Sheridan's pursuers and saved Early
from possible disaster. (VM)

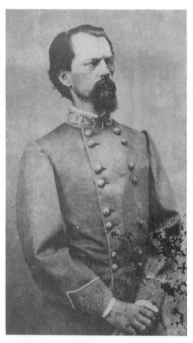

Old Jubal smarted under his twin defeats, and
through September and into October he planned a
counterattack. At Cedar Creek on October 19,
1864, he made it. Spearheading the attack was
a bold march around Sheridan's flank led by Major
General John B. Gordon, one of the fightingest
generals in the Confederate Army. (NA)

Along with Gordon's flank march, Kershaw's brigade crossed Cedar Creek here to assist in the flank attack. It achieved complete surprise and threatened to put the Yankees to rout. A postwar image. (USAMHI)

This hill is where the Federals' unsuspecting left was placed when Early struck. The bluecoats could not stand in the face of a lightning attack. (USAMHI)

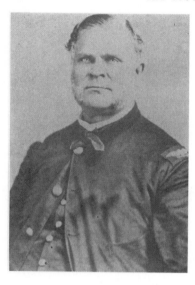

Brigadier General Daniel D. Bidwell fell with a mortal wound while trying to resist Early's assault. (USAMHI)

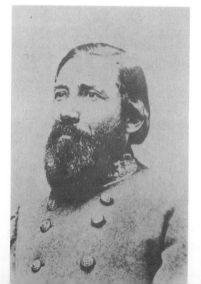

Confederates like Brigadier General Cullen Battle paid a price for their surprise, however. Leading a brigade in Gordon's attack, Battle took a wound that put him out of the war for good. (USAMHI)

Only the heroic efforts of men like Brigadier General Lewis A. Grant managed to build a line where the retreating Federals could hold long enough for reinforcements to come and resist Early's drive. (P-M)

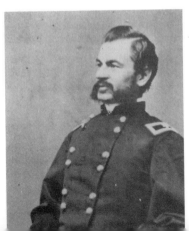

Brigadier General Alfred T. A. Torbert's cavalry division also stood in the face of the advancing Confederates, buying enough time for Sheridan to rush to the battlefield and start sending more regiments. A native of Delaware, Torbert actually held a commission in the Confederate Army briefly at war's outset but was at the same time raising the 1st New Jersey. (USAMHI)

Sheridan was some distance behind the lines when Early struck. Feverishly, he rode his charger forward to take command and rally his army. This postwar image of his horse was made in Leavenworth, Kansas, by photographer E. E. Henry. (USAMHI)

Here, on the Valley turnpike, Sheridan rejoined his army and began salvaging victory from imminent defeat. (USAMHI)

Once more the Federals advanced, across ground like this where they had been placed that morning, unsuspecting the storm that Early would unleash. (USAMHI)

By that afternoon it was Early who was hard-pressed. Here sat his left flank when the revitalized XIX Corps and VI Corps struck in an unstoppable attack that drove the Southerners from the field. Early had his third consecutive defeat. (USAMHI)

Sheridan made his headquarters at Belle Grove mansion, seen here in the distance, a magnificent country house built by the Fairfax family. Here after the battle mortally wounded Confederate Brigadier Stephen D. Ramseur was brought to die. Old friends like Custer and Merritt surrounded him at his deathbed. (USAMHI)

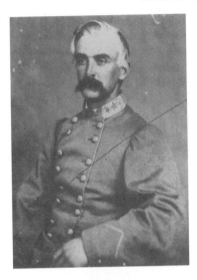

And that was virtually the end of the Valley
Campaign. Through the fall and on into the
winter of 1865 the armies glowered at each other,
but Early could no longer risk meeting his foe.
New officers came to him, men like Colonel
Thomas T. Munford, who would command his
remnant of cavalry, but they were too few to save
the Shenandoah. (VM)

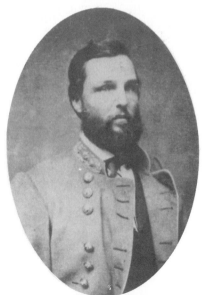

Early himself was relieved in March 1865 and
replaced by Major General Lunsford L. Lomax, in
command of the Valley District. By then it was a
command without an army. (USAMHI)

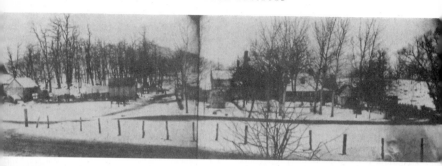

Through that winter the Federals, too, played a game of watch and wait. For them and for the Valley, the war was almost over. Here, just outside Winchester, the camera captures the headquarters of Colonel Alexander Pennington's cavalry brigade on February 23, 1865. (USAMHI)

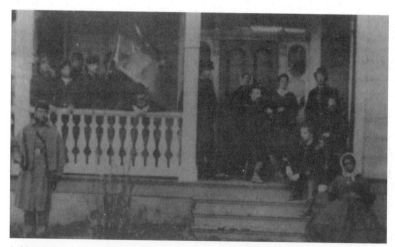

And here in Winchester a jaunty Brigadier General George A. Custer sits at the head of the steps, surrounded by his wife and friends. The boy general had distinguished himself in the campaign. (AMERICANA IMAGE GALLERY)

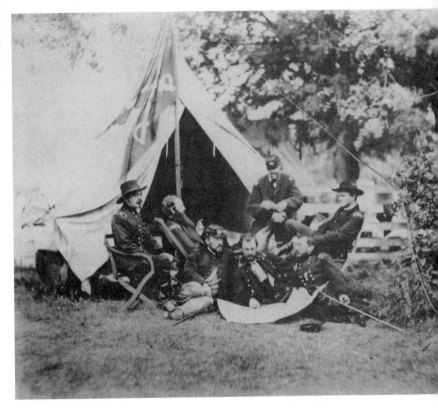

They had all distinguished themselves, and with Early dispatched, Sheridan and his generals could be off for the east of the Blue Ridge, back to Grant, and the last irresistible surge at Lee. Sitting on the ground are Brigadier General James H. Wilson, at left, Torbert in the center, and Sheridan at right. Seated behind them are Brigadier General Thomas Davies at left, Brigadier General David M. Gregg in profile, and Merritt at far right. They were a constellation of stars. (KA)

A Campaign That Failed

LUDWELL H. JOHNSON III

Cotton and politics and the Red River
make strange war in Louisiana

THE RED RIVER EXPEDITION, like the Shenandoah campaign part of the Union's nation-wide advance, was perhaps as strange and compli-cated an episode as the Civil War has to offer. It originated in a combination of motives that in-cluded a missionary-imperialist impulse to promote a New England settlement of Texas, fears of French influence in Mexico, President Lincoln's de-termination to establish a Unionist state govern-ment in Louisiana, the machinations of unscru-pulous cotton speculators and textile mill interests, the U.S. Navy's thirst for prize money, and the strategic vagaries of Chief of Staff Major General Henry W. Halleck.

The Union plan of campaign called for a pow-erful column based in New Orleans to advance to the Red River from the south, another force to come down the Mississippi from Vicksburg, a third to march southwestward from Little Rock, and the Mississippi Squadron to accompany the main force up the Red River. The objective was to capture Shreveport, headquarters of the Confederate Trans-Mississippi Department, and from there to invade Texas. The campaign was to begin in March 1864, when the Federals needed every available man for the decisive campaigns east of the Mississippi. It was set in motion against the wishes of U. S. Grant,

who succeeded Halleck as chief of staff soon after the expedition began. It continued without benefit of an overall commander, met with severe reverses, almost saw the Mississippi Squadron lost or sunk, tied up thousands of troops that otherwise would have been employed with Sherman in Georgia and in an attack on Mobile, and ended in total failure.

Commanding the column coming up from New Orleans was Nathaniel P. Banks, a Massachusetts politician with no prewar military experience who had been repeatedly beaten by Stonewall Jackson in Virginia. Late in 1862, Banks replaced Ben-jamin F. Butler as commander of the Department of the Gulf, where his principal task was the politi-cal reorganization of Louisiana. The Vicksburg column, detached from W. T. Sherman's army, had for its leader the hard-bitten A. J. Smith, who came under Banks' orders when he reached the Red River. Naval forces consisted of the Missis-sippi Squadron, 23 vessels, mostly ironclads. The admiral of this armada was David Dixon Porter, courageous, vainglorious, and money-hungry, whose sailors were skilled in "capturing" cotton as a prize of war. Frederick Steele led the troops who were to come down from Little Rock. Preoccupied by the task of Republicanizing Arkansas and acutely aware of the logistical pitfalls of a march

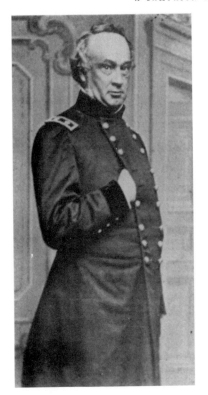

cavalry contesting Steele's advance. Bearing the brunt of the Federal invasion up the Red was Richard Taylor, son of the late Zachary Taylor and brother to Jefferson Davis' first wife. Highly educated and widely read, Taylor was a very capable amateur soldier who had won his spurs with Jackson in the Shenandoah Valley. He was supremely confident, pugnacious, a leader of men, and an imaginative strategist.

Both Smith and Taylor found it hard to believe reports of an impending offensive against Shreveport. Surely, said Smith, the enemy could not be so "infatuated" as to divert troops from the central South, where the war would be decided. All doubts were laid to rest when Porter's squadron and A. J. Smith's 11,000 veterans appeared at the mouth of the Red River on March 11. The Federal troops marched inland and overwhelmed the little garrison at Fort De Russy. Porter then carried part of Smith's command to Alexandria, which was occupied on the 15th. When Banks' men reached the town ten days later, Federal forces totaled 30,000 troops, while on the river there were 60 vessels, including transports. To confront this host Taylor had 7,000 men. His only course was to fall back, collect reinforcements, and hope for an opportunity to strike the enemy in detail.

At Alexandria, while Banks was holding elections for the "restored" government of Louisiana, Porter's men rounded up wagons and teams and ranged the countryside collecting cotton. They stenciled "CSA" on the bales to convince the prize court it was Confederate-owned cotton, and under that "USN." One envious army officer told Porter the initials stood for "Cotton Stealing Association of the United States Navy." Porter also had less congenial work to attend to at Alexandria. The river had failed to rise at the usual season, a fact that would give the Navy much grief before the campaign was over, but 13 gunboats and 30 transports managed to scrape into the upper Red, including the huge ironclad *Eastport.*

When Banks pushed out from Alexandria, Taylor fell back before him. Union infantry entered Natchitoches on April 1, having marched 80 miles in four days. A few miles farther, at Grand Ecore, the main road to Shreveport turned away from the river and, for Banks, away from the shelter of Porter's big guns. On April 6, without waiting to look for a river road, which did exist, Banks plunged

When an invasion of the Red River was proposed, many, including the man who would lead it, were not enthusiastic. But chief of staff Major General Henry W. Halleck managed to force it to be undertaken. (USAMHI)

through south-central Arkansas, Steele would have preferred to make a mere demonstration, but Grant ordered him to move on Shreveport in cooperation with Banks.

Confederate forces were under the general direction of E. Kirby Smith, commander of the Trans-Mississippi Department. Sterling Price, silver-maned former governor of Missouri, led the

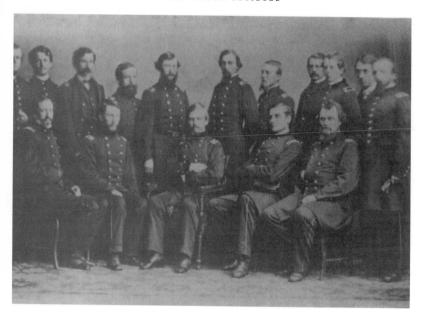

The man who would actually command the expedition was Major General Nathaniel P. Banks of Massachusetts, seated at center among his staff. A man of no military experience, and even less ability, he was a political powerhouse, and that got him command. Halleck complained that it was "but little better than murder" to put men like Banks in the field. (MHS)

into the forbidding pine woods. Porter continued up the narrow, winding river the next day. Taylor withdrew as far as Mansfield, about 40 miles from Shreveport; there he made a stand, deployed his little army, and waited for Banks. Smoldering with anger because reinforcements were so few in number and so long in reaching him, bitterly resenting the gossipers at departmental headquarters who blamed him for the failure to stop the invaders, Taylor was in a dangerous frame of mind.

The Federals tramped through Pleasant Hill and on toward Mansfield. First came the cavalry, then the cavalry's large wagon train, then the infantry. At noon on April 8 the troopers emerged into a clearing, on the far side of which they could see the Rebel skirmish line. Infantry filed into line but did not attack. By four o'clock Taylor's small store of patience was exhausted, and he came down on the enemy with crushing force. Outflanked, the Federals fell back, stiffened as reinforcements arrived, then broke and ran for the rear. When they found the narrow road blocked by the cavalry train, panic spread through the ranks. At last, two miles from the battlefield, a fresh Union division checked the pursuers well after night had fallen. In the darkness, cries of the wounded mingled with joyous shouts as the Confederates plundered the captured wagons. Banks

To back Banks in the Red River Campaign, Washington assembled a mighty ironclad fleet, including 13 ironclads and several more gunboats. A part of that fleet poses here on the Red in May 1864. (USAMHI)

fought most of the battle with about 7,000 men, as compared to Taylor's 8,800. Banks lost 2,235 men, of whom two thirds were captured. Taylor lost 1,000 killed and wounded; there was no report of anyone missing. He captured 20 pieces of artillery and 156 wagons, valuable booty for the lean gray army.

Banks retreated to Pleasant Hill, where he took up a defensive position, strengthened by A. J. Smith's command. Taylor followed, having been reinforced by two small divisions under Thomas J. Churchill. These troops had recently arrived from Arkansas in response to orders from Kirby Smith, who had correctly decided to concentrate against Banks first.

Taylor had followed Stonewall Jackson to some purpose and did not intend to make a simple frontal attack at Pleasant Hill. His plan called for Churchill to envelop the Union left while the rest of the infantry attacked in front. Cavalry would move around the enemy's right flank. If successful, Taylor would cut off all of Banks' avenues of re-

treat. Churchill's weary soldiers, who had marched 45 miles during the last day and a half, advanced with spirit at three in the afternoon, drove the Federals back, reached the road to Natchitoches, and seemed to have the battle well in hand. However, the Federal left was not where it seemed to be. Churchill had in fact crossed his right in front of A. J. Smith, who attacked at just the right moment. Although it resisted stubbornly, the Confederate right gave way in disorder. Darkness ended the fighting; Taylor had been sharply repulsed.

Banks rode up to Smith. "God bless you, General," he exclaimed, "you have saved the army." Later, without consulting Smith, Banks decided to retreat; soon after midnight the army started down the road to Grand Ecore. At Pleasant Hill each side had had approximately 12,000 men engaged. Banks lost 1,400 casualties, Taylor more than 1,600. The "Fighting Politician" had been lucky. With another general there would have been no need to retreat, but probably most of Banks' officers would have agreed with William B. Frank-

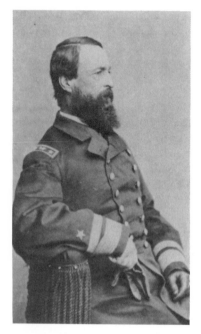

Commanding the naval end of the operation was Admiral David D. Porter, flamboyant, scheming, and anxious to confiscate the abundant cotton on the Red River for the prize money. (USAMHI)

lin, commander of the XIX Corps: "From what I had seen of General Banks' ability to command in the field, I was certain that an operation depending on plenty of troops, rather than skill in handling them, was the only one which would have probability of success in his hands."

One arm of the pincers movement on Shreveport was broken when Banks retreated from Pleasant Hill. The other, Steele's army, was advancing on the Confederate stronghold from the northeast; by the time Taylor attacked Banks, the campaign in Arkansas was two weeks old. For the Federals it was a dismal ordeal from start to finish. Steele set out from Little Rock with 6,800 effectives on

March 23. A cooperating column of 3,600 men joined him at Elkins' Ferry on April 9, but brought no supplies. The roads were wretched, food and forage scarce, and Price's cavalry swarmed about the column. "Our supplies were nearly exhausted and so was the country," said Steele. "We were obliged to forage from 5 to 15 miles on either side of the road to keep our stock alive." Therefore, on April 12, Steele abruptly changed his direction from southwest to east and made for the town of Camden. There he hoped to accumulate supplies and eventually to resume the offensive.

Ironically, just as Steele was turning back, Kirby Smith decided to strip Taylor of most of his infantry and take them to Arkansas, even though he had learned that Steele was heading for Camden and posed no immediate threat to Shreveport. Taylor argued to no avail for a concentration against Banks and Porter; Kirby Smith was obdurate. He marched off, leaving the fuming Taylor with his cavalry and one small division of infantry. Without doubt this was a strategic mistake of the first magnitude, one that not only affected operations on the Red River, but conceivably had an important bearing on the major campaigns east of the Mississippi.

Kirby Smith left for Arkansas on April 16, the same day that the rear of Steele's column entered Camden. There the beleaguered Federals began their search for food. The capture of a Confederate steamer loaded with corn eased the pinch somewhat, as did the arrival of a wagon train from Pine Bluff with ten days' half-rations. But these successes were more than offset by the loss of a wagon train in a bloody little affair at Poison Spring that cost the Federals almost a third of the escort, and of another in a bigger fight at Marks' Mills, where 1,300 of 1,600 men were lost. The capture of these trains precipitated a crisis: Steele no longer had the means to feed his men and animals. There was only one possible decision: on April 25 Steele ordered an immediate retreat to Little Rock.

With the infantry from Taylor's army now at hand, Kirby Smith took up the pursuit. This was his second serious mistake. The proper course would have been to return swiftly to Louisiana and join Taylor in attacking the Federals before they could extricate themselves from the Red River country. Instead he kept on after Steele, both ar-

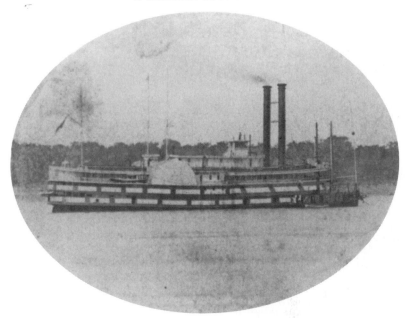

Porter himself made the famous Black Hawk *his flagship. She sits here at anchor in the Mississippi with a small steam tug at her bow.* (GLADSTONE COLLECTION)

mies contending with rain and mud, bridging rivers, struggling against hunger and exhaustion. On April 30 he overtook Steele at Jenkins' Ferry, a crossing of the Saline. Fighting across flooded bottom lands, knee-deep in water, assaulting log breastworks, the Confederates made little headway. All during the battle Steele labored to get his trains and artillery across the river. By early afternoon the bloodied Confederates had given up the attack, and the Federals staggered the last miles into Little Rock in peace. The Arkansas phase of the campaign was over.

Back on the Red, Banks had entrenched at Grand Ecore, presenting the strange spectacle of 25,000 men hemmed in by 5,000. Meanwhile, Porter's flotilla had proceeded up the river, headed for Shreveport. When Porter learned of the army's re-

treat, he managed to turn his vessels around in the narrow, shallow channel and begin the difficult trip downstream. Grinding along the bottom, sticking on submerged stumps, colliding with one another, braving Confederate musketry and artillery fire, they at last reached Grand Ecore safely. This trip, however, was only a foretaste of troubles yet to come.

Banks dismissed his chief of staff and two cavalry generals, scapegoats for his failure, called up reinforcements, and even thought of resuming the offensive. The thought passed quickly; on April 19 he began the retreat to Alexandria. His route took him down a long island formed by the Cane and Red rivers, and Taylor attempted to encircle the enemy as they prepared to leave the island at Monett's Ferry. Had the infantry Kirby Smith

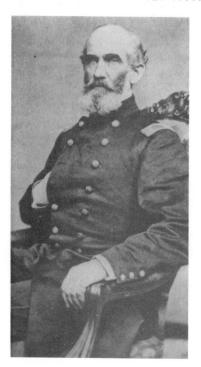

Brigadier General A. J. Smith, shown here as a colonel in late 1861, was ordered to cooperate with Banks. He was not very popular with his men, some of whom hissed him when he rode past. And later in the campaign he would suggest arresting Banks for incompetence. (LC)

marched off to Arkansas still been with Taylor, his plan might well have succeeded; now the odds were too heavy. Pushing the Confederates aside after brisk fighting, Banks' men reached Alexandria on the 25th. They had left behind them a smoking wasteland. "The track of the spoiler," said one observer, "was one scene of desolation. . . . A painful melancholy, a death-like silence, broods over the land, and desolation reigns supreme."

A. J. Smith's men, not long back from Sherman's devastating Meridian expedition, were the stars of the drama. "The people now will be terribly scourged," promised one of Smith's generals, and scourged they were.

As the navy paralleled the army's withdrawal, Porter was having more trouble. The ponderous *Eastport,* sunk below Grand Ecore by a torpedo and laboriously refloated, proved to be a dangerous encumbrance to the vessels assigned to shepherd her downstream. After grounding repeatedly, *Eastport* finally stuck fast, and Porter had to blow her up. The other boats, including Porter's flagship *Cricket,* had to run an artillery gauntlet five miles above the mouth of Cane River. Two transports were total losses, *Cricket* received 38 hits and, like *Juliet* and *Fort Hindman,* suffered heavy casualties. To make matters worse, when Porter reached Alexandria, he found that the river had fallen, trapping above the falls the backbone of the Mississippi Squadron: *Lexington, Fort Hindman, Osage, Neosho, Mound City, Louisville, Pittsburg, Chillicothe, Carondelet,* and *Ozark.* Should the army continue its retreat, they, like *Eastport,* would have to be destroyed.

On April 21 the War Department heard that the army, badly damaged, had retreated to Grand Ecore. Grant, who had intended to use Banks' force in a campaign against Mobile, gave up all idea of using those troops east of the Mississippi that spring. Banks would be lucky, it seemed, not to lose the army and the fleet. Something had to be done to secure better leadership. Remove Banks, Grant told Halleck, but Lincoln demurred. "General Banks," Halleck told Grant, "is a personal friend of the President, and has strong political supporters in and out of Congress." Lincoln would remove him only if Grant insisted upon it as a military necessity. Ultimately, too late to affect the campaign, a middle way was found: Banks' Department of the Gulf was absorbed in the newly created Military Division of West Mississippi under the command of Edward R. S. Canby. Although nominally retaining his position, Banks would never again take the field.

Ignorant of his impending demotion, Banks was fortifying Alexandria lest his 31,000 men be overwhelmed by Taylor's 6,000. It was an unhappy time for the man whose soldiers derisively called him "Napoleon P. Banks," or sometimes just "Mr.

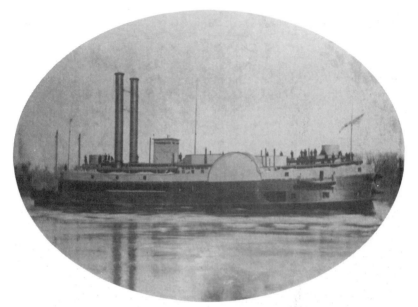

Quickly the armies gathered, and the fleet assembled. The USS Ouachita *had formerly been a Confederate warship, the* Louisville, *before her capture in 1863. Now she was preparing to steam up the Red.* (MHS)

Banks." He could not stay where he was indefinitely, and he could not retreat without abandoning the navy, which was unthinkable. The way out of this dilemma came from an engineer on Franklin's staff, Lieutenant Colonel Joseph Bailey of Wisconsin. Experienced in the logging country, Bailey proposed to build a temporary dam to raise the water level on the falls. Porter was skeptical, but was in no position to reject any scheme, no matter how improbable. Banks made available the necessary manpower and gave much personal attention to the project. Work began late in April.

Porter and Banks were not the only people unhappy with the campaign so far. Cotton speculators who had trailed along with the expedition expecting a rich haul saw their dreams go up in smoke, or else into the holds of the gunboats. Part of the cotton which had been hauled into Alexandria was seized for use in building the dam, including some owned by one of Lincoln's old friends who had appeared on the Red with the President's permission to go through the lines and buy cotton from the Confederates. "I wish you would take somebody else's cotton than mine," he protested, "that is very fine cotton!"

The Confederates blockading the river below the town inflicted serious losses on Union shipping. On May 4, *City Belle,* with the 120th Ohio on board, was captured, and on the 5th a transport loaded with the 56th Ohio was lost, as were two gunboats, *Covington* and *Signal.* But Taylor's small force was unable to do the one thing that would have meant disaster for the enemy: stop construction of Colonel Bailey's dam.

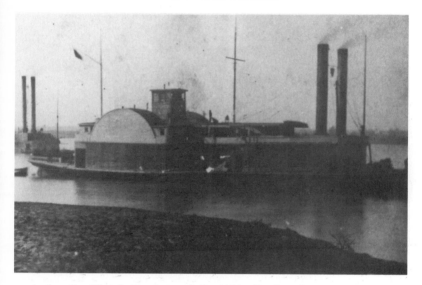

Another captured Confederate gunboat was the General Price. *Now she was in the Yankee service, though the commander of the gunboat* Conestoga, *lying astern of her in this January 20, 1864, image by Baton Rouge artist A. D. Lytle, might well have wondered whose side the* General Price *was really on. Seven weeks after this photo of the two was made . . .* (COURTESY OF ROBERT G. HARRIS)

At the site of this formidable undertaking, the river was 758 feet wide, the water four to six feet deep, and the current a full ten miles an hour. By building from both banks simultaneously and by using every conceivable material, by May 8 Bailey had succeeded in creating a significant rise in the water level. The gunboats would have been able to come down then, but for reasons still unknown Porter had issued no orders to lighten ship by removing guns, ammunition, and stores, to say nothing of the "prize" cotton with which the vessels were gorged. Finally, at the urging of the dam builders, the navy came awake. On the 9th, four gunboats shot the roaring gap in the dam. The others were lightened, and by May 13 all were safe in easy water below the falls. "I have had a hard and anxious time of it," Porter wrote his mother.

Now the army was free to leave Alexandria. Soldiers spread out through the town, smearing wooden buildings with turpentine and camphine and setting scores of fires. A. J. Smith rode amid the flaming buildings exclaiming, "Hurrah, boys, this looks like war!" Some of Banks' staff and headquarters guard tried unsuccessfully to put out the fires. By noon on the 13th the town had been leveled. The burning continued all along the army's line of retreat. On the 16th, Taylor made one last effort to block the invaders, but after holding them back for several hours near Mansura he had to give way before odds of three to one, although he still harried the column's flanks and rear. But Banks marched on, and by May 20 his men had put the Atchafalaya between themselves and the persistent Confederates. The campaign was over.

. . . with Lieutenant I. F. Richardson in command, seated at right . . . (COURTESY OF ROBERT G. HARRIS)

. . . the General Price *collided with the* Conestoga *while both were on their way to the Red River. The* Conestoga *sank, ending a distinguished river career.* (NA)

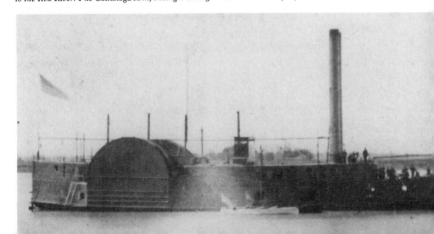

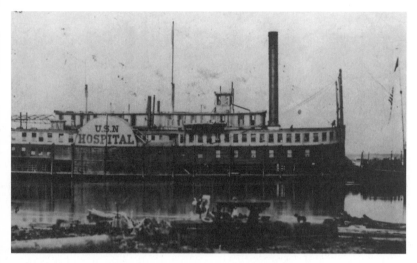

Also along for the campaign was the hospital ship Red Rover. *She, too, had been a Confederate vessel, a barracks ship until captured and converted into the Navy's first commissioned medical ship.* (NHC)

Half of Porter's fleet, it seemed, had changed sides during the war. The Eastport *began its war career as a Confederate warship, an unfinished ironclad completed and put into service by the Yankees. On April 15, 1864, she would strike an underwater mine or "torpedo," and a few days later, crippled, she was sunk to avoid capture.* (USAMHI)

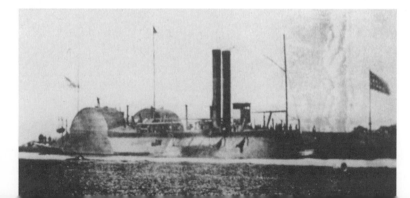

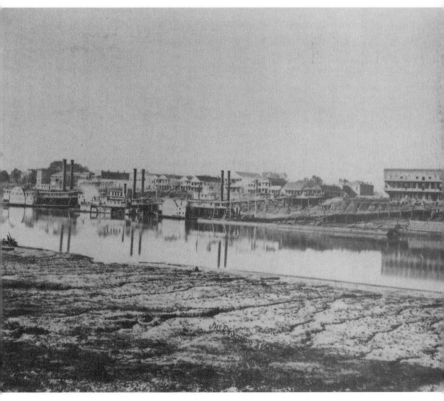

This McPherson & Oliver photograph shows Banks' goal, Alexandria, Louisiana, on the Red River. Federals took it unopposed on March 15 as Porter's fleet steamed up to the wharves. (USAMHI)

The Confederate commander of the Trans-Mississippi Department, General E. Kirby Smith, shown here in an early war photo, was ill prepared or equipped to resist a major invasion. (USAMHI)

His army commander at Alexandria, Lieutenant General Richard Taylor, was the son of President Zachary Taylor and an officer of unusual ability. He also knew he could not resist Banks at Alexandria, so he evacuated. (CHS)

Within a few days Banks had his army at Alexandria, and as ready to march on as he would ever be. With him was the 19th Kentucky, its headquarters photographed here by Lytle at Baton Rouge a few weeks before. (KA)

With him, too, were men of the 47th Illinois, led by these officers. (COURTESY OF WILLIAM ANDERSON)

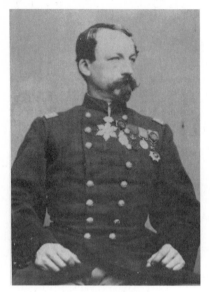

With Banks' army there were a mixed bag of officers, including even a professional adventurer, Colonel C. Carroll Tevis, commanding the 3d Maryland Cavalry. His first name was really Washington, but names never were a point of accuracy with him. In the 1850s he served in the Turkish Army under the name Nessim Bey. When made a major in 1854 he changed his appellation to Bim-bachi, and with his next promotion became Quaimaquam! (P-M)

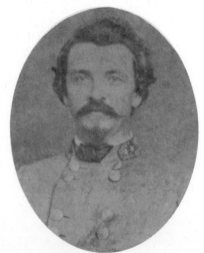

When finally the armies met for the first time, it was at Mansfield, or Sabine Cross Roads, on April 8. Brigadier General J. Patrick Major and his cavalry brigade held the left of the Confederate line. Going into battle, he shouted at his troopers to give the enemy "hell." (GOELET-BUNCOMBE COLLECTION, SHC)

Leading one of the two Southern infantry divisions was Major General John G. Walker, whose Texans outflanked the Federals and drove them back. (LSU)

The next day another battle was fought at Pleasant Hill, and this time Taylor was repulsed. Brigadier General Thomas J. Churchill of Kentucky opened Taylor's attack, but Banks stood his ground. (LC)

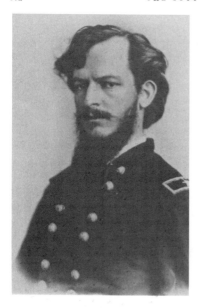

Commanding Banks' cavalry in the campaign was Brigadier General Albert L. Lee of Kansas. He had no more military experience than Banks, but better sense. Still, Banks would relieve him of command at the end of the expedition. (USAMHI)

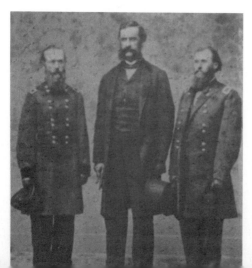

There was another aspect to the Red River Campaign that proved to be ill-fated. Major General Frederick Steele was to move from his headquarters in Little Rock, Arkansas, with a column to support Banks. Steele took his time. Brigadier General Eugene A. Carr, standing at right, commanded his cavalry. Steele stands at left, with giant James Baker of the 13th Iowa between them. (RP)

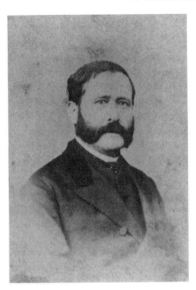

Brigadier General John M. Thayer led one of Steele's two infantry divisions, little suspecting that their expedition would never reach Banks and would almost end in disaster. (USAMHI)

At Little Rock, Arkansas, Steele marshaled his forces and supplied his army from these warehouses. The men in the ranks supplied themselves from saloons like the one at left, the Star Saloon & Coffee Stand. (NA)

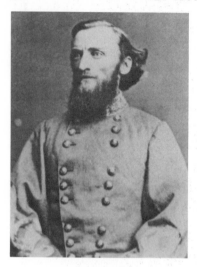

By the time Steele reached Camden, Arkansas, Banks was in retreat, and Steele was on his own. At Poison Spring, Brigadier General John S. Marmaduke of Missouri struck a supply train and captured or destroyed over 200 supply-laden wagons. (WA)

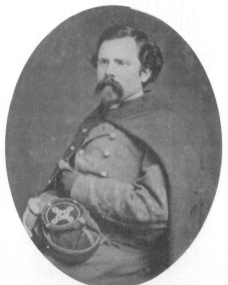

Major Thomas P. Ochiltree of Texas was one of the staff officers in the Confederate Army led personally by Kirby Smith to strike at Steele in Camden. Steele would hurry back to Little Rock instead. (NA)

Meanwhile, Taylor's depleted army kept Banks at bay at Grand Ecore. Major General John A. Wharton commanded about 2,500 cavalry, nearly half of the "army" with which he held Banks' 25,000 in check. A most able officer, Wharton would be killed only days before war's end when he quarreled with an officer, slapped his face, and was shot in return. This is an unpublished portrait. (VM)

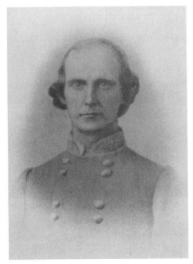

When Banks finally retreated from Grand Ecore, Wharton pursued him, and Brigadier General Hamilton P. Bee was supposed to use his cavalry to cut off the enemy retreat. At Monett's Ferry, however, Bee was driven off and Banks managed to escape back to Alexandria. (TU)

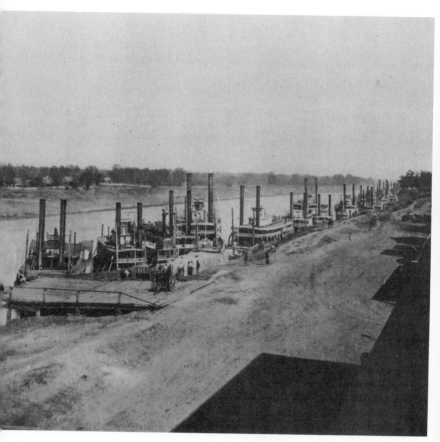

But Alexandria did not mean automatic safety. Though the wharf shown here gives no indication of it, the river's rapids near the city were so low that only four to five inches of water stood in places. The fleet was trapped. (USAMHI)

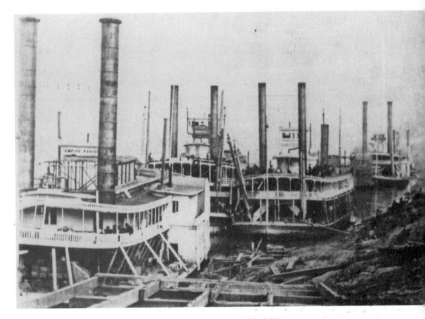

All these steamers and transports, not to mention the ironclads, might fall into enemy hands or have to be destroyed. (USAMHI)

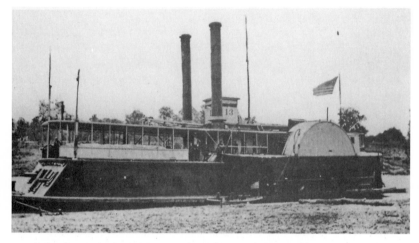

So heavy was the fire that the Fort Hindman *waited an extra day to brave the
Confederate fire. A shot struck her steering and she drifted down the river out of
control, luckily passing the enemy cannon to safety.* (USAMHI)

The unusual ironclad monitor Osage, *mounting its turret forward and its stern
wheel protected by the iron hump at the rear, appears here on the Red River.
She got back to Alexandria without difficulty under the capable leadership of
her commander . . .* (NHC)

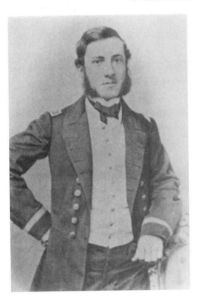

. . . Captain Thomas O. Selfridge. When firing the ship's guns, he reportedly sighted them by looking through a hand-held periscope from the turret. (USAMHI)

As the fleet reassembled at Alexandria, waiting for the water to rise or the Confederates to close in, the mammoth Mississippi River ironclads like the Mound City *took their stations in the line of warships. This image was almost certainly made on the Red River during the campaign. (NHC)*

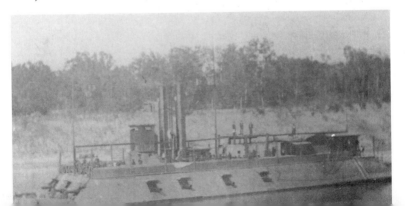

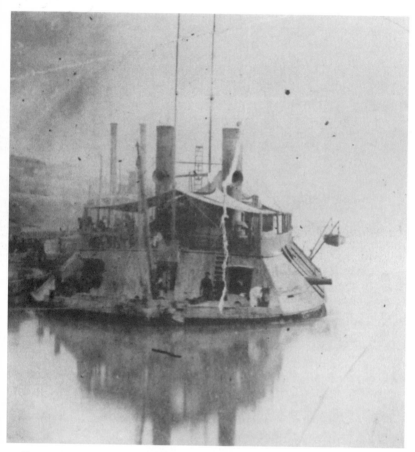

Here, too, was the USS Louisville, *shown in a photograph taken at Memphis the previous year.* (NHC)

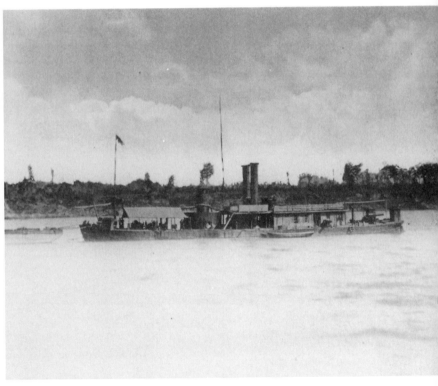

And the unusual little monitor Ozark *had been in service just two months when she joined Porter's fleet. She, too, seemed to be trapped by the low water.*
(USAMHI)

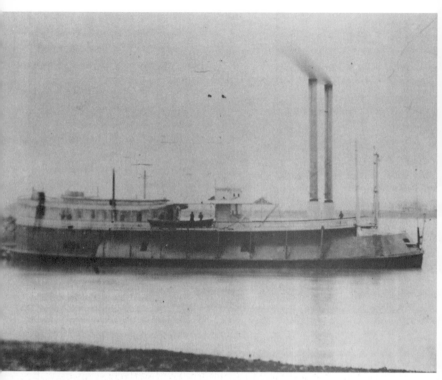

The "tinclad" No. 19, the St. Clair, *steamed up from Baton Rouge to help*
support the fleet while it lay trapped at Alexandria. (LSU)

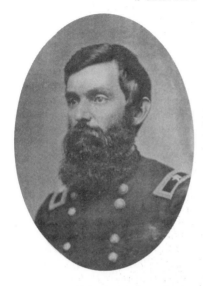

But it took the ingenuity of Colonel Joseph Bailey, an engineer, to save the fleet of 33 vessels. He proposed damming the river to raise the water level. He was made a brigadier, as he appears here, for his feat. He saved the fleet. (USAMHI)

Photographers McPherson and Oliver captured the scene as Bailey's dam approached completion. It left just room enough between its wings for the ships to pass through. (USAMHI)

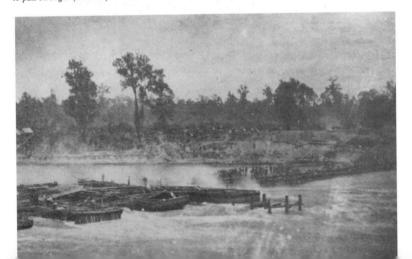

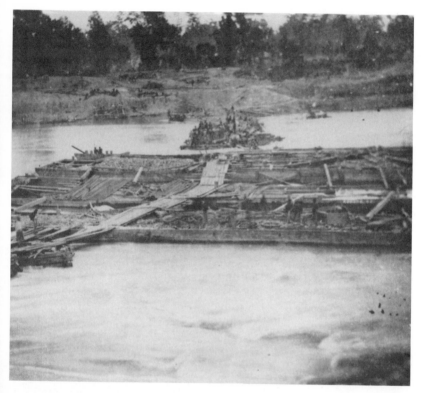

Bailey occupied 3,000 men in building the makeshift dam. Many thought it would not work. (USAMHI)

But Porter would be ever after grateful. "Words are inadequate to express the admiration I feel," said the admiral. "This is without doubt the best engineering feat ever performed." (USAMHI)

Thereafter, it was a race to escape the harassing Confederates. The Covington, shown here off Memphis in 1863, was attacked even before the fleet left Alexandria, disabled, and captured. (NHC)

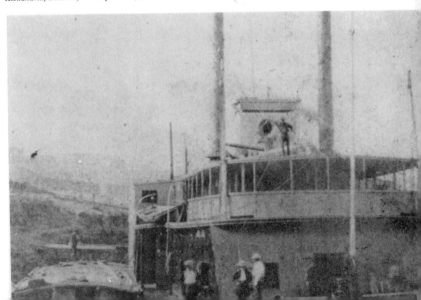

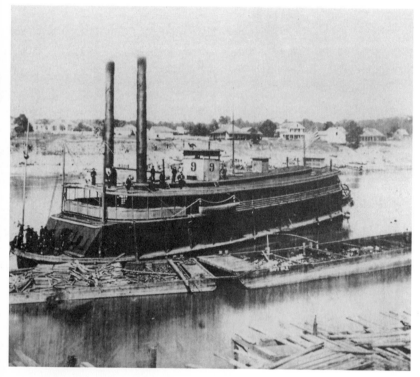

Captured with her was the Signal, *shown here just a few days before assisting with Bailey's dam. The two warships were some compensation to the Confederates for the failure to bag Banks and his army.* (USAMHI)

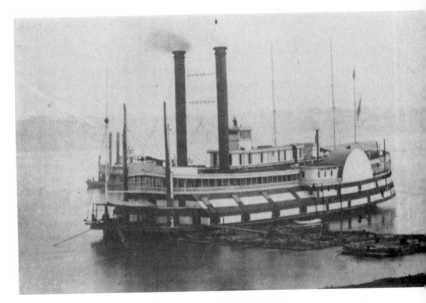

As for Admiral Porter, he could regard their loss as a small price to pay for saving his fleet, and for saving him any further adventures with Banks. The general would be relieved from field command, and Porter could return to the Black Hawk, *shown here in September 1864, to plan his next voyage.* (USAMHI)

The Forgotten War: The West

MAURICE MELTON

From the Mississippi to the Golden Gate,
the Civil War is everywhere

THE RED RIVER CAMPAIGN was only part of the war in the vast "West." When the issues of the mid-1800s boiled into war, the United States was but half settled. Beyond the Mississippi the West was a mosaic of contrasts—plains, deserts, mountains, seacoasts, bustling cities, wide open spaces, and desolate waste. There were states, territories, and open and unclassified lands. Some areas were settled and relatively civilized, enjoying the traditional social structures of the eastern states. They took the North–South schism seriously, and in some places warfare erupted in intensely personal, no-quarter contests. Other areas were basic American frontier: Indians, outlaws, widely scattered white settlements, and little or no practical government. Wild and raw, the frontier demanded so much for simple survival that the war in the East often went almost unnoticed.

Missouri had been in the thick of the growing sectional split for decades. The act that opened the way to her statehood, the Compromise of 1820, was an effort to balance the opposing forces 40 years before the war. And the partisans who made Kansas bleed in the '50s begot the bushwhackers and Jayhawkers who burned and murdered across the length and breadth of Missouri during four years of official war.

Missouri's early settlers were Southerners. But commerce linked her economy to the North. Her elected officials in 1861 were predominately secessionist, and intended ultimately to ally Missouri with the Confederacy. They nearly succeeded in 1861 when defeat at Wilson's Creek drove Federals out of much of the state.

The Federals returned under Major General Samuel Curtis, who regrouped his forces and drove the Confederates out of Springfield. He followed them into northern Arkansas, where Major General Earl Van Dorn had marshaled a large Confederate force.

Curtis defeated Van Dorn at Elk Horn Tavern. Major General Ben McCulloch was killed and Major General Sterling Price wounded, and Missouri appeared safely in the grasp of the Union. The Federals even held northern Arkansas, from which they could threaten Little Rock, and parts of Louisiana and Texas beyond.

But the border defenses were porous, and control of Missouri was tenuous at best. Price and other Missouri Rebels regularly led military expeditions into Missouri, and fighting raged all over the state from war's outbreak until war's end.

Worse than the regular army campaigns and cavalry jaunts were the bushwhacking raids of the

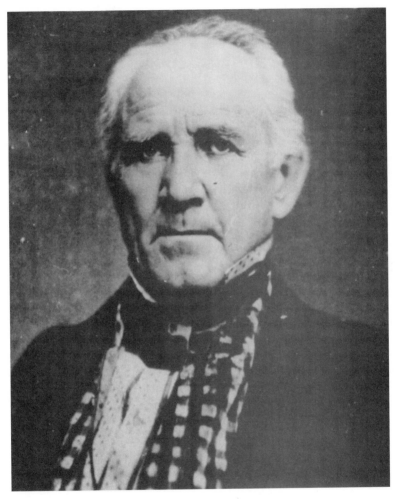

The confused and troubled nature of the war west of the Mississippi went back long before the Red River Campaign. Texas suffered as much as any state or territory. Her governor in 1861 was the old hero Sam Houston. He opposed secession and resigned when a convention voted the Lone Star State out of the Union. (NA)

Only seven brave men in that convention stood with Houston and voted against secession. Proud of their stand, they posed for the camera soon afterward, even as Texas readied to join the Confederacy. (AUSTIN-TRAVIS COUNTY COLLECTION, AUSTIN PUBLIC LIBRARY C03277)

guerrillas. For despite Missouri's 40 years of statehood, her place on the edge of the frontier lent a savage madness to her war. Four years of border warfare in Kansas had fostered hatreds that festered and lingered. By the time the East followed Kansas and Missouri into war, there was a hardened cadre of Kansas militants ready to strike back at Missouri, and Missourians in general had gained a national reputation—unwarranted—as radical slavers, secessionists, and border ruffians.

The most notorious of the Kansans was Senator James H. Lane of Lawrence. Lane demanded extreme retribution against secessionists and slaveholders, and his Jayhawkers robbed and murdered with near impunity in Missouri, turning multitudes of Unionist and neutral Missourians toward the Confederate camp. Lane's raid on Osceola, his plundering and burning of the town, and the execution of nine of Osceola's citizens was a typical example of warfare on the border.

The savagery of the civilian conflict brutalized the entire Missouri occupation. The leading guerrilla bands, under William Clarke Quantrill, "Bloody Bill" Anderson, George Todd, and William Gregg, were farm boys mostly, children of families harassed, intimidated, robbed, burned out, or murdered by Federal soldiers or Kansas volunteers. They quickly evolved into the prototype of the hard-riding outlaw bands of the postwar West. The guerrillas used the firepower of their many revolvers, their mobility, and their local support to outmatch detachments of Union troops. Often they dressed in blue uniforms and hailed Federal columns as comrades before opening fire. Theirs was a ruthless, brutal war of extermination.

Major General Henry W. Halleck swelled the ranks of the guerrilla bands with a declaration of no neutrality. Those who were not for the Union, he decreed, would be considered against it. Then, in response to the no-quarter tactics of the guer-

Texans began to flock to the secession banners, and regiments were raised to be sent to Virginia in 1861. These are men of the 1st Texas, taken at or near Camp Quantico, Virginia. (AUSTIN-TRAVIS COUNTY COLLECTION, PICA03674)

rillas, he decreed that any civilian caught in arms could be tried and executed on the spot. Executions soon were extended to regular Confederate soldiers captured in Missouri and, occasionally, to townspeople chosen at random in reply to the murder of some local Union man.

The execution of soldiers and civilians, the abridgment of basic civil rights by the military, punitive taxation of towns in areas of heavy guerrilla activity, and finally a state-wide draft of all able-bodied men to help fight the guerrillas, all broadened the bushwhackers' base of support. In 1863 the Federals began attacking this base, imprisoning or exiling the friends and families who provided the guerrillas weapons, information, shelter, and sustenance. In August a group of women—including Bill Anderson's sisters and Cole Younger's cousin—were imprisoned in a dilapidated three-story brick building in Kansas City. Within a few days the building collapsed, killing four women and injuring others. The tragedy touched off an uproar in the South and the Midwest, newspapers accusing Federal authorities of undermining the prison.

Quantrill used the bitter emotions of the moment to pull several guerrilla bands together for their greatest effort, a massed raid on Senator Lane's home, Lawrence, Kansas. Within six days of the Kansas City tragedy, Quantrill had nearly 500 raiders at the outskirts of Lawrence. They struck the unsuspecting town at dawn, rampaging

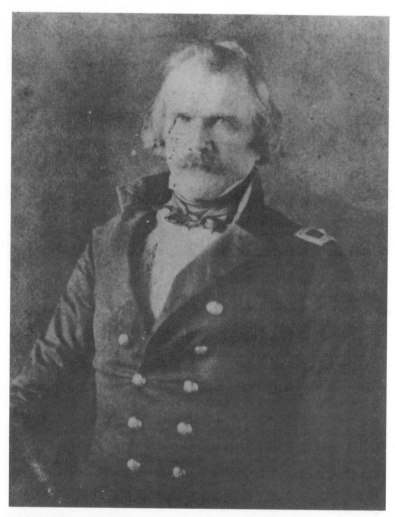

In the early days of 1861, the threat and influence of the war to come stretched even out to California. There Colonel Albert Sidney Johnston was commander of the Department of the Pacific. When Texas seceded, he resigned and came east, to die a year later at Shiloh. (NA)

through the streets, dragging men from their beds, killing them in their own hallways and yards. Stores and homes were looted and burned, and the guerrillas killed every male they could find who looked big enough to carry a gun. Senator Lane, home on vacation, hid behind a log in back of his house and escaped.

Brigadier General Thomas Ewing's response to the Lawrence raid was drastic. His Order No. 11 virtually stripped the population from a four-county area near the Kansas border, requiring everyone residing more than a mile outside a major town to move from the region. Whether Confederate, Union, or neutral in sympathies, people were forced to abandon their homes, possessions, and livelihoods. The order drew harsh criticism, the press both North and South filled with tales of families brutally uprooted and forced, helpless, into the unknown.

Order No. 11 failed to defuse the guerrilla war, however. In fact, within a few months Quantrill's group destroyed a sizable Federal garrison at Baxter Springs, Kansas, then caught and slaughtered the escort party of Major General James G. Blunt, commander of the District of the Frontier.

Campaigns, raids, and guerrilla actions ranked Missouri third (behind Virginia and Tennessee) in the number of engagements fought during the conflict. The state was the dominant area in the frontier theater of war, and training ground not only for the James and Younger gangs, but for Union scout "Wild Bill" Hickok (who occasionally rode as a spy in Sterling Price's ranks), and for a 7th Kansas recruit named William F. Cody.

UNLIKE MISSOURI, the Territory of Minnesota opened its western lands to white settlement only in the decade before the war. In two 1850s treaties the Federal government forced the Santee Sioux to relinquish nine tenths of their Minnesota lands. In return, they were left a ten-mile-wide strip of reservation, an opportunity to learn the white man's ways of farming, housing, and dress, and cash annuities for 50 years.

Chief Little Crow, courtly, gentlemanly, and a consummate politician, had signed the 1850s treaties. He led a quiet cultural revolution that saw substantial brick homes and tilled fields developed on the reservation. But 1861 brought a bad crop

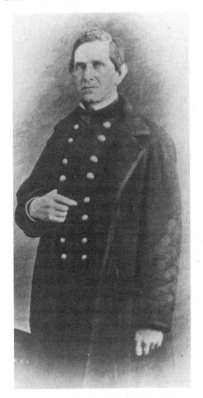

In New Mexico Territory, Colonel—later Major General—E. R. S. Canby commanded, and here blunted one of the earliest Confederate campaigns of the war when Sibley tried to invade New Mexico. Canby, after a distinguished career, would be killed by Indians in 1873. (P-M)

year; 1862 was another. The cash subsidies should have seen the Indians through in comfort, but payments were delayed. Hunger became a fact of life for the Sioux, banned now from hunting on lands that had supported them for generations. For a year and more, poverty deepened and discontent

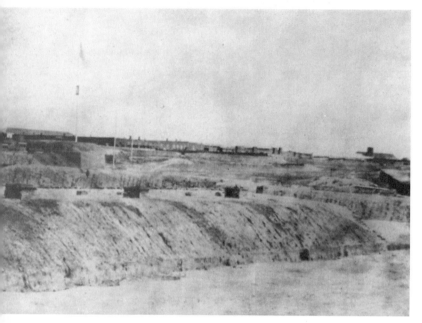

Fort Union, New Mexico Territory, was headquarters in 1862 for . . . (NA)

grew. Indian traders stocked food the Indians could subsist on, but because government subsidies were always late, the Indians could do limited business, and only on credit. Sioux who had learned to cipher kept track of their accounts, and found their figures consistently at variance with those kept by the traders. They were not surprised —just angry—when the government refused to accept their figures, paying their annuities directly to the trading posts to settle accounts on the traders' books.

In late August 1862, Little Crow met with Indian agent Thomas Galbraith to complain of the traders' embezzlement, the government's tardy payments, and his people's hunger. When Galbraith relayed these complaints to Indian trader Andrew Myrick, the storekeeper replied, "If they're hungry,

let them eat grass and their own dung." The reply spread rapidly through the Sioux reservation and, two days later, four young braves killed four white men and two women.

Little Crow, struggling to make the best for his people in a desperate situation, saw his tribe's doom in the braves' act. For retribution, he knew, would be visited on all Indians. There was no beating the whites in a war: there were far too many and they were too well armed. But there would be no escaping the white man's wrath. In a late-night council, Little Crow outlined for his chiefs the consequences. "You will die like rabbits when the hungry wolves hunt them," he said. Then he added, sadly, "But Little Crow is not a coward. He will die with you."

The next morning Little Crow's braves launched

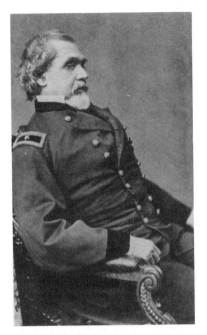

. . . *Colonel Gabriel R. Paul, who helped support the repulse of Sibley. A year later, now a general at Gettysburg, he lost his sight when a bullet struck his eyes.* (USAMHI)

the Sioux Indian War. First they struck the nearby trading post, then surrounding white settlements. Andrew Myrick, the contemptuous white trader, was left stretched dead outside his store, his mouth stuffed full of grass.

Troops at nearby Fort Ridgely heard the firing. They sent out a rescue expedition, but Little Crow was ready. He ambushed the column, killing 23 troopers, and soon attacked the fort itself. For two days the whites beat back Indian assaults. Heavy rains broke early in the battle, pouring so much water that fire arrows died in the shingles and logs of the stockade fort.

Frustrated, the Sioux withdrew and turned on the town of New Ulm, where fierce fighting raged from house to house. But again armed and aroused whites held off the Sioux.

At St. Paul, Colonel Henry Hastings Sibley gathered the 6th Minnesota Volunteers, 1,400 strong, and brought them west to fight. Sibley maneuvered through skirmishes and ambushes for a month before finally luring the Sioux into a pitched battle, breaking the back of organized Indian resistance in Minnesota. The Sioux scattered, some north to Canada, some west into Dakota. Some stayed, hoping for an arrangement that would allow them to continue existence on their own lands.

Aware from the outset that they could not win, the Sioux had taken a large number of prisoners to barter for terms. Sibley agreed to a truce to talk about prisoner exchange. Using the talks as a diversion, he surrounded the Indian camp, took back the white prisoners, and forced the Indians to capitulate. Over 300 warriors were imprisoned at Fort Snelling, where 36 were convicted and hanged for war crimes. The rest of the tribe was transported to a barren reservation in Dakota Territory, where nearly a quarter of them died the first winter.

The Sioux continued a desultory war in the Dakotas, occasionally raiding back into western Minnesota. In the summer of 1863, Major General John Pope, banished from the white man's war after Second Manassas, was sent north to resolve the Indian problem. He organized a two-pronged expedition and sent it deep into Dakota Territory, Sibley leading one column, Brigadier General Alfred Sully the other. Sibley fought three pitched battles in late July, and Sully destroyed a large Sioux village in August, driving the Indians across the Missouri River. Sporadic incidents continued, however, and another campaign was mounted in the summer of 1864, pushing the Indians into Montana Territory. This was the last major Indian campaign of the war years, but far from the last gasp of the Sioux. They would continue fighting in the northwestern territories for more than a decade.

MANY WESTERN SETTLERS were from the South, and their raucous vocal support of the Confederacy raised fears of dark conspiracies, armed Southern uprisings, and conquest by a great Rebel army from

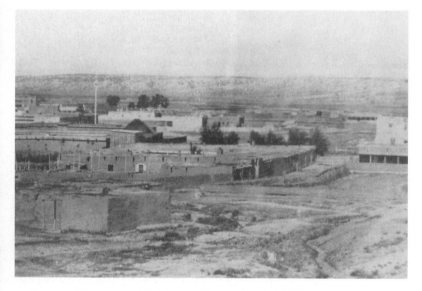

*New Mexico Territory, which included modern Arizona, was tenuously held by
a string of frontier forts, like Fort Craig shown here in 1865.* (NA)

Texas. With the Federal government's preoccupation with the crisis in the East, and a spirit of Southern nationalism apparent in Colorado, Nevada, New Mexico, and California, reasonable men thought they could see the prospect of an American West annexed to the new Confederacy.

The Lincoln administration paid considerable attention to Nevada, for her mines were turning out millions of dollars in gold and silver for the U.S. war effort. Nevada gained territorial status in 1861 and achieved statehood in 1864, just in time to cast Republican votes in the national election.

California was vital to the U.S. war effort, too. Her mining industry, with ten years maturity, was an El Dorado to the Treasury Department. Californians feared for their gold shipments, for Southerners were highly visible around the state's towns and mining camps. They were organizing companies and drilling in the spring of 1861, and some

were, as feared, interested in disrupting the state's flow of gold. A delegation approached the commander of the Department of the Pacific, Colonel Albert Sidney Johnston, to enlist his aid in an attack on the gold shipments. But Johnston, still commissioned in the U.S. Army, refused to hear them. He soon resigned, and began a trek east to join the Confederate Army.

Most California secessionists (both Southern-born and California-born) had no intention of joining California to Sidney Johnston's Southern Confederacy. They envisioned, instead, an independent Pacific Republic. California's isolation had fostered the notion of a destiny of her own, and the idea of a Pacific Republic had long been popular. The chaos in the East gave its proponents the opportunity to open a strong campaign for California's independence, and it gained quick popularity in the press. Republicans and Union

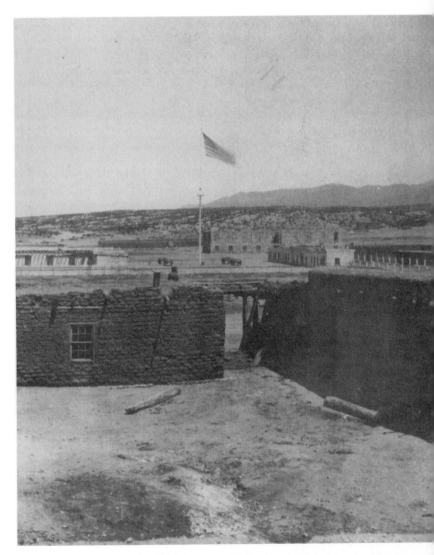

And like Fort Marcy, at Santa Fe, headquarters of the department. (LC)

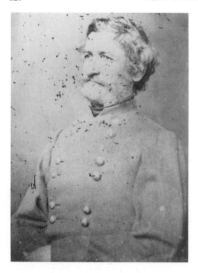

It was the goal of Confederate Brigadier General Henry H. Sibley's abortive campaign in the spring of 1862. It was rumored that Sibley was more devoted to alcohol than his duty. (VM)

Democrats combined to fight the movement in the State Assembly, and the firing on Fort Sumter swung opinion heavily in favor of the Union and California's continued place in it.

California was seriously threatened, however, by the early Confederate acquisition of the lower half of New Mexico Territory, which stretched from California to Confederate Texas. New Mexico was naturally divided, a gulf of desert splitting the region into two habitable sections, north and south. The north, with the territorial capital at Santa Fe, was tied to Missouri, where her trails ran. Supplies, news, and settlers all came through Missouri, and that state's decision would determine whether northern New Mexico Territory went Confederate or stayed Union. The southern half was linked in the same way to Texas.

An enmity between the two had already developed, the south feeling that the north dominated territorial government and ignored the south, even to the point of keeping all the troops in the north, exposing southern New Mexicans to death at the hands of the Apache or robbery and murder by marauding outlaws. So headstrong were the southerners that they had already broken with New Mexico and established their own Territory of Arizona, without a hint of official sanction, well before South Carolina seceded. Then, with new national boundaries drawn and a war having broken out, Arizona leaders met at La Mesilla, an Overland Mail stop above El Paso, and voted to ally their new Arizona Territory with the Confederacy. On the western border, near California, the 68 voting citizens of Tucson passed their own ordinance of secession and elected a delegate to the Confederate Congress.

Union influence crumbled rapidly in both territories. Most of the army officers in the West were Southern, and had resigned. The flow of resigned officers moving east from California, traveling from post to post across New Mexico, made it appear that the majority of the U.S. Army's officer corps was resigning and going south. The loss of military leadership compounded the effects of the daily difficulties under which the western soldier labored —few horses, a chronic shortage of supplies, and pay as much as half a year in arrears.

Brigadier General E. V. Sumner, Sidney Johnston's replacement, established control over California by disarming and disbanding the state's lingering secessionist groups. Then he sent an expedition to garrison Fort Yuma, on the Colorado River crossing from Tucson. In Nevada and Colorado the operating governments held firm against the early clamor of Southern secessionists. And in northern New Mexico, Colonel E. R. S. Canby, an obscure subordinate on the Indian frontier, banded together the demoralized, leaderless troopers scattered across the territory and began organizing a territorial defense.

Canby had no time to lose, for his brother-in-law and former superior, Brigadier General Henry Hopkins Sibley, had gone south and was gathering a small army in Texas to move into northern New Mexico. At the beginning of 1862, Sibley brought his troops north through the Rio Grande Valley, the only invasion route that could sustain a large body of troops. Canby and Sibley clashed at Val Verde, just outside Canby's base at Fort Craig. Unable to destroy Canby or take the fort, Sibley left

*The invasion stopped here, at Glorieta, near Santa Fe, shown here in a June
1880 image. On March 28, Sibley won a tactical victory here while, in his rear
. . .* (COURTESY OF MUSEUM OF NEW MEXICO)

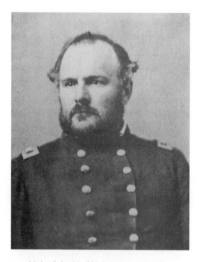

. . . *Major John M. Chivington struck and*
destroyed the Confederate supply train. That
ended Sibley's campaign and made a name for
Chivington, who later achieved notoriety of
another kind by massacring 500 Cheyennes and
Arapahoes at Sand Creek, Colorado, in 1864.
(COLORADO HISTORICAL SOCIETY)

the Federal force intact in his rear and marched on
to Albuquerque. All along the route the Texans
pillaged, alienating Southerners who might have
welcomed them as liberators and countrymen.

The plundering occurred primarily because of
the Confederates' short supplies. Sibley had gath-
ered few rations in west Texas, and his men were
hungry. Yet at Albuquerque, Sibley ordered the
burning of accumulated Federal stores and food-
stuffs, and fed his men nothing.

From Albuquerque, Sibley sent Major C. S.
Pyron with a column to occupy Santa Fe, where
officers again directed the burning of captured
stores while troops stood by suffering in hunger.

The territorial governor fled Santa Fe for Fort
Union, northeast on the Denver road. The fort was
the strongest military post in the territory. Sibley
had commanded it once and felt confident of tak-
ing it, solidifying Confederate control of New Mex-
ico and Arizona. But Fort Union had been moved
and rebuilt since Sibley's day and newly garrisoned
by the 1st Colorado Regiment, commanded by
Colonel John Slough.

Colonel Canby ordered Slough to hold Fort
Union. Instead, the Colorado regiment took the
road to Santa Fe in hopes of surprising the Rebels.
Pyron left Santa Fe with intentions of occupying
Fort Union, and the two collided in Glorieta Pass.

Slough's lead elements were commanded by the
Reverend John Chivington, who had taken a ma-
jor's commission in the 1st Colorado. Chivington
bested Pyron in the initial fighting, and both sides
fell back at nightfall and sent for reinforcements.
Slough took a day and a night to reach the bat-
tlefield with the rest of his force, and the Confed-
erates waited. Finally, after the entire Federal force
had reached the field, Pyron attacked. While
Slough and Pyron battled in the pass, Chivington
led a raiding party behind the Confederates. In a
daylong fight Pyron gained dominance on the bat-
tlefield, but Chivington's raid to the rear destroyed
the Confederates' wagon train. The Rebels thought
they had been struck by Canby's army from Fort
Craig, abandoned Glorieta, and fell back to Santa
Fe.

Canby ordered Slough to break off further ac-
tion and wait, for Canby soon had his own force in
motion and hoped to crush Sibley in a pincer.

Slough resigned in protest at Canby's orders.
Chivington assumed his command, and Sibley,
caught between the Federal soldiers to the rear and
Chivington's Colorado volunteers ahead, commit-
ted his army to a pell-mell retreat through the des-
ert. Hungry and short of ammunition, the army de-
generated into a leaderless drove struggling for
survival. Canby might have captured the lot, but
had barely enough rations for his own men and
none to feed prisoners. Some few Texans did sur-
render. Some made for California, many of these
falling victim to the Apache. Most found their way
back to Texas, happy to have survived the desert
and the Indians.

The occupation of New Mexico and Arizona
was done and Sibley's army had evaporated, leav-
ing Texas' western border open and undefended.
The loss of Missouri and northern Arkansas raised
rumors of invasion from the north, and the fall of
New Orleans nearly sealed off the state from the

Even after Sibley withdrew, New Mexico was still full of colorful characters, none more so than Major W. F. M. Arny, Indian agent for the territory. His Indian finery is in marked contrast to the typical army camp scene in the painted background. (M. J. WRIGHT COLLECTION, SHC)

east. The Mexican border was open, however, and a major trade route developed from San Antonio to Brownsville, then across the river to Matamoros. The Mexican town boomed as a free port, Texas cotton flowing out, war goods for the Confederacy coming in.

IN MARCH OF 1863, Lieutenant General Edmund Kirby Smith assumed command of the Confederacy's Trans-Mississippi, officially composed of Texas, Louisiana, Arkansas, Missouri, and the Indian Territory. The area clung to the east by a slender corridor open across the Mississippi from Vicksburg to Port Hudson. In July these two bas-

tions fell and Kirby Smith's new command was completely cut off.

The general had inherited a department disorganized, dispirited, desperately short on manpower, and virtually leaderless. In an effort to turn the area around and make it productive, self-reliant, and defensible, he called a governors' conference at Marshall, Texas. There, the chief executives of the Trans-Mississippi's states grudgingly relinquished to the military many of their rights, duties, and powers in hopes of seeing the area run with some efficiency. The general now had a domain that would come to be known as "Kirbysmithdom."

The next spring the Trans-Mississippi came under attack. Major General Nathaniel Banks invaded, with support from David Porter's fleet, while Major General Frederick Steele pushed south from Little Rock to join forces. But Banks met defeat at the hands of Richard Taylor, Steele was beaten back to Little Rock, and Porter nearly lost his fleet to low water in the Red River. The Trans-Mississippi, it seemed, had established some defense. But in November the Federals moved again and captured Brownsville, cutting the vital trade route to Matamoros.

Meanwhile, the Indians had re-established control on the western border. Texas frontier troops were absorbed into the Confederate Army and moved east, and from early on, the far West was virtually defenseless. Kiowa and Comanche rampaged in west Texas and the Apache terrorized New Mexico. By the time Brownsville fell they had pushed white settlement out of west Texas and were threatening the middle of the state.

When reaction came it was brutal, in the nature of the untamed West. Texas volunteers caught and slaughtered a tribe of peaceful Kickapoo migrating to Mexico. Ironically, the Indians were fleeing the incessant warfare of the Indian Territory, where factions fought over internal disagreements within the Creek, Cherokee, and Chickasaw tribes. At Sand Creek, Chivington's Colorado volunteers attacked and destroyed a village of Arapaho and Cheyenne, killing men, women, and children. The slaughter was so indiscriminate and savage, even by frontier standards, that it resulted in Chivington's court-martial and blackened the name of his command.

Back in east Texas, Colonel John Ford raised a small army, retook Brownsville, and reopened

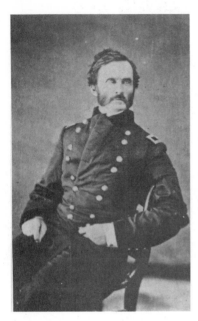

Brigadier General James H. Carleton led his colorful "California Column" east from the Golden State to relieve New Mexico during Sibley's threat. He stayed to take over command of the department and kept it until war's end.

North of New Mexico, in Nevada and Utah, Colonel Patrick E. Connor tried to control affairs in those territories, mainly keeping the mail and telegraph lines open to California and combatting occasional Indian outbreaks. It won him a major generalcy, as he appears here at the end of the war.

trade with the outside world. And as the U.S. Navy systematically sealed off the Confederacy's eastern ports in the last year of the war, the fast iron ships running the blockade found their way more and more to the Texas coast and Matamoros.

Free trade and the Trans-Mississippi's manufacturing made life in Texas more bearable than in the rest of the war-ravaged, poverty-stricken South. But farming steadily deteriorated as farmhands, draft animals, and equipment disappeared. Runaway inflation reduced the worth of government vouchers to the point that farmers and ranchers finally refused to accept them for their remaining livestock and produce. Commissary agents responded by appropriating horses, cattle, and crops without pay. The Trans-Mississippi, like the eastern Confederacy, was withering on the vine.

With Lee's surrender, strong Federal armies overwhelmed Confederate remnants in North Carolina, south Alabama, and western Louisiana. The last fight of the war flared in Texas, at Palmito Ranch outside Brownsville on May 13, 1865. Northern prisoners told the Texans they were the only ones left fighting. Two weeks later Kirby Smith surrendered the last Confederate army to the western Confederacy's old nemesis, Major General E. R. S. Canby.

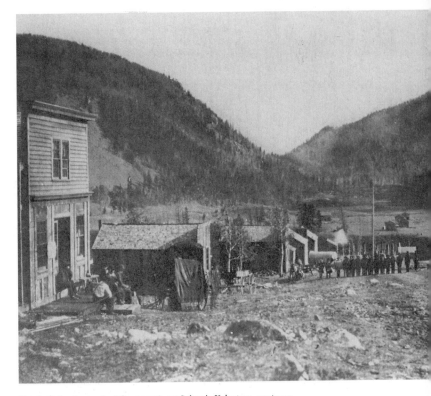

*Here in Colorado recruits of Company G, 1st Colorado Volunteers, muster on
the main street of Empire in 1862. It was a long way to the war, but they would
find it.* (COLORADO HISTORICAL SOCIETY)

So would the 6th California Infantry, commanded by Colonel Henry M. Black. Their war would be one of few and brief Indian skirmishes. Most of their time they spent garrisoning an island in San Francisco Bay, Alcatraz. (USAMHI)

Up in faraway Oregon the Union had a general, too, Brigadier General Benjamin Alvord, who had nothing to do but keep the peace between settlers and the Nez Percé Indians. Out in the West it was largely a war of boredom for commanders who perhaps dreamed of the glory to be had in Virginia. (EUGENE WOODDELL)

*Of course, there were those who had tried for glory in
Virginia and failed, and the War Department looked to the
West as a convenient place to shelve unsuccessful officers.
Thus came Major General Irvin McDowell to command
the Department of the Pacific. Defeat at Manassas in 1861
and again in 1862 had been too much for him to survive.
He sat out the rest of the conflict in San Francisco.*
(USAMHI)

*San Francisco was not such a bad place to sit. Here lay Fort Point, on the
Golden Gate, one of the few casemated seacoast fortifications built before the
war that never heard a hostile shot.* (NA)

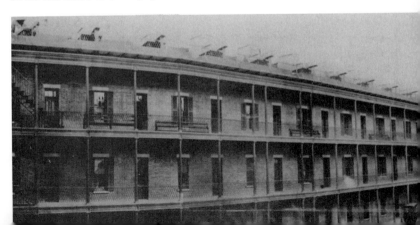

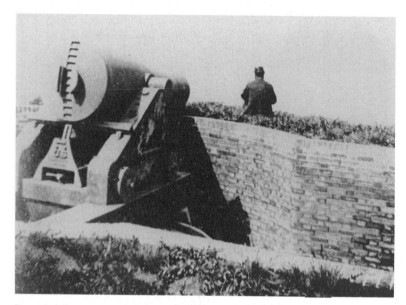

Its guns looked out upon a quiet, thriving harbor, with only a very occasional scare of Confederate sea raiders that never came. (THE BANCROFT LIBRARY)

If Confederates should come, McDowell's command would be ready for them. Artillery drill at the Presidio of San Francisco, during or just after the war. (THE BANCROFT LIBRARY)

Indeed, even the Navy would be ready for any Rebel foolhardy enough to sail into the harbor. In 1863 the Navy Department sent the Aquila *around the Horn, bearing a very heavy cargo for San Francisco—a dismantled monitor!*
(COURTESY OF CHARLES S. SCHWARTZ)

Unfortunately, shortly after arrival the vessel sank at Hathaway's Wharf, with the ironclad still aboard. With enormous effort, the Aquila *was raised from the bottom.* (css)

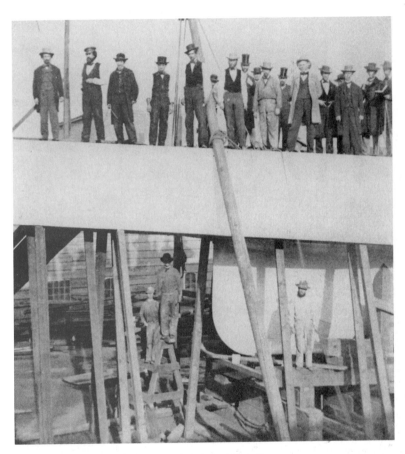

Then began the work of assembling, piece by piece, the ironclad monitor
Camanche. *Here proud workers stand on, and under, her bow as she sits in the*
ways. Local photographers Lawrence and Houseworth made these images, never
before published. (CSS)

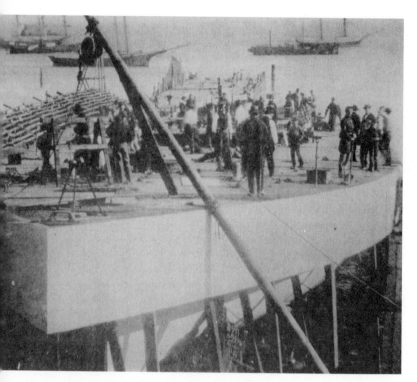

In time the ship's hull and below decks were done, with always plenty of spectators around to gawk and get in the way. (NHC)

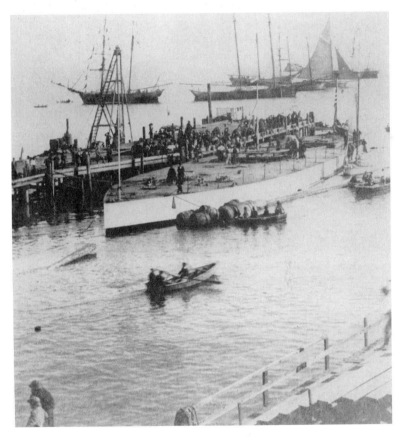

And finally she was ready to launch. On November 14, 1864, she rides the waves once more, still minus the distinctive turret of the monitor. (CSS)

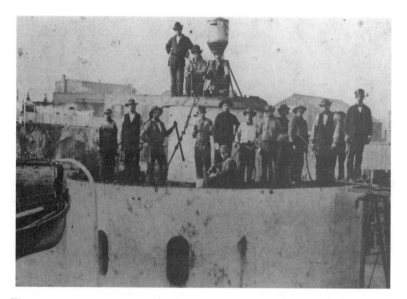

That came next, as workmen with tools in their hands stand atop the installed gun turret and the pilot house above it. The projection from the top of the turret is perhaps some form of periscope, since no eye slits are visible on the tower itself. (CSS)

Finally, in January 1865, she was completed. The only trouble was, the war was almost over. (R. L. HAGUE)

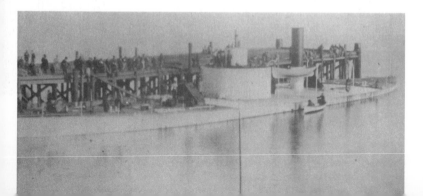

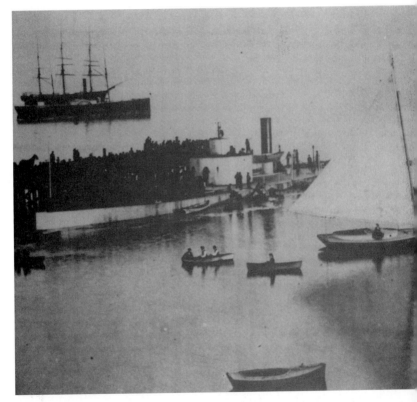

Ready for her maiden voyage, an ironclad that would never see battle or fire a hostile shot, the Camanche *is about to leave the wharf at the foot of Third Street. She will finally be commissioned in August, months after the war is done.* (CSS)

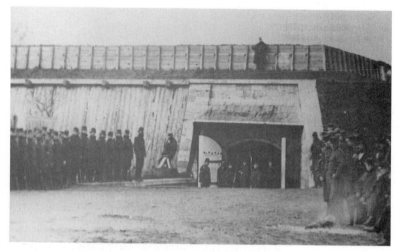

It was a long way from the far West to the old Northwest, yet here, too, it was a war of little action and long waiting. No Confederate army ever threatened Fort Wayne, near Detroit, Michigan. For these overcoated soldiers, then, there was only garrison duty and, perhaps, the hope of being ordered off to Virginia. (BURTON HISTORICAL COLLECTION, DETROIT PUBLIC LIBRARY)

Even more removed was St. Paul, Minnesota, nestled peacefully on the bank of the Mississippi. (MHS)

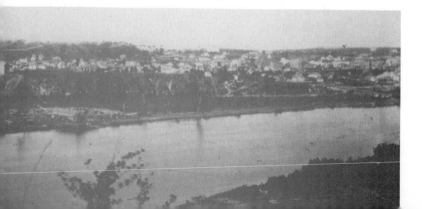

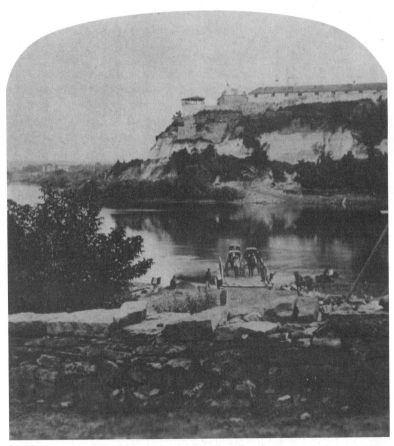

*Powerful Fort Snelling brooded over the mouth of the Minnesota River, assuring
protection to the inhabitants.* (MHS)

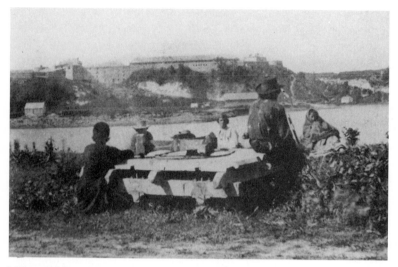

Soldiers and civilians and local Indians could pass the time together peacefully enough. (MHS)

It was even peaceful-looking enough out at Fort Ripley, near the Sioux reservations. (MHS)

In the frontier-like settlements such as Mendota, near Fort Snelling, there was no thought of threat or defense. (MHS)

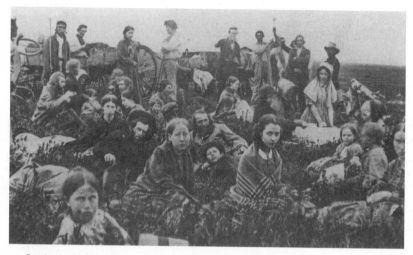

But then in 1862 the Sioux arose in a bloody campaign that in the end took perhaps 500 white lives, and saw 38 Sioux leaders executed. These settlers rushed toward the forts and larger settlements to escape the Indians, who were enraged at being allowed to starve on their reservations. (MHS)

Within days the outbreak spread to South Dakota. These two women with their children were taken captive by a band of Santees and held prisoner for three months before being rescued by friendly Sioux called "Fool Soldiers." (SOUTH DAKOTA STATE HISTORICAL SOCIETY)

Over 1,000 Sioux were eventually captured and imprisoned here in this camp at Fort Snelling. Instead of drawing attention to their legitimate plight, the Sioux uprising only made their treatment more harsh. (MHS)

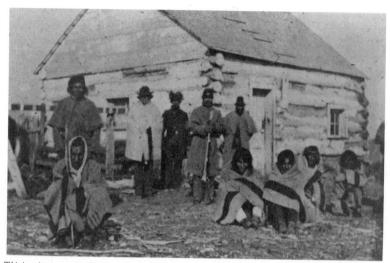

This is only one of the jails that held the captives, some of them huddling in their blankets before their guards, one of them, standing at left, an Indian himself. (MHS)

For the rest of the war, places like Fort Rice in the Dakota Territory were built to contain the Indians and prevent more outbreaks. (USAMHI)

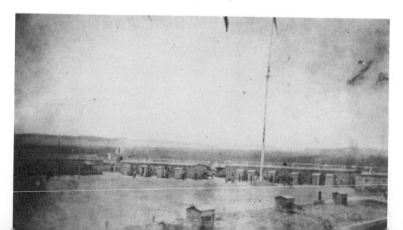

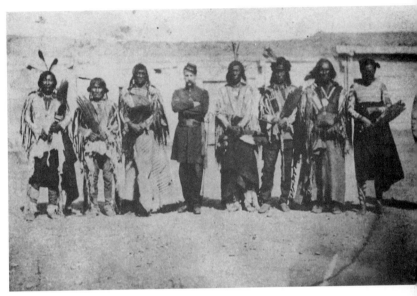

Major Charles A. R. Dimon of the 1st U.S. Volunteers commanded the new Fort Rice and poses here with some of the local chiefs during a more tranquil time. They feared him for his harsh, trigger-happy, methods. (USAMHI)

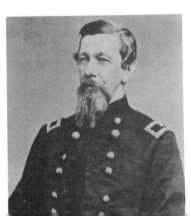

Brigadier General Alfred Sully came to command the District of Dakota in 1863, and in the spring of 1865 made an attempt to make peace with the Indians at Fort Rice. Dimon, now a colonel, ruined his chances. (USAMHI)

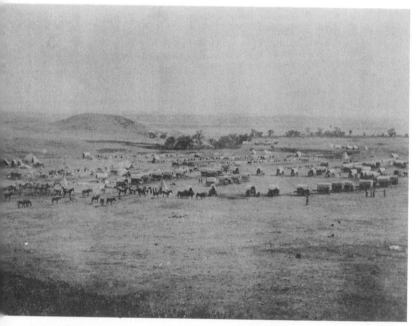

*And so Sully had to lead another campaign against them. Here the camp of the
6th Iowa Cavalry near Fort Berthold, where Sully hoped again to make terms.
He failed, and the problems with the Sioux would go on for decades after the
Civil War was done.* (MHS)

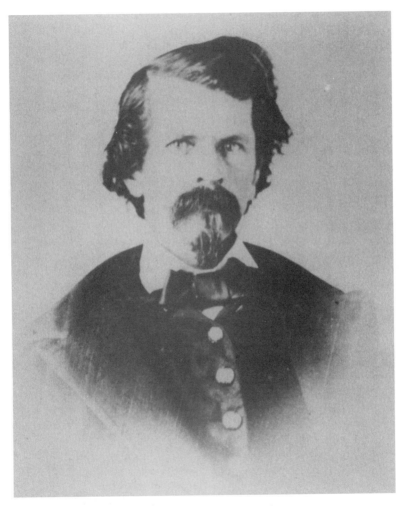

It was a more conventional war a few hundred miles south of Dakota and Minnesota. Indeed, some of the earliest meetings of Blue and Gray came in Arkansas and Missouri. The first real Confederate hero of the West was Major General Earl Van Dorn, though he lost the Battle of Pea Ridge. A year later he would be murdered by a jealous husband. (MC)

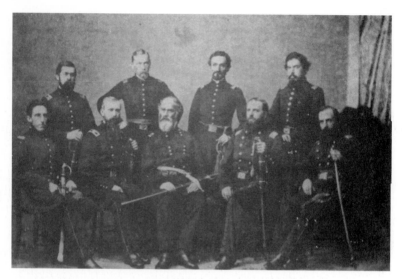

The man who beat Van Dorn at Pea Ridge was Samuel Curtis, seated here in the center of his staff, wearing the uniform of a major general. He later commanded in Missouri, but never again fought a major battle. (MICHAEL J. HAMMERSON)

After Curtis left Arkansas, Major General Frederick Steele replaced him, and in his first act led a campaign that resulted in the capture of Little Rock. (USAMHI)

Curtis had already occupied Helena, Arkansas, and started the work of erecting Fort Curtis, shown here. And before Steele came, there would be other battles in the state. (LC)

Major General Thomas C. Hindman, commanding Confederate forces in the state, led his army against a much smaller Federal command in the northwest part of Arkansas at Prairie Grove. Here Hindman sits in uniform with his children on October 22, 1865. He would be assassinated a few years later. (RJY)

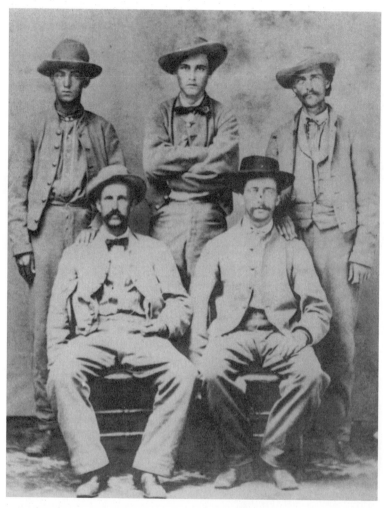

Hindman's army was made up of lean young Arkansas volunteers like these privates. (ARKANSAS HISTORY COMMISSION)

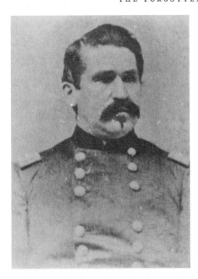

They were attacking the small command of Brigadier General James G. Blunt, a one-time Jayhawker and friend of John Brown of Kansas. (NA)

All that saved Blunt and his little army was the incredible march of Francis J. Herron and his two divisions, who covered 115 miles in three days to reach the battlefield and help defeat Hindman. He sits at center here with his staff, as a brigadier. After Prairie Grove he was promoted, becoming for a time the youngest major general in the war. Photograph by J. A. Scholten of St. Louis. (MICHAEL J. HAMMERSON)

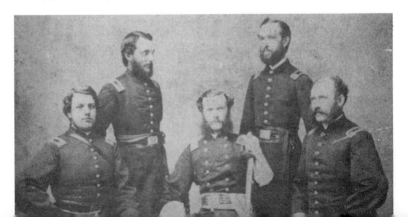

After Prairie Grove, and Steele's capture of Little Rock the following year, Arkansas was made relatively safe for the Union, and Steele could begin the buildup of Little Rock into a major base and supply center. A view across the Arkansas River of several of his supply warehouses. (NA)

Warehouses No.'s 27 and 28 sat right on the river, next to an ice house and bakery. (NA)

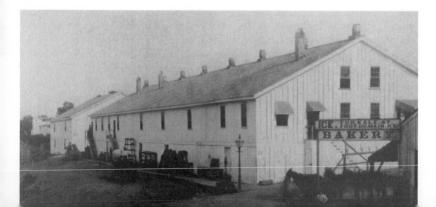

The commissary department made its headquarters among a row of dry-goods and auction houses. These images, probably made by artist White of Little Rock, are so clear that the broadsides posted on the walls are legible. They have not been previously published. (NA)

It took a lot of employees to run Steele's quartermaster operation. They lived in these quarters, very comfortable by Civil War standards. The picnic table was a real extra. (NA)

The Federals also established a large general hospital to serve the department. It was, all told, a very well-organized and -constructed post that Steele established in Little Rock, and he needed it. (NA)

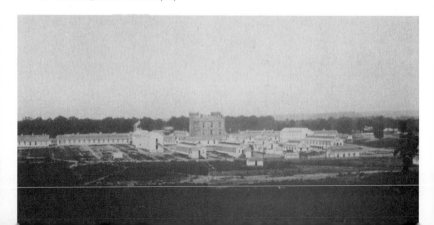

The state was never completely safe from Confederate raids. Besides the posts set up in the country, gunboats patrolled the rivers, particularly the Arkansas. The USS Fawn *appears here opposite Devall's Bluff on December 31, 1863, only weeks after a skirmish with Rebel raiders.* (NHC)

Even Porter's mighty flagship Black Hawk *sometimes ventured into Arkansas waters to protect river traffic.* (NHC)

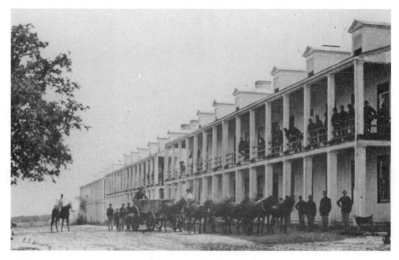

Protecting the Federals' western flank, both in Missouri and Arkansas, was Fort Leavenworth out in Kansas. E. E. Henry's image was made around the end of the war. (USAMHI)

And protecting the department from threats within were prisons like this military penitentiary at Little Rock. No region in the country was more threatened by divided loyalties and civilian "treason." (NA)

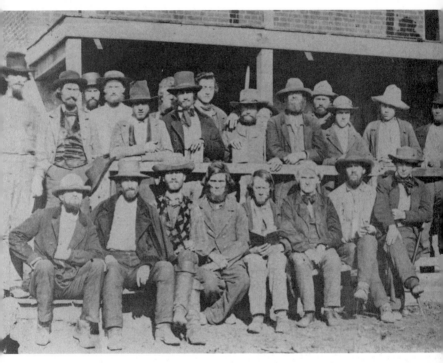

Here in St. Charles, Missouri, on November 4, 1862, a group of suspected
Confederate sympathizers pose for the camera. Missouri would cause more
problems of civilian unrest and aid to the enemy than any other border state.
(INTERNATIONAL MUSEUM OF PHOTOGRAPHY)

Among other things, the population often harbored or assisted daring and ruthless guerrillas, most notably the partisans led by William C. Quantrill. Here three of Quantrill's men sit for the camera. Fletcher Taylor stands at left. The other two are better known for their postwar deeds. Frank James sits in the center, obviously hamming for the camera with his flashy trousers and a major general's uniform blouse, though he never held any commission. And standing at right is his brother, Jesse James. Missouri was a training ground for their outlaw depredations. (STATE HISTORICAL SOCIETY OF MISSOURI)

Among those depredations was Quantrill's attack at Baxter Springs, Kansas, on October 6, 1863. He and his men brutally murdered scores of Federals in General James G. Blunt's headquarters band, which was with him. The instruments they carry in this image fell into Quantrill's hands, and every one of the bandsmen was killed. That was the warfare of the border. (KANSAS STATE HISTORICAL SOCIETY)

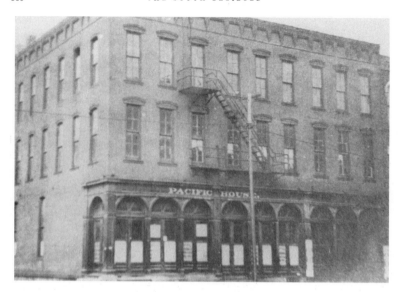

The Pacific House, on Fourth and Delaware in Kansas City, Missouri, was headquarters for Brigadier General Thomas Ewing in 1863. There, in an attempt to control the guerrillas, he issued his orders No. 10 and 11, which virtually depopulated four Missouri counties that had harbored Quantrill. A postwar image. (JACKSON COUNTY HISTORICAL SOCIETY)

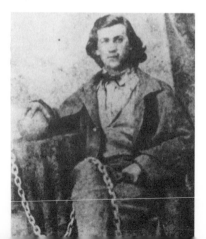

But nothing but bullets and bars could finally control the Missouri raiders, many of whom used Confederate uniforms as only an excuse for outlawry. Here Jim Anderson, brother of "Bloody Bill" Anderson, sits subdued for a time by Yankee ball and chain. (COURTESY OF CARL BRIEHAN)

A photographer was equally delighted to capture in death a last look at Bloody Bill Anderson, one of Quantrill's most feared and deadliest henchmen. (STATE HISTORICAL SOCIETY OF MISSOURI)

Those who could not be captured were often killed. Sometime in 1864 Federals caught up with Captain William H. Stuart. Photographer O. D. Edwards copyrighted and sold images of the guerrilla's bullet-riddled corpse. (COURTESY OF WILLIAM TEMPLEMAN)

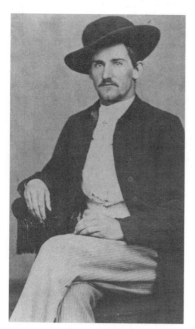

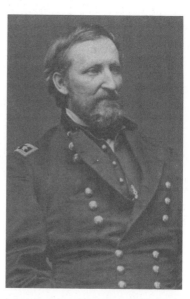

Undoubtedly part of the problem in controlling Missouri was that here, as in the far West, Washington sent officers who had failed into exile. In 1864, Major General William S. Rosecrans, disgraced after Chickamauga, took command of the Department of Missouri. (USAMHI)

Still others survived the war and their own penchant for pillage. "Little Arch" Clements even took to wearing a crucifix. (LSU)

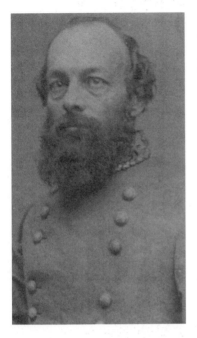

*He faced a formidable foe in command of the
Confederate Trans-Mississippi Department,
General E. Kirby Smith, veteran of First Manassas
and the Kentucky campaign of 1862. He so
organized and administered his department that it
came in time to be called "Kirbysmithdom."*
(ATLANTA HISTORICAL SOCIETY)

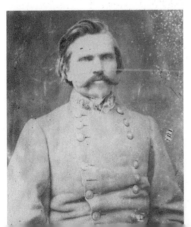

*And Smith was served by some able assistants,
most notably Lieutenant General Simon B.
Buckner, who came in 1864 to be his chief of staff.
The bold Kentuckian would live until 1914, and
would run for Vice President in 1896. His running
mate was Union Major General John M. Palmer.*
(VM)

Also serving as chief of staff at times was Brigadier General William R. Boggs of Georgia. This portrait was made in 1864 at Smith's headquarters in Shreveport, Louisiana. (TU)

For the men who commanded out in the Trans-Mississippi, it was a war of too little with too few. Brigadier General Elkanah Greer of Texas had been commander of the pro-secession Knights of the Golden Circle before the war. His war service was as chief of conscription for Smith, a thankless task that netted him few recruits and many enemies. (COURTESY OF JACK T. GREER)

Richmond, too, looked upon the West as a dumping ground for officers who were in the way in Virginia. Major General Benjamin Huger of South Carolina was banished to the Trans-Mississippi on staff duties after his lackluster battlefield performance in the Seven Days' battles. (LSU)

And Smith also got his share of political appointees, though some proved to be happy choices. Henry W. Allen began the war as a Louisiana private. He was made a brigadier general in 1863, and the year later became governor of Louisiana. He proved a strong right arm to Smith in administering Louisiana. Unwilling to live in the United States after the war, he went to Mexico with thousands of other exiles and died there in 1866. An unpublished portrait of General Allen, made probably in 1864. (LSU)

*A former governor of Louisiana was Paul O.
Hébert, shown here as colonel of the 1st Louisiana
Artillery in the summer of 1861. He became a
brigadier and was sent for a time to command one
of the most neglected places in the Confederacy,
the Department of Texas.* (VM)

*He was later succeeded by Major General John B.
Magruder, "Prince John" of Virginia, a
little-appreciated officer who brought real talent to
Texas and managed his undermanned department
skillfully.* (CWTI)

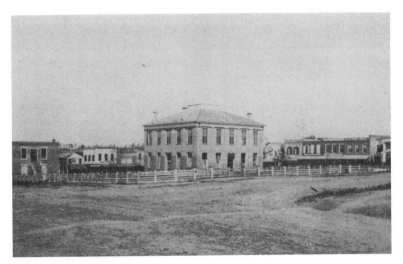

It was a state of small towns and modest cities, like Huntsville, where old Sam
Houston died in 1863. F. B. Bailey of Navasota brought his camera here to
record the court house square. Towns like this could produce only so many
soldiers and so much supply, and too much of it was drained off to Virginia.
(USAMHI)

With what was left them, however, the Texans did
very well. One of the war's great heroes was
Lieutenant Richard Dowling. Shown here as a
major, the twenty-five-year-old Irishman defended
Sabine Pass against four Yankee gunboats with
only 47 men and two boats shielded with cotton
bales. His victory was so needed and so spectacular
that he and his men were awarded the only medals
ever presented in the Confederacy. (LSU)

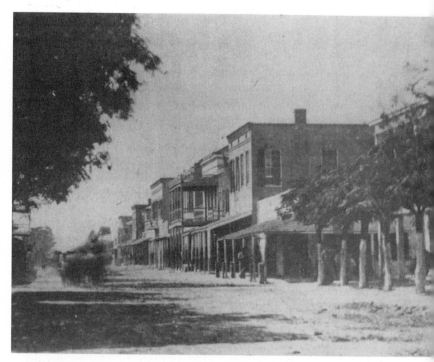

There were few photographers in Texas, and it is not surprising that little survives to show the war in the Lone Star State. Nevertheless, A. G. Wedge of Matamoros, Mexico, probably came to Brownsville on November 6, 1863, when the Confederates had to evacuate the town on the Rio Grande, and he left an important record of the event. (COURTESY OF GARY WRIGHT)

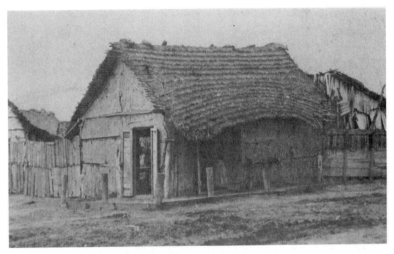

It was a border town as much Mexican as Confederate. (GW)

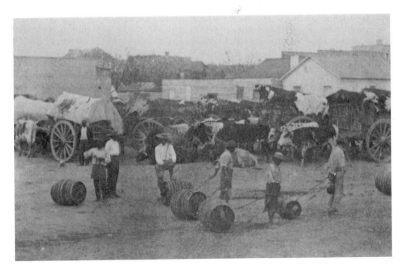

Brigadier General Hamilton Bee had a large supply of stores and cotton at Brownsville, and when superior forces of Federals approached, he packed up what he could take with him and destroyed the rest. (GW)

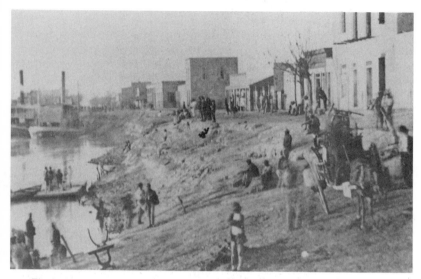

The riverfront was alive with activity, many people even loading their furniture to take it with them in the evacuation. Bee had only two steamers at his disposal, loading them with supplies to ferry over the Rio Grande to Matamoros, Mexico, for safety. (GW)

A pontoon bridge across the river helped to carry wagons across. (GW)

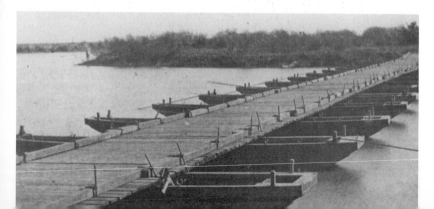

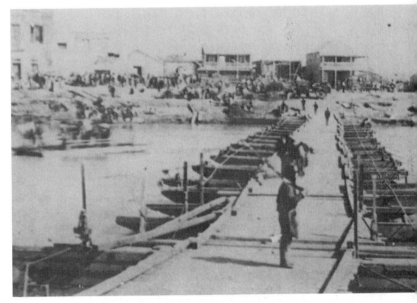

The photographer took his camera across the bridge to the Matamoros side to get this rare and somewhat blurred image of the bustle and confusion of the evacuation. Wagons and people are everywhere, and some are even trying to ferry themselves across on the skiff at left. Guards on the bridge are apparently holding it for military traffic alone. (TEXAS SOUTHWEST COLLEGE LIBRARY, BROWNSVILLE)

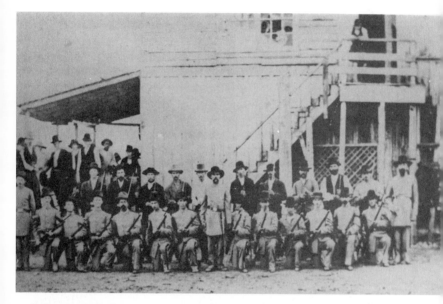

By the spring of 1864 the reserves of manpower in Texas were nearly exhausted.
Here in Ellis County in late March or early April, First Lieutenant William J.
Stokes could display for the camera just ten new recruits for his company. His
veterans kneel in uniform, the new men standing behind in their civilian attire.
Stokes himself is probably one of the three officers standing. They were all a part
of the 4th Texas Cavalry, called the Arizona Brigade, and this rare image is the
only one known to exist that shows Texans outdoors in their home state. Equally
rare by 1864 are those sparkling new uniforms his veterans wear. (ELLIS COUNTY
MUSEUM, INC.)

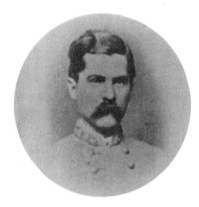

By late 1864 there were barely eleven depleted brigades in the whole department. Lower Louisiana was defended by just two brigades, one of them commanded by Brigadier General William P. Hardeman, a veteran of the Red River Campaign. (CWTI)

Many of the troops in the Confederate service claimed a Mexican or Spanish heritage, including these officers of the 3d Texas Cavalry. They are, from the left, Refugio Benavides, Atanacio Vidaurri, Cristobal Benavides, and John Z. Leyendecker. (URSALINE ACADEMY LIBRARY)

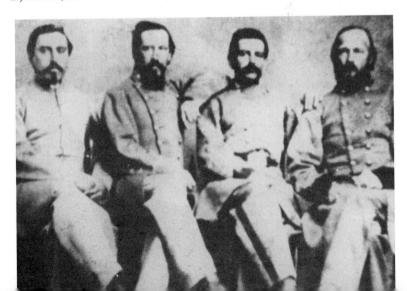

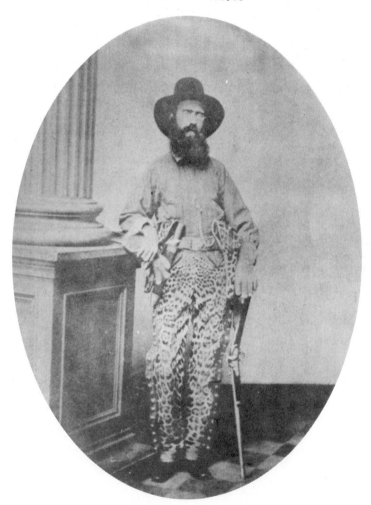

Helping them defend their homeland were colorful characters like the resplendent Captain Samuel J. Richardson, probably the only Confederate of the war outfitted in leopard skin. (MC)

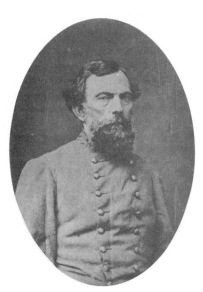

The last real Confederate offensive of the war in
the West somehow managed to come out of the
beleaguered Trans-Mississippi. Its foundations were
laid when the always incompetent Lieutenant
General Theophilus H. Holmes resigned as
commander of the District of Arkansas in the
spring of 1864. (LC)

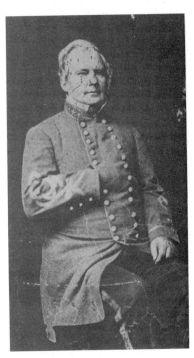

That made Major General Sterling Price of
Missouri his successor. Kirby Smith had little use
for Price, but in September he sent him with all
the cavalry he could scrape together on a raid deep
into Missouri. It would be the last Southern
attempt to retake the state. (VM)

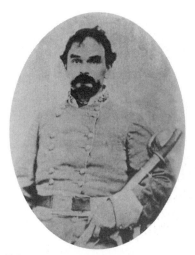

*Major General Mosby Munroe Parsons of
Missouri commanded one of Price's two infantry
divisions on the advance into Missouri. He, like
Price and many others, would go to Mexico after
the war. There, on August 15, 1865, he was killed
by guerrillas while apparently serving with
Mexican Imperial forces. An unpublished portrait.*
(RJY)

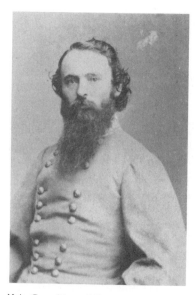

*Major General James F. Fagan of Kentucky led
the Arkansas cavalry division on the raid. A
handsome, capable officer, he commanded the
rearguard just before the climactic Battle of
Westport on October 23. In the battle itself, his
division was scattered.* (WRHS)

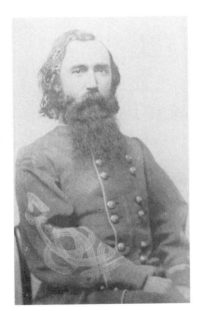

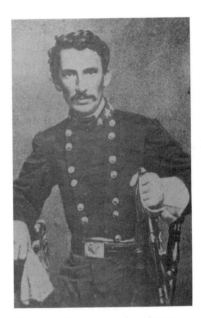

Colonel Archibald S. Dobbin led one of Fagan's brigades, and like the rest was soundly beaten in the battle. He later claimed to have been made a brigadier, and here wears the uniform of a general. (MC)

Along, too, for the campaign was another man who wore a general's blouse without ever being formally promoted, the "Swamp Fox" of Missouri, M. Jefferson Thompson. He had raised armies, commanded a gunboat fleet in battle on the Mississippi, and become one of the most engaging and ubiquitous characters of the Trans-Mississippi. (MC)

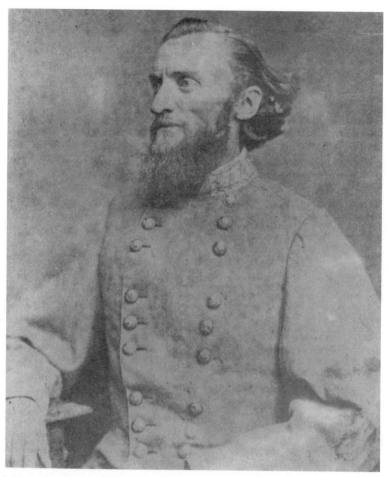

And by far the most talented and colorful of Price's generals was Brigadier General John Sappington Marmaduke, the magnificent Missourian leading the second cavalry division. Young, handsome, dashing, a daring horseman, he was also a skilled marksman. In 1863 he fought a duel with fellow General L. M. Walker and left his antagonist dying. Covering the rear of Price's retreating army after Westport, he was captured. While in prison he will be promoted to major general, the last such appointment in the Confederate Army. Twenty years later Missouri will elect him governor. (LSU)

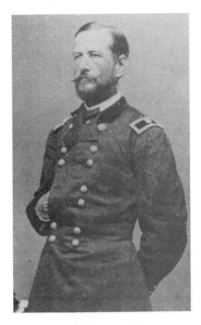

It was one of those "shelved" generals from the East who defeated Price at Westport. Commanding the Federal cavalry, Major General Alfred Pleasonton struck Marmaduke in Price's rear and set off the rout of the Confederates. (P-M)

That was the last threat to the Union in the Trans-Mississippi. By the summer of 1865 the war in the West was over, the Confederates disbanded, and Federals like the band of the 4th Michigan could pose for the camera in San Antonio, Texas, ending the era of the war and beginning the occupation of the South that became Reconstruction. (COURTESY OF PAUL DE HAAN)

Private John J. Williams of the 34th Indiana would not be there to see it, however. On May 13, 1865, in a skirmish at Palmito Ranch, Texas, he became probably the last soldier killed in the Civil War. The first to die in any war are remembered—the poor man who is last is all too soon forgotten. Like the rugged frontier war he fought in out here in the West, Private Williams was doomed to obscurity. (USAMHI)

The End of an Era

The end of the long road at last. For four years the cry in blue had been "On to Richmond!" At last, in April 1865, they were there, the Stars and Stripes flying once more over the Confederate Capitol. The Confederates themselves were gone, their cause, like much of Richmond, in ruins.

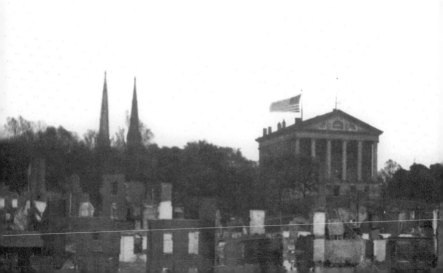

The End of an Era

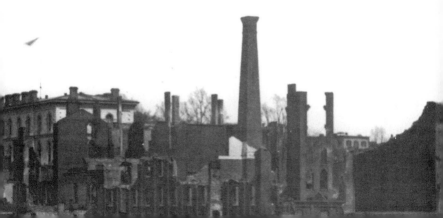

The Modern Army

RUSSELL F. WEIGLEY

Years of war, of trial and error, produce at last
a fighting machine in the shape of things to come

WHEN Major General William Tecumseh Sherman's Union armies of the West emerged at Savannah to complete their march across Georgia from Atlanta to the sea in December 1864, a full reoutfitting of quartermaster supplies awaited the force of some 60,000 men. "Clothing, shoes, shelter tents, forage, provisions, spare parts of wagons, wagons complete, harness, leather, wax, thread, needles, and tools for all the trades which were plied on the march and in the camp were collected in the harbor of Hilton Head," reported Quartermaster General Montgomery C. Meigs. As soon as naval vessels off the coast reported Sherman's storming of Fort McAllister, a great quartermaster fleet set out for the mouth of the Savannah River with these supplies.

After seeing Sherman's soldiers warmly clothed, the fleet steamed northward again, laden with captured cotton for the Union's mills and the fabrication of more cloth. "All this," the quartermaster general added, "was done in the dead of winter. Light-draft, frail river-steamers trusted themselves, under daring Yankee captains and crews, to the storms of the stormiest coast of the world, and all arrived safely at their destination."

General Meigs considered the replenishing of

Sherman's armies the climax of the Union logistical operations of the Civil War, the proof positive that the United States Army had come of age as a finely geared yet immensely powerful machine that could exert its power across almost any distance. Meigs took equal pride in the knowledge that simultaneous with the sailing of the fleet to Sherman, quartermaster vessels were also sustaining other Union detachments all along the Southern coast from Virginia to Texas. To keep in the field the armies with which Lieutenant General Ulysses S. Grant was laying siege to Petersburg and Richmond, the Quartermaster Department had transformed City Point, Virginia, into one of the largest seaports of the world. On an average day forty steamships, seventy-five sailing vessels, and a hundred barges unloaded their cargoes at wharves there running for more than a mile along the James River and extending up the Appomattox River. Behind the wharves sprawled huge warehouses and open storage areas for all kinds of quartermaster stores —the uniforms, tents, forage, and so on that Meigs had also supplied to Sherman at Savannah —as well as the commissary, medical, and ordnance stores that were procured by departments other than Meigs's but transported by the quar-

Managing the U.S. War Department was the humorless but unfailingly effective Secretary of War Edwin M. Stanton. A master of organization, he oversaw the transformation of his department into a virtual war machine.
(U.S. ARMY MILITARY HISTORY INSTITUTE)

Acting as adjutant general, one of the most important posts in the U.S. Army, responsible for communicating with and directing much of the enterprise of making war, was Brigadier General Lorenzo Thomas. Unlike Stanton, he proved sufficiently ineffective for the Secretary to order him out of Washington in 1863 and keep him on the road thereafter. (USAMHI)

termaster to the front—the army's foodstuffs, medicines, and row on row of cannon, pile on pile of rifle bullets and cannon shot and shell. From the City Point depots the United States Military Railroads, a branch of Meigs's department, operated a twenty-one-mile railroad all along the rear of Grant's lines south of the Appomattox. The trains that carried supplies to the lines returned with the wounded, who went first to a two-hundred-acre, ten-thousand-bed military hospital on a high bluff above the Appomattox.

Before the war, City Point had been the eastern terminus of Virginia's Southside Railroad, and the military railroad used seven miles of the Southside's right of way between City Point and Petersburg. But these seven miles had had to be almost completely rebuilt (and the gauge altered from five feet to the newly standard four feet, eight and a half inches), while the bulk of the military railroad was altogether new, including all the repair facilities to keep the cars rolling. By late 1864, however, railroad operation, construction, and reconstruction were routine activities for the Quartermaster Department. In the West, during Sherman's advance from Chattanooga to Atlanta, eleven bridges were reconstructed and seventy-five miles of completely new track laid, with many more miles of track re-

An adjutant was stationed with each army as well, and every general and even colonel had an adjutant to transmit his orders, manage his paperwork, and frequently act as his amanuensis. With the Army of the Potomac, it was Brigadier General Seth Williams, who was later made a major general in recognition of his able services. (WAR LIBRARY AND MUSEUM, MOLLUS-PENNSYLVANIA)

It was to be a war far different from that known by the aged Union General-in-Chief Winfield Scott, and though he left active service in 1861, many of the old ideas that he represented lingered on in what was to be a modern war. (USAMHI)

paired. The Railroad Construction Corps typically began the rebuilding of a bridge over the Oostenaula River while the old bridge was still burning, the work being slightly delayed "because the iron rods were so hot that the men could not touch them to remove the wreck." When General John Bell Hood's Confederate army subsequently tore up twenty-seven miles of track in a spectacular raid, the Construction Corps had the break repaired in seven and a half

days. To ease such rebuilding, the Quartermaster Department took over an uncompleted Confederate mill at Chattanooga for the rolling of rails.

For the accumulating and transporting of the vast quantities of military stores depicted in the photographs of Union Army depots, the mighty industrial capacity of the North obviously underlay such improvisations near the front as the reopened Chattanooga rolling mill and the transformation of City Point into a bustling seaport. Apart from the Union Army's sheer size—probably over two million men served in it dur-

Here in Washington, D.C., was the hub of the giant military wheel created by the Union to ride down the rebellion. The War Department stands at left and the Navy Department at right. Calling forth millions of men and hundreds of millions of dollars, they brought victory through organization. (USAMHI)

ing the course of the war and slightly over a million were on its muster rolls when the war ended—the most modern dimension of the army was the lavishness of its subsistence and equipment.

As early as December 1861 Brigadier General Irvin McDowell testified that "a French army of half the size of ours could be supplied with what we waste." Meigs began the war by establishing wagon transport beyond the railroads on a scale based on Napoleon's allocations of wagons to his troops. This scale proved much too limited. It demanded too much dependence on subsisting

off the country through which the Union armies campaigned to permit the swift mobility over great distances needed to conquer the Confederacy. Brigadier General Rufus Ingalls, through much of the war Chief Quartermaster of the Army of the Potomac, led the way in developing more generous allowances of transport wagons and supplies for the wagons to carry. Meigs responded by investigating more current French practice and adapting it to make further enlargements and improvements. By the time of his marches late in the war, Sherman, though he was famous for traveling light, was employing three

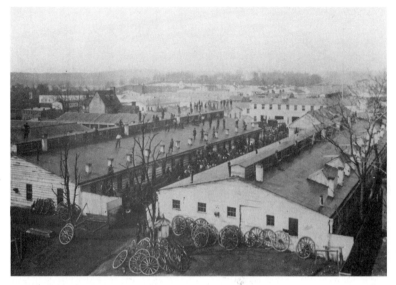

Washington itself became a major center for army services. Massive
government repair shops like these, shown in April 1865, were established to
keep the armies moving. (USAMHI)

times as many wagons as Napoleon had used for
a similar number of men.

The Union Army could be outfitted and sus-
tained on a scale unprecedented in world mili-
tary history because behind it lay an economy
well into the Industrial Revolution and rich in
agriculture as well, the whole economy bound
together by railroads. The industrial and trans-
portation capacities of the North had advanced
far enough for the Union Army to be the first
mass army to be supplied on a scale comparable
to that of the armies of the twentieth-century
world wars.

Saying that about the Union Army, however,
like examining the pictures of its supply depots,
risks suggesting the cliché that because of the
North's economic strength, the South never had
a chance of winning the war. The North's in-
dustrial and agricultural wealth, and the Union

Army's becoming through that wealth the first
modern mass army in the plenitude of its re-
sources, probably did not carry quite that much
importance for the outcome of the war. Notwith-
standing the logistical modernity of the Union
Army, the Civil War, unlike World War II, can-
not be described as a "gross-national-product
war," in which the decisive issue was which bel-
ligerent could outproduce the other. In World
War II the productive capacity of the United
States permitted the Allied coalition to bury the
Axis under a sheer weight of armaments—an
insurmountable tide of tanks, big guns, big ships,
airplanes, shells, and bombs. The Union Army
in the Civil War, for all its modernity, did not
have modern arms. The weapons of the 1860s
were still simple enough—mainly muzzle-loading
rifles and single-shot cannon—for the Confeder-
acy to produce or otherwise acquire enough of

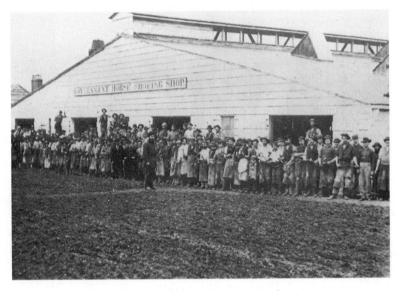

Hundreds of men were employed at keeping animals shod, not least at the government horse shoeing shop. (USAMHI)

to put up a pretty equal contest on the battle-field. The material plenty of the North and of the Union Army applied less directly to the clash of arms than to the enhancement of Union morale and the gradual erosion of Confederate morale.

Nor did the North's economic strength by itself guarantee the lavishness and modernity of the Union Army's sustenance, clothing, and equipment. The experience of Great Britain in the Crimean War less than a decade earlier showed that even the most advanced industrial nation of the nineteenth-century world, sec-onded by the world's largest merchant fleet and navy in using maritime lines of communication, could not support a modern army in the field if the army's own administration was antiquated and incompetent. British economic power not-withstanding, British army strength in the Cri-mea fell from about 42,000 to about 12,000

effectives in less than a year because British mili-tary staffs were too dull-witted and disorganized to maintain the physical health and well-being of the larger force. Thus the Union Army's ad-ministrators and logisticians merit considerable credit for translating the economic potential for ample military supplies into reality.

Quartermaster General Meigs deserves the foremost share of this credit. Not a modest man, he described his job of procuring all the Union Army's supplies except ordnance, foodstuffs, and medical items, and transporting everything, in-cluding the three latter categories, as the second most important position in the Army, next only to the post of general-in-chief. His assessment was correct. Many of Meigs's lieutenants in the field accomplished similarly impressive work within their spheres, especially Ingalls and the railroad men Colonel Daniel C. McCallum and Brigadier General Herman Haupt. McCallum

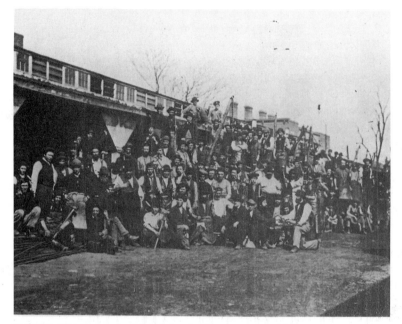

*Mechanics at the government repair shops pose for the camera, armed with
the weapons of their war—wrenches, mauls, hammers, and leather aprons.*
(USAMHI)

was director of the United States Military Rail-
roads, Haupt director of railroads in the north-
eastern theater of war through much of 1862
and 1863.

The Union Secretaries of War contributed
much also, even the frequently abused Simon
Cameron. It is true that Cameron presided over
the initial outfitting of the Union Army with ex-
cessive financial laxity and excessive regard for
rewarding political friends. As Quartermaster
General Meigs put it, however, in responding to
criticisms of the quality of the materials pur-
chased when the Army's numbers of men multi-
plied twenty-seven times during the first four
months—a growth much more rapid than that of
either world war—"the troops were clothed and

rescued from severe suffering, and those who
saw sentinels walking post in the capital of the
United States in freezing weather in their draw-
ers, without trousers or overcoats, will not blame
the department for its efforts to clothe them,
even in materials not quite so durable as army
blue kersey." Cameron accomplished more than
is sometimes acknowledged toward creating the
army of which General McDowell could testify,
while Cameron still headed the War Depart-
ment: "There never was an army in the world
that began to be supplied as well as ours is."

Cameron's more efficient successor, Secretary
of War Edwin M. Stanton, contributed much to
the continuing workability of the whole admin-
istrative and logistical system. The contributions

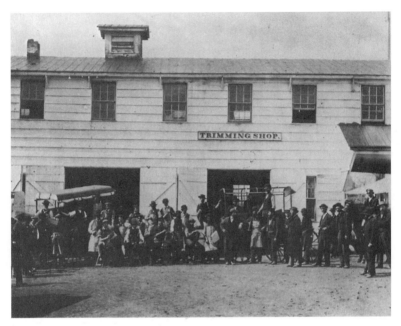

It was the same at the government trimming shop, where leather and canvas were fitted to make awnings and harnesses and whatever else needed to be "trimmed." (USAMHI)

of such individuals to Union military supply have to be stressed because success was achieved largely through a triumph of human talents over organizational arrangements that were not much better than those that wrecked the British Army in the Crimea. The various supply bureaus of the United States Army and the related administrative bureaus—the Adjutant General's Department, the Inspector General's Department, the Judge Advocate General's Department, and the Pay Department—along with the Corps of Engineers and the newly created Signal Corps, each habitually had gone its own way with little overall coordination, let alone any combined planning for the development of a coherent supply system for the entire army. Called the General Staff, the heads of these departments in no way constituted the slightest approximation of a modern general staff in the sense of a planning body. It was Stanton's contribution to the making of a modern army that by dominating the War Department, not through the medium of organization charts, but by force of an overpowering, even sometimes ruthless personality, he imposed a functional coordination upon the administrative and supply bureaus. Without him, Civil War logistics in the Union Army might well have been as chaotic as those of the later Spanish-American War, for the relationships among the bureaus were otherwise the same as in 1898.

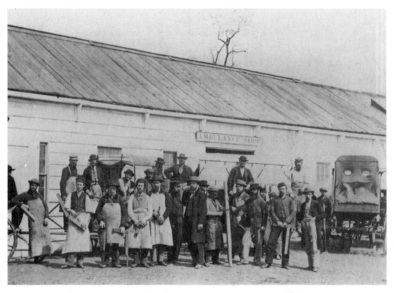

There were special government shops for repairing and fitting out ambulances, its glum-looking crew wielding their squares and saws, augurs and broadaxes. (USAMHI)

Stanton had to deal also with the problem of establishing a modern command system for the combat operations of an army modern in scale. A lawyer by profession, he could intervene to less direct effect in the technical military issues of combat than in administration because combat was too far removed from his own expertise. The regulations of the Army, furthermore, seemed to confine the jurisdiction of the Secretary of War to administration and finance, leaving combat command to the ranking military professional, the general-in-chief—though thus excluding the President's civilian deputy raised questions involving the constitutional principle of civilian control of the military. When to these various difficulties was added the fact that a capable combat commander for an army of from half a million to a million men is never easy to

find, most of the war had been fought before the command system of the Union Army matched the effectiveness of the Army's administration and logistics.

In the beginning, the general-in-chief was Brevet Lieutenant General Winfield Scott, who had occupied this lofty post for twenty years and had been a general officer since the War of 1812. A hero of the latter war and of his great campaign from Vera Cruz to the City of Mexico in the Mexican War, Scott had grown fat, dropsical, and tired by 1861. His military brain was still good, and he was the principal designer of the "Anaconda Plan" for strangling the Confederacy by naval blockade as well as pressure by land. But as a strategist Scott had always favored the pre-Napoleonic, eighteenth-century mode of limited war, and even if he had been younger

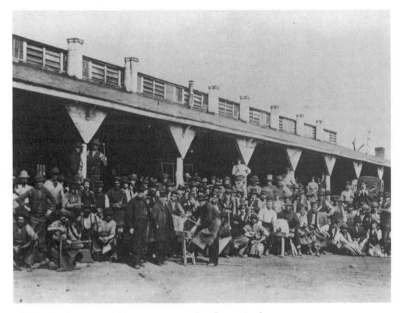

The blacksmiths were probably more numerous than the rest, for they worked in iron, and it was a war fought on iron—iron rails, iron rims, iron horseshoes. (USAMHI)

and more vigorous, he might never have developed enough ruthlessness to seek that utter destruction of Confederate armies and resources which was probably necessary to achieve so sweeping a war aim as the complete extinction of Confederate claims to independence.

President Abraham Lincoln therefore acquiesced when a much younger and seemingly much more vigorous soldier, Major General George B. McClellan, maneuvered Scott aside in November 1861. Already commanding the Army of the Potomac, McClellan moved up to be general-in-chief as well. Unfortunately for the Union, McClellan's youth—he was only thirty-five—proved to assure no more resolution than Scott had shown when it came to risking bold in-

vasions of the South; and if ruthlessness was needed, McClellan possessed less of that commodity than the old man. McClellan at least recognized, however, that an overall strategy would be necessary for the winning of the war, that it was not enough simply to have tactical ideas for the winning of particular battles; and for this reason, "Little Mac" despite his faults was a better choice for the top Union command than most of the available generals would have been.

Yet McClellan proved to lack a narrower but essential ingredient of generalship—the tactical skills to win the particular battles. Consequently he could not give his strategic design—to push the Confederacy militarily just hard enough to

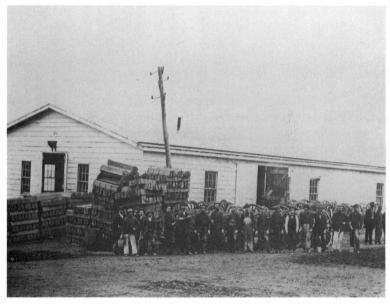

Another small legion of workers fought with brushes, their battlefield the government paint shop. They stand, buckets and brushes in hand, posing with a pile of wheels and boxes awaiting their attention. (USAMHI)

convince the South it could not win, while otherwise conciliating the Southerners with promises of the safety of their property, especially slavery —a real test to demonstrate whether it could work. Lincoln became dissatisfied with McClellan and removed him from the office of general-in-chief as early as March 11, 1862, though for the time being he permitted the general to keep command of the Army of the Potomac. Finding, however, no one else with a strategic grasp comparable to McClellan's, Lincoln now undertook the direct, personal exercise of the role of Commander in Chief, giving orders to the armies himself, with Stanton's help.

In the process, Lincoln oversaw the riposte to Major General Thomas J. "Stonewall" Jackson's Valley Campaign, and the maneuvers he designed might have trapped Jackson had the President enjoyed better cooperation from the Union generals on the scene. Jackson's escape, however, helped prove that Lincoln had too many other duties to be able to exercise sufficiently precise direct command over field forces, so the President decided he had to find a new professional general-in-chief, notwithstanding the dearth of strategists. He turned to an officer who had at least written and translated books about strategy, Major General Henry Wager Halleck. As commander of much of the Western theater of war from November 1861 to Lincoln's choosing him as general-in-chief in July 1862, Halleck had shown only the most limited promise of trans-

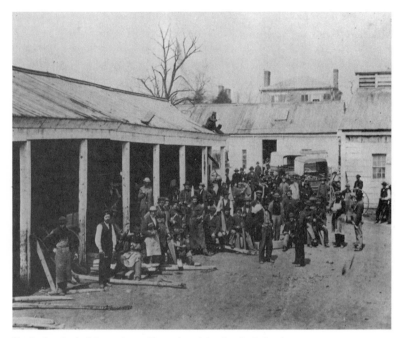

Nearby the wheelwrights work at making and repairing the wheels that the painters paint. Downtown Washington was a sea of enterprise as the government repair shops proliferated. (USAMHI)

forming book learning into strategic accomplishment. Still, he merited some of the credit for his subordinate Grant's Fort Henry, Fort Donelson, and Shiloh campaigns, and all in all he was the most suitable choice on the horizon.

Halleck reinforced the War Department's administrative skills, and his presence assured yet further that the Union Army would be managed and supplied as befitted a modern mass army. But far from exerting a strong strategic grasp, Halleck refused to risk taking responsibility for most of the command decisions on which might turn the outcome of battles or the war. He would give Lincoln and Stanton strategic advice;

he would not take strategic command. After July 1862 Lincoln found himself by default still the architect of Union strategy.

Fortunately for the Union, the President had grown to be a strategist of considerable accomplishment—so much, indeed, that in 1926 a British soldier, Colin Ballard, was to write a book called *The Military Genius of Abraham Lincoln*, and some other historians were to bestow accolades almost as enthusiastic as Ballard's. Strategy, the conduct of campaigns and the fitting of them together in a pattern designed to win a war, does not demand nearly so much technical, specialized knowledge of war as does tactics, the manipula-

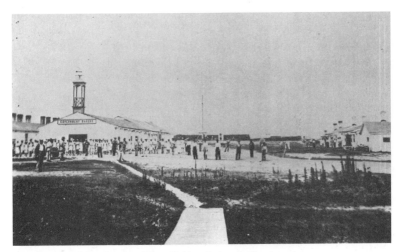

Of course, armies had to be fed, and that called for a legion of white-aproned cooks at the government bakery. The armies in the field usually baked their own bread, so this bakery serviced just the troops around the capital.
(USAMHI)

tion of troops in battle. His strategic vision unclouded by tactical detail, furthermore, Lincoln perceived certain essential principles of the Union war effort more clearly than did almost any professional military man. The professional soldiers had been taught at West Point and from the study of Napoleon's campaigns, for example, that a military force should be concentrated, gathered up to strike a few strong blows or even a single blow against a key objective such as the enemy's political capital or an important road junction. Lincoln recognized, however, that to concentrate Union power against so obvious an objective as Richmond permitted the enemy to concentrate there also in defense, and the effect was to allow the Confederates to make the most of their limited resources. If, on the contrary, the Union used its superior resources not to concentrate but to attack all around the borders of the Confederacy, the enemy did not have the ability to match Union strength everywhere and

somewhere around the Confederacy's periphery the defenses were sure to cave in. Similarly, Lincoln recognized clearly that the principal strength of the Confederacy resided in its armed forces and that the main objectives of the Union should not be geographical points even as prominent as Richmond but rather the destruction of the enemy armies.

For all that, Lincoln's lack of professional military credentials, as well as the need for him to attend to a multitude of tasks besides military strategy, undercut his efforts to lead his generals to apply his strategic perceptions. He continued to seek a professional soldier who would share those perceptions and assume strategic and operational command of the Union armies in the manner that only a professional soldier could. When the triumphs of Vicksburg and Chattanooga in 1863 brought Grant to the forefront among Union commanders, Lincoln shared the wide conviction in Congress and among the

And to keep the men garbed, the office of the U.S. Depot of Army Clothing and Equipage occupied the better part of a city block. A more genteel service bureau, this office could afford a few frills—an ornate eagle painted above its door and a lamp post with stars and CLOTHING DEPOT *illuminated in the glass.* (USAMHI)

public that Grant should receive the full rank of lieutenant general, vacant since George Washington, and should displace Halleck as general-in-chief, which he did in March 1864. When Lincoln came to know Grant, the conviction deepened. Grant agreed firmly that the destruction of the Confederate armies should be the main objective of Union strategy and that applying pressure against all the enemy armies simultaneously should be a principal means of achieving their destruction.

To what extent the rise of Grant can be said to have given the Union's modern mass armies a modern command system remains nevertheless debatable. Grant decided that as commanding general he would take the field with the Army of the Potomac, directly supervising that army and its commander, Major General George G. Meade, while overseeing other armies less directly via the telegraph and General Halleck. For that purpose, Halleck remained in Washington with the new title of Chief of Staff, but he was not Chief of Staff of the Army in the twentieth-century sense, since he was subordinate to Grant. Halleck's administrative skills and military knowledge made him on the whole an

admirable conduit between Grant and the other Union generals. But there were awkwardnesses in these arrangements: in the distance of the chief professional soldier from Washington and in his focusing on one of several armies; in his dependence on a Chief of Staff who remained reluctant to take on responsibilities and who in a legal sense was not ultimately responsible; in Grant's continuing dependence on Secretary Stanton and the chiefs of the supply bureaus to sustain the armies, while the bureau chiefs were under Stanton's, not Grant's, command so that the relationship between the powers of the general-in-chief and the Secretary of War remained unclear.

The command system of the Union Army functioned well in the final year of the war because the personalities involved worked well together. Lincoln, Stanton, Grant, Halleck, and Meigs all earned high marks for cooperation with each other. On any organization chart, however, the ultimate Union Army command structure would look like a nightmare. Not least of the problems, there was still the fundamental question as to how Grant's authority as general-in-chief was to be reconciled with the constitu-

To erect all these buildings, as well as to supply the Union armies with the raw materials of forts and bridges and stockades and more, the government used veritable forests of timber. This government lumber yard was in Alexandria, Virginia, probably photographed by Captain A. J. Russell. (USAMHI)

tional power of the President as Commander in Chief. This problem was not to be resolved until long after the Civil War, with the creation in 1903 of the twentieth-century version of the Army Chief of Staff as the ranking professional soldier but, unlike a Civil War general-in-chief, claiming no authority to command independent of the President and the Secretary of War.

Whatever the problems of Grant's status, his method of achieving his and Lincoln's objective of the destruction of the Confederate armies added another modern dimension to the Union

Army's waging of war. In the campaign of 1864–65, Grant eventually destroyed the principal enemy field force, General Robert E. Lee's Army of Northern Virginia, by the grim expedient of locking it in battle almost every day and inflicting casualties until Lee's army was no more. The campaign became one of deadly attrition, foreshadowing the long-stalemated bloodbath on the Western Front of the First World War, of the Eastern Front of the Second World War, and of the Korean War. At Appomattox, Lee surrendered only some 26,765 men; his army had num-

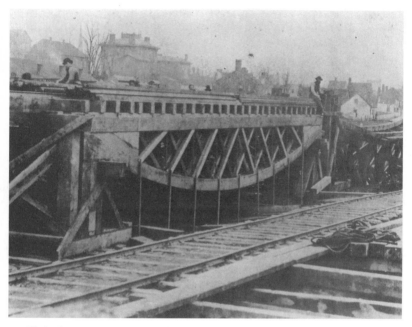

The lumber went to build experimental "shad-belly" bridges like this one, photographed by Russell. It had just been subjected to 168,000 pounds of weight for nine hours and stood the test. (NATIONAL ARCHIVES)

bered 66,000 just one year before. To be sure, Grant's strategy of nearly continuous battle imposed tremendous casualties on his own army as well, but the general-in-chief knew that the Union could replenish his ranks while the Confederacy could not replenish Lee's.

Nor was Grant merely the strategic butcher that hostile portrayals have sometimes made him seem. He had demonstrated a superb capacity for agile maneuver in his Vicksburg Campaign before becoming general-in-chief, and he would have preferred to trap and capture Lee's army by maneuver in 1864–65 rather than trade casualties with it. But the combination of Lee's tactical skills and the improved nature of weapons by the

1860s left Grant with no alternative method of destroying the enemy army than its slow attrition in protracted combat.

The final modern dimension of the Civil War, one assuring the resemblance of the Petersburg trench systems to the elaborate field fortifications of later wars, lay in the firepower of the rival armies. Fifteen years earlier, the men who were to be the generals of the Civil War had fought against Mexico a war whose weapons remained much like those of the American Revolution: smoothbore muskets and cannons. The Civil War, in contrast, was a war of rifled muskets and to a large extent of rifled artillery. In the short time between the Mexican and Civil

The wood built platforms like this on which bridge arches were constructed.
Built on the upper flat surface, the arches were then . . . (NA)

wars, the American adoption of mass-production methods of permitting muzzle-loading weapons to fire rifled projectiles despite the difficulties of loading—particularly the American adoption of the French Captain Claude Étienne Minié's "minie ball"—wrought a revolution in warfare out of all proportion to the seeming smallness of the source.

With smoothbore muskets, effective range had been limited to 200 yards or less. As Grant remarked in his memoirs, "At the distance of a few hundred yards a man might fire at you all day without your finding out." With the Model 1855 or 1861 Springfield rifle and other rifled shoulder arms, effective range leaped to 400 or up to 600 yards. Rifled field artillery attained a maximum effective range of some 2,500 yards. Now a defending force could fire so many accurate shots at an attacker during the time he was within range that any frontal assault against reasonably well trained and resolute troops was almost sure to fail. Even attacks against flanks

and rear—in devising which the Union Army's great adversary General Lee was the most skillful tactician since Napoleon—no longer produced quite the devastating effect that they had in Napoleon's day; the firepower of rifled weapons much enhanced the possibility that the victim of such maneuvers might be able to form a new front. Even the best generalship failed to preserve attacking forces from devastating casualties under the defenders' rifles. At Second Bull Run, in August 1862, and Chancellorsville, in May 1863, Lee achieved masterpieces of Napoleonic maneuver against his enemy's flanks, but the Union Army's rifled firepower nevertheless extracted from Lee's forces in those battles casualties of some 19 and 22 percent, respectively. The victor's losses were too high for the victory to yield decisive advantage.

The appalling casualty rates of Civil War battles—at Gettysburg, in July 1863, 23,000 out of some 85,000 for the Union Army, 28,000 out of 75,000 for the Confederate Army—were achieved

. . . tipped over on the hinged platform, to be joined into finished sections of bridge. (NA)

mainly with single-shot, muzzle-loading shoulder arms and artillery. A relatively small number of breech-loading cannon were used, but problems in satisfactorily locking the breech to permit the firing of adequate powder charges were not yet fully solved. Controversy has always swirled around the question whether the Union Army should have made itself still more modern through a speedier adoption of breech-loading and even repeating muskets and carbines. Both Union and Confederate armies used some such weapons, more often cavalry carbines than infantry rifles because cavalry did not have so much need of long range and sustained firing capacity; breechloaders tended to suffer from gas leakage and fouling of the breech mechanism to the detriment of these qualities.

About 100,000 Sharps carbines and rifles are estimated to have been used by both sides, employing a single-shot breech-loading mechanism patented by Christian Sharps in 1848. By the time of Gettysburg in July 1863, some Spencer breech-loading repeating rifles were in Union service; on July 13, 1863, just after Gettysburg, the Federal Ordnance Department placed its first order for Spencer repeating carbines. Eventually the department ordered 64,685 Spencer carbines and 11,471 Spencer rifles. The seven-shot Spencer repeating carbine, using copper rim-fire cartridges, became the standard arm of the Union cavalry by 1864. But like all breechloaders of the era, it still had problems. The cartridge contained only forty-five grains of black powder, so the weapon lacked range and power.

Bridge sections such as this were used to build a new span over the Potomac for the Washington, Alexandria & Georgetown Railroad. They would make a bridge 5,104 feet in length. (KEAN ARCHIVES)

When the carbine grew hot, the cartridges tended to stick in the chamber.

In its rejection of breechloaders as the standard infantry weapon, the Ordnance Department was not obtusely conservative. The famous Prussian needle gun, adopted as early as 1843, had less range than standard Union Army muzzle-loaders. Brigadier General John Buford reported that at Gettysburg some of his Union cavalry troopers armed themselves with muzzle-loading infantry muskets in place of their breech-loading carbines; the soldiers knew which was the better weapon in a hard fight.

The rifled muzzle-loading musket and rifled muzzle-loading artillery could do damage enough. They pushed the Civil War armies finally into entrenchments that foreshadowed the Western Front in World War I. They deprived individual battles of decisiveness and transformed the war into a prolonged tactical deadlock resolved only when harsh attrition had brought one of the contestants to exhaustion. They gave the modernity of the Union Army its fullest but most disturbing dimension. Like other modern armies in subsequent modern wars, the Union Army, despite all its resources, could gain the political objectives for which it fought only through the grim strategies of Grant and Sherman. It had to annihilate the enemy armed forces through day-by-day attrition, or it had to carry destruction beyond the enemy armies to the enemy's economy and civilian population.

It was a model of wartime engineering. Off in the extreme right distance, the Capitol dome looks across to the wonders being done by Lincoln's modern army. (KA)

Furthermore, the builders of the U.S. Military Railroad could erect major depots anywhere they could lay a rail. Here on the James River, at City Point, Virginia, they made the terminus of the road that kept Grant supplied at Petersburg for nearly a year. A Russell image. (USAMHI)

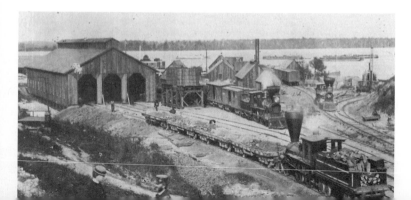

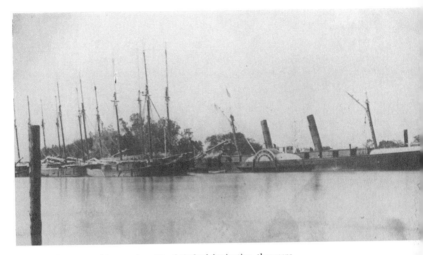

And when boxcars could not go by rail to their final destination, they were put aboard the first "container ships"—steamers and schooners that could hold the cars on their decks. (NA)

Besides rail communications, the Union Army expanded the use of the telegraph to previously undreamed limits for the military. Here in Georgetown, photographer William Morris Smith captures a view of the Signal Corps "camp of instruction," where hundreds of men were trained in Morse code and communication by "wigwag" flags. (LIBRARY OF CONGRESS)

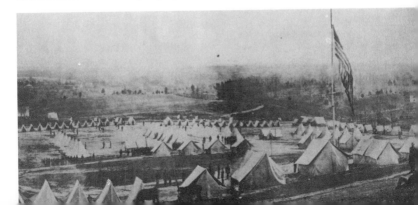

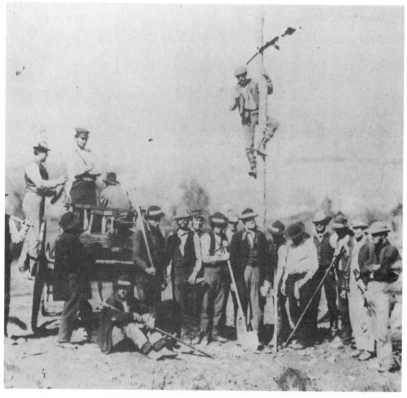

Signal corpsmen erecting telegraph poles and preparing to string wire.
Lincoln's armies, by 1865, could carry instant communication along with
them almost anywhere. (AMERICANA IMAGE GALLERY)

The photos of the several balloons used by the Union Army observation are well known, but less well remembered are the gas generators used to inflate them. T. S. Lowe's generators Nos. 7 and 8 were government property, just part of an ever-expanding arsenal of weapons. (NA)

So that no waterway might present an impassable obstacle for the marching Union armies, special wagons were designed and equipped with canvas pontoons as well as an anchor to hold the pontoons in place. (P-M)

Whole trains of pontoons, equipped with oars for maneuvering, followed the marching Union armies. (NA)

And when a bridge was not available, "blanket boats" were made by stretching rubberized blankets or canvas over wooden frames, lashing them together, and launching away. It could carry a squad of soldiers and a cannon and limber, as in this Russell photo. (LC)

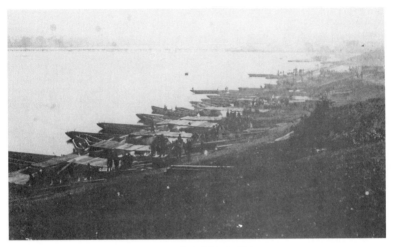

One photographer, perhaps Russell, recorded the building by Union engineers of a pontoon span near Washington. Here the pontoons are ready for "laying." (USAMHI)

Here another view as the working parties assemble. It is to be a timed test. (USAMHI)

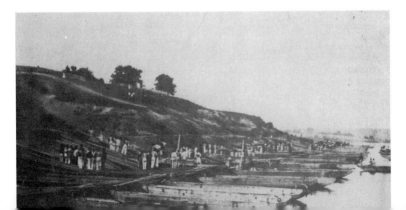

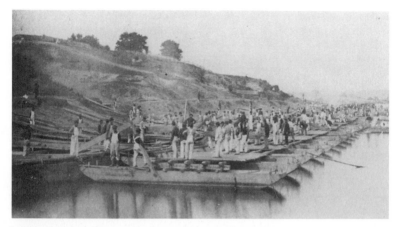

Some 450 men are working at wooden boats and canvas pontoons, some of them joined in giant rafts. In the first twenty minutes they have 1,300 feet ready for the passage of heavy vehicles, including artillery. (USAMHI)

The bridge assembled in record time, the proud engineers pose in squads along its length. It is a marvel of hasty yet serviceable construction. Again and again in the war, Yankee engineers will "throw" bridges across every stream in their path. (USAMHI)

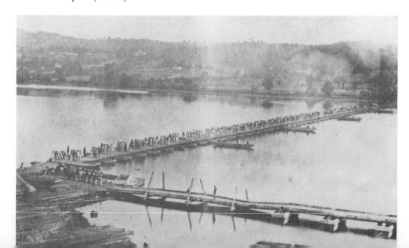

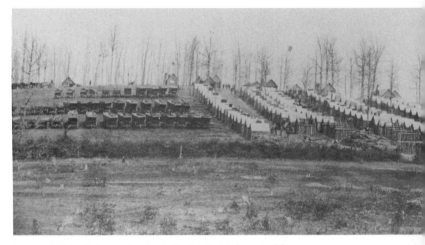

*They would do it with huge trains of boats like these beside the camp of the
50th New York Engineers at Rappahannock Station, Virginia, in February
1864. A Timothy O'Sullivan image.* (KA)

*When something more substantial than pontoons were needed, the engineers
could make indestructible bridges out of river barges.* (COURTESY OF
TERENCE P. O'LEARY)

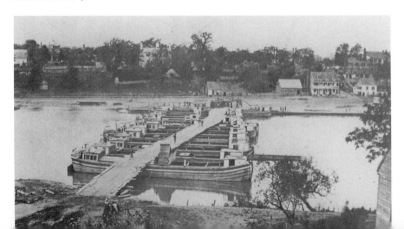

The man in charge of all these ingenious builders was Brigadier General Joseph G. Totten, Chief Engineer of the U.S. Army and one of the oldest men in the service. He was seventy-three when the war began and still a man of active mind. He died in 1864 while still on active duty. (USAMHI)

The camps of the engineers were to be found wherever the Yankee armies went. Here at Chattanooga in 1864 sits the camp of the 1st Michigan Engineers and Mechanics, with Lookout Mountain in the distance. (MICHIGAN STATE ARCHIVES, LANSING)

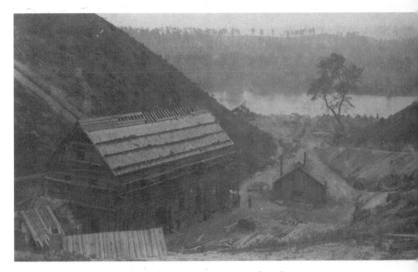

And here in Chattanooga, near the Tennessee River, is a waterworks under construction by Federal engineers in 1864. (NA)

And here it is finished. They did good work. (NA)

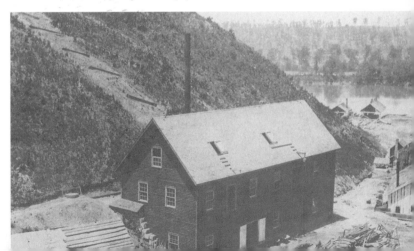

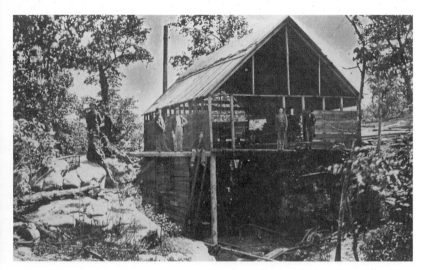

Government sawmills like this one on Lookout Mountain, Tennessee, fed the voracious appetites of the engineers. The army simply took the machinery with it wherever it went. (USAMHI)

A good sharp saw-toothed blade, steam-powered, could make as much of a contribution to the Union war effort as a cannon on the field, and sometimes more. (USAMHI)

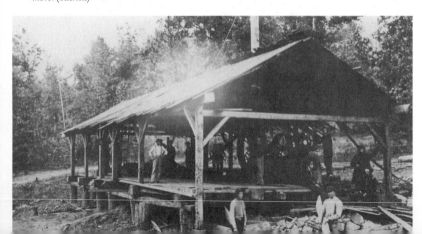

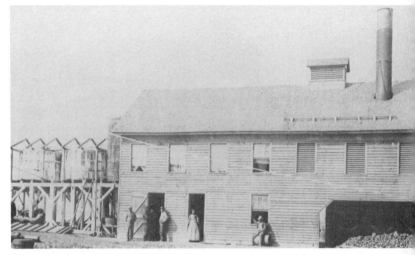

Wherever the Yankees went, they adapted to their environment, using their skill and engineering ingenuity to the profit of the march to victory. Here at Beaufort, South Carolina, they erected a massive condenser to distill pure water from seawater, leaving vital salt as a by-product. A Samuel Cooley image from November 1864. (NA)

Here in Beaufort, too, arose the carpenters' shops, this one doing just a little bit of everything. Wagons are repaired, building skylights made, and signs manufactured. Leaning against the wide door at the left is a billboard headed INSTRUCTIONS FOR THE OFFICER OF THE GUARD. *More somber reminders of the war sit to the left of it—grave markers for Privates Charles Williams and Blainwell Sweatt.* (NA)

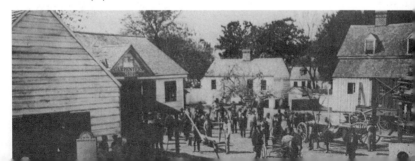

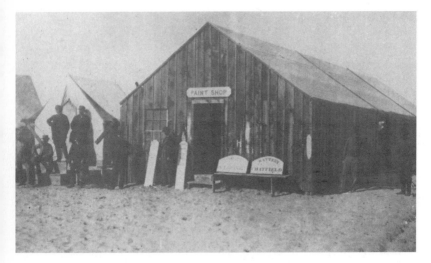

Of course, the Beaufort paint shop put the lettering on the signs, and the grave markers. Two more of each rest against the wall here. (NA)

On Hilton Head Island, South Carolina, the U.S. Government established a slaughterhouse to provide freshly butchered meat for the soldiers. The piles of hooves and horns outside attest to recent work. Soldiering, it seemed, was not all glory and fighting after all. They also served who only made steaks. (NA)

All across the North and the South, signs of Union might and organization were evident. In Nashville, Tennessee, the vast Taylor Depot went up. (PRIVATE COLLECTION)

In Cincinnati, Ohio, the U.S. Government wagon yard occupied a huge park at Eighth and Freeman streets. (NA)

A few blocks away stood the "tent manufactory," not only where canvas tents were made, but also where mass-produced uniforms were cut from patterns. (NA)

All of this organization required a lot of fuel for the steam engines, the locomotives, and the ships. Here in Alexandria Russell's camera looks at only a part of the government wharves, with their mountains of cordwood for the fuel burners and another mountain of alfalfa for the hay burners. (USAMHI)

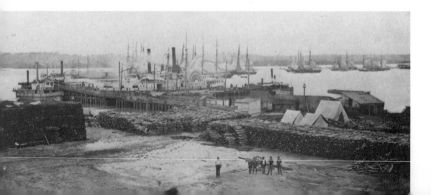

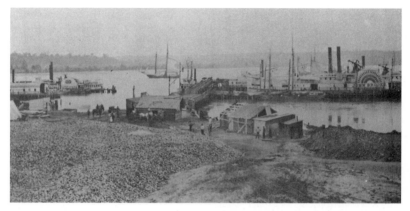

Next door the yard of the Cumberland Coal & Iron Company promised plenty of food for the smoke-belching furnaces aboard the John Brooks and other steamers. (USAMHI)

Union transport fleets like this one kept all these supplies moving from major centers such as Alexandria to the supply bases established with the advancing armies. Such supply was a marvel of modern logistical design. (NA)

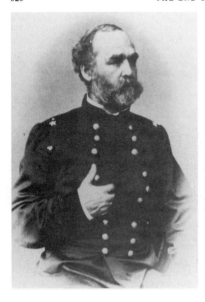

*The man who kept all of these supplies coming
to the Union armies was Quartermaster General
Montgomery C. Meigs, himself an amateur
photographer and an organizer of wonderful
efficiency. The men in blue rarely went hungry.*
(RONN PALM COLLECTION)

*Each army in the field had its own quartermaster as well, and with the Army
of the Potomac it was the capable Brigadier General Rufus Ingalls. He was
the only staff officer with that army to serve from beginning to end of the
war, enjoying the esteem of every commander he served under.* (USAMHI)

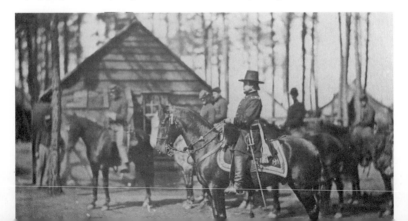

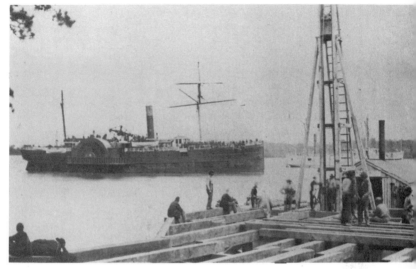

Generals like U. S. Grant had sophisticated docks and wharves built to receive their supplies, understanding that armies did move on their stomachs. City Point, Virginia, in 1864. (USAMHI)

The James teemed with every variety of ship, once the City Point docks were ready, all bringing in massive stockpiles of supplies. (NA)

Supplies came straight off the ships and onto the cars of the railroad built by Grant, or into mountainous piles like these barrels of potatoes and salt pork and boxes of hardtack. (P-M)

The commissary depot at Cedar Level, Virginia, in August 1864 actually looked like a mountain. (USAMHI)

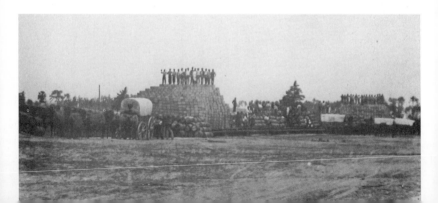

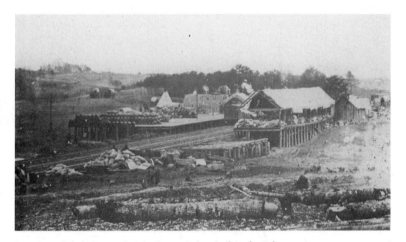

Lesser but still imposing supply depots lay everywhere in the wake of the Union Army. Here at Stoneman's Station, Virginia, in June 1863, sat a depot that tempted Confederate cavalry into dashing raids to destroy or capture much-needed supplies. (USAMHI)

And from those depots massive wagon trains like this Army of the Potomac supply train at Brandy Station, Virginia, in October 1863, brought the life-sustaining food and matériel to the front. A Timothy O'Sullivan image. (CHICAGO HISTORICAL SOCIETY)

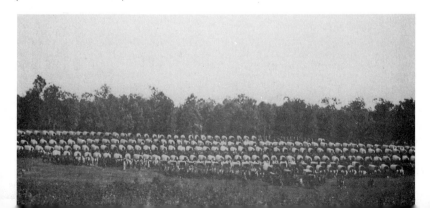

Along with the Union armies themselves moved large herds of cattle for fresh meat. This herd is seen at Giesboro, in Southeast Washington, D.C. So prized was beef during the Civil War that in 1864 Confederate Major General Wade Hampton would lead one of the most daring raids of the war—to capture a cattle herd. (NA)

All the Union services that were so comfortably ensconced back in Washington and the other major centers had their counterparts with the armies themselves. Here at Petersburg, Virginia, in August 1864, an engineer battalion is engaged in making gabions—wicker baskets filled with earth for defenses. (P-M)

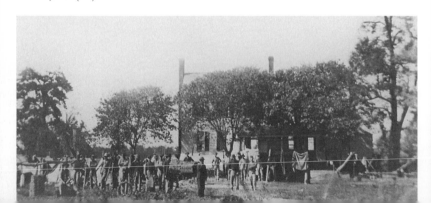

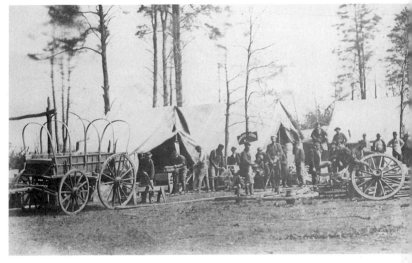

Here, too, Union repair shops replaced bad wheels or made new signs. (P-M)

Communities of vendors and mechanics made tiny villages with the armies. Here a church, a sutler, and a photographer advertising his AMBROTYPE & PHOTOGRAPHIC GALLERY *stand side by side.* (NA)

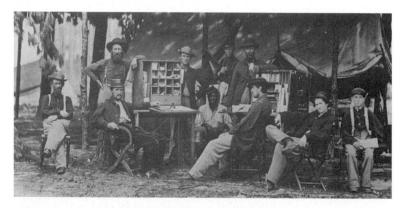

Keeping the men in the field happy meant keeping the mail running between them and their homes. These field desks are for the Union Army's postal service, for sorting letters and packages. A box of "Honey Soap" is in the large pigeonhole of the desk at the left. (USAMHI)

In the more permanent Union installations, the camp cooks in the kitchen became men of particular importance, as the third fellow from the left in the front row seems to appreciate. He stands hand in apron in the same Napoleonic stance so beloved of the officers. After all, he was a soldier too. (USAMHI)

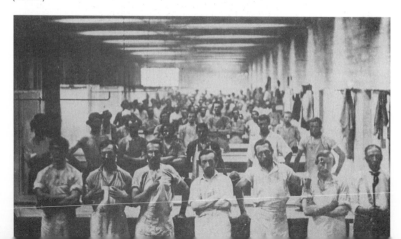

*The soldiers had to keep clean somehow, and for many of them that was
something new. Huge laundries like this one at Camp Holt in Jeffersonville,
Indiana, made it a little easier for them.* (INDIANA HISTORICAL SOCIETY
LIBRARY, INDIANAPOLIS)

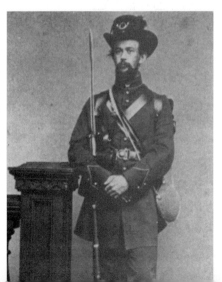

*But all of this was ancillary to the Union
Army's constant and pressing need to
keep those men, clean or dirty, armed
with the weapons necessary to do their
job. This infantryman in full field
equipment, with Sharps rifle and saber
bayonet, is ready for the enemy, thanks
to the work of thousands who served
behind the lines.* (MICHAEL J. MC AFEE
COLLECTION)

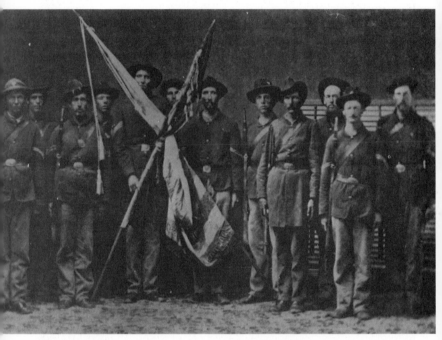

Without that work, these men of the 118th New York, the "Adirondack Regiment," would not be armed with modern Spencer repeating rifles and carbines. (MICHAEL J. MC AFEE COLLECTION)

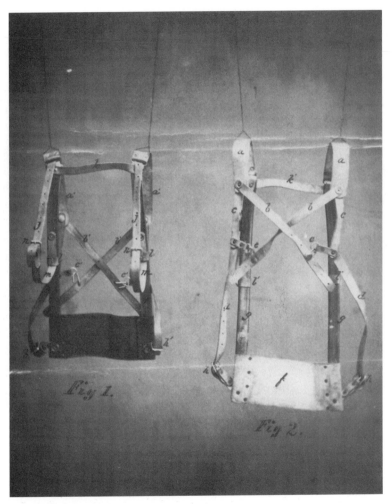

Above all, the War Department had to be willing to try things that were new, something nineteenth-century armies all too often resisted. Inventors bombarded it with contraptions like Baxter's knapsack supporter, designed to give the wearer full mobility and freedom of movement in the field. (NA)

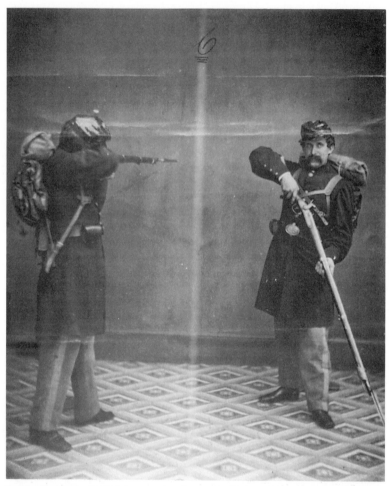

Inventor Baxter even supplied demonstration photographs with his petition, apparently not realizing that the Civil War soldier rarely if ever went into battle wearing his knapsack. (NA)

Then there was the Adams hand grenade, here attached to the wrist of its inventor, perhaps. It was little more than a hollow shell filled with powder and balls, with a fuse attached. By throwing it, the user set off the timed fuse when the leather strap attached to his wrist jerked a priming pin. It could have been embarrassing if his throw was a little too weak. (NA)

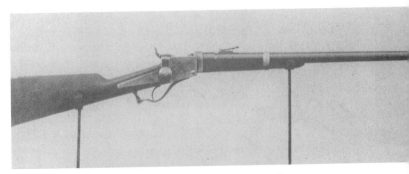

Of more conventional weapons, the War Department considered an untold number, all of them subjected to performance and accuracy tests. The Starr carbine went through tests on October 31, 1864, and was approved for limited use by cavalry. (NA)

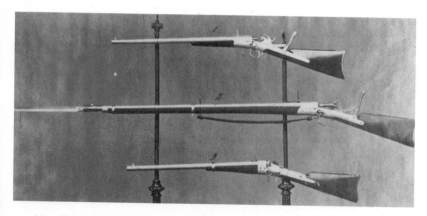

Not so Brand's patent breech-loading firearms. Three versions were offered, the .44 caliber carbine at the top, the .54 caliber rifled musket in the center, and the .54 caliber carbine at the bottom. The weapon at the top was fired some 3,000 times in testing. A self-contained cartridge is shown partially inserted in the breech. For the musket in the center the entire cartridge in the loading and ejecting mechanism are shown. The carbine at the bottom is ready to fire. Inventors would continue designing breechloaders, and all too often a conservative War Department would reject them. (NA)

Lee's breechloader was tested in April 1864. The barrel slipped sideways to allow a cartridge to be slid in. The thing projecting backward from the breech provided one solution to the biggest problem with breechloaders— how to eject the spent casing. This one just pushed backward, forcing the shell out. (NA)

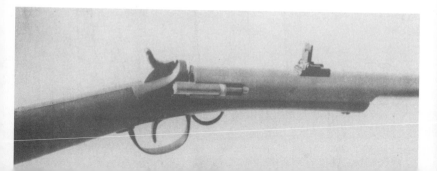

Johnson's breech-loading carbine was even more novel. The whole breech twisted to allow insertion of the cartridge. It is shown here closed. Carbines like this were tested against the standard Sharps carbine. (NA)

Here the barrel and breech of the Johnson carbine are twisted open, to allow insertion of the cartridge. (NA)

Now and then, of course, a design came through which could not be ignored. That is what happened when Lamson's repeating carbine was examined in May 1864. The government did not adopt it—it was too similar to the Spencer already in use—but the increased rate of fire offered by the repeaters caught the attention of men in Washington. (NA)

What finally caught their attention for good, and that of the next generation with them, was Henry's repeating carbine. Its serviceability and simplicity of design made it stand above the others. (NA)

Oliver F. Winchester, president of the New Haven Arms Company, who wanted to produce the Henry, was present for its trials. The carbine performed badly that first time out, but in time it would see limited use in the war and afterward it would be the progenitor of the "gun that won the West." (NA)

Because a rifle, no matter what kind, was only as good as its sighting, experiments were made with telescopic sights for sharpshooters' weapons. This one was attached to an American rifle with the massive barrel used for big game like buffalo or for very long-range shooting. (NA)

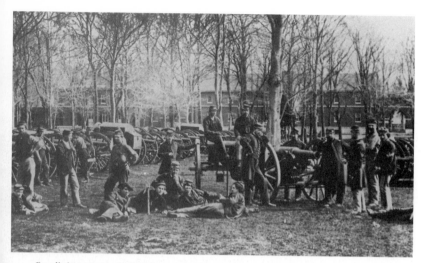

Equally important to the U.S. Government were the designs coming in for the bigger guns. The yard here at the Washington Arsenal was packed with all manner of cannon during the war, including the Wiard gun supporting the officers at right. (USAMHI)

Every army in the field had a chief of ordnance, officers like Union Captain Stephen Vincent Benét, grandfather of the distinguished American poet. They had to take what Washington sent them and keep it serviceable. (USAMHI)

Massive seacoast cannon, like this 15-inch Dahlgren smoothbore, were cast and tested in Washington. Next door to the Dahlgren sits a huge Parrott rifle, its projectiles lined neatly about its carriage. (LC)

The big guns were favorites for play and posing. It took a special gun cradle to transport them by rail, one that could support the 42,500 pounds of iron in such a weapon, not to mention the man inside. (MICHAEL J. HAMMERSON)

Many of them were brought here to Fort Monroe, Virginia, for testing, firing at targets out in Hampton Roads. A cannon like this could hurl its 440-pound shot well over four miles. A Rodman smoothbore. (USAMHI)

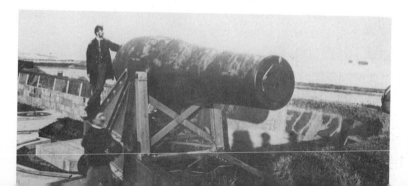

*It took a special apparatus to move the big guns in the field. William Browne
made this 1865 image of a captured Confederate 8-inch Brooke rifle slung
from a huge Confederate sling cart.* (CHS)

*Without one, a mammoth gun tube
could not be managed.* (USAMHI)

And of course, whatever the size of the guns, the artillery required mountains of projectiles, like those in this scene at the Washington Arsenal made by Captain A. J. Russell, military photographer. Several projectile sizes are evident, including a stack of British Whitworth rifle solid bolts, probably 5-inch, directly in front of the men at left. In the background cannon and mortars and carriages and targets are scattered all about. (AIG)

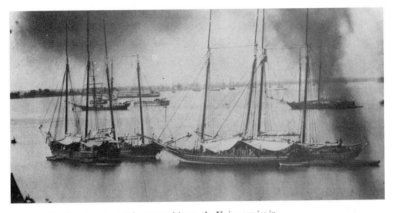

Schooners like these transported the ammunition to the Union armies in Virginia or to major supply stations like Fort Monroe. (USAMHI)

It was in U.S. Army laboratories like this one, at Sixth and Oxford streets in Philadelphia, that much of the ammunition was designed and even produced. The window at upper right sports a distinctly unmilitary adornment, a window box with plants. (LLOYD OSTENDORF COLLECTION)

*The work of the inventors did not stop at small arms. They looked also to
ammunition, with items such as Dodge's cartridge filler. By a series of
shiftings and pumpings, powder was automatically placed in the tubes, ready
to be topped with bullets and then wrapped in waxed paper. The War
Department wisely did not adopt it.* (NA)

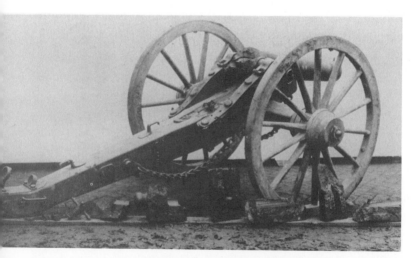

*The so-called wire gun had a barrel made up largely of steel wire wrapped
tightly around the bore. It was not an impressive success.* (NA)

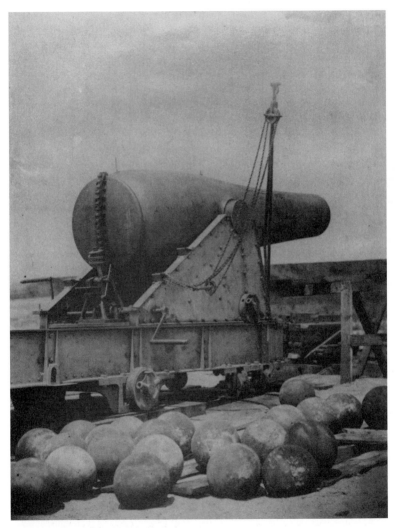

Major testing for experimental new big guns for the Union armies was done either at Fort Monroe or in Washington. Here in the former, a cast-iron 15-inch Rodman sits ready for a series of stress tests. (NA)

And here it is after one charge too many, a still-intact counterpart quietly awaiting its turn in the distance. (NA)

A steel and iron gun fared no better. (NA)

The rifling inside the bore shows handsomely in this "exploded" view of the pieces of the steel and iron gun. The ordnance testers were fascinated with the camera for recording the results of their experiments. (NA)

This cast-iron cannon managed to stand up after 1,600 firings. That was more like it. (NA)

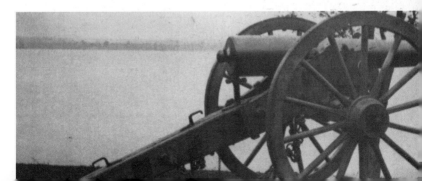

*The inventors never gave up. H. B. Mann stands here behind his new
breech-loading cannon. This early version is being admired by an onlooker
and his dog. Mann would refine it considerably before . . .* (NA)

. . . submitting it for testing by the U.S. Government in June 1865. By that time the war was done, of course, and Mann was out of luck. Just what he did with his 2,000-pound toy is unknown. (NA)

Lee's breechloader fared no better. It went through U.S. Government trials in August 1865, with little hope of a contract now that the fighting was over. In the testing, the supervising officer revealed the prejudice against this type of weapon when he referred to "the arguments against breech-loading guns as a class." Washington learned slowly sometimes. (NA)

Broadwell's breechloader was wonderfully simple. The slide sitting on the ammunition box was inserted in the slot in the side of the gun's breech. With the slide pulled out, the shell at left could be inserted into the barrel. Then the slide was pushed in behind it, sealing off the chamber ready for firing. In the distance above the barrel is a target used for testing. (NA)

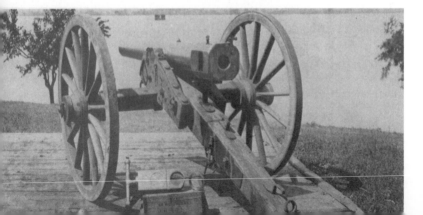

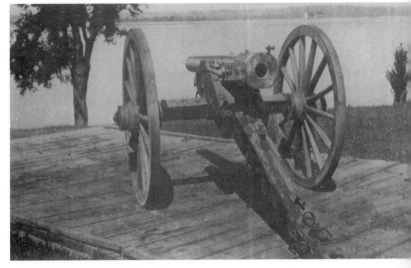

Broadwell's gun with the slide in place. (NA)

It took constant attention to the projectiles those guns fired to keep the armies in the field well supplied. Shot and shell were experimented with just as much as cannon. The shells at bottom are fitted with experimental fuses, made up of the rings at the center, with the fuse plug at the upper left and right inserted using the tool in the top center. It all had to work. (NA)

The Pevey shell was another such experiment, and one not adopted by the government. The soft tin or lead casing at its base was intended to expand into a gun's rifling grooves, to give the shell a spin as it emerged. (NA)

And here another Pevey shell designed for antipersonnel work—a hollow sphere with powder in the center cavity and iron balls in the outer chamber. American inventors could create decidedly lethal concepts in their pursuit of profits. (NA)

Even the men in uniform, who had the most experience, after all, sometimes turned tinkerer. Philo Maltby of the 14th Ohio Artillery designed this Rotary Sight for siege or seacoast guns. It could adapt to changes in light and was on the whole very refined. Indeed, the examining officer complimented the inventor: "It was constructed by Artificer Maltby in the field with such tools as a soldier in his vocation would there have at his command, and whatever may be said of its adaptability to general service, certainly reflects great credit on his skill and perseverance." Having said that, the officer then concluded that Maltby's was "misdirected ingenuity," condemning all such attempts as "the efforts of a class of persons, ingenius [sic] and well meaning it may be, but who have mistaken the desideratum in the field of invention on which they have entered." The closed mind was already well entrenched in the U.S. military in August 1864. (NA)

*Items like the iron siege carriage for heavy guns got a little more attention,
but proved to be simply too heavy for horses to pull.* (NA)

*Real ingenuity came when the imagination tried to fire more than one shot
at once. It produced specimens like the volley gun, a simple clustering of
121 barrels inside a cylinder and a breechblock containing 121 charges and
bullets.* (NA)

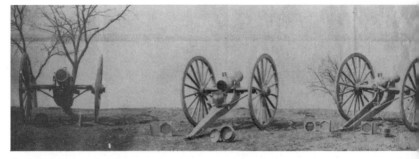

The volley gun required a fair amount of special apparatus and, after all, only sent its hail of bullets out into a very limited area. (NA)

Somewhat more to the point was the Requia battery, which actually saw limited service with the Union forces at Charleston, South Carolina. It was just twenty-five barrels side by side, with a strip of brass holding the charges and bullets inserted in the breech. The lanyard-controlled firing hammer is just visible at the rear center. (NA)

If all these weapons of war worked even a fraction as well as their inventors expected, then there were going to be a lot of wounded. And so the designers tried also to perfect the ambulance. E. Hayes & Company of Wheeling, West Virginia, submitted this prototype army ambulance to the U.S. Government in February 1862. Besides being very attractively appointed, it also boasted two water or spirit casks built right into the back panel. (NA)

And for those who did not survive the ingenious means of death being devised for them, the Union laid out cemeteries. It was all part of the job of a modern, organized army that left little to chance. Here in 1864 surveyors are at work laying out a major military cemetery . . . (NA)

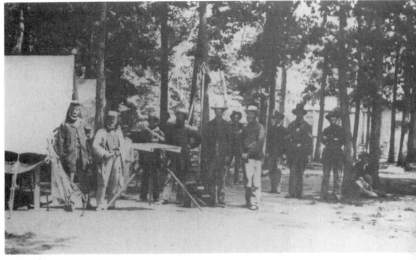

. . . on Arlington Heights, Virginia, across the Potomac from Washington.
(NA)

Here, on ground which had been the home of Confederate General Robert E. Lee, they began the work of what would become Arlington National Cemetery. From enlistment to arming to death, the organized war was complete. (NA)

"Damn the Torpedoes!"

CHARLES R. HABERLEIN, JR.

Ships of iron, and men to match,
battle on an August morning for Mobile

REAR ADMIRAL David Glasgow Farragut returned to the Gulf in January 1864. Refreshed by five months in the North, with his flagship *Hartford* refitted, he was eager to begin the next step in reducing the Confederacy's south coast.

Farragut had begun this work nearly two years previously by boldly running past the fortifications defending New Orleans. With the South's greatest seaport in Federal hands, he had continued with vigorous thrusts up the Mississippi River. Now but one important Rebel port remained on the long Gulf of Mexico shore.

Mobile, Alabama, with its fine rail and water links to the Confederate heartland, was a valuable asset to the South. Located at the head of large, shallow Mobile Bay, the port was well defended. On the mainland an earthwork, Fort Powell, guarded the bay's southwestern "back door." Between Dauphin Island on the west and Mobile Point on the east, on the bay's lower edge, the main entrance was flanked by twin antebellum masonry fortifications, Fort Gaines and Fort Morgan. Since 1861 additional batteries had been added to each. The waterway between them had been largely obstructed by driven pilings and moored mines, or "torpedoes," in the contemporary terminology. A few hundred feet

of deep channel remained open, directly under Fort Morgan's heavy guns.

Through this channel passed fast little Confederate steamers with exports of cotton and imports of war-sustaining munitions. The blockade-running trade was harassed, but not prevented, by Federal warships lurking offshore and cruising in the sea-lanes. Only direct occupation of the entryway would effectively blockade Mobile. To effect this was Farragut's intention.

Naval assaults on well-defended fortifications would not succeed without cooperating troops, and these were unavailable during the winter and spring of 1864. As the latter season progressed through May, another factor appeared on Mobile Bay: the new Confederate ironclad ram *Tennessee*. Her long-anticipated arrival provoked a brief outbreak of "ram fever" even in the intrepid Farragut. Fretting over the prospect of the Rebel ironclad steaming out into the Gulf, laying waste to the blockaders and perhaps even spearheading efforts to wrest Pensacola, Florida, and New Orleans, Louisiana, from their Northern occupiers, he badly wanted ironclads of his own.

Enemy plans worried the other side, too. Confederate Admiral Franklin Buchanan was ulti-

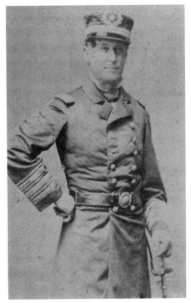

There was a gleam in the eyes of Rear Admiral David Glasgow Farragut. When C. D. Fredericks photographed him in New York, the loyal old Tennessean was laden with glory from his capture of New Orleans and the opening of the Mississippi. In 1864 he wanted another assignment and looked to Mobile, Alabama.
(WILLIAM GLADSTONE COLLECTION)

people I can get at.'' The routine blockading and patrolling continued from the Rio Grande to Florida, occasionally punctuated by minor raids and counter raids.

Unknown to the West Gulf Blockading Squadron, Washington had in fact decided on Mobile. The end of the ill-conceived Red River expedition in May and lack of progress in capturing Charleston freed monitors for other employment. Major General William Tecumseh Sherman's army, marching on Atlanta, needed diversionary support. In June orders went out to four Union monitors to proceed gulfward. Major General E. R. S. Canby, the area's army commander, received instructions from Washington to cooperate with the navy in a Union attack on Mobile.

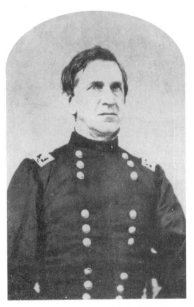

So did Union Major General E. R. S. Canby. After the fiasco of the Red River Campaign in May, his troops needed active and successful employment. A joint move against Mobile with the navy would serve the purpose. (USAMHI)

mately too cautious for a dash into the Gulf. *Tennessee* and her three wooden consorts, the gunboats *Selma, Gaines,* and *Morgan,* remained inside the bay, assigned to help defend the forts.

Since his return, Farragut had bombarded the Navy Department with requests for ironclad monitors and army support. He did not delude himself about the response, writing a colleague: ''The Government appears to plan the campaigns, and Mobile does not appear to be included just yet. . . . I shall have to content myself going along the coast and pestering all the

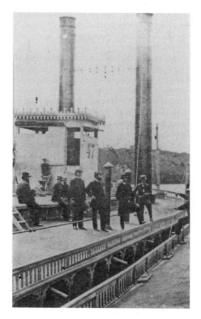

The Union had been interested in Mobile and its bay, center for Confederate West Gulf blockade-running operations, for some time. Converted "tinclad" steamers like the USS Elk *patrolled regularly off Mobile's waters.* (USAMHI)

Hints of these developments reached Farragut within a few weeks. Solid confirmation, in the form of the monitor USS *Manhattan*, steamed into Pensacola harbor early in July. With three more monitors on the way, Farragut and Canby perfected their plans.

Farragut's fleet was to steam past Fort Morgan into Mobile Bay and eliminate the Confederate squadron. Simultaneously, Union Army forces would land on Dauphin Island to assault Fort Gaines. If Fort Powell was taken, so much the better. Once communication was secured between the fleet inside, the logistics system outside, and the troops in between, Fort Morgan

would be doomed. Canby put together a 2,000-man contingent with enough transports for the job and appointed Major General Gordon Granger to command them.

In the fleet, ships were coaled, stored, and stripped for action. Superfluous spars and rigging were taken down and stowed. Anchor chain, sandbags, and spare sails were worked in around vital spaces for additional protection. Guns were shifted to the right, or starboard, sides to increase the firepower bearing on Fort Morgan.

Farragut ordered his ships to double up. Each of the more powerful sloops of war would have a gunboat or smaller sloop lashed to its unengaged port side. The lighter ships could then pass into the bay protected by the thicker bulwarks and heavier armament of their partners. In return, the big ships received backup propulsion in case they were disabled.

The four monitors were instructed to stand inshore of—and parallel to—the sloops and gunboats and to bombard Fort Morgan vigorously, to suppress its fire and prevent the *Tennessee* from interfering. All ships were warned to stay east of the black buoys anchored a few hundred yards out from the Fort Morgan shore. These, it was correctly assumed, marked the location of the minefield. The fort's gunfire was less dangerous than a catastrophic explosion of a big torpedo.

Granger's troops went ashore on Dauphin Island as planned, on the third of August, covered by several minor warships. Fort Gaines was immediately invested. However, the Union monitor *Tecumseh* arrived late, forcing postponement of the navy's mission. Farragut was mortified because he could not uphold his end of the plan, but admitted later that the delay was beneficial. During the intervening hours, the Confederates pushed reinforcements into Fort Gaines, where they were easily captured a few days later.

In the wee hours of August 5 the fleet formed up. An unfortunate change of plan, reluctantly adopted by Farragut, assigned the lead to the big sloop *Brooklyn*. Her forward-firing battery was heavier than his flagship *Hartford's*, and she had a torpedo rake on her bow, presumably capable of fending off any mines encountered. The flagship took second position, followed by the other big sloop, *Richmond*. These three were

paired with the fast, light-draft paddle-wheelers *Octorara, Metacomet,* and *Port Royal.* Once past the fort, these "double-ender" gunboats would be cast off to drive away the *Selma, Gaines,* and *Morgan,* which were of similar force.

Following the lead trio were four more pairs: sloops *Lackawanna* and *Seminole,* sloop *Monongahela* and gunboat *Kennebec,* smaller sloop *Ossipee* and gunboat *Itaska,* and, at the rear, small sloops *Oneida* and *Galena.* The ironclad squadron, parallel and inshore, was led by the single-turret *Tecumseh,* followed by the identical *Manhattan.* Each had two 15-inch guns, the most effective weapons available for countering the *Tennessee.* Light-draft monitors *Winnebago* and *Chickasaw,* each with twin turrets and four 11-inch Dahlgren guns, completed the inshore force.

At 6 A.M. the lines of ships stood in over the bar and headed slowly toward Fort Morgan. Under cloudy skies, the westerly wind fluttered battle ensigns out from every masthead and peak. The flood tide would help carry the ships past the fort, and the breeze was just right for blowing dense black-powder smoke directly into Confederate gunners' eyes. Conditions were virtually ideal for Farragut's scheme.

In Fort Morgan, Brigadier General Richard L. Page sent his men to their guns. Nearly twenty heavy smoothbores and rifled cannon and a similar number of medium guns prepared to rake the ships as they approached, bludgeon their sides as they passed, and rake them again as they stood up into Mobile Bay. Admiral Buchanan, on board the *Tennessee,* hovered near the fort's north side, ready to attack any Union ships that got past the batteries. Farther north his three gunboats were positioned to fire freely at oncoming Federals with little risk of effective reply. A short distance out in the channel the torpedoes waited silently.

Fort Morgan boomed out its initial challenge at six minutes past seven. *Brooklyn*'s 100-pounder Parrott bow rifles answered, followed by *Hartford*'s. Other ships opened up as they came into range. Farragut had climbed into the mainmast rigging of his ship, the better to see over the gunsmoke. From there he had good communication with his pilot in the maintop, with *Hartford*'s captain on the quarterdeck, and with *Meta-*

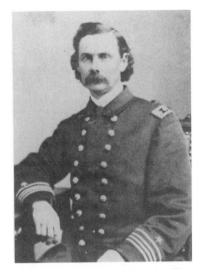

Men like Lieutenant Commander George U. Morris, whose first ship, the USS Cumberland, *had been sunk by the Rebel ironclad* Virginia *(Merrimack),* commanded the *Port Royal in constant blockade duty off Mobile during 1864.* (USAMHI)

comet's commander alongside. Below the admiral the twelve broadside gun crews stood by, ready to throw 9-inch shells as soon as Fort Morgan loomed into their field of fire. On the forecastle, Parrott-rifle gunners were already loading another round.

The monitor *Manhattan,* second in her line, began slow fire from her one serviceable 15-inch gun. The whole ship shuddered as the piece discharged. Thick smoke wafted down into the hull below the turret. From there, smoke penetrated the hot, poorly ventilated machinery spaces, where conditions were so hellish that sweating coal heavers and engineers required frequent relief. Smoke was so intense topside that the captain, in his tiny conning tower over the turret, could see his consorts and target only with difficulty.

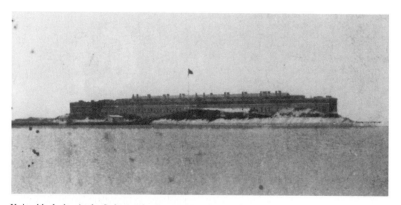

Union blockaders in the Gulf were hard pressed for adequate bases and sometimes had to use far-flung spots like Florida's Fort Taylor on Key West. (USAMHI)

The commanders of the faster-firing double-turret monitors elected to conn from out in the open, where vision was better. *Chickasaw*'s young captain, George H. Perkins, was so excited that he stood atop one of his turrets "waving his hat and dancing about with delight and excitement." Despite the heavy surrounding cannonade, neither he nor *Winnebago*'s captain were touched.

In the leader, *Tecumseh*, Commander T. A. M. Craven sent off a pair of heavy shells at the very start of the engagement, then reloaded with solid shot and the heaviest powder charges. He was saving his power for the *Tennessee*.

Buchanan watched the Union lines nearing the midpoint of their passage, exchanging a spirited fire with Fort Morgan. He ordered his ponderous ship into motion out into the channel, only a few hundred yards from the *Tecumseh*. Craven turned to port to intercept. Through his conning tower slits he saw a black buoy ahead, seemingly closer inshore than it should have been. Obsessed with stopping the *Tennessee*, he set his course just to the west of the buoy and in the path of the second column of slower-moving ships.

Brooklyn's captain James Alden was surprised and confused by Craven's move. He signaled the flagship: "The monitors are right ahead. We can not go on without passing them. What shall we do?" Farragut was also perplexed. His orders were very clear. Nothing was to prevent the column's advance. Slowing or stopping under the intense fire of the fort risked disaster. The ironclads had been strictly enjoined to keep out of the wooden ships' way. Now, five hundred yards ahead, the *Tecumseh* had turned into his path, and the *Brooklyn* was turning, too.

Suddenly, in what seemed only a matter of seconds, *Tecumseh* shuddered, lurched from side to side, pitched bow down, capsized, and disappeared. Then the *Brooklyn* stopped and began backing hard. Her lookouts had spotted torpedoes in the channel just ahead.

All the careful plans were collapsing, as the battle line began to pile up behind the wayward *Brooklyn*. The ironclads blocked the right-hand route. Above the surface, only the course through the minefield lay clear.

Farragut offered up a hasty prayer for guidance and received the only answer consistent with his character: "Go on!" He called out to those below: "Damn the torpedoes! Four bells!"

Responding to this order, *Hartford*'s engines

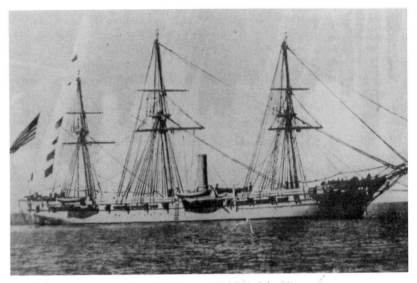

Farragut, if he could, would make a Yankee base out of Mobile. In July 1864 he staged his mighty fleet in the Gulf, ready to move on Mobile Bay when the moment was right. Flagship of the fleet was his legendary Hartford, *here photographed by McPherson & Oliver, wearing the coat of gray paint used to make her less visible at sea. The first-class sloop appears shortly after her fight in Mobile Bay.* (MARINERS MUSEUM)

went ahead full. *Metacomet* backed hard. The two ships pivoted to port, the double-ender put her engines back ahead, and the two sped past the *Brooklyn* into the lines of torpedoes. At that instant, two shells struck *Hartford*'s battery directly below the admiral's perch, sweeping away most of two gun crews. While the survivors silently removed the bodies of their comrades and brought their guns back into action, other men felt the torpedoes thudding against the hull. Some thought they heard primers snapping.

Nothing happened. Apparently the mine cases were leaky, and their powder had been rendered inert.

Leaving a boat to rescue the *Tecumseh*'s few survivors, *Hartford* and *Metacomet* pressed northward. *Tennessee* tried to ram them, but was evaded amid an exchange of broadsides. Fire from the Confederate gunboats was more serious. All three peppered the *Hartford* freely, since her bow guns could engage but one enemy ship at a time. One of these rifles was soon knocked out. Another shell exploded between the two foremost broadside guns, causing severe casualties. Again *Hartford*'s dead and wounded were quickly removed and the two guns returned to action.

Bearing this murderous fire for several painful minutes, the *Hartford* finally reached a point where her broadside would bear on the enemy. Successive discharges put *Morgan*, *Gaines*, and *Selma* to flight. The *Metacomet* shot off in pur-

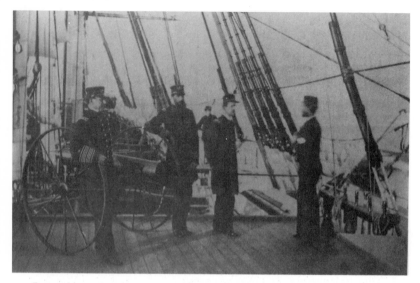

Farragut leans against a howitzer on the poop deck of the Hartford, *with the ship's commander, Captain Percival Drayton, leaning against the opposite wheel. The two complemented each other perfectly, Drayton highly organized and efficient and Farragut brilliant, intuitive, and impatient for action.* (NAVAL HISTORICAL CENTER)

suit, running down and capturing the *Selma* within an hour. The mortally injured *Gaines* beached herself to avoid sinking. Only the *Morgan* survived; sheltering under the fort's protection until nightfall, she escaped up the bay in the darkness.

West of Fort Morgan, it was about 8 A.M. when *Brooklyn* got the situation sorted out and started forward again. Her captain's indecision had left her the center of attention for the Rebel gunners, who made many damaging hits on her battery, hull, and rigging. Astern, the *Richmond* was hardly struck at all. Both rapidly steamed up the channel, engaging the *Tennessee* in turn. Once clear of that enemy, they also sent their consorts off to chase the fleeing Confederate gunboats.

The intense fire of the monitors and leading three sloops apparently drove many of Fort Morgan's gunners under cover, for the next three pairs of wooden ships passed through with modest damage. Rearguard *Oneida*, smallest of the sloops, received a redoubled fire. In a rain of shot and shell, her starboard boiler was hit and exploded, scalding many of her engineers. The other boiler supplied some steam to the engine, and with the *Galena* gamely pulling at full power, the *Oneida* was able to continue on, pursued by enemy fire until out of range.

Tennessee continued to contest the passage of the follow-up ships. Too slow for successful employment of her ram, she fired as rapidly as a four-gun maximum broadside and unreliable gun primers permitted, making some hits. One

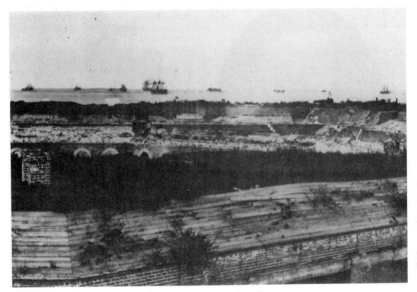

Here McPherson & Oliver capture the Yankee fleet as it rests at anchor outside Mobile Bay, above the parapets of Fort Morgan. Though taken sometime after the battle, the photograph gives a fair idea of what the Confederates might have seen the day before the fight. (NA)

hit badly injured long-suffering *Oneida's* captain. The ironclad received in return a forceful but ineffective ramming from the *Monongahela* and a number of inconsequential shot hits from the wooden fleet. By 8:40 *Tennessee* had been left behind and returned to the fort to assess the situation.

Farragut had achieved his initial objective. His fleet had entered Mobile Bay, still fit for action. The bay was now closed to enemy use. The forts were isolated. Only the *Tennessee* remained as an unpredictable factor, and he could deal with her in due time. His ships anchored in the pocket of deep water northwest of Fort Morgan and prepared to stand down from the tension and horror of the early morning.

Within minutes, however, lookouts saw the *Tennessee* steaming toward them. Admiral Buchanan had decided to expend her modest coal supply in a desperate last attempt to prevent the loss of Mobile Bay. Even if this failed to destroy the Union fleet, he reasoned, his ironsided ship could still return to Fort Morgan and do what she could to buy time for strengthening the upbay defenses.

It was a forlorn hope. Farragut quickly sent *Lackawanna* and *Monongahela* off to intercept and ram the enemy ironclad while the rest of the fleet got ready. Receiving his orders to engage, *Chickasaw's* Perkins almost somersaulted overboard with joy. Exuberant as he appeared, Perkins' cool conduct in the following hour largely determined the outcome.

The *Monongahela* went full speed at the *Ten-*

making a negligible impression on *Tennessee*'s iron casemate. The latter's low-set broadside discharged directly into the *Hartford*'s berth deck, causing heavy casualties among her ammunition party. Farragut's flagship steamed away to try again, but collided with the *Lackawanna*. The battle was over for both of them, though their injuries were not crippling.

The Federal monitors arrived. A Confederate officer watched as "a hideous-looking monster came creeping up on our Port side, whose slowly revolving turret revealed the cavernous depths of a mammoth gun." It was the *Manhattan*. Only one of her 15-inchers worked that day, but it made damaging hits, smashing away armor plate, crushing backing timbers and shocking the enemy with the force of her blows. The *Chickasaw* doggedly clung to the *Tennessee*'s flanks, hammering away at the aft part of her casemate with 11-inch shot. Other ships fired from a distance. In less than half an hour, *Tennessee*'s steering was destroyed, her smokestack knocked away, most of her gunport shutters jammed and her casemate smashed nearly to collapse.

Mobile's defenses had been well designed. Confederate Brigadier General Danville Leadbetter was a native of Maine and as an engineer in the U.S. Army and after 1857 as a civilian had spent years here building harbor works. In 1863 he returned to Mobile to supervise the defenses being erected by Southerners. (USAMHI)

Inside, Admiral Buchanan and a working party were trying to clear one of the after port shutters, so some reply could be made. A shot hit directly opposite them. Despite armor, the concussion and splinters devastated those nearby. Two men were killed and Buchanan's leg so badly broken that he had to be carried below.

Although no Federal projectiles had entered the protected casemate, the *Tennessee* was by this time "sore beset." Unable to steer, unable to fire, power plant crippled by the loss of the smokestack, hull leaking from the effects of rammings, and the casemate aft wall on the verge of falling in, she had little choice. Reluctantly, inevitably, a white flag was pushed up from the battery grating. Firing ceased. The onrushing *Ossipee*, bent on another ramming attempt and unable to stop in time, struck one final blow. Sending a boat, *Ossipee* took possession of the prize. With that, just at ten o'clock in the morning of August 5, 1864, the Battle of Mobile Bay was over.

Months earlier, Farragut had commented: "How unequal the contest is between ironclads and wooden vessels in loss of life." How correct he was. His fleet had suffered more than fifty

nessee, hit her sharply on the starboard side, shuddered to a halt, and backed away. She received a crushed bow and two shots into the berth deck for her trouble. *Tennessee* seemed unscathed. *Lackawanna* followed with a similar blow to the ironclad's other beam, with like result. The opponents exchanged shots, musketry, insults, and thrown debris as they separated.

Close behind, the *Hartford* also tried to ram, but struck obliquely. Her unshipped anchor took the blow and was bent beyond use. Ironclad and sloop passed port side to port side, a few feet apart. Admiral Farragut watched from an impromptu battle station in the port mizzen shrouds as *Hartford*'s massed 9-inch smoothbores blasted away with solid shot and heavy charges,

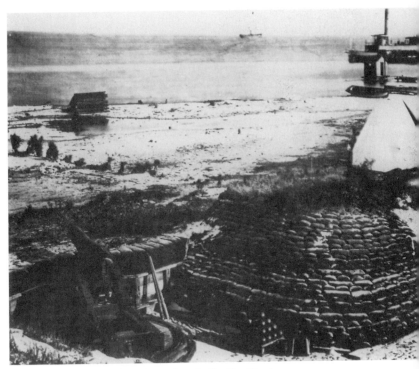

The Alabama shorefront bristled with water batteries like this captured Confederate one outside Fort Morgan, photographed by New Orleans artists Moses & Piffet in September 1864. (NA)

men killed, nearly half of them on his own flagship, plus over ninety souls carried down with the torpedoed *Tecumseh*. Confederate casualties were almost trivial by comparison: a dozen killed in the ships, one man dead in the fort.

But battles are not decided on "points." The Southern squadron had been swept away. Within a few days, Fort Powell had been evacuated and Fort Gaines surrendered. On August 23, after General Granger's siege lines reached Fort Morgan's walls and heavy shellfire threatened to destroy its garrison inside inadequate "bombproof" bunkers, General Page capitulated. Mobile city remained in Confederate hands nearly until

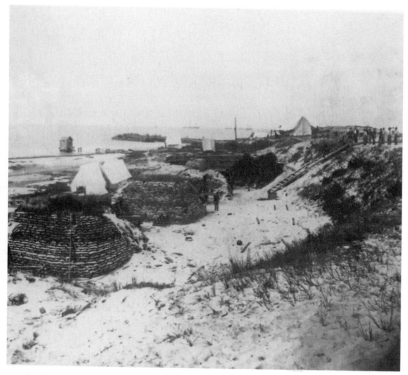

McPherson & Oliver made a better image of the batteries that September and followed it with others . . . (USAMHI)

war's end, but its value to the Confederacy was gone.

Strategically, the Battle of Mobile Bay was a sideshow to the vast campaigns then underway in Georgia and Virginia. Even within the blockading effort, it was not more than a junior partner to the greater undertakings at Charleston, South Carolina, and Wilmington, North Carolina. The numbers of men and ships involved were slight—a few thousand troops and a modest fraction of the navy on the Northern side, even

fewer on the Confederate. Mobile's neutralization was simply another ratchet notch in the great Union windlass that was by then inexorably reeling in the South.

However, this August morning with Farragut provides a peerless object lesson in the benefits of close, friendly cooperation between army and navy. Most importantly, it is an unexcelled instance of inspired leadership and heroic determination. More than a century later, it still commands attention and respect.

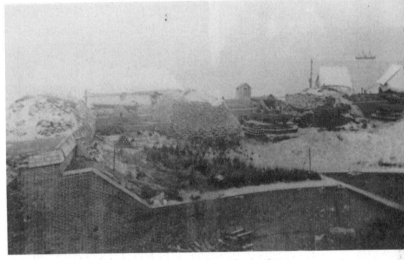

. . . like this picture of three more captured Confederate guns facing the sea.
(NA)

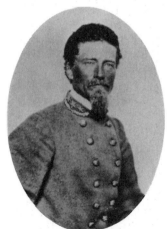

The Confederate commander of Mobile was a distinguished officer with a hopeless task, Major General Dabney H. Maury of Virginia. He had too few men with too little weaponry against too much. It was the old Confederate story. (P-M)

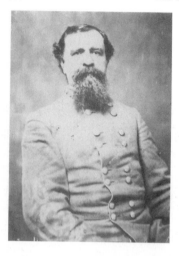

Maury's subordinate commanding the post of Mobile was Brigadier General Thomas H. Taylor of Kentucky, a veteran of Vicksburg where he was captured, who came back into the service after his parole and exchange only to be assigned to another doomed city. (VALENTINE MUSEUM)

There were several forts protecting Mobile, but the only one of real consequence was powerful Fort Morgan, a giant masonry and earth fortification built several years before the war. McPherson & Oliver made a series of views of the place after the fight, including this one of the front facade. The wreckage left by the bombardment it suffered is plain to see. (CHS)

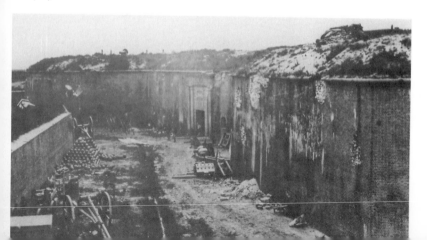

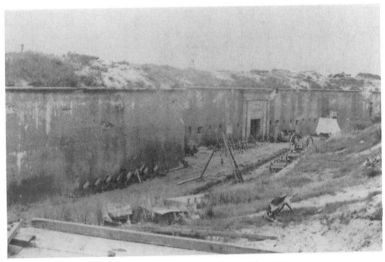

Another front view of the fort shows a row of mortars awaiting emplacement, several Union soldiers with their arms stacked, and on the horizon the badly battered lighthouse. (CHS)

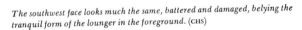

The southwest face looks much the same, battered and damaged, belying the tranquil form of the lounger in the foreground. (CHS)

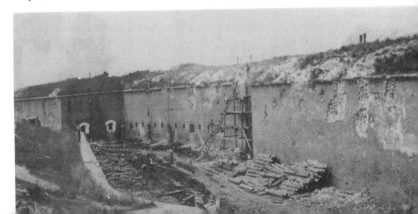

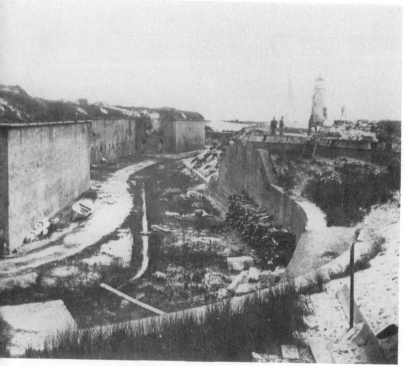

The front and west side of Fort Morgan shows a little less damage, but the poor lighthouse seems barely able to stand. (USAMHI)

On August 5, 1864, Farragut, seated right, ordered his fleet to steam past Fort Morgan's batteries and into the bay. Drayton, left, was flag captain for the day, commanding the Hartford. (NHC)

The USS Hartford's helm, manned just as it was that morning of the attack, with, left to right, Seaman Joseph Cassier, Captain of the Forecastle John McFarland, Landsman James Reddington, and Quartermaster James Wood. McFarland in particular distinguished himself, receiving the Medal of Honor for outstanding performance of his duty in the battle. (NHC)

Here men of the Hartford's *after guard pose near one of her 9-inch guns. Directly behind them, rising out of the picture, are the mizzen shrouds where Farragut placed himself during the battle with the ironclad* Tennessee. (NHC)

The Hartford's *gun deck, by McPherson & Oliver. The starboard battery of 9-inch Dahlgrens is at the right, these being the guns that engaged Fort Morgan during the passage of the fleet. Here was done terrible carnage among Farragut's gun crews. The two officers standing at the left are Lieutenants George Mundy and La Rue P. Adams, who commanded most of those guns. Adams himself was wounded.* (NHC)

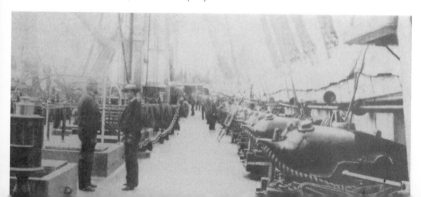

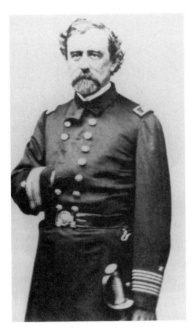

Captain James Alden was supposed to take the lead with his sloop Brooklyn, *but he ran into a problem and caused considerable confusion before* Hartford *surged on past him. He and the admiral were never very friendly again.* (NHC)

The USS Ossipee, *photographed at Honolulu in 1867, was a light sloop that Farragut stationed toward the rear of his line as it braved Fort Morgan's guns. She suffered almost no damage at all.* (NHC)

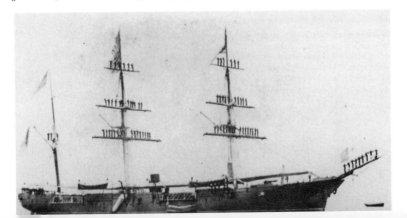

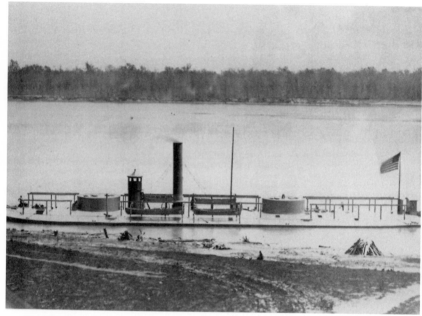

This Winnebago-*class monitor is probably the* Kickapoo, *sister ship of the monitors* Chickasaw *and* Winnebago *that brought up the rear of Farragut's line. Neither the admiral nor the monitors' commanders had too much faith in them, and* Winnebago *was nearly put out of action in the battle. The* Kickapoo *joined the fleet at Mobile some weeks after the battle.*
(U.S. MILITARY ACADEMY, WEST POINT)

Only one ship was actually crippled by
Confederate fire, the sloop Oneida commanded
by Commander J. R. Madison Mullany. He had
begged to get into the action that day, and
Farragut temporarily assigned him to the
Oneida. Fire from the CSS Tennessee damaged
his left arm so badly that it had to be amputated.
(NHC)

One of the greatest heroes of the fight, however,
was Ensign Henry C. Nields of Metacomet.
When the USS Tecumseh hit a mine and sank,
he took a boat out into the channel under heavy
fire to rescue her survivors. He saved ten of them.
(NHC)

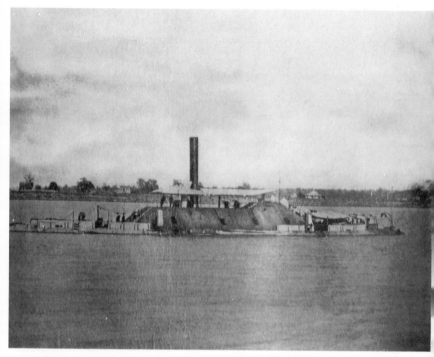

*The most feared enemy for Farragut were not the mines—called "torpedoes"
—but the dreaded Rebel ironclad Tennessee, shown here after her surrender
in a photo probably made in New Orleans. Built like almost all Confederate
ironclads, she had the strengths and weaknesses of her type. Her four 6.4-inch
and two 7-inch Brooke rifles were no match for some of Farragut's heavy
cannon.* (LC)

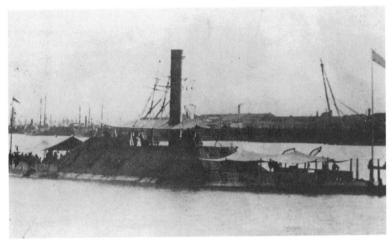

Still, she was a formidable vessel and well handled under the command of a real veteran of ironclad warfare . . . (NHC)

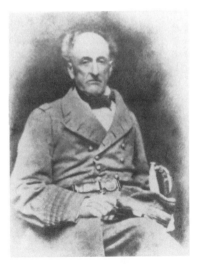

. . . Admiral Franklin Buchanan. He it was who commanded the CSS Virginia *in her fight with the* Cumberland *two years before, taking a wound in the battle. In the fight with Farragut, Buchanan's leg was badly shattered.* (NHC)

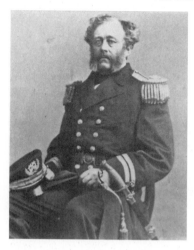

Buchanan's chief adversary was Commander James Strong, who brought his sloop Monongahela *in close and repeatedly rammed the Rebel ironclad with his specially prepared prow. This portrait is by Gurney & Son of New York.* (CIVIL WAR TIMES ILLUSTRATED COLLECTION)

And all the while, Fort Morgan's guns were bombarding the Union fleet as it passed. The fort's batteries were so arranged that Farragut had either to risk coming in close to them and taking a heavy shelling or passing through a more distant channel filled with torpedoes. By accident he chose the latter. Fort Morgan itself came in for its share of bombardment later on. (NA)

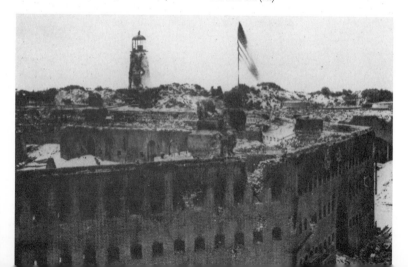

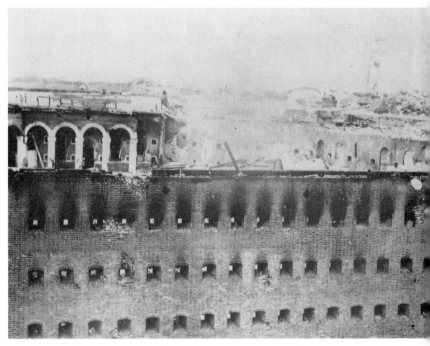

An elevated view of the fort shows the extensive damage it suffered from the land bombardment on August 22 that followed Farragut's passage. Like all masonry forts in the war, Fort Morgan did not stand up well under siege artillery. (CHS)

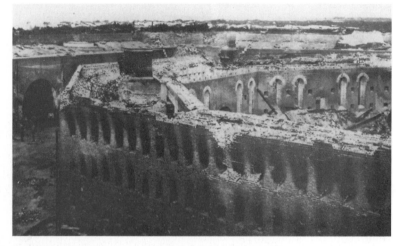

The bombardment made a mess of its parapets. (NA)

*The so-called citadel of Fort Morgan, viewed from the south by McPherson &
Oliver, shows the collapsed roofs and toppled chimneys of a beleaguered
fortress. The Confederate gunners did not dare serve their guns on the top
tier.* (KA)

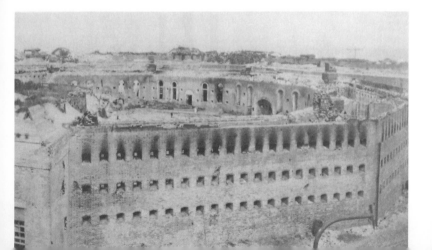

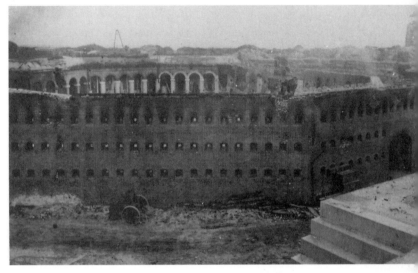

Instead, they had to hide below in equally unstable "bombproofs" while the Yankees sent shell after shell at them. (KA)

It proved very frustrating indeed for the fort's commander, Brigadier General Richard L. Page of Virginia. He had been a captain in the Confederate Navy, then switched to the Army. Fort Morgan was to be his only command. He stands here with his family. (WILLIAM ALBAUGH COLLECTION)

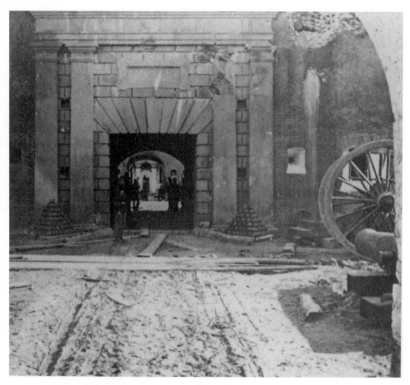

The main gate, or sally port, of Fort Morgan. Even though the damage from the bombardment is not yet cleaned up, already the conquering Yankees have built ornamental shot pyramids beside the portals. A giant gun sling stands at far right. (NA)

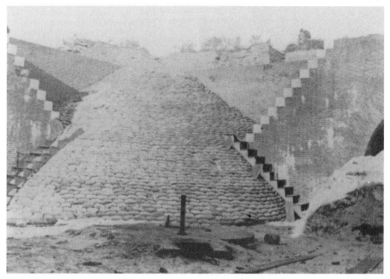

Part of the interior of the fort shows a reinforced bombproof and sandbagged parapet, hasty measures to futilely resist the enemy's heavy siege guns. (NA)

The parade of the fort looks like a wasteland after its surrender. (NA)

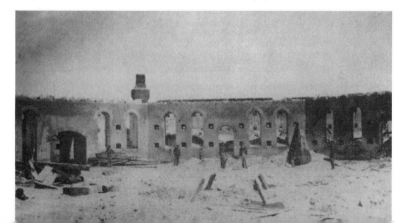

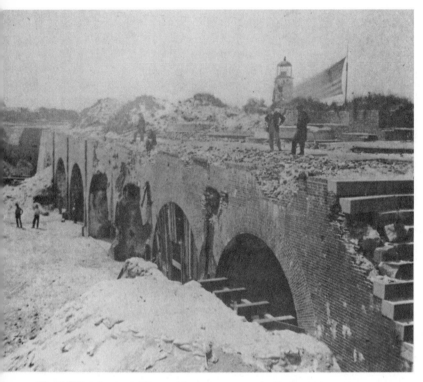

The Civil War almost ended the era of the masonry seacoast fortification, and the damage done to Fort Morgan shows why. Page and his garrison were fortunate to hold long enough to surrender without being buried alive. (NA)

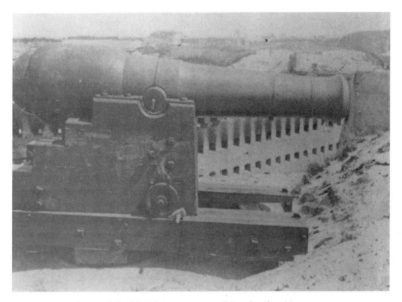

Their guns, like this 8-inch British Blakely, were no match for what the Yankees could throw at them. (NA)

Fort Morgan's southeast bastion in September 1864, the guns now silent, looked out upon nothing but the quarters of some of the victorious Federals. (KA)

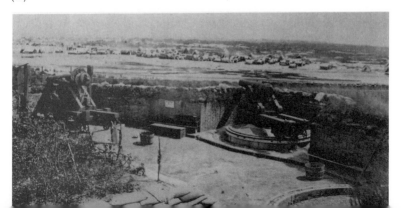

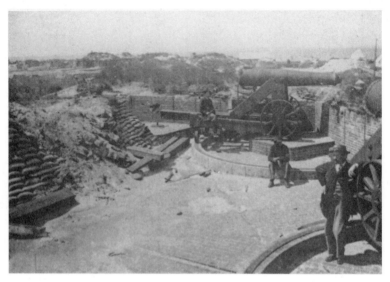

The fort's once thundering parapet is now a place for loungers and sightseers.
(NA)

*There they could see the damage done to this dismounted Columbiad by
accurate Yankee fire.* (NA)

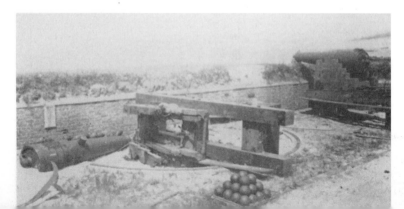

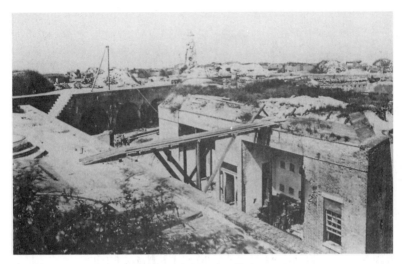

They could also view the whole scene of destruction and read in it some metaphor for the doom of the Confederacy. (KA)

Fort Morgan was a great scene of devastation, so overwhelming that McPherson & Oliver could not stop photographing it, though some of their shots were becoming redundant. (KA)

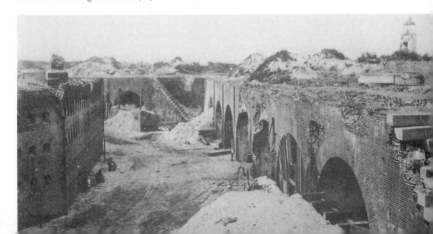

Though not itself a target, the lighthouse on Mobile Point, near the fort, was particularly damaged by shots that went high and passed over the fort. In the distance stands a makeshift signal tower, while at the foot of the lighthouse sits the hot-shot furnace. Out on the parapet, men have placed comfortable chairs to enjoy the midday air and sea breezes. (KA)

Somehow the battered lighthouse seems symbolic of the fallen fortress and of the Southern cause for independence that by this time was teetering in precarious balance. (NA)

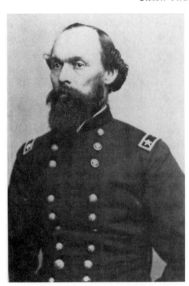

While Farragut handled the naval end of the victory at Mobile Bay, it was Major General Gordon Granger, a hero of Chickamauga, who besieged Fort Morgan into submission. (USAMHI)

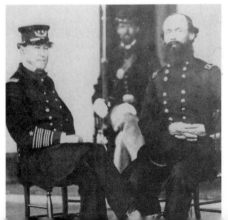

The fort surrendered on August 23, 1864, almost three weeks after the naval battle was over. After the surrender Farragut and Granger met for a camera sitting, having offered in their operations a model of Army-Navy cooperation not often emulated. Granger's commanding officer, Major General E. R. S. Canby, would remark later that "the relations that have existed between the two services . . . have been of the most intimate and cordial character and have resulted in successes of which friends of both the Army and the Navy have reason to be proud." (USAMHI)

Later the old USS Potomac, a sailing frigate more than thirty years old, played host to the captured officers of the Rebel ironclad Tennessee. Too old for active fighting, the proud old wooden ship played its support role to the end. (USAMHI)

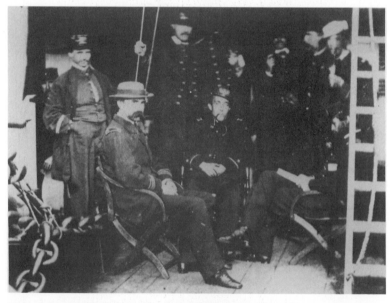

It was a welcome rest when the operations for Mobile Bay were complete, and officers of the USS Hartford could relax on deck. All of these men were aboard during the battle. They are ensigns, lieutenants, and surgeons and a captain of marines. It is a well-earned rest. (NHC)

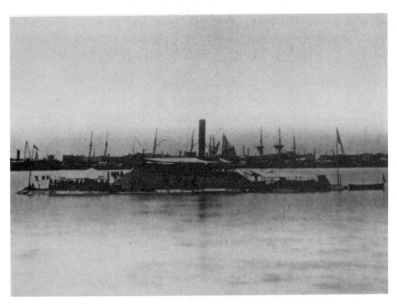

As for the CSS Tennessee, there will be no rest for her. Here she is in New Orleans, being refitted to go into service as the USS Tennessee. Having done their best to destroy her, her captors are now ready to add the ship to the ever-growing arsenal of Union naval might. (USAMHI)

Houghton at the Front

A PORTFOLIO

The little-known Vermont photographer G. H. Houghton
went to the war in 1862 for an unforgettable series

AS WITH SO MANY of the war's camera art-
ists, little is known of the Green Mountain
photographer G. H. Houghton, of Brattleboro,
Vermont. This is all the more unfortunate given
the unusually high quality of his work. In at
least two trips to the Virginia front in early 1862
and early 1863, Houghton made nearly a hun-
dred images that survive, and probably more that
do not. He photographed Vermont soldiers on
the Peninsula in what was a considerable change
of pace for an artist whose usual work was out-
door scenes of his native state. But Houghton
was an unusual artist. Though few hometown
photographers went any farther than the army
camps when they came to the war zone, Hough-
ton went beyond the camps and took his camera
very close indeed to the front. And unlike those
of many of his contemporaries, his war views
eschewed the modest carte de visite format and
appeared instead in large, beautifully detailed
prints which he marketed back home in Brattle-
boro.

A brave, able, and innovative artist, G. H.
Houghton of Vermont exemplified the hun-
dreds of unknown photographers who recognized
that in this war lay the greatest event of their
generation, something worth the effort and the
danger to record.

"Photographer's Home," Houghton called this scene. It was one seen throughout the war-torn country—the itinerant artist's tent studio or hastily erected "Picture Gallery," ready to capture for the boys in blue or gray their likenesses. Houghton's establishment here at Camp Griffin, Virginia, was a bit different, however, for he came to record the look of his fellow Vermonters in the field as they battled on the Peninsula in the spring of 1862. (VERMONT HISTORICAL SOCIETY)

Few photographers of the war could surpass Houghton's ability with the lens. There was a tranquillity about his work that belied the deadly business that populated these tents with fighting men around Brigadier General William F. Smith's headquarters at Camp Griffin. (VHS)

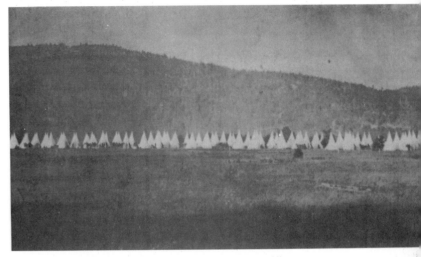

Houghton, in fact, began chronicling the career of Green Mountain soldiers even before they left home. Here he records the camp of the 1st Vermont near Brattleboro. (VHS)

And now, down in Virginia, he captures the scene of the 4th Vermont in Camp Griffin, the regiment drawn up, company after company, off to the left, while their band prepares to enspirit them with martial song. (VHS)

The 2d Vermont was here in Camp Griffin, too, less formal for the camera. The man in the center of the standing group appears to hold a newspaper. (VHS)

Houghton caught the 16th Vermont in their "winterized" tents at Union Mills. (VHS)

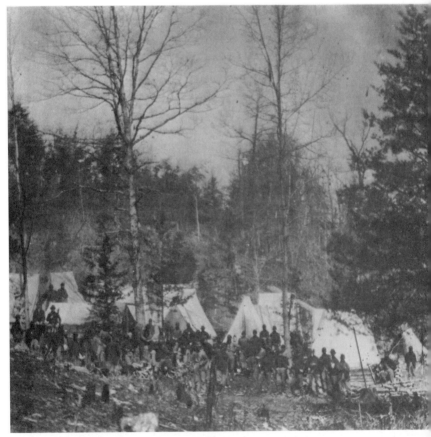

And the men of the 12th Vermont at Wolf Run Shoals. The men of Company B are ready for a hard winter. The leaves have left the trees, and already the stumps left by ravenous firewood parties testify to the cold. (VHS)

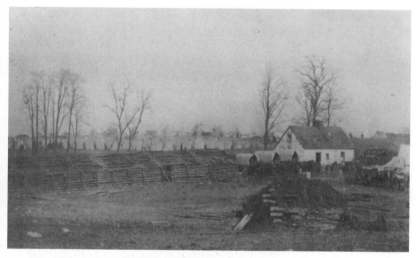

The 3d Vermont camp in Virginia revealed an unusual, if rude, bit of construction, probably a stable for the wagon teams or a commissary storehouse. It would not provide much obstruction to the wind. (VHS)

Company A of the 13th Vermont went into camp directly next to a battery it was supporting. Between clearing the woods for a field of fire for the cannon, and foraging for firewood, the forest is representative of the devastation done to Virginia's woodlands by the war. (VHS)

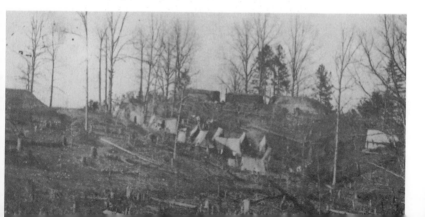

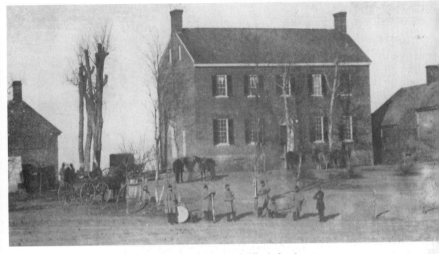

The 6th Vermont made its headquarters here at Camp Griffin, its bandsmen standing proudly—if somewhat chilly in their greatcoats—with their instruments. (VHS)

Houghton turned his camera to the places where power stayed, like General Smith's headquarters at a place called Becky Lee's Opening. (VHS)

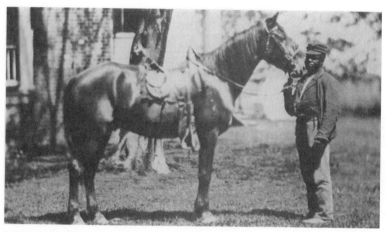

Smith's favorite campaign horse made a more than fitting subject for the lens, seemingly as casual about the camera as the young "contraband" holding his head. (VHS)

The generals themselves, as always, were happy to pose for Houghton. Brigadier General William F. Smith, standing in the center, a Vermonter, was soon to command a division in the VI Corps. His hat conceals the thin hair that led to his nickname "Baldy." Standing at the right is Brigadier General John Newton, a Virginian who remained loyal to the Union. And at the left is Brigadier General Winfield Scott Hancock. Eighteen years from now he will narrowly lose a bid for the presidency to another former Civil War general, James A. Garfield. (VHS)

Hancock himself made his headquarters under this mulberry tree at Cold Harbor, Virginia. He sits at the left of the shadowy group under its branches. (VHS)

And he sits at the left here, too, legs crossed and looking casual as he is joined by one of his fellow brigade commanders in Smith's division, Brigadier General William T. H. Brooks, seated next to him. Ironically, in 1864, even before the war was over, Brooks resigned his commission and began farming —in Alabama! (VHS)

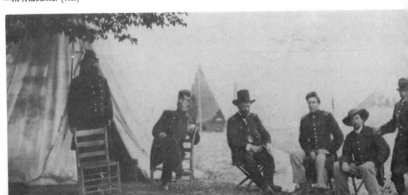

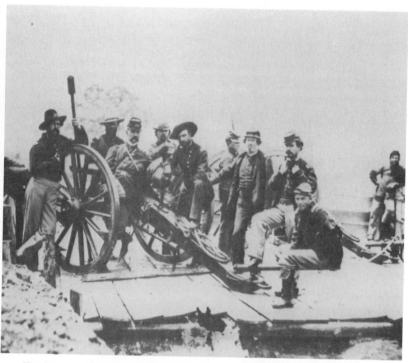

Houghton turned his camera to a group of officers in Fort Lincoln that
winter as well. Colonel Hiram Berdan, leader of the famed Berdan's
Sharpshooters, leans backward (left center) against the cannon tube. Leaning
on it with him, his foot on the carriage trail, is Brigadier General John W.
Davidson, a native Virginian now commanding a brigade in Smith's division.
(VHS)

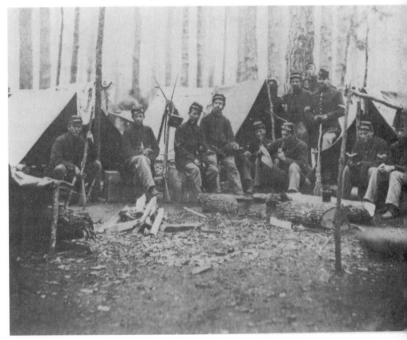

For all the attention he gave the officers, Houghton was really more interested in the common soldiers. He came to the camp of Company F, 4th Vermont, where the Green Mountain boys agreeably struck the variety of camp poses that the people back home liked to see. (VHS)

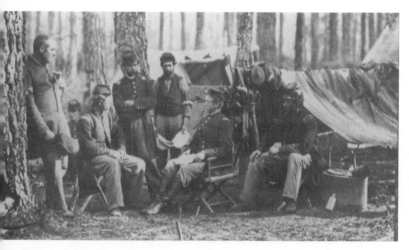

Even some of the company officers struck a homey pose. For reasons of their own, they dubbed the agreeable young lieutenant seated right "Infant John." (VHS)

Sergeant Rogers' men of Company A, 4th Vermont, look suitably rustic. It is to be hoped that the tiny tent was not supposed to hold all four of them. (VHS)

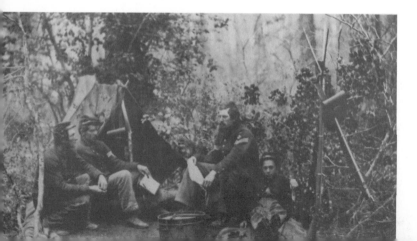

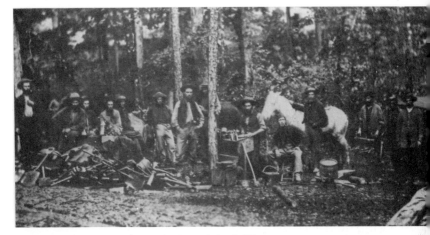

Houghton caught the teamsters and mechanics attached to Smith's headquarters at their work. All manner of tools—shovels, wagon jacks, axes, and mauls—litter the ground at the left; a portable forge and smithy stands at the far right. (VHS)

Regimental bands like that of the 4th Vermont were always happy to dress up for the camera. (VHS)

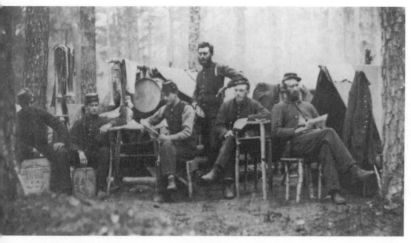

Less formally attired, the bandsmen relax in camp amid their instruments and boxes of "pilot bread" (hardtack) like the one making a seat for the soldier at the left. (VHS)

One might have expected a lot of sour notes from all those dour Vermont faces. (VHS)

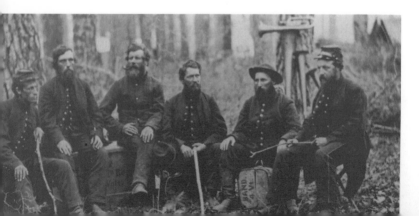

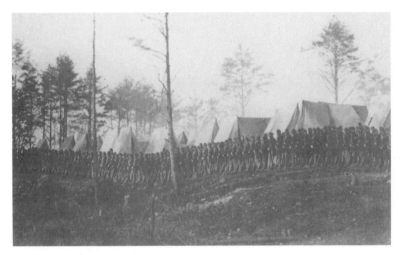

But dour or no, these Vermonters could look splendid when they wanted to. The 12th Vermont presents an immaculate line for Houghton at Wolf Run Shoals. (VHS)

Company A of the 4th Vermont looks formidable indeed as they pose at charge of bayonet. Yet there is still a lot of innocence in some of those young faces. War has not yet hardened them. (VHS)

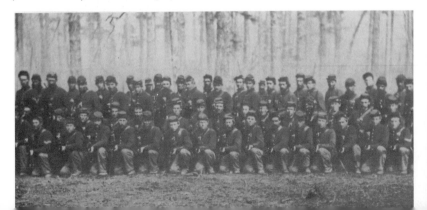

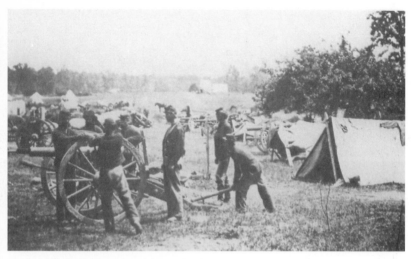

One of Smith's batteries runs through its drill. (VHS)

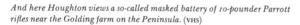

And here Houghton views a so-called masked battery of 10-pounder Parrott rifles near the Golding farm on the Peninsula. (VHS)

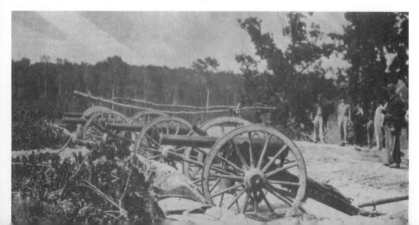

Here an entire battery stands in position, banner flying and officers leaning on their swords. This is dress rehearsal for the sake of the camera, not the way they would look in battle. (VHS)

Houghton, like other photographers, did not focus his lens on actual battle scenes, but he did follow the army's movements a little in Virginia. Here he shows part of one regiment breaking camp near Newport News, the wagons loading tents and equipment for the march. (VHS)

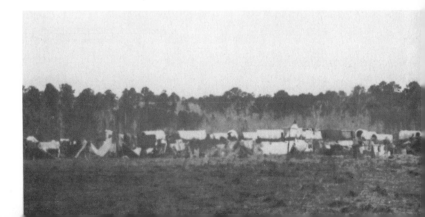

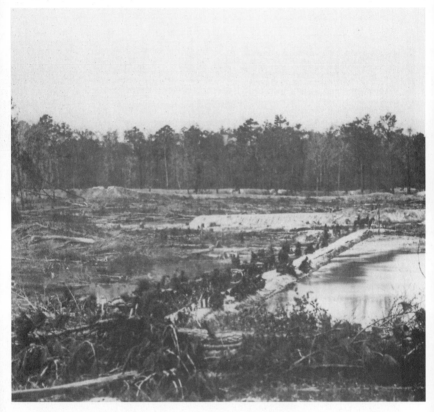

And here at Lee's Mill, Houghton watches as a battery of Major General Romeyn Ayres's Union artillery crosses an earth dam built by the Confederates. Defenses once occupied by the enemy show in the background. (VHS)

The previous image must have been taken sometime after this one was made, showing the same scene from a different angle. Houghton later claimed that the Rebels were still in their works when he exposed this negative. If so, the graycoats were acting very camera shy. (VHS)

Houghton also looked at some of the country through which his Vermont compatriots tramped and fought, finding some marvelous scenes like this one of Ford's old mill at Wolf Run Shoals. Soldiers are popping out of the windows. (VHS)

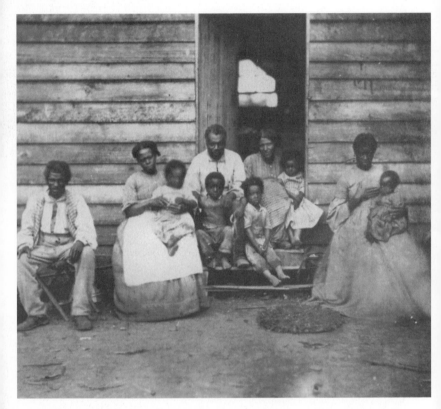

He found this slave family at the Gaines house, facing untold changes in their lives in the years to come. (VHS)

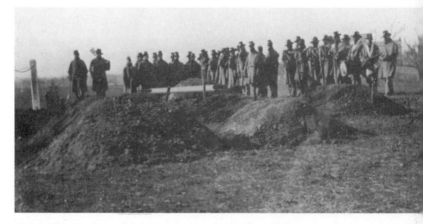

And Houghton found some Vermont boys for whom life's last change had just taken place. Soldiers stand quietly, out of respect for their dead comrades at Camp Griffin. (VHS)

Alas, it was the most oft-repeated scene of the war. Men of the 6th Vermont, alive just before the fight at Lee's Mill, are now reduced to names on rude headboards in the Virginia soil. (VHS)

There they would wait until their government or their families could have them brought home. (VHS)

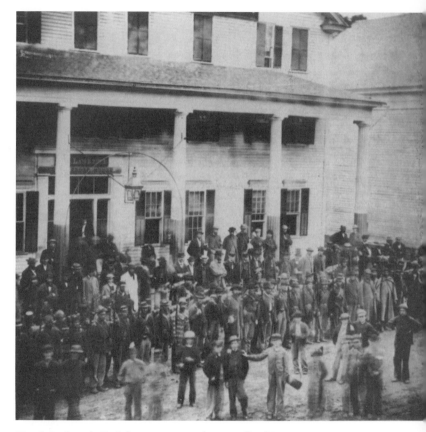

Happily for those who lived, there was a return to home as well, and to a jubilant reception. Here the 4th Vermont comes home to Brattleboro, their uniforms and posture showing that they are hardened veterans now. It is no wonder that the admiring schoolboys cluster and caper around them. They are all local heroes. And so, too, is G. H. Houghton, who went to war with them and brought home the record of their time of trial. (VHS)

The Great March

JOHN G. BARRETT

"From Atlanta to the sea" and on through the Carolinas,
the indomitable Sherman could not be stopped

IN THE LATE AUTUMN of 1864 Major General William T. Sherman with 62,000 men; 35,000 horses, mules, and cattle; 2,500 wagons; 600 ambulances; and a horde of followers marched across the heart of Georgia, leveling much of the countryside and demoralizing the civilian population. This campaign, from Atlanta to Savannah, known as the "March to the Sea," was but one part of a larger operation which had begun the previous May at Chattanooga, Tennessee, and was to end near Durham, North Carolina, in April 1865.

Only in the mountains of northwest Georgia and around Atlanta did the Federal army meet sustained resistance. Thus the moves from Atlanta to the coast and up through the Carolinas were important for reasons other than victories on the battlefield. Their primary significance rests upon the fact that these campaigns provided a glimpse of what later was called "total war."

Two years earlier, while on duty in western Tennessee, Sherman had evolved his philosophy of total war. Concluding that it was impossible to change the hearts of the people of the South, he decided that he could "make war so terrible" that Southerners would exhaust all peaceful remedies before starting another conflict. He stated that while the Southern people "cannot be made to love us, [they] can be made to fear us and dread the passage of troops through their country." Considering all of the people of the South as enemies of the Union, Sherman planned to use his military forces against the civilian population as well as against the armies of the enemy. He believed this plan of action would demoralize not only the noncombatants but also the men under arms. His program of warfare also called for the destruction of the enemy's economic resources. In bringing the war to the home front he hoped to destroy the South's will to fight. With Sherman war was not "popularity seeking." War was "hell." Still, it was not a sense of cruelty and barbarism that prompted him to formulate his new theory of war. It was more a search for the quickest and surest means to end a bloody conflict.

The first application of this new philosophy of war was to be in Mississippi. In Georgia and the Carolinas, however, Sherman repeated the performance but on a much larger scale.

On November 15, 1864, Sherman's army moved out of Atlanta, which had been in its possession since early September, to begin the

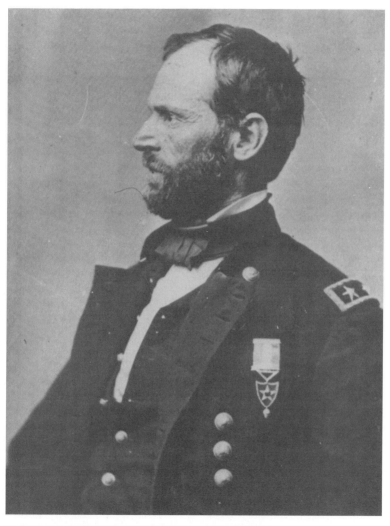

*On the march again. Major General William T. Sherman would not stop
with the capture of Atlanta in early September 1864. There was the rest of
Georgia to conquer and a war to win.* (NEW-YORK HISTORICAL SOCIETY)

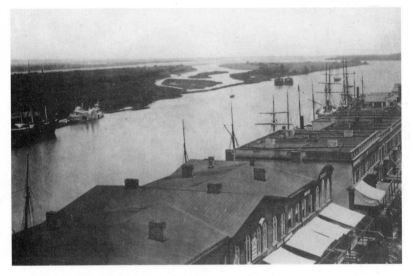

And now his goal would be one of the loveliest cities in all the South, a perfect jewel untouched by the ravages of the war, Savannah. George N. Barnard captured this image of the peaceful river town shortly after the war. (LC)

March to the Sea. This move was a bold, imaginative stroke, but not one designed to draw off enemy troops. Confederate General John Bell Hood, after losing Atlanta, had hoped, by assuming the offensive in late September and marching for Tennessee, to checkmate his foe. But Sherman, after a futile pursuit, decided to abandon the chase and to move, instead, into the interior of Georgia "to smash things up." So in mid-November one of the curiosities of the war occurred. This date found the two main armies in the Western theater, bitter antagonists for three years, purposely moving in opposite directions, never to meet again.

The Federal army on its March to the Sea was divided into two parts. Major General Oliver O. Howard commanded the right wing which was composed of the XV and XVII Corps commanded respectively by Major Generals Peter J. Osterhaus and Francis P. Blair, Jr. The left wing, under Major General Henry W. Slocum, consisted of Brigadier General Jefferson C. Davis' XIV Corps and Brigadier General Alpheus S. Williams' XX Corps. The cavalry was led by Brigadier General Hugh Judson Kilpatrick.

This army marched from Atlanta in three parallel columns, five to fifteen miles apart, and forming a thirty- to sixty-mile front. Averaging ten to fifteen miles a day, it pushed relentlessly toward the coast. The right wing moved through Jonesboro and then to Monticello, Gordon, and Irwinton. The left wing headed toward Covington, Madison, Eatonton, and Milledgeville, the state capital. In the meantime, Kilpatrick's cavalry struck toward Macon and

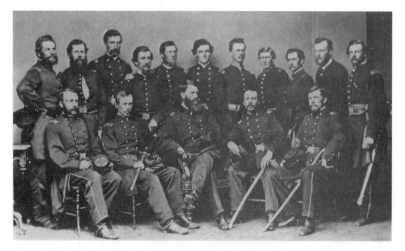

*It was a rested and ready army that Sherman led on its March to the Sea. A
close friend from Missouri, Major General Francis Preston Blair, Jr.,
commanded the XVII Corps. Seated here in the center with his staff, Blair
finished the war a bankrupt, having spent himself dry in behalf of the Union
cause.* (USAMHI)

then withdrew to Gordon and rejoined Sherman
at Milledgeville. The general was traveling with
the left wing. By November 23 Slocum's entire
command was united in and around the capital
city. The right wing was close by at Gordon,
twelve miles to the south.

In Milledgeville the governor's mansion,
which served as Sherman's headquarters, and the
capitol were spared the torch by the Federal
soldiers. The penitentiary, arsenal, and depot,
however, were destroyed by the men in blue,
who also took great delight in holding a mock
session of the Georgia legislature. They declared
the ordinance of secession repealed and voted the
state back into the Union.

The next day the march resumed. Sherman
accompanied the XX Corps which took the di-
rect road to Sandersville. This small community
was reached simultaneously with the XIV Corps
two days later. Earlier, Howard's right wing had
started its movement along the Georgia Central

Railroad toward the coast, tearing up the track
as it went. By December 10 all four of the
Federal corps had reached the vicinity of
Savannah.

When Sherman learned that the city's defenses
had recently been strengthened by the arrival of
15,000 troops under Lieutenant General Wil-
liam J. Hardee, he decided that before launching
an attack he should first establish contact with
the Federal fleet in Ossabaw Sound, south of the
city. The quickest route to the water was along
the banks of the Ogeechee River which flowed
into the sound. But on the south side of the
Ogeechee, near its mouth and fifteen miles from
Savannah, stood small yet formidable Fort Mc-
Allister.

Sherman ordered Brigadier General William
B. Hazen's division to cross the river and take
the fort. The successful assault, lasting barely
fifteen minutes, took place late on the afternoon
of December 13 under the approving eyes of

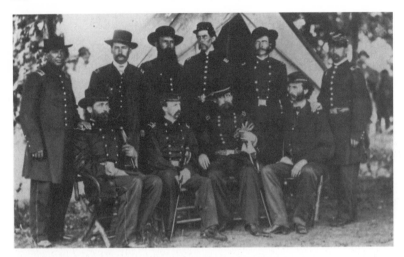

Leading the XIV Corps was Brevet Major General Jefferson C. Davis, a veteran of the ill-fated defense of Fort Sumter in April 1861, a man who had shot and killed—some said murdered—a fellow Union general in an argument, and a fighter of unquestioned ability. He sits, gloves and sword in hand, among his staff in a photograph made in Washington in July 1865. (USAMHI)

General Sherman who remained on the north bank of the Ogeechee. Hazen's casualties were three times those of the enemy. Still, he managed to capture the entire Confederate garrison along with fifteen guns.

That night, aboard the gunboat *Dandelion* in Ossabaw Sound, Sherman wrote Secretary of War Edwin Stanton that he regarded "Savannah as already gained," and so it was. Hardee abandoned the city on the night of December 20, retreating across the Savannah River on pontoon bridges covered with rice straw to muffle the sound of horses and wagons. By the next morning the port city was in Federal hands, and on December 22 Sherman wired President Lincoln: "I beg to present you as a Christmas-gift the city of Savannah, with one hundred and fifty guns and plenty of ammunition, also about twenty-five thousand bales of cotton."

For the Federal soldiers the march through Georgia had been "one big picnic." Having destroyed the railroad to his rear, Sherman was dependent upon the countryside for supplies. The army, in order to subsist, was permitted to forage freely as it moved through the fertile lands of the state. Meeting only token resistance from Major General Joseph Wheeler's cavalry and the Georgia militia, the men, as one of them put it, "rioted and feasted on the country," and the order to "forage freely" was interpreted by some to loot and burn. On a sixty-mile front the army had devastated the land as it moved toward the coast.

By all of the accepted rules of strategy, Sherman's veterans should have been transferred immediately to a theater where they "could pull their own weight." The Federal Navy had the ships to transport them to Virginia where Lieu-

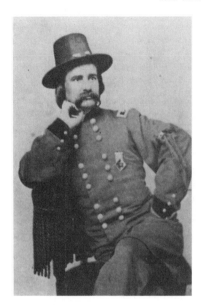

One of the foremost non-West Point-trained officers of the war led the XV Corps after January 8, 1865, as the Union Army made its way north from Savannah. Major General John A. Logan was a politician with a natural bent for war. In this portrait made at war's end, he wears mourning crape for President Lincoln on his sleeve, and a XV Corps badge on his blouse. (CWTI)

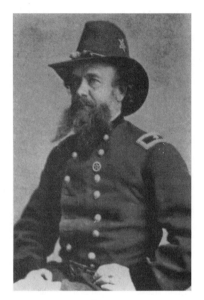

Brigadier General Alpheus S. Williams temporarily commanded the XX Corps on the March to the Sea. He wears on his blouse the star badge of his corps. (USAMHI)

tenant General Ulysses S. Grant had General Robert E. Lee bottled up behind fortifications at Petersburg. Grant was desirous of this move but Sherman was not. He wanted, instead, to apply total war to the Carolinas. Every step northward from Savannah, he felt, was as much a direct attack on Lee at Petersburg as would be operations within sound of the artillery of the Army of Northern Virginia. Furthermore, Sherman was not adverse in the least to the idea of punishing South Carolina for her role in bringing on the war.

When the news of Major General George Thomas' resounding Union victory over Hood at Nashville, Tennessee, reached Grant on December 18, he penned Sherman a confidential note giving him permission to move through the Carolinas. This communication reached Savannah on Christmas eve. An elated Sherman immediately informed his chief that he expected "to be ready to sally forth again" in about ten days.

In Savannah the Federal troops were generally well behaved. Brigadier General John W. Geary's division of Easterners garrisoned the city and, with the exception of a few minor incidents, all depredations ceased. Sherman even went so far as to permit Episcopal churches to omit prayers for the President of the United

The men that these and other generals led would really decide the outcome of the campaign, and they were the raw, toughened Western fighters who had already been blooded at places like Shiloh and Chickamauga. "In my judgment," said Sherman, they were "the most magnificent army in existence." (USAMHI)

States, saying at the same time to ministers who asked if they might pray for the Confederate President, "Yes, Jeff Davis and the devil both need it." Also, the general wisely allowed the city officials to retain their posts, and he strengthened the hand of the mayor, Dr. Richard D. Arnold, whom he had known before the war. In fact, the situation was so peaceful in "handsome" Savannah that every day seemed like a Sunday to Sherman.

During this period of relative tranquillity, preparations for the march north were not neglected. It was a busy time. Nevertheless, very few changes were made in the organization of the army. As during the March to the Sea, it comprised two wings of two corps each. The cavalry remained under Judson Kilpatrick. In the upper command posts there was only one major change. Major General John A. Logan replaced Osterhaus as commander of the XV Corps.

Sherman's plan of campaign called for feints on both Augusta, Georgia, and Charleston, South Carolina, and a march directly on Columbia, the South Carolina capital, and then to Goldsboro, North Carolina, by way of Fayetteville, on the Cape Fear River. Goldsboro was chosen as the destination because that city was connected to the North Carolina coast by two rail lines running, respectively, from Morehead City (via New Bern) and Wilmington, to the south. By this circuit the Federal army could destroy the two chief railroads of the Carolinas, disrupt enemy supply transportation, and devastate the heart of the two states.

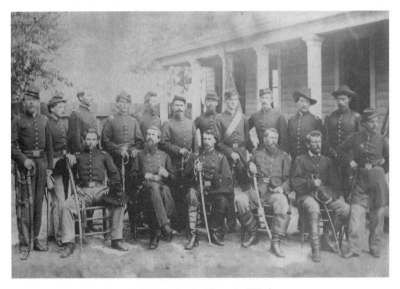

The officers, like these of the 82d Illinois posing in Atlanta, could look civilized enough, indeed resplendent at times. (CHS)

Sherman planned to cut himself off completely from his base in Savannah, hence he could expect no government supplies until he reached the Cape Fear River. His wagons could carry only limited provisions. Thus the army once again would have to "forage liberally on the country during the march." To regulate the foraging parties, very strict orders were issued. But, as was the case in Georgia, there was a wide discrepancy between the orders and the actions of some of the men. Foraging parties many times degenerated into marauding bands of mounted robbers which operated not under the supervision of an officer but on their own. Most of the pillage and wanton destruction of property in both Georgia and the Carolinas was the work of the "bummers," as this peripheral minority of self-constituted parties of foragers was called.

When Sherman crossed the Savannah River and commenced his march through the Carolinas

the latter part of January 1865, the meager Confederate forces that could possibly be brought to oppose him were scattered from Virginia to Mississippi. So by February 7 the major part of the Federal army had penetrated without difficulty well into South Carolina and was encamped along the South Carolina Railroad. Five days later Orangeburg, to the north, was in Sherman's hands.

From Orangeburg the army moved out in the direction of the capital city of Columbia, destroying the railroad as it went. By late afternoon of February 15, only two weeks and a day after the invasion of the Palmetto State had begun in earnest, Sherman's troopers were within four miles of Columbia, called by them the "hell-hole of secession." That evening the so-called Battle of Columbia began when a division of the XV Corps quite carelessly camped within range of the Confederate artillery east of the

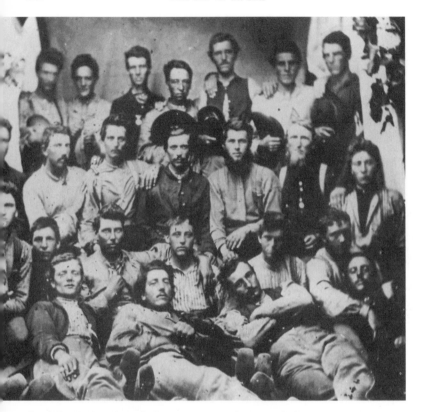

But the boys in the ranks, unlike their counterparts in the Army of the Potomac, never took the spit and polish of soldiering to heart. They were as content with informality as these men of the 17th Ohio, posing with friends back home. (LO)

Congaree River and got a mild shelling. The next morning, February 16, Federal skirmishers carried the Confederate defenses around the Congaree River bridge but found only the charred timbers of the structures remaining. On this same date Sherman issued his instructions for the occupation of the city. General Howard

was to "destroy public buildings, railroad property, manufacturing, and machine shops" but was to "spare libraries, and asylums, and private dwellings."

By this time Columbia had become a city without law and order. Chaos prevailed. The establishment of martial law on February 17 had

not prevented acts of robbery and pillage. Negroes, soldiers, and local citizens either vied with one another for government provisions or turned their attention to the looting of shops and stores.

Early on the morning of the same day Columbia was awakened by a tremendous explosion at the South Carolina Railroad depot, caused in all probability by a looter accidentally igniting the powder stored there. And with the coming of daylight the looting got worse. The state commissary was plundered and in some parts of Main Street, it was reported, "corn and flour and sugar cover[ed] the ground." All the while Lieutenant General Wade Hampton's Confederate cavalry was slowly withdrawing from the city along the Camden and Winnsboro roads.

Columbia, undefended and deranged, was now at the complete mercy of the enemy. Sometime before noon Sherman, with a few members of his staff, rode into the city. Fewer than twelve hours later a large part of South Carolina's capital, including the state house and other public buildings, scores of private homes, several churches, and even a convent lay in smoldering ruins, the result of a great fire that had raged uncontrolled throughout the night. The origin of this conflagration has been the subject of considerable controversy from the day it occurred.

The most likely explanation is that it began from burning cotton. Columbia at this time was a virtual firetrap because of the hundreds of cotton bales in her streets. Some of these had been ignited before Sherman arrived, and a high wind spread tufts of the burning fiber over the city. Also, poorly disciplined troops, many of whom were intoxicated, became incendiaries. In a laconic statement made after the war General Sherman summed up his sentiments on the burning of Columbia: "Though I never ordered it and never wished it, I have never shed any tears over the event, because I believe that it hastened what we all fought for, the end of the war."

The Federal army remained in the city for two days, destroying under orders railroad and public property. The Evans & Cogswell Company, which held the contract for printing Confederate money, was burned, as was the state armory on Arsenal Hill. "They destroyed everything which the most infernal Yankee ingenuity could devise means to destroy," said one native of

But such an army could march and fight. Indeed, Sherman's wagon trains, like this one photographed near Savannah, were often hard put to keep pace. (USAMHI)

Columbia. Then, on February 20, to the accompaniment of hisses and boos from the people along the streets, the troops moved out in the direction of Winnsboro.

This historic old town, as well as Camden to the southeast, and Cheraw to the northeast, suffered much at the hands of the Federal troops. At Cheraw, the army's last stop in South Carolina, Sherman learned that his former antagonist in Georgia, General Joseph E. Johnston, had replaced General P. G. T. Beauregard as commander of the Confederate Army of Tennessee in North and South Carolina. He now concluded that Johnston would unite his widely scattered forces and, at a place of his own choosing, strike one of the Federal corps on the move. Fully aware that the battle he wished to avoid was, in all probability, unavoidable, Sherman put his army in motion for Fayetteville, North Carolina, some seventy miles northeast of Cheraw.

South Carolina was now free of this army which had applied total war in its severest terms within her borders. Lieutenant Charles S. Brown of the 21st Michigan never spoke truer words

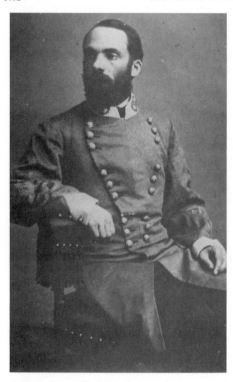

They also had to be wary of lightning raids by Confederate cavalrymen like Major General Joseph Wheeler, who accounted for much of the Southern attempt to keep Sherman at bay during the March to the Sea. It was a hopeless task. And it came at a price, for the dashing Wheeler could not control his men. One superior wanted him relieved "for the good of the cause, and for his own reputation." Yet he would go on fighting, and thirty-four years later he would fight again, this time for the United States. In the Spanish-American War, old Joe Wheeler became a Major General of U.S. Volunteers. (LC)

than when he said: "South Carolina may have been the cause of the whole thing, but she has had an awful punishment."

General Sherman entered North Carolina at the beginning of March with the confident expectation of receiving a friendly welcome from its supposedly large number of pro-Union citizens. Thus he had his officers issue orders for the gentler treatment of the inhabitants, and when the state line was crossed, he circulated new instructions regulating foraging activities. But no orders were drafted prohibiting the burning of the great pine forests within the state.

North Carolina's turpentine woods blazed in fantastic splendor as "bummers touched matches to congealed sap in notches on tree trunks." Seldom did the soldiers pass up an opportunity to fire these pine forests, for the burning rosin and tar created a spectacle of flame and smoke that surpassed in grandeur anything they had ever seen before.

On March 8 North Carolina for the first time felt the full weight of the Federal army, the right wing having crossed the state line on this date. General Sherman, traveling with the XV Corps, made his headquarters near the Laurel Hill Presbyterian Church, a region his soldiers thought looked "real Northernlike," but tor-

Major General Ambrose R. Wright commanded one of several Confederate defense lines across portions of Georgia, designed in the futile hope of stopping Sherman. Wright was also president of the Georgia state senate, next in line for the governorship, and when Yankee invasion split part of the state away from the capital in Milledgeville, Wright proclaimed himself governor of the remnant. No one paid any attention. (VM)

Another erstwhile politico trying to stop the Yankee invasion was Brigadier General William M. Browne. An Irishman by birth, he had been on Confederate President Jefferson Davis' personal staff, and for a little over a month in 1862 served as temporary Secretary of State of the Confederacy. (LC)

rential rains soon turned the roads into a sea of mud and water, making them almost impassable for either man or beast. The most formidable obstacle in the path of the army lay in the dark, swirling waters of the Lumber River and its adjacent swamps. It took a tremendous effort on the part of the Pioneer or Engineer units to get the army through this region. Sherman called it "the damnest marching I ever saw."

To the southeast, in South Carolina, the Federal cavalry under General Kilpatrick crossed the Pee Dee River on March 8. Here Kilpatrick learned that the Confederate cavalry under Wade Hampton was only a few miles behind

him and moving rapidly on Fayetteville. Hoping to intercept the enemy, the Federal general set a trap for the Confederates only to have his own camp at Monroe's Crossroads surprised and his troops put to flight on March 9 by the enemy horsemen. To make his own escape, Kilpatrick, clad only in his underclothes, had to spring from the bed of a lady companion, mount the nearest saddleless horse, and disappear into a neighboring swamp.

Since the Federal cavalrymen eventually drove the Confederates out of their camp, there was considerable disagreement over who got the better of the fighting, contemptuously tagged by the Federal infantry as "Kilpatrick's Shirttail Skedaddle." Yet the fact stands that by engaging

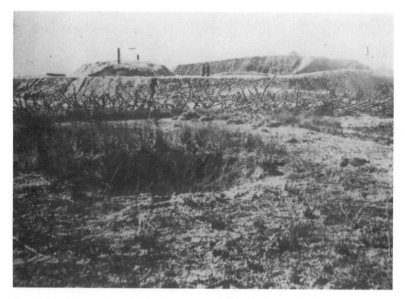

None of the Confederates, amateur or professional, could keep Sherman from the sea. On December 13, 1864, the Federals launched their attack on Fort McAllister, principal coastal guardian of Savannah, and that same day it was all over. (LC)

Kilpatrick in battle, Hampton was able to open the road to Fayetteville which the Federal camp blocked. The Confederate cavalry joined General Hardee's army near Fayetteville the evening of March 10.

The Confederate forces withdrew across the Cape Fear River on March 11, burning the bridge behind them. At the same time the Federal advance entered Fayetteville from the south. The city suffered a great deal as a result of the Federal occupation. Besides the destruction of numerous public buildings, including the United States arsenal which had served the Confederacy for four years, there was considerable pillaging by the bummers before Major General Absalom Baird garrisoned the city with three brigades.

While at Fayetteville Sherman took the opportunity to replace all the rejected animals of his trains with those taken from the local citizens and to clear his columns of the vast crowd of white and black refugees that followed the army. He called these followers "20,000 to 30,000 useless mouths." To Major General Alfred H. Terry at Wilmington, North Carolina, he wrote: "They are dead weight to me and consume our supplies."

By the middle of March Sherman had his entire force across the Cape Fear, and the move on Goldsboro had begun. The general was in a happy frame of mind as he watched his troops march by. The campaign was running smoothly. Goldsboro, he felt sure, would be his in a few days.

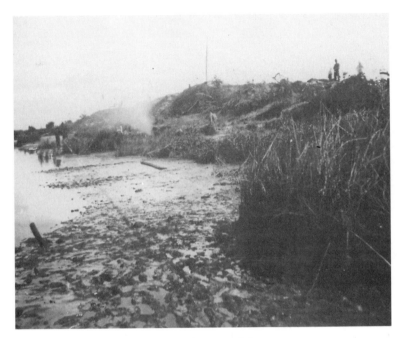

Though the fort's parapets like this one were well constructed, there were too few defenders inside. Samuel Cooley photographed the fort a few months after its fall. (LC)

From Savannah to Fayetteville Sherman had moved his army in flawless fashion, but from this latter place to Goldsboro his operations were definitely characterized by carelessness in the management of a large command. He placed little importance on Hardee's delaying action at Averasborough on March 16. Also, he allowed his columns to become strung out to such an extent that the Confederates came close to crushing his XIV Corps at Bentonville. At this small village west of Goldsboro General Johnston had skillfully managed on March 19 to concentrate his sparse and widely scattered Confederate forces. They totaled only 21,000 effectives, and

this included both junior and senior reserves as well as the battered remnants of the Army of Tennessee. Fortunately for Johnston there were many able lieutenants in his small command. In no engagement of the Civil War were so few men led in battle by so many veteran officers of high rank. Two full generals of the Confederacy and four lieutenant generals were among the galaxy of officers present at Bentonville. For a while it looked as though the day would be carried, but Federal reinforcements late on the afternoon of March 19 blunted the Confederate offensive.

More Federal troops reached the field on March 20, and by the next day Sherman had his

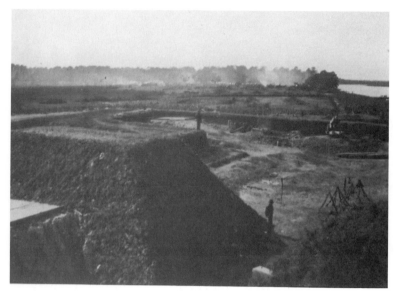

The Savannah River, in the distance, flows by Fort McAllister, where Yankee sentinels now stand post. (LC)

entire command in the vicinity of Bentonville. That night Johnston withdrew his small force to Smithfield fifteen miles to the north. Rather than pursue his badly outnumbered opponent, Sherman decided to march his victorious troops into Goldsboro. There they were joined by the command of Brigadier General John M. Schofield which had marched up from Wilmington and New Bern.

This completed the task Sherman had set out to do upon leaving Savannah. His army was now united with that of Schofield's. Large supply bases on the North Carolina coast were available by rail and the countryside from Savannah to Goldsboro, in a swath an average of forty miles across, had been laid waste.

Sherman now decided it was time to discuss with Grant the plans for a possible junction of their armies around Richmond. He was a na-

tional hero as a result of his Georgia and Carolinas campaigns, and as yet the climactic battle of the war had not been fought. So, with Grant's permission, he could still share with the Army of the Potomac the glory of capturing the Confederate capital.

Late in the day of March 25 Sherman boarded a train for City Point, Virginia, Grant's headquarters. In a festive mood before departure, the general told friends that he planned to see Grant in order "to stir him up" because he had been behind fortifications so long "that he had got fossilized."

Back in North Carolina, at Smithfield, Johnston, uncertain of Sherman's next move, used the time to reorganize his hodgepodge forces. He even held a review for Governor "Zeb" Vance of North Carolina and several ladies from Raleigh. It was thought that the troops "once

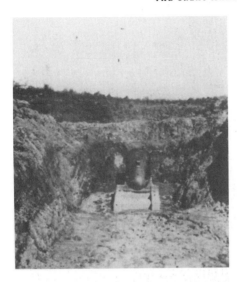

Mortars like this were absolutely useless against Sherman's attack on the fort. It fell with almost the entire garrison within hours. (USAMHI)

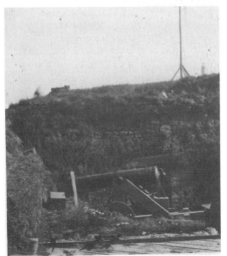

Fighting was hand to hand for a time, as the defenders were pushed back into their bombproofs like the openings behind this cannon. The hole behind the cannon is a powder magazine. (LC)

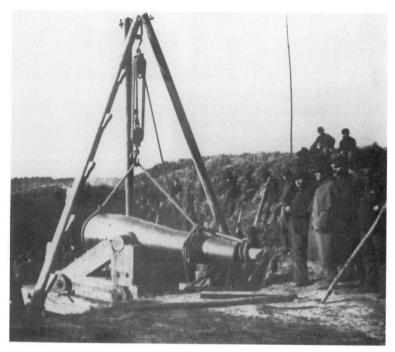

Then commenced the inevitable cleanup, and the conversion of Fort McAllister into a Union strongpoint. A work party is removing a Confederate Columbiad from its carriage. (LC)

more" looked "like soldiers." The general was well pleased with the way his men had fought at Bentonville, but in early April, when rumors began to circulate around the camps that Richmond had fallen, morale among the troops started to wane badly. Desertions increased dramatically. Patrols were busy night and day arresting men absent from camp without leave. "Heavens the gloom and how terrible our feelings," wrote a staff officer.

Johnston had no illusions about the future. Shortly after Bentonville he had informed General Lee that "Sherman's force cannot be hindered by the small force I have. I can do no more than annoy him." More and more he became convinced that the only hope lay in bringing the Confederate armies in Virginia and North Carolina together. Even so, Johnston must have thought that hostilities were about to end for at this time he ordered Lieutenant General A. P. Stewart to suspend all executions of deserters. The time for all killing to stop was almost at hand. If the South could go on at all now, the decision rested in the hands of Lee at Petersburg.

And here an endless procession of workmen is hauling projectiles for big guns like that Columbiad, as McAllister is rearmed and fortified for the Union.
(UNIVERSITY OF GEORGIA LIBRARY, ATHENS)

Now the Columbiad must guard a Yankee-controlled Savannah River and provide a strong base in his rear. For "Uncle Billy" Sherman is going to turn north toward the Carolinas. (LC)

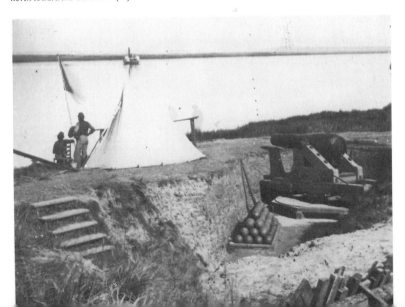

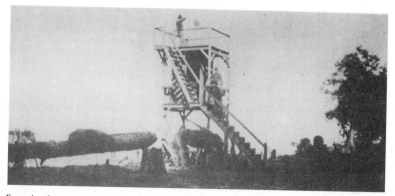

From signal towers like this one, Federal messages will pass to the ships in the river or to outposts on the other side. Savannah will be ringed with Yankees. (NA)

It is all Union territory now. When George Barnard turned his lens toward the river soon after the war's close, almost all sign of the conflict had been erased. (LC)

The fighting done, Savannah and its people returned quickly enough to peaceful pursuits. Here at Buena Ventura plantation Barnard might well have wondered if there had ever been a war at all. (LC)

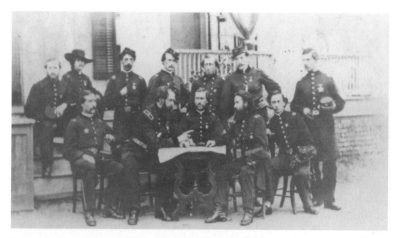

Few occupied cities in Sherman's path suffered so little from their conquerors as Savannah. Sherman put Brigadier General John W. Geary in charge as military governor. Geary, shown here at the table with his staff, his finger pointing, ruled fairly and firmly. He would later become governor of Pennsylvania. (LC)

A Savannah photographer named Beckett captured several views of the city during its occupation, and they attest to its tranquillity. Here is the Pulaski Hotel on Broughton Street . . . (LO)

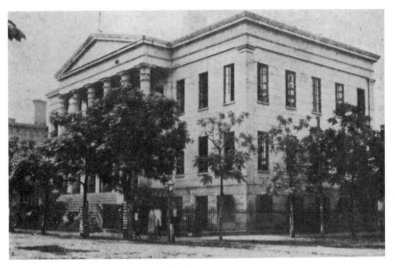

. . . and here the customs house and post office. (LO)

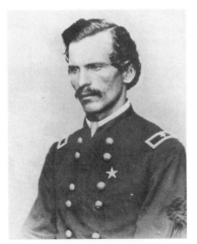

Colonel Henry A. Barnum became Geary's provost in the city, carefully keeping order and a tight rein on unruly soldiers. Repeatedly wounded during the war, he had actually been proclaimed dead and buried two years before, until someone discovered that they had misidentified the man in the ground. He appears here at war's end in his new rank as brigadier. (P-M)

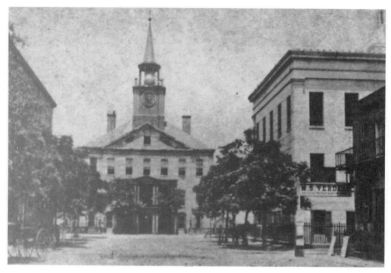

Savannah city hall at the foot of Bull Street attracted Beckett's camera one day at 12:23 by the tower clock. (LO)

Only a few outward signs show that there was still a war going on. This beautiful Greek Revival building became an ordnance depot for a time . . . (LO)

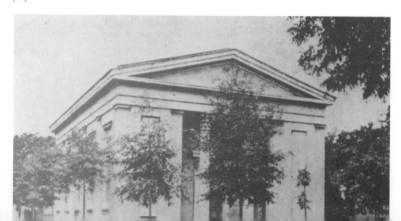

. . . and Oglethorpe Barracks, once home to Confederate units, now bristles with bluecoats, who would hold Savannah while Sherman marched on, at the end of January 1865, toward the Carolinas. (USAMHI)

Oddly, the Confederates had done little to anticipate defending South Carolina from Sherman. Worse, they had a surplus of generals and a dearth of soldiers. Major General D. H. Hill and others tried to plan a defense of the state, but their counsels were divided and their troops too few and too scattered. (CWTI)

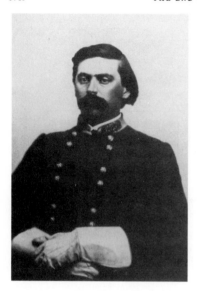

Once again it fell largely to the cavalry to try to retard Sherman's progress. Brigadier General Pierce M. B. Young led his tiny mounted division in repeated attempts to slow the enemy advance, all to no avail. (LC)

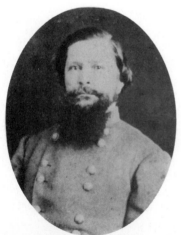

The Southerners tried their best to block passage of the rivers in Sherman's path. Brigadier General Zachariah Deas attempted to guard the crossings of the Edisto River, but when the enemy approached, he had to retire to avoid being overwhelmed. (CWTI)

And so, inevitably, on February 17, 1865, Sherman captured Columbia, capital of South Carolina. When he arrived, he found the new state house, still uncompleted. (USAMHI)

And in the wake of occupation came the burning and near destruction of the city. Barnard put his camera on the state house grounds to view the ruins of the city in 1865, a devastation that would unjustly mar Sherman's reputation for a long time to come. (LC)

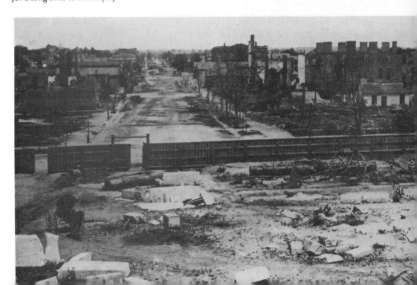

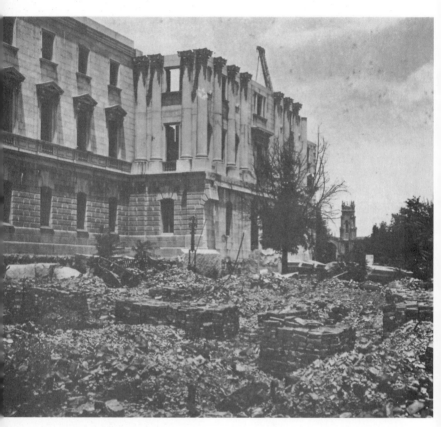

The state house itself did not survive the conflagration. (LC)

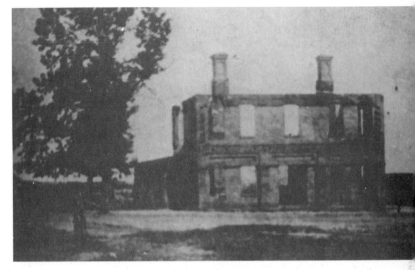

The burned-out offices of the South Carolina Railroad. (SOUTH CAROLINIANA LIBRARY)

The remains of Hunts Hotel, now only chimneys and rubble. (SCL)

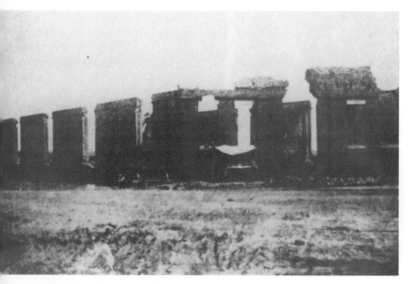

All that remains of the South Carolina Railroad's freight depot . . . (scl)

. . . of the bridge over the Congaree River . . . (scl)

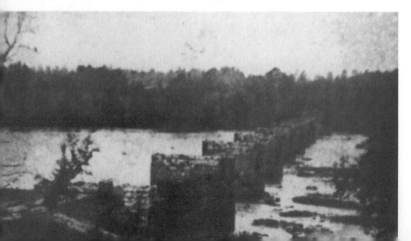

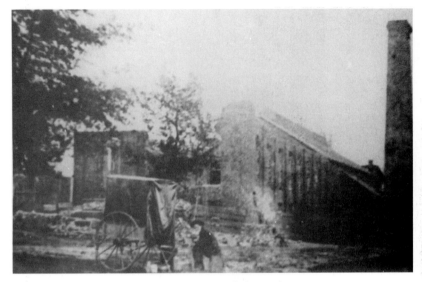

. . . of the state armory on Arsenal Hill, with the photographer's wagon in the foreground. (SCL)

Even the Presbyterian lecture room fell to the flames. (SCL)

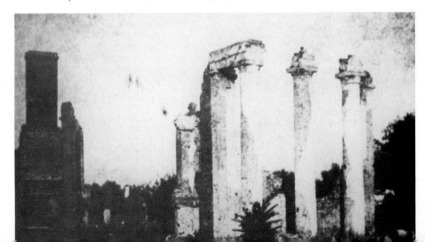

Here is what is left of the printing establishment of Evans & Cogswell on West Gervais Street. Confederate treasury notes had been printed here for years. Now even though some of the presses were gotten away safely before Sherman came, the building is as worthless as the scrip it had been printing. (SCL)

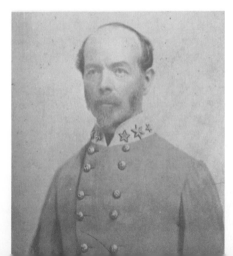

When Sherman's march brought him into North Carolina at the beginning of March, he came face to face once more with his old adversary from the Atlanta Campaign, General Joseph E. Johnston. It would be their final confrontation, and Uncle Billy would have it all his own way. (VM)

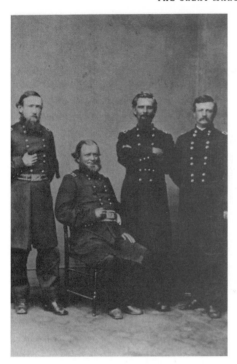

The first real fight in North Carolina came at Averasborough on March 16, with the division of Brigadier General William T. Ward of the XX Corps in place for an attack. Ward is seated here with his brigade commanders. Brevet Brigadier General William Cogswell stands at right, next to Brevet Brigadier General Daniel Dustin. And standing at far left is another brevet brigadier, Benjamin Harrison of Ohio. Twenty-three years from now he will be elected President. This very image was widely distributed in the 1888 campaign. (USAMHI)

Major General Henry W. Slocum was one of Sherman's favorites and exercised overall command of two corps that pushed back the Confederates at Averasborough. He advanced immediately toward Bentonville, North Carolina. (USAMHI)

The erratic cavalryman Brigadier General Hugh Judson Kilpatrick helped bring the enemy to bay at Bentonville. Sherman called him "a hell of a damned fool." (USAMHI)

And in the battle that followed at Bentonville, on March 19, Slocum made his headquarters in this home, the Harper house. (WESTERN RESERVE HISTORICAL SOCIETY)

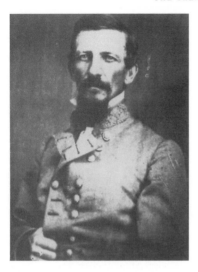

The first Confederate force on the scene to meet Slocum was the corps of Lieutenant General A. P. Stewart of Tennessee. Johnston hoped for a surprise attack against Slocum at Bentonville. (VM)

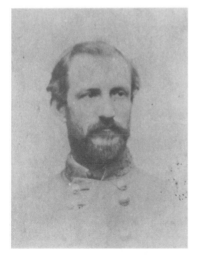

The first fighting came in the Confederate center, where the North Carolina division of Major General Robert F. Hoke repulsed an attack by the Federals. (SOUTHERN HISTORICAL COLLECTION, UNIVERSITY OF NORTH CAROLINA)

One of Hoke's regiments was the 31st North
Carolina, led by dapper Colonel J. V. Jordan.
The enemy had long known what he looked like,
for this portrait of him was captured in New
Bern, North Carolina, when the town and its
photographer's studio fell to the Federals in
1862. (USAMHI)

Among the Confederates in the ranks was Private
William Washington Cavender of the 1st
Georgia Cavalry. Reputed to be an excellent
marksman with the pistol, he apparently took his
skill seriously enough to point it directly at the
camera. (DALE SNAIR COLLECTION)

Sherman had such a surfeit of troops by this time that whole army corps were left out of the fighting. Major General Alfred H. Terry and the X Corps spent most of the campaign marching rather than in battle, much to the derision of the combat veterans from other commands. Against such numbers, the Confederates were almost powerless. (NA)

And so, by the end of March 1865, the Carolinas, like Georgia before them, were conquered. Shortly after the war George N. Barnard came back to Savannah to make a series of images, among them this one of a fountain. Standing in the distance, to the right of the fountain, are two officers, apparently Confederates still wearing their uniforms. If so, it is fitting that one of the photographs with which Barnard concluded his Civil War coverage should include men that he and Sherman had spent so many months pursuing. (IMPERIAL WAR MUSEUM, LONDON)

Petersburg Besieged

RICHARD J. SOMMERS

After three years the Union finally has Lee at bay,
but the quarry goes to ground and Grant can only wait

CONFIDENT CAPITAL of a nascent nation, Richmond for two years owed her redemption and salvation to General R. E. Lee's Army of Northern Virginia. Lee defended her best by keeping the enemy far afield. By late spring 1864, however, Lieutenant General U. S. Grant's Federals forced Lee back to Richmond's immediate vicinity. Then in the final decisive struggle the two great chieftains grappled for Petersburg, guardian of Richmond's lifeline to the Southern heartland. Through the Cockade City, as Petersburg called herself, ran the railroads linking the capital to the upper Shenandoah Valley and to the blockade runners' Atlantic ports. Whoever controlled Petersburg would control Richmond.

As early as May 1864, while Grant and Lee battled at Spotsylvania, Major General Benjamin F. Butler's Army of the James seized a central position on Bermuda Hundred and briefly threatened both cities. Confederate General Pierre G. T. Beauregard's victory at Drewry's Bluff on May 16 contained that danger, and Petersburg's tiny garrison under Brigadier Generals Henry A. Wise and James Dearing and Lieutenant Colonel Fletcher Archer checked another threat on June 9—a date the city thereafter celebrated as her time of deliverance. Sal-

vation looked short-lived, though, as Grant's main force assaulted the rail center a week later. Major General William F. Smith's XVIII Corps stormed Petersburg's outer defenses on June 15. Behind him came Major General George G. Meade's Army of the Potomac, which had moved through Charles City Court House and crossed the broad James River at Wilcox's Landing by boat and pontoon bridge. Still, Union hesitancy and Confederate valor, especially that of Major General Bushrod Johnson's division, stopped the onslaught short of Petersburg itself between June 16 and 18.

As he had since May 7, Grant responded to a frontal check by extending his left around the graycoats' right. His severe defeat in the resulting Battle of the Weldon Railroad on June 22—and his recognition that his troops needed rest after seven weeks of incessant fighting—caused him to settle down before the Confederate works east of Petersburg. Grant's war of maneuver was over. The Siege of Petersburg had begun. Here would be decided the fate of the rail center, the capital—perhaps even of Lee's army and the Confederacy itself.

This decision would not come in one great Napoleonic battle. No Civil War battle—except

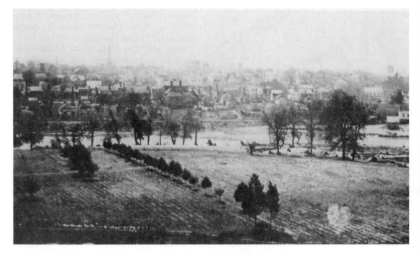

Petersburg, Virginia, major railroad city of the state and key to the capture of Richmond. In June 1864, after months of fighting in the Wilderness and at Spotsylvania, Lieutenant General U. S. Grant and his Union Army were finally close enough to Petersburg to strike. (USAMHI)

Nashville—achieved those results, and the Petersburg operation did not even aspire to them. Yet Petersburg was not really a siege in the classical European sense, either. Rather it was a grim, relentless effort through which Grant fixed the Southerners in place strategically and tactically to wear them down in a war of attrition. Rather it was, too, a valiant and increasingly desperate effort by Lee to retain tactical mobility, regain strategic mobility, and avert impending disaster. "We must destroy this army of Grant's before he gets to James River," Lee had warned in May. "If he gets there, it will become a siege, and then it will be a mere question of time." Yet as ever, the Virginian did not resign himself to apparent ill fate but strove against the odds to make his own fate. Petersburg would be his greatest such effort—and virtually his last.

For nine and one-half months he and Grant vied for Petersburg and Richmond. Their clash involved battles, of course: flare-ups of heavy but brief fighting punctuating weeks and even months of relative quiescence. But still more it involved supply lines and supplies, permanent fortifications and light fieldworks, and ever expanding fields of operations eventually spanning two rivers and stretching for almost fifty miles.

Supply lines, after all, were what made Petersburg militarily important. A short north–south railroad just west of Bermuda Hundred linked Richmond to Petersburg. Four other railroads fanned out from the city—one northeast toward City Point; one southeast toward Norfolk; one south toward Weldon and Wilmington, in North Carolina; and one—the Southside Railroad—west toward Burkeville and Lynchburg. The two easterly lines fell to Grant when he arrived before Petersburg in mid-June. Not until two months and four tries later, though, did he finally get a permanent choke hold on the Weldon Railroad at Globe Tavern. Even then the

*For the first time in the campaign, Grant
managed to steal a march on his
adversary . . .* (ROBERT J. YOUNGER)

creasing numbers of sick and wounded, and
Provost Marshal General Marsena Patrick's
"bull pen" for captured graycoats awaiting
transfer to Federal prisons in the North.

Also near City Point Grant established his
permanent headquarters and eventually his
1864–65 winter living quarters. From that cen-
tral location he initiated his onslaughts against
Southern positions; some battles he waged on
distant sectors without even leaving City Point,
though he usually preferred riding to the front
to observe events.

From City Point, too, flowed the supplies for
his command. Some went to nearby garrisons.
Other supplies crossed the lower Appomattox at
Broadway Landing and Point of Rocks to Ber-
muda Hundred. From Bermuda Hundred the
supply lines eventually bridged the James—
from Jones's Neck to Deep Bottom in June, from
Jones's Landing to Aiken's (Varina) Landing in
September—to support the growing Northern
presence on the Peninsula that threatened Rich-
mond directly. Most supplies meantime headed
southwest toward the main body aiming for
Petersburg. To haul these supplies, the Federals
operated the captured City Point and Weldon
railroads, connected them via the U.S. Military
Railroad that provided lateral service along the
Union battle line to Globe Tavern, and ran
spur lines westward to Poplar Spring Church
and Cummings's farm.

These railroads were the final link that
brought the North's vast agricultural and in-
dustrial resources to City Point, and thence to
Grant's soldiers in the field. Superior numbers,
backed by superior matériel, could better en-
dure the hot, dry summer when the siege began
and the cold winter through which it continued
—could better endure the grueling ordeal of
close trench warfare and the bitterness of re-
peated checks—than could the starving, tattered,
thinning ranks in gray. In the long run, such
superiority could not help but tell. To Grant's
credit, he understood how to convert these po-
tential advantages—which, after all, his prede-
cessors in the East had enjoyed, too—into posi-
tive achievements.

Over against Federal advantages, the Con-
federates increasingly suffered from their de-
teriorating logistical situation. Temporary or

graycoats could use the latter tracks northward
to Stony Creek Depot, from where they trans-
shipped supplies to Petersburg by wagon. Five
Federal drives westward against those wagon
roads and against the Southside Railroad set the
course for the rest of the campaign. The Yankees
finally severed the Southside tracks on April 2,
1865; that night Lee abandoned Petersburg.

Long before Grant reached that final Con-
federate supply line, he made sure his own forces
remained in good supply. The James River, con-
trolled by the U.S. Navy and guarded by six
Union garrisons, afforded an unbreakable supply
link from Hampton Roads westward to City
Point, seven miles northeast of Petersburg, at the
mouth of the Appomattox River. The City Point
hamlet soon swelled into the well-fortified nerve
center of a mighty army. To its rapidly expanded
wharves came ships bearing reinforcements,
munitions, and supplies. In its environs grew up
warehouses for those supplies, hospitals for in-

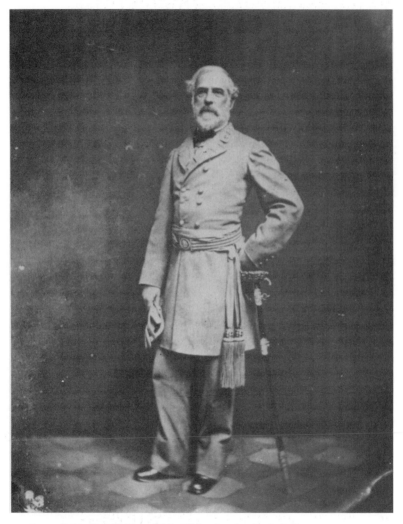

. . . the seemingly unbeatable General Robert E. Lee. Seen here in a portrait by Richmond photographer Julian Vannerson, the Gray Fox seems invincible. (VM)

Grant already held an outpost on the James River about fourteen miles northeast of Petersburg, at Bermuda Hundred, shown here months later as supplies of hay for the Union Army's animals grow into virtual mountains. (USAMHI)

permanent loss of supply lines into Petersburg produced immediate problems. Widespread destruction of supplies and communications elsewhere in the Confederacy by Major Generals William T. Sherman, Philip H. Sheridan, and Alfred H. Terry created even graver difficulties. These hostile actions hastened the collapse of the always primitive Southern supply system, and its revitalization in the war's waning weeks came too late to accomplish much. Hungry, ill-clad, outnumbered troops could still win battles but were not likely to win a long campaign—especially against such well-supplied opponents as the Federals.

This increasing disparity lowered some Secessionists' morale. Awareness that their families were also suffering added to their dismay. And the overwhelming reelection of President Lincoln on November 8—with its unmistakable mandate of four more years of unrelenting war—drastically intensified some

soldiers' disaffection. Over the winter of 1864–65 their desertion—to the Union forces, to the hills, or to home—increased dramatically. Their departure made the disparity between Southern and Northern armies even worse.

Yet Lee had always striven against long odds, and to the very end at Petersburg he continued doing so—through daring feints, bold counterattacks, and great reliance on earthworks—to offset his numerical weakness. More than any other Civil War campaign, Petersburg was marked by extensive use of fortifications.

Both that city and Richmond were ringed with permanent defenses when the campaign began. The capital, indeed, had three such rings, plus two forward water batteries on the James at Chaffin's and Drewry's bluffs. When Union Major General Benjamin Butler occupied Deep Bottom, the Rebels dug a trench eastward from Chaffin's to New Market Heights to contain him. His big breakthrough at Fort Harrison on

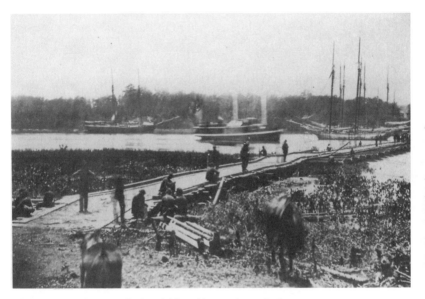

Then, on June 15, Grant completely fooled Lee with a surprise crossing by portions of his army over the James River. Over this speedily erected pontoon bridge at Weyanoke Point, some 2,200 feet long, the IX Corps sped toward unprotected Petersburg. A James Gardner photo. (P-M)

September 29 rendered that trench and much of the Exterior Line of Richmond's permanent defenses untenable—indeed, breached the main camp on Chaffin's Bluff itself. Lee, however, soon stopped that threat and retained the main Richmond works—and the city they guarded—until the final collapse. Yet he could not hurl back the bluecoats, secure in their own fieldworks from Fort Brady through Fort Burnham and thence curving back east toward Deep Bottom.

Comparable stalemate settled over the James itself and Chesterfield County between the two cities. Because the Union Army and Navy had obstructed shallow Trent's Reach to prevent the Confederate Navy disrupting Grant's crossing of the James in mid-June, for the assault on Petersburg, the Yankee vessels were subse-

quently unable to move upriver above the reach. To bypass those obstructions, Butler dug a canal through narrow Dutch Gap neck between August 1864 and January 1865. Beset with engineering difficulties and annoying but not particularly damaging mortar fire, the canal proved a fiasco, unusable by the Union squadron (though after the war it became the river's main channel), because the graycoats established three major batteries along the right bank between the existing defenses at Drewry's and Howlett's bluffs to blast the ships if they came. Even more needed by the Rebels were the fieldworks running south from Howlett's to protect the railroad and "cork Butler in his bottle" at Bermuda Hundred. Yet corresponding Federal trenches across the mouth of the "bottle" twice stopped Beauregard's efforts to overrun the area. And Northern

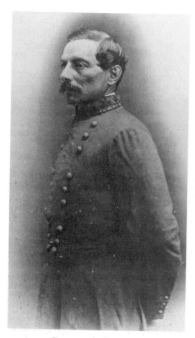

Awaiting them to the east of the city was an old and familiar face, that of General P. G. T. Beauregard. Yankees had fought him at Fort Sumter and First Bull Run and Shiloh, and now, with a handful of defenders, he would meet them again. (USAMHI)

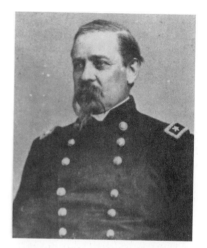

It fell to Major General William F. "Baldy" Smith to make the first Union attack on Petersburg before Confederate reinforcements could arrive. Alas, everything went wrong. (USAMHI)

batteries, along with river obstructions and the characteristic breakdown of Confederate iron-clads, checked the one Southern naval sortie down the James on January 24, 1865.

Meanwhile, the military situation south of the Appomattox in mid-1864 was more fluid, and the ever extending fieldworks there reflected that fact. The initial Northern onslaught on Petersburg on June 15 overran the permanent defenses to the east, but first one, then another line of trenches that Beauregard hastily threw up halted the drive short of the city. Those temporary works connected with the original permanent defenses at Rives's Salient on the Jerusalem Plank Road, the great southeastern angle where the Confederate ramparts bent back westward before turning northward to reach the Appomattox above Petersburg.

The bluecoats promptly dug their own field-works close up against Beauregard's position east of town, from the lower Appomattox to the Jerusalem Plank Road. West of that highway, the fortifications drew apart, out of rifle range. As the Army of the Potomac drove west—to Globe Tavern, to Poplar Spring Church, to Hatcher's Run—it dug trenches to secure each new conquest and link it to previous gains. Moreover, a rear line from the church back northeastward to Blackwater Creek guarded against cavalry raids.

The Confederates, though, made little effort against the Union rear except for sabotaging an

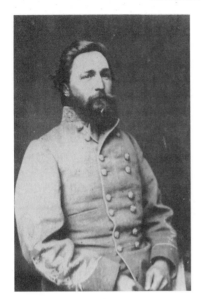

Beauregard held out, assisted by able subordinates such as Brigadier General Alfred H. Colquitt of Georgia. So sparse were Confederate troops by now that within weeks Colquitt would be ordered off to North Carolina to counter threats there. (VM)

ern front line, thirty miles long, whether fieldworks or permanent defenses, constituted a series of redoubts connected by trenches or infantry parapets. Most such Northern forts were named for officers killed from the Wilderness in May 1864 through Petersburg. The Confederates preferred naming strongholds after living commanders on those sectors—such as Lee himself. The respective practices eventually proved less dissimilar, though. Several of those Confederate generals, too, would lose their lives in or near their redoubts or would ultimately die of wounds received there.

Generals could give their names to forts, but trained engineer officers had to design and refine the works. Moreover, special engineer units—the 1st, 15th, and 50th New York Engineers, the U.S. Engineer Battalion, and the 1st and part of the 2d Confederate Engineers—performed much of the sophisticated technical construction, such as assuring proper slopes and angles and sinking mines and countermines. Most of the actual labor with pick and shovel, however, was provided by fatigue parties of infantry, cavalry, and artillery on both sides and also, on the Southern side, by slaves. Combat troops could establish light works of logs, rails, and earth right on the battlefield. Subsequently, engineer officers and labor parties would strengthen the profile with revetments and gabions, improve angles and fields of fire, and perhaps obstruct approaches with abatis, chevaux-de-frise, or a moat. Such refinements converted the primitive initial sheltering parapets into nearly impregnable fortifications.

Behind those fortifications most soldiers could camp in relative safety and even ease, first in tents, then in winter quarters. But men of both armies holding the sector east of Petersburg where shelling and sniping flared daily knew no such respite. Yet even they could seek shelter—against the parapet or in supposedly "bombproof" dugouts, where they waited out the fire and yearned for transfer to a quieter stretch of line—or, better still, a transfer to reserve or to the unravaged country outside the works.

To view that open country, those reserve positions, and the defenses themselves and to send semaphore messages, signal towers rose over each army's trenches on both sides of the James.

ordnance barge to explode at City Point on August 9, rustling a large cattle herd downriver from there on September 15–17, and constantly committing guerrilla depredations. Their main concern, however, lay in protecting their own front, so they dug two lines of fieldworks running southwestward from the city's main fortifications. The forward line guarding the vital supply routes along the Boydton Plank Road and the Southside Railroad remained in Lee's possession until the end. Its eventual capture on April 2, 1865, was what doomed Petersburg.

For fifty-one miles—from west of Richmond on around Petersburg—these Confederate lines eventually stretched. The corresponding North-

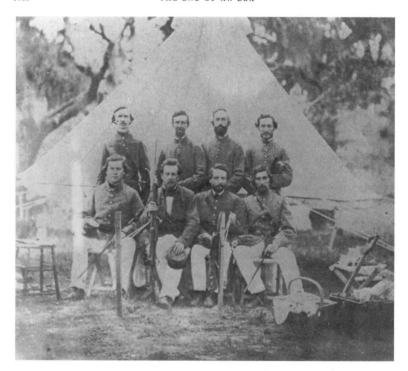

The 25th South Carolina, including whatever remained of this 1861 group from the Washington Light Infantry of Charleston, were among Petersburg's valiant defenders. (WASHINGTON LIGHT INFANTRY, CHARLESTON, SOUTH CAROLINA)

Surer communications clicked along telegraph lines uniting the far-flung sectors to City Point and to Lee's various headquarters: Dunn's Hill, Mrs. Chaffin's, and Edge Hill. Indeed, the relatively static siege was ideal for using telegraph, and within days of units reaching each new position, telegraph wire linked it to the communications net as surely as new earthworks connected it to existing fortifications.

Those fortifications thus provided shelter to the communications and camps behind them

and to the garrisons within them. They also afforded platforms for each army's fieldpieces, siege guns, and light and heavy mortars (like the Federal 13-inch seacoast mortar "Dictator") that shelled each other north from the Jerusalem Plank Road to the lower Appomattox. Such artillery fire, however, was generally intended to annoy enemy troops and civilians and to silence enemy fire. Blasting down ramparts, and digging mines—hallmarks of classical European sieges—played little role in the Siege of Petersburg.

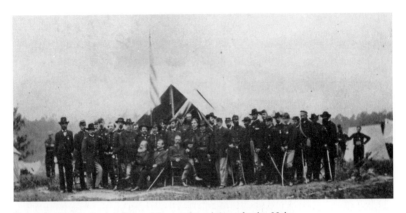

Even as Smith's attack was failing and Lee raced to reinforce the city, Major General George G. Meade sped with the bulk of his Army of the Potomac to join in the attacks. This image by Brady & Company was made just days before, on June 12, at Cold Harbor, northeast of Richmond. Meade is seated at center with his legs crossed, surrounded by his staff. Major General Andrew A. Humphreys is on his right, and seated to the right of Humphreys is the army's provost marshal, Brigadier General Marsena Patrick. Standing immediately on Meade's left is his quartermaster, Brigadier General Rufus Ingalls, and the man second to Ingalls' left is Meade's artilleryman Brigadier General Henry J. Hunt. (USAMHI)

Nor were the works—especially the permanent fortifications around the two cities—scenes of heavy fighting. The severe losses and small results from May 5 to June 18, 1864, had made Grant wary of assaulting well-prepared and well-guarded defenses. Thereafter he generally avoided such frontal charges. To him, his own works were not a forward line for delivering direct charges on nearby enemy ramparts. Rather, they were a great entrenched camp, or staging area, from which he could safely launch heavy forays into the relatively unfortified areas beyond either flank. Such forays would either cut the supply lines and capture Richmond or else would at least force the graycoats to leave their works and fight in the open.

Lee was not averse to fighting in the open. His permanent defenses were safe bases from which Beauregard's and Lieutenant General A. P. Hill's infantry and Lieutenant Colonel William Pegram's artillery could sally against the threats, and his fieldworks were ready means for slowing, stopping, or bluffing Union forays until he could counterattack. Also available to him in the open and screening his communications was his usually superior cavalry—an arm that provided extra mobility for meeting threats on several sectors. Such mobility, along with trench defense and surprise attacks, often made three or four Southern brigades the equal or the better of three or four Yankee divisions. Thus, most of the so-called Siege of Petersburg was not a siege at all but a series of forays and counterblows in largely open country.

The defeat of the first Union drive for the Weldon Railroad on June 22 and the rout of Northern cavalry raiders at Reams' Station on June 29 not only converted the mobile maneu-

James Gardner was present at Charles City Court House on June 14 to capture this image, just as Meade's army was moving through the place on its way to the planned attack. (USAMHI)

ver of spring into the static semisiege of summer but also set the tone for the rest of the campaign. For nearly a month the exhausted armies rested. Then, on July 27, three Federal corps under Sheridan and Major General Winfield Scott Hancock crossed the James above Petersburg and burst forth from the Deep Bottom bridgehead toward Richmond itself. Lieutenant General Richard H. Anderson's Rebels, heavily reinforced from Petersburg, stopped that push far short of its goals. Hancock, however, at least succeeded in drawing most of the Confederate army to the Peninsula. He then hastily returned south of Petersburg to support the impending attack against the weakened Southside Railroad.

In a rare frontal blow, Major General Ambrose E. Burnside spearheaded that attack by exploding a mine under Elliott's Salient east of Petersburg in the early morning of July 30. The resulting Battle of the Crater threatened the city with capture, but Yankee blunders, Union Brigadier General James Ledlie's cowardice, the rout of Brigadier General Edward Ferrero's Negro division, a stout defense by Johnson, and repeated counterattacks by Brigadier William Mahone converted the operation into disaster for the Union forces and restored Lee's front.

Upset but undaunted, Grant struck again on August 14. For a second time, Hancock sallied from Deep Bottom, above Petersburg; for a second time, local Rebels under Major Gen-

When the army reached Wilcox's Landing on the James, it started crossing on steamers. A Brady cameraman made this image probably on June 15, while the crossing was under way. The wharf is crowded with steamers and wagons, as a mighty army is on the move. (WRHS)

eral Charles Field, reinforced by troops from the Southside, checked him right away; and for a second time, the Army of the Potomac sought to take advantage of the diversion of enemy units to north of the James. This time, though, Major General Gouverneur K. Warren's V Corps entered the unfortified country west of the Jerusalem Plank Road and cut the key Weldon Railroad at Globe Tavern on August 18. For four days, his Northerners reeled under Beauregard's and Lee's savage counterattacks, but—reinforced in the nick of time by Brigadier General Orlando Willcox's IX Corps divisions—they retained their hold on the railroad. Subsequent efforts by the returned Hancock to tear up track southward from there, however, met disaster at Reams' Station on August 25. Lee, reluctantly reconciled to losing Globe Tavern, thereafter sought to contain the Federals there and to cover the wagon roads leading into Petersburg.

After another interlude of five weeks, Grant drove for those wagon roads and also for Richmond. On September 29 most of Butler's army crossed the James at Deep Bottom and at a new bridge at Aiken's Landing. His right wing under Major General David B. Birney was again checked temporarily at New Market Heights, but this time his upriver column under Major General Edward Ord stormed the outer Confederate defenses at Fort Harrison (later renamed Fort Burnham). This breakthrough on Chaffin's Bluff bade fair to capture the capital, but Unionist errors and the heroic defense by Brigadier General John Gregg and Lieutenant General Richard Ewell checked the disjointed attempts to press on. However, Anderson failed bloodily to retake Fort Harrison the following day. Lee's own effort to roll up the Northern right on the Darbytown Road on October 7 met initial success but eventual defeat. Federals in force were on the Peninsula

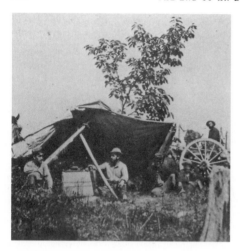

To maintain instant communications with Grant and the rest of the Union Army, a hasty telegraph office was established at the landing. (USAMHI)

to stay, and all Lee could now do was to erect new works to contain them. At least, he had little difficulty parrying Brigadier General Adelbert Ames's feeble probe against those works on the Darbytown Road on October 13.

The Union story on the Southside line was similar. On September 30, Brigadier General Charles Griffin punched through the outer defenses at Poplar Spring Church. Major General John G. Parke's halting efforts to continue toward the Boydton Plank Road and the Southside Railroad, though, were routed by Major General Cadmus Wilcox's and Lieutenant General Wade Hampton's skillful counterblows. Yet neither Wilcox, Hampton, nor Major General Henry Heth could recapture the ground initially lost. Meade thus retained another sector, linked it to his previous conquests, and established his headquarters in Aiken's house, nearer to the new front and the scene of future action. From this latest gain, he would launch Major General Romeyn Ayres's limited probe up the Squirrel Level Road on October 8 and three massive onslaughts and a major raid later in the siege.

The first big blow fell on October 27, as Meade and Butler struck simultaneously against both Confederate flanks. Lieutenant General James Longstreet easily blunted Butler's hesitant Army of the James at Fair Oaks. The situation below Petersburg was more touch-and-go. Three Union divisions finally reached the Boydton Plank Road below Hatcher's Run, only to be heavily counterattacked from four sides. In this his final battle, that splendid Union tactician Hancock repulsed every charge, then skillfully extricated his imperiled corps. With him recoiled the whole Army of the Potomac. On both flanks Grant had struck simultaneously; on neither had he accomplished anything.

This conspicuous failure of his two-pronged assault led Grant to revise his strategy. Thereafter he would mass his forces on the left for a heavy first strike below Petersburg. The initial effort there was simply Warren's destruction of the Weldon Railroad from Jarratt's Station to Belfield in December. Better indication of the new strategy came on February 5, 1865, as Meade again struck for Hatcher's Run. When fighting ended two days later, Warren's V Corps had been

in 1864 (eight of Grant's divisions, five of Lee's). Subsequently, four Gray and five Blue infantry divisions bolstered Lee and Grant from the Shenandoah, and then in early March 1865 Sheridan's two powerful Union cavalry divisions crushed the Confederate Army of the Valley and raided overland from the Blue Ridge to the Peninsula. The two feeble Rebel mounted divisions that rode east from the Shenandoah to resist him hardly offset this mighty build-up of Federal horse at Petersburg.

As this threat to Lee descended from the northwest, even more ominous danger loomed from the south, as Sherman moved irresistibly through the Carolinas, ever closer to Petersburg. Meantime, from north and west, respectively, Hancock's and Major General George Thomas' Union armies threatened Lynchburg. And all the while, Grant tenaciously grappled with the Army of Northern Virginia, determined to pin it down while his subordinates devoured the rest of the Confederacy and then joined him for the final kill.

Lee, as ever, fought back against impending doom. On March 25, 1865, in a daring strike through no-man's land east of Petersburg, Major General John Gordon's Rebels stormed Fort Stedman. But as with so many breakthroughs in the siege, they could not exploit it, and Parke's and Brigadier General John Hartranft's counter-attack soon drove them out. Meantime, Humphreys' and Major General Horatio Wright's corps profited from Gordon's diversion to the center and captured the entrenched picket line on the Confederate right.

Holding that picket line proved advantageous when Grant launched his final offensive on March 29. Sheridan, reinforced by Warren, spearheaded the onslaught south of Hatcher's Run. Humphreys engaged just below that stream, and Wright and Parke stood ready farther north. This time most of the Army of the James, now under Ord, left the Peninsula to join the attack below Petersburg. Brave to the last, the Confederates repeatedly counterattacked this new drive, and time and again they trounced Union divisions. On this occasion, however, the Northerners kept coming. Sheridan routed the last mobile flank guard, Major General George Pickett's command, at Five Forks, April 1. In an

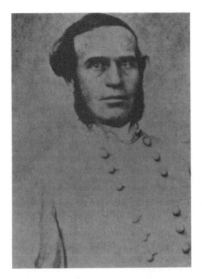

But despite all Grant's efforts, Confederates in Petersburg held out long enough for Lee to bring the bulk of his army to the city. Major General Bushrod R. Johnson, a native of Ohio, fought valiantly to halt the first assaults.
(DEPARTMENT OF ARCHIVES AND MANUSCRIPTS, LOUISIANA STATE UNIVERSITY, BATON ROUGE)

roughly handled, but Confederate Brigadier General John Pegram was dead, and Hancock's successor, Major General Andrew A. Humphreys, had permanently extended the Union line to that stream.

Thereafter, Lee and Grant became increasingly aware of the impact of military developments in other theaters on their own operations. Throughout the Petersburg siege, for that matter, both generals had sent troops elsewhere to block threats, win victories, suppress treachery, and enhance prospects around Petersburg. Seven Southern and eleven Northern brigades permanently moved to the Carolinas the winter of 1864–65. Even more did the Shenandoah Valley divert forces from the Tidewater

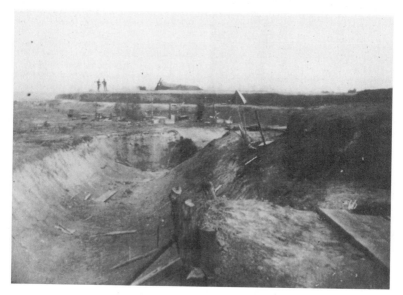

*One of many redoubts placed along the outer Confederate line and captured
in the first assaults in June 1864.* (P-M)

even more decisive stroke the following day,
Sunday, Wright stormed the works covering the
Boydton Plank Road and killed A. P. Hill, long
the chief guardian of Petersburg. Later that day,
Major General Nelson Miles defeated the last
defenders of the Southside Railroad at Suther-
land's Station. Only in the fortifications of
Petersburg itself did Gordon, Wilcox, and Briga-
dier General Nathaniel Harris blunt Parke's and
Ord's repeated charges until Longstreet's rein-
forcements could finally arrive from Richmond.

Except for permitting an orderly retreat,
though, those reinforcements were too late. This
time disaster for the Southern cause was real—
and irretrievable. The last wagon road was gone;
the last railroad linking Richmond and Peters-
burg to the outside was gone; and with them was
gone the last military justification for holding

Petersburg. To stand siege within the city would
simply lose the army, too. Yet there was no place
else on the James to stand, either. Richmond
was now as untenable as the Cockade City.

Overnight, April 2–3, Lee abandoned them
both. In his wake, civilian looters burned much
of the capital. With daylight came Major Gen-
eral Godfrey Weitzel's and Parke's bluecoats,
who at last entered ruined Richmond and bat-
tered Petersburg unresisted. Meantime their
triumphant comrades in Grant's main body
south of the city were in excellent position to
intercept Lee's desperate flight toward North
Carolina. The Army of Northern Virginia, once
mighty, had been too weakened at Petersburg to
continue long in the open field. For Lee and his
men, within just one week, the road from Peters-
burg would lead to Appomattox.

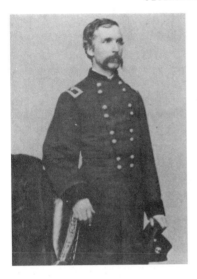

Yankees, too, were heroic in their efforts to break through the enemy lines. Colonel Joshua L. Chamberlain of the 20th Maine won a battlefield promotion to brigadier general on June 18 in one of the last assaults. (WRHS)

Stopped in front of the city, Grant tried to work around it on the south to cut off Confederate communications via the Weldon Railroad. Here, near Globe Tavern, he was turned back. Captain A. J. Russell made this image late in 1864. (KA)

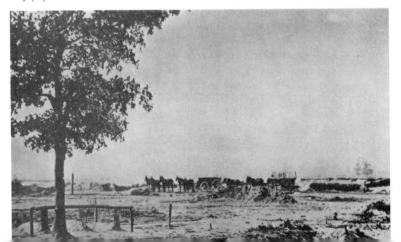

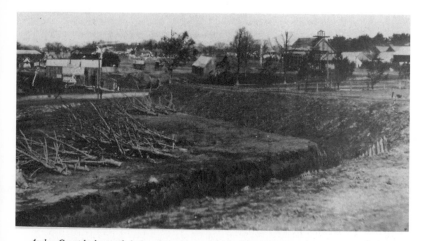

And so Grant had to settle in for a long siege and that meant building a major supply base. He chose City Point, on the James, about seven miles northeast of Petersburg, and here established the greatest such base of the war. Egbert G. Fowx caught this image of City Point, including his own log-built Fowx's Photographic Gallery at the left. (USAMHI)

At City Point Grant built an ordnance wharf that could accommodate the ceaseless comings and goings of the supply steamers. Probably a Russell image. (LC)

Transports like the Neptune *disgorged their supplies directly onto the rail cars that would speed them around Grant's lines wherever needed. Probably a Russell image.* (USAMHI)

Everywhere there were masts and lines of guns and caissons, a ceaseless activity that continued around the clock. (KA)

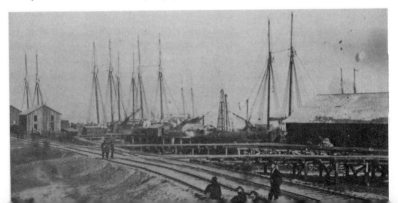

The trains await whatever they must carry. (NA)

So did the supply wagons that would go where the railroad did not. (LC)

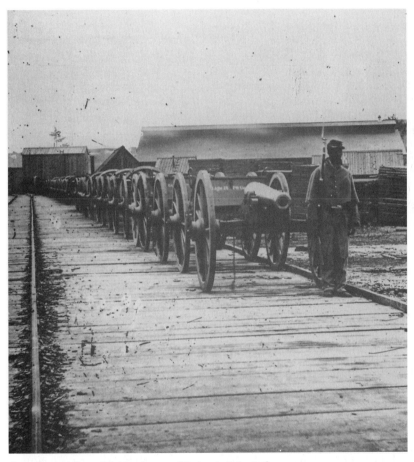

A row of 12-pounders and their carriages, awaiting transportation to the front. (LC)

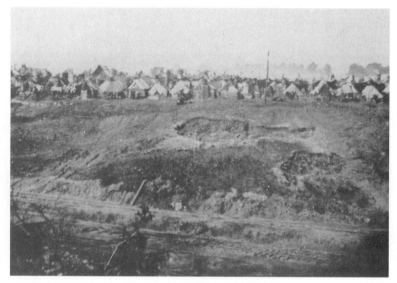

Maintaining the mammoth City Point supply base required hundreds of
special laborers, and that in turn required a special encampment for them.
Here their winter quarters outside the base kept them close to their unending
work. (USAMHI)

Soon a more sophisticated telegraphic operation was under way as well,
employing a dozen and more key operators, shown here in their rustic
summer quarters. (LC)

Grant set up outdoor summer headquarters at City Point, shown here in a Brady & Company image taken in late June or early July 1864. Grant and his staff are seated under the shade of the tree. (USAMHI)

Another Brady image taken at the same time shows Grant seated third from the left. Already there is at least one war trophy: partially furled on a staff leaning against the tree at left is a Confederate battle flag. (USAMHI)

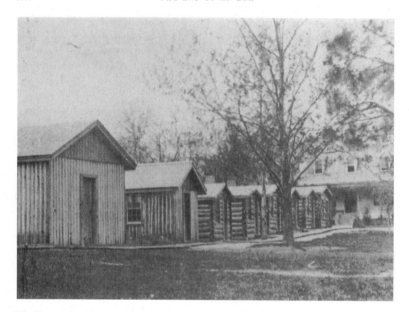

The bluecoats would be at City Point for a long time, though Grant did not know that this summer. Nearly a year later, in spring 1865, his headquarters looked like this in an E. & H. T. Anthony Company image. (RJY)

Though he was the aggressor here in Virginia, Grant knew that he had to look to his own defense, with the wily Lee as an adversary. Fortifications were built to protect City Point. (P-M)

And regiments like the resplendent Zouave 114th Pennsylvania were detailed as provost guard and garrison troops. They pose here in August 1864. (LC)

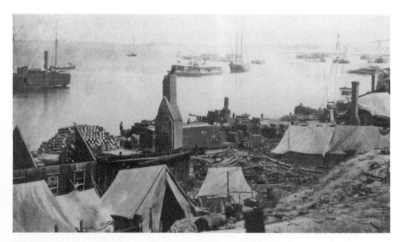

*Even then, City Point felt at least one blast of destruction. On August 9,
1864, an explosion went off, set by Confederate saboteurs. It rocked the
ordnance wharves. Russell caught the scene.* (USAMHI)

And it left an enormous mess in its wake. The culprits were never caught.
(USAMHI)

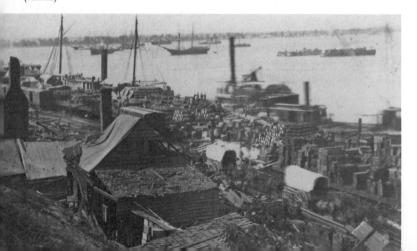

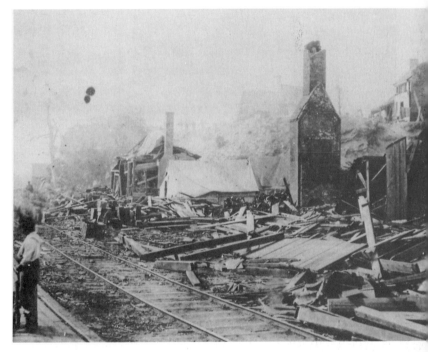

Grant himself was listening to an officer who claimed that enemy spies were infiltrating City Point when they heard the explosion. (KA)

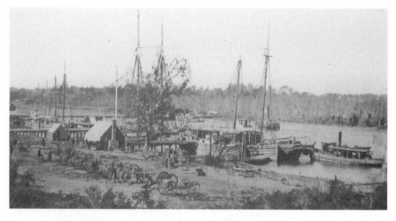

From City Point the supply network spread out wherever the army went. One major route carried succor to Bermuda Hundred by way of Broadway Landing on the Appomattox River. (WRHS)

Much of the ground was like this—too swampy in the winter for passage. An early 1865 image, published by E. & H. T. Anthony Company. (LC)

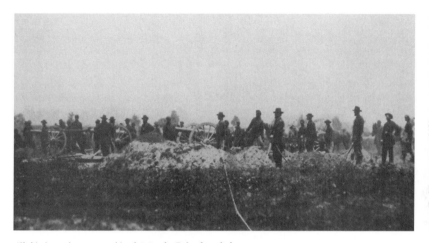

All this done, there was nothing left for the Federals to do but to start pounding away at Lee. Indeed, even before City Point was well established, Grant's artillery began the work. A Brady photographer made this view of Captain James H. Cooper's Battery B, 1st Pennsylvania Light Artillery, on June 21, 1864. Though long identified as being taken "under fire," Brady's images were made at a time and place when the Confederate lines were about a mile away, and this image was almost certainly posed for the camera. (LC)

Brady himself stepped into the picture in this image of the same battery that day. He stands, hands in pockets, just behind the cannon at center. (LC)

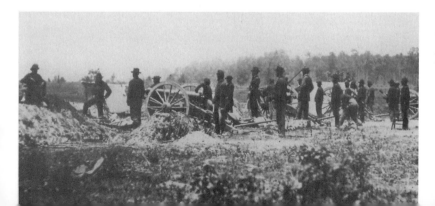

Real fighting was done by men like these Zouaves of the 164th New York, the Corcoran Legion. At Deep Bottom, about fifteen miles north of Petersburg, on July 27–28, they met the enemy, only to be repulsed. (USAMHI)

As a result of the stalemate, the Confederates, too, had to settle down to what would be a long siege. Shown here are some of the Southern winter quarters captured in June 1864, now home to grinning Yankees. (P-M)

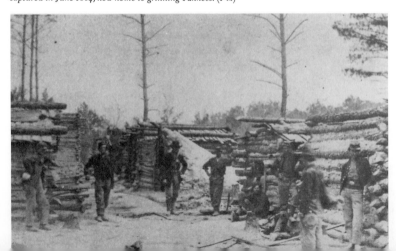

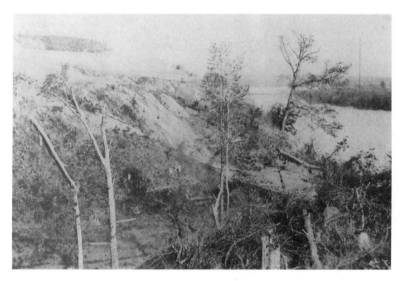

To contain the enemy's relentless attempt to encircle and strangle them, the Confederates maintained formidable fortresses like this one at Drewry's Bluff on the James, north of Petersburg, but no naval attack was forthcoming.
(USAMHI)

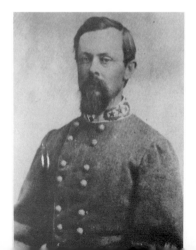

Able defenders like Brigadier General Johnson Hagood turned back Major General Benjamin Butler's May 1864 land attack. (LC)

Following the fighting at Fort Darling, as the earthwork at Drewry's Bluff was called, obstructions placed in the river were intended to interdict ships. (USAMHI)

Old steamers were brought out into the channel and scuttled. (VM)

They made a virtual barricade across the James. (USAMHI)

In Fort Darling itself, the Confederate officers had dug themselves several substantial gun emplacements, with sunken magazines, bombproofs, and a well. (USAMHI)

The officers' quarters were barely a stone's throw from the earthworks. (USAMHI)

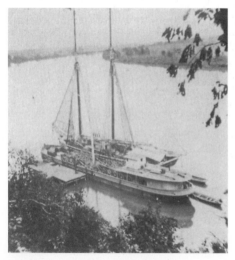

Once the fort fell to the Yankees, however, it became a useful bastion for them as well. Federal transports filled with artillery tie up at the tiny dock. (USAMHI)

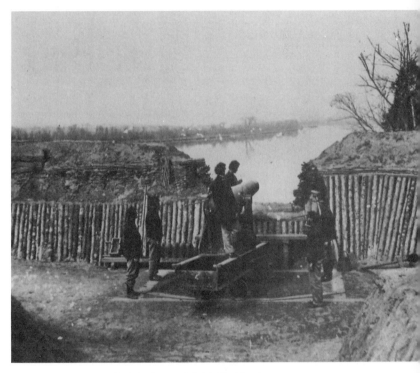

Elsewhere along the James the Federals secured their hold with water batteries like this one below Fort Brady. (P-M)

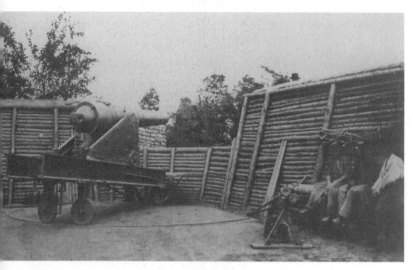

*Here a large Parrott rifle stares out over the James, not far from Dutch Gap,
above Petersburg.* (NA)

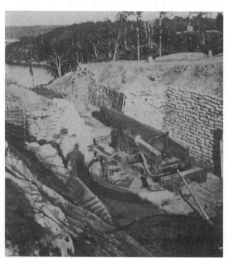

*Confederate water batteries were also
located near Dutch Gap, mounting
formidable guns like this banded Brooke
rifle. The Union could not make full use
of the James until they could get past
obstructions and batteries like these.*
(USAMHI)

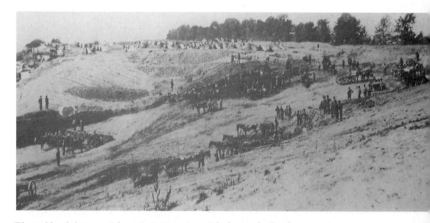

The problem led to one of the war's great, unsuccessful schemes, the Dutch Gap Canal. Butler's Army of the James spent months digging a canal across the narrow neck of land left by a great loop in the river. When completed, it would have allowed ships to bypass enemy water batteries. Captain Russell brought his camera to record the work and probably made this image in August or September 1864. (CHS)

Again it was probably Russell who made this fall 1864 image showing the work on the canal well under way, the work parties, surveying instruments, and barges and tracks for removing earth all perfectly visible. (NA)

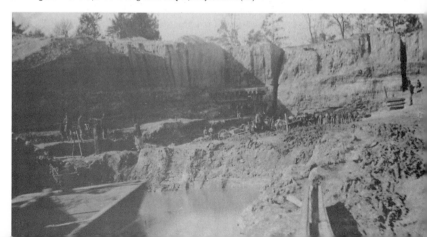

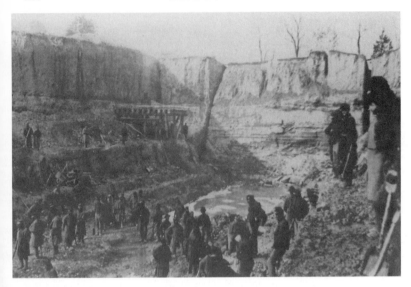

The greatcoats on the working parties attest to the coming of the cold season late in 1864. The workers are almost entirely Negro troops, their white officers standing on the upper level supervising. (NA)

In November Russell made this image showing the last stages of the canal before the remaining earth was blasted away to complete the ditch. Everything is ready, and giant crevices have been sliced through the earth. On January 1, 1865, it needs only the touch of a spark to the powder charges laid and . . . (P-M)

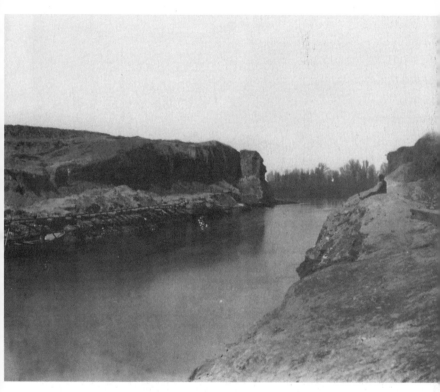

. . . the Dutch Gap Canal is open. (P-M)

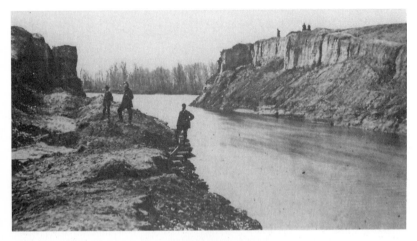

In succeeding days and weeks the canal mouth will be widened and deepened to allow traffic to pass through, but in fact the canal will prove to be militarily pointless. It was not completed until April 1865 and by then it was too late to be of use. In later years, ironically enough, the James will shift its course slightly and the canal will become part of the main channel. (USAMHI)

Much of the work was done under nagging but largely fruitless artillery fire from Confederate batteries. One shot did manage to sink this dredge. (LC)

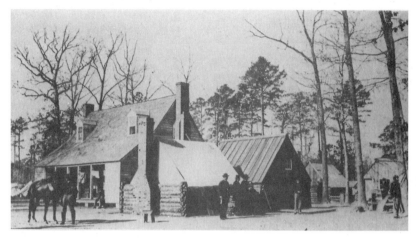

Meanwhile, Butler fretted and fumed here in his headquarters, thoroughly disgusted with his bad fortune, and thoroughly out of favor with Grant. (NA)

His engineers, like the 15th New York, went into winter quarters such as these and suffered through the cold and damp and mud. The log breastworks with their sandbag firing posts were never used to repel enemy attack. (KA)

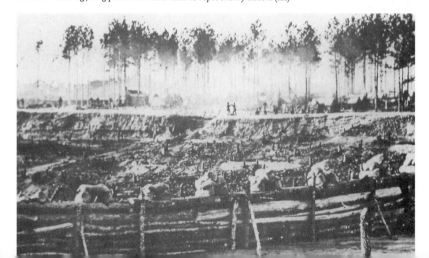

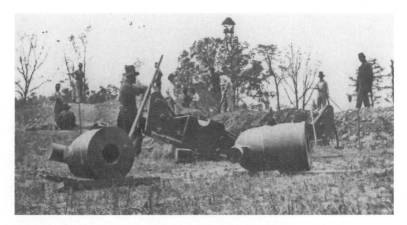

*Butler further fortified Dutch Gap with heavy mortars like these and built
the landmark Crow's Nest signal tower in the background to keep an eye on
the enemy.* (LC)

*To protect themselves from the Confederate shelling, some of Butler's people
dug bombproofs into the side of the hill. This image was made on
Thanksgiving Day in 1864 while Rebel artillery was firing from afar. It is
possibly the work of Captain Russell's assistant Egbert G. Fowx, with whom
Russell would later fondly reminisce about the dangers of making
photographs while under fire.* (USAMHI)

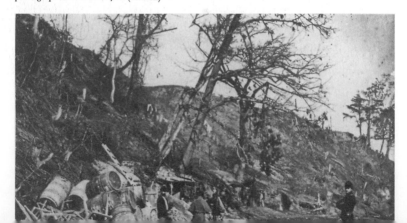

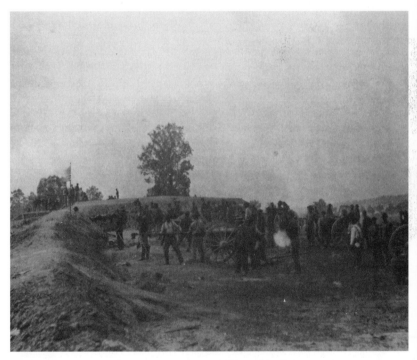

Meanwhile, back on the main Union lines stretching around Petersburg, the work of reducing the enemy continued. On June 20, 1864, a Brady cameraman recorded this image of the 12th New York Battery, now operating in a captured Confederate earthwork, Battery 8. Brady himself appears once again, standing in straw hat in the center. Just two days later this entire battery would be captured in a Confederate attack in another sector. (WRHS)

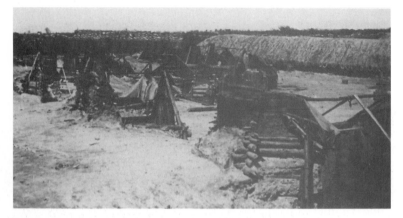

Slowly the ring of Union fortifications grew. Fort Rice shows the winter huts built to keep the men during the siege. (USAMHI)

Fort Sedgwick went up on the Jerusalem Plank Road, south of Petersburg. It was a massive earthwork incorporating gabions, abatis, and chevaux-de-frise. (USAMHI)

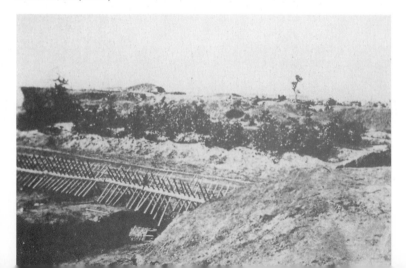

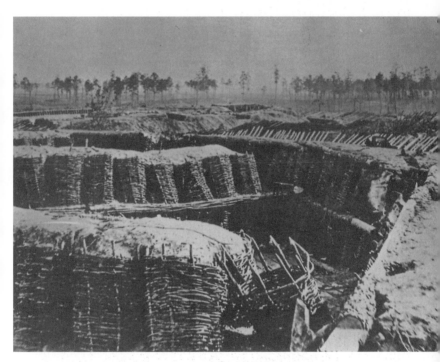

The maze of trenches and gabions—earth-filled baskets—soon was dubbed "Fort Hell" by the Confederates. (USAMHI)

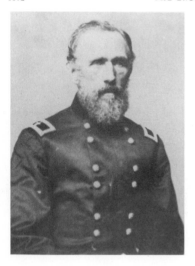

There was a lot of engineering going on in both armies and that done by the Federals was chiefly under the direction of Brigadier General John G. Barnard, Grant's chief field engineer. (P-M)

Formidable movable obstructions like these chevaux-de-frise were built to break up enemy assaults. (USAMHI)

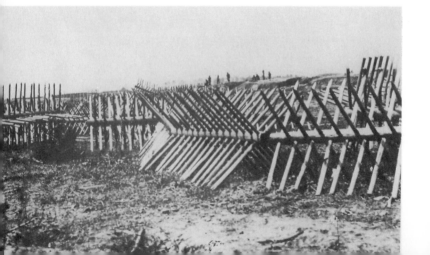

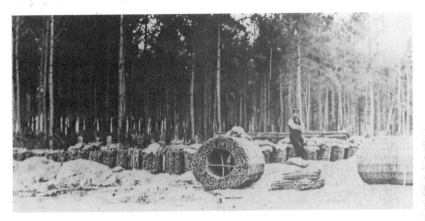

Tons of twigs and branches were carefully woven into the gabions that formed the basis of much of the earthworks. (KA)

The sticks were even woven into mats like these, for a variety of purposes, in a rat's maze of tunnels and ditches. (LC)

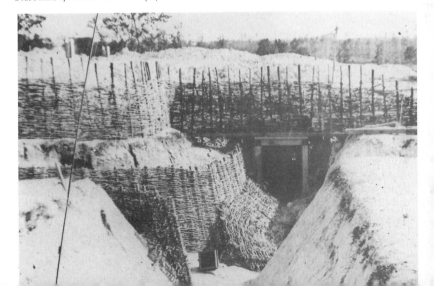

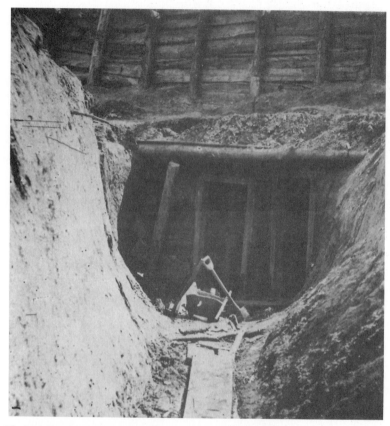

The Confederates meanwhile were doing some engineering of their own.
From Fort Mahone, they began digging a tunnel underground toward Fort
Sedgwick, their intention being to detonate a powder magazine and breach
the fort. It did not work, perhaps because the Yankees had already tried that
trick themselves and were wary. (LC)

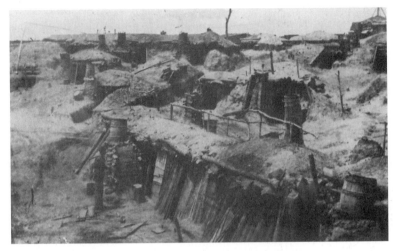

Besides, these bombproof quarters at Fort Sedgwick were already such a maze of tunnels and holes in the ground that a mine underneath them could hardly go undetected. (LC)

Everywhere men were living in homes carved out of the dirt. Here is a kitchen among the Union bombproofs. (P-M)

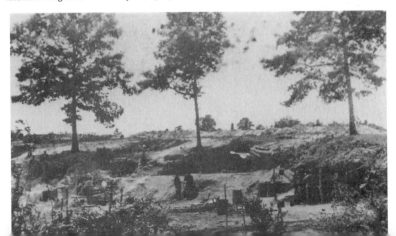

And here just one simple soldiers' shelter from flying enemy shells. (P-M)

Even the horses enjoyed bombproof stables. (P-M)

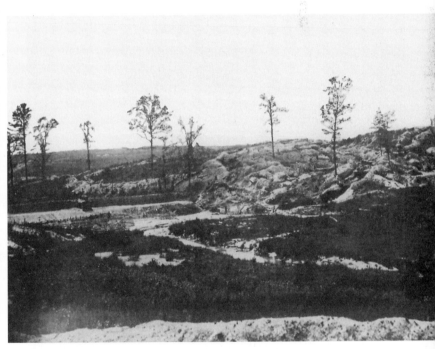

For the Confederates it was much the same. Here at Gracie's Salient all manner of digging and moving has taken place. To show the proximity of the opposing lines by the end of the siege, the Federal earthworks can be seen in the left distance. (USAMHI)

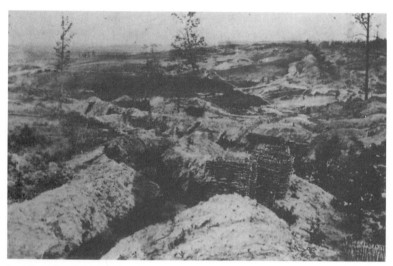

*Atop the works at Gracie's, the camera can see nothing but the results of
endless burrowing in the dirt.* (USAMHI)

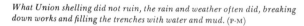

*What Union shelling did not ruin, the rain and weather often did, breaking
down works and filling the trenches with water and mud.* (P-M)

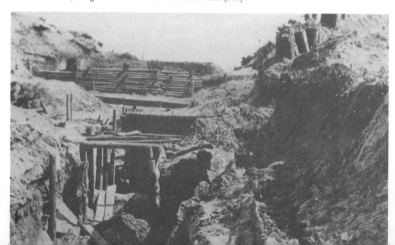

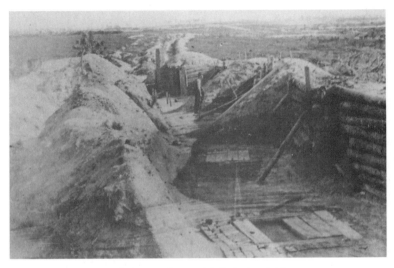

Everywhere the Confederate ditches seemed to stretch to the horizon. (P-M)

Captain Russell's early April 1865 image of one Rebel cannon mounted in the inner line of defenses. In the distance all around it appear more and more lines of works. (LC)

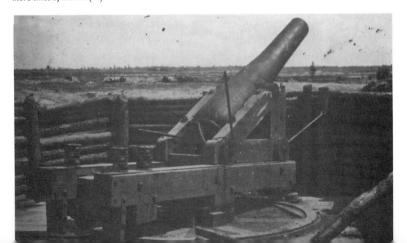

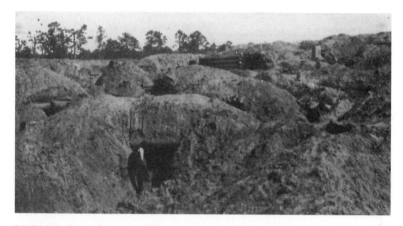

Conditions in the trenches were no different for the Federals. The rain and mud attacked them as well. (USAMHI)

Their work seemed just as endless as, like a colony of ants, they went on with the work of tearing up the soil of Virginia. (USAMHI)

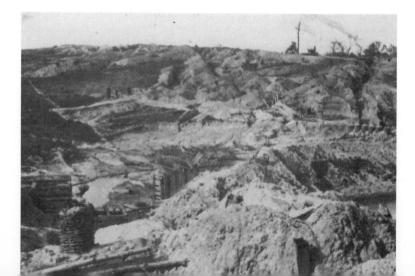

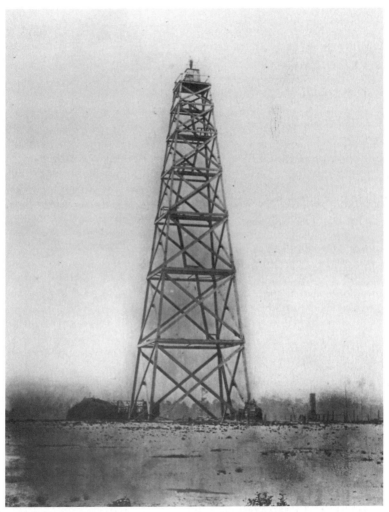

Happy by contrast were those Yankees who could spend their part of the siege in the sky. Grant's engineers built a series of signal towers like this one on Peeble's farm. From it they could watch enemy movements . . . (P-M)

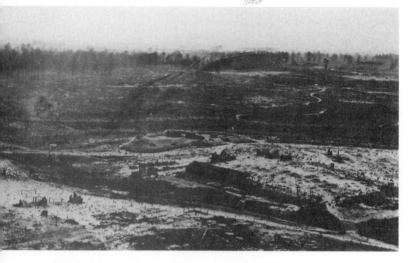

. . . *150 feet below. Winter quarters and log breastworks are evident in the Union lines in the foreground, and beyond them two feathery lines of sharpened stakes or branches stand ready to delay any enemy attack. The redoubt in the center is probably Fort Conahey.* (P-M)

Another less tall but more famous signal tower was the Crow's Nest, 136 feet high, near the Dutch Gap Canal. It was a landmark for Yankees all about. (USAMHI)

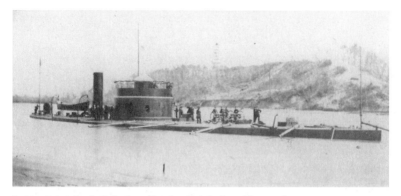

And particularly for the Federal warships that plied the James River nearby.
The Union monitor Sangamon *rests at her mooring below the Crow's Nest.*
(WILLIAM GLADSTONE COLLECTION)

Farther off, near Bermuda Hundred, yet another tower kept at least a few
Yankees high, if not dry. (USAMHI)

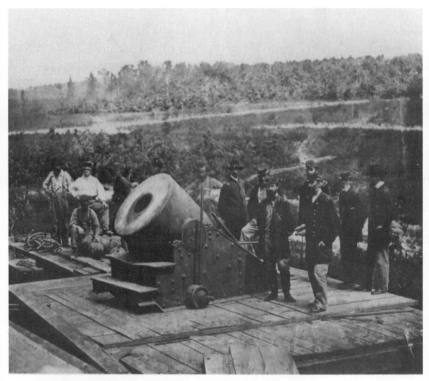

When not building, the Yankees were shooting, often mammoth seacoast mortars like this 13-inch behemoth called the Dictator. Its service at Petersburg was neither distinguished nor unusual except for its railroad mounting, but it captured the interest of more than one photographer, and they subsequently made it one of the most famous cannon of the war. O'Sullivan or his assistant David Knox photographed it here on September 1, 1864, mounted on the railroad flatcar that transported it. The officer standing at right center, holding the field glasses, is Brigadier General H. J. Hunt, Meade's chief of artillery. (LC)

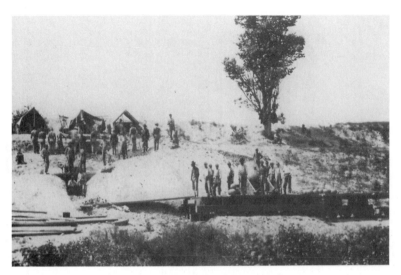

And here that same day O'Sullivan or an assistant recorded the scene as the Dictator pointed toward the enemy works beyond the ridge. (USAMHI)

Certainly the most notorious endeavor of the Yankee engineers, however, was the Great Mine. Dug by coal miners in the 48th Pennsylvania, it ran across the no-man's land between the lines and under the Confederate works. It fell to Major General Ambrose Burnside, standing in the center, his hand in his blouse, here with his staff, to make the attack that would follow the explosion of four tons of powder at the end of the 511-foot shaft. He was a poor choice. (NA)

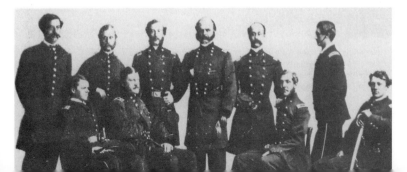

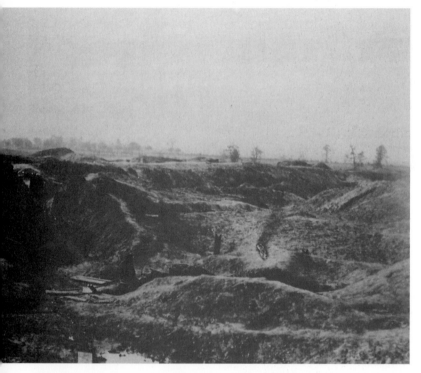

When the charge went off—on July 30, 1864—this "crater" was formed, 30 feet deep, 170 feet long, and from 60 to 80 feet wide. It literally blew a whole section of Confederate works—with their defenders—out of existence. Portions of the shaft are still visible in this 1865 image. (USAMHI)

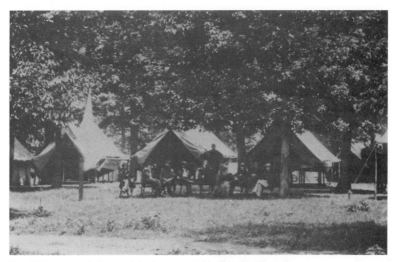

Burnside's troops rushed in, one brigade commanded by Brigadier General W. F. Bartlett, seated here fourth from the right with his staff at war's end. He already wore an artificial cork leg, and now it was shattered in the attack and he taken prisoner. (USAMHI)

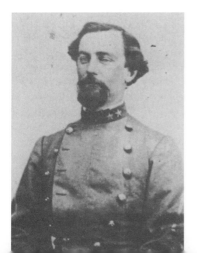

Occupying the salient that was blown up was Brigadier General Stephen Elliott. He was himself seriously wounded in repulsing Burnside's poorly organized assaults and would not see service again until Bentonville, North Carolina, at the end of the war. (USAMHI)

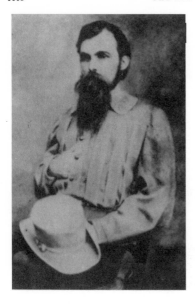

By the time the Federals were falling into confusion after the explosion, some of them trapped in the crater itself, Brigadier General William Mahone had rushed his Confederate division to the threatened spot. In time he drove the bluecoats out and won for himself a battlefield promotion. (CHS)

After Petersburg's fall a cameraman made this view from the hole, looking off toward the Union lines in the near distance. It shows just how close the opposing parties came in their mole's work. (USAMHI)

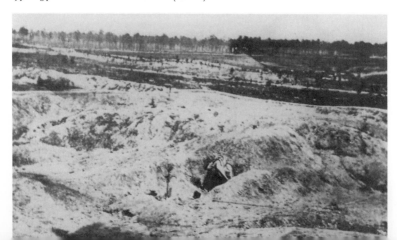

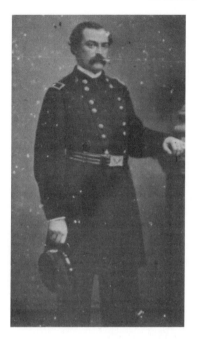

The whole Union effort had been a shambles, thanks chiefly to dreadful leadership. Brigadier General James Ledlie, commander of the Federal attack, hid, drinking, in a bombproof while his division went into the slaughter. (NA)

Brigadier General Edward Ferrero, shown seated at the center a few days after the attack, commanded the Negro division that supported Ledlie. Ferrero, too, hid with Ledlie while his command was torn apart. He managed to survive the resulting court of inquiry, though not without censure, but Ledlie would soon leave the service in disgrace. (USAMHI)

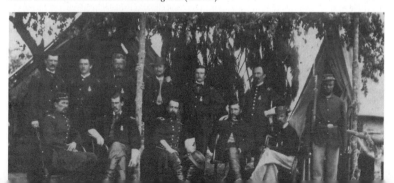

The crater itself would survive down to the present, but 5,500 good men of
both sides perished or were wounded in the fight for it. Even among
regiments like the 40th Massachusetts, assigned as a reserve and never thrown
into the actual battle, men fell. This image shows them at drill in the winter
of 1862–63 at Miner's Hill, Virginia. It is an important image for another
reason. It is one of the two photographs that were the start of the massive
40,000-image collection of the Massachusetts Commandery of the Military
Order of the Loyal Legion of the United States (MOLLUS), the largest
collection of Civil War images in existence, now at Carlisle Barracks,
Pennsylvania. (USAMHI)

In August 1864, still smarting from the setback at the crater, Grant sent part of his army farther out around the Confederate fortifications south of Petersburg and had them strike at Globe Tavern on the Weldon Railroad. (USAMHI)

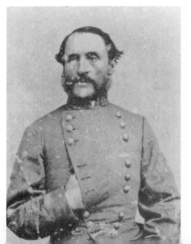

The subsequent fighting was savage. Confederate Brigadier General Thomas Clingman was so seriously wounded that he never again saw real field service. Regarded as incompetent, he was not sorely missed. (NA)

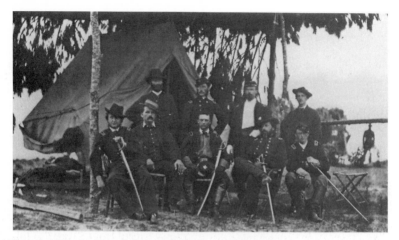

*It was the reinforcing Union division of Brigadier General Orlando B.
Willcox, seated second from the right, that finally secured the Weldon line.
This image was made in August 1864, a few days before the fighting.*
(USAMHI)

*Grant's September offensive involved swift river crossings. The slender finger
of land on the other side in this view of a Union pontoon bridge across the
James is Jones' Neck. Captain Russell probably made this image that same
month.* (USAMHI)

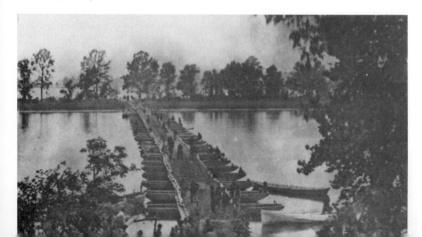

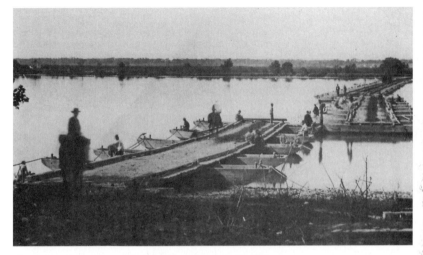

There was another crossing at Aiken's Landing, this one a bridge with a removable section to allow Union steamers to pass through. It is just being opened in this image. (USAMHI)

And here the bridge is ready to allow river traffic passage. The engineers could accommodate anything they set their minds to. (MINNESOTA HISTORICAL SOCIETY)

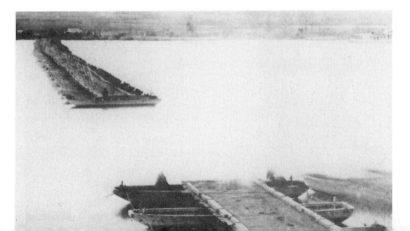

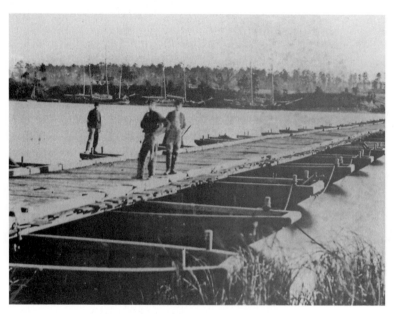

Over these boards tramped the Union army corps of men like . . . (KA)

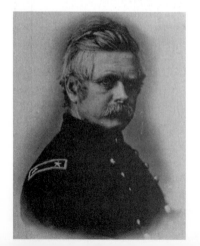

. . . Major General Edward O. C. Ord. He was on his way toward Chaffin's Bluff, there to assault . . . (USAMHI)

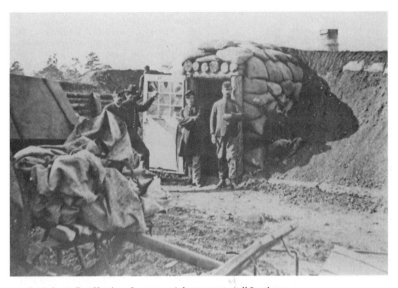

. . . Confederate Fort Harrison. It was one of the strongest of all Southern forts north of Petersburg. Should it fall, the Federals would have taken a major step on the road to Richmond. A bombproof in the fort after the Federals took it and renamed it Fort Burnham. (KA)

Here, in the rear of Fort Gilmer, near Fort Harrison, sits a 27-foot ditch dug to prevent another underground tunnel like that which led to the Great Mine outside Petersburg. (LC)

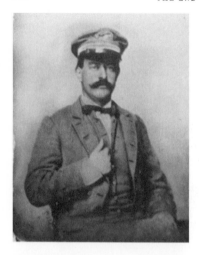

Even Confederate ships like the ironclad Richmond *supported the defense of the capital by firing from the river on Ord's attacking Federals. Robert Wright was an engineer aboard the vessel.* (PAUL DE HAAN)

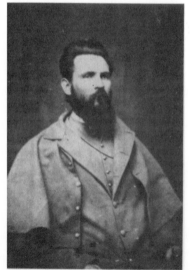

Brigadier General John Gregg was one of the defenders of Fort Harrison. Only a week later he was killed in fighting a few miles away. (VM)

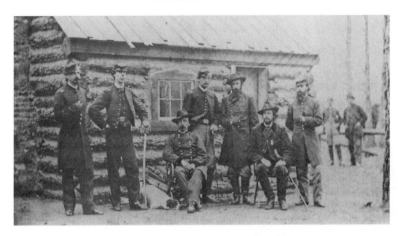

Brigadier General Adelbert Ames, seated center, poses here with his staff in the winter of 1864–65, not long after his attempt to penetrate Lee's new defenses south of Richmond failed. (SOPHIA SMITH COLLECTION, SMITH COLLEGE, NORTHAMPTON, MASS.)

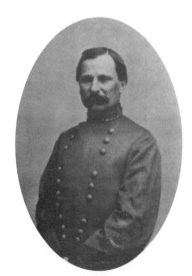

There were Yankee probes and attacks everywhere, it seemed, and most of them were turned back by skillful and desperate commanders like the Confederate Cadmus M. Wilcox, the major general who later at the siege's end managed to hold off the Federals long enough for his army to escape. (WRHS)

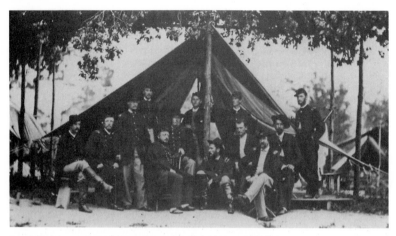

Late in October 1864 Major General Benjamin Butler became actively
engaged north of the James again, but failed. Butler sits on the chair at left
center, with Brigadier General Godfrey Weitzel seated on the floor next to
him. A Brady operator made the image at Bermuda Hundred in the late
summer of 1864. (USAMHI)

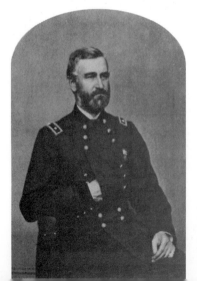

While Butler was being repulsed, Meade was
fighting a desperate battle near Hatcher's Run,
southwest of Petersburg, one of his divisions in
the fray being led by Major General Gershom
Mott. They narrowly averted disaster before a
skillful withdrawal. (USAMHI)

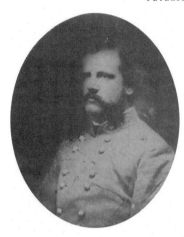

There were hard losses, too, for the Confederates. On December 2 the capable and well-liked Brigadier General Archibald Gracie was killed by a sharpshooter. A New Yorker by birth, he had a large family who remained loyal to the Union. An unpublished ambrotype. (MUSEUM OF THE CONFEDERACY)

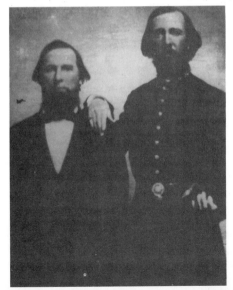

Upon Gracie's death, his command was turned over to Colonel Young M. Moody, a Virginian who would make brigadier in March 1865, one of the last generals appointed in the Confederacy. He stands here at right. (VM)

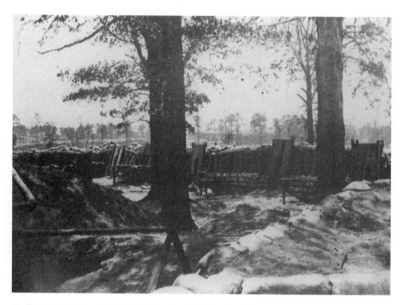

Finally, in late March 1865, the last Union push for Petersburg began.
Trying to preempt such an offensive, Lee launched his last great attack of the
war, the March 25 assault on Fort Stedman, a Union strongpoint west of the
city. (P-M)

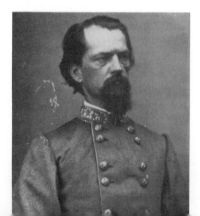

Leading the attack was one of the last of Lee's
premier fighting officers, Major General John B.
Gordon. With no formal military training, he
yet became one of the ablest battlefield
commanders of the war. Fort Stedman was just
the last of many courageous assaults for the
combative Georgian. (NA)

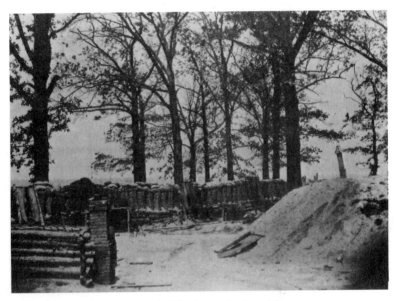

Within these defenses at Fort Stedman the Federals were taken by surprise by the advancing enemy and nearly put to flight. (P-M)

As he led his brigade against the fort, Brigadier General Philip Cook suffered a dangerous wound that ended his war service. (VM)

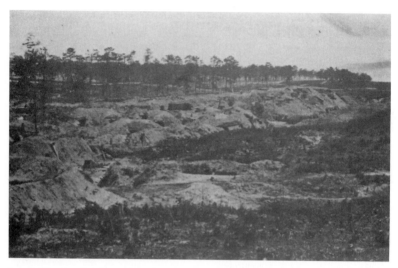

It was in this sector that the Rebels broke through—the line between Fort McGilvery and Fort Stedman. (USAMHI)

But in the end, the Federals behind these Fort Stedman defenses retook what was lost. (USAMHI)

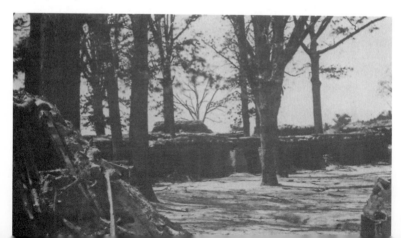

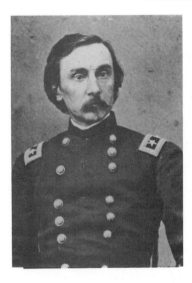

Then on March 29 Yankee divisions led by commanders like Major General Gouverneur K. Warren began to strike at the last available avenue of retreat for the Confederates. (USAMHI)

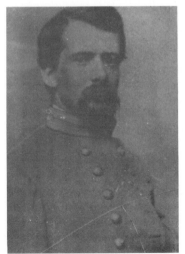

There were too few Confederates left to stop them. The attrition in Lee's high command had been dreadful. Just the month before, the brilliant and handsome young Brigadier General John Pegram was killed on Hatcher's Run, three weeks after his marriage. (VM)

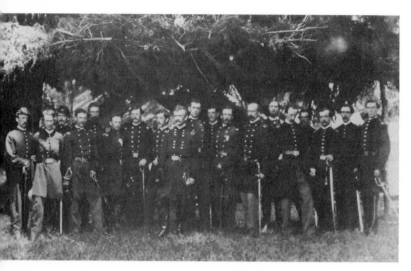

Major General Andrew Humphreys, standing hat in hand at the center, led his Union corps in the attack on Hatcher's Run late in March, having become one of Meade's most capable corps commanders. (USAMHI)

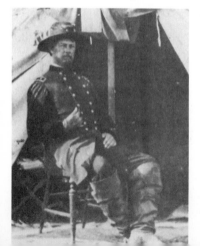

Major General Horatio Wright sent his VI Corps into the fight against the Rebels at the same time. (MHS)

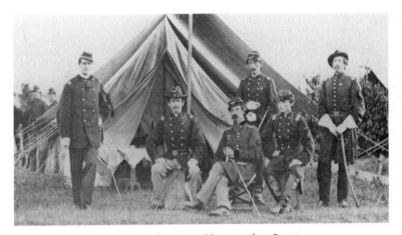

There was fighting all along the line as Grant pressed Lee everywhere. Brevet Brigadier General Robert Nugent, seated holding his sword, led his "Irish Brigade" in the fighting on the Southside Railroad on April 2, helping cut off the Confederates' final avenues of escape. (USAMHI)

That same day the IX Corps launched its assaults from Fort Sedgwick, the oft-dubbed "Fort Hell." Captain Russell probably made this view two or three days later, with the battle barely done. (MJH)

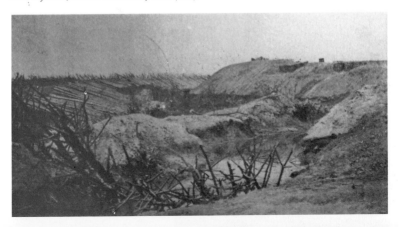

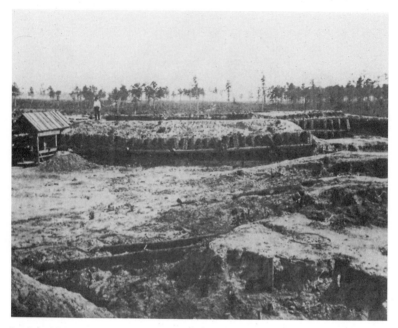

Fort Sedgwick fascinated the photographers, who covered every inch of it with their cameras. (USAMHI)

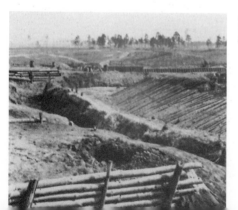

Another Russell image looking along the Union lines from which the attackers sprang on April 2. (USAMHI)

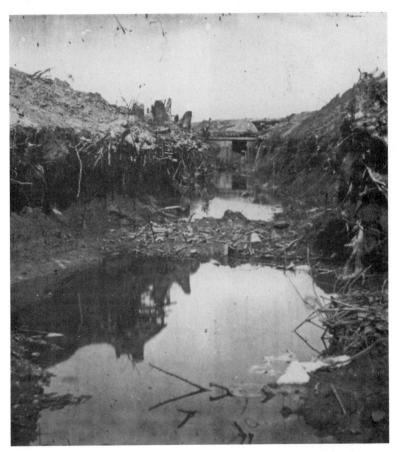

The rains that preceded the final assaults left Fort Sedgwick a muddy mess by the time a cameraman arrived to capture the scene. (LC)

The fall of Five Forks, some thirteen miles southwest of Petersburg, sealed the fate of the city. There, on April 1, the Yankees had pushed aside the valiant resistance of Brigadier General Eppa Hunton and others, cutting Lee's dwindling lines of retreat. (VM)

Units like the 17th Virginia, commanded by Colonel Arthur Herbert, could not withstand the overwhelming numbers of the enemy. With Five Forks lost, Lee had to abandon Petersburg. (LEE WALLACE)

In the collapse of the Petersburg line, the Confederates lost good men everywhere, but no loss was more disastrous than the death of Lieutenant General A. P. Hill. He had been a pillar of support for Lee. His death was emblematic of the loss of thousands who could not be replaced. (USAMHI)

Among the last Confederate commands to hold out was the brigade of Brigadier General Nathaniel H. Harris. His men bought time for the rest of the army to make its escape. (USAMHI)

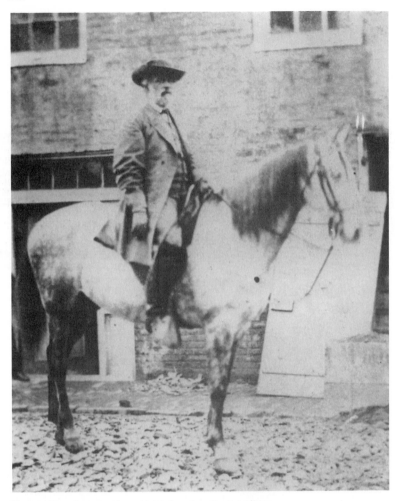

*The loss of Petersburg was a heavy blow to Lee. According to tradition,
sometime during the siege of Petersburg the tired old warrior mounted his
warhorse Traveller and posed outdoors for an unknown photographer. The
war was slowly killing him, but still there is the firmness and stature of the
leader about him. This is how his soldiers would ever after remember
"Marse Robert."* (DEMENTI STUDIO, RICHMOND)

And here, at last, lay Grant's prize. All he had to do was march in. The spires that had for nearly a year been distant landmarks, were now in his grasp. (NA)

James Reekie probably made this image of a street scene in Petersburg. Taken around April 10, it depicts a commonplace sight of train after train of Union supply wagons rolling through the city on their way to the army that followed Lee to Appomattox. (LC)

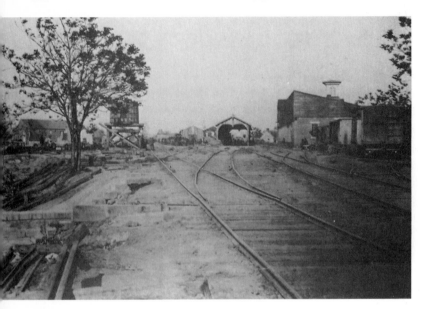

Captain Russell's image of the principal rail junction in the city, the reason
for its military importance and the reason that Lee had to defend the city to
the last. Burned cars rest on the tracks at right. The crooked and broken
ribbons of rails attest to the inability of the Confederacy to maintain its
railroad lines against wear and tear. (LC)

Signs of damage were visible everywhere.
The Dunlop house shows where a
Federal shell managed to find a
nonmilitary target. (USAMHI)

Inside the house all was rubble and ruin. (MHS)

Russell's camera found one bridge that was torched with an engine still upon it, leaving the whole a twisted mess of masonry and iron. (KA)

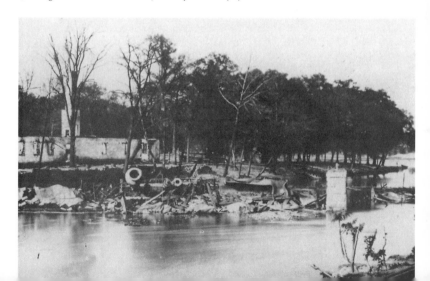

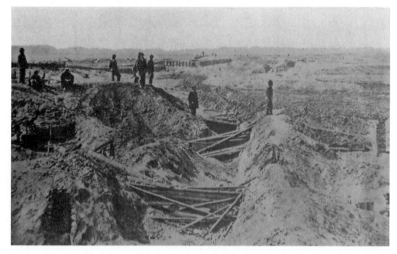

With Petersburg fallen, the Federal soldiers rushed to the parapets of the Confederate forts to play the tourist and to pose for the cameras. Here Russell found them at Fort Mahone, perhaps as early as April 3. (USAMHI)

Their curiosity seems boundless, that and the relief in at last being able to stand up straight on top of the ground without fear. (USAMHI)

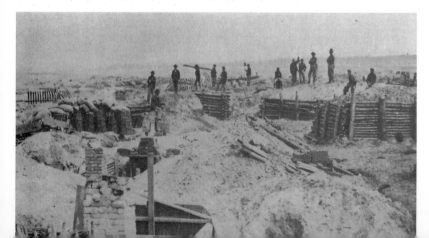

A few had fun posing behind now captured Confederate picket posts like these gabions. T. C. Roche photographed them on April 3. (USAMHI)

The cannonballs and impedimenta strewn about the ground lent an added touch of realism to scenes that were entirely posed. (USAMHI)

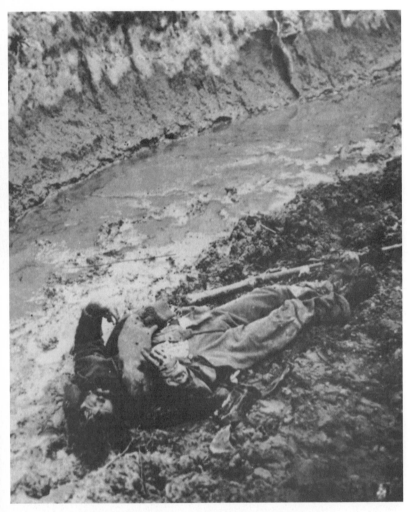

*So did the dead, and the photographer found them everywhere, Confederates
who died in the attempts to stave off Grant's final onslaught. Roche found
this body in the trenches at Fort Mahone on April 3.* (MHS)

Lying almost as if asleep, this man died in "Fort Damnation," the nickname for Fort Mahone. The bare feet attest to the dreadful scarcity of shoes in the Southern army. Either he simply did not have shoes when he died or else a fleeing comrade took time out from the evacuation to remove what the dead soldier no longer needed. (CHS)

Only a few yards away from this fallen soldier stands the picket post that Federals posed in for Roche's camera. (RJY)

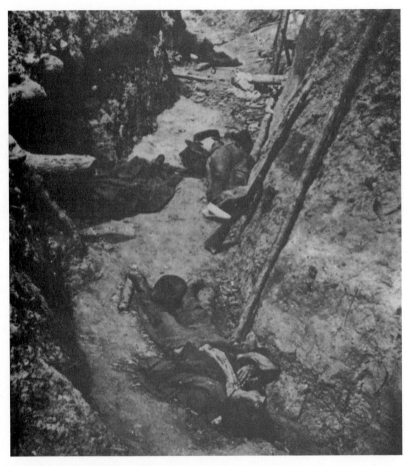

Roche seemingly could not stop recording scenes of death as he took his camera into Fort Mahone on April 3. They were all over the place. (MHS)

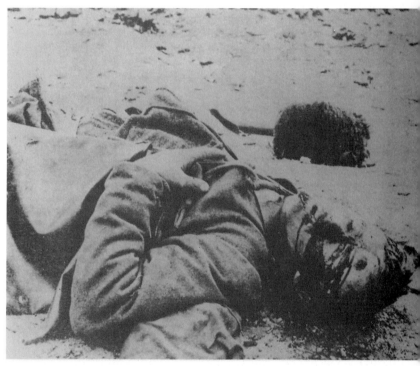

A Confederate artilleryman who has done his best and rests forever. For him, as for all of his comrades, living and dead, the Siege of Petersburg is over. (CHS)

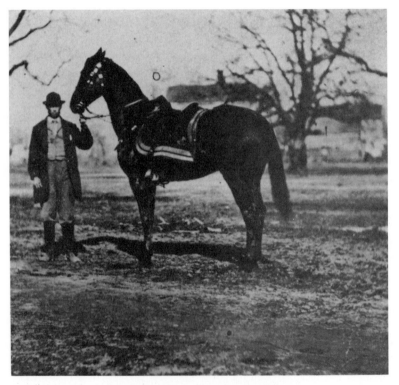

To the victor belongs the glory, but U. S. Grant will spend precious little time riding about his prize on his old warhorse Cincinnati. For Grant's quarry was never a city—it was a man. And though Petersburg has fallen, Lee is still in the field, and with him the Confederacy still lives. (USAMHI)

Richmond, City and Capital at War

EMORY M. THOMAS

Symbol of the Confederacy, the Virginia metropolis
fights to the last

RICHMOND IN 1860 was an amalgam of mills and magnolias. The place was at once an old Southern town and a young "modern" city.

Located at the falls of the James River, Richmond had been for some time essentially the trading-post community her founder William Byrd II had projected in 1733 and established in 1737. The Virginia legislature during the Revolution had voted in 1779 to move the state capital from Williamsburg to Richmond, and soon after, in 1781, Benedict Arnold honored this distinction by leading a British force into the new capital to raid and burn the town. During the nineteenth century Richmond attracted national attention as the scene of Gabriel Prosser's abortive slave insurrection in 1800, the site of Aaron Burr's treason trial in 1807, and the home of John Marshall and Edgar Allan Poe. The city continued to attract political interest as a state capital and developed a fairly active mercantile economy as a commercial link between the regional countryside and the wider world.

On the eve of the Civil War, though, Richmond was more than a sophisticated trading post. Her principal distinction among Southern cities lay in a somewhat "un-Southern" emphasis upon manufacturing. Much of this activity involved the elemental refinement of local agricultural products, especially tobacco and grain. Twelve mills produced annually three million dollars' worth of flour and meal, and fifty-two tobacco manufacturers processed a gross product worth five million dollars. However important were grains and tobacco to Richmond's economy, the city's iron industry was even more significant. No other city south of the Potomac possessed more than a fraction of Richmond's iron production, which was worth nearly two million dollars in 1860. Joseph R. Anderson's Tredegar Iron Works was the city's largest and most versatile plant and the only establishment in the South capable of producing cannon and railroad rails. Tredegar also led the way in two other atypical Southern activities, the attraction of immigrants (mostly German and Irish) and the adaptation of slave labor to industry. In total value of manufactures, Richmond ranked thirteenth among American cities in 1860 and first among cities that soon after composed the Confederacy.

Richmond boasted a relatively sophisticated financial community in 1860—strong banks and insurance companies. The city's slave traders, too, did a brisk business; Richmond ranked

*Richmond, capital of the Confederacy, for almost four years symbol of
Southern independence and determination. It had been a lovely, rather quiet
city in 1861 and looks little different in this 1865 view by the Philadelphia
partners Levy & Cohen. The state house stands at right, while to the left is
the spire of Broad Street Methodist Church and, beside it, an equestrian
statue of George Washington. Confederates looked to the example of the
"Father of His Country." He was father to theirs as well.* (KA)

second only to New Orleans among the nation's
slave markets during the 1850s. At the same
time that some Richmonders were manipulating
capital with the facility of "Yankees," others
were trading with equal facility upon the South's
"peculiar institution." And no one seemed to
notice the irony.

Despite the urban influence of trade, finance,
and manufacturing in Richmond, the place was
in many ways still an overgrown town in 1860.
The city's population—37,910 total, 23,635
white, 2,576 free Negro, and 11,699 slave—
ranked third in 1860 among "Confederate"
cities, but twenty-fifth among all American cities.
Roughly 38,000 people were not very many,
compared to urban centers like New York

(1,080,330), Philadelphia (565,529), and Balti-
more (212,418). Perhaps even more significant
was the dominance of planters and professionals
in the upper strata of Richmond social life. As
one astute observer noted, "Trade, progressive
spirit, and self-made personality were excluded
from the plain of the elect, as though germini-
ferous. The 'sacred soil' and the sacred social
circle were paralleled in the mind of their
possessors."

Mayor Joseph Mayo served as the city's ex-
ecutive and also as a sort of urban "overseer."
The city attempted to act as surrogate master,
not only to the slave population, but to the free
Negroes, as well. Mayo held court daily to deal
with breaches of the city's peace and of Rich-

Here Virginia's wartime governors lived and tried their mightiest to manage the state's government separate from that of the Confederacy. In time, Richmond, Virginia, and the C.S.A. seemed indistinguishable. (USAMHI)

mond's "Negro Ordinance" which proscribed a rigid code of conduct for both free and bonded Negroes.

Prosperous burgers who occupied a majority of the twelve City Council seats had proven themselves quite capable of running the city. Mayor Mayo was a vigorous man despite his seventy-six years. Whether the men and governmental machinery which ran the small, stable city could rise to the challenges of a swollen, wartime capital was an unanswered question in 1860.

Indeed the question was unasked. Richmond was a conservative city in 1860, and she gave few political indications that she even desired membership in a Southern Confederacy, much less the leadership role implied in becoming its capital. Traditionally the vast major-

ity of Richmond voters were Whigs; Democrats referred to themselves as "the Spartan band." In the presidential election of 1860 Richmonders went Constitutional Union, giving neo-Whig moderate John Bell a two-to-one majority. Then in the selection of delegates to the Virginia convention that considered secession, the city's voters chose two Unionists and one Secessionist. Throughout the winter months of 1861 Virginia's convention sat in the capitol in Richmond and voted moderation while the states of the Deep South seceded and formed the Confederacy at Montgomery.

As the crisis at Fort Sumter between the United States and the Confederate States intensified during the early spring of 1861, the mood in Richmond shifted. By April editorials in all four of the city's newspapers were

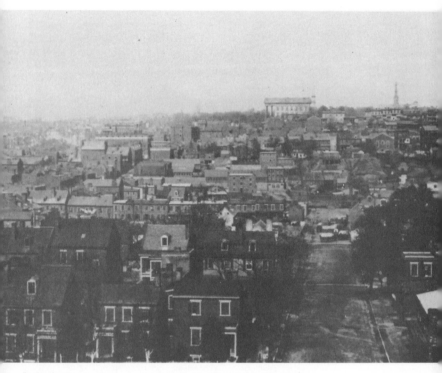

In April 1865 a Northern cameraman, probably Alexander Gardner, made a broad multi-image panorama of the city. Two of his images are joined here, and it presents a scene that would be little different from the look of the capital two or three years before. The state house, as always, dominates the skyline in the left-hand image. (USAMHI, NA)

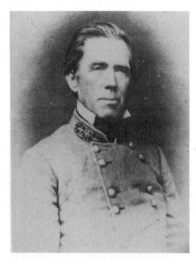

One governor, William Smith, spent two years in the Confederate Army as a brigadier general before going to the state house to lead Virginia in the last years of the war. He was called "Extra Billy" because of his penchant for expanding his one-time mail route in return for extra fees from the United States Government back before the war. In battle he wore a beaver hat and carried an umbrella if rain threatened. (VM)

threatening secession if the Washington government attempted to coerce the seceded states back into the Union. On April 4 the radicals in the state convention failed by only three votes to have a secession referendum put to Virginia voters. Former Virginia Governor Henry A. Wise then called a kind of counter-convention, the "Spontaneous Southern Rights Convention," to meet in Richmond in an effort to stampede the state into radical action.

Then on April 12 came news of the firing on Fort Sumter. Overnight, it seemed, Richmond was transformed. Amid demonstrations of Southern fervor, the state convention passed an ordinance of secession on April 17, and two days

later the city exploded in celebration. Ten thousand people, nearly half the white population, poured into the streets, and bonfires, bands, torches, bells, and fireworks hailed the revolution.

A few days later Confederate Vice President Alexander H. Stephens journeyed to Richmond to hasten Virginia's alliance with the Confederacy. In the process he stated, "It is quite within the range of probability that . . . the seat of our government will, within a few weeks be moved to this place." Stephens' remark became prophecy on May 20, when the Confederate Congress voted to move the capital from Montgomery, Alabama, to Richmond.

The presence and influence of Virginia's delegation to the Congress played some role in the decision. Other considerations, however, were also significant. Montgomery in 1861 was small (10,000 people) and ill-prepared to be the seat of a sizable government. Some congressmen were reportedly ready to move anywhere to escape Montgomery's crowded hotels and voracious mosquitoes, and Richmond promised the new government more adequate accommodations and facilities. Perhaps most important, Richmond seemed to offer a war government in proximity to its war. The Confederates assumed that Virginia would become the major battleground in their conflict, and thus moving the government to Richmond seemed a natural way to facilitate the conduct of the war.

Hindsight has offered a set of serious reservations about the wisdom of establishing the Confederate capital at Richmond. Located on the geographical fringe of the nation, the new capital tended to isolate its government from the vast Southern interior. Too, proximity to Washington rendered Richmond a tempting target for Union armies and thus, as one scholar has suggested, a "beleaguered city." And because the South's war eventually included many battlefronts, Richmond's location and defense may have overpreoccupied the Confederate government and precluded attention to other theaters which had equal or greater strategic significance. Such latter-day judgments are not unjust, and certainly the Confederacy's prime reason for moving to Richmond (to be close to the war) proved tragically naïve.

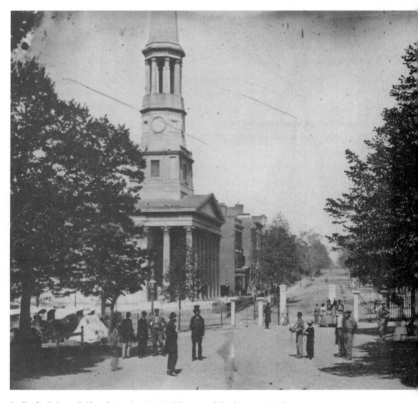

St. Paul's Episcopal Church stood on Capitol Square, while the square itself was always a popular gathering place for loungers and idle gossipers. (LC)

Yet Richmond was not a bad choice for the capital. To be sure, the location imposed some military strain upon Southern armies; but during the first two years of the war the Tredegar Iron Works were perhaps as crucial to the Confederacy as the government. Southern arms had to hold Richmond whether or not the capital was there. More important, Richmond's role as magnet in attracting Federal armies probably cost the Union more than it did the Confederacy.

The North's "on-to-Richmond" enthusiasm drained men, matériel, and energy that might have been used more effectively elsewhere, and for four years Richmond's defenders defied the invaders and their hope of quick victory. Far from leading to a quick victory, the hundred miles between capitals became a killing ground on which the North suffered its greatest frustration. Near the end, Richmond's role changed from magnet to "millstone"—hung about the

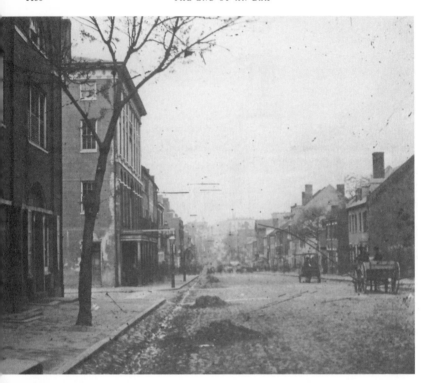

The view looking west on Main Street. Taken in April 1865, it shows Yankee wagons rolling off in the distance. (LC)

neck of Lee's Army of Northern Virginia. But by then the war had brought about Southern exhaustion everywhere, and though the trenches prolonged the life of Lee's Richmond army, they also trapped them.

In May of 1861, however, the Confederacy lived in blissful ignorance of these gloomy second thoughts, as Jefferson Davis led his government's exodus from Montgomery. Richmond became very quickly the center of intense political and military activity. War was at first parades

and picnics in Richmond. "We ought to be miserable and anxious," wrote Mary Chesnut in her famous diary, "and yet these are pleasant days. Perhaps we are unnaturally exhilarated and excited."

The new capital's euphoria certainly lasted through midsummer of 1861, and Richmonders rejoiced over the Southern victory at First Bull Run. But then came the ambulances and trains bearing wounded soldiers and with them an initiation into sobering reality. Richmond be-

The view from the Confederate "White House" of the Shockoe Valley and the section of Richmond called Butcher Town. It had been, literally, the place where cattle were slaughtered. (NA)

came a hospital center in 1861 and continued as one throughout the war. Richmond also became a prison center for captured Federals, and despite efforts to move the captives to prison camps established farther South, Richmond often held 10,000 enemy soldiers on Belle Isle (enlisted men) and in Libby Prison (officers). Wounded friends and captured foes represented only the most obvious challenges faced by Richmond as wartime capital.

Richmond became quickly overcrowded; her population grew eventually to an estimated 100,000, an increase of 150 percent since 1860. The city's crime rate increased as well. Drunken soldiers thought it great sport to seize watermelons, throw them into the air, and try to catch them on their bayonets. Gambling houses,

"hells," as they were called, flourished despite repeated raids by the city police force, and Richmond became, according to the leading historian of soldier life in the Confederacy, "the true mecca of prostitutes." One madam was so bold as to open for business across the street from a YMCA hospital. There "ladies of the evening" advertised themselves from the windows and enticed convalescent soldiers from one bed to another. Although the City Council increased the size of the police force and Mayor Mayo reactivated the "chain gang" for lesser offenders, Richmond remained in the newspaper *Examiner*'s phrase a "bloated metropolis of Vice." Perhaps the most effective method of combating lawbreakers was the policy of the surgeon-in-charge of one of the city's military hospitals.

There were several nationally famous hostelries in the city, none more so than the Spotswood Hotel, shown here in an April 1865 image by Gardner's assistant James Reekie. Here President Jefferson Davis lived in 1861 until the executive mansion could be readied for him. Here General Robert E. Lee stayed when he "went South" in 1861, and throughout the war the greatest luminaries in the Confederate constellation passed through its doors. (USAMHI)

Less well known but still popular was the Ballard House, at left, in this April 14, 1865, Reekie image. Its unusual walkway over Franklin Street connected it with the unseen Exchange Hotel. (USAMHI)

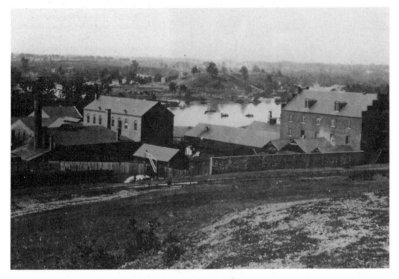

Of course, as a major city in war, Richmond offered a few guest accommodations that were less desirable, such as those afforded to enemy prisoners. Belle Isle in the James River rises in the center distance, a place where thousands of Yankees languished and not a few died. (USAMHI)

Lacking a guardhouse, the officer detained unruly patients and staff in the hospital "dead house" (morgue). Thereafter, he reported, he "never heard anything more from them."

Crowding and crime were both symptom and source of chaotic economic conditions. Richmond did become a center of war industry; the shops and laboratories of Major Josiah Gorgas' Ordnance Bureau multiplied in number and grew in size, as did other government enterprises that produced everything from cannon to currency. Among private enterprises the Tredegar Iron Works, for example, nearly tripled its work force and increased its production to the limit of its ability to secure pig iron. In competition with the wartime prosperity that affected everyone from "iron puddlers" to prostitutes, though, was the inflationary spiral of Confederate currency and the scarcity of life's necessities in the city. Wages never kept pace with prices, and crowding compounded the difficulty of supplying the capital with food and fuel. To make matters worse, many of the fields that normally produced food for the city became fields of battle.

Prices rose to the point at which the Richmond *Dispatch* estimated that a family's weekly groceries that cost $6.65 in 1860, cost $68.25 in 1863. Rumors circulated of vast profits made by "extortioners" who hoarded large quantities of provisions and became rich from the sufferings of others. Early spring was the leanest time; new crops were not ready to harvest and stored supplies ran low. In mid-March of 1863, to make a bad situation worse, the Confederate Congress authorized the Army to impress foodstuffs. The new law had the effect of unleashing army com-

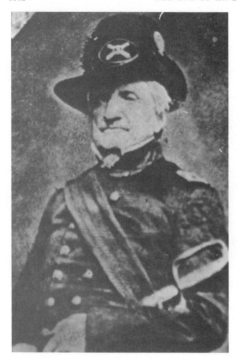

The man in Richmond given charge of these prisons, and all Confederate prisons, was Brigadier General John H. Winder, shown in this unpublished portrait in his prewar uniform as an officer in the United States Army. His task so exhausted him that, like many prisoners in his charge, he died before the war was done. (VM)

missary agents upon the city's marketplaces. Civilian food supplies became quite scarce, and prices of what was available rose alarmingly.

The *Whig* spoke of being "gouged by heartless extortioners and robbed by official rogues," and a War Department official recorded in his diary, "There is a manifest uneasiness in the public mind different from anything I have noticed heretofore."

Then on March 19 and 20, 1863, nine inches of snow blanketed the city and rendered travel in and out of Richmond all but impossible. The weather soon warmed, but as a result roads became quagmires. Those farmers and gardeners who still had food to sell and who were willing to risk impressment at prices now below the market level were all but unable to transport their produce into the city.

On the morning of April 2 a group of working-class housewives gathered at Belvidere Hill Baptist Church. Their neighborhood of Oregon Hill was near the outskirts of the city, and many of their husbands worked in the nearby ironworks. The women talked about their plight and their empty cupboards and then decided to petition the governor for immediate relief. The walk from Oregon Hill to Capitol Square was long, but the day was mild, and as the women walked others joined the march. By the time they reached the governor's mansion the group was sizable, and men and boys had joined the housewives. Governor John Letcher listened to

More somber to Richmonders was the Virginia State Penitentiary, shown here in an April 1865 image. When the city fell, its 287 inmates escaped, fired the place, and rampaged through the city. (USAMHI)

their problems and offered his sympathy, but nothing else. When he had made his offering, Letcher went back inside the mansion, leaving the several hundred people in his front yard to mill about in frustration.

The gathering attracted attention and greater numbers. Soon the gathering became a mob and a leader emerged. Mary Jackson, "a tall, daring Amazonian-looking woman," with a "white feather standing erect, from her hat," urged the people to action. And they followed her white feather away from the governor's mansion toward Richmond's commercial district.

Waving knives, hatchets, and even a few pistols, the mob swept down Main Street shouting for bread. The mob then became a riot. Throughout an area of ten square blocks the rioters broke into shops and warehouses and took food. Some seized the opportunity to take jewelry and clothing as well.

Governor Letcher appeared on the scene and attempted to stop some of the looting, but no one seemed to notice him. Mayor Mayo tried to read the riot act, but no one heard him. Then a company of soldiers, reserve troops from the Tredegar Iron Works, came marching up Main Street. The column drove the advanced rioters back upon the rest and was rapidly clearing the street until someone pulled a horseless wagon across the soldiers' path. The wagon formed a hasty barricade between the troops and the mob, and into the impasse strode the President of the Confederacy.

Jefferson Davis stepped onto the wagon and shouted to the mob. Women hissed while Davis tried to make himself heard. He emptied his pockets, threw his money into the crowd, and then he took out his pocketwatch and gestured at the company of troops. "I will give you five minutes to disperse," he stated, "otherwise you will be fired on."

As if to punctuate the President's demand, the

Yet there were quieter, more peaceful places. Richmond was a city of churches, and not just the great steepled edifices on Capitol Hill. St. John's Church stood at Broad and 24th streets in the eastern part of the city. A Brady cameraman made this image, and his employer, Mathew Brady himself, stands behind and just right of the tombstone. Here in this church ninety years before, in 1775, Patrick Henry made—or is said to have made— his "Give me liberty" speech. (USAMHI)

captain of the company commanded, "Load!" The men complied, although no one knew for sure whether they would enforce the President's ultimatum by firing on the crowd of their fellow citizens, some of whom may have been neighbors and relatives. Davis kept his eyes on his watch, and for what seemed a long time no one moved. Then the mob began to drift away, and soon the President and the soldiers were alone in the street. The riot was over.

The City Council met in emergency session the same afternoon and concluded that the riot had been instigated by "outsiders." And instead of hunger the councilmen attributed the riot to "devilish and selfish motives." After resolving that Richmond's "honor, dignity, and safety will be preserved," the city fathers adjourned. During the night artillery batteries unlimbered their pieces on Main Street. The Secretary of War ordered the telegraph office to transmit "nothing of the unfortunate disturbance of today over the wires for any purpose" and made a "special appeal" to Richmond's newspapers "to avoid all reference directly or indirectly to the affair." Thus, on April 3, 1863, the *Dispatch* carried a lead editorial headed "Sufferings in the North."

Although several days later Mayor Mayo was still requesting more troops to prevent further

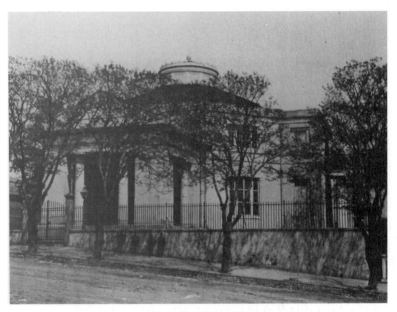

Monument Church, or the Monumental Church of Richmond, stood on Broad Street, not far from the Capitol. It was built by private subscription in memory of seventy-two people who died in the 1811 Richmond Theater fire on this site. (USAMHI)

violence, no more bread riots occurred in the capital. The events of April 2 did point out that many Richmonders lived in want. When the City Council met a week after the riot, the members' shock and indignation had worn off. Acting through the Overseers of the Poor, an existing charitable agency, the council directed that needy Richmonders receive food and fuel tickets redeemable at two "free markets."

Two months later the council expanded the relief program by ordering two "visitors" into each of twenty districts to determine need and distribute tickets. Still later the council, faced with declining amounts of food and fuel in the "free markets," established a Board of Supplies to coordinate a search in the countryside for food

to be sold at cost in the city. Despite the indifferent success of the board's agent, the city was able to supply food at cost to an average one thousand families per month during the following winter. Eventually the council abandoned the distinction between poor Richmonders and wealthy Richmonders; it ordered the Board of Supplies to secure food "for the city." This exercise in wartime welfare did not prevent some people from being hungry in Richmond. Yet the resourcefulness of the City Council probably prevented many from starving as the pressure of "total war" increased upon the capital.

The sustained strains of home-front war in the Rebel capital severely challenged the hitherto

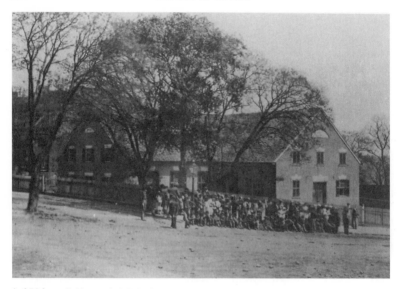

And Richmond's Negroes had their place of worship, too, the First African Baptist Church. It stood just down the street from Monument Church and had one of the South's largest Negro congregations. Many of them pose here on Broad Street for a Brady cameraman. (USAMHI)

conservative city. It would be easy to say that Richmond's response was often too little too late. Yet there were no solutions to problems that only compounded as the military situation deteriorated. Richmond confronted wounded soldiers, Federal prisoners, refugees, crime, inflation, privation, class conflict, riot, and more. In meeting the challenges of home-front war the city was ever "becoming," always making some new sacrifice in order to endure, and never "being," in the sense of being able to celebrate some point at which she had prevailed.

Richmond did become a national capital. A Prussian visitor probably said it best: "The moral force of the resistance was also centered in Richmond, the capital of the rebellion. . . . The energy of the Confederate resistance that was typified in Richmond impressed me almost as much as the great efforts of the army . . . to hold the field [at Gettysburg] against an overwhelming adversary."

When Major General Thomas "Stonewall" Jackson died as a result of wounds in May of 1863, they bore his body to Richmond to lie in state at the Capitol. A crowd estimated as the largest ever assembled in the city gathered at the railroad station and followed Jackson's coffin to Capitol Hill. After the prolonged procession of three bands, the hearse, and Jackson's riderless horse through the city, an observer noted, "I should think that every person in the city of Richmond had today buried their nearest and dearest friend." More than the nerve center of government and military command, as "moral force of the resistance" Richmond made a strong bid for the Confederacy's heart as well.

The city alms house stood at the northern edge of the capital. It served as a
Confederate hospital during the war until December 1864. Then it became
the temporary quarters of the Virginia Military Institute. This Gardner
image shows graves in the Shockoe Cemetery in the foreground. (USAMHI)

By 1863 the institutions of the capital were also national institutions. Religious denominations printed newspapers, sermons, and tracts in the city and distributed them throughout the South. The Medical College of Virginia was the only medical school in the Confederacy to remain open throughout the war period. And Richmond's press was one of the most active and probably the most influential in the South. During 1863 the Alexandria *Sentinel* moved its office to Richmond and became the capital's fifth daily newspaper. The *Sentinel* and the *Enquirer* were important as quasi organs of the Davis administration; the *Whig* and *Examiner* were equally important as consistent critics of the government. The *Dispatch* continued a more localized focus and pursued a less predictable policy on national issues. Periodicals also grew

and prospered in the wartime city. The *Southern Literary Messenger, Southern Illustrated News,* and *Magnolia, A Southern Home Journal,* especially, attracted wide readership, and *The Southern Punch,* modeled on the London humor magazine, offered humor of varying quality to the Confederacy.

Richmond also offered, as the *Whig* reported, "no lack of resources with which to banish dull care." The city's theaters attracted the best entertainers in the South and presented everything from Shakespeare to minstrels. The capital's "official society" led by Varina Davis, the President's wife, entertained its members, even in January 1864, with luncheons of "gumbo, ducks and olives, lettuce salad, chocolate cream, jelly cake, claret cup, champagne, etc." And "insiders" complained of Richmonders' capacity to

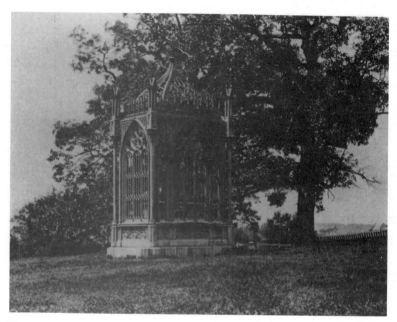

There were other places where the war did not seem to intrude, places like the tomb of President James Monroe in Hollywood Cemetery. Reekie made this image on April 15, 1865, the same day that the body of another President, Abraham Lincoln, was being carried to the embalmers. (USAMHI)

"swallow scandal with wide open mouths." Less grandiose gatherings were those of the Mosiac Club, whose members, the brightest of the South's intellectuals, gathered whenever one of them fell heir to a quantity of food or drink. Later "starvation parties" came into vogue; host and guests contributed toward musical entertainment and swilled vintage "James River, 1864" for refreshment. No less an authority than General Robert E. Lee encouraged parties in the city for the diversion and relaxation of his troops. And even during the war's last year Mary Chesnut could proclaim from Richmond, "There is life in the old land yet!"

From the beginning, Richmonders were con-

cerned, with reason, for the military security of the capital. In the eastern theater of the war, Confederate armies confronted an enemy whose rallying cry was "on to Richmond."

During the spring and summer of 1862 Richmond was the target of Major General George B. McClellan's Peninsular Campaign, and the war reached the suburbs of the city. Richmond's initial response to this peril was a corporate variety of panic. On March 1 President Davis issued a proclamation of martial law in his capital, and Brigadier General John H. Winder became responsible for conducting military rule within a ten-mile radius of the city. He immediately banned the sale of liquor in Richmond, estab-

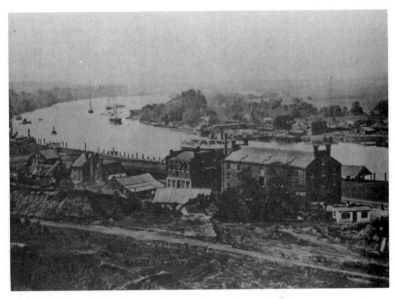

Richmond was a city playing host to a government at war, and as a result much of the city's normal routine was disrupted and many buildings were converted to wartime purposes. Here the camera views part of the Confederate States Navy Yard at Rocketts, on the James River. The large building in the center is the Quartermaster Department's supply warehouse, one of several buildings in the city devoted to managing supplies for the army. (USAMHI)

lished a system of passports to control movement to and from the city, and began a series of arbitrary political arrests. On April 22 the Confederate Congress voted itself a pay raise and hastily adjourned. All the while McClellan's army moved closer to the city, making ready for what seemed would be a final thrust. And meanwhile in Richmond, Unionist slogans—"Union Men to the Rescue!" and "God Bless the Stars and Stripes!"—appeared in chalk on walls and fences. Elizabeth Van Lew, an old lady who openly proclaimed her Unionist sympathies, prepared a room in her mansion for General McClellan to be her guest.

Although no one could know it at the time, the crisis in Richmond's fate during the spring of 1862 occurred on May 15. With the USS *Monitor* in the van, Union gunboats were steaming up the James to shell the city. Only hastily prepared obstructions and guns at Drewry's Bluff, about seven miles below Richmond, offered any hope of halting the flotilla. At that point, with so much reason to despair, the city seemed to take heart and assert its will. Governor Letcher called a mass meeting at City Hall to organize citizen-soldiers. As the crowd gathered at five in the afternoon, the guns at Drewry's Bluff opened fire on the enemy ships in the river.

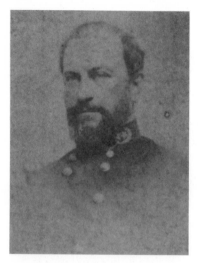

Confederate Quartermaster Brigadier General A. R. Lawton was a familiar figure in Richmond and one of the most capable men in the military hierarchy. (MC)

Those assembled realized that if the ships got past the river defenses, the Federals would be able to shell the city at will. Then Mayor Mayo arrived and to the tense crowd shouted defiance at the imminent danger. Mayo vowed that should the occasion arise, some other mayor would have to surrender the city. "So help me God, I'll never do it." Next Letcher took the stump. He said he did not know anything about surrender, but were he given the option of giving up the city or watching it shelled, he would respond, "Shell and be damned." Only later that day did the anxious city learn that Drewry's Bluff had held, that the Union ships were returning downriver, and that the immediate danger was past. And later the genius of Lee emerged to drive McClellan's army from the capital's gates.

Although Federal infantry did not so threaten Richmond again until 1864 and 1865, the city had significant scares in 1862 and 1863 from

Union cavalry. During the Chancellorsville Campaign, on May 3, 1863, Richmonders learned that the enemy horsemen were in nearby Hanover County and advancing south toward Richmond. Chaos broke out as bells rang and volunteers hurried out to man the city's fortifications. The commander of Confederate troops in the area announced to a friend that he wished he were dead. The citizen-soldiers were in such a rush to meet the foe that they forgot to carry gunpowder with them for their artillery, and once they remedied that oversight, someone noticed that they had no friction primers with which to fire the weapons. Brigadier General George Stoneman's cavalry came within five miles of the city and turned away. Had they come farther, the 1,500 Federals would have confronted about 900 civilians with impotent artillery.

On March 1, 1864, the *Whig* reported that a column of enemy cavalry had been seen behind Lee's lines, but predicted the Federals would "hardly remain long enough to do much damage." As it happened there were two sizable contingents of Union horses converging upon Richmond. Just after noon that day 3,000 troopers commanded by Brigadier General Hugh Judson Kilpatrick appeared on the northern perimeter of the city; they formed for a charge, but then unaccountably withdrew. A bit later in the afternoon the second body of Federal cavalry threatened the city from the west until driven off by Confederate reserves and volunteers. Richmonders correctly concluded that the two thrusts were designed to be a coordinated attack. But only later did the capital learn the full, frightening details of the Federal plan.

The second Union mounted force rode into an ambush as it attempted to withdraw, and its commander, Colonel Ulric Dahlgren, was among those killed in the fray. On Dahlgren's body were found what appeared to be his orders to his command for the ill-fated mission. The colonel had written that he planned to free the captured Federals on Belle Isle, then cross into the city, "exhorting the released prisoners to destroy and burn the hateful city, and . . . not allow the Rebel leader, Davis, and his traitorous crew to escape." Both Confederates and Federals were horrified at such unchivalric intentions,

There was a city to run as well as a nation, and here at City Hall, on 11th Street, the affairs of Richmond were attended to by a devoted mayor . . . (USAMHI)

and controversy over the authenticity of the "Dahlgren papers" raged long after the event.

In the summer of 1864 General Ulysses S. Grant attempted to pound Lee into submission. That failing, Grant assaulted Petersburg, the small city about twenty miles south of Richmond. Petersburg was important to Richmond as a railroad junction; if Petersburg fell, only one rail line would remain to connect the Confederacy with its capital. Lee's army held Petersburg; Grant settled down to siege—a campaign of attrition against Petersburg, Richmond, and Richmond's army. Lee accepted the siege; he could see no alternative. His army was too weak, numerically and logistically, to fight "those people" (as Lee termed his enemies) in the open, and trenches might keep the odds nearly even until the Federals tired or erred. Earlier, Grant had vowed "to fight it out on this line, if it takes all summer." It did take all summer, and fall, and winter too; Richmond's army remained steadfast to the end, and some of its finest hours came near the close of its life.

Although the fifty miles of trench networks around the capital remained fairly static, battle-line fighting took place daily. When a Confederate strongpoint fell or a portion of the line wavered, reserve troop units composed of industrial laborers and bureaucrats formed and

. . . Joseph Mayo. Early in the war he declared that he would never give up his city to an enemy. In April 1865 he actually went riding out into the countryside looking for the Federals to come and accept the city's surrender and help put out the fires. (VM)

The real seat of power in Richmond, however, was here in the old Brockenbrough house, turned into an executive mansion for President Jefferson Davis. Reekie photographed it on April 12, 1865, just nine days after its former occupant had fled. A few days later, President Lincoln had visited the city and sat in Davis' chair here. (USAMHI)

hurried to reinforce Lee's regulars. Then the work of the industry and government in Richmond ceased for the duration of the emergency, and the Confederacy crumbled a little more. Reliance upon these citizen-soldiers became so frequent that in October 1864, it inspired poetic praise for the "Richmond Reserves":

> Like a beast of the forest, fierce raging
> with pain,
> The foe in his madness, advances again;
> His eyeballs are glaring, his pulses beat fast,
> While the furies are hastening this effort,
> his last.
> But the seven-throned queen [Richmond]
> a calm presence preserves,
> For they've sworn to defend her—the
> "Richmond Reserves."

However deficient as poetry, the verse displayed an urban consciousness all but unknown three

years earlier. And Richmonders who were not poets exhibited a special pride in their city.

On April 1, 1865, the day before Lee evacuated the city, the *Sentinel* offered this thought: "We are very hopeful of the campaign which is opening, and trust that we are to reap a large advantage from the operations evidently near at hand." Not unlike Brussels on the eve of Waterloo, Richmond during the winter of 1864–65 had erupted into a veritable carnival of parties and weddings—*carpe diem*. One resident remembered that people held "not the brilliant and generous festivals of the olden days in Richmond, but joyous and gay assemblages of a hundred young people, who danced as though the music of cannon shells had never replaced that of the old negro fiddler—who chatted and laughed as if there were no tomorrow."

"Tomorrow" came on Sunday, April 2, 1865. Southwest of Petersburg, at Five Forks, the day

Confederate Vice President Alexander H. Stephens lived here at 12th and Clay streets, on the corner opposite the Executive Mansion. Though neighbors, the two executive officers spoke as little as possible. (USAMHI)

before, Major General George Pickett's division had been cut off and devoured by the Federals; the thin line of earth and men at Petersburg which stood between Richmond and capture was broken. Lee responded to the situation with his usual professional competence; he endeavored to save his army by abandoning the now untenable capital.

Jefferson Davis was at St. Paul's Church when Lee's telegram arrived from Petersburg. As the Reverend Charles Minnegerode read the ante-Communion service, Davis read the sentence of doom pronounced upon his capital. The President quickly left the church and began the process of evacuating his government. By the time Richmond's churches had concluded their worship, the mass exodus of government officials from the services had confirmed the worst.

Pandemonium broke out that Sunday afternoon. "The office-holders were . . . making arrangements to get off. Every car was ordered to be ready to take them South. . . . The people were rushing up and down the streets, vehicles of all kinds were flying about, bearing goods of all sorts and people of all ages and classes who could go. . . ." The City Council met to try to provide protection for private property and to plan the destruction of liquor supplies in the city. Meanwhile, the army prepared to destroy whatever military supplies could not be moved. Darkness did not slow the frantic activity.

By the early hours of April 3, most of the military and nearly all of the government officials had left. About three o'clock in the morning a fire began. The blaze probably started as part of the Confederacy's attempt to destroy everything that might be of value to the enemy. The flames engulfed the tobacco warehouses, the railroad bridges, the arsenal, and soon raged out of control and burned a large area of the city, from Capitol Square to the James River. As the massive fire blazed, rioting began. Several thou-

There were many fine homes in the city, like this, the Van Lew mansion. Its occupant, Elizabeth Van Lew, pretended to be eccentric, earning the sobriquet "Crazy Bet," but she also remained loyal to the Union and sometimes sent information through the lines to the Federals. (USAMHI)

sand people tried to reach the stored rations in the commissary depot before the flames. As a committee appointed by the City Council dumped barrels of whiskey into the streets, rioters drank from the gutters.

The evacuation fire, which smoldered in the debris until late June 1865, was devastating. It consumed more than twenty square blocks and all but destroyed the city's commercial district. Every bank, every saloon, and almost every press in the city was destroyed. Between eight hundred and twelve hundred buildings went up in flames, and damage estimates reached thirty million nineteenth-century dollars.

At dawn on April 3 a Confederate rear guard fired the last remaining bridge over the James and dashed away. Soon thereafter Mayor Mayo, who had sworn never to give up the city, rode out of Richmond to try to find someone to whom to surrender. Eventually he found Union Major General Godfrey Weitzel and made arrangements for the restoration of law and order under an occupation regime. At eight o'clock the Federals entered Richmond and marched through the city to Capitol Square.

A few days later President Abraham Lincoln came to survey his prize. And someone wrote a song to celebrate Richmond's capture. Perhaps more than anything else that song expressed what Richmond had meant to the Confederacy:

Now Richmond has fallen, rebellion is done,
Let all men rejoice for the victory is won!
The city where slavery once dwelt in her pride
Is now in our hands and the rebellion has died.
Now Richmond is taken, they'll harm us no more
For treason is crushed and rebellion is o'er.
Our armies have triumphed, the traitors have fled.
We've captured their city, secession is dead.

The last hope of the Confederacy perished in the flames of the fallen capital.

And here on Franklin Street stood the wartime residence of General Robert E. Lee. The house would become almost as sacred to Virginians as the executive mansion. (USAMHI)

In the environs of the city, war industry bloomed during the war, most notably here at the Tredegar Iron Works, chief cannon makers for the Confederacy. Despite a shortage of raw materials, Tredegar was a model of modern efficiency and production in wartime. (USAMHI)

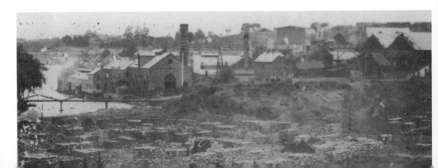

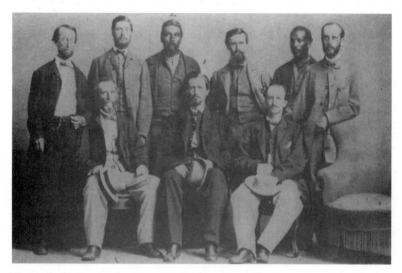

These men worked for the Confederate Nitre and Mining Bureau, trying to collect the raw materials for gunpowder and lead and employing a few Negroes in the process. (MC)

The Richmond arsenal manufactured what guns it could with the shortage of materials. (VM)

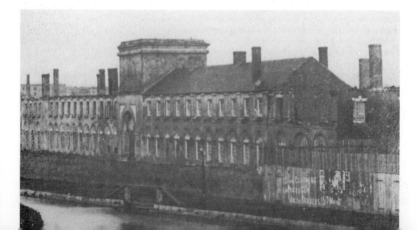

*In this small factory near Hollywood Cemetery, small-arms ammunition was
manufactured for the Confederates in the field.* (VM)

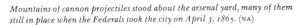

*Mountains of cannon projectiles stood about the arsenal yard, many of them
still in place when the Federals took the city on April 3, 1865.* (NA)

*Besides munitions, Richmond produced flour in abundance, flour that fed
the Confederacy's armies. Here are some of the mills in Manchester, across
the James from the capital. (USAMHI)*

Another view of one of the Richmond mills. (USAMHI)

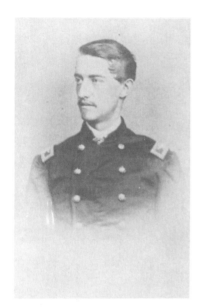

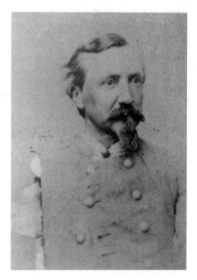

The capital was rarely in imminent danger before late 1864. Union Colonel Ulric Dahlgren did lead a daring raid on the city on March 2, 1864, but it failed and he was killed in the attempt. His father was Admiral John A. Dahlgren, inventor of the famous Dahlgren gun. For years afterward the controversy raged over whether or not the colonel had instructed his men to kill Jefferson Davis. (P-M)

Brigadier General Walter H. Stevens was in charge of Richmond's defenses, as well as being Lee's chief engineer. He helped supervise the evacuation of the city on the night of April 2–3, 1865, and was one of the last to cross the Mayo bridge over the James before it was put to the torch. (SOUTHERN HISTORICAL COLLECTION, UNIVERSITY OF NORTH CAROLINA, CHAPEL HILL)

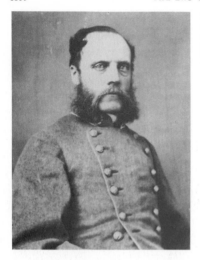

Brigadier General Patrick T. Moore was provost in Richmond, and when the dreadful last day came, it was he who ordered government stores burned. The fires spread, and on April 3 the Yankees marched into a . . . (VM)

. . . devastated city. A whole section of Richmond had been razed to the ground. Though rebuilt almost immediately, for decades to come this area would be known as the "Burnt District." (NA)

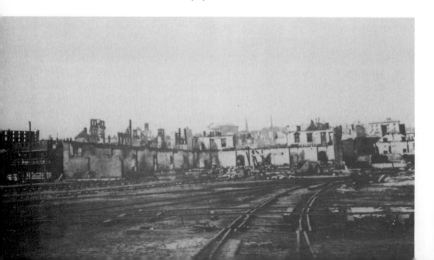

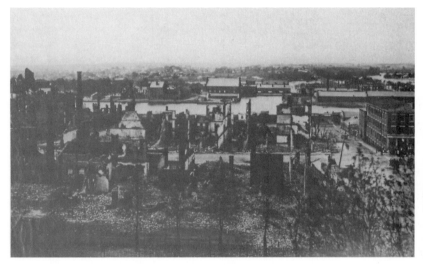

Whole blocks of warehouses along the James River were destroyed. (NA)

Levy & Cohen came to record their own views of the ruined city. The large white building still standing was the old U.S. Customs House, which served as the Confederate Treasury. (KA)

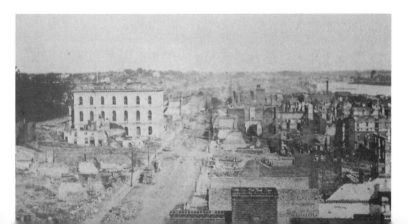

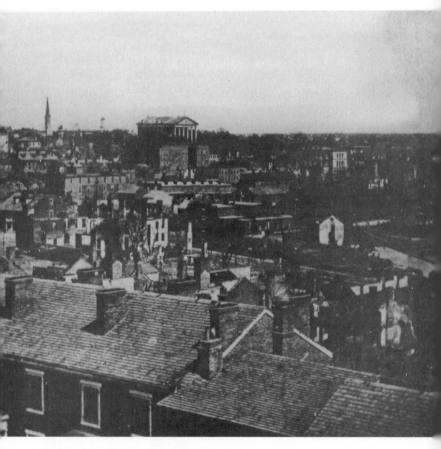

On April 6, with the rubble barely cool, Alexander Gardner made this
panoramic view of the Burnt District, with the state house in the distance.
(USAMHI, VM)

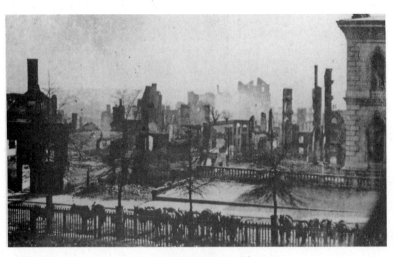

*Yankee horses wait quietly outside the Confederate Treasury, right next to
extensive ruins from the fire that was rather selective in its destruction.*
(USAMHI)

*The people of Richmond were soon up and about again in the city, searching
among the ruins for surviving belongings, for lost friends and relatives, or
just for some remnant of a way of life now suddenly vanished.* (USAMHI)

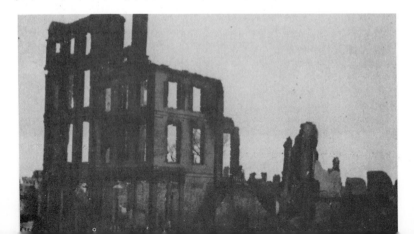

A paper mill that did not survive. (USAMHI)

Part of the mammoth Gallego Flour Mills, totally destroyed. Pictures of their ruins would stand for more than a century as the perfect image of . . . (USAMHI)

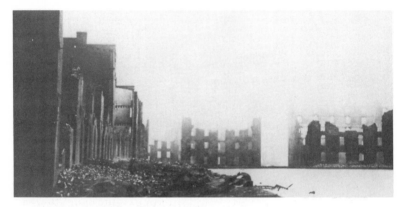

. . . the utter destruction of modern war. (USAMHI)

Though water still flowed over the mill wheel, the machinery no longer turned. Like the Confederacy, it had ground to a halt. (USAMHI)

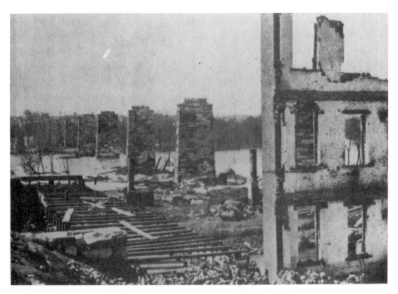

Everything of military value had to be destroyed. The fleeing Rebels set fire to their railroad bridges like this one on the Richmond & Petersburg line. (USAMHI)

Only portions of the line, like this section connecting Belle Isle with Manchester, remained. (USAMHI)

All else was ruin. (USAMHI)

When the Yankees came, they quickly saved what they could, repaired more, and got the city working again. Pontoon bridges over the James allowed traffic to cross once more. (NA)

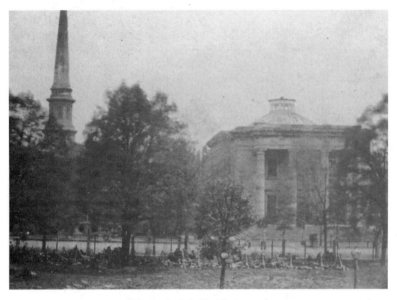

City Hall might not bustle for a time, but the Federal soldiers camped across the street ensured that things would be orderly. (USAMHI)

The arsenal yard was a shambles. (USAMHI)

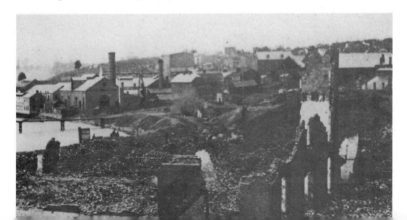

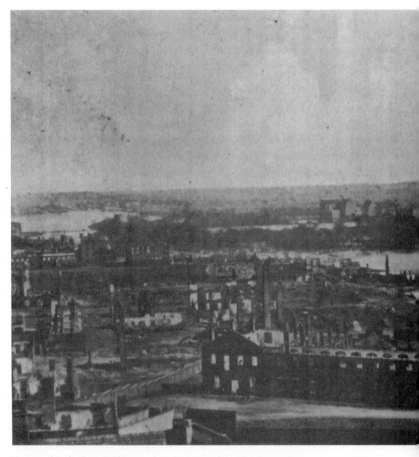

The arsenal itself, shown in this panorama, lay in complete ruins. (USAMHI)

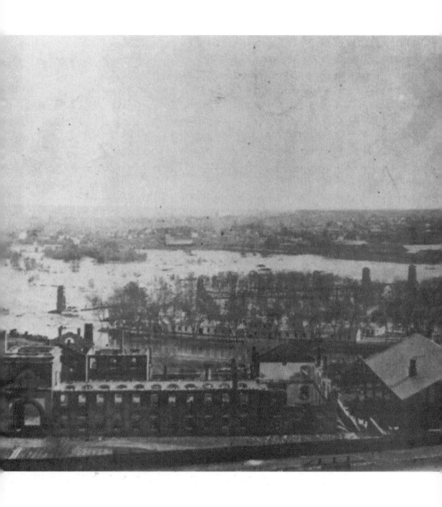

*Camps of laborers, many of them Negroes like these, sprang up to do the
work of rebuilding the railroads.* (KA)

*The canal along the waterfront filled once again, but now with U.S.
Government transports.* (USAMHI)

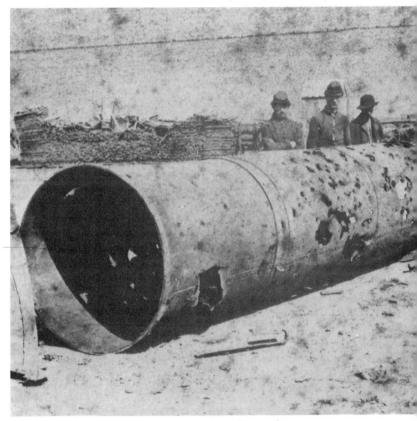

And relics of the Confederacy became objects of curiosity for the new rulers of Richmond. Here, the shot-riddled smokestack of the ironclad Virginia II.
(MM)

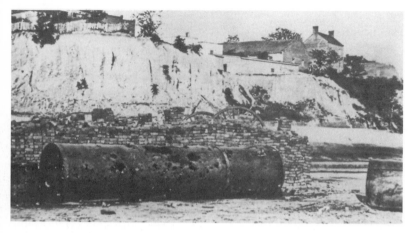

It was a trophy of war now. (USAMHI)

So were scores of pieces of Confederate artillery, lined up at Rocketts for use by the Federals or to be transported to the North. (LC)

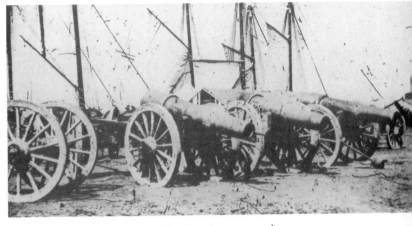

Captured guns, still caked with mud from the spring rains, were everywhere.
(NA)

And so was their attendant equipment, like this giant gun sling for carrying pieces of heavy artillery. (LC)

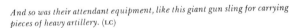

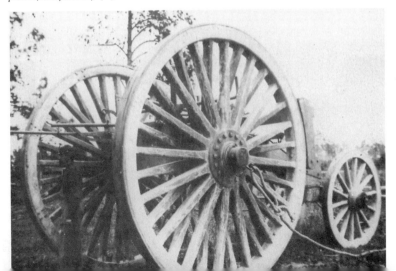

There were even a few bits of exotica, like the English Whitworth breech-loading rifle that could fire a solid bolt as far as five miles. (LC)

Now the Stars and Stripes flew over Libby Prison, its cells empty of the human misery that made it infamous. (USAMHI)

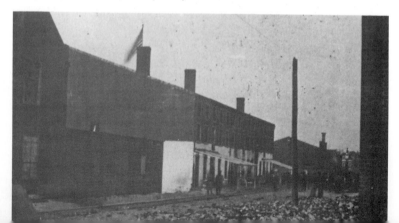

There was a new governor in the governor's mansion, Francis H. Pierpont,
who had helped organize the new state of West Virginia and served during
the war as "governor" of those Virginia counties under Federal control. Now
he took a seat on the porch of his new mansion, ruling the entire state at last.
(KA)

The burned bridges over the James were rebuilt. (NA)

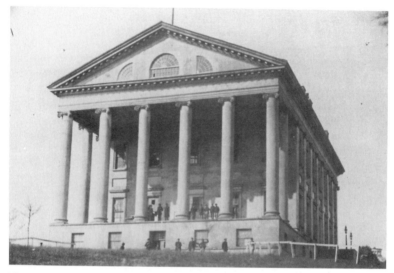

The Virginia state house, once Capitol of the Confederacy, despite a few broken window panes, went back to the work of housing a state legislature only. Mathew Brady stands fifth from the right on the porch. (USAMHI)

Crowds milled about the Washington monument in Capitol Square once more, where Reekie photographed both Federal soldiers and recently paroled Confederates on April 14, 1865. (USAMHI)

Yankee officers like Major General E. O. C. Ord could pose with his wife and daughter on the porch of the Confederate executive mansion. (USAMHI)

And Old Glory waved at last over a burned and battered but surviving Richmond. In a remarkably short time the city would rebuild, moving with the reunited nation into a new era. (NA)

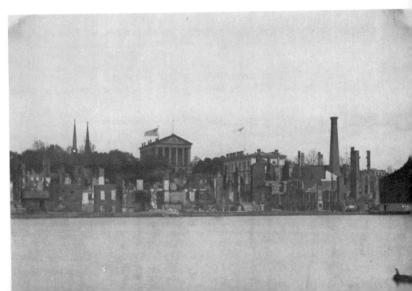

An End at Last

LOUIS MANARIN

When blood and bravery and indomitable will could do no more,
the Southern banners were furled

"AFTER FOUR YEARS of arduous service, marked by unsurpassed courage and fortitude, the Army of Northern Virginia has been compelled to yield . . ." Thus began General Robert E. Lee's farewell address to his army. The decision to yield had not come easy. Only after it became obvious that it would be useless to go on did Lee agree to surrender those who had remained steadfast to the end.

When the end came, it was not unexpected. The Confederate ranks had been thinned by battle, attrition, and the realization that will and determination were not enough. The valiant defense of the Petersburg line, the battle at Sayler's Creek southwest of Richmond, the retreat to the west, and the running attacks of Major General Philip Sheridan's cavalry had taken their toll in dead, wounded, captured, and missing. Many of the last had taken the opportunity to slip away in the confusion of battle and the retreat march.

The night sky on April 8, 1865, presented Lee's men with visible evidence of the military situation. They had been fighting rearguard and flank attacks, but now the sky reflected the red glow of campfires to the east, south, and west. The Federal army had succeeded in moving past the Rebel left flank and across the route of re-

treat. Only to the north was there an absence of the red glow. Lee's army was almost surrounded.

As the troops bedded down, there was an uneasiness. The army was stretched out and vulnerable to the hit-and-run attacks of the Federal cavalry. Out of the night the blue-clad troopers would swoop down and do their damage and then retire under the cover of darkness. Brigadier General Lindsay Walker's artillerists had successfully repulsed one lightning Federal strike, but when Brigadier General G. A. Custer's troopers struck a second time, about nine o'clock in the evening, they captured twenty-four pieces of artillery. The silence from Walker's camp told the Confederates what had happened.

Lee met with Lieutenant General James Longstreet, Major General John Gordon, and Major General Fitz Lee during the evening of April 8 and informed them of the correspondence he had had with Union General U. S. Grant. After reading Grant's letter of April 7 calling for the surrender of the Army of Northern Virginia, Longstreet had counseled his commander with the words "Not yet." In response to Lee's reply asking for clarification on terms, Grant had called for surrender of the

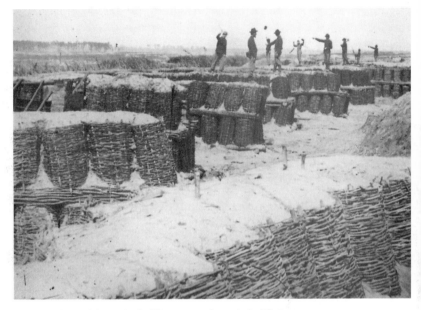

Petersburg theirs, jubilant Federal soldiers caper on the ramparts of Fort Sedgwick, raising their hats and pointing off toward the now silent Confederate lines. (LC)

army under conditions stating that the men would be on parole until properly exchanged. Surrender was the last option for Lee, and as long as he could, he would keep his army in the field. He proposed to meet with Grant to discuss the restoration of peace, not to negotiate a surrender. He had not received a reply at the time of his meeting with his generals on the evening of April 8. After discussing their options, they agreed that one more effort would be made to break through toward Lynchburg. If they could make it through, the army would turn southward. The plan called for the cavalry under Fitz Lee, supported by the II Corps under Gordon, to drive the Federals back in front, wheel to the left and hold the enemy while the army moved behind their screen.

When the sun came up on Palm Sunday morning, April 9, 1865, Gordon's men, numbering about 1,600, were in position a half mile west of Appomattox Court House. On his right, Gordon saw that Fitz Lee's 2,400 troopers extended his line. As darkness turned to light, the Federal earthworks became visible across the field. If Federal cavalry defended them, then Gordon and Fitz Lee felt they could force them back. If the Federal infantry was up, then the end was at hand.

Major General Bryan Grimes, the fiery North Carolinian, asked to lead the attack and Gordon told him to advance all three divisions. The Federal troopers behind the earthworks gave way as Gordon's men pressed forward and captured two pieces of artillery. Wheeling to the

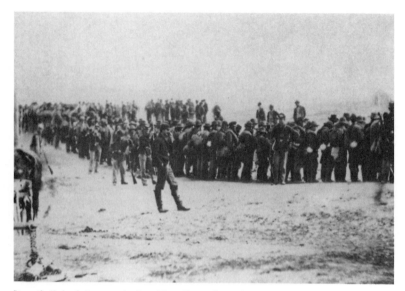

It was the Federal victory on April 1, 1865, at Five Forks, southwest of Petersburg, that forced General R. E. Lee at last to evacuate that city and Richmond. Here Rebel prisoners captured in the fight line up on their way to the rear. (USAMHI)

left, the jubilant gray-clad infantry opened the road to Lynchburg. Within an hour, Fitz Lee, on Gordon's right flank, reported the presence of Federal infantry. Major General Edward Ord, with three Union divisions, had marched his men all day and night and had arrived "barely in time." Gordon sent for reinforcements, but Longstreet was being pressured and expected an attack momentarily on the rear guard. Union regiments appeared on Gordon's right and rear, and Federal cavalry began to demonstrate on his left flank as if to drive a wedge between the Confederate forces. Within three hours the situation had changed from a glimmer of light to darkness.

When he received reports from his commanders, Lee decided to meet with Grant between Longstreet's and Major General George Meade's lines. A truce was ordered and Longstreet was told to inform Gordon. Upon receipt of the order, Gordon directed an officer to ride out under a white flag to inform Ord of the truce. The officer returned with Custer who demanded immediate and unconditional surrender in the name of General Sheridan. Refusing to recognize Custer's authority, Gordon declined to surrender. Custer demanded to see Longstreet and Gordon sent him to the rear under escort. When Custer repeated his demand to Longstreet, "Old Pete" also refused to recognize him and ordered him to leave. In the meantime, Gordon had given the word to Fitz Lee, and Lee pulled Brigadier General Thomas Rosser's, Brigadier General Thomas Munford's, and the greater part of his cavalry command out of the action to escape the surrender. Recognizing General Sheridan coming through the lines, Gordon rode out

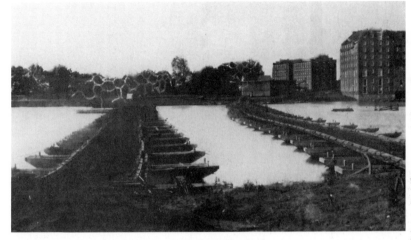

And now the Yankees lay pontoon bridges over the James River for the march into Richmond, occupied at last. A Russell view showing some of the Manchester mills, across the river from the capital. (USAMHI)

to meet him. Gordon showed him Lee's truce order and both men agreed to a cease-fire until they received word from their commanders.

Grant notified Lee that he could not discuss terms of peace but that he hoped no more blood would be shed. Lee then wrote and asked Grant for a meeting to discuss terms of surrender. Meanwhile, Lee met with Meade, and a truce was declared on that part of the line. Lee then returned through Longstreet's lines to await word from Grant. On the edge of an apple orchard, he stretched out on a pile of fence rails covered with a blanket. Little was said. Officers came up to discuss the situation with members of his staff and Longstreet came to meet with his commander. Lee was worried about the terms. It had been a hard fought struggle and his men had given their all. Now, he was faced with having to admit defeat. Word was passing through his army. Men cried out in rage for one more fight. Tears came to the eyes of many when they received word that the army was going to be sur-

rendered. Others breathed a sigh of relief that it was over. Artillerists on the move were told to turn in to the nearest field and park their guns. Some units had made it through to Lynchburg before the end came, but those that remained did not like the idea of surrendering the powder they had been forced to save.

A little after noon on April 9, a Federal courier rode up to the Confederate camp to accompany Lee to the meeting with Grant. Colonel Orville E. Babcock delivered Grant's reply to Lee's letter. Grant agreed to meet and asked Lee to pick the place. Lee would not delegate the responsibility of arranging the surrender. He asked Colonel Walter Taylor, his adjutant general, to accompany him, but that officer asked to be spared the unpleasant task on the grounds that he had been on two long rides that morning. Lieutenant Colonel Charles Marshall of Lee's staff mounted his horse as did Sergeant G. W. Tucker, who had been at Lieutenant General A. P. Hill's side when he was

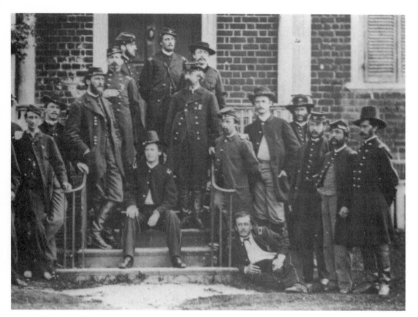

Major General Godfrey Weitzel is the general who first takes over the city,
sending out a telegram that announced on April 3, "We entered Richmond."
He stands, boots crossed, on the left of the steps, along with his staff. (VM)

mortally wounded before Petersburg. Lee, Marshall, and Tucker, accompanied by Babcock, rode toward Appomattox Court House. Marshall was sent forward to find a suitable place to hold the meeting. Tucker was sent with him.

As they rode into the small village, Marshall met Wilmer McLean. This gentleman had lived about a mile from Manassas Junction. After witnessing the battle there in 1861, McLean moved to Appomattox to escape the war. Marshall told him of his mission and McLean showed him an old dilapidated unfurnished house. When Marshall informed him that it was not adequate, McLean offered his home as a meeting place. Marshall sent Tucker back to tell Lee and Babcock while he went into the house

to select a room. When they arrived, Lee and Babcock joined Marshall in the parlor. Babcock stationed an orderly outside to direct General Grant.

About a half hour later, Grant rode up. Babcock opened the door and Grant entered the room alone. The two generals shook hands, exchanged greetings, and sat down. After whispered conversation with Grant, Babcock left the room and returned with a number of Federal officers. Among the group were Generals Sheridan and Ord, Brigadier General Horace Porter, Colonel Adam Badeau, and Lieutenant Colonel Ely Parker. They formed a semicircle behind Grant.

After some pleasantries with Grant about ser-

Immediately Yankee ships like the Unadilla *start the work of clearing the James of obstructions and "torpedoes," opening it to traffic.* (KA)

vice together in the Mexican War, Lee broached the subject of surrender terms. Grant outlined his thoughts calling for the surrender of all equipment and supplies. The men would be paroled not to take up arms until properly exchanged. Lee acknowledged acceptance and Grant put the terms in writing. Lee reviewed them and when Grant asked if he had any suggestions, Lee did mention that the terms did not provide for the horses owned by the men in the ranks. Pointing out that it did provide for the officers, Grant replied that he would not change the terms but he would instruct his officers to allow any man who claimed to own a horse or mule to keep it for farming.

Grant instructed that his letter be copied and Lee directed Marshall to draft a reply. While the writing was being completed, Grant introduced his officers to Lee. It was not a pleasant experi-

ence for Lee, and as soon as the formalities were over, he brought up the matter of Federal prisoners. Grant agreed to accept them. When Lee requested that a train from Lynchburg be allowed to pass so he could supply his men with provisions, it was learned that the train had been captured by Sheridan the night before. Grant offered to send Lee food, and after discussion as to the amount, he directed that 25,000 rations be sent to Lee's men.

Lee made some changes in Marshall's draft of the letter accepting the surrender terms. Borrowing a piece of paper, Marshall copied the letter and Lee signed it. Marshall sealed the letter and presented it to Colonel Parker who gave him Grant's surrender terms letter. The exchange of letters formally completed the surrender of the Army of Northern Virginia. Before leaving, Lee asked that Meade be notified of the surrender to

*And quickly the traffic commenced. General U. S. Grant's headquarters boat,
the* River Queen, *can now ply the waters of the James. Aboard this boat the
abortive Hampton Roads Peace Conference had taken place back in February
1865. President Lincoln and Grant met aboard the vessel for conferences in
March, and on April 4 it brought the President to Richmond for a tour of
the captured city.* (USAMHI)

avoid any possible flare-up of fighting. He also
requested that the two armies be kept separate
for the time being. Grant agreed and dispatched
men to notify Meade. It was close to 4 P.M. when
Lee and Grant shook hands again, and Lee
bowed to the other officers and left the room. On
the porch, he called for his horse, and as he
mounted, Grant came down the steps. The
Union general removed his hat and his sub-
ordinates followed. Lee acknowledged their
gesture by raising his hat. Without a word, he
turned Traveller and rode out of the yard.

Lee knew that Grant had given favorable
surrender terms. What could have been a hu-
miliating experience was made more bearable
by the genuine courtesy and respect displayed on
both sides. As he rode into his lines toward his
camp at the apple orchard, Lee's veterans began
crowding around asking if the army had been

surrendered. With tears in his eyes, he told them
that it had been. Expressions of anger, frustra-
tion, and sorrow came from the men. Upon Lee's
arrival at the camp, he notified Colonel T. M. R.
Talcott, commanding the Engineers, that the
rations would be coming in. Lee then walked
away to be by himself. He paced up and down
to relieve the pressures pent up inside of him.
His solitude was interrupted by visiting Federal
officers who wanted to meet him. After receiving
a letter from Grant appointing commissioners to
arrange the details of the surrender, Lee
mounted Traveller to return to his own head-
quarters. Along the road he was met by more
men from his army. The word of the surrender
had passed quickly and the road was lined on
both sides. Officers on horseback stood behind
the lines. When he arrived at his headquarters,
others were waiting to see him, to talk to him,

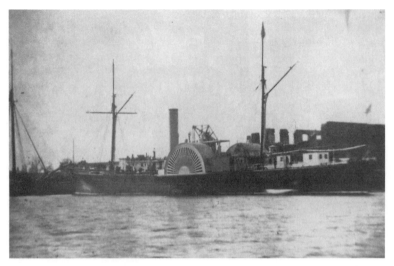

Lincoln transferred to the USS Malvern *for part of the journey to Richmond, entertained by its flag commander . . .* (USAMHI)

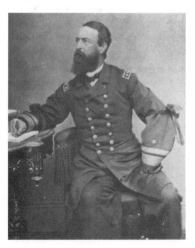

. . . Rear Admiral David D. Porter. Porter here wears crape in mourning for the President, who lay dead barely more than a week after his visit. (USAMHI)

Soon the visitors flooded the docks at City Point and Richmond both.
Members of Major General George Meade's family crowd the deck of this
steamer at City Point, anxious to see the general and to view the scenes of
conquest. (P-M)

to shake his hand. That evening, while seated around the campfire, Lee instructed Marshall to draft a farewell address to the army.

The next day, April 10, Lee dispatched orders to his subordinate commanders to prepare final reports on the last campaign. When he found that Marshall had not prepared the draft of the farewell address, he told him to go into his ambulance where he would not be disturbed. Longstreet, Gordon, and Brigadier General William N. Pendleton were appointed by Lee as commissioners to draft the surrender procedures. Grant had appointed Major Generals John Gibbon, Charles Griffin, and Wesley Merritt. These men met in the McLean house the same day to make arrangements for the formal

surrender, the transfer of public property, private horses, and mules, and the lease of transportation to officers. It was also agreed that the terms would embrace all men within a twenty-five-mile radius of the courthouse and units that were operating with the army on April 8, except those that were over twenty miles from Appomattox on the ninth. Each parole was to be signed by the soldier's commander or his staff officer, not by the Federal provost marshal. The signed parole was sufficient for passage through Federal lines. By a separate order, Grant authorized free travel on Federal transports and military railroads.

During the morning of April 10, Grant had attempted to ride over to meet with Lee but

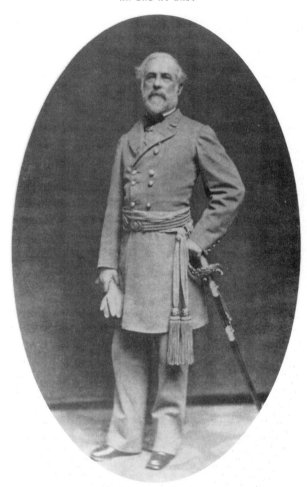

But though the enemy capital had fallen, the war was not over. It could never be over so long as this wily and elusive adversary remained at large. Another Julian Vannerson portrait of Robert E. Lee gave little hint that the man behind this peaceful aspect was a champion of war. (VM)

But now he was on the run. As he evacuated Richmond, he took with him what he could and destroyed what he could not. Within days Reekie photographed wreckage left behind. (USAMHI)

was stopped by Confederate pickets. When he heard of this, Lee mounted Traveller and rode out to meet his former adversary. The two men greeted each other by lifting their hats. Grant expressed a desire to prevent further bloodshed and suggested that if the other Confederate armies would surrender then peace would come. He felt that Lee could use his influence and prestige to bring this about, but Lee felt it was not his decision but President Jefferson Davis'. After about a half hour, the two men parted. On his way back to camp, Lee met General Meade. The two conversed and then rode back to Lee's headquarters.

When Marshall finished his draft of the farewell address, Lee reviewed it. He struck out one paragraph that he felt was too harsh and changed some of the words. The address was then copied

and given to Lee for his signature. Once signed, copies of General Order No. 9 were made, signed by Lee, and distributed to his subordinate commanders. They had it transmitted to the men in the ranks. Copies were made by officers and men and brought to Lee for his signature.

The next day, April 11, the campaign reports came into Lee's headquarters from his subordinate commanders, and he began to prepare his own final report. Muster rolls were made out for all Confederate units and copies were forwarded to both headquarters. A total of 28,231 men of all arms of the service were reported. The paroles, which had to be printed, were received. Formal surrender of the artillery and cavalry occurred on this day. Union Major General John W. Turner's division, of the Army of the James, witnessed the transfer of equipment and

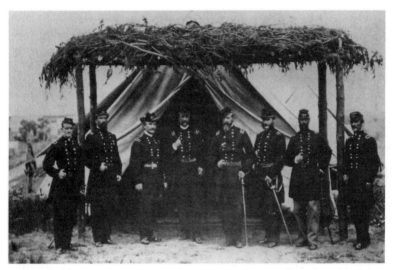

Meade was after the fleeing Confederates, Meade and his generals. Shown here a few weeks later, they are, from the left, Brevet Brigadier General George Macy, provost; Brevet Major General A. S. Webb, chief of staff; Major General Andrew A. Humphreys, commanding the II Corps; Major General Charles Griffin, commanding the V Corps; Meade; Major General John G. Parke, commanding the IX Corps; Brevet Major General Henry J. Hunt, chief of artillery. The brigadier at right is unidentified. (USAMHI)

animals as the members of Confederate artillery units left their guns parked for the last time. Those who claimed horses or mules were allowed to keep them. Upon receipt of their paroles, they said good-bye to comrades and began the trek home. The remaining Confederate cavalry of Major General W. H. F. "Rooney" Lee's division laid down their swords and firearms before Major General Ranald Mackenzie's troopers. With their paroles in hand, they rode off, not to take up arms until properly exchanged.

The Confederate commissioners had asked that the infantry be allowed to stack arms, cartridge boxes, and flags in their camps, but Grant would not consent. The surrender could not be a symbolic gesture of walking away from the instruments of war. It had to be an act of relinquishing equipment and flags and the act had to be witnessed. Declining to give up their battle flags, some units tore them up and distributed pieces to the members. Some flags were smuggled out by men who refused to surrender and slipped away during the night. Some were secreted under the clothing of men who took part in the final ceremony.

On the morning of April 12, the Confederate infantry prepared to carry out the final act. The units formed in ranks, with officers and flags in position. General John Gordon's command started down the ridge first. As the Confederate column came up the hill, Brigadier General

It was Major General Philip Sheridan who brought on the Confederate disaster at Five Forks, and thereafter his cavalry dogged the retreating Rebels all along their route. Then, on April 6, he and part of Meade's infantry caught them at Sayler's Creek. (USAMHI)

Joshua L. Chamberlain, commanding the Federal division, gave orders for the bugler to sound carry arms, the marching salute. Gordon responded by saluting Chamberlain and ordering his men to carry arms. Victor saluted vanquished and they returned the honor. Gordon's men marched beyond the Federal column and halted. The ranks were dressed and the order was given to fix bayonets. The command to stack arms came next, and the men moved across the road and stacked their arms. Cartridge boxes were hung from the muskets and battle flags were rolled up and laid on the stacks.

The units re-formed in the road and marched past the courthouse and halted. Here they broke ranks, shook hands, and bade each other farewell as the other units moved through the cordon to stack arms. Some men returned to camp, but most of them turned toward home. Men from the same area usually left in small groups under command of the ranking officer. They carried with them the news that the Army of Northern Virginia had been surrendered. Lee officially notified President Davis of this in his report of April 12, and although he did not witness the surrender, Lee remained on the field until the act was completed. With his own parole in hand he turned his face toward Richmond, and with members of his staff he started the long journey back.

In fact, on April 10 news of Lee's surrender reached Davis at Danville, in southern Virginia, where he had paused on his flight from Richmond, and late that day he left by rail for Greensboro, North Carolina. The Confederate cavalry and artillery units that had escaped before the army was surrendered made their way to Lynchburg, in the west, where, after consulting the Confederate Secretary of War John C. Breckinridge, they disbanded. Some units made their way south intent on joining General Joe Johnston in North Carolina, while others struck out for home. As word of Lee's surrender crossed the mountains and men from his army brought the word, other units began to dissolve or disband. Major General Lunsford Lomax's command, operating between Lynchburg and Danville began to disintegrate as the Virginia units left the ranks. Word of Lee's surrender caused Colonel William Nelson to disband his artillery battalion at Pittsylvania Court House and to distribute the horses among the men. The Federal cavalry entered Lynchburg on April 13 and on April 15 General Lomax and Brigadier General William L. Jackson disbanded their commands at Buchanan, in the Shenandoah Valley. Federal Major General Winfield Scott Hancock extended Grant's terms to all soldiers of the Army of Northern Virginia in the valley if they would come in and receive their paroles. At Millwood, on April 21, Colonel John Singleton Mosby disbanded his Rangers. Effective resistance was at an end in Virginia by the end of the month.

Meanwhile, at Greensboro, President Davis

It was terrible. Nearly one third of Lee's army was captured, including Brigadier General Seth Barton. (USAMHI)

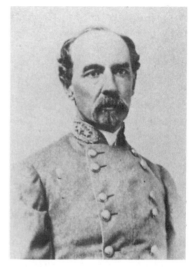

Also taken was Brigadier General Montgomery D. Corse. The Yankees simply overwhelmed them. (USAMHI)

met with Generals Johnston and P. G. T. Beauregard and his Cabinet on April 12. Johnston's army was at Hillsborough while Major General William T. Sherman's was preparing to enter Raleigh. Johnston recommended negotiation but Davis felt that it would only result in surrender. Outvoted, Davis agreed to authorize Johnston to meet with Sherman. While they were discussing conditions in North Carolina, the last major city of the Confederacy fell. Mobile, Alabama, was occupied by Union troops under Major General E. R. S. Canby. Confederate forces under Major General D. H. Maury had evacuated the night before toward Meridian, Mississippi, with hopes of joining Johnston's army in North Carolina.

Sherman's men occupied Raleigh on April 13 and pressed on to Durham Station the next day. On the fourteenth Johnston communicated with Sherman and sought a temporary suspension of hostilities pending discussions of peace. After negotiations as to time and place, they agreed to meet on April 17 on the road between Durham Station and Hillsborough. Sherman left Raleigh by train for Durham Station, and there he met Brigadier General Hugh Kilpatrick who provided a Union cavalry escort. As Sherman's party set out with a cavalryman in the lead carrying a flag of truce, Johnston and Lieutenant General Wade Hampton were moving toward Durham Station with an escort. Hampton's orderly carried the flag of truce.

When the two groups met, Johnston and Sherman shook hands and introduced their aides. Johnston noted that he had passed a small farmhouse, so he and Sherman rode back down the road to James Bennett's log farmhouse. Lucy Bennett met them at the door, and after granting their request to use the house, she retired with her four children to one of the outbuild-

The next day Major General Thomas Rosser attempted to hold the vital railroad crossing of the Appomattox River at High Bridge, west of Petersburg. A desperate little fight ensued. (VM)

Brigadier General James Dearing engaged Federal Brigadier General Theodore Read in a pistol duel that left Read dead and Dearing dying, the last Confederate general to die of wounds in battle. (USAMHI)

ings. The two men closed the door to the one-room house and discussed amnesty and surrender terms in private. Unable to reach a decision on all points, they agreed to meet again the next day. On the eighteenth Confederate Secretary of War Breckinridge joined the discussion and it was then that Sherman drew up a memorandum of agreement.

In their discussion the three men went beyond the original intent of the meeting and considered terms for a general armistice, dealing with reconstruction policies that were not in fact within Sherman's authority to establish. Sherman believed he was expressing President Lincoln's wishes in his terms. But Lincoln was dead, murdered on April 14, and Andrew Johnson now sat in the White House.

The agreement did put an end to the fighting, even though the other terms would be rejected by the Federal authorities. With the exception of Major General James H. Wilson's Union cavalry raids in Georgia and Alabama and Major General George Stoneman's in western North Carolina, most of the remaining engagements east of the Mississippi were minor skirmishes. Jefferson Davis moved to Charlotte where he approved Johnston's agreement with Sherman. Unknown to Davis at the time, Sherman was being informed that the agreement had been disapproved by Washington and he was directed to resume active campaigning within forty-eight hours if Johnston did not surrender.

At Johnston's request, Sherman met with him again at the Bennett place on April 26. By the terms of the agreement of that day, Johnston's

High Bridge and the nearby wagon road bridge were supposed to be burned by the Confederates once they had crossed over them. (USAMHI)

army was to be mustered at Greensboro and there the ordnance supplies were to be turned in and the men were to be paroled. Brigadier General John M. Schofield, who was to be Federal departmental commander, agreed to six supplemental terms when Johnston objected to the general terms. He assured Johnston that there would be sufficient transportation, that each brigade could keep one seventh of their arms until they reached their state capital, that both officers and enlisted men could retain their private property, that troops from Texas and Arkansas were to be provided water transportation, and that all naval forces within the limits of Johnston's command were also included. The men were to be supplied with ten days' rations

so they would not have to live off the countryside. The agreement, signed by Johnston and Schofield, brought an official end to hostilities in North Carolina.

Johnston announced the termination of hostilities to the governors of the Confederate states and the Confederate Army. When word was received that the Army had been surrendered, men began leaving. Major General Joseph Wheeler vowed he would not surrender and he left with those of his command who would follow him to attempt to find President Davis. Wade Hampton, who was not personally with Johnston's army at the time, declared that he was not included in the surrender and would not stay. When his cavalrymen left, he rode after them and ordered

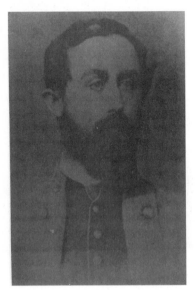

However, Colonel T. M. R. Talcott of Lee's staff was unable to get the fires set in time, and the Yankees rushed the bridge and put them out. Everything for Lee was going awry now. (VM)

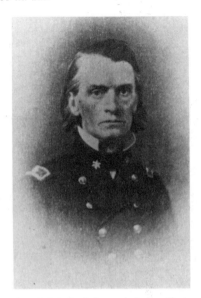

After Sayler's Creek, Lee was in danger of having more generals than privates. On April 7 Brigadier General Henry A. Wise joined him. Former Virginia governor and a brother-in-law of the General Meade now dogging them, Wise led a battered division out of the trap at Sayler's Creek. When Lee teased him, saying he could be shot for what he said about a superior officer who ran away, Wise replied "Shot! I wish you would shoot me. If you don't, some Yankee probably will within twenty-four hours." (USAMHI)

them to return. While they did so, he rode to join President Davis. For those units remaining with the Army, muster rolls were prepared and paroles were issued. Those units at Bush Hill, Randolph County, were paroled on June 29 and each man received $1.25 in silver as final pay. This was part of the approximately $38,000 in Confederate Treasury silver that Johnston ordered to be distributed equally to officers and men. Those units at Greensboro were paroled on May 1 and 2, and on the latter day, Johnston's farewell address, General Order No. 22, was read to the troops.

Meanwhile, those units that had remained in northeastern North Carolina had been isolated. Some simply disbanded when they received word of Lee's surrender or of the first Johnston-Sherman agreement. Brigadier General Laurence S. Baker withdrew his force from Weldon on April 13. When he heard of Lee's surrender, he decided to disband his force and to make an attempt to join Johnston's army with those who would follow. Efforts to penetrate beyond the Union scouting parties and pickets failed, so he sent word to the Union commander at Raleigh that he would surrender his force under the first

The next day, April 8, Lee hoped to find provisions for his starving army awaiting him here at Appomattox Station. He found nothing. (LC)

Johnston-Sherman agreement. His offer to surrender was accepted and his men were paroled at Bunn's House, Nash County, on April 20, 1865.

Other units refused to surrender and simply took their arms and went home. One section of Company C, 13th Battalion North Carolina Light Artillery had been on detached service with the Army of Northern Virginia and had made it to Lynchburg before Lee's surrender. Instead of disbanding, they made their way south and joined the other section of the company attached to Johnston's army near Greensboro. When word of Johnston's surrender came, the men of the first section, fearing they would be covered by its terms and thus not properly exchanged, left camp and were not reported on the company's final muster roll.

As Johnston's army began disbanding after April 26, Lieutenant General Richard Taylor and Canby formulated surrender terms on May 2 based on the Appomattox agreement. Two days later, at Citronelle, Alabama, General Taylor surrendered the forces in the Department of Alabama, Mississippi, and East Louisiana. Major General Sam Jones, commanding at Tallahassee, Florida, surrendered the forces under his command on May 10, the day President Davis was captured near Irwinville, Georgia.

Small groups continued to surrender east of the Mississippi, but because the main forces in that area had surrendered, President Johnson proclaimed "armed resistance . . . virtually at an end." West of the Mississippi, Brigadier General M. Jeff Thompson surrendered at Chalk Bluff, Arkansas, on May 11. He, too, agreed to

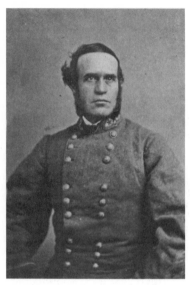

*Now the generals who had lost their commands
began to find their way into his lines. Major
General Bushrod Johnson lost his, or so he
thought, at Sayler's Creek. His men fought their
way out under Wise.* (USAMHI)

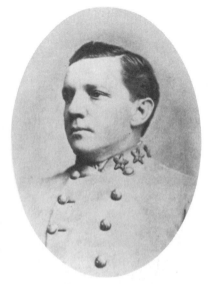

*Brigadier General William P. Roberts, the
youngest general in the Confederacy, was only
twenty-three and lost his command at Five Forks.
Lee had no more men to give him at
Appomattox.* (USAMHI)

the Appomattox terms. The last remaining Con-
federate army in the field was under General
E. Kirby Smith. The Army of Trans-Mississippi
was surrendered under Appomattox-type terms
agreed to during a meeting at New Orleans on
May 26. At that meeting Lieutenant General
S. B. Buckner represented General Kirby Smith
and Major General Peter J. Osterhaus repre-
sented General Canby. When General Kirby
Smith approved the agreement on June 2, the
army was surrendered. Except for some troops
under Brigadier General Jo Shelby, who refused
to accept the surrender terms and led his men
into Mexico, Confederate military resistance
was at an end.

On the high seas, the CSS *Shenandoah* con-
tinued to attack Union whaling vessels until

word was received on August 2 that the war was
over. Lieutenant James Waddell, commanding
the *Shenandoah* set sail for Liverpool, England,
where he surrendered his ship to British authori-
ties on November 6, 1865. It was not until
April 2, 1866, that President Johnson pro-
claimed the insurrection at an end in Georgia,
South Carolina, Virginia, North Carolina, Ten-
nessee, Alabama, Louisiana, Arkansas, Missis-
sippi, and Florida. On August 20, 1866, he ex-
tended his proclamation to include Texas, the
last of the Secessionist states. The terms set down
by Grant and Lee had set the tone for those to
come. They were magnanimous, not harsh, but
firm. They acknowledged respect for the van-
quished and the need to begin jointly the re-
building of the Union.

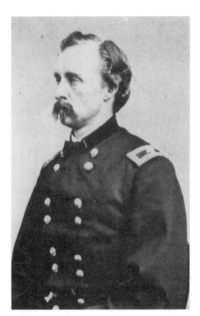

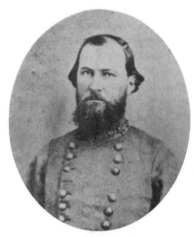

Lee was trapped. Desperately he allowed Major General Bryan Grimes to make a last attack on the morning of April 9. He could not cut his way out, and that left no alternative but for Lee to meet Grant to discuss terms of surrender. (USAMHI)

By April 9 the last avenue of escape for Lee was cut off, largely thanks to the swiftness of one of Sheridan's best division commanders, Brigadier General George A. Custer. He would never again experience the glory he knew at Appomattox. Eleven years later he would die looking for it at Little Big Horn. (USAMHI)

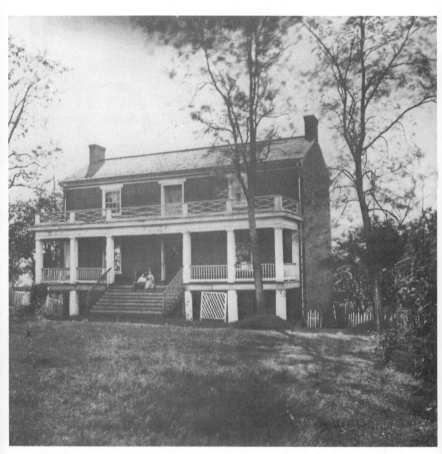

They met here, in the Wilmer McLean house, in Appomattox Court House.
Walking up these steps . . . (LC)

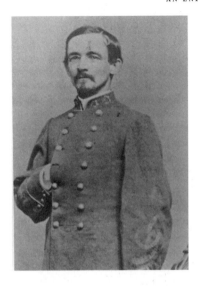

. . . accompanied by his military secretary,
Lieutenant Colonel Charles Marshall . . .
(TULANE UNIVERSITY, NEW ORLEANS)

. . . Lee entered this parlor. A postwar image shows the now bare room
where Lee and Grant met to make peace. For the Army of Northern
Virginia, four years of arduous service were done. (NA)

Grant detailed a few of his most trusted generals to meet with Lee's lieutenants to work out the formalities of surrender. Major General Charles Griffin was one. (USAMHI)

The gallant cavalryman Major General Wesley Merritt was another. For him the Civil War was only the beginning of a brilliant career that went on for thirty-five more years and included service in the Spanish-American War. (CWTI)

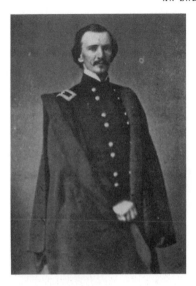

On April 12, 1865, when the Confederate infantrymen formally marched up and stacked their arms for the last time, Grant detailed Brigadier General Joseph J. Bartlett to receive them. With that symbolic act, the war in Virginia was done. (P-M)

The collapse was everywhere. Down in North Carolina, Major General William T. Sherman finally brought Confederate General Joseph E. Johnston and his army to bay near Durham Station. In this modest home, the Bennett place, Johnston and Sherman met to arrange the surrender of yet another Confederate army. (LC)

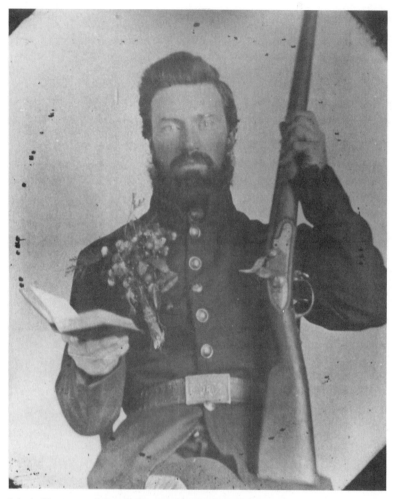

Johnston's army was a shadow. Regiments had been so depleted that men like this private from the 33d Tennessee were members of units composed of five and six regiments combined and still understrength. (HERB PECK, JR.)

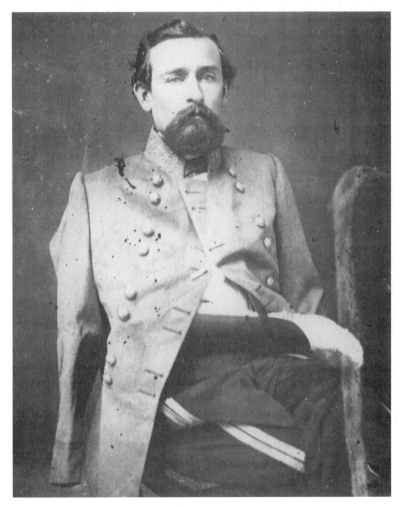

The generals in North Carolina were as battered as the army. Brigadier General Laurence S. Baker could hardly wear his uniform for all the wounds he bore, and still he was on active service. (VM)

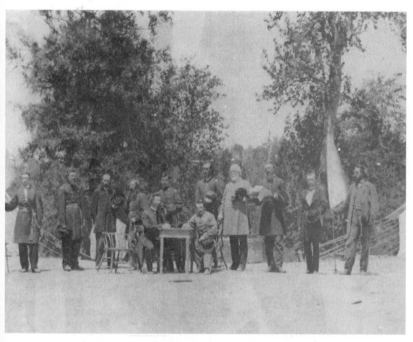

Out in Mississippi the story was the same. Near Vicksburg the Federals set up a special camp for the exchange of prisoners, realizing that the war was all but over. Here in April 1865 a photographer caught what was probably one of the very last such meetings as Confederate officers confer under flag of truce with their Yankee counterparts. (VITOLO-RINHART GALLERIES, NEW YORK CITY)

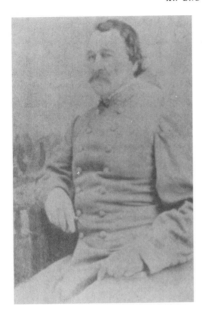

Officers without commands, like Brigadier General William R. Peck, simply came into Federal lines to take their parole. A mammoth six feet six inches tall, Peck made quite a catch. (STEVE MULLINAX)

Everywhere the signs of impending Union occupation sprang up. In Huntsville, Alabama, Brigadier General Emerson Opdycke established his headquarters in this house, obviously there to stay for a while. (USAMHI)

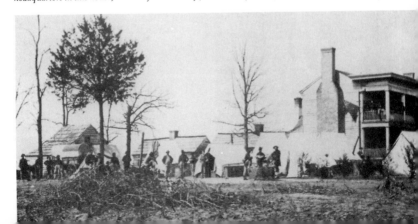

Nearby Major General David Stanley set up his IV Corps headquarters.
(USAMHI)

There was no one in Alabama to stop them. On May 4 the last Confederate army east of the Mississippi surrendered to Major General E. R. S. Canby near Mobile. (USAMHI)

The last army was that of Lieutenant General Richard Taylor, son of President Zachary Taylor and brother-in-law of Jefferson Davis. (DAM, LSU)

Here at the Baton Rouge, Louisiana, arsenal, the artillery of Taylor's army sits, row upon row, after the surrender. (DAM, LSU)

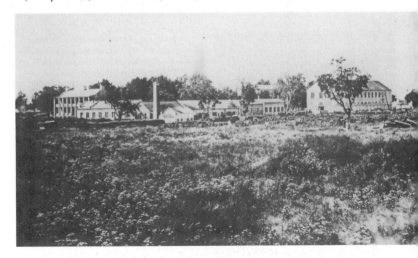

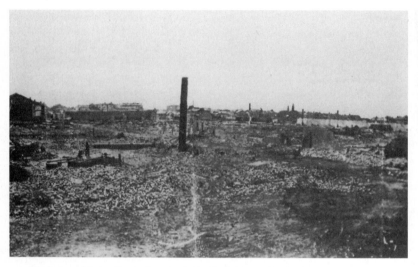

The havoc and destruction continued even after Taylor's surrender. On May 25 some twenty tons of Confederate powder exploded in a warehouse in Mobile, leveling a fair-sized area and doing $5 million in damage. (USAMHI)

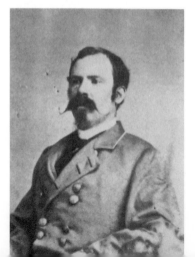

The only substantial Confederate force left in the field was the Trans-Mississippi, and on May 26 it too succumbed. Colonel Thomas P. Ochiltree of Texas could affect a brigadier's uniform that he was not entitled to wear, but all his protestations of inevitable victory could not affect the outcome of the war for his army. (MC)

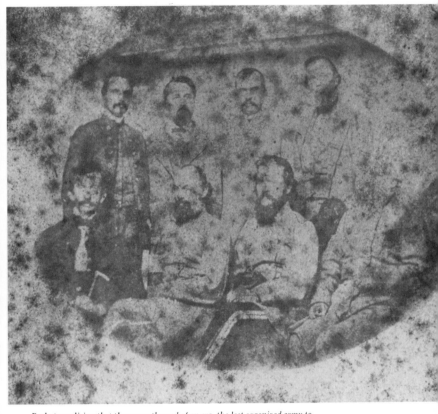

Perhaps realizing that they were the end of an era, the last organized army to surrender, the ranking officers of the Trans-Mississippi met to preserve their portrait for posterity in one of the most remarkable Confederate photographs in existence. Seated second from the left is the army commander, General Edmund Kirby Smith. Seated to his right, is Brigadier General Henry W. Allen, forced to use a cane after a wound suffered at Shiloh, now governor of Confederate Louisiana. He helped Smith negotiate the surrender terms. Seated at Smith's immediate left is his chief of staff, Brigadier General William R. Boggs. The identity of the remaining officers is unknown, but they are presumably members of Smith's staff. The presence of Allen makes it probable that this image was made at the time the surrender negotiations were under way. If so, it is the last image made of Confederate generals on active service. (CONFEDERATE MUSEUM, NEW ORLEANS)

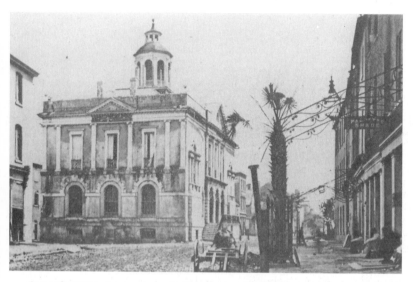

*Even as the armies were surrendering, the Federals were reclaiming the
South. Charleston fell to them back in February 1865, and now Yankee
soldiers filled the streets of the former seedbed of secession. The Post Office
was put back in business. (JAMES G. HEAVILIN)*

*And the grounds of the Charleston Arsenal once more held Union guns—
Parrott rifles used in the siege of Charleston—mixed with captured
Confederate cannon. Flags and bunting draped from the trees reveal that
this image was probably made on April 14, the fourth anniversary of the fall
of Fort Sumter. (NYHS)*

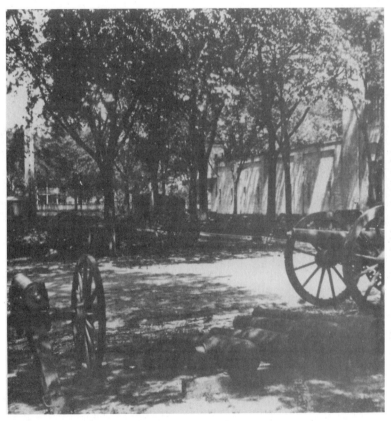

Dignitaries flocked to Charleston on that day for the special ceremonies. For their edification, they could view row upon row of cannon and ammunition. (CHS)

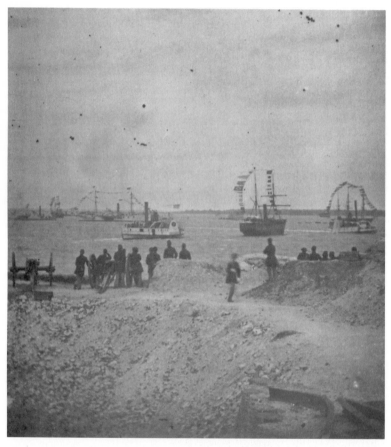

But above all they could go out to Fort Sumter. The Federal fleet in the harbor sent its most colorful flags up the halyards to celebrate the day. (LC)

And old and ailing Major General Robert Anderson, now retired, who had lowered the Stars and Stripes on April 14, 1861, was there.
(USAMHI)

After the speeches and ceremony Anderson raised on the Fort Sumter flagpole the very same Stars and Stripes that he had taken down four years before. With the war now all but done, all that remained was the ceremony and the symbolism, working to give some meaning to all that had happened.
(T. SCOTT SANDERS)

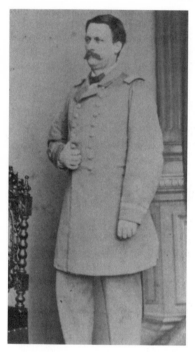

Yet the final surrender would not come for months. Lieutenant James I. Waddell, commanding the Confederate commerce raider Shenandoah, did not learn of the surrenders until August. And on November 6, 1865, seven months after Lee surrendered and almost six months after Smith, Waddell gave up his ship to British authorities in Liverpool. That, at last, was an end to it. (MC)

The guns at last were silent, never to speak again. (NA)

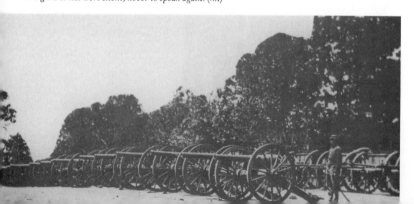

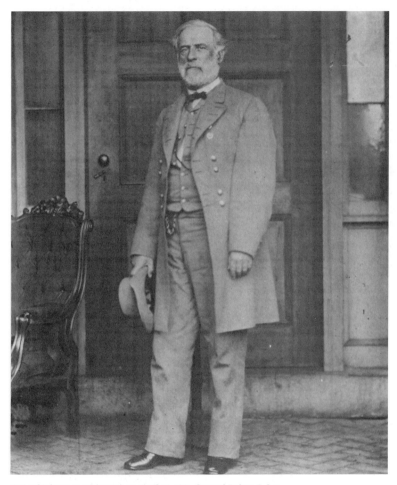

And at his home in Richmond, on April 16, 1865, General Robert E. Lee posed for his portrait for the last time in the uniform he had ennobled. Mathew Brady importuned him to pose, and in the end the general consented. For all the wear that the years and the cares have inflicted, there is still in his eyes the look of a man who may have been worn down to defeat but who was never beaten. Already he is on his way to becoming an immortal hero to all Americans. (NA)

But for a few, even the admission of defeat is too much. Old Edmund Ruffin of Virginia, the fire-eating Secessionist who fired one of the first shots at Fort Sumter in 1861, who hailed John Brown's raid on Harpers Ferry in 1859 because it would bring on secession, and who loathed all things Northern and Yankee, refused to yield. On June 17, 1865, after everyone had surrendered, Ruffin wrote in his diary: "And now . . . with what will be near to my latest breath, I hereby repeat . . . my unmitigated hatred to Yankee rule—to all political, social, & business connection with Yankees, & to the perfidious, malignant, & vile Yankee race." Then he put a rifle muzzle in his mouth and pulled the trigger. Having fired one of the war's first shots, he fired as well one of its last. (VM)

The "Late Unpleasantness"

WILLIAM C. DAVIS

*The war done, there was peace to wage, and battles anew
with the hatreds remaining, and challenges ahead for a nation reuniting*

IT WAS ALL BUT DONE, the long unimaginable nightmare over. General Robert E. Lee's once seemingly invincible Army of Northern Virginia was reduced to a shadow and surrendered on the grassy roadside of Appomattox. In North Carolina the South's other major eastern army was at bay and its commander, General Joseph E. Johnston, was suggesting to his antagonist Major General William T. Sherman that they meet to explore the possibilities of peace. Mobile, the Confederacy's last great city, had fallen. The flag of the Union flew once more over the unrecognizable ruins of Fort Sumter, where the whole dreadful business began. The small Southern armies farther west still held out, but the avenues of escape open to them were dwindling. The Confederate government was in flight after the fall of Richmond, and to more and more of its soldiers the awful truth became evident that there was nothing left to keep fighting for. It was all over.

But like the dying moments of a robust man worn down by illness, there could still be a last, sudden outburst, some final surge of desperate energy before death. The Civil War would not quietly die in its sleep. There was a final act of bitter, blinding, senseless hate to perform, and

who better to stage it than an actor. For months John Wilkes Booth, nationally famed player, sometime oil speculator, inveterate rakehell with the ladies of Washington and New York, had been planning his greatest performance. He would never take up arms to defend the South he so loudly espoused, but late in 1864 he devised a theatrical scheme to kidnap President Lincoln and spirit him away to the Confederacy as hostage for the release of Confederate prisoners held in the North—even for Southern independence itself. How much of the plan sprang from genuine patriotism and how much came from the simple egotistical impulse of a born posturer may never be known. What is certain is that repeated attempts were foiled through accident or ineptitude. Then came Lee's surrender and the symbolic end of the war. All else would be anticlimax, and now Booth's plan seemed pointless. But rather than abandon his schemes, he simply gave their goal a new and more sinister direction. Now Lincoln must die, not to save the Confederacy but in vengeance for having conquered it.

Booth chose a theater for his stage, of course, and the April 14, 1865, evening performance at Ford's Theatre of *Our American Cousin*. The

In the midst of jubilation came terror, a last act of hate to poison the peace.
Here, in the theater of John T. Ford, on the evening of April 14, 1865,
President Lincoln came to see a play. (LC)

Lincolns were to attend. The dreadful act of that night is engraved indelibly upon every American consciousness. At about 10:20 P.M. actor Harry Hawk down on the stage delivered one of the most amusing lines of the farce, calling an actress a "sockdologizing old mantrap!" There was an outburst of laughter in the theater. Perhaps Lincoln, sitting in a box to the right of the stage, laughed as well. Ironically, the four letters at the end of that line, "trap," formed the

last human syllable he would ever hear. At that very instant he was himself sitting in a trap. As Hawk delivered the line, Booth stepped silently into the box, unseen, directly behind the President. He held a small derringer pistol in front of him, its muzzle no more than six inches from the back of Lincoln's head. Before the laughter died down, he pulled the trigger.

A round bullet, an ounce or more of lead, burst from the muzzle and struck Lincoln an

The President and his wife sat in the box at the right, their guests in the one at the left. A portrait of George Washington and a United States Treasury guard flag decorated the railing. (USAMHI)

inch or two behind his left ear. Starting to flatten as it pounded its way through his skull, driving bits of hair and tissue and bone before it, the missile entered the brain, shock waves from the impact sending fractures racing around both sides of the skull. Already Lincoln's head was virtually destroyed. Meanwhile the bullet careered onward through the cerebellum, causing Lincoln to raise his right arm convulsively, though by then the deadly lead had continued in its path, destroying the million and more instinctive and learned reflexes that had made

But actor John Wilkes Booth staged a different play that night. When he leaped from that railing to the stage in his last dramatic performance, he left behind him confusion and shock in the box, and a bullet in Lincoln's brain. (LC)

Across the street, to the Peterson rooming house, they carried the President, and into this back room. Here, all through the night, he labored for breath, unconscious. Here at 7:22 A.M., April 15, he died. Within minutes after the body was carried out, photographer Julius Ulke brought his camera into the still undisturbed room. Here he made at least two images that would remain lost for nearly a century. They showed the bed in which the President died, the coverlet that left his bare feet protruding as they laid the long and lanky Kentuckian diagonally on the mattress. And they showed the pillow soaked with Lincoln's blood as it oozed from his head wound. From humble beginnings he had come, and so he went, in a humble rooming house. Yet it was no place for the death of a President. (LO)

The White House went silent in shock, and the Union prepared for a long mourning. (USAMHI)

Lincoln a good rail-splitter and a miserable dancer.

The cerebellum was largely a ruin when the bullet smashed into the hypothalamus and thalamus, probably destroying all of Lincoln's senses except smell. Here, too, lay all the seats of ancient instincts for flight from danger, but now it was too late to fly. Finally the fatal ball plunged on into the forepart of the cerebral cortex, erasing as it went untold memories—the faint recollections of his beloved mother, the truth of his supposed love for Ann Rutledge, the pain of the loss of two of his sons, and the incalculable burden of leading his nation through war to the peace that lay at hand. Finally Booth's messenger of hate halted its path somewhere behind the right eye. The President was unconscious. Out of pure physical reflex, the body would struggle on, holding to life until the next morning. Carried from Ford's Theatre to a rooming house belonging to one William Peterson across 10th Street, it would ooze blood onto pillows and gasp at breath for several hours. But all that had made Lincoln what he was had died before the laughter trailed away from Hawk's portentous last word, "mantrap."

The North lurched into mourning, a grief more prolonged than any in its history. So great a tragedy coming in train with so great a triumph almost unnerved many Americans, even some in the South. The public outpouring of lamentation from pulpit and press was staggering. Lincoln's body literally went on tour for funerals in New York, Philadelphia, Baltimore, and elsewhere. For twenty days the casket traveled before at last it came to rest in Springfield, Illinois, the city he had moved to as a young man.

Back in Washington, Ford's Theatre was closed and the Peterson house across the street became a tourist attraction. A Massachusetts soldier, Charles Nightingale, returning from the war, visited the place and stepped into the room

The funeral parade up Pennsylvania Avenue in Washington, D.C., began the formal outpouring of grief. A wing of the Capitol appears in the right distance. (USAMHI)

where Lincoln died. Neatly placed on the simple bedstead he saw "the bloody pillow upon which the nation's martyr passed from time to eternity." Nightingale, as so many others, could not but be moved. "I shall never forget my feelings as I stood there gazing with feverish excitement upon that blood-stained pillow," he wrote a few days later. "They were of awe and madness, indescribable, deep."

For two weeks after the murder the dark days continued. The manhunt for Booth and his accomplices spread throughout the nation. Some who had been his confederates in the kidnapping scheme were quietly arrested. So was Mary Surratt, mother of one of the plotters and keeper of a Washington boardinghouse where kidnapping —and some said murder—plans were hatched. Finally, on April 26, Booth was cornered in a

shed near the Rappahannock River in Virginia. Refusing to surrender himself, he fell to a bullet fired in the dark, perhaps from one of his pursuers, perhaps from his own gun. He died shortly after dawn, the same day that General Johnston surrendered at last to General Sherman in North Carolina and the war east of the Alleghenies came virtually to an end. The next day, as if to add a final terrible coda to the most doleful fortnight in living memory, the steamer *Sultana,* loaded with 2,000 or more Union soldiers, most of them recently released prisoners who had survived Confederate prison camps and were going home from the war, exploded on the Mississippi as she steamed north of Memphis. At least 1,200 died and perhaps hundreds more that were unaccounted for. It was up to that time the worst single marine disaster in history,

And then the funeral train began its long journey, bringing Lincoln's remains to a host of cities in the North so that the people could pay their final respects to the man who led them from war to peace. When the train arrived at Harrisburg, Pennsylvania, on April 22, a local photographer came out to record this previously unpublished image of the engine and cars at the depot. (EDWARD STEERS, JR.)

and once more, so recently euphoric over victory, the North was plunged into gloom and mourning.

The Union badly needed something to cheer it from its despair. After all, it had won the war, preserved itself, put down rebellion, ended slavery, and—some claimed—prevented the death of democracy for all time. There were a million heroes in blue to honor for their services before they took discharge, and Washington decided to stage a mammoth celebration both to do the Union veterans justice and to lift the nation from its grief. A Grand Review was scheduled for May 23–24, 1865.

The first day the noble old Army of the Po-

tomac marched from the Capitol down Pennsylvania Avenue and past the White House. This was the aristocrat of Federal armies, marching smartly, well dressed, tempered by repeated defeats and vindicated by final victory. All the memories of the Seven Days, of Second Manassas and Antietam and Fredericksburg, of humiliation at Chancellorsville and revenge at Gettysburg, filed past the stands as rank upon rank of blue marched out of time and into posterity. The next day came Sherman's armies from North Carolina, Westerners mostly, roughly dressed, rawboned, ill-disciplined, lackluster on parade, yet bringing with them the greatest string of victories of any army on the continent.

City Hall in New York City, on April 24, is thronged with people eager for a last look at the kindly visage of Father Abraham. (INTERNATIONAL MUSEUM OF PHOTOGRAPHY AT GEORGE EASTMAN HOUSE, ROCHESTER, N.Y.)

Two days later the last remaining Confederate army surrendered in Louisiana, and it was all done.

To be sure, there were still a few Confederate holdouts, not least the remnant of the Rich- mond government. Having fled their burning capital, President Jefferson Davis and his Cabinet hopped from place to place, establishing temporary capitals as they tried to stay ahead of their pursuers and rally their remaining soldiers.

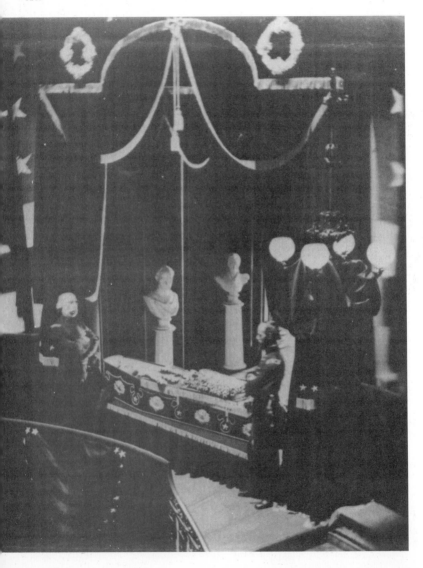

They reached North Carolina only in time to consult with Johnston while he asked Sherman for terms, and then the flight continued. Along the way, members of his Cabinet who had stood by him for years one by one dropped out of the party to make their own separate peace with the victors, until by May 4, at Washington, Georgia, there were none remaining but his Secretary of War, John C. Breckinridge, and his Postmaster General, John H. Reagan. While Breckinridge set out to lead their pursuers on a false trail, Davis left to make a last bid to escape the country. But near Irwinville, Georgia, on May 10, the President's party was surprised by Federal troops and captured without struggle. Of all the high officers of the government, only Breckinridge and Secretary of State Judah P. Benjamin finally escaped to safety.

Retribution was inevitable, yet slow in coming and on a lesser scale than for any other civil conflict in human memory. The first to feel it would be those involved in the President's murder. In June 1865, in a long and controversial trial, eight defendants, including Mrs. Surratt and the Maryland doctor Samuel Mudd who treated Booth during his flight, were put on the dock charged with conspiracy to assassinate Lincoln. Though all probably had knowledge of or involvement in the kidnapping schemes, it is still uncertain which if any of them had foreknowledge of Booth's eleventh-hour decision to kill the President. In the end, four who could not be directly connected with the assassination were sentenced to long prison terms. Four others, including Mary Surratt, were sentenced to the gallows. Their hangings on July 7 drew international attention, more because of the execution of a woman than for any other reason.

And for a time the executions seemed to satisfy much of the North's need for vengeance against the South. Indeed, incredible as it seems after four years of the costliest and bloodiest war yet fought in the hemisphere, only one Confederate would actually be brought to trial and charged with crimes. Major Henry Wirz, the hapless and admittedly unsympathetic commandant of the infamous Confederate prison camp near Andersonville, Georgia, was accused of willfully torturing and starving, even murdering, defenseless Union prisoners under his command. No one will ever completely sift truth from fancy in his story, though it is probable that he was no worse and no better than any other unfortunate Southern officer assigned to oversee tens of thousands of captured Federals packed into cramped quarters with too little food and almost no sanitation. But Andersonville had become in the North a symbol of Rebel cruelty and barbarism on an emotional scale so great that a scapegoat was inevitable—some small taste of Southern blood to balance the scale against the deaths from starvation and disease of thousands of Union men. On November 10, 1865, Wirz went to the scaffold, in relative terms probably an innocent man. Yet, ironically, he was symbolic of the incredible tolerance and magnanimity of the victors, for—however unjust—his would be the only execution of an enemy soldier for war crimes, a restraint unparalleled in the history of civil conflict.

Perhaps there was little time for retribution because the men of both armies, North and South, were too busy returning home to find what remained of the life they had left four years before. It was a staggering problem. In 1865 the Union had just over 1,000,000 men

This is what they saw. The only known image of Lincoln in death was made as he lay here in City Hall, flanked by his honor guards, Rear Admiral Charles Davis on the left and Brevet Brigadier General Edward D. Townsend on the right. Jeremiah Gurney, Jr., made the image, which shows Lincoln's face dimly visible in the open casket and, resting on top of the coffin, the flowered initials "AL." Secretary of War Edwin M. Stanton objected to the photograph because he found it macabre and ordered it suppressed and the negative destroyed, but this one print survived, to be discovered again in 1952. (ILLINOIS STATE HISTORICAL LIBRARY, SPRINGFIELD)

Albany, New York, hung with crape, awaits the arrival of the funeral train.
(ALBANY INSTITUTE OF HISTORY AND ART)

under arms, spread literally from Atlantic to Pacific, Maine to Texas. Just the transportation needed to get Massachusetts men home from Texas and Hoosiers back from Virginia, taxed every resource of rail and water. The Union armies could not be disbanded all at once, either. First, new recruits would be released. Then men in hospitals, then men whose enlistments expired earliest. The disbanding and discharge was already under way in the East before the last Confederate army in the West had yet

surrendered. And when the soldiers were finally mustered out, they were sent home with money in their pockets, some $270,000,000 of it.

How different it was for the defeated Confederates, and yet it could have been far worse. Following the magnanimous course of Grant at Appomattox, there were no punishments or recriminations when the other Southern armies capitulated. Men and officers were made only to take their paroles, surrender their arms, and go home. Federal supply trains were opened to their

*And back in Springfield, Illinois, Lincoln's home is draped in black in
preparation for the last of the funeral ceremonies before he is laid to rest.*
(CHICAGO PUBLIC LIBRARY)

former foes, men who claimed to own horses
were allowed to take them, and the still-proud
Confederates were simply permitted to find their
way home. The few who refused either to take
parole or admit defeat fled to the hills, intent
upon continuing the war in partisan fashion, but
they were few indeed, accomplished nothing, and
either abandoned their efforts or, as in Missouri,
abandoned their patriotic pretensions and
simply became brigands.

For weeks following the surrenders, the roads
of the South were filled with passing Confeder-
ates, ragged men, often in tears, occasionally
stopping to ask food or water and to pass the
news of the surrenders. Grant and Sherman ar-

ranged some transportation for those who lived
far to the West, but most of them walked, some-
times for weeks, before they found their homes.
A New York journalist in the South watched
the exodus, and could not conceal that he was
"daily touched to the heart by seeing these poor
homesick boys and exhausted men wandering
about in threadbare uniforms, with scanty outfit
of slender haversack and blanket roll hung over
their shoulders, seeking the nearest route home."

The receptions that met the men in blue and
gray when they found their homes were as differ-
ent as the flags they had fought for. Throughout
the North there was jubilation, a joy that could
not entirely be stilled even by the Lincoln

tragedy. As regiment after regiment came marching home, great cities and tiny courthouse towns bedecked themselves with bunting and flags to give their boys a cheering welcome. One last time the hardened veterans marched in parade down their home streets. Many stood in rank for a final photograph, to be reproduced by the score and treasured for years to come. Officers and men, equals once more, shook hands, slapped backs, laughed, and more often wept, as they said farewell not only to their war service, but also to the most exciting days of their lives. The conflict lay behind them now, and so, with it, they left much of the best of their youth.

There was joy in the South as well, of a different kind. The war was lost and no one could be joyful about that, but at last it was over and the men were coming home. Everyone could take some comfort at least from that. But there were no parades in Richmond or New Orleans. The regiments arrived in bits and pieces, not as whole units, and the men quietly went to their homes, or what remained of them. In a region worn and starved to gauntness by the past four years, there was little enough for survival, much less for lavish receptions. Many Confederates found their homes fallen to ruin from neglect or destroyed by Northern raiders or Southern vandals. The families they had left in 1861 had often been forced to flee as refugees, often moving hundreds of miles to stay ahead of the enemy. Cut off from contact for months, some soldiers would have to spend more months, even years, trying to find the loved ones left behind.

Yet in at least one way, soldiers of both the Union and Confederacy were the same. They could take comfort from the fact that they had lived to go home again. So many others did not. Hundreds of thousands lay buried in the soil of Tennessee and Virginia and Pennsylvania and so many other places. Many had been hastily interred after battle. Even more had succumbed to accidents and disease. Tens of thousands on both sides had died in prisons. As quickly as possible, families on both sides began the often heartbreaking and frustrating work of trying to find the remains of their sons and husbands, to bring them home. It was a great silent exodus, wagons and trains and steamers carrying a veritable host of mute, moldering passengers, whose bodies were making a final journey that their spirits had made long before.

In the defeated and impoverished South, there was neither money nor inclination to establish formal cemeteries for the Confederate dead, beyond those already dictated by circumstance near the battlefields. But in the North, even before the end of the war, a movement began for the creation of national military cemeteries to honor the fallen brave. Lincoln had spoken at the dedication of one in Gettysburg, Pennsylvania, on November 19, 1863. Others were established at Alexandria, Virginia; at Vicksburg, Mississippi; and most notably at Arlington, Virginia. Here on the southern bank of the Potomac, on grounds that once were part of the estate of Robert E. Lee, one of the most beautiful cemeteries in the nation was established shortly before war's end. Lee would never return here again, but thousands who died fighting him would rest beneath his land.

Just as they memorialized their dead, so did the men of the Union begin almost immediately to memorialize what they had done. Well before the war ceased, local officials at Gettysburg and Antietam and elsewhere began envisioning parks, lands at the battlefields to be set aside to preserve the memory of what had occurred there. And by 1864 there were even a few markers and monuments starting to sprout on the landscape, all of them Northern. In the winter of 1864–65 men of Brigadier General William Gamble's brigade built two red sandstone pyramids on the field near Manassas, Virginia, each commemorating the men in blue who fell in the battles of First and Second Bull Run. On June 10, 1865, with the war done, several hundred soldiers and dignitaries came to formally dedicate the monuments, the first of hundreds of such scenes in the years to come.

Confederates, too, joined in the drive to preserve the memory of what they had tried to achieve, though understandably in a region depressed by the war, the immediate impetus was more economic than historical. At Petersburg, Virginia, within months after Lee's surrender, an enterprising former Confederate was operating probably the first battlefield museum in the country, charging twenty-five cents for visitors to view relics of the great Battle of the Crater.

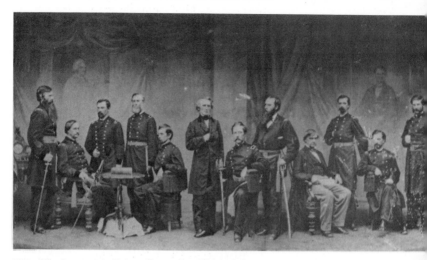

Meanwhile, the rest of the Union will not rest until justice is done to Lincoln's murderer and his accomplices. When all the accused are apprehended, they will stand trial before this military commission, posing here in Mathew Brady's Washington studio. They are, from the left, Colonel Charles H. Tompkins; Major General David Hunter, president of the commission; Major General August Kautz; Brevet Brigadier General James Ekin; Major General Lew Wallace; John A. Bingham; Brigadier General Albion Howe; Brigadier General Thomas M. Harris; Judge Advocate General Joseph Holt; Brigadier General Robert S. Foster; Colonel Henry L. Burnett; and Colonel D. R. Clendenin. (NA)

A quarter could be a lot of money in a stricken region. Every resource in the South had been stretched to exhaustion by the war, and those not used up by the Confederates themselves had most likely been destroyed or damaged by the invading Federals. Transportation was at a standstill. Rolling stock and tracks had either been ruined from lack of maintenance or parts taken up and melted to make cannon, or wrecked by raiders. There were virtually no sound river steamers to get waterborne commerce moving again. The telegraph lines were down, and there was little good news for them to carry in any case. While some regions were almost untouched by the war, others had seen their fields ravaged by overplanting and the demands of feeding armies, and their cities ruined by bombardment, razed by fires, or turned squalid from overcrowding by refugees. At war's end Southerners were not only largely a displaced people; the South was almost a displaced region. Lee and the other most sensible Confederate leaders knew this without having to look and offered the wisest counsel they could. Go home, they told their men, go home quietly, without bitterness, and go to work rebuilding. Accept the verdict of the war and put it behind.

The most prominent Confederate of them

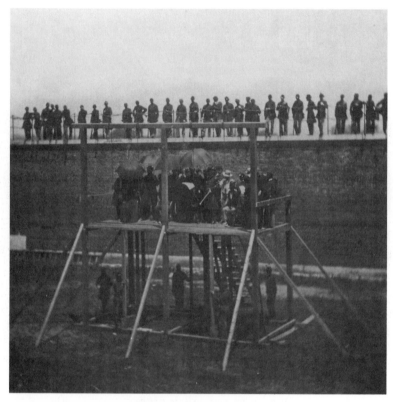

Their verdict reached on June 30, 1865, the commission sent four conspirators to the gallows. Here on July 7, in the yard of the Old Penitentiary in Washington, D.C., they mounted the scaffold. They sat down while Brigadier General John Hartranft read aloud their sentences and the order for execution. He stands beneath the umbrella in the center of the group, paper in his hand. Seated at the far right is George Atzerodt, charged with attempting to murder Vice President Andrew Johnson. Immediately next to him sits David Herold, who had fled with Booth and helped in his foiled escape attempt. Sitting just behind the center post is Lewis Paine, who tried to assassinate Secretary of State William Seward; just visible on his head is a straw hat that he had playfully snatched from the head of a bystander before he mounted the steps. Seated at far left is Mrs. Mary Surratt, who kept the boardinghouse where the conspirators met. (LC)

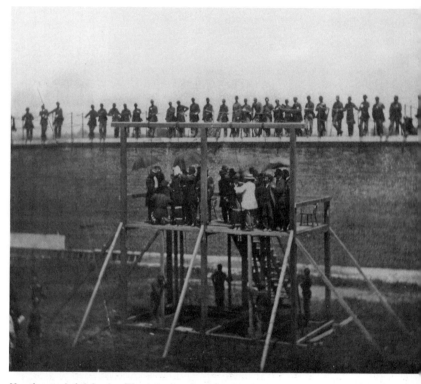

Now they stand, their hands and legs being bound and the nooses put in place. Chief executioner Christopher Rath is personally placing Paine's noose. Everyone grudgingly admired the courage of the young man. "I want you to die quick," Rath was saying to Paine. "You know best," replied the condemned. (LC)

all would never accept the outcome of the conflict. Yet as the postwar era began, Jefferson Davis was awaiting a verdict of his own. He and several other Confederate politicians who had held office in the old Union, were under indictment for treason, which should hardly have been a surprise. In most other nations of the nineteenth-century world, they would have been stood against a wall and shot. But here a peculiar mix of tolerance, exhaustion, and uncertainty produced an entirely different sort of denouement for the leaders of the rebellion. Of them all, only Davis would come close to trial, and in even his case it would become evident that the Union government did not really know what to do.

The trap is sprung and justice is done. (LC)

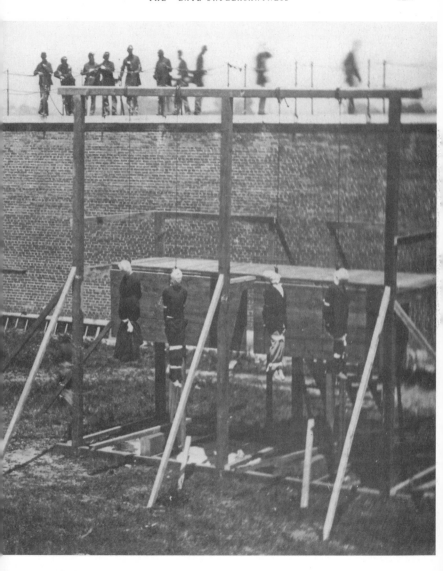

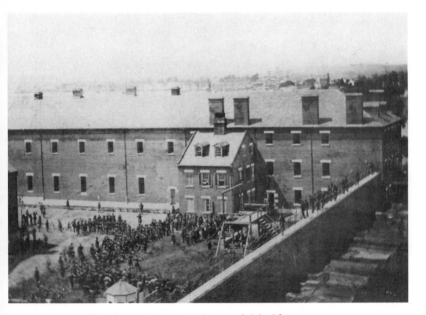

As the bodies still dangle from their ropes, the boxes for their burial are stacked beneath them as the crowd starts to melt away. The gallows will be sawed into souvenirs. (LC)

At first Washington officials believed—or wanted to believe—that Davis and his leaders had been involved in the Lincoln murder. Indeed, there is some evidence that prosecutors may even have tried to persuade deponents at the assassination trial to perjure themselves to implicate Davis, but the attempt failed. For two years Davis was kept a prisoner at Fort Monroe, Virginia, but the Federal authorities would never bring him before a jury. By 1867 friends had arranged for his release on bail, and passions had cooled to the point that the government actually believed that trying Davis for treason could be an embarrassment. He would certainly be convicted if tried, and then what should they do with him? The law prescribed

execution, but that would only enrage the South, thus far rather docile in defeat, and probably cause controversy with European nations that had entertained some sympathy with the Confederacy. In the end the Federal authorities simply let the case lapse, and Davis remained a free man, bitter and unwilling to the end to admit defeat. The few other imprisoned leaders went free as well. It was a remarkably bloodless aftermath to the bloodiest war in American history.

Yet the South was not to pass from war to peace without paying some price, gentle though it may have been compared to that paid by other defeated peoples. Reconstruction of loyal state governments had already begun under Lincoln

as Southern territory came once more under Federal control. "We must extinguish our resentment if we expect harmony and Union," Lincoln had told his Cabinet the very day he was shot. Emissaries including General U. S. Grant traveled through the South to gauge the temper of the people, and most concluded with Grant that Southerners accepted the verdict of the war and wanted to rejoin the Union as quickly as possible.

For nearly two years there was surprisingly little interference in Southern affairs, as white Southerners once more elected men of their own kind to their legislatures and tried to send them to Congress. But during that time it became increasingly evident that an old pattern was re-emerging. The same men who had led the South before the war were in charge once again and attempting to act as if the war had not happened. Once again they were claiming for their states the right to decide in matters in which the Republican majority in Congress believed Congress' right was paramount. Worse, though the slaves had all been freed, Southern states were enacting "Black Codes" which in effect returned them to a kind of servitude by enormously restricting their freedoms. In April and June 1866, when it came time to debate the civil rights act and the Fourteenth Amendment to the Constitution, which, among other things, guaranteed the vote to Negroes, the South balked, and the radical wing of the Republicans, who had always favored stern treatment of the former Confederate states, decided that the South had not learned its lesson. Triumphant in Congress, the Radical Republicans succeeded in instituting for the next decade a plan of "reconstruction," the excesses of which have been exaggerated in the ensuing century but which nevertheless did visit upon the Southern mind and spirit a wound never yet erased.

The day of the "carpetbagger" had come—the Yankee opportunist went South to profit from cheap land and labor while native Southerners barely survived. There is truth to some of the carpetbagger legend, though the reverse of the coin is that these entrepreneurs brought with them an influx of capital and energy which played a strong role in reviving the Southern economy.

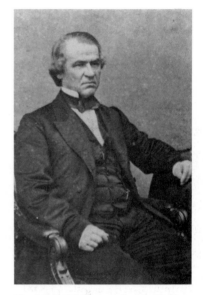

Lincoln's death leaves a new President in his stead. Andrew Johnson of Tennessee, Lincoln's second Vice President, a man who will try to follow in Father Abraham's steps, without much success. (USAMHI)

Republicans went South, and some Southerners joined with them—the "scalawags"—to run the Reconstruction state governments. Most Southern states at one time or another after the war fell under Republican rule. Often it was good, honest government, but in some few celebrated cases it was corrupt and abusive. Despite the long-held myth that the former slaves came to control several states, the fact is that in only one state, South Carolina, did Negro representatives hold a majority and that for only a single term in one house. There were no Negro governors, nor were the great mass of freed slaves a serious social threat to their former masters. Nevertheless, so fearful were Southerners of their former chattels, that groups like the Knights

There is more tragedy to come even when the fighting is stopped. With thousands of Federal prisoners being freed from Confederate prison camps, steamers like the Sultana *were brimmed with passengers as they transported men up the Mississippi from Vicksburg to the North. On April 27, just the day after this image of the ship was made, her boiler exploded in midstream north of Memphis and the vessel went down in the darkness. With over 2,000 men aboard, she took nearly three fourths of them down with her. It was the worst ship disaster in the nation's history.* (LC)

of the White Camellia, the White Brotherhood, and of course the Ku Klux Klan arose to intimidate the Negroes and preserve white supremacy. Even prominent Confederate leaders condemned the violence and lawlessness of these vigilante groups, though their rise is hardly surprising. Having just suffered the humiliation of being the first and only Americans ever defeated in a war—and Southerners had always prided themselves on their military prowess—they were in its aftermath faced simultaneously with economic collapse, social and political revolution, and the sudden appearance in their midst, as free

men, of millions of Negroes who had every reason to despise Southern whites. The white Southerners were in their way every bit as terrified as the Negroes they sought to intimidate.

Of course, there were many—perhaps as many as 10,000—who simply refused to take part in the South's travail, or who felt they dare not. Beginning with the flight of some of the Cabinet members and generals in 1865 and continuing on through the late 1860s, thousands of Southerners abandoned the country to go into exile, fearful of indictments against them, unwilling to live again under Yankee rule or bent on starting

While the military surrenders were taking place in early April, there was a small band of Confederates trying to flee the country—President Jefferson Davis and his Cabinet. (LC)

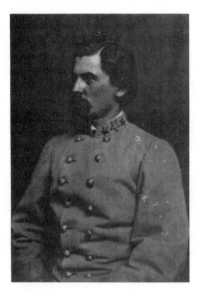

Brigadier General Henry H. Walker commanded the Confederate troops in the Danville, Virginia, area, and Davis ordered him to go to North Carolina and join General Joseph E. Johnston's army, not knowing that even then Johnston was preparing to sue for terms. (VM)

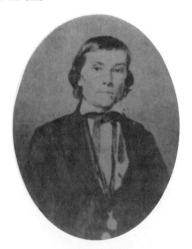

One by one the officers and Cabinet members with Davis dropped along the wayside, to attempt their own individual escape or else to surrender and take their chances. Vice President Alexander H. Stephens simply went home and awaited his arrest, accepting it calmly. (CM)

new lives elsewhere. By far the majority of them went to Mexico where whole colonies of ex-patriates were founded. Many of the generals took service there with the Emperor Maximilian, while their families tried to carve out new lives in the revolution-torn country. It did not work, however, and within a few years most of them had returned to the South.

Similar colonies were set up in Brazil and in other South and Central American countries. A small band of ex-Confederates dwelled in Havana for years after the war, and many more went to Europe. Judah P. Benjamin, Davis' Secretary of State, remained in England for the rest of his life, becoming a successful barrister and Queen's Counsel. Major General William W. Loring left the United States in 1869 and entered the service of the Khedive of Egypt, ironically serving in the same army as some adventuring ex-Union officers. And many, like the escaped Breckinridge, simply wandered abroad until the indictments against them were lifted, anxious simply to return home and start their lives anew. Breckinridge himself went from Cuba to Canada to Europe and back to Niagara, Canada, once more, patiently looking across the border to the United States and longing for the day of his return. He and the thousands of others may have been Confederates for four years, but they had been Americans a lot longer, and very few would not return to their homes eventually.

In the United States Southerners looked to many things to help them rebuild their personal and sectional fortunes. Recognizing the utter destruction of their transportation systems in the

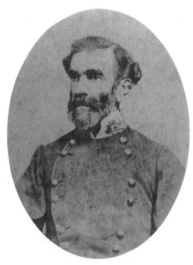

General Braxton Bragg, on the other hand, stayed with the presidential party almost to the end, acting as Davis' chief military adviser. An unpublished portrait made probably by the Montgomery, Alabama, photographer A. C. McIntyre in 1862. (CM)

In the end the last Cabinet officer standing by Davis was his Secretary of War, John C. Breckinridge, also a major general. He commanded the escort as the fleeing President moved through the Carolinas and into Georgia. (USAMHI)

war and needing to modernize and rebuild in order to once more get their crops to market, a boom wave of railroad building commenced throughout the South, often financed by Northern entrepreneurs. To lend a cachet of authority to the enterprises, a host of former Confederate military luminaries became active or figurehead officers of the new lines. Joseph E. Johnston, Nathan B. Forrest, Breckinridge, P. G. T. Beauregard, and many more became railroad presidents, and most took an active role in leading the struggle to rebuild. When states like Louisiana instituted lotteries to rebuild their treasuries, men like Beauregard and feisty old Major General Jubal A. Early supervised them. And scores of former Confederates entered the life insurance business as several new firms were capitalized to sell policies and raise investment

funds for rebuilding. Of course the old Confederates could not stay out of politics either. Though they had to take a loyalty oath and those who had been under indictment had to formally apply for restoration of their rights of citizenship, in a short time their voices were once more heard in state legislatures and the halls of Congress. No longer did they have the power to cripple or halt the national government as before, but in alliance with Northern Democrats and others tiring of Radical Republican rule, they finally came back to the point where in the disputed 1876 presidential election, they controlled the deciding electoral votes. Thus they made their bargain. Republican Rutherford B. Hayes, with fewer popular votes than his Democratic rival, Samuel J. Tilden, would be President, but Reconstruction would end. With Federal soldiers withdrawn from the South and control of civil

Here in Abbeville, South Carolina, in the home of Armisted Burt, Davis held his last council of war. He wanted to continue the war; Breckinridge and the others told him it was over. (USAMHI)

affairs once more entirely in the hands of Southerners, the final political vestiges of war and defeat were removed. Now it remained to heal the emotional wounds.

The old Union—the states of the North—was not idle in the decade after the war. It continued to grow in power and prosperity, virtually forcing the rest of the world to take notice of the infant Yankee giant come to adulthood in the family of nations. All the industrial world had watched the war, and now it saw the manifestations of a newly confident, even belligerent, United States rising to its potential. Yankee trade expanded throughout the globe and virtually dominated its own hemisphere. The bright new and mighty squadrons of American warships cruised the world's seas, demonstrating Union naval power and modernity. American influence in the affairs of other nations began to be felt, and her old friend and older adversary Great Britain was once again made to feel the sting of defeat by her Yankee cousin. Already fearful that the cocky and powerful Americans would renew the age-old drive to wrest Canada from her, Britain was forced to submit to international arbitration in 1872 over the *Alabama* claims, American demands for millions of dollars in reparations for the damage done to Union shipping by Confederate raiders fitted out in British ports. The British paid their penalties manfully,

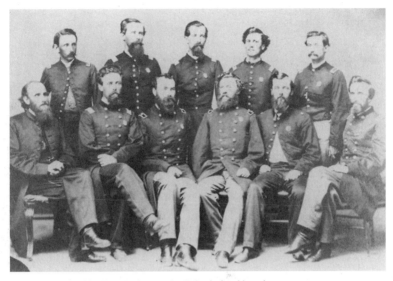

Finally, near Irwinville, Georgia, the pursuing Federals closed in and captured Davis. Lieutenant Colonel Benjamin Pritchard led his 4th Michigan Cavalry against Davis' camp and thereby won himself a brevet rank of brigadier. Pritchard sits third from the left. (DUDLEY H. PRITCHARD)

and the long Anglo-American friendship, though often strained, would continue.

If as a result of the war the Union became a world power, so, too, did the conflict ensure its grasp on territory already claimed as its own. The years of fighting had a profound impact upon the settlement of the great expanse of unsettled, uncharted West. A few campaigns, even a few small battles, had been fought for control of the hundreds of thousands of miles of plains and mountains. The Indians could hardly profit from the great war taking place in the East. At best it gave them a brief rest from the inevitable push to dispossess them. Yet even before the war ended, the massive migration of whites began, and directly as a result of the conflict. Besides the soldiers who came West and besides the civilians and camp followers who inevitably clustered about the army camps, there came also thousands of men who had little choice. No one knows how many deserted from both armies during the war, but very few of them could be expected to go home to probable capture and certain disgrace. They went West instead. Hardly the most desirable of settlers, they almost ensured that the next few years would be lawless and wild in a land of men without creed. And when the end of the war left thousands more too accustomed to the practice of raiding and near-lawless adventuring to quit, it was inevitable that they, too, should go West. As a result the so-called Wild West was the direct offspring of the Civil War, and not unnaturally it would fall also to veterans of the war to go to the new settlements to preserve law and order. The James brothers had been Confederate guerrillas. "Wild Bill" Hickok

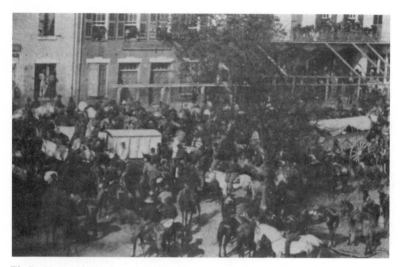

The President and his band were brought to Macon, Georgia, where photographer A. J. Riddle made this May 13, 1865, image of the ambulance and wagon which carried Davis and his party. Pritchard's troopers fill the street in front of Major General James Wilson's Federal headquarters. Prison awaited Davis, though he would never be tried or convicted of treason. (USAMHI)

had served the Union. For them and many more the days of the Old West were little more than a continuation of the adventure of the war.

For every bully boy and bravo who crossed the plains, however, thousands of other more peaceable settlers came, tired of the East, ruined by the war, or simply anxious for something better than what they had. These are the people who "won" the West, not from the Indians or the bandits but from the land itself. Southerners and Northerners alike made the trek, and it went far toward reconciliation that they built towns and counties and states together. All that land out there just waiting gave them something to fight for in common, something to help rebuild the fraternal bonds that war had severed. Were it not for the West, reconciliation might have taken far longer than it did.

Of course, time would be the greatest healer of them all. As the years passed and the soldiers got older and gentler, so too did the passions. By the end of the century nostalgia and forgiving memory had already erased much of the bad, covering what remained in a patina of romance and myth. Veterans of both sides banded together in fraternal organizations—the mighty Grand Army of the Republic, the proud United Confederate Veterans. Intended originally as political action groups, they came in time to look more toward the care of the aging veterans, the infirm, those disabled by the war. Around the country, North and South, homes for the indigent and helpless veterans appeared. In annual conventions, the old generals and leaders came forth again and again to talk to their comrades of past glories and present patriotism. Through

Some were more fortunate than Davis. Secretary of War Breckinridge did successfully escape in a hair-raising adventure through Florida and across the Gulf Stream that saw him dodging Federal patrols, turning pirate, and nearly perishing in a storm at sea. The month-long ordeal showed in his face when, a few days after reaching Cuba, he sat for this photograph, probably by Charles D. Fredericks' Havana studio. (WILLIAM C. DAVIS)

the dim, teary-eyed vision of the old fading soldiers, the memories grew less and less distinct, and all the more treasured.

In time they all had to go, to follow in death all those uncountable legions already departed on the nation's battlefields. Ironically, of the great men, Lee was the first to depart. The war killed him as surely as if a bullet had struck him down. He lived only until 1870, when he was only sixty-four, a symbol of peaceful acceptance of the war's verdict, a champion of reconciliation. Grateful and tolerant to the last, he threatened one of his professors at Washington College with dismissal if the man ever spoke

disrespectfully of General Grant in his presence. The mourning was universal throughout the South and even in the North at the great warrior's passing, noble to the very end.

His old adversary Grant outlived him by fifteen years, with a nobility that, in its way, matched that of Lee. Lifted in 1872 to the highest office in the gift of the American people for his victory, Grant the President endured scandal and disgrace and financial disaster, to end his days still universally admired as a simple, honest soldier. His heroic struggle in his last days to complete his memoirs and provide for his family touched men everywhere. He beat the cancer that killed him only by days, leaving behind one of the finest memoirs ever written by a soldier and an example of courage which even his former enemies admired.

Of course there were those who held their bitterness to the end. Jefferson Davis would never admit defeat, never accept the war's lessons. To the last of his days he sought to win with his pen what his sword had lost. Though they never loved him as they did Lee, still his people admired and respected their old President. When he died in 1889, the last of the great political leaders of the war, even the North was respectful.

But the people were always the more touched by the generals and soldiers, the men who really fought the war, and they were the ones who seemed more readily able to forgive and forget. Nothing could be more touching than the last days of the archrivals Sherman and Johnston. They had not met prior to the war. Their acquaintance began at First Bull Run. They met again in the Vicksburg Campaign and then all across Georgia on the road to Atlanta. In the war's last days they faced each other in the Carolinas until finally Johnston surrendered. Thereafter the two became cordial friends, in the manner of thousands of others, and when the great Sherman finally passed away in 1891, his old friend and enemy Johnston was there as an honorary pallbearer, standing bareheaded in the pouring rain. A friend admonished the old Confederate to put his hat on, but he would not. If the positions had been reversed, he said, and Sherman were standing there mourning a dead Johnston, the Federal would not have put his hat

With all the tragedy that attended their victories, the Federals needed some means of celebrating their triumph. The War Department called for a Grand Review of Major General George Meade's and Major General William T. Sherman's armies in Washington on May 23–24. Viewing stands were erected for the dignitaries along Pennsylvania Avenue. The stand draped with flags was for President Johnson, the Cabinet, the generals, and special guests. (NYHS)

on. And so the old Confederate took cold and was dead of pneumonia within weeks.

More and more the remaining vestiges of the old war reminded Americans of their common bonds and virtues rather than their onetime controversies. Grand reunions of veterans blue and gray were held to celebrate the anniversaries of dates once held terrible. At Gettysburg in 1913 and again in 1938, mammoth reunions paid for by the nation brought thousands of old soldiers forth once more to walk the field of battle where some had fought and relive the old times. All across the country national military parks were established to memorialize what both sides stood and fought for. In time they all came to realize that it had been a very American war, exemplifying, North and South, all of the best and worst in themselves as Americans.

And throughout it all, from Appomattox on, for generations forward, down to the last living veteran, the constant companion of the Civil War experience, the camera, was there recording the passing of an era. Like America itself, the photographers after the war moved on, to the West, out into the world. They, like their nation, had given their youth, their best years, to the epic struggle of North and South. But they were not finished by that war. They and their craft would move ahead while their achievement made it possible for future generations always to look back.

They were all timeless men in their way, preserved in the images for all time. They had lived the spirit of their era, of an age now gone by but which can never die, thanks to them. They were all men, now long dead, who will yet live forever.

Crowds gathered early all along the route, anxious to cheer the brave men who had delivered the Union and put down the Rebellion. (USAMHI)

They were not disappointed. In the most magnificent parade the capital had ever seen, thousands upon thousands of blue-clad soldiers marched from the Capitol down Pennsylvania Avenue toward the Executive Mansion. Captain A. J. Russell took his camera into the Capitol dome to record this outstanding view of one brigade marching down the avenue. (USAMHI)

At the other end of the street, near Willard's Hotel at right, Alexander Gardner or an assistant made scene after scene of the passing heroes. An unidentified major general lifts his hat in salute before his command passes by. (USAMHI)

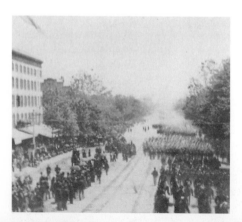

The first infantry to pass in review on May 23 was the IX Corps of Major General John Parke. The general and his staff ride at the front. (USAMHI)

Major General A. A. Humphreys and his II Corps soon followed, Humphreys a blurr of motion in the lead. (USAMHI)

THE PUBLIC SCHOOLS OF WASHINGTON WELCOME THE HEROES OF THE REPUBLIC. HONOR TO THE BRAVE—*so read one of hundreds of signs that greeted the soldiers. This one is on the Capitol building, as crowds of men, ladies, and school children line the street. In the background, the building's columns are still wrapped in mourning for the dead Lincoln.* (USAMHI)

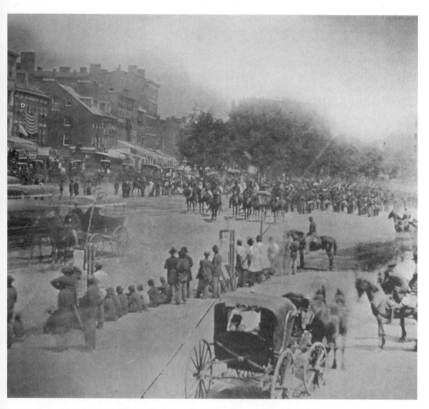

Hour after hour the soldiers and their wagons and cannon passed along the street, marching to the beat of their drums and the sound of the special march composed for the occasion. (NYHS)

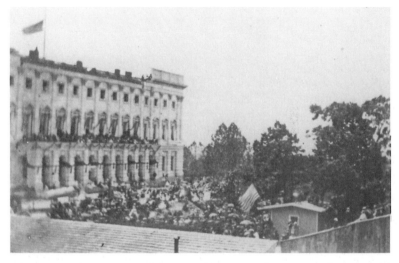

The flag flew at half staff, but it and all the crape could not dampen the spirits of this two-day orgy of patriotism and celebration. (USAMHI)

Every new regiment marching down Capitol Hill did so to resounding cheers from the men and boys and the ladies waving their handkerchiefs. (P-M)

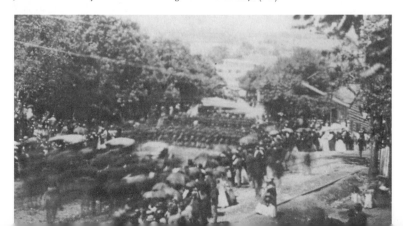

Johnny was at last marching home again. (P-M)

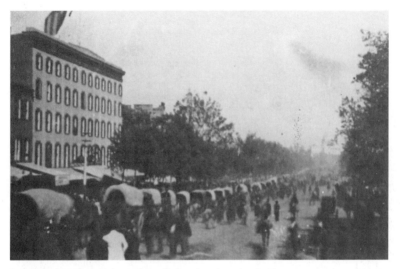

Sometimes the enthusiastic bystanders walked out into the avenue itself to get a closer look. (USAMHI)

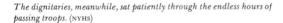

The dignitaries, meanwhile, sat patiently through the endless hours of passing troops. (NYHS)

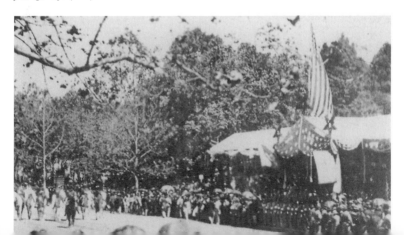

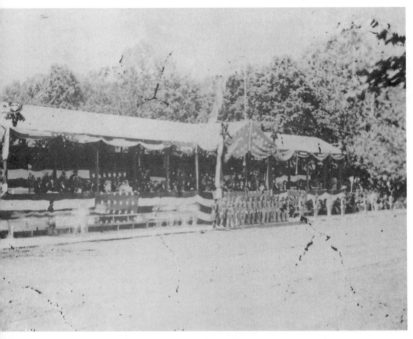

*The victories of the armies were printed on the bunting hanging from the roof of the reviewing stand—*SPOTSYLVANIA, ANTIETAM, CHATTANOOGA, *and more. In this image made on the second day of the review, as Sherman's army passes by, General Meade sits at the far right of the central part of the stand. Next to him, holding a newspaper, is General Sherman. Secretary of the Navy Gideon Welles sits in the center of the group, just to the left of a bouquet of flowers, and at the far left of the advanced gallery Secretary of War Stanton turns his head to talk with an unseen Lieutenant General U. S. Grant.* (KA)

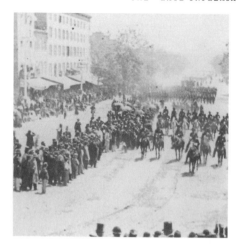

On this second day, Major General Henry W. Slocum rode at the head of his Army of Georgia. (USAMHI)

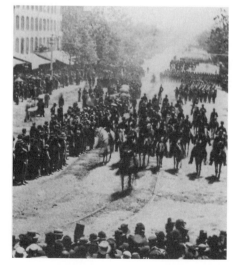

Soon Major General John A. Logan followed, behind him the Army of the Tennessee stretching back to the horizon. (USAMHI)

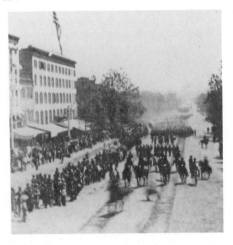

Brigadier General Jefferson C. Davis led the XIV Corps, his horse a mere blur in the image, along with what appears to have been a bystander running across the street. (USAMHI)

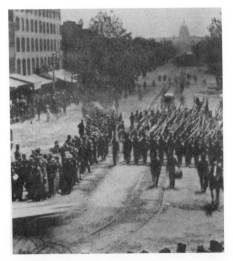

Then came the XX Corps, as the endless procession lasted on through the day. (USAMHI)

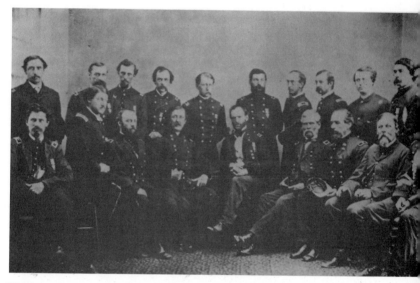

With their marching done, the officers of the armies gathered before the camera of Alexander Gardner for a final group portrait, the last time they would all be together. General Sherman sits here in the center, with the generals and other members of his staff. (LC)

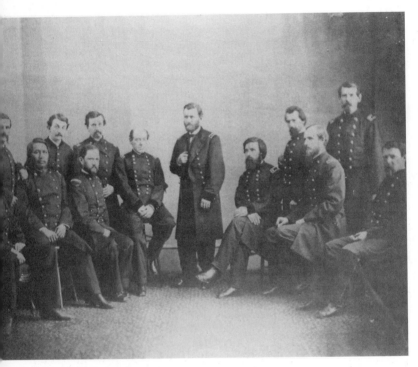

General Grant stands at the center with his staff, including Lieutenant Colonel Ely S. Parker, seated second from the left, a Seneca Indian who served as Grant's military secretary. It was he who transcribed Grant's terms to Lee at Appomattox. Brevet Major General John Rawlins, Grant's chief of staff, sits on Grant's immediate left, and Adjutant General Seth Williams sits on the other side of Grant. (AIG)

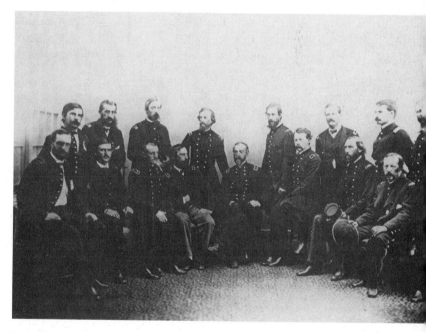

General Meade and his staff sit for Gardner, Meade in the center. Artillery chief Major General Henry Hunt sits at Meade's immediate right. (MHS)

*Then it was time to celebrate around the Union. Philadelphia dresses itself
up to receive its sons once more.* (FREE LIBRARY OF PHILADELPHIA)

The generals, too, went home, though not all of them for good. Galena, Illinois, decorated one of its main streets for the return of a man who was once one of its most obscure citizens, Lieutenant General U. S. Grant. GENERAL: THE "SIDE-WALK" IS BUILT *reads the banner, perhaps referring to some bit of civic progress while Grant was busy with the war.* (CARL H. JOHNSON, JR.)

An Ohio regiment lines up for the last muster in Cleveland, a glad time, yet not without sorrow. Most of these young Americans would never again experience anything to compare with their days at war. (LC)

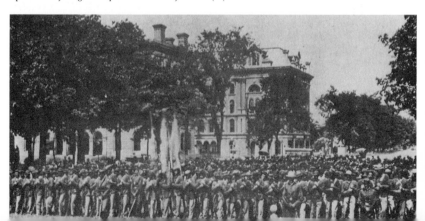

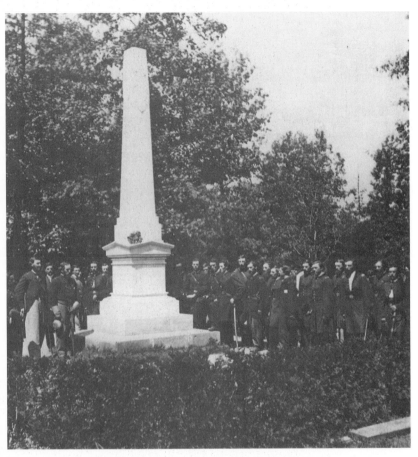

On July 26, 1865, the 23d Ohio was mustered out of service, and its officers
met here at the monument they had already erected to the regiment in
Cleveland after its service at Antietam, Maryland, in 1862. It is perhaps the
first—certainly one of the first—regimental monuments erected, and it marks
as well the rise to prominence of two future American Presidents from the
regiment. Brigadier General Rutherford B. Hayes, once colonel of the 23d
Ohio, stands immediately left of the monument, his head just visible above
the shoulder of the man in front of him. And the officer standing second to
the right from the marker is probably Major William McKinley. Few
regiments could claim such distinguished alumni. (USAMHI)

There were those who would never go home. Now that the battlefields were silent, the work of removing the hastily buried dead and reinterring them could begin in earnest. It was an odious and difficult task. (USAMHI)

But it was worth the effort, and quickly the nation gave its honored dead a fitting resting place. Here is a soldiers' cemetery in Alexandria, Virginia. Many of the dead could not be identified; only numbers appear on their grave markers. (USAMHI)

At Arlington National Cemetery, on grounds that were once the property of Robert E. Lee's family, thousands more were laid to rest. Ironically, Privates J. Kelly and J. Richards, beneath the two stones at front center, both died on their country's birthday, July 4, 1864. (USAMHI)

And the work of marking and memorializing the battlefields began, with Bull Run (Manassas) being fittingly the first. On June 10, 1865, William Morris Smith made this image of the ceremonies dedicating the battle monument on Henry House Hill. (LC)

There were speeches to listen to, and this crowd is reasonably attentive.
Standing hands on hips at the right is Major General Samuel P. Heintzelman,
who fought in the battle here at Bull Run in 1861. Next to him, arms folded,
is Major General Montgomery C. Meigs, quartermaster general of the Union
armies, and next to him, at his left, is Brigadier General Alexander B. Dyer.
(AIG)

And here the generals and bystanders stand for the camera, beneath the
plaque that offers the monument "IN MEMORY OF THE PATRIOTS." (NA)

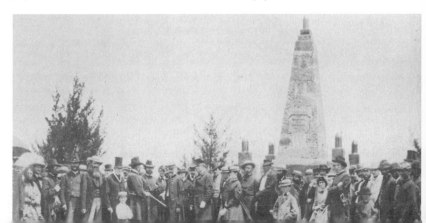

Elsewhere in Virginia, the survivors of a shattered Confederacy will have to wait awhile before they can erect their monuments. They are even hard put just now to care adequately for their dead. Here in Richmond's Hollywood Cemetery, in April 1865, the mounds of earth testify to fresh burials, and the rude headboards testify to the utter inability to provide more than the barest ceremony for these fallen men. That would change in time. (LC)

There were difficult years ahead for the South. Happily, there were few reprisals against individuals as a result of the war. Champ Ferguson of Tennessee would suffer one of them, however. Guilty of murdering several white and Negro Federal soldiers in 1864, he was tried in Nashville in the summer of 1865. This portrait was made the day before his hanging. (HP)

Only one Confederate officer was brought to trial for "war crimes," Major Henry Wirz, the commander of the infamous prison camp at Andersonville, Georgia. Despite his probable lack of intent in bringing about the deaths of thousands of Union prisoners, the horrors of Andersonville had to be avenged. On November 10, 1865, reporters gather in Washington, D.C., to witness Wirz's execution. (LC)

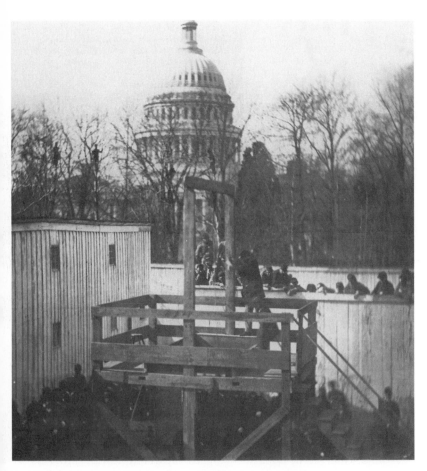

*Alexander Gardner brought his camera to capture the scene as, with the
Capitol dome in the background, the trap is released and Wirz plummets to
his death.* (LC)

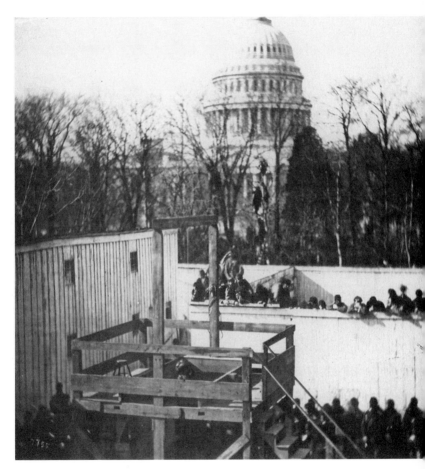

As his lifeless body swings at the end of the rope, the dead of Andersonville are revenged. (LC)

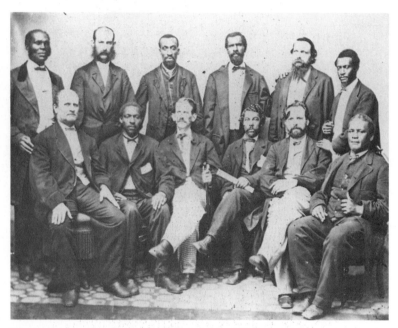

Jefferson Davis was indicted for treason in May 1866, but no trial was
forthcoming. These were the jurymen before whom he was to be tried, yet
the trial never came. In 1867, after exactly two years in prison, Davis was
released on bail. (VM)

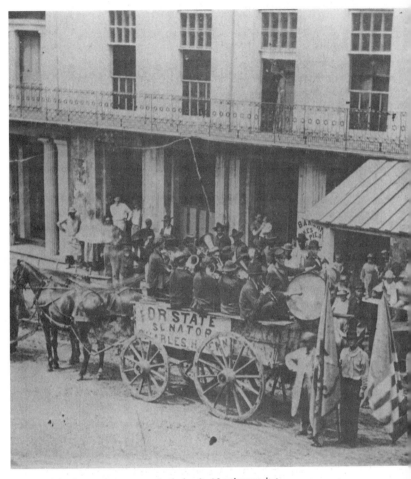

For a time, elections were left once more in the hands of Southerners, but more and more Northern Republicans would come to enlist the new votes of the freed slaves to win office. Actual rule by the carpetbaggers was greatly exaggerated by ex-Confederates, but it did happen. The number of Federal uniforms in this Baton Rouge, Louisiana, electioneering wagon, speaks to the support given one candidate by the Northern conquerors. (DAM, LSU)

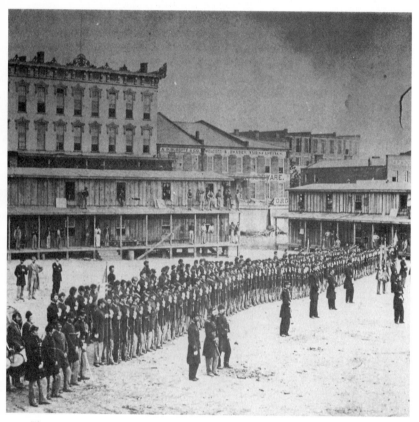

Then came the occupation of the South by Federal troops and the years of Reconstruction. A regiment of Union troops in Memphis, Tennessee, in June 1865. (HP)

With the South divided into military districts, Federal generals were sent to administer them. Here in Atlanta, in 1868, General Meade sits (center right) on the porch of his residence as district commander. (P-M)

The former Confederates fought back however they could, in the legislative halls and in out-of-the-way places by night, seeking to intimidate both the Negroes and the whites who collaborated with them. They rode out of the darkness dressed in frightening robes and hoods. (LO)

In time the disorganized raiders formed more formal secret societies, the most notorious coming to be called the Ku Klux Klan. Here, on December 20, 1871, one of their members who had been captured and turned state's evidence poses in his regalia at Holly Springs, Mississippi. (HP)

The great Confederate cavalry chieftain Lieutenant General Nathan B. Forrest for a time served as Grand Wizard of the Klan, but around 1868 ordered it disbanded when he perceived that it was leading only to ineffective violence. (DAM, LSU)

Other former Confederates tried in different ways to survive Reconstruction and rebuild themselves as well. General P. G. T. Beauregard was proud enough of his service as late as 1872 to be still autographing his wartime portrait. He and other generals looked to railroading to bring the South into the industrial age. (VM)

Some, like Wade Hampton, once a great cavalryman, fought in the political arena to combat Reconstruction. Hampton became governor of South Carolina in 1876, was reelected in 1878, and then served two terms as a U.S. senator. (CM)

Thousands who could not face life in a defeated South emigrated to other countries, most notably Mexico. The family of Major General Sterling Price suffered a shipwreck on its way to Mexico in 1865. They pose here with other survivors, Mrs. Price seated at the center. (MISSOURI HISTORICAL SOCIETY, ST. LOUIS)

Awaiting them in Mexico in 1865 were some of the generals who had exiled themselves rather than surrender. Standing left is Major General John B. Magruder and next to him is Brigadier General William P. Hardeman. Seated from the left are Major Generals Cadmus Wilcox, Sterling Price, and Thomas C. Hindman. All would eventually return to the United States when the Mexican colonization attempt failed. (NA)

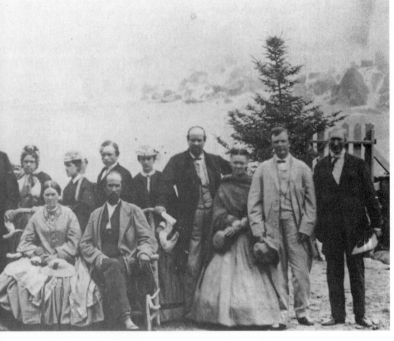

Others went to Canada. Here, standing at the far left, is the Confederacy's last Secretary of War, Major General John C. Breckinridge, posing with his family in front of Niagara Falls in 1867. Still under indictment for treason, Breckinridge did not dare return to the United States, though he wanted to desperately. The best he could do was come here to Canada to live, so he could look across the Niagara River and see the country from which he was self-exiled. In 1869 he finally returned after amnesty was declared by President Johnson. (WCD)

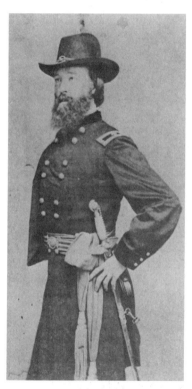

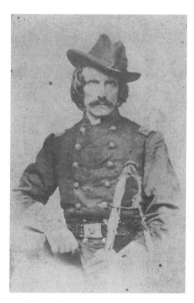

President of the Fenians was Colonel John O'Mahony of the 40th New York. (WG)

Meanwhile, the Confederates' old adversaries were spreading out and leaving the country, though for other reasons. Irishmen like Brigadier General Thomas Sweeny, born in County Cork, began to look to Canada as a place to attack England so as to force her to free their native Ireland. Sweeny and other so-called Fenians invaded Canada in 1866, but the whole movement failed comically. (THOMAS SWEENEY)

THE END OF AN ERA

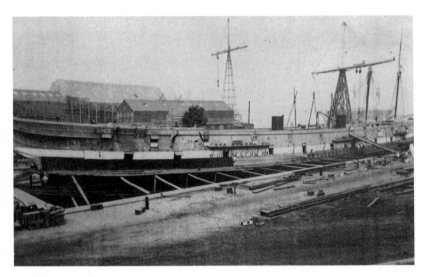

The Union itself was expanding, looking to stretch its influence beyond its borders. The shipbuilding begun during the war continued. War vessels like the USS Ammonoosuc, a cruiser here under construction at the Boston Navy Yard in 1864, would be completed after the war to join one of the most modern fleets in the world. (MM)

The mighty USS Madawaska, largest commissioned vessel in the Navy, was renamed Tennessee in 1869 and made flagship of the Adriatic and North Atlantic Squadron. (USAMHI)

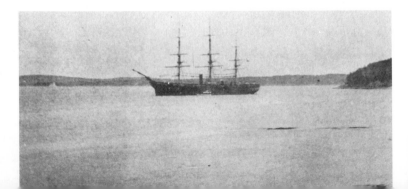

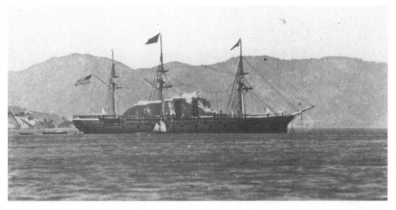

Here at Rio de Janeiro, Brazil, the USS Guerriere, *flagship of the South Atlantic Squadron, sits at anchor.* (USAMHI)

The powerful USS Kearsarge *cruised the Pacific, stopping here in Sydney, Australia, in 1869.* (NHC)

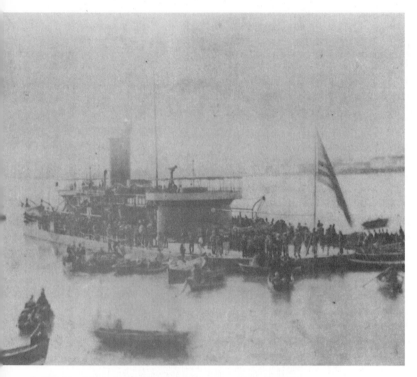

And the powerful monitor USS Miantonomoh *was sent on a major European tour in 1866–67, to learn what she could of naval facilities there and to impress Europeans with the new naval might of the United States. She certainly did the latter. "The wolf is in our fold," lamented the London* Times. *She appears here at Málaga, Spain, early in 1867.* (NHC)

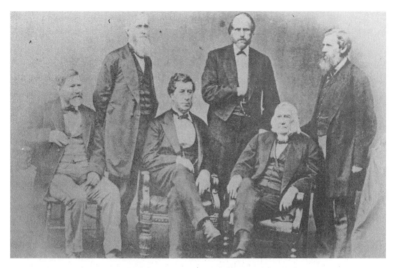

So much did the Union now feel its muscle that it took Great Britain to task in 1869 for serving as outfitting agent for Confederate ships like the raider Alabama. *In the deliberations over claims for damage done to Union shipping by that vessel and other raiders, these Yankee commissioners . . .* (WG)

. . . negotiated in 1872 with these British leaders for the eventual payment of $15 million to the United States. (WG)

The Yankees were moving West, too, expanding their influence in their own
continent. Here at Fort Sanders, Wyoming, in 1866, there was a notable
gathering of luminaries. Former Major General Grenville M. Dodge stands
at far left; he had now left the Army and was building the Union Pacific
Railroad. Second to the right from Dodge is Major General Philip Sheridan,
and second to the right from him is Major General John Gibbon; both
Sheridan and Gibbon were now facing hostile Indians on the Plains.

Wearing a white hat and leaning on the fence to the right of Gibbon is
Lieutenant General U. S. Grant, now commanding general of the Army, and
the man in white vest standing in the very center of the photo is Major
General William T. Sherman. Standing at far right is Major General John A.
Rawlins, and next to him is Colonel Adam Badeau. The white-bearded man
in cape and top hat is Brevet Major General William S. Harney, now retired.
They were all on a tour of inspection of the route of the Union Pacific.
(GENE PANTANO)

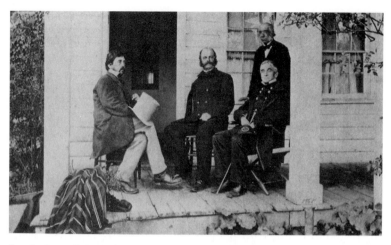

For other former Union generals the years after the war were less exciting, less active. Major General Ambrose Burnside sits at center, with Major General Robert Anderson seated at the right. It is 1865 and Burnside would go on into industry and politics. Anderson would be dead in 1871, worn out by the war. (VITOLO-RINHART GALLERIES, NEW YORK CITY)

Some tried to profit as best they could from their war experiences. The actress Pauline Cushman made a shabby career of sorts by appearing in her uniform and telling the story of her dramatically unsuccessful days as a Federal spy. (NYHS)

But for many of the other veterans, there was nothing left but a lifetime on public or private charity. This New Jersey soldier gave a lot for his country. (WILLIAM C. MC KENNA)

The nation tried to do what it could in return, and indeed few war veterans were ever cared for better than the Union's boys in blue. Here in the National Home for Disabled Volunteer Soldiers in Dayton, Ohio, an excellent library was provided for the soldiers' entertainment. An 1876 image by the Mote Brothers. (RJV)

Gradually the old leaders grew older. Age is marking Generals Heintzelman and Sheridan as they sit here, second and third from the left. And Admiral David Farragut is weighted with years as well as gold braid. Gradually they will die away. Farragut will be the first of this group to go, in 1870.
(CHICAGO PUBLIC LIBRARY)

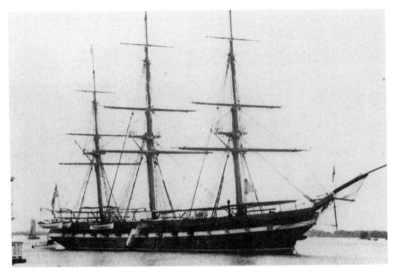

And his once proud warship the USS Hartford *will, like Farragut, grow old. In 1876 she came to Philadelphia for the great Centennial Exposition.* (P-M)

Other veteran ships like the USS Idaho *will simply be laid up in the navy yards, with nothing left to do.* (NHC)

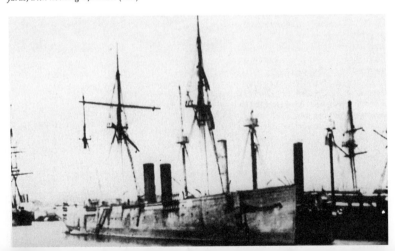

For the once proud monitors USS Shawnee *and USS* Wassuc *the same fate lay ahead, to be tied up at the Boston Navy Yard with nothing to look forward to but salvage for scrap.* (CHS)

Even the USS Miantonomoh, *after its world cruise, would wind up at a slip on the Charles River next to the two monitors.* (NHC)

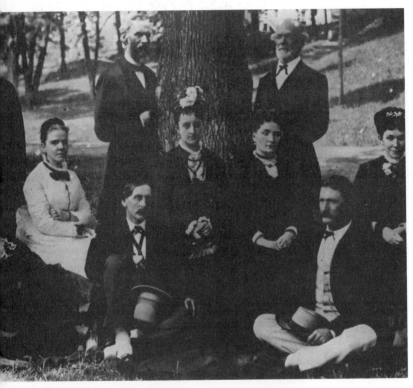

*As the years went on, the colors faded and the old Confederate leaders slowly
began to wane and disappear. Here at White Sulphur Springs, Virginia, in
the 1870s, General Joseph E. Johnston stands to the right, with family and
friends. Major General Jeremy Gilmer stands on the opposite side of the
trunk; at far left of the picture stands Brigadier General John S. Preston;
and the man seated at right is Major General George Washington Custis Lee,
son of . . .* (VM)

. . . *General Robert E. Lee. Photographer A. H. Plecker of Lynchburg captured this image of Lee and Traveller during the summer of 1866. The general was aging rapidly.* (AIG)

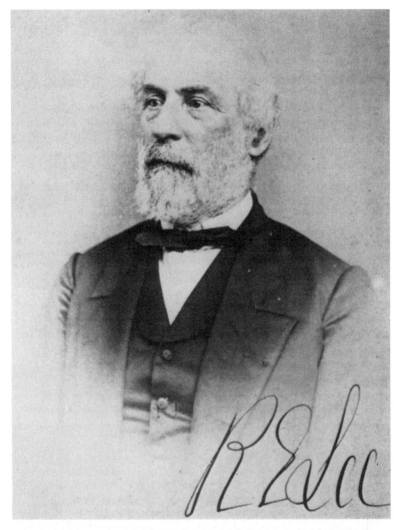

By *1869, when he sat for this unpublished Brady portrait, Lee was just sixty-two and had barely a year to live.* (wcd)

*In October 1870 the great general was dead. On October 14 this procession
carried his remains from his residence in Lexington, Virginia, to the chapel
of Washington College, of which he had been president since 1865.*
(WASHINGTON AND LEE UNIVERSITY, LEXINGTON, VIRGINIA)

*The next day the funeral services were held in the chapel, while the crowds
outside gathered to pay their respects. Gray-clad cadets of the Virginia
Military Institute at Lexington stand in the center. For Virginia and the
South it is a farewell to their most memorable era, and to their greatest
national hero.* (WASHINGTON AND LEE UNIVERSITY)

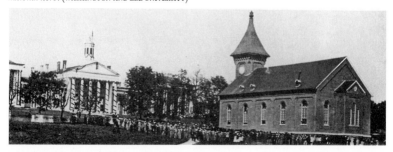

There are more heroes left to die. On July 22, 1885, with two clouded terms as President and four years as one of the greatest generals of his age behind him, U. S. Grant is dying of cancer in a cottage at Mount McGregor, New York. He had just finished the heroic task of writing his memoirs against the most immutable deadline of all, his own death. (CHAPMAN R. GRANT)

The next day the general's chair was empty, draped in black. Another era ended. (CHAPMAN R. GRANT)

"Little Aleck" Stephens, troublesome Vice President of the Confederacy, lived until 1883, unrepentant to the last, and uncompromising. (WA)

For Jefferson Davis, there was at least the small satisfaction of outliving all of the other major leaders of the war—Lincoln, Grant, Lee. Here he stands on the steps of his home Beauvoir in Mississippi. (TU)

He devoted the last years of his life to writing his history of the Confederacy, trying to win with the pen what he had lost by the sword. He, too, never fully admitted defeat or error and never entirely forgave his old foes. (CONFEDERATE RELIC ROOM AND MUSEUM, COLUMBIA, SOUTH CAROLINA)

Here in this study at Beauvoir Davis began the work of creating his version of the Lost Cause myth. Here he wrote his Rise and Fall of the Confederate Government, *his personal apologia and the first in the unending stream of works by former Confederates designed to prove that even if the South did not win the war, it should have done so. The echoes that began in this modest, book-lined room are sounding still.* (LC)

But he, too, had to answer the final call. In 1889, in New Orleans, the Confederacy's one and only President lay dead, and with him went much of the history and the enduring myth of the Lost Cause. (CONFEDERATE RELIC ROOM AND MUSEUM)

*In 1876 trees and grass grew on the heights overlooking Fredericksburg, Virginia, where in 1862 they sprouted only guns. An image by Edward L. Wilson & W. Irving Adams. (*DUKE UNIVERSITY LIBRARY, DURHAM, NORTH CAROLINA*)*

*At Gettysburg, Pennsylvania, greatest battlefield of them all, the soldiers were laying cornerstones for monuments as early as July 4, 1865, when the 50th Pennsylvania Infantry gathered here for a dedication. At the end of that month they were mustered out of service. (*OAKLAND MUSEUM, OAKLAND, CALIFORNIA*)*

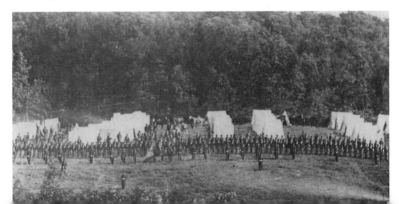

As the years went on, the monuments and markers multiplied. By the 1880s Little Round Top already bristled with them. Gettysburg was on its way to becoming the best-marked battlefield in the world. (USAMHI)

The soldiers came back after the war to establish homes like this Gettysburg house, as orphanages for the children left behind by men who fell for the cause. Grant himself stands second from the right in this 1867 image. The Soldiers' Orphans Home at Gettysburg operated until 1887. (LC)

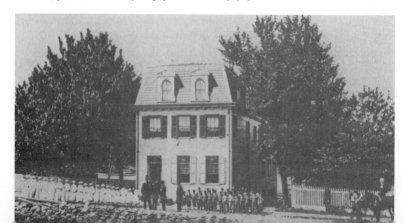

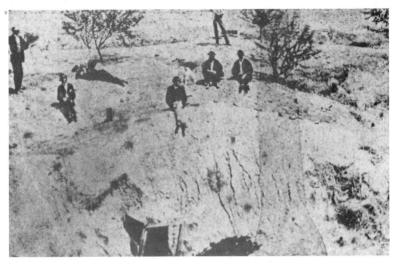

*Enterprising Southerners beat out their old adversaries in realizing the
tourist potential of the battlefields. It was late in 1865 when a Virginian
opened a small museum here at the Crater at Petersburg.* (TU)

*The Crater became a popular tourist attraction, each visitor paying
twenty-five cents to view the artifacts and look at the great hole made by the
Yankee mine in July 1864, during the siege. When this image was made in
1867, visitors were a daily occurrence.* (LEE A. WALLACE, JR.)

*For all of them, the men and generals and photographers and the people who
stayed at home and waited, it had been the most momentous experience of
their lives. Never again would they and their country endure such a trial,
and emerge so ennobled. They had lived the last days of American innocence.*
(KA)

The old soldiers themselves got older, the memories fading along with the old animosities. The veterans gathered in reunions, North and South, and even the once-maligned Negro soldiers were often welcome. Old Jefferson Shields was Confederate Major General Stonewall Jackson's wartime cook and now a frequent visitor at Stonewall Brigade reunions. This image was made around 1905, forty years after the war ended. (LEONARD L. TIMMONS)

As the parades went on year after year, there were fewer and fewer of the old heroes to fill the wagons. Here in 1913, fifty years after Gettysburg and Vicksburg, the old gentlemen are looking ever closer to the grave. (LEONARD L. TIMMONS)

Many of the soldiers had gone to war as beardless boys; they emerged as men, in a modern nation bright with promise for the future. Behind them now lay the hatreds, the blood . . . (HP)

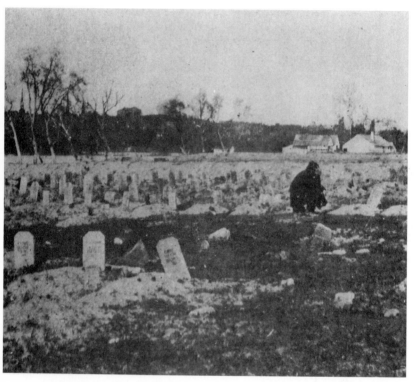

. . . and the memories. (NA)

ABBREVIATIONS

AIG	America Image Gallery, Gettysburg, Pennsylvania
CHS	Chicago Historical Society, Chicago
CM	Confederate Museum, New Orleans
CSS	Charles S. Schwartz
CWTI	Civil War Times Illustrated Collection, Harrisburg, Pennsylvania
DAM, LSU	Department of Archives and Manuscripts, Louisiana State University, Baton Rouge
GDAH	Georgia Department of Archives and History, Atlanta
GW	Gary Wright
HP	Herb Peck, Jr.
ISHL	Illinois State Historical Library, Springfield
JM	Jack McGuire
JMB	Joe M. Bauman
KA	Kean Archives, Philadelphia
KHS	Kentucky Historical Society, Kentucky Military Museum, Frankfort, Kentucky
LC	Library of Congress, Washington, D.C.
LJW	Larry J. West
LO	Lloyd Ostendorf Collection
LSU	Louisiana State University, Department of Archives and Manuscripts, Baton Rouge
MC	Museum of the Confederacy
MHS	Minnesota Historical Society
MJH	Michael J. Hammerson
MJM	Michael J. McAfee
MM	Mariners Museum, Newport News, Virginia
NA	National Archives, Washington, D.C.
NHC	U. S. Naval Historical Center
NLM	National Library of Medicine, Bethesda, Maryland
NYHS	New York Historical Society, New York
OCHM	Old Court House Museum, Vicksburg, Mississippi
PHS	Pensacola Historical Society, Pensacola, Florida
P-M	Pennsylvania-MOLLUS Collection, War Library and Museum, Philadelphia
RJY	Robert J. Younger
RP	Ronn Palm
SCL	South Carolina Library, University of South Carolina, Columbia
SHC	Southern Historical Collection, University of North Carolina, Chapel Hill
TU	Louisiana Historical Association, Special Collections Division, Tulane University Library, New Orleans
USAMHI	U. S. Army Military History Institute, Carlisle Barracks, Pennsylvania
VHS	Vermont Historical Society
VM	Valentine Museum, Richmond, Virginia
WA	William Albaugh Collection
WCD	William C. Davis
WG	William Gladstone Collection
WRHS	Western Reserve Historical Society, Cleveland, Ohio

The Contributors

George Washington Adams established himself many years ago as perhaps the leading authority on Civil War medicine with the publication of *Doctors in Blue: The Medical History of the Union Army in the Civil War*. Educated at Harvard University, Dr. Adams taught at his alma mater and at Massachusetts Institute of Technology before becoming Dean of Colorado College.

John G. Barrett has spent three decades on the faculty of the Virginia Military Institute at Lexington, is a Guggenheim fellow, and is the author of several acclaimed Civil War books, including *Sherman's March Through the Carolinas*, *The Civil War in North Carolina*, and *North Carolina Civil War Documentary*.

Edwin C. Bearss is chief historian of the National Park Service and the author of many important books on the Civil War, including *Decision in Mississippi*, *Forrest at Brice's Cross Roads*, and *Hardluck Ironclad*, about the sinking and salvage of the Civil War ironclad *Cairo*.

Dee Brown became an internationally known author with the publication of his bestselling history of the Indian, *Bury My Heart at Wounded Knee*. But, in fact, he had been a prolific writer of fiction and nonfiction for many years before, his works including Civil War studies such as *Grierson's Raid*, the story of the North's most dashing cavalry expedition of the war.

Frank L. Byrne is one of the few Civil War scholars ever to turn their attention to the prisons of the war. A professor of history at Kent State University, he has written numerous articles on the subject, and continues active research in the field while publishing books on such topics as prohibition and temperance history.

William C. Davis, who conceived and edited this work, was for many years editor and publisher of *Civil War Times Illustrated* and other historical magazines. Among his many works are *Breckinridge: Statesman, Soldier, Symbol*, *The Orphan Brigade*, *Battle at Bull run*, and *The Imperiled Union, 1861–1865*.

Norman C. Delaney has made the story of the Confederate commerce raiders the object of intense investigation for many years. A professor at Del Mar College of Corpus Christi, Texas, Delaney is the author of *John McIntosh Kell of the Raider Alabama*.

Charles R. Haberlein, Jr. is Photographic Curator and Historian at the Naval Historical Center in Washington, D. C., the nation's finest collection of naval illustrations. He has been of inestimable assistance with naval matters in the production of this work.

Herman Hattaway of the University of Missouri at Kansas City won the Jefferson Davis Award for the best book in Confederate History with his biography of General Stephen D. Lee.

Ludwell H. Johnson III has been for many years a professor of history at the College of William and Mary and a noted specialist in the Civil War. Among his works are *The Red River Campaign, Politics and Cotton in the Civil War* and *Division and Reunion: American 1848–1877*, a provocative and decidedly pro-Confederate history of the Civil War era which has challenged many long-accepted ideas about the conflict.

Robert K. Krick is a historian with the National Park Service, and the author of several books on the Confederate Army, including *Lee's Colonels, A Biographical Register of the Field Officers of the Army of Northern Virginia*, and *Parker's Virginia Battery*.

Harold D. Langley, curator and supervisor of the Division of Naval History of the Smithsonian Institution's National Museum of American History, has a considerable reputation as as student of the American Navy in the years prior to the Civil War. Among his works are *Social Reform in the U. S. Navy, 1798-1862* and an edition of the papers of Henry L. Stimson.

Louis Manarin, state archivist at the Virginia State Library in Richmond, has long been associated with research and writing on the Confederacy and the Civil War. Among his works are *Richmond Volunteers* and *The Bloody Sixth*, as well as *North Carolina Troops 1861–1864: A Roster*.

Maurice Melton is a specialist in Confederate Naval History, and the author of *Confederate Ironclads*. He serves on the board of advisors for the Confederate Naval Museum at Columbus, Georgia.

Frank J. Merli is a professor of history at Queens College. His book *Great Britain and the Confederate Navy 1861–1865* is one of the preeminent works of modern times on Civil War diplomacy and the much-neglected naval side of the conflict.

Richard M. McMurry is a historian specializing in the Civil War and the Confederacy. Among his books are *The Road Past Kennesaw: The Atlanta Campaign of 1864* and *John Bell Hood and the War for Southern Independence*.

Rowena Reed, professor of history at Dartmouth College, is the author of *Combined Operations in the Civil War*, a major reassessment of Army-Navy cooperation during the war and the opportunities won or lost because of it.

Everard H. Smith has long specialized in the story of the campaign for the Shenandoah Valley in 1864. A cum laude graduate from Yale, he took his Ph. D. at the University of North Carolina and is currently teaching history and political science at High Point College in North Carolina.

Richard J. Sommers, Archivist at the U. S. Army Military History Institute, is one of the foremost authorities on the military aspects of the Civil War. He has long been a contributor of articles to magazines and journals concerned with the period, and he is the author of the acclaimed *Richmond Redeemed: The Siege at Petersburg*, the winner of the first Bell I. Wiley Prize for distinguished research and writing in the field of the Civil War.

Emory M. Thomas is professor of history at the University of Georgia. Among his works on the Confederacy and Reconstruction

are *The Confederacy as a Revolutionary Experience, The Confederate Nation, The Confederate State of Richmond: A Biography of the Capital,* and *The American War and Peace, 1860–1877.*

Russell F. Weigley is one of America's most distinguished military historians. A profes-

sor at Temple University, he is the author of *Quartermaster General of the Union Army,* a biography of General Montgomery C. Meigs, *History of the United States Army,* and *Eisenhower's Lieutenants: The Campaign of France and Germany, 1944–1945,* among many other distinguished works.

Arabic boldface numbers denote photographs of the subject mentioned. Commonly known abbreviations are used for frequently repeated terms—e.g., HQ for headquarters, POWs for prisoners of war, RR for railroad.

A

Abbeville, S.C., Burt house, **1264**
Abercrombie, John J., **649,** 669
Acworth, Ga., 685
Adams, Charles Francis, Jr., **135**
Adams, John, 474, 529
Adams, LaRue P., **978**
Adams, W. Irving, 1319
Adams hand grenade, **937**
Adirondack Regiment, **934**
Adriatic and North Atlantic Squadron, 1302
Agawam, USS, **388**
Agriculture, North, 895
Agrippina, the, 136
Aiken's house (Meade HQ), 1070
Aiken's Landing, Va., **425,** 1060; bridge at, 1069, **1123–24;** POW exchanges at, 400, 425
Alabama, Confederate cavalry in, 313, 333; Federal invasion of, **456–57;** Federal occupation, 1213, 1217, **1227–28;** Union cavalry raids in, 1214. *See also* Mobile Bay, Battle of
Alabama, CSS, 135–36, 137, **139–42,** 143–45, 151, 157, 361, 389; in Cherbourg, 140, **146;** sinking of, 142–43, 149, 373
Alabama claims, 144, 1264, 1305
Albany, N.Y., **1250**
Albemarle, CSS, 373
Albuquerque, N.M., Territory, 830
Alcatraz Island, 834
Alden, James, 966, 979
Alexander, Edward Porter, 467, 468, 469, **521**
Alexander's Bridge (Chickamauga Creek), 458
Alexandria, La., **797,** 805; burning of, 794; Union capture of, 787, 791–92, 797–99; Union ships trapped at, 792–94, **806–12, 816**

Alexandria, Va., 752; Battery Rodgers in, **114;** convalescent camps, **265–66;** hospitals, 248, **260;** government lumber yard, **905;** Marshall House, **127,** 1252, **1285;** slave pens, **126;** Soldiers' Rest kitchen, **263;** wharves, **297, 924–25**
Alexandria *Sentinel,* 1167
Algeciras, Spain, 153
Allaire Works, 368
Allatoona, Ga., **697, 698**
Allatoona Pass, 684, 685, **697**
Allegheny City, Pa., penitentiary, 432
Allen, Henry W., **871, 1231**
Alsop house (at Spotsylvania), 654
Alton, Ill., State Prison, 398, 400
Alvord, Benjamin, **834**
Ambrotypes, 109
Ambulance corps bill (North), 243
Ambulances, 236; drill, **232;** Letterman Plan, 239, 241, 243; staff, **235;** stretchers, **233;** types of, 234; wagons, **232, 234, 960**
Ambulance shop, government, **899**
America, SS, **164**
American Red Cross, 267, 269
Ames, Adelbert, 1070, **1127**
Ammonoosuc, USS, **1302**
Ammunition, **976, 1177;** design, 947, **948, 955;** Union laboratory, **947**
Amnesty, postwar, 1300
Amputations, 237, **242, 244, 262;** fake demonstration, **241**
Anaconda Plan, 166, 899
Anacostia River, 303
Anderson, "Bloody Bill," 820, 821, 866; in death, **867**
Anderson, E. M., **141**
Anderson, Ephraim, 25–26
Anderson, Jim, **866**
Anderson, Joseph R., 1151
Anderson, Richard H., 617, **641,** 1068, 1069
Anderson, Robert, **1235, 1307**
Andersonville prison, 403–4, 406,

407, 409, 424, **434–40,** 708, 1249, 1289; cemetery, **449;** death rate, 436, 439; number of POWs at, 404, 434
Andrew, John A., 145
Andrews, George L., **71, 82**
Anesthetics, anesthesia, 238, **241–42**
Annapolis, Md., 400–1
Anthony, E. & H. T., 1080, 1084
Antietam, Battle of, 133, 239, 250, 307; memorials, 1252, **1284;** Northern participants in, 1284
Apache Indians, 831
Appalachians, 680
Appomattox, 1141; Grant–Lee meeting at, **1204–6, 1220–21;** McLean house, 1204, 1208, **1220–21;** RR station, **1217;** surrender at, 313, 679, 1072, 1200–1, 1203–6, 1208, 1210–12; surrendering number of rebels, 905–6; surrender terms, 1205–6, 1228, 1217, 1218, 1250
Appomattox River, 252, 892, 1060, 1064, 1066, **1084;** High Bridge crossing, 1214, **1215,** 1216
Aqueduct, Washington, **91**
Aqueduct Bridge (Potomac, at Georgetown), **280**
Aquia Creek, IX Corps embarking at, **47**
Aquila, USS, **837, 838**
Arago, the, **546, 584**
Arapahoe Indians, 830, 831
Archer, Fletcher, 1058
Archer, the, 145
Arctic Ocean, 148, 163
Ariel, SS, 138
Arizona, 826, 828, 830
Arizona Brigade (4th Texas Cavalry), **878**
Arkansas, 786–87, 818, 830–31, 853–62; cavalry raiders in, 312, 334, 351; volunteers in, **856**
Arkansas, CSS, 17
Arkansas River, **858, 861**
Arledge, George H., **575**
Arlington National Cemetery,

961, 1252, **1286**

Armory Square General Hospital (Washington, D.C.), **262–64**

Arms, 895–96, 906–9, **933–34, 937–59**; cavalry, 308, 324, 331, 908; firepower, smoothbore vs. rifle, 906–7; production, 907, 947, 1176–77. *See also* Artillery; Cannon; Carbines; Muskets; Rifles

Armstead & Taylor, 49, 57

Armstead & White, 131

Armstrong, Frank, **333**

Armstrong, Richard, **142**

Army of Georgia, in Grand Review, **1277**

Army of Northern Virginia, 678, 905, 1058, 1200; brigades dispatched to Tennessee, 458, 613; deserters and stragglers, 1062, 1200; last battle, 1201–2, 1219; at Petersburg, 1058, 1071–73, 1171–73, 1200; strength at time of surrender, 905–6, 1210; strength going into Wilderness defense, 617; surrender of, 1200–1, 1203–6, 1208, 1210–12, 1217, 1221, 1223; Wilderness defense, 613–27. *See also* I Corps (Northern Virginia); II Corps (Northern Virginia); III Corps (Northern Virginia)

Army of Tennessee (Confederate), 239, 700; in 1863–64 struggle for Tennessee, 455–81; opposes Sherman, 680, 691, 1031, 1035

Army of the Cumberland, 311, 481; in Atlanta Campaign, 680, 684, 692, 695, 711; in fight for Tennessee, 455, 456, 457, 461–62, 498; strength of, 680. *See also* IV Corps (Cumberland); XIV Corps; XX Corps; XXI Corps

Army of the James, 1058, 1070, 1071, 1093, 1210

Army of the Ohio, 467, 526, 680. *See also* XXIII Corps

Army of the Potomac, 904, 1030; adjutant of, **893**; black troops,

621, 1068, **1095**, 1119; cavalry units, 308, **309**, 313, **323**; Chief Quartermaster of, 894, **926**; commanded by Hooker, 308–9; commanded by McClellan, 302, 900, 901; commanded by Meade, 92, 613, 619, 904, 1058; Grand Review (1865), 1246, 1268, **1270–75**; HQ near Brandy Station (1864), **93, 617**; HQ near Culpeper (1863), **92–93**; HQ guard, **676**; HQ wagons, **104, 638**; James River crossings, 627, 1058, 1063, 1068, **1069, 1122–23**; medical care and facilities, 233, 239, **248**; Provost Marshal of, **95**; scouts and guides, **96–97**; several corps sent West, **47, 462**; in siege of Petersburg, 1058, 1063, 1067–72; strength going into Wilderness, 617; supply wagon train, **929**; surgeons of, **249**; in Wilderness Campaign, 613–27; Wilderness Campaign preparations, 613–15, **616–21**; Wilderness Campaign river crossings, **622–23, 627, 661–68**; Wilderness supply bases, 620, 622, 623, **646–50, 660, 668–69**; winter camps, **618, 621**. *See also* I Corps (Potomac); II Corps (Potomac); III Corps (Potomac); IV Corps (Potomac); V Corps (Potomac); VI Corps (Potomac); IX Corps (Potomac); XI Corps (Potomac); XII Corps (Potomac); XVIII Corps (Potomac); XIX Corps (Potomac)

Army of the Tennessee (Union), 462; in Atlanta Campaign, 680, 689, 692, 711; in Grand Review (1865), **1277**; under Howard, 689, 711; under McPherson, 680; strength of, 680

Army of the Valley, 1071

Army of Trans–Mississippi, 1218, 1230, **1231**. *See also* Trans–Mississippi Department

Arnold, Benedict, 1151

Arnold, Richard D., 1028

Arny, W. F. M., **1028**

Artillery: Confederate, surrender of, 1210–11, **1229**; smoothbore vs. rifled, 906–7, 909, **943**. *See also* Blakely guns; Cannon; Dahlgren smooth-bores; Mortar batteries; Parrott rifles; Rodman guns; Sand batteries; Water batteries; Whitworth rifle guns; Wiard guns; *and see specific artillery units*

Artists and correspondents, **117–21**

Ashley River, 166, 168

Atchafalaya River, 794

Atlanta, CSS (*later* USS), 415, 550, 551–2, **573**, 574, 576; converted from *Fingal*, 550

Atlanta, Ga., 167, 235, 681, **721–25, 733–42**, 1022, 1029; battle for, 689, 707, 708, 709, 726–27; battle defenses of, **713–20, 725–27, 736–38**; city hall, **733–34**; destruction scenes, **724–25, 732–33, 739–41**; fall of, 692, 726, 1024; forts, **735–38**; Peachtree Street fortifications, **726**; postwar occupation, **1295**; railroad depot, **723**; Trout House, **722**

Atlanta (blockade runner), 146. *See also Tallahassee*, CSS

Atlanta & West Point RR, 689, 692

Atlanta Campaign, 680–93, 731, 892, 963; Confederates in, **688, 693–95, 699–700, 702, 705–7, 709, 714, 718, 729–30**; at Ezra Church, 690, 714, 720; at Jonesboro, 692, 728, 729, 730, 731; at Kennesaw Mountain, 685–86, 701, 702, **703–4**, 705, 726; at New Hope Church, 684–85, **698–99**; at Peachtree Creek, 687–88, **707**, 708; at Resaca, 681–83, **689**, 690, **691**, 692, **693–94**; Union

participants, **685, 690, 701–3, 708–12, 720, 728, 731**
Atlantic Blockading Squadron, 166. *See also* East Gulf Blockading Squadron; North Atlantic Blockading Squadron; South Atlantic Blocking Squadron; West Gulf Blockading Squadron
Attrition, war of, 905–6, 909, 1059, 1171
Atzerodt, George, **1254–57**
Auburn, Va., 316; Castle Murray at, **314**
Augur, Christopher C., **65**
Augusta, Ga., 167, 521, 1028
Augusta, USS, 545
Australia, 148, 149, 163
Averasborough, N.C., 1035, 1053
Averell, William W., 309, **322**
Ayres, Romeyn B., 1016, 1070
Azores, 136
Azuma, HIJMS, **161**

B

Babcock, Orville E., **522**, 1203–4
Bache, Alexander Dallas, 539
Bache, F. M., **95**
Badeau, Adam, **657**, 1204, **1306**
Bahia, Brazil, 144
Bailey, F. B., 873
Bailey, Joseph, 793–94, **813**, 814, 816
Bailey's Cross Roads, Va., **130**
Bainbridge, Ala., 481
Baird, Absalom, **701**, 1034
Baker, James, 802
Baker, Laurence S., 1216, **1225**
Bakeries, Union army, **903**; in camp and field, 903
Balfour house (McPherson HQ), **41**
Ballard, Colin, 902
Balloon observation, 309; inflation gas generators, **913**
Baltimore, Md., 248, 398, 747, 1244; population, 1152
Baltimore & Ohio RR, at Harpers Ferry, **744–45**
Bands, military, **124, 186, 492, 563, 865, 1001, 1005, 1011–12;**

cavalry, **316**; in convalescent camp, **266**; parade, **90**; in POW camps, **422, 431**
Banks, Nathaniel P., **61**; demoted, 792, 817; in Port Hudson Campaign, 16, 22–23, 24, 27, 61–62, 81; in Red River Campaign, 786–94, 798–805, 817, 831; with his staff, **788**
Barlow, Francis, **634**, 645
Barnard, George N., 128, 284, 285, 293–96, 460, 498, 499, 500, 506, 515, 530, 535, 686–87, 694–98, 701, 707, 713–14, 717, 720–21, 724–26, 732, 741, 1024, 1040–41, 1047, 1057
Barnard, John G., 539, 679, **1102**
Barnard & Bostwick, 115
Barnard & Gibson, 96
Barnes, James, **431**
Barnes, Joseph K., 242, **251**
Barney, Joseph N., 144, **152**
Barnum, Henry A., **1043**
Barry, William F., **703, 735**
Bartlett, Joseph J., **1223**
Bartlett, William F., **70, 1117**
Barton, Clara, 246, **267**
Barton, Seth, **32, 1213**
Barton, W. B., **563**
Bate, William B., 478, 688
Baton Rouge, La., 16, 19, 350, 365, 812; arsenal, **61, 1229**; Augur and staff at, **65**; Federal cavalry camps, **317, 349**; Federal troops in, **799**; postwar electioneering, **1293**; surrendered Rebel artillery at, **1229**; 13th Connecticut cemetery at, **132**
Battery Beauregard, 169
Battery Brown, **599**
Battery Cheves, **176**
Battery Gregg, 169, 171
Battery Hays, **598–99**
Battery Kirby, **609**
Battery Marion, **177**
Battery Meade, **601**
Battery Rodgers, 114
Battery Rosecrans, **596–97**
Battery Sherman, **58**
Battery Strong, **598**
Battery Wagner. *See* Fort Wagner

Battle, Cullen, **778**
Battlefield memorials and museums, 1252–53, **1286, 1320–21**
Baxter's knapsack supporter, **935–36**
Baxter Springs, Kan., 823, **865**
Baylor, T. G., **735**
Bay Point, S.C., machine shop at, **566, 590**
Beacon House (Morris Island), **605**
Beall, W. N. R., 16, **66**
Beatty, Samuel, **526**
Beatty, "Tinker Dan," **340**
Beaufort, S.C., desalination condenser, **921**; Episcopal Church prison, **445**; Federal capture of, 542; government shops, **921–22**; hospitals, **254**
Beauregard, Pierre G. T., 220, 1031, **1064**, 1213; at Fort Sumter, 168–69, 171, 190; at Petersburg, 627, 1058, 1063–65, 1067, 1069; after war, 1263, **1297**
Beauvoir, Miss., Davis home, **1317–18**
Beckett (photographer), 1042–44
Beckwith, A., **735**
Becky Lee's Opening, Va., **1005**
Bee, Hamilton P., **805**, 875–76
Belfield, Va., 1070
Bell, Anne, **237**
Bell, John, 1153
Belle Grove mansion (Sheridan HQ), **782**
Belle Isle, 1187; POW camp, 397, 402, 409, 1159, **1161**, 1170
Belle Plain, Va., 620; POWs at, 398–99, **650**; Union supply base, **646–49**, 660; wharves, **647–49**
Bellows, Henry W., 232, **271**
Benavides, Cristobal, **879**
Benavides, Refugio, **839**
Ben DeCord, USS, **565**
Benét, Stephen Vincent, **942**
Benham, Henry W., 168, 170
Benjamin, Judah P., 1249, 1262
Bennett, James and Lucy, 1213

Bennett, James Gordon, 567
Bennett house (Sherman–Johnston meeting place), 1213–14, **1223**
Benton, USS, 18
Bentonville, Battle of, 313, 1035–36, 1038, 1053–55, 1117
Berdan, Hiram, **97, 1008**
Berdan's Sharpshooters, 97, **1008**
Bering Sea, 148, 163
Berlin, Md., bridge ruins, **91**
Bermuda, 541
Bermuda Hundred, Va., 1058, 1063, **1128;** signal tower at, **1113;** supply depot, 1060, **1062,** 1084
Bethesda Church, Va., 625, 671
Beverly Ford, Va., 309
Beverly house (at Spotsylvania), **652**
Beville, F., **414**
Bickerdyke, "Mother" Mary Ann, 246
Bidwell, Daniel D., **828**
Bierce, Ambrose, 479
Big Black River, 21, 22, **33**
Big Black River Station, Miss., **32**
Big Harpeth River, 473, 481
Bingham, John A., 1253
Bird's Point, Mo., 507
Birkenhead, England, 137, 161
Birney, David B., **634,** 645, 1069
Black, Henry M., **834**
Blackburn's Ford, Va., **127;** camp near, **111**
Black Codes, 1259
Black Hawk, USS, **791, 817, 861**
Blacks, free in Confederate navy, 362; in Northern army service, 23–24, **56,** 184, **608,** 621, **1006,** 1068, **1094, 1119;** in postwar South, 1259–60; POWs, 401, 409; recruitment, 362; of Richmond, 1151, 1152–53, **1176, 1192;** Southern orderlies and servants, **210,** 246, **1324;** in Union navy, 362, 365, **383, 385, 394, 545;** used in military construction, 1065, **1094;** voting right, 1259, 1293. *See also* "Contraband" blacks; Freedmen; Slavery and slaves

Blacksmiths, army, **1011**
Blacksmith shop, government, **900**
Blackwater Creek, 1064
Blair, Francis Preston, Jr., **46,** 1024, **1025**
Blair, Montgomery, home of, 761–62
Blakely guns, **58, 194, 227, 991**
Blakeslee cartridge box (the Quick–loader), 308
Blandford Church (near Petersburg, Va.), **283**
Blanket boat, **914**
Blockade, 143, 149, 166–67, 369–70, 373, 539, 541, 558, 583–92, 899, 972; of Charleston, 166, **377,** 972; effectiveness of, 560–61; failure in Texas, 831, 832; of Florida, 587; at Mobile, 569, 962, 963, 965, 966, 972; of Savannah, 541, 544, 546, 549, 559, 563, 564; Strategy Board, 166, 539–40, 545; of Wilmington, N.C. (Cape Fear River), 972. *See also* East Gulf Blockading Squadron; North Atlantic Blockading Squadron; South Atlantic Blockading Squadron; West Gulf Blockading Squadron
Blockade runners, 137, 146, 147, 155, 158, 541–44, 569, 583–85, 962; POWs, 412; profits of, 560–61; success rate of, 560; wrecks of, **586**
Blockhouses, for railroad and bridge protection, **355, 460**
Blood poisoning, 238
"Bloody Angle, The" (Battle of Spotsylvania), 620–21, 643
Blue Ridge Mountains, **99,** 329, 744, 749, 785
Blue Springs, Battle of, **514;** IV Corps drill at, **502**
Blum, G., **414**
Blunt, James G., 823, **857,** 865
Boat bridges, **917**
Boggs, William R., **870, 1231**
"Bohemian Brigade," 119
Bombproofs, **192, 602,** 971, 987, **989, 1037,** 1065, **1089, 1098,**

1105–6, 1125
Booth, John Wilkes, 582, 1239–40, **1242,** 1245, 1249, 1254
Borke, Heros von, **325**
Boston, Mass., 540. *See also* Fort Warren
Boston *Herald,* reporters of, **117**
Boston Navy Yard, **1302;** mothballed warships in, **1311**
Bounding Bet (fieldpiece), 24
Bowden, J. R., 210
Bowen, John S., **30**
Bowers, Theodore S., **615**
Bowling Green, Ky., Federals crossing Green River, **133**
Boydton Plank Road, 1065, 1070, 1072
Bradley, Luther P., **526**
Brady, Mathew B., 282, 636, 669, **1085, 1099,** 1128, **1164, 1198,** 1237, 1253, 1314; assistants of, 1069
Brady & Company, 105, 110, 253, 429, 647, 655, 1067, 1079
Bragg, Braxton, 20, 310, **464,** 484, 489, 508, 511, **1263;** at Chickamauga, 457–60, 462, 464–65, 521; commander of Army of Tennessee, 455; Kentucky Campaign of 1862, 306–7; at Missionary Ridge, 465–67, 498, 503–4
Brandon, D. F., 420
Brand's breechloaders, **938**
Brandy Station, Va., 107, 286; Army of the Potomac HQ at, **93, 617;** Army of the Potomac stationed near, 617–18, 621, **629, 929;** Battle at, 309–10, 325, 329; 1st Brigade Horse Artillery at, **315;** U.S. Sanitary Commission HQ at,
Brannan, John M., 459, **685**
Brattleboro, Vt., 998, 1001; soldiers' homecoming, **1021**
Brazil, 144, 153, 1262, 1303
Breckenridge, John C., defense of Virginia in 1864, 748, 750, 753, 761; family of, **1300;** as Secretary of War, 1212, 1214, 1249, 1264; after war, 1262, 1263, **1267, 1300;** Washington,

D.C., home of, **261;** in the West, 460

Breech–loading arms, 308, 908–9, **933, 938–39, 952–55, 1196**

Brest, France, 144, 151, 154, 155

Brice's Cross Roads, Battle of, 312, 335

Bridgeport, Ala., 457; Howe Turn, bridge at, **463**

Bridges: design, **906–10;** protection, **355, 460–61, 696.** *See also* Boat bridges; Pontoon bridges; Potomac River; "Shad–belly" bridges

Brigade hospitals, 238

Bristoe Station, Va., cavalry raid at, **340**

British observers, **96**

British Sanitary Commission, 232

Broadway Landing, Va., 1060, **1084**

Broadwell's breechloader, **954–55**

Brock Road, Va., 614, 617, 640

Brooke guns, **176–77, 945,** 982, **1092**

Brooklyn, USS, 964–68

Brooks, William T. H., **1007**

Brown, Charles S., 1031

Brown, John, 344, 857, 1238

Brown, John C., 474, 476, **526,** 528

Browne, William M., **1033**

Brownsville, Texas, 831, 832, **874–76**

Bryan, Goode, **675**

Buchanan, Franklin, 962, 965–66, 969–70, **983, 984**

Buchanan, Va., 744, 1212

Buckland Mills, Battle of, 311

Buckner, Simon Bolivar, 456, **869,** 1218

Bucktails: 149th Pennsylvania, **662**

Buena Ventura plantation, **1041**

Buford, John, 309, **326,** 909

Bulloch, James D., 135, 147–48, 159, 540–44

Bull Run, Blackburn's Ford, **127;** ruins of Stone Bridge, **128, 284**

Bull Run, First Battle of (1861),

44, 236, 333, 835, 869, 1158; Confederate cavalry at, 303; monument dedication (1865), 1252, **1286–87;** POWs, 396, **405**

Bull Run, Second Battle of (1862), 248, 835, 1252; field hospitals, **1252;** Lee's flanking maneuver, 907

Bull's Bay, S.C., 177

Bull's Gap, Tenn., 467

"Bummers," 1029, 1032, 1034

Bunnell, Dr., 273

Bunn's House, Nash County, N.C., 1217

Burial, field, **132, 652, 654–55, 694, 707, 1019–20, 1326;** exhumation for reinterment, 1252, **1285.** *See also* Cemeteries, military

Burnett, Henry L., 1253

Burnside, Ambrose E., 562, 621, 1068, **1115,** 1117, **1307;** in West, 467, 468, 470, **512,** 513, 514, 522

Burr, Aaron, 1151

Burt, Armisted, 1264

Burt house, Abbeville, S.C., **1264**

Bush Hill, N.C., Confederate surrender at, 1216

Butcher Town, Richmond, Va., **1159**

Butler, Benjamin F., 565, 786; James River HQ, **1097;** James River operations, 626, 627, 1058, 1062–63, 1069–70, 1087, 1093, 1097, **1128;** signal towers at, **1098;** use of Negro labor and troops, **1094**

Butler, Matthew C., **329**

Butterfield, Daniel, **86, 495**

Buzzard Roost, Ga., **687**

Byrd, William II, 1151

C

Cahaba, Ala., POW camp at, 406

Cahawba, USS, 589

Cairo, Ill., 18, 25

Calais, France, port of, 143, 150

Caleb Cushing, the, 145

California, 826, 828, 832; troops, 832, 834

California Column, 832

Calomel, banning of, 242

Camanche, USS, **839–43**

Camden, Ark., 804

Camden, S.C., 1031

Cameron, Simon, 233, 897

Camp Butler, POW camp at, 399

Camp Chase, POW camp at, 400

Camp Douglas, POW camp, 399–400, 406, **417–20;** death rate, 400

Camp Ford, 406, 441, 449

Camp Griffin, **999–1002, 1005;** burial rite, **1019**

Camp Holt, laundry, **933;** hospital, **258**

Camp Hunter, **306**

Camp Letterman, **250, 252,** 271; amputation at hospital, **242;** embalmings at, **246;** Sanitary Commission tent, **270**

Camp Morton (prison), 400, **421–24**

Camp Nelson, Soldiers' Home at, 270

Camp Parole, 400–1

Camp Quantico, **821**

Camp Randall, POW camp at, 399

Camps and camp life, **110–11, 186–87, 281, 594–96,** 998, **999–1005, 1009–15;** bakeries, 903; breaking camp, **1015;** cavalry, **311–19,** 784; drill and review, **306, 318, 493, 502, 564, 1001, 1013–15, 1120;** kitchens, **932, 1105;** laundry, **933;** mail, **932;** music and musicians, **186, 492, 563, 1001, 1011–12;** sanitation, **234;** shamming for the camera, **113–15;** sutlers, **168, 315, 492, 931;** tent interiors and amenities, **282;** in trench war, 1060, **1105–6, 1111;** winter quarters, **682, 1002–3, 1078, 1086, 1097, 1111;** women's presence, **187, 316**

Camps of instruction, Signal Corps, **911**

Camp Stoneman (Giesboro Point), cavalry depot at, 303,

304–5, 307
Camp Winder, hospital at, **255**
Canada, 398, 1264; exiles in, 1262, **1300;** Sweeney's invasion of, 692, 1301
Canandaigua, USS, **590**
Canby, E.R.S., 792, **823,** 828, **963,** 964, 995, 1213, 1217–18, **1228**
Cane River, 791
Cannon, 895, 906–8, 909, **942–45, 948–55, 958–59, 1013–14;** ammunition for, **946, 955–56;** breechloaders, **952–55, 1196;** captured at Richmond, **1194–96;** rifled vs. smoothbore, 906–8, 909, **943;** rotary sight for, **957;** testing of, **944, 949–51;** transport of, **914, 944–45, 958, 1114;** volley guns, **958–59.** *See also* Blakely guns; Dahlgren smoothbores; Mortar batteries; Parrott rifles; Rodman guns; Water batteries; Whitworth rifle guns; Wiard guns
Canonicus USS, **366**
Cantey, James, **708**
Canton, CSS, 143
Cape Fear River, 1028–29, 1034
Cape Horn, 837
Cape Town, South Africa, 142
Carbines, 308, 908–9, **937–39;** repeating, 908, **934, 940–41**
Carleton, James H., **832**
Carolinas Campaign, 330, 1027–36, 1039, 1045–57, 1071; at Averasborough, 1035, 1053; Bentonville battle, 1035–36, 1038, 1053–55; campaign plan of Sherman, 1028–29, 1034–35; fall of Columbia, and fire, 1031, **1047–52;** fall of Goldsboro, 1036; at Monroe's Crossroads, 1033; Northern participants, **1053–54;** Southern defenders, **1045–46, 1052, 1055–56;** total war waged, 1022, 1027, 1031
Carondelet, USS, 792
Carpenter's shop, government, **921**
Carpetbaggers, 1259, **1293**

Carr, Eugene A., **802**
Carroll, Samuel S., **635**
Carter, Fountain B., 472–73
Carter, John C., 476, 529
Carter farm (at Franklin, Tenn.) 473, 474, **525,** 526, **527**
Cartersville, Ga., Mark Cooper Iron Works at, **696**
Cartes de visite, 122
Cassier, Joseph, **977**
Cassville, Ga., 684
Castle Fort battery, **57–58**
Castle Murray (Auburn, Va.), **314**
Castle Pinckney (Charleston, S.C.), defenses, **196–97;** POWs at, 397, **405**
Castle Thunder (Richmond prison), 396–97, **400–1**
Casualty rates, 907–8; total number of casualties, 885
Catharpin Road, Va., 640
Cattle herds, army, **930**
Cavalry, 301–13, **314–60,** 361, **533;** in Battle at Brandy Station, 308–10, 325, 326, 329; camps, **306, 311–19, 784;** Confederate, **317,** 489; Confederate, in Carolinas, 1031, 1032, 1033–34, 1046; Confederate superiority, 301–2, 303, 310, 1067; Confederate, surrender and disbandment, 1210–11, 1212; depots, 303, **304–5, 307,** 320; "draw sabers" command, **302;** Federal, at Appomattox, 1200, 1202; Federal raids on Richmond, 311, 1170–71, **1179;** Federal units, 302, 303, 307–9, **311–20,** 1071; Federal units training, **306;** at First Bull Run, 303; fodder supplies, **309;** Jeb Stuart's "ride around McClellan," 304, 307; in Kelly's Ford battle, 309, 322; on parade, **303, 318;** in Red River Campaign, 802, 805; Sherman's army, 1024, 1028, 1033–34, 1054; in Valley Campaign (1864–65), 312, 750, 757, 758, 772, **774,** 775, 779, 1071; weapons, 308, **324,**

331, 908; in the West and Deep South, **306, 318,** 330–36, **349–56;** in Wilderness Campaign, 619, 640, **670,** 679. *See also* Raiders, cavalry; *and see specific cavalry units*
Cavender, William Washington, **1056**
Cedar Creek, Battle of, 312, 753, 776, **777,** 778–80, **781**
Cedar Level, Va., commissary depot, **928**
Cemeteries, military, **132, 775, 960, 1252, 1288;** at Alexandria, 1252, **1285;** at Andersonville prison, **449;** at Arlington, **961,** 376, **410;** near Baton Rouge, **132;** at City Point, **274;** at Elmira, 406; at Fredericksburg, **655;** at Gettysburg, 1252; at Vicksburg, 1252. *See also* Burial, field
Centreville, Va., Stevens house field hospital, **236**
Chaffin's, Va., 1062, 1066
Chaffin's Bluff, Va., 1063, 1069, 1124
Chalk Bluff, Ark., Confederate surrender at, 1217
Chalmers, James R., 478, 479
Chamberlain, Dr., **246**
Chamberlain, Joshua L., **1073,** 1212
Chambersburg, Pa., Confederate burning of, 749, 751, 763, **764–67**
Champion's Hill, Battle of, 21, 22, 32, 33, 59
Chancellorsville, Battle of, 613, 614, 1170; Lee's flanking maneuver at, 907
Charles City Court House, Va., 1058, **1068**
Charleston, S.C., 166, **189, 218–30,** 386, 1028; April 14, 1865, victory celebration, **1232–35;** Arsenal, **1232;** blockade of, 166, **377,** 976; Circular Church, **218;** Citadel, **189, 223;** City Hall, **228;** "Davids" beached at, **591;** fortifications

and defenses around, 166–68, 169, **174–83**, **185;** fortifications within city, 190, **191–97;** Hibernian Hall, **219;** Market House, **223;** Mills House Hotel, **220–21;** naval attacks of 1863 on, 168–70, 171–72, 198–200, **201, 203,** 553, 556; naval attack of 1864, 209; Northeastern RR Depot, **219;** POW camps, 397, **405,** 407, 409, **446;** Secession Hall, **218;** siege of, 166–77, 209–12, 553, 555–58, 593, 963; siege casualties, 168, 174, 959; siege damage, **193–95, 218–21;** surrender of, 177, 218, 1232; symbolic importance of, 552–53; Vanderhoff's Wharf, **230;** Vendue Range, **221;** waterfront defenses, **192–93, 195;** Yankee occupation, **226–29,** **1232–35.** *See also* Castle Pinckney; Fort Sumter; Fort Wagner

Charleston & Savannah RR, 176

Charleston Harbor, **1234;** defenses, 168–69; ironclads at, **203**

Charleston Hotel, 221

Charleston Light Artillery Palmetto Battery, **210**

Charles Town, W.Va., raid on Yankee outpost at, **344**

Charlotte, N.C., 1214

Charlotte Pike, 478

Charlottesville, Va., 311, 744

Chattahoochee River, 681, 684, 686, 687, 688, **705**

Chattanooga, SS, 462, **487**

Chattanooga, Tenn., 282, **291,** 456, 457, 459, **480,** 484, 512, 680, 681; Battle of, 240, 462–67 *(see also* Missionary Ridge, Battle of); Bragg's evacuation of, 456; "cracker line" to, 461, **484,** 491; engineers' camp at, **918;** Grant's HQ, **483;** Indian mound in, **490;** photographers and artists at, **119–24,** 291–93; railroads at, **511;** rolling mill at, 893; Sherman's

HQ, **483;** siege of, 483, 484, 490–92; Thomas's HQ at, **481;** Union gunboat patrols at, **489–90;** waterworks at, **919**

Chattanooga & Cleveland RR, **507**

Chattanooga Creek, 465

Chattanooga Valley, 462

Cheatham, Benjamin Franklin, 478, **524,** 525, 688

Cheatham's Hill, 686

Cheraw, S.C., 1031

Cherbourg, France, 140, 146

Cherokee Indians, 831

Chesapeake Bay, 401

Chesapeake General Hospital (Fort Monroe), **257**

Chesnut, Mary Boykin, 142, 1158, 1168

Chesterfield Bridge (North Anna River), 622, **664,** 667

Chevaux-de-frise, **212, 1100, 1102**

Cheyenne Indians, 830, 831

Chicago, Ill., 233; POW camps, **417–20;** World's Columbian Exposition, 403

Chicago Light Artillery, **507**

Chickahominy River, 304, 673

Chickamauga, Battle of, 310, 457–62, 469, 509; battle sites, **465–66, 474;** casualties, 462; Northern participants in, **462,** **469–70, 472–73, 475–79, 995;** Southern participants, **464,** **467–68, 471–73, 477, 521**

Chickamauga, CSS, 146, 147

Chickamauga, SS, **486**

Chickamauga Creek, 457–79, **465–66**

Chickamauga Room, Libby Prison, **404**

Chickasaw, USS, 965–66, 969–70, 980

Chickasaw Bayou, Miss., Battle of, 17, 21

Chickasaw Bluffs, Miss., 21

Chickasaw Indians, 831

Chicora, CSS, 172

Chief of Staff, position of, 904–5

Chillicothe, USS, 475

Chimborazo military hospital,

247, **273**

Chivington, John M., **830,** 831

Chloroform, use of, 238, **243**

Choctaw, USS, **28–29**

Church, Frank L., **390**

Churchill, Thomas J., 789, **801**

Cincinnati, Ohio, government wagon yard, **923;** Marine Hospital, **258;** tent manufactory, **924**

Cincinnati (Grant's horse), **614, 1150**

Citadel, The (Charleston, S.C.), **189, 223**

Citadel (Port Hudson), **76–78,** 81

Cities and towns, population figures, **1152;** of South, **1154–55.** *See also individual cities*

Citronelle, Ala., Confederate surrender at, 1217

City Belle, USS, 793

City Point, Va., 478, 1036, 1059, 1066, **1074–83, 1208;** Army of Potomac general hospital at, **248;** cemetery, **274;** fortifications, **1080;** Grant's HQ at, 1060, **1079–80;** sabotage explosion at, 1065, **1082–83;** Union supply center, 891–92, 893, **910, 927,** 1060, **1074–77,** 1084; wharves, **927, 1074–75, 1081**

City Point RR, 1060

Civil War Centennial, 409

Clarence, the, 145

Clarendon, Ark., 334

Clark, William T., **720**

Cleburne, Patrick R., 460, 465, 466, 474, 476, **529**

Clements, "Little Arch," **868**

Clendenin, D. R., **1253**

Cleveland, Ohio, homecoming and mustering out at, **1283–84**

Clingman, Thomas, **1121**

Clothing, soldiers', 924; U.S. Army Depot, **904.** *See also* Uniforms

Cloyd's Mountain, Va., 346, 749

Coaling yards, **925**

Cockrell, Francis M., **705**

Cody, William F., 823

Cogswell, William, **1053**

Cold Harbor, Va., 632, **1007;**
Battle of, 625–27, 671, 673,
674, 675, 679; Grant at, **615,**
679; Meade and staff at, **1067**

Cole, Dan, **96**

Collins, Napoleon, 144–45, **156**

Colorado, 826, 828; 1st Volun-
teers, 830, **833**

Colorado River, 828

Colquitt, Alfred H., **1065**

Colt, the, wreck of, **586**

Columbia, S.C., 1028, 1029,
1047–52; armory, Arsenal Hill,
1031, **1051;** Battle of, 1029–30;
fall of, and fire and destruc-
tion, 1031, **1047–52;** Hunts
Hotel, **1050;** POW camp at,
409; state house, **1047–48**

Columbia, Tenn., 472

Columbia Pike, at Franklin, 525

Columbus, Ohio, POW camp at,
400

Comanche Indians, 831

Commerce raiders, 134–49, **150–**
65; British indemnity to U.S.
for (1872), 144, 1264, 1305;
British–U.S. differences over,
135, 138, 162; hit-and-run
strategy of, 134; impressment,
146; raids on whaling, 134,
148–49, 163. *See also names of
cruisers*

Commissary stores and depots, at
Cedar Level, **928;** at Little
Rock, **859**

Commodore McDonough, USS, **603**

Conasauga River, 683

Conestoga, USS, **794,** 795

Confederate Congress, 134, 231,
243, 307, 361, 1161, 1169;
move to Richmond, 1156

Confederate Engineer Bureau,
190

Confederate Medical Depart-
ment, 231, 243, 272

Confederate Navy, free blacks in,
362; officers as POWs, 412,
413, 415; Rocketts Yard, **1169,**
1194; shipbuilding program,
134–37; warships bought in
Europe, 134–35, 143–44, 148–

49, 151, 159, 162, 539, 1264.
See also Blockade runners;
Commerce raiders; Naval
operations; Navy Department
(CSA)

Confederate Nitre and Mining
Bureau, 1176

Confederate States of America:
created, 1153; early high war
spirit, 1158; later demoraliza-
tion, 511, 1062; Richmond as
capital of, 1156–59, 1166–67,
1168–70

Confederate States War Depart-
ment, 1162

Confederate Treasury, **1181,**
1184, 1216

Congaree River, 1030, **1050**

Connecticut regiments: 13th,
Baton Rouge cemetery of,
132; 23rd, **449**

Connor, Patrick E., **832**

Conrad, the, 146

Conspirators, Lincoln assassina-
tion, 1249, 1258; executions,
1249, **1254–57;** trial commis-
sion, **1253,** 1254. *See also*
Booth, John Wilkes

Construction Corps. *See* U.S.
Military Railroad Construc-
tion Corps

"Contraband" blacks, flocking to
Union army, **1006**

Convalescent camps, **265–66**

Cook, George S., 201, 202, 203

Cook, Philip, **672, 1131**

Cooke, Philip St. George, 304

Cooley, Samuel A., 187, 198, 207,
584, 921, 1035

Coonskin Tower (at Vicksburg),
49

Cooper, James H., 1085

Cooper, Samuel, 760

Cooper Iron Works (Cartersville,
Ga.), **696**

Cooper River, 166

Cooper Union (New York City),
266

Corcoran Legion (164th New
York), **1086**

Cordes, Henry, **731**

Corinth, Miss., 13

Corps hospitals, 238, 241

Corse, John M., **720**

Corse, Montgomery D., **1213**

Cosby, George B., **52**

Cosmopolitan Company, 367

Cotton, confiscations, 66, 891,
1026; Red River Campaign
booty, 786, 787, 790, 793

Courts–martial, 242–43

Covington, Ga., 1024

Covington, USS, 793, **815**

Cox, Jacob D., 472–73, 474, **695,**
696

Cox's Landing, Va., POW
exchange at, **425**

Crane, Charles H., 251

Crater, Battle of the, 1068, **1116,**
1117, **1118,** 1119–20; mu-
seum, 1252, **1321**

Craven, John J., **243**

Craven, T.A.M., 966

Crawford, Uriah, **699**

Creek Indians, 831

Crews, Charles C., **331**

Cricket, USS, 792

Crimean War, 232, 245, 896, 898

Crittenden, R. D., **414**

Crittenden, Thomas L., 457, 458,
461, **473**

Crocker, Marcellus, **42**

Crook, George, **336, 345,** 743–44,
749, 755

"Crowd poisoning," 245

Crow's Nest signal tower, **1098,**
1112, 1113

Crow Valley, 681

Cuba, 160; Southern exiles in,
1262, **1267**

Culpeper, Va., 309; Army of the
Potomac at (1864), 613, **616,**
620; Meade HQ at, **92–93**

Culpeper Mine Road, 615

Cumberland, Md., 345

Cumberland, USS, 965, 983

Cumberland Coal & Iron Co.
yard, **925**

Cumberland Gap, Tenn., **459;**
Federal capture of, 459, 467

Cumberland River, 312, 478

Cumberland Sound, 546

Cummings, A. Boyd, 64

Cummings' farm (near Peters–

burg), 1060

Cummings Point, S.C., 166, 170, 172, 176

Curtis, Edward, **251**

Curtis, Samuel, 818, **854**, 855

Cushman, Pauline, **1307**

Custer, George Armstrong, 309, 311, 313, **323, 336, 339**, 782, **784, 1219**; at Appomattox, 1200, 1202, 1219; in the Shenandoah, 312, 336, 755, 784

D

Dahlgren, John A., 170, 171–72, 175, 176, **198**, 200, 201, 203, 348, 552, 555–56, **576**, 577, 580, 582, 587, 1179

Dahlgren, Ulric, 311, 348, 1170–71, **1179**

"Dahlgren papers," 1171, 1179

Dahlgren smoothbores, **139, 571, 577, 579, 943, 978**, 1179

Dai Ching, USS, **581**

Dakota Territory, 825, 848, 850–51

Dallas, Ga., 684

Dalton, Ga., 467, 680, 681, 685

Dame, George W., **433**

Dana, Charles A, **657**

Dandelion, USS, **1026**

Danville, Va., 1242; prison, 402, 409, **432–33**

Darbytown Road, 1069–70

Dauphin Island, 962, 964

David, CSS, 373

"Davids" (submersible torpedo boats), 134, **590–92**

Davidson, John W., **1008**

Davies, Henry E., **327**

Davies, Thomas, **785**

Davis, Charles H., 539, **1248**

Davis, Henry Winter, 555

Davis, Jefferson, 20, 231, 396, 1158, 1160, 1167, 1172, **1261**; assassination plot against (Dahlgren), 1170, 1179; and bread riot, 1163–64; cabinet members of, 157, 1249, 1260–62; capture of, 336, 1217, 1249, 1265, **1266**; death of,

1267, **1318**; on flight from Richmond, 1173, 1212–13, 1214, 1215–16, 1247, 1249, 1263, 1264; and Hood's Tennessee Campaign, 470, 481; imprisonment of, 243, 1258, 1266, 1292; indictment for treason, 1255, 1258, 1292; Johnston and, 681, 688–89; Lee's reports to, 1173; martial law declaration of (1862), 1168; plantation home of, **129;** and surrender, 1210, 1212–13, 1214; after the war, 1267, 1292, **1317,** 1318; mentioned, 158, 467, 787, 1229

Davis, Jefferson C., **685, 728,** 1024, **1026, 1278**

Davis, Josiah S., 423

Davis, Theodore R., **118–20**

Davis, Varina, 1167

Dayton, L. M., **735**

Dayton, Ohio, veterans' home, **1308**

Dearing, James, 1058, **1214**

Deas, Zachariah C., **729, 1046**

Decatur, Ala., 471

Decatur, Ga., 689

Deep Bottom, Va., 1060, 1062–63, 1068, 1069, **1086;** pontoon bridge at, **281**

Deer Creek expedition (Vicksburg Campaign), 18

Deerhound, the, 142

Delaware, SS, **380**

De Leon, David, 231

Democratic party, Northern, postwar, 1263

"Demoralizer" (columbiad), 24

Dent, Frederick, **657**

Department of Alabama, Mississippi, and East Louisiana, surrender, 1217

Department of Missouri, 868

Department of Texas, 872

Department of the Gulf, 786, 792

Department of the Pacific, 822, 826, 835

Department of the South, 170, 243; Hilton Head HQ, **167**

Desalination condenser (Beau-

fort, S.C.), **921**

Desertion, deserters, 1265; South, 1038, 1062, 1200

Detroit, Mich., 844

Devall's Bluff, Ark., **861**

"Dictator" (railroad battery), 1066, **1114–15**

Dimon, Charles A. R., **851**

Disease, 24, 234–35, 248–49; in POW camps, 402, 406, 423, 424, 437; on shipboard, 375

Disinfectants, 238, 242

District of Arkansas, 881

District of Dakota, 851

District of the Frontier, 823

Ditcher, Benjamin, **608**

Division hospitals, 238, 241

Dix, Dorothea, 245–46, **247**

Dix, John A., **268**

Dobbin, Archibald S., **883**

Dodge, Grenville M., **1306**

Dodge's cartridge filler, **948**

Doles, George P., 626, **671,** 672

Douglas, Henry Kyd, 409

Douglas, Stephen A. ("Little Giant"), Washington, D.C., home of (Douglas Hospital), **261**

Dowling, J. L., 279

Dowling, Richard, **873**

Drayton, Percival, 169, **199, 968, 977**

Dredge, canal, **1096**

Drewry's Bluff, Va., 1062, 1063, **1087–88;** 1862 naval battle, 1169–70; 1864 battle, 1058. *See also* Fort Darling

Drill and review, **458, 493, 502, 564, 1001, 1013, 1120;** ambulance drill, **232;** artillery, **1014–15;** cavalry, **302–3, 306, 318;** gun, shipboard, 368, **369–72**

Drummer boys, **677, 1325**

Duck River, 455, 472

Dudley, Thomas H., 135

Duffie, Alfred, 309

Duke, Basil W., 308, **353**

Dunn's Hill, Va., 1066

Du Pont, Henry A., **754**

Du Pont, Samuel Francis I., 167, 168, 169–70, 539, 540–41, **543,**

545, 546, 548, 549, 552, 553, 555, 556, 577, 580; flagship of, **543–44**

Durham, N.C., 1022, 1213, 1223

Duryea, Richard, 73

Dustin, Daniel, **1053**

Dutch Gap, Va., 1063; batteries at, **1092, 1098;** Canal, 1063, **1093–96,** 1112

Dyer, Alexander B., **1287**

Dysentery and diarrhea, 234–35; in POW camps, 402, 424, 437

E

Early, Jubal A., 627, 746–49, **757,** 763, 767, 768, 775, 781, 783, 785; at Cedar Creek, 312, 753, 776–81; raid on Washington (1864), 747–49, 758–59, **760–62;** after war, 1263; at Winchester, 771, 772, 773, 774

East Gulf Blockading Squadron, 540

Eastman Dry Plate and Film Co., 14

East Point, Ga., 689, 692

Eastport, USS, 787, 792, **796**

East Tennessee & Virginia RR, **515**

Eatonton, Ga., 1024

Economy: North, 895–96, 1264; South, 1151–52, 1161–62; Southern postwar, 1253, 1259

Edge Hill, Va., 1066

Edisto River, 168, 1046

Edith, the, 146

Edward, the, **566**

Edwards, O. D., 867

Edwards Station, Miss., 22

8th Kentucky, 465

8th Kentucky Cavalry, 33

8th Michigan, 677

8th New York Heavy Artillery, 678

8th Ohio National Guard Light Artillery, **416**

8th Pennsylvania Cavalry, 324

8th Texas Cavalry, 339

8th Wisconsin, **40**

XVIII Corps (Potomac), 626, 675, 1058

18th New York Artillery, **75**

18th U.S. Infantry, 731

82nd Illinois, **1029**

Ekin, James, **1253**

Elections: of 1860, 1153; of 1864, 1062; of 1876, 1263; in postwar South, 1259, **1293**

XI Corps (Potomac): sent West, commanded by Hooker, 462

11th Rhode Island, **108**

El Ferrol, Spain, harbor of, **159**

Elk, USS, **964**

Elk Horn Tavern, Battle of, 818

Elkin's Ferry, La., 790

Elliott, Stephen, 172–73, **1117**

Elliott, Washington L, **526**

Elliott plantation (Hilton Head), **283**

Elliot's Salient, 1068, 1117

Ellis County, Texas, recruits, **878**

Ellsworth, E. Elmer, 127

Ellsworth, George, 306

Elmira, N.Y.: Hoffman Street POW camp, 406, 407, **444;** National Cemetery, 406

El Paso, Texas, 828

Ely's Ford, Va., 613

Embalming establishments, **246, 273**

Emma, the, 584, 585

Empire, Colo., **833**

Enfield rifles, 308

Engineers' units, 1065; camps, **917, 918, 1097;** Confederate, 190, 1065; Federal, **915–16,** 918, 1065. *See also* 1st Michigan Engineers; 15th New York Engineers; 50th New York Engineers; U.S. Army Corps of Engineers

Engle & Furlong, 438

English Channel, 138

Enlistment, of volunteers, **275;** of sailors, 361–62; in the West, **833, 878.** *See also* Recruiting

Entertainment, for soldiers, **266.** *See also* Camps and camp life, leisure activities; Sailor's life, leisure activities

Erysipelas patients, 238

Estill Springs, Tenn., **295**

Etowah River and Bridge, 684, 696

Evans & Cogswell Co., 1031, **1052**

Ewell, Richard S., 1069; in Wilderness defense, 613, 615, 621, 623

Ewing, C., 735

Ewing, Thomas, 823, 866

Executions: of Lincoln assassins, 1249, **1254–58;** military, 1038; in Missouri, 821; of spies, **131;** for war crimes, 1249, **1289–91**

Exile, Southerners in, 871, 882, 1218, 1260, 1262, **1267, 1298–1300**

Ezra Church, Battle of, 690, 714, 720

F

Factories, North, **924–25, 947;** South, 1151, **1175, 1177–78, 1185**

Fagan, James F., **882,** 883

Fairburn, Ga., 692

Fairfax Court House, Va., **106**

Fair Oaks: 1862 Battle of, 238 *(see also* Seven Pines, Battle of); 1864 Battle of, 1070

Falls Church, Va., **125;** soldiers' marks of passing (graffiti), **116**

Farragut, David Glasgow, **24,** 138, 962, **963–64, 968, 1308;** conquest of the Mississippi, 24, 60; flagship of, **60,** 964, **967–68,** 970, **971–72;** flotilla of, 964–65, **969, 1310;** at Mobile Bay, 964–70, **977,** 978–985, **995**

Fawn, USS, **861**

Fayetteville, N.C., 1028, 1031, 1033–34

Fenians, 692, **1301**

Fenton, Roger, 886

Fernandina, Fla., 545, 546, 587

Ferrero, Edward, 1068, **1119**

Field, Charles W., **641,** 1069

Field hospitals. *See* Hospitals, field

V Corps (Potomac), 613; under Griffin, 1211; under Warren, 618, 620–21, **622, 638, 643,**

661, 663, 1069, 1070

5th Ohio Cavalry, **332, 357**

5th U.S. Artillery, 735

XV Corps (Sherman's army), **683,** 1024, 1027, 1028, 1029, 1032

15th New York Engineers, 1065; winter quarters, **1097**

15th South Carolina, 522

50th New York Engineers, **103, 663,** 1065; camp, **917**

50th Pennsylvania, **1319**

52nd Massachusetts, graves at Baton Rouge, **62**

54th Massachusetts, 170, 184

54th Virginia, 699

55th Massachusetts Volunteers, 608

56th Massachusetts, **633**

56th Ohio, 793

57th Massachusetts, **633**

Finegan, Joseph, **678**

Fingal, the, 135, 541–44, 549, **550.** *See also Atlanta,* CSS

Finley, Clement A., 232–33, 240, 241

Fire Brigade, U.S., building and equipment of, **262**

1st Brigade Horse Artillery, **315**

1st Colorado Volunteers, 830, **833**

1st Confederate Engineers, 1065

I Corps (Northern Virginia): under Anderson, 617; under Longstreet, 613, 617, 637

1st Georgia, 528

1st Georgia Cavalry, **1056**

1st Illinois Artillery, **507**

1st Indiana Heavy Artillery, 74; at Port Hudson, **74**

1st Louisiana Artillery, 872

First Manassas. *See* Bull Run, First Battle of (1861)

1st Michigan Engineers, camp of, **918**

1st New Jersey, 779

1st New York Engineers, 1065

1st Pennsylvania Light Artillery, **1085**

1st South Carolina Artillery, 172

1st Texas, **821**

1st U.S. Artillery, **187, 605–7;**

batteries at Port Hudson, **73, 80**

1st U.S. Cavalry, **338**

1st U.S. Volunteers, 851

1st Vermont, camp of, **565**

1st Virginia Cavalry, 303

Fisher's Hill, Battle of, 752, 774, **775, 776**

Five Forks, Battle of, 337, 338, 635, 702, 736–37, **766,** 776, 782

Flag, USS, 545

Fleetwood, cavalry battle at, 310

Floating mines. *See* Torpedo mines

Florence, S.C., POW camp at, 409

Florida, Union blockade of, 587

Florida, CSS, 135, 143, 144, 145, **151,** 153, **155,** 156, 157, 361; officers of, **152, 154**

Florida, USS, 587

Floyd, Richard S., **154**

Folly Island, S.C., 166, 170; Union foothold, **173, 596, 608–9**

Food of armies, 896, 922, **928,** 929–30; hospital kitchens, 246, **263;** impressment, 1161–62; mealtime on the march, **108–9;** nutritional imbalances, 235; on ships, 368, 369, 376; shortages, in South, 235, 1161–65. *See also* Foraging

Foote, Andrew H., 555, **577**

Foraging, 235, 1026, 1029, 1032

Ford, Lieutenant, **318**

Ford, John, 831

Ford, John T., 1240

Ford's Mill (Wolf Run Shoals), **1017**

Ford's Theatre, Washington, D.C., 1239, **1240–41,** 1244

Foreign Enlistment Act (Great Britain), 135–36, 143, 144, 148

Forrest, Nathan Bedford ("Old Bedford"), 301, 305–6, 310, 313, **335,** 336, 895, **925;** in Brice's Cross Roads battle, 312, 335; expedition through Tennessee and Kentucky (1864), 311–12, 471, 472, 478;

after war, 1263, **1296**

Forsyth, James W., **336**

Fort Berthold, 852

Fort Brady, battery emplacements near, 1063, **1091**

Fort Burnham *(formerly Harrison)*, 1062, 1063, 1069, **1125,** 1126

Fort Byington, 516

Fort Carroll, **298–99, 310**

Fort Clinch, 546

Fort Columbus, POW camp at, 398

Fort Conahey, **1111**

Fort Craig, **826,** 828, 830

Fort Curtis, **855**

"Fort Damnation," **1147.** *See also* Fort Mahone

Fort Darling, **1088–90.** *See also* Drewry's Bluff

Fort Delaware, POW camp at, 398, 401, 407–9, **411,** 424

Fort De Russy, 787

Fort Donelson, 577, 902; fall of, 305–6; POWs at, **399**

Fort Fisher, 147

Fort Gaines, 962, 964, 971

Fort Gilmer, **1125**

Fort Harrison *(later Burnham)*, 1062, 1063, 1069, **1125,** 1126

"Fort Hell," **1101, 1135.** *See also* Fort Sedgwick

Fort Henry, 577, 902

Fort Hill (at Knoxville), **516**

Fort Hill (on Lake Erie), **415**

Fort Hill (near Vicksburg), **36–37,** 56; Federals' capture of, **50**

Fort Hindman, USS, 792, **808**

Fort Huntington Smith, **516**

Fort Johnson, 168, 176, **208–9;** Union flag over, **229**

Fort Lafayette, POW camp at, 398

Fort Lamar, 168

Fort Leavenworth, **862**

Fort Lincoln, **1008**

Fort McAllister, 891, 1025, **1034–39**

Fort McGilvery, 1132

Fort McHenry, POW camp at, 398

Fort Mahone, **1104, 1144, 1146–48**

Fort Marcy, **827**

Fort Marshall, **181**

Fort Monroe, 143, 947; armament testing grounds, **944, 949–51**; Chesapeake General Hospital at, **257**; Davis imprisoned in, 1258

Fort Morgan, 962, 964–66, 968–**69**, 971, **974–76**, 977–79, **984–94**; "bombproofs," 971, 987, **989**; guns and parapets, **986, 991–92**; parade grounds, **989**; sally port, **988**; siege and surrender of, 971, 985, 995; water batteries at, **971–73**

Fort Moultrie, 166, 169, 170, **174–82, 230**, 553; guns, **175–79**; sally ports, **180**; Yankee ironclads firing at, **203**. *See also* Sullivan's Island

Fort Negley, **537–38**

Fort No. 7 (Atlanta), **735, 736**

Fort No. 8 (Atlanta), **736**

Fort No. 10 (Atlanta), **737**

Fort No. 12 (Atlanta), **737**

Fort No. 19 (Atlanta), **738**

Fort Pemberton, 18, **210**

Fort Pillow, 334; Confederate capture of, 311–12

Fort Point, **835–36**

Fort Powell, 962, 964, 971

Fort Pulaski, 170, 182, 542, 545–46, 547, 548–49, 551, 553; bombardment damage, **554–58**; Federally occupied and rebuilt, **559–64**

Fort Rice, **850**, 851, **1100**

Fort Ridgely, 825

Fort Ripley, **846**

Fort Sanders (at Knoxville), 468, 469, **518–520**, 521, **522**

Fort Sanders (Wyoming), **1306**

Fort Schuyler Hospital, 259

Fort Sedgwick, **1100–1**, 1104, **1105, 1135–37, 1201**

Fort Snelling, 825, **845–46**, 847; Sioux prison camp, **849–50**

Fort Stanley, 516–**17**, 518

Fort Stedman, 1071, **1130–32**

Fort Stevens, 743, **759**, 760, 761

Fort Sumter, 44, 169, 183, **201–4, 208**, 218, 396, 1156; Anderson's flag and flagpole, **1235**; in April 1865, **212, 230, 285, 1235**; 1861 fall, 1235; in 1861, following surrender, 166; 1863 landing attempt, 171–72, 205; 1865 naval attack, 169, 171–72, 582; 1863–65 siege and bombardment of, 169, 171, 174–75, 176–77, **201–4**, 205, **206–7, 212–17**, 558, **596–97, 600–1, 605, 609**; 1865 fall of, 1232; first shots, 1238; gun parapets, **217**; officers' quarters, **202, 216**; parade grounds, **204, 216**; shelling of, from Morris Island, **188**, 205, **206–7**, 600, **601**; shot furnace at, **202**

Fort Taylor, **966**

Fort Union, **824**, 830

Fort Wagner, 169, **183, 602**; bombardment and siege of, 170–71, 183–88, 198, 599, **600**, 605, 610; Confederate abandonment, 171, 185; model of, **185**; Union occupation of, **205, 602**

Fort Warren, 145–46; prison at, 398, 401, **412–15**, 574

Fort Wayne, **844**

Fort Yuma, 828

Foster, John G., 175–76

Foster, Robert S., **1253**

Foulke, A., sutler store of, **315**

IV Corps (Cumberland), 478, **502**; under Stanley, 526, 1228

4th Georgia, **672**

4th Illinois Cavalry, **306**

4th Michigan, band, **885**

4th Minnesota, band of, **492**

4th Texas Cavalry (Arizona Brigade), **878**

4th Vermont, **1001, 1009–11, 1013, 1021**

Fourteen–Mile Creek, skirmish at, **21**

Fourteenth Amendment, 1259

XIV Corps (Cumberland), 456, 457, 508; in Sherman's army, 701, 1024–26, 1035, **1278**

14th Ohio Artillery, 957

40th Massachusetts, drill, **1120**

40th New York, **1301**

43rd Virginia Cavalry, **341**

44th Indiana, **476**

45th Illinois, **45**

47th Illinois, **129, 799**

47th Pennsylvania, 121

48th New York, **563–64**

48th Pennsylvania, 1115

Foux, Egbert G., 375, 1074, 1098; gallery at City Point, **1074**

Fox, Gustavus Vasa, 168, 539, 553

France, 150, 894; Confederate warships built in, 151, 159; neutrality, 135; recognition of CSA, 135

Franklin, Benjamin, 539

Franklin, Tenn., 481, **523**; Battle of, 472–76, 477, 523, 524, **525**, 526, **527**, 528–30, 533

Franklin, William B., 789–90

Franklin County court house, **766**

Franklin Pike, 481

Frederick, Md., 748; Federal parade on North Market Street, 89–90; invading Confederates in, **133**

Fredericks, Charles D., 963, 1267

Fredericksburg, Battle of, 48, 309

Fredericksburg, Va., 620, 651; Augustine Washington marker at, **125**; 1876 scene, **1319**; interment of dead, **655**; Marye House, 651. *See also* Fredericksburg, Battle of

Freedmen, 1259; hospitals for, 255; number of, 885; on plantations, **283**; voting rights, 1259, 1293

Frémont, John C., 539

French, William H. ("Old Blinkey"), 620

French & Company, 38, 42, 43, 44

French observers and volunteers, **96, 320**

Frying Pan Shoals Lightship, 572

Fuels, **924–25**

Fulton, the, cooks, stewards, purser, **376**; engine, **368**

Funchal, Madeira, harbor of, **155**

G

Gabions, **930**, 1100, **1101, 1103, 1145**
Gaines, CSS, 963, 965, 967–68
Gaines House, slave family at, **1018**
Gaines's Mill, Battle of, 626
Galbraith, Thomas, 824
Galena, Ill., Grant homecoming celebration, **1283**
Galena, USS, 965, 968
Gallatin Pike, skirmish at, 306
Gallego Flour Mills, Richmond, Va., **1185**
Gallery Point Lookout, **291**
Galveston, Texas, 140
Gamble, William, 1252
Gardner, Alexander, 47, 113, 117, 1154, 1167, 1182, 1270, 1279–81, 1290
Gardner, Franklin, l6, 22, 23, 24, 27, **70**, 71, 72, 76, 80
Gardner, James, 92, 621, 1063, 1068
Garfield, James A., **469**, 1006
Garrott, Isham W., **47**
Gas generators, for balloon inflation, **913**
Gault, B. H., **324**
Geary, John White, 463, **495**, 1027, **1042**, 1043
Geddes, Andrew, **122**
General Grant, USS, **490**
General Hospital of Philadelphia, **259**
General–in–Chief, position of, 899–902, 904–5; held by Grant; held by Halleck; held by McClellan, 900–1; held by Scott, 899
General Price, USS (*formerly* CSS), 81, **794–95**
General Staff, US, 898
Geneva, Switzerland, 144, 272
Georgetown, D.C., 248; aqueduct, **280**; Signal Corps training camp, **911**
Georgia, cavalry raids in, 317, 1214; Sherman's march through, 177, 235, 313, 407, 681–92, 891, 1022–26, 1036 (*see also* Atlanta Campaign; March to the Sea); total war, 1022
Georgia, CSS, 138, 143
Georgia Central RR, **732**, 738, 1025
Georgia RR, 688, 689
Georgia regiments: 1st, 528; 1st Cavalry, **1056**; 4th, **672**
Germanna Ford, Va., 615, 622
Germanna Plank Road, 615, **632**
Getty, George Washington, 614
Gettysburg, Battle of, 311, 908, 909; casualties, 907; cavalry engagements, 308–10, 325, 326, 329; Pickett's Charge, 616; POWs, **397**
Gettysburg, Pa., Camp Letterman Hospital at, **242, 246, 250, 252, 270,** 271; monuments at, 1252, **1319–20**; Soldiers National Cemetery at, 1252; Soldiers' Orphans Home, **1320**; veterans' reunions at, 1272, **1320**; Waud on battlefield, **119**. *See also* Gettysburg, Battle of
Gibbon, John, **634**, 635, 1208, **1306**
Gibraltar, 138
Gibraltar, the, **137**. *See also Sumter*, CSS
Gibson, James F., 284
Gibson, Randall L., **694**
Giesboro Point (near Washington, D.C.), 298, 930; Camp Stoneman cavalry depot at, 303, **304–5, 307**
Gihon, J. L., 411
Gillem, Alvan C., **356**
Gillmore, Quincy A., 170–71, 172, 174, 175, **182**, 183, 185, 188, 190, 193, 206, 212, **553,** 554, 558, 593, **595,** 596, 598, 600, 602, 604–5, 610–11
Gilmer, Jeremy F., **190, 1312**
Gilmor, Harry, **343**
Gist, States Rights, 476, 528, 529
Gist, William M., **522**
Globe Tavern, Va., 1059, 1060, 1064, 1069, **1073, 1121**
Glorieta Pass, Battle of, **829**, 830
Goffee, James, **392**
Golding's Farm, Va., 1014
Goldsboro, N.C., 1028, 1034–36
Goldsborough, John R., **587**
Gordon, Ga., 1024–25
Gordon, George W., 476
Gordon, James B., **327**, 620, **652**
Gordon, John B., 615, **636, 776,** 777, 778, 1071–72, **1130**; at Appomattox, 1200–3, 1205, 1211–12
Gorgas, Josiah, 1161
Govan, Daniel C., 480, **730**
Government repair and supply shops, **895–905, 921–24, 931**
Governor's Island, N.Y., prison, **411**
Gracie, Archibald, **1129**
Gracie's Salient, **1107–8**
Graffiti, soldiers', **116**
Granbury, Hiram C., 529
Grand Army of the Republic, 1266
Grand Ecore, La., 787, 789, 791, 805
Grand Gulf, Miss.: Confederate evacuation, 19; Grant's crossing at, 28

H

Hammond, William A., 240–41, 245, **247,** 248, 251, **258;** court–martialed, 242–43
Hampton, Wade, 309, 313, **329,** 627, 930, 1031, 1033–34, 1070, 1213, 1215, **1297**
Hampton Roads, Va., 545, 589, 944, 1060
Hampton Roads Peace Conference, 1206
Hancock, Winfield Scott, **1006–7,** 1068–69, 1070–71, 1212; in Wilderness Campaign, 616, 619, 634, 664, 665
Hand grenade, Adams, **937**
Handy, Levin, 13
Hangings, 1249, **1254–58, 1289–91**
Hanover Junction, Va., 622

Hanovertown, Va., 623, 668
Hardee, William J., 467, **508, 729;** in Atlanta Campaign, 680, 683, 688, 689, 692, 729; in Carolinas Campaign, 1034–35; at Savannah, 1025–26
Hardeman, William P., **879, 1299**
Harding, William, **357**
Harding Pike, 478
Hardtack, 279
Hard Times, La., 19
Harewood Hospital (Washington, D.C.), 248, **260;** mess room, **264**
Harney, William S., **1306**
Harper House (Slocum HQ), **1054**
Harpers Ferry, Va., 282, **290,** 743, **744–45;** John Brown's raid at, 1238; U.S. Arsenal ruins at, **744**
Harper's Weekly, 24, 118
Harris, D. B., 170, **190**
Harris, Nathaniel H., 1072, **1139**
Harris, Thomas M., **1253**
Harrisburg, Pa., Lincoln funeral train at, **1246**
Harris farm (at Spotsylvania), 621, 627
Harrison, Benjamin, **1053**
Hart, O. H., 286
Hartford, USS, **60,** 64, 902, 964–66, **967–68,** 970, **977–78,** 979, **996, 1310**
Hartranft, John, 1071, **1254**
Hatch, John P., 176, **227,** 229
Hatcher's Run, Va., 1064, 1070, 1071, 1128, 1133–34
Hathaway's Wharf, San Francisco, 838
Hatteras, USS, 142
Haupt, Herman, 896–97
Havana, Cuba, 160; Southern exiles in, 1262, **1267**
Hawk, Harry, 1240, 1244
Hawkins farm ("Orange Turnpike"), **630**
Haw's Shop, Va., 625
Hayes, Rutherford B., **774, 1284;** 1876 election, 1263
Hayes (E.) & Co. ambulance wagon, **960**

Haynes' Bluff (Yazoo River), Federal landing at, 19, 28
Hays, Alexander, **629**
Hays, Harry T., **642**
Hazel River, **280;** pontoon bridge, **107**
Hazen, William B., 1025–26
Head, Truman ("California Joe"), **97**
Hébert, Paul O., **872**
Heffelfinger, Jacob, **109**
Heintzelman, Samuel P., after the war, **1287, 1309**
Helena, Ark., **855**
Helm, Ben Hardin, 460, **468**
Helm, W. W., **414**
Hendershot, Robert H., **677**
Henry, E. E., 780, 862
Henry, Patrick, 1164
Henry Hill, Va., Civil War monument, **1286–87**
Henry's repeating carbine, **940–41**
Herbert, Arthur, **1138**
Herold, David, **1254–57**
Herron, Francis J., **48, 857**
Heth, Henry, **677,** 1070
Hibernian Hall (Charleston, S.C.), **219**
Hickok, William ("Wild Bill"), 823, 1265
Hicks, David, **645**
High Bridge, Va., 1214, **1215,** 1216
Hill, Ambrose Powell, 614, 615, 623, 1067, **1139,** 1203; death of, 1072, 1139
Hill, Daniel Harvey, **1045**
Hillsboro Pike, 478, 479
Hillsborough, N.C., 1213
Hilton Head, S.C., **167,** 382, 541; Elliott plantation, **283;** Federal capture of, 167, 543; "Merchant Row," **168;** ordnance yard, **208;** Port Royal House, **169;** slaughterhouse, **922.** *See also* Bay Point, S.C.
Hindman, Thomas C., 457, 855, 456, 457, 1299
Hitchcock, Ethan Allen, 401, **429**
H.L. Huntley, the, 590
Hoffman, William H., 397–99,

400, 401, 402, **406,** 411, 415–17, 444
Hoffman's Battalion, 400, **416**
Hoke, Robert F., **1055,** 1056
Holiday celebrations, soldiers', 264
Hollow Tree Gap, Tenn., 481
Holly Springs, Miss., 20, 1296
Holmes, Oliver Wendell, Jr., 749
Holmes, Theophilus H., 881
Holston River, 516, **517–19,** 521; railroad bridge, **354, 515**
Holt, Joseph, **1253**
Homecomings, **1021,** 1251–52, **1282–84**
Hood, John Bell, 339, 460, **523,** 680, **706;** Atlanta Campaign, 680, 683, 684, 688–92, 706–7, 714; invasion of Tennessee (1864), 470–81, 523, 524, 529, 533, 535–38, 1024, **1027;** Johnston replaced by, **687–88, 706**
Hooker, Joseph ("Fighting Joe"), 238, **712;** at Chancellorsville, 613, 712; commander of Army of the Potomac, 308–9; on Lookout Mountain, **496;** resignation of, 711; in Tennessee Campaign, 462, 465–66, **495,** 500, 505, 508, 512
Hoover's Gap, Battle of, 331, 455
Horse artillery, **313, 315**
Horse shoeing shop, government, **896, 900**
Hospital No. 15 (Beaufort, S.C.), **254**
Hospitals, **54,** 236, **237–38,** 240–49, **254–65,** 301; bed statistics, 248; brigade, 238; corps, 238, 241; division, 238, 241; field, **236–37, 238,** 240, 245, 246; field, at Appomattox, 892; field, reorganization of, 238–39, 250; general, 240, 245, 248, **257, 259–60, 273, 860;** kitchens and food, 246, **263;** makeshift, 241, 245, 247, **254–56, 261;** Marine, **258;** mobile, 239; number of (1865), 248; pavilion, 231, 241, 245, 247, 248, 258–60; plumbing and

amenities, 245; POW, **445;** regimental, 238; "special," 243–45; staffing of, 241–42, 245–46, **249–50;** transporting of wounded to, **234,** 235–36, 239. *See also* Ambulances; Medical care

Hospital ships, **40,** 240, **252–53, 796**

Hospital stewards, 245, **249**

Hospital trains, 240

Hotel de Zouave (casement dungeons), **405**

Houghton, G. H., 998; picture gallery of, **999;** portfolio of Green Mountain Boys at the front, **999–1021**

Housatonic, USS, 373, 590

Houston, Sam, **819,** 820, 873

Hovey, Alvin P., 22

Howard, Oliver O., in Atlanta Campaign, 689, **711,** 712; on March to the Sea, 1024–25; on March through Carolinas, 1034

Howe, Albion P., **1253**

Howe Turn bridge, **463**

Howlett's Bluff, Va., 1063

Huger, Benjamin, **871**

Humphreys, Andrew A., **1067,** 1071, **1134, 1211, 1271**

Hunchback, USS, **369, 379, 383**

Hunt, Henry J., **1067, 1114, 1211, 1281**

Hunter, David, **170,** 627, **756, 1253;** command of the Department of the South, 168, 170, 171; commander in Valley, 744–46, 749, 752, 756, 757, 763; ruthlessness toward Southerners, 744–45, 756

Hunton, Eppa, **1138**

Huntsville, Ala., 492; Opdycke HQ in, **1227**

Huntsville, Texas, **873**

I

Idaho, USS, 1310

Illinois regiments: 1st Artillery (Chicago Light Artillery), **507;** 4th Cavalry, **306;** 17th, **59;** 39th, **186;** 45th, **45;** 47th, **129, 799;** 82nd, **1029**

Illinois River, Camp Hunter on, **306**

Illinois State Prison, 398, 400

Imboden, John D., **343,** 344, 346

Immigration, 1151

Impressment, 146

India, the, **566**

Indiana, Morgan's raid in, 308

Indianapolis, Ind., POW camp near, 400, **421–24**

Indiana regiments: 1st Heavy Artillery, **74;** 9th, **479, 731;** 17th Cavalry, 331; 34th, 886; 44th, **476**

Indians, 65, 818, 823–25, 1265, 1306; massacres, 830, 831; in Union service, 679, 1280; uprisings, 825, 831, 834, 848, **849–52**

Industry, mass production, **907;** Northern, 895; Southern, 1151. *See also* Factories

"Infernal machines," **225–26, 601.** *See also* Torpedo mines

Inflation, in South, 1161–62

Ingalls, Rufus, 894, 896, **926, 1067**

Intelligence agents, 98

International Humanitarian Convention (1864), 272

Iowa regiments: 6th Cavalry, **852;** 13th, 802; 19th, **441–43**

Irish Brigade, **1135**

Irish Sea, 138

Ironclads, river, in the West, **28, 30,** 786, **789,** 807, **808–12.** *See also* Monitor–type ironclads, individual ships

Irwinton, Ga., 1024

Irwinville, Ga., Davis captured in, 1217, 1249, 1265

Island No. 10, fall of, 40, 253, 577

Itasca, USS, 965

J

Jackson, Mary, 1163

Jackson, Miss., 52, 58; Union occupation of, 21

Jackson, Thomas J. ("Stonewall"), 184, 614, 623, 786, 787, 1324; at First Bull Run, 303; funeral of, 1166; in Seven Days Battles, 305; in Valley Campaign, 746–47, 901

Jackson, William H., **709**

Jackson, William L., 1212

Jackson Hospital, 247

James, Frank and Jesse, 823, **864,** 1265

James, W. E., 228

James Island (Charleston Harbor), 166, 168, 170, 171, 172, 176, **208**

James River, **281,** 305, **348,** 625, 626, 1059–60, 1072, 1096; batteries along, 1062, 1063–64, **1091–92;** Belle Isle prison, 397, 402, 409, **1161;** City Point depot on, **910, 927,** 1060, **1074;** crossed by Union forces, 627, 1058, **1063,** 1068, **1069, 1122–23;** Drewry's Bluff and Fort Darling, **1087–90;** ironclads on, **200, 366, 573, 1113,** 1169; POW drowning, 403; POW exchange points, 400, 425; at Richmond, 1151, **1161, 1169,** 1174, 1179, **1188, 1197, 1203;** torpedo mines cleared from, **1205;** Union opening of, **1205–8;** Union patrol of, 1060, **1113**

James River Squadron (CS), 142, 368

James Watson, SS, 83

Japan, 161, 540

Jarratt's Station, Va., 1070

"Jeff Davis" hat, **109**

Jefferson Hospital, 248, **257**

Jeffersonville, Ind., 933; hospitals, 248, **258**

Jenkins, Albert G., **346, 749**

Jenkins, C. T., **414**

Jenkins, Micah, 467, 469, 616, **637**

Jenkins Ferry, Ark., 791

Jericho Mills, Va., **276;** crossing by Union army at, 622, **661–63,** 664

Jerusalem Plank Road, 1064, 1066, 1069, 1100

John Brooks, SS, **925**

John's Island (Charleston harbor), 176
Johnson, Andrew, 1214, 1217, 1218, **1259**, 1268, 1300; assassination plot against, 1254; tailor shop of, **128**
Johnson, Bradley T., **763**, 764
Johnson, Bushrod R., 458, **471**, 1058, 1068, **1071**, **1218**
Johnson, Color Sergeant, **742**
Johnson, Richard W., **685**
Johnson (spy), **131**
Johnson's breechloader carbine, **939**
Johnson's Island Prison, 398, 400, 401, 415–17
Johnson's Mill (at Petersburg, Va.), **278**
Johnsonville, Tenn., Rebel cavalry raid at, **353–54**, 471
Johnston, Albert Sidney, **822**, 826, 828
Johnston, Joseph E., 304, **1052**; in Carolinas, 1031, 1035–36, 1038, 1052, 1055, 1212; death of, 1268; farewell address of, 1216; and Sherman, 1267–68; truce negotiations and surrender, 1213–17, 1223–24, 1245, 1249, 1262; after the war, 1263, 1267–68, **1312**; in the West, 16, 20, 21, 24–25, 46, 52, 681–88, 691, 696, 698, 700, 704–6
Johnston, R. D., **771**
Jones, John Marshall, **627**
Jones, Samuel, **748**, 1217
Jones, William E. ("Grumble"), 309, 346, 744
Jonesboro, Ga., 1024; Battle of, 692, 728, 729, 730, 731
Jones's Landing, Va., 1060
Jones's Neck (on James River), 1060, **1122**
Jordan, J. V., **1056**
Jordan, Thomas, 174
Julia, the, **155**, 583
Juliet, USS, 792
Jury, for Jefferson Davis trial, **1292**

K

Kanawha Canal, **348**
Kansas, 818; guerilla warfare in, 821, 823
Kansas City, Mo., 821; Pacific House, **866**
Kansas regiments, 7th, 823
Kautz, August V., **349**, **1253**
Kearsarge, USS, 140, 142, **145**, **146–49**, 373, **1303**
Keen, W. W., 245
Kell, Blanche, **389**
Kell, John McI., **136**, **139–40**, 389
Kelley, Benjamin F., **345**
Kelley's Ferry, Tenn., 462
Kelly, J., grave of, **1286**
Kelly's Ford, Battle of, 309, 322
Kennebec, USS, 965
Kennesaw Mountain, Battle of, 685–86, **701**, 702, **703–4**, 705, 726
Kentucky, Bragg's 1862 campaigns, 306, 869; cavalry raids in, 305, 311–12, 351, 352; Confederate abandonment of, 306–7
Kentucky regiments: 2nd Cavalry, 306; 8th, 465; 8th Cavalry, 33; 19th, **799**
Kenwood, USS, **83**
Keokuk, USS, 169, 553
Kernstown, Va., 749
Kershaw, Joseph B., 777
Key West, Fort Taylor, **966**
Kickapoo, USS, **980**
Kickapoo Indians, 831
Kilpatrick, Hugh Judson ("Kill-cavalry"), 309, 311, 313, **316**, **348**, 1024, 1028, 1033–34, **1054**, 1170, 1213
Kilpatrick, Mrs. Hugh Judson, **348**
Kimball, Nathan, **526**
King, John H., 509, **685**
Kingston, Ga., 695
Kiowa Indians, 831
Kitchens: camp, **932**; hospital, 246, 263; in trench war, 1105
Kittoe, E. D., **735**
Knap, Fred N., **269**
Knapsack supporter, Baxter's, 935–36
Knights of the Gohlen Circle, 870
Knights of the White Camellia, 1259–60
Knox, David, 1114
Knoxville, Tenn., 355, 462, **516–19**; Federal occupation and defense of, 467–70, 512, 513, **514–15**, **519–20**, 521–22; railroad approach, **515**
Korean War, 905
Ku Klux Klan, 1260, **1295–96**
Kunstman, William, 94

L

Lackawanna, USS, 965, 969–70
Lacy House (near Fredericksburg, Va.; Warren HQ), 614, **628**
Lady Davis (gun), 24, **62**
La Fayette, Tenn., 456
Lafayette, USS, **23**
Laird rams, 135, **161**
Lake, I., **154**
Lake Erie, 398, 415
Lake Providence expedition, 18
La Mesilla, Arizona Territory, 828
Lamson's repeating carbine, **940**
Land mine "torpedoes," **225–26**, **601**
Lane, James H. (Kansas Senator and Jayhawker), 820, 821, 823
Larkin, J. E., 444
Laughlin, John M., **172**
Laurel Hill, N.C., 1032
Laurel Hill farm, W.Va., **617**
Law, Evander McI., **676**
Lawrence, Kan., 821
Lawrence & Houseworth, 839
Lawson, Thomas, 232
Lawton, A. R., 1170
Lawton, W. J., **511**
Lay's Ferry (Oostenaula River), 683
Leadbetter, Danville, 468, **970**
Ledlie, James, 1068, **1119**
Lee, Albert L., **350**, **802**
Lee, Edwin G., **715**
Lee, Fitzhugh, 305, 309, **337**,

626, **673**; at Appomattox, 313, 1200–2

Lee, Robert E., 20, 135, 167, 311, 333, 336, 338, 346, 349, 546, **624**, 637, 677, 681, 905–6, **1061**, 1158, 1160, 1168, 1179, **1209**, **1237**; appointed commander of Army of Northern Virginia, 304; at Appomattox, 313, 832, 1200–1, 1202–6, 1208, 1210, 1212, 1218, 1221; Arlington home of, 961, 1252, 1286; at Chancellorsville, 907; cornered at Five Forks, 337–39; death of, 1267, 1315; defense of Richmond, 745–46, 1058, 1170–73; farewell address to his army (General Order No. 9), 1200, 1208, 1210; flanking tactics of, 907; funeral services for, **1315**; at Gettysburg, 308, 326; invasion of North in 1862, 133; at Petersburg, 1027, 1038, 1058–60, 1062–63, 1065–72, 1127, 1130, 1133, 1135, 1138–42, 1171, 1202; from Petersburg to Appomattox, 1200, 1213, 1216–19; at Second Bull Run, 907; and Seven Days Battles, 305; on Traveller, **1140**, **1313**; wartime residence of, **1175**; after the war, 1253, 1267, 1313–14; Wilderness defense of 1864, 613, 615–17, 619–27, 640, 651–53, 656, 659, 661, 668, 670–71, 673, 679; mentioned, 91

Lee, Stephen D., 17, **44**, **333**, 472, 477, 480, 536, 690

Lee, Washington Custis, **1312**

Lee, William H.F. ("Rooney"), 309, **338**, 625, 679, 1211

Lee & Gordon's Mills, 457, **465–66**

Lee's breechloader, **938**; cannon, **954**

Lee's Mill, Va., 1016; Battle of, 1019; graves at, **1019–20**

Legaré's plantation (S.C.), 168

Lehigh, USS, 176, **200, 372, 387, 389**

Letcher, John, 1162–63, 1169–70

Letterman, Jonathan, **239, 250**

Letterman Ambulance Plan, 239, 241, 243

Levy & Cohen, 1152, 1181

Lewinsville, Va., picket guard at, **110**

Lexington, Ky., Confederate occupation of, 306

Lexington, USS, 792

Lexington, Va., 753, **1315**

Lexington Rifles, 306

Leyendecker, John Z., **879**

Libby & Son, 397, 402

Libby Prison, 397, 400, **402–4**, 406, **426, 447–48**, 1159, **1196**; escape tunnel, **403**

Liberty Gap, Battle of, 455

Lilley, Robert D., 762

Lincoln, Abraham, 135, 166, 170, 311, 1026, 1127, 1168, 582, 1214, 1239–44, 1258; autopsy, 251; and blockade, 149, 539, 556; cabinet of, 240, 762; call for troops, 1178; in his casket, **1248**; as Commander in Chief, 901–3, 905; and commerce raiders, 138; deathbed of, **1243**; and Early's raid on capital, 749, 761; election of 1864, 752, 1062; funeral services and mourning for, 1244, **1245**, 1246, **1247–48**, **1250–51, 1271, 1273**; funeral train, **1246**; his generals-in-chief, 900–2; and Grant, 903–4; peace terms of, 1214; and Reconstruction, 1258–59; relations with McClellan, 901; Springfield home of, **1251**; Valley Plan of, 901; visit to Richmond (1865), 1172, 1174, 1204–5; and war in the West, 24, 27, 478, 786, 792; mentioned, 128, 143, 363, 460, 468, 679, 701, 793

Lincoln, Benjamin Franklin, **679**

Lincoln Hospital (Washington, D.C.), **261**

Linden, USS, **39**

Linn, Royan M., 123, 291, 496

Little Crow (Sioux chief), 823,

824, 825

Little Rock, Ark., 786, 790, 791, 802, **803**, 831, 854, **858–60**; hospital, **860**; penitentiary, **862**

Little Round Top (Battle of Gettysburg), monuments at, **1320**

Liverpool, England, 135, 137, 164, 1218, 1236

Lockett, S. H., 26

Lodge for Invalid Soldiers (Washington, D.C.), **269**

Logan, John A. ("Blackjack"), **41**, 478, **710**, 711, **1027**, 1028, **1277**

Lomax, Lunsford L., **783**, 1212

London *Times*, 743, 1304

Longstreet, James ("Old Pete"), **637**, 1070, 1072; at Appomattox, 1200, 1202–3, 1208; corps transferred to West by railroad, 458; in Tennessee Campaigns, 458, 459, 468–70, 519–21, 637; in Wilderness defense, 613, 616, 617, 637, 641; wounded, 617, 637, 641

Lookout Mountain, **120–24, 291–92**, 293, 480, **496, 506, 509, 918**; Battle of, and battle sites, 462–63, 465, **494–96**, 497, 498, 512 *(see also* Missionary Ridge); government sawmill at, **484**; Lookout House, **497**; Umbrella Rock, **121**

Lookout Valley, 462

Loring, William W., 22, 685, 1262

Loudon road, 467

Louisiana, 255, 786, 831, 871, 879, 827; Confederate surrender in, 1217–18, **1229**, 1247

Louisiana regiments: 1st Artillery, 872; 3rd Cavalry, 28; Washington Artillery of New Orleans, **504, 536**

Louisville, CSS. *See Ouachita*, USS

Louisville, Ky., 240, 248, 455

Louisville, USS, **30, 84**, 792, **810**

Lovejoy's Station, Ga., 731

Low, John, 146, **157**

Lowe, Thaddeus S., gas genera-

tors of, **913**
Lowrey, H. B., **578**
Loyalty oath, 1263
Luanda, Angola, 142
Lu–La Lake, 296
Lumber River, 1033
Lumber yard, government, **905**
Lyford, Dr., **246**
Lynchburg, Va., 627, 744, 745–46, 1059, 1071, 1201–3, 1205, 1212, 1217
Lyon, Hylan B., **33**
Lytle, Andrew D., 65, 317, 318, 349, 794, 799
Lytle, William H., 461, **473**

M

MacArthur, Arthur, **527**
MacArthur, Douglas, **527**
McArthur, John, 480, **535**
McCallum, Daniel C., 896–97
McCausland, John, 749, **763**
McClellan, George B. ("Little Mac"), 167, **286–87**, 625; at Antietam, 307; commands Army of the Potomac, 302, 900, 901; General–in–Chief, 900–1; in Peninsular Campaign, 304–5, 1168–70; and Seven Days Battles, 305
McClernand, John A., **43**, 44
McClurg, A. C., **728**
McCook, Alexander M., 457, 461, **472**, 473
McCulloch, Benjamin, 818
McDowell, Irvin, **395**, 396, 894, 897; commander at First Bull Run, 303
McFarland, John, **977**
Machine–Shop Creek, **566, 571**
Machine shops, U.S. Navy, **566, 571, 590**
McIntosh, James, **772**
McIntyre, A. C., 1263
MacKenzie, Ranald, 1211
McKinley, William, **1284**
McLaws, Lafayette, 467, 469, **521**
McLean, Wilmer, 1204, 1220
McLean House, at Appomattox, 1204, 1208, 1220–21
McLeish, Archer, 224

McLemore's Cove, Tenn., 457
McManus, Purser, **376**
McMaster, Fitz William, **211**
McNeill, John H., **344,** 345
Macon, Ga., 1024, **1266;** POW camp at, 406, 407
Macon & Western RR, 689, 692
McPherson, James B., **41,** 42, **709,** 720; in Atlanta Campaign, 680, 682, 688, 689; death of, 689, 709, 710, 712
McPherson & Oliver, 62, 76, 797, 813, 967, 969, 972, 974, 978, 986, 993
Macy, George, **1211**
Madawaska, USS, **1302**
Madison, Ga., 1024
Madison, Wis., POW camp at, 399
Maffit, John Newland, 140, 144, 145, **151,** 152
Mage brothers, 154
Magruder, John Bankhead ("Prince John"), **432, 1299**
Mahan, Alfred Thayer, 561
Mahone, William ("Scrappy Billy"), 1068, 1118
Mahopac, USS, **209**
Mail, soldiers', **932**
Maine regiments: 9th, 594; 20th, 1073
Major, Patrick J., **800**
Málaga, Spain, harbor of, **1304**
Malaria, 24, 235, 248
Mallory, Stephen Russell, 134, 135, 143, 145, 361, 544, 551; commerce raider strategy, 134, 135, 143, 145
Maltby, Philo, 957
Malvern, USS, **1207**
Manassas, Va., Civil War monuments, 1252, **1286–87.** *See also* Bull Run; Bull Run, First Battle of; Bull Run, Second Battle of
Manassas Junction, 305, 1204
Manchester, Va., 1187; mills, **1178, 1203**
Maney, George, **730**
Manhattan, USS, 964, 965, 970
Mann, H. B., **952,** 953
Manning, Peyton T., **520**

Mann's breechloader, **952–53**
Mansfield, Battle of (Sabine Cross Roads), 788–89, 800
Mansura, La., 794
March, armies on, **86–133, 1015–16**
"March to the Sea," 471, 692, 739, 891, 1022–26, 1032, 1034; participants in, **1023,** 1024, **1025–30, 1042**
Marietta, Ga., 685, 686
Marine Corps. *See* U.S. Marine Corps
Marine hospitals: Cincinnati, **258;** Vicksburg, **54**
Mark Cooper Iron Works, **696**
Market House (Charleston, S.C.), **223**
Marks' Mills, La., 790
Marmaduke, John Sappington, **804, 884,** 885
Marshall, Charles, 1203–5, 1208, 1210, **1221**
Marshall, J. E., **735**
Marshall, John, 1151
Marshall, Texas, 831
Marshall House (Alexandria, Va.), **127**
Martindale, John H., 770
Marye House (Fredericksburg), **651**
Maryland, Lee's invasion of 1862, **133.** *See also* Antietam, Battle of
Maryland regiments, 3rd Cavalry, 800
Mason, John T., **164**
Massachusetts regiments: 2nd, 742; 2nd, camp of, **734;** 2nd Cavalry, camp, **311;** 24th, 172; 34th, **752;** 36th, **633;** 38th, 66; 40th, **1120;** 52nd, Baton Rouge graves of, 62; 54th, 170, 184; 55th Volunteers, 608; 56th, **633;** 57th, **633**
Massanutten Mountain, **746,** 753–55
Massaponax Church, 622, **656;** Grant's council of war at, **657–59**
Mass production, 906, 924
Matamoros, Mexico, 831, 874,

876, **877**

Maury, Dabney H., **973**, 974, 1213

Maury, Matthew Fontaine, 143, **150, 165**

Maury, William L., 138, 143

Maximilian, Emperor of Mexico, 1262

Mayo, Joseph, 1152–53, 1159, 1163–64, 1170, **1171**, 1174

Meade, George G., 94, 203, 1070, 1114, 1128, 1134, 1212, 1216; at Appomattox, 1202, 1203, 1205–6, 1210; commands Army of the Potomac, 92, 613, 619, 904, 1058; Culpeper HQ of, **92–93**; his family, **1208**; at Gettysburg, 326; in Grand Review (1865), **1276**; postwar Atlanta district command, **1295**; with his staff, **619, 1067, 1211, 1281**; in Wilderness Campaign, 613, 620–21, 624, 634, 657–58, 675

Meade, George, Jr., **94–95**

Meade, Robert L., **203**

Meal stop, on march, **108–9**

Mechanicsburg, Pa., Confederate capture of, 346

Mechanics shops, **897, 902**; field units, **918, 931, 1011**

Medal of Honor, for women, 240

Medical care, 231–49, **250–74**; convalescent camps, **265–66**; diagnoses, 234–35; drug shortages, 232, 239; morbidity and mortality rates, 248–49; number of doctors (1865), **231**; sanitary conditions, 234–35; septic conditions, 237, 241; supplies, 891, 896. *See also* Ambulances; Amputations; Hospitals; Nurses; Surgery; U.S. Army Medical Department

Medical College of Virginia, 1167

Meigs, Montgomery C., 399, 406, 891–92, 894, 896–7, 904, **926, 1287**

Melbourne, Australia, 148

Melville, Herman, 376

Memorials, Civil War. *See* Monu-

ments

Memphis, Tenn., 17, 18, 19, 305, 810, 815; Federal panic retreat to (1864), 312; Union hospitals in, 240, **256**; Union postwar presence, **1294**

Memphis & Chattanooga RR, 460

Mendota, Minn., **847**, 848

Mendota, USS, **370, 378, 391**

Mepham (W. G.) and Bro. (Memphis), as officers' hospital, **256**

"Mephfluvia," 245

Merchant's Cotton Mill (Petersburg, Va.), **277**

Meridian, Miss., 85, 1213

Merrimack, the. *See Virginia*, CSS

Merritt, Wesley, **327, 336, 774**, 782, **785**, 1208, 1222

Mervine, Charles K., 369

Metacomet, USS, 965, 967–68, 981

Mexican War, 23, 248, 543, 692, 899, 906, 1205

Mexico, 786, 876; Confederate exiles in, 871, 882, 1218, 1262, **1298–99**; Confederate trade with, 831

Miami, USS, **371, 391**

Miantonomoh, USS, **1304, 1311**

Michigan and Pennsylvania Relief Association, **253**

Michigan regiments: 1st Engineers, **918**; 2nd, **48**; 4th, 885; 7th, 316, 358; 8th, 677; 21st, 1031

Miles, Nelson, 1072

Miles, William Porcher, **190**

Military Division of the Mississippi, 680

Military Division of West Mississippi, 792

Military Genius of Abraham Lincoln, The (Ballard), 902

Military Railroads. *See* U.S. Military Railroad Construction Corps; U.S. Military Railroads

Military Telegraph Service. *See* U.S. Military Telegraph Corps

Militia units, **282**

Milledgeville, Ga., 1024–25, 1033

Millen, Ga., stockade near, 407

Miller, Dora, 26

Miller, Francis T., 505

Milliken's Bend, Battle of, 29

Mills, flour, in Richmond area, **1178, 1185–86**

Mills House Hotel (Charleston, S.C.), **220**

Millwood, Va., 1212

Milroy, Robert H. 747

Milroy's Fort, **747, 770,** 771

Miner's Hill, Va.: army drill at, **1120**; signal tower at, **87**

Mines. *See* Land Mine "torpedoes"; Torpedo mines

Minié, Claude Étienne, **907**

Minié bullets (Minnie balls), 237, 907

Minnegerode, Charles, 1173

Minnesota regiments: 4th, **492**; 6th Volunteers, 825

Minnesota River, **845–46**

"Minnesota Row" *(later* Douglas Hospital; Washington, D.C.), **261**

Minnesota Territory, 823–25

Minnie balls. *See* Minié bullets

Missionary, SS, **485, 488**

Missionary Ridge, Battle of, 462, 465–66, 502, 505, 511; battle sites, **498–501, 503–4, 506–7**; guns captured, **509**; RR tunnel, **507**; Southern participants, 504–5, **508**; Union participants, **502–3, 505, 507–8**

Mississippi, blacks of, in Union army, **56**; Confederate cavalry in, 333; Confederate surrender in, 1217, **1226,** 1228; "total war" of Sherman in, 1022

Mississippi Marine Brigade, 258

Mississippi River, 31, 308, 680, 786, **844,** 883; ironclads, **28, 30, 809;** *Red Rover* hospital ship on, **40,** 253; *Sultana* disaster, 1245, 1260; Union conquest of, 16–18, 60, **83–85,** 962; Union patrol, **83.** *See also specific cities, e.g.* Baton Rouge; Memphis; New Orleans; Port Hudson; Vicksburg

Mississippi Squadron, 22; in Red
 River Expedition, 786–87, 789,
 792–94, **795–97, 806–12, 815–
 17**
Missouri, 818–23, 828, 830–31,
 853–54, 862–68, 884; cavalry
 raiders in, 312, 351, 818, 868,
 881–84; guerrilla warfare in,
 818, 820–21, 823, 864–66;
 martial law in, 820–21
Missouri Compromise, 378
Missouri River, 825
Missroon, J. S., 545
Mobile, Ala., 144, 151, 681, 786,
 792, 962, 971–72, 973, 974,
 1228; Confederate powder
 explosion at, 1230; fall of,
 1213
Mobile Bay, Ala., 962; blockade
 at, 569, 962, 963, 965, 966,
 972; blockaderunners, 962;
 minefield, 962, 964, 966–67,
 982, 984
Mobile Bay, Battle of, 962–72;
 casualties, 970–71; Southern
 participants, **973–74, 981, 983,
 987, 995**; Union participants,
 963, 965, 968, 977, 981, 984;
 Yankee fleet, 964–5, **967–69,
 977–80.** *See also* Fort Morgan
Mobile Point, 962; Lighthouse,
 994
Moccasin Point, Tennessee River,
 463, **480**
Monett's Ferry, La., 791, 805
Monitor, USS, at Drewry's Bluff,
 1169–70
Monitor–type ironclads, at
 Charleston, 168, 169, 170,
 175, 176, 177, **198–200,** 201,
 203, 209, 553, **570, 580,** 963 ;
 at Mobile Bay, 963–70, **980;**
 river–monitors, **366;**
 Winnebago class, **980**
Monocacy, Battle of, 748, 758,
 759
Monongahela, USS, 965, 969–70,
 984
Monroe, James, tomb of, **1168**
Monroe's Crossroads, N.C. 1033
Montana Territory, 825
Montauk, USS, **582**

Montgomery, Ala, 241, 1153,
 1156, 1158; population, 1156
Monticello, Ga., 1024
Monument Garden (Chatta-
 nooga), **484**
Monuments, Civil War, **84,** 1252,
 1284, 1286–87, 1319–20
Moody, Young M., **1129**
Moor, August, **758**
Moore, Henry P., 283
Moore, J. M., 33, 40
Moore, Patrick T., **1180**
Moore, Samuel Preston, 231–32,
 243, 245, 255, **272,** 273
Morehead City, N.C., 1028;
 medical care facilities, **256**
Morell, George, **87**
Motell, W. J., **575**
Morgan, CSS, 963, 965, 967–68
Morgan, John Hunt, 306–7, 308,
 310, **351–52,** 353; capture and
 imprisonment, 310, 349;
 death, 313, 356; POWs from
 his command, 401, **420, 432**
Morgan Iron Works engine, **367**
Morocco, 138
Morphine, use of, 236
Morris, Charles M., 144, **152**
Morris, George U., **965**
Morris Island, S.C., 166, 169,
 174, 593, 599; Confederates
 on, **187;** Federal foothold,
 170–72, 182, **594–612;** guns,
 597–601, 604, 612; lighthouse,
 603; ordnance yard, **207;**
 POWs at, 171, 409, **446;**
 shelling of Sumter from, **188,**
 205, **206–7,** 600, **601;** surgical
 treatment at, **243;** telegraph
 shelter, **602;** wreck of *Ruby* at,
 586. *See also* Fort Wagner
Morrow, Stanley J., **429,** 430, **431**
Morse code, 911
Mortar batteries: "Dictator,"
 1066, 1114–15
Mosby, John Singleton, 301, 308,
 310–11, **341–42,** 343, 744, **750,**
 755, 1212
Mosby's Confederacy, 342
Moses & Piffet, 971
Mote Brothers, 1308
Mott, Gershom, **1128**

Mound City, Ill., hospital, 240
Mound City, USS, 792, **809**
Mount McGregor, N.Y., Grant
 home at, **1316**
Mount Sterling, Ky., Morgan's
 raid on, **352**
Mower, Joseph, 85
Mudd, Samuel, 1249
Muldraugh's Hill, railroad bridge
 at, 306–7
"Mule Shoe, The" (in Battle of
 Spotsylvania), 618–20, 645. *See
 also* "Bloody Angle, The"
Mullany, J. R. Madison, **981**
Mulligan, James A., **772**
Mundy, George, **978**
Munford, Thomas T., **783,** 1202
Murfreesboro, Tenn., 455;
 Confederate capture of, 306;
 railroad track repair after
 cavalry raid, **356**
Murfreesboro Pike, 478
Museums, battlefield, 1252–53,
 1321
Muskets, smoothbore vs. rifled,
 906–8, 909
Mustering in, **275, 833.** *See also*
 Enlistment
Mustering out, at end of war,
 1250, **1283–84,** 1319; pay,
 1250
Muzzle–loading arms, 907, 908,
 909
Myers, Henry, 138
Myrick, Andrew, 824, 825

N

Naglee, Henry M., **325**
Nahant, USS, **571, 572**
Napoleon I, Emperor, 894–95,
 903, 907
Napoleon III, Emperor, 143
Nashville, CSS, 137
Nashville, Tenn., 306, 455, 471,
 531–33; Battle of, 477–81, 530,
 531, **534–35,** 536, **537–38,**
 1027, 1059; hospitals, **237,**
 245; State House at, **530–31;**
 Taylor Depot, **923**
Nashville & Chattanooga RR,
 455, **531**

Nassau, port of, 144
Natichitoches, La., 787, 789
National cemeteries. *See* Cemeteries, military; Gettysburg
National Home for Disabled Volunteer Soldiers (Dayton, Ohio), **1308**
Naval Academy. *See* Confederate States Naval Academy; U.S. Naval Academy
Naval operations: Confederate shipbuilding program, 134–37; at Drewry's Bluff, 1169–70; off French coast, 140, 146, 150, 151; James River, **200**, **366, 573**, 1060, **1113, 1205–8**; manpower shortages, 362; at Mobile Bay, 962–72, **973–83**, 984, 995; at Port Hudson, 16, 22, 24, **60, 64, 65**; at Port Royal, 16667; Red River Campaign, 786, 787, **789**, 792–94, **795–97, 806–17**; siege of Charleston, 166–77 (*see also* Charleston, S.C.); torpedo mine clearing, **1205**; Union shipbuilding program, **1302**; at Vicksburg, 17–18, 22, 25, **26–27**, 29, **30, 39–40**; on Yazoo River, **18, 28, 31**. *See also* Blockade; Blockade runners; Commerce raiders; Confederate Navy; Ironclads; Monitor-type ironclads; North Atlantic Blockading Squadron; Sailor's life; South Atlantic Blockading Squadron; U.S. Navy; *and see names of officers and ships*
Navasota, Texas, 873
Navy Department (CSA), 134–35, 362, 543–44, 561
Navy Department (U.S.), 145, 169, **894**, 963; Blockade Strategy Board, 166, 539–40, 545
Negley, James S., 457, **470**
Negroes. *See* Blacks; Contraband blacks; Freedmen; Slavery and slaves
Negro Ordinance (Richmond), 1153
Neill, T. H., **770**

Nelly Baker, the, **588**
Nelson, Lord, 155
Nelson, William (Cadet), **753**
Nelson, William (Confederate artillery officer), 1212
Neosho, USS, 792
Neptune, the, **1075**
Nevada, 826, 828, 832
New Berne, N.C., 1028, 1036, 1056; quartermaster's depot, **279**
New Creek, W.Va., Federal outpost at, 342
New England, 786; commerce raiders off coast of, 145, 157, 158
New Hampshire, USS, **374, 587–88**; crew members, **376–77, 393–94**
New Haven Arms Co., 941
New Hope Church, Battle of, 684–85, **698–99**
New Ironsides, USS, 169, **203**, 546, 553
New Jersey regiments: 1st, 779; 33rd, **690**
New Market, Va., Battle of, 743, 753, 754, 755
New Market Heights, Va., 1062, 1069
New Mexico Territory, 823, 826, 828–31; forts, **824, 826–27**
New Orleans, La., 61, 65, 350, 786, 830, 1218, 1318; prisons, 397, **441**; slave trade in, 1152; Union occupation of, 962. *See also* Washington Artillery of New Orleans
Newport News, Va., 144, 1015
Newspapers, in South, 1167; war reporters, **117**
Newton, John, **1006**
New Ulm, Minn., 825
New York (City), 266, 398; City Hall, **1247–48**; harbor raid scheme, 147; Lincoln funeral services in, 1244, **1247–48**; population of, 1152
New York (State), hospitals for soldiers, 233, 259; prison camps, 398, 406, 411
New York (Fire) Zouaves, 303

New York *Herald*, field HQ of, **117**
New York regiments: 1st Engineers, 1065; 6th National Guard, **288–89**; 7th Cavalry, **320**; 8th Heavy Artillery, 678; 12th Battery, **1099**; 13th Cavalry, **303, 313**; 15th Engineers, 1065, **1097**; 22nd State Militia, **282**; 40th, 1301; 48th, **563–64**; 50th Engineers, **103, 663**, 1065; 50th Engineers HQ and camp, 917; 118th (Adirondack Regt.), **934**; 141st, 116; 156th, 76; 164th (Zouaves, the Corcoran Legion), **1086**; 170th, **107**
Nez Percé Indians, 834
Niagara, USS, **159, 540**
Nichols, G. W., **735**
Nields, Henry C., **981**
Nightingale, Charles, 1244–45
Nightingale, Florence, 245
IX Corps (Potomac), 1069, 1135; ambulance officers, **235**; commanded by Burnside, 621, 664; commanded by Parke, 1211, **1270**; embarking at Aquia Creek for Vicksburg, **47**; hospital stewards, **249**; James River crossed by, **1063**
IX Corps, Union, in West, 47, 514, 522
9th Indiana, **479, 731**
9th Maine, 594
XIX Corps (Potomac), 748, 770, 781
19th Iowa, **441–43**
19th Kentucky, **799**
Nipsic, USS, **583**
Norfolk, Va., 1059; POWs taken at, **397**
North Anna River, **276**; 1864 Union army crossings, 622, **661–67**; Quarles Mill, **284**; soldiers bathing, **112**
North Atlantic Blockading Squadron, 540
North Carolina, 1065, 1212; end of hostilities in, 1213–16, 1223–25, 1245; Sherman in, 1028, 1032–36, 1052–57

North Carolina regiments: 31st, 1056; Light Artillery, 1217
North Edisto River, 168
Nugent, Robert, 1135
Nurses, **237**, 245–47, **264, 270**, 273; lightly wounded soldiers as, 239
Ochiltree, Thomas P., **804, 1230**
Octorara, USS, 965
Ogeechee River, 1025–26
Oglethorpe Barracks (Savannah, Ga.), **1045**
Ohio, 401, 415; Confederate Cavalry raids in, 308, 346
Ohio regiments: cavalrymen, **319**; 5th Cavalry, **332, 357**; 8th National Guard Light Artillery, **416**; 14th Artillery, **957**; 17th, **1030**; 23rd, **1284**; 28th, 758; 56th, 793; 105th, **122**; 120th, 793; 125th, **702**; 128th (Hoffman Battalion), 400, **416**
Ohio River, 308, 310
"Old Abe" (eagle mascot), **40**
"Old Abe" (mortar), **585**
Old Church, Va., 625, **670**
Olley's Creek, 686
Olmstead, Charles H., **548**
Olmsted, Frederick Law, 232
Olustee, CSS, 147
O'Mahony, John, **1301**
O.M. Pettit, USS, **541**
104th U.S. Pennsylvania, 172
105th Ohio, **122**
114th Pennsylvania (Zouaves), **676, 1081**
118th New York (Adirondack Regiment), **934**
120th Ohio, 793
125th Ohio, **702**
128th Ohio (Hoffman Battalion), 400, 416
141st New York, Falls Church graffiti of, **116**
149th Pennsylvania (Bucktails), 662
156th New York, 76
164th New York (Zouaves), **1086**
170th New York, **107**

O

Oneida, USS, 965, 968–69, 981
Onondaga, USS, **425**
Oostenaula River, 682, 683, 684, 893
Opdycke, Emerson, 474, **526, 527**, 1227
Opequon Creek, 752, 768
Opium pills, 236
Orange & Alexandria RR, **281**; Confederate raiders at, **340**
Orangeburg, S.C., 1029
Orange Plank Road, 613–16
Orange Turnpike, 613–15, **625, 630, 632**
Orchard Knob (at Lookout Mountain), 466, **498**, 499
Ord, Edward O. C., 1069, 1071–72, **1124**, 1126, **1199**, 1202, 1204
Ordnance. *See* Artillery; Cannon
Ordnance Department (CSA), 1161
Ordnance Department (U.S.), 891, 908–9, 942
Ordnance shipments: at City Point wharf, 1074, **1077**
Ordnance yards: Hilton Head, S.C., **208**; Morris Island, **207**; Richmond, **1177, 1194–95**
Ordway, Albert, **172**
Oregon, 834
Osage, USS, 792, **808**
Osceola, Mo., 820
Ossabaw Sound, 1025–26
Ossipee, USS, 965, 970, **979**
Osterhaus, Peter J., 1024, 1028, 1218
O'Sullivan, Timothy, 106, 111, 112, 276, 281, 284, 340, 556, 622–23, 638, 654, 664–65, 676, 917, 929, 1114–15
Ottawa, Ill., 306
Ouachita, USS (*formerly* CSS *Louisville*), 793
Ould, Robert, 401
Owen, S. W., **319**
Oxford, Miss.: Federal camp at, **20**; 47th Illinois in, **129**
Ox Ford, Va., 622, 623
Ozark, USS, 792, **811**

P

Pacific House, Kansas City, **866**
Page, Richard L., 965, 971, **987**, 990
Paine, Lewis, **1254–55**
Paint shops, government, **465, 466**
Palfrey, J. C., 72, 73
Palmer, I. N., **320**
Palmer, John A., HQ of, **683**
Palmer, John M., **508**, 869
Palmer's (*or* Saunder's) Field, 614, **625–26**
Palmetto barricades, **174, 213, 215–16**
Palmito Ranch, Texas, 832, 886
Pamunkey River, bridges, **668**; Union crossing (1864), **668**; Union supply base on, 625, **668–69**
Para, USS, **585**
Parades, **90, 563–64**; cavalry, **303, 318**
Pargoud, J. F., **28**
Parke, John G., **512**, 514, 1070, 1071–2, **1211, 1270**
Parker, Ely S., **679**, 1204–5, **1280**
Parrott rifles, **75, 80, 188, 205, 388**, 596, 598–601, 604, 943, 1014, 1092, 1232
Parsons, Mosby Munroe, **882**
Passaic, USS, **198–99, 393, 566, 570**
Patapsco, USS, 553, **580, 582**
Patrick, Marsena R., **95**, 1060, **1067**
Paul, Gabriel R., **825**
Pawnee, USS, 388, 576, 579–80
Peach Orchard Hill (at Nashville), 479, 480
Peachtree Creek, Battle of, 687–88, **707**, 708
Pea Ridge, Battle of, 853, 854
Pearl River, railroad bridge, 21
Peck, William R., **758, 1227**
Peeble's farm signal tower (near Petersburg, Va.), **1111**
Pee Dee River, 1033
Pegram, John, 625, **769**, 1071, **1133**

Pegram, Robert B., 137
Pegram, William, 1067
Pelham, John, 304, 309, **322**
Pemberton, John C., 23, **34**; at
 Champion's Hill, 22; defense
 of Vicksburg, 16, 17, 20, 21–
 22, 23, 24, 25, 26–27, 34, 50,
 70, 84
Pendleton, William N., 1208
Peninsula, Union presence
 1864–65, 1060, 1068, 1069–70
Peninsular Campaign (1862),
 248, 304–5, 1168; Gaines's
 Mill battle, 626; Houghton's
 portfolio of, **999–1017**;
 Stuart's "ride around
 McClellan," 304, 307
Pennington, Alexander, 784
Pennsylvania, 401; Confederate
 cavalry raids into, 307, 308,
 326, 346
Pennsylvania regiments: 1st Light
 Artillery, **1085**; 3rd Cavalry,
 313, 319; 8th Cavalry, 324;
 47th, 121; 48th, 1115; 50th,
 1319; 104th, 172; 114th
 Zouaves, **676, 1081**; 149th
 (Bucktails), 662
Pensacola, Fla., 962–64
Peosta, USS, **489**
Peritonitis, 237
Perkins, George H., 966–69
Perrin, Abner, **645**
Perryville, Ky., 306
Peters, J., **575**
Petersburg Campaign and Siege,
 906, 1027, 1038, 1058–72,
 1171, 1172–73, 1200; 1864
 (June) attack, 627, 1058,
 1063–64, **1067, 1072**, 1073;
 1865 attack, 1071–72, 1133–
 38, **1146–49**; fortifications,
 1062–63, 1064–65, 1067, **1072**,
 1073, **1080**, 1087–92, **1097–
 1110, 1112, 1125, 1130–32,
 1135–37, 1144–45, 1201**;
 railroad battery, **1114–15**;
 railroads as objective, 1058–
 60, 1065, 1067, 1068–72, **1073,
 1121, 1142**, 1171; river
 crossings during, 1058, **1063**,
 1068, **1069, 1122–24**; siege

army, **1063–64, 1067–70, 1073,
 1078–81, 1085–86, 1097–99,
 1114–15, 1119–20, 1122–24,
 1127–28, 1133–35**; siege
 defenders, **1064–66, 1071,
 1087, 1117–18, 1121, 1126–27,
 1129–31, 1133, 1138–40**;
 Southern attack on Fort
 Stedman, 1070, **1130–32**;
 supply lines of Lee, 1058,
 1059–60; supply of U.S. army
 at, 892, **910, 927–28**, 1060,
 1062, 1074–77, 1082–84;
 surrender, 1060, 1065, 1072,
 1138–40, **1141**, 1142–50, **1202**;
 telegraph and signal commu-
 nications in, 1066, **1070, 1078,
 1098, 1111–13**
Peterson, William, 1244
Peterson rooming house (Wash-
 ington, D.C.), **1243**, 1244
Petty, J. W., 505, 536
Pevey shell, 956
Philadelphia, Pa., 398, 411, 1244,
 1310; dressed for troop
 homecoming, **1282**; hospitals
 in, 245, 248, **259**; population
 of, 1152; U.S. Army Labora-
 tory, **947**
Philadelphia, USS, **386**
Philadelphia Navy Yard, **569**
Photographers, photography,
 275–300, 593, 998; equipment,
 121, 375; equipment wagons,
 1051; galleries and studios, **94,
 291, 931, 999**; night-time,
 290; portable darkrooms, **375**
Photographic History of the Civil

War (Miller), 505
Picket duty, **109–10**. *See also*
 Sentry duty
Pickett, George E., 1071, 1173
Pickett's Charge, 616
Pickett's Mill, Ga., 685
Piedmont, Battle of, 744, 757,
 758
Pierpont, Francis H., 1197
Pine Mountain, **700**, 701
Piney Branch Road, Va., 640
Pittsburg, USS, 792
Pittsylvania Court House, Va.,
 1212
Plains Store, Battle of, 22
Plantations, **283**; slave quarters,
 129, 283
Planter, SS, **252**
Platt Creek railroad bridge, **355**
Pleasant Hill, Battle of, 788–89,
 801
Pleasonton, Alfred, 307, 309,
 311, 312, **316, 323**, 325, **885**;
 Castle Murray HQ of **314**
Plecker, A. H, 1313
Plue, Dan, **96**
Pocahontas, USS, 545, **547–50**
Poe, Edgar Allan, 1151
Poe, Orlando M., **522, 735**, 738
Point Lookout, Md., 248; POW
 camp at, 401, 429, **430–31**;
 POW band, **431**
Point of Rocks (Appomattox
 River), 1060
Poison Spring, Mo., 804
Polk, Leonidas, 460, 466, **467**,
 682, 683, **700**, 702; death, 685,
 700
Polk, Lucius E., **702**
Pontoon bridges, **33, 92, 107,
 622–23, 661–63, 667, 876–77,
 1063, 1122–24, 1188, 1203**;
 canvas pontoons for, 103, 913,
 916; construction of, **915–16**;
 transport wagons, **913–14**
Pope, Major General John, in the
 West, 825
Poplar Spring Church, Va., 1060,
 1064, **1070**
Porter, David Dixon, **22**, 138,
 790, 815, 1207; his flagship
 Black Hawk, **791, 817, 861**; on

Mississippi River, 19, 22, 23, 24, 83; on Red River, 786–88, 790–91, 796, 797, 806, 809, 811–17, 831

Porter, Horace, **657**, 1204

Porter, Peter, **678**

Port Gibson, Miss., 19, 30

Port Hudson, La., 16

Port Hudson Campaign, 16, 18–19, 21–24, 60, 61, 134; battle sites, **66–67**; black troops in, 23–24; bombardment, 16, 18–19, **63, 68–69, 77**; casualties, 24, 27; Citadel, **76–78**, 81; Confederate defenders, **66, 70**; Confederate defenses, **62–63, 67–69, 75–79**; Federal batteries, **73–75, 77, 80**; Federal earthworks, **73–75, 79**; Federal fleet in, 16, 22, 24, **60, 64–65, 81**; seige, 22–24, 65, **72–81**; surrender, 27, 76, 82; Trench Cavalier, **79**; Union participants, **61, 64–65, 70–71, 79, 82**

Portland, Me., 145

Portrait photography, 286–87; group portraits, 289

Port Royal, S.C., 393, **567**, 568, 569; capture of, 166–67, 540, 543, 545, 546; fleet maintenance at, **565–66**

Port Royal, USS, 965

Port Royal, Va., Union supply base, 622, **660,** 668

Port Royal House (Hilton Head), **169**

Portsmouth, N.H., **145**

Post offices, **1043, 1232**; field, **932**. *See also* Mail

Potomac, USS, **996**

Potomac River, 303, 307, 401; Aqueduct Bridge, 280; at Belle Plain supply base, 646, **647–49**; at Berlin, Md., **91**; at Harpers Ferry, **290**, 744; soldiers fishing, **280**; Washington, Alexandria & Georgetown RR bridge, **909–10**

Prairie Grove, Battle of, 855–58

Preble, George H., **152**, 155, 156,

569

Press. *See* Newspapers

Preston, William, 461, **477, 1312**

Price, Birch & Co. (slave pen establishment), **126**

Price, Sterling, 312, 786, 818, 823, **881,** 882, 884–85, **1299**; family of, **1298**

Prisoners-of-war, **1202**; blacks, 401, 409; Confederate notables, 412, **413–15**; Confederates at Belle Plain, 620, **650**; escape attempts, 397, 398, 401, 402, **403**, 409, 430; exchanges of, 171, 400–1, 409, **425**, 429, **1226**; punishment of, **430**; *Sultana* disaster, 1245, **1260**; used as target, to discourage fire, **171**, 446

Prisons and prison camps, 396–409; death rates in, 400, 402–3, 406, 409, 411, 436, 1252; disease in, 402, 406, 423, 424, 437; food shortages, 402, 403, 406, 409, 436; in North, 397–400, 401, 402, **407–8, 411–13, 415–24, 444–45**; sanitation, **424**, 436, **437**; in South, 396–97, **400**, 401–4, **405**, 406–7, **426–28, 432–43, 447–49**, 1159, 1161, 1249; state penitentiaries used as, 401, 432. *See also* Prisoners-of-war; *and see names of prisons, e.g.* Andersonville; Belle Isle; Belle Plain; Camp Douglas; Castle Thunder; Danville; Elmira; Fort Delaware; Libby Prison

Pritchard, Benjamin, **1265**, 1266

Prospect Hill, Va., 13th New York Cavalry at, **303, 313**

Prosset, Gabriel, 1151

Provost Marshal General (U.S.), **95**

Pulaski, Tenn., 471, 472

Pyron, C. S., 830

Pywell, William R., 32

Q

"Quaker guns," **63, 113**

Quantrill, William Clarke, 820,

821, 823, 864–67

Quarles Mill (on North Anna River), **284**, 622, 664

Quartermaster Department (CSA), Richmond supply depot, **1169**

Quartermaster Department and Corps (U.S.), 239, 926; offices and depots, **265, 297, 860**

Queen City, USS, 312, **334**

Quickloaders (Blakeslee cartridge boxes), 308

Quinine, use of, 237

Quinn, G. W., **154**

R

Raccoon Mountain pass, **460–61**

Radical Republicans, 1259, 1263

Raiders, cavalry, 306–8, 310–11, **339–44, 346–47, 351–56, 750**, 818, **881–84**; Confederate, railroad destruction by, 306–7, **340, 254–56**; Yankee, 348–50

Railroads, 176, 896–97; blockhouses, **355, 460**; box cars, **910**; bridge design, **909–10**; bridge protection, **355, 460–61, 696**; canal and waterway junctions, **909–10, 928, 1075–76**; at Chattanooga, 511; Confederate cavalry raids on, 306–7, **340, 354–56**; Construction Corps, 893; destruction methods, **739–41**; hospital trains, 240; locomotives, **281**; North vs. South, 895; at Petersburg, 1058–60, 1065, 1067, 1068–72, **1073, 1121, 1142, 1171**; postwar expansion of, 1263, 1297, 1306; POW camp connections, 399, 407; rail track gauges, 892; "shad–belly" bridges, **906**; strategic uses of, 723; transport of armies and supplies by, 34, 458, **744–45, 892–93**; transport of cannon, **944, 1114**; in Valley Campaigns, **744–45**; yards and depots, **34, 457, 723, 910, 1050**. *See also* U.S. Military Railroads; *and see specific*

railroad companies

Raleigh, N.C., 1213, 1216

Ramseur, Stephen D., 625, 782

Ransom, Robert, **758**

Ransom, Thomas E. G., **728**

Rapidan River, 1864 crossing by Union army, 613, 617, **622**

Rappahannock, CSS, 143, **150**

Rappahannock River, 309, 310; 1864 crossing by Union army, 622, **623**; officers' sleighing party on, **113**; pontoon bridges, **92**; at Port Royal Union supply base, 622, **660**, 668

Rappahannock Station, Va., 50th New York Engineers at, **103**, **917**

Rath, Christopher, **1255**

Rations, 235, 457. *See also* Food of armies

Rattler, USS, 31

Rawlins, John A., **46**, **615**, **657**, **679**, **1280**, **1306**

Rayburn, Howel A. ("Doc"), **351**

Raymond, Miss., engagement at, 21

Read, Charles W., ("Savaz"), 145–46, **157**

Read, T. Buchanan, 754

Read, Theodore, 1214

Reading, J. T., 175, 178, 179, 192

Reagan, John H., 1249

Reams' Station, Va., 1067, 1069

Rebecca, the, **567**

Reconstruction, 1258–59, 1263, **1294–95**, 1297; Congressional, 1259

Recruiting, **878**; of blacks, 362; of sailors, 361–62. *See also* Enlistment

Reddington, James, **977**

Redoubt Harker, Tenn., **456**

Red River, 17, 18, **789**, **797**, **806**; Bailey's dam, 793–94, **813–14**, 815, **816**

Red River Campaign, 786–94, 818, 819, 831, 879, 963; Alexandria captured, 787, 791–92, 797–99; Confederate defenders, **798**, **800–1**, **804–5**; at Mansfield (Sabine Cross

Roads), 788–89, 800; at Pleasant Hill, 789–90, 801; Union participants, **788**, **790**, **792**, **795**, 799–800, 802–3, **809**; Union ships stranded, 792–94, **806–12**, 831

Red Rover, the, **40**, **253**, **796**

Reed's Bridge (Chickamauga Creek), 458

Reekie, James, 1141, 1160, 1168, 1172, 1198, 1220

Reekie, John, 674

Regimental hospitals, 238

Religion, shipboard services, 392, **393**

Repair shops, government, **895–902**, **921**, **931**; U.S. Navy, **566**, **571**, **590**

Repeating carbines and rifles, 908, **934**, **940–41**

Reporters, war, **117**

Republican party, Radicals, 1259, 1263; and Reconstruction, 1259, 1293

Requia battery, 959

Resaca, Battle of, 682–83, **689**, 690, **691**, 692, **693–94**

Revolutionary War, 134

Reynolds, A. W., **49**

Reynolds, D. H., **714**

Rhode Island regiments: 3rd Heavy Artillery, **560–62**; 7th, 644; 11th, **108**

Rice, E. W., **720**

Rice, Henry M., Washington home of, **261**

Richards, J., grave of, **1286**

Richardson, J. F., **795**

Richardson, Samuel J., **880**

Richmond, CSS, 1126

Richmond, USS, **64**, 74, 964, 968

Richmond, Va., 362, 455, 903, 1036, 1151, **1152–55**, **1157–61**, **1163–69**, **1171–78**, **1180–99**; alms house, **1167**; arsenal, **1176–77**, **1189–91**; Ballard House, **1160**; Belle Isle prison, 397, 402, 409, 1159, **1161**; blacks of, 1151, 1152–53, 1166, **1176**, **1192**; bread riot in, 1162–64; "Burnt District," **1180–91**; Castle Thunder

prison, 400–1; cemeteries, **1167**, **1288**; churches, **1157**, **1164–66**; City Hall, **1065**, **1169–70**, **1171**; as Confederate capital, 1156–59, 1166–67, 1168–69; defenses, 1161–62, 1065, 1169–70, 1171; as economic center, 1151–52; 1862 threat to, 167, 305, 1168–70; 1862–64 Union cavalry threats to, 311, 1170–71, 1179; 1864 threats to, 627, 1058–59, 1060, 1067–69, 1125–27, 1170, 1171–72; evacuation fire, 1072, 1163, 1171, 1173–74, 1180; Executive Mansion, 1160, **1172**, 1173, 1175, **1199**; fall of, 1038, 1072, 1172–73, 1202, 1210; in Federal hands, 1174, **1184**, **1188–89**, **1192–98**, **1203–4**; governor's mansion, **1153**, **1197**; hospitals, 247–48, **254–55**, **273**, 1159, 1167; Libby Prison, 397, 400, **402–4**, 406, **426**, **447–48**, 1159, **1196**; life in wartime, 1158–68, 1172; life of "total war," 1165–66; Lincoln in, 1172, 1174, 1204–5; Main Street, **1158**, 1163–64; mansions, **1172–75**; mills, **1178**, **1185–86**, 1203; population, 1152, 1159; POW treatment in, 396–97, 409; Spotswood Hotel, **1160**; state house, **1152**, **1154**, **1182**, **1198**; U.S. Military Telegraph Corps at (1865), **101**; vice and crime in, 1159, 1161; war industry, 1151, 1157, 1161, **1175–1177**; Washington monument, **1152**, **1198**

Richmond & Petersburg RR, **1187**

Richmond & Yorktown River RR, Richmond *Dispatch*, 1161, 1164, 1167

Richmond *Enquirer*, 1167

Richmond *Examiner*, 1159, 1167

"Richmond Reserves," 1172

Richmond *Sentinel*, 1167, 1172

Richmond *Whig*, 1162, 1167, 1170

Riddle, A. J., 434, 436, 1266
Rifles, 308, 895, 906–8; breech-
 loading, 908–9, **933, 938**;
 muzzleloading, 907, 908, 909;
 repeating, 908, **934**; telescopic
 sights for, 941
Rilliet de Cansdourt, Louis, **320**
Ringgold, Ga., 458, **686**; Thomas
 HQ at, **684–85**
Rio de Janeiro, Brazil, **1303**
Rio Grande, 828, 874, **876–77**
*Rise and Fall of the Confederate
 Government, The* (Davis), 1318
River Queen, USS, **1206**
Rives's Salient, 1064
Roberts, William P., **1218**
Robertson, Beverly H., **326**
Roche, T. C., 1145–47
Rocketts, Va., CS Navy Yard,
 1169, 1194
Rock Island, POW camp at, 401
"Rock of Chickamauga," 461, **475**
Rocky Face Ridge, 681, 682
Rodes, Robert E., **769**
Rodgers, C.R.P., **546**, 549
Rodgers, John, 169, 551–52, **568,**
 572
Rodman guns, **114, 944, 949–50**
Rogers, Sergeant, **1010**
Rolling Fork expedition, 18
Roman Catholic Church, 246
Rome, Ga., 682, 684
Rondin, Francois, 146, 149
Rose, Thomas, 403
Rosecrans, William S., 311, 455–
 57, **22, 428;** at Chattanooga,
 455–56; at Chickamauga, 458–
 62, 465, 467, 470, 473, 480,
 868; loses command, 462, 481;
 Tullahoma Campaign, 20, 455
Rosenstock, J., 89, 133
Ross, John, 500; house of
 (Rossville Gap), **501**
Rosser, Thomas L., **337**, 1202,
 1214
Rossville Gap (Missionary
 Ridge), 465, 466, **500–1**
Roswell, Ga., 687
Rowett, Richard, **720**
Royer, Samuel, 462, **662**
Ruby, the, wreck of, **586**
Ruffin, Edmund, **802**

Runde, James, 76
Russell, A. J., 649, 655, 905, 914–
 15, 924, 946, 1073, 1075, 1081,
 1093, 1098, 1099, 1122, 1135–
 36, 1142–44, 1203, 1269;
 railroad photographs of, **906**
Russell, David A., **770**

S

Saber bayonet, **933**
Sabine, USS, **143**
Sabine Cross Roads (Mansfield),
 Battle of, 788–89, 800
Sabine Pass, Battle of, 873
Saco, USS, **156**
Saddle Rock (Tennessee), **510**
Sailor's life, 361–75, **376–95**;
 daily routine, 367–73; disease,
 375; gun drills, 368, **369–72**;
 impressment by CSA, 146;
 laundry, **378**; leisure activities,
 370–72, 373, **380–85**; liberty,
 375, **391–92**; liquor, 373;
 mate's call, **362–63**; meals,
 368, 369, 376; merchant vs.
 warship service, 146; music,
 382–84; officers, **378–
 79, 386–88**; pay scales, 362;
 sabbath services, 392, **393**;
 shamming for the camera,
 373, **389–90**; watch duty, 369–
 70, **377**
St. Charles, Mo., 863
St. Clair, USS, **812**
St. Louis, Mo., 18, 233, 320;
 Gratiot Street Prison, 398;
 hospitals in, 240
St. Louis, USS, **153**, 154, **155**
St. Maurice, the, **65**
St. Paul, Minn., 825, **844**
Saline River, 791
Salisbury, N.C., POW camp at,
 397, 400, 409
San Antonio, Texas, 831, 885
Sand Creek, Colo., 830, 831
Sanders, William P., 467
Sandersville, Ga., 1025
Sandusky, Ohio, 398, 417
San Francisco, Calif., 479, 834–
 37; Fort Point, **835–36**;
 Presidio, **836**

Sangamon, USS, **378, 1113**
Sanitary Commission. *See* U.S.
 Sanitary Commission; Western
 Sanitary Commission
Sanitation: in camps, 234; in
 hospitals, 245; in POW camps,
 424, 436, 437
Santa Fe, N.M., 827, 828, 829
Santee Sioux. *See* Sioux Indians
Saugus, USS, **375**
Saunder's (*or* Palmer's) Field,
 614, **625–26**
Savannah, Ga., 166, 167, 170,
 543–44, 550, 564, **1024,** 1034,
 1036, 1040–41, 1042, **1057;**
 blockade of, 541, 544, 546,
 549, 559, 563, 564; city hall,
 1042; customs house and post
 office, **1043**; fall of, 177, 1026;
 federal troops in, 1027–28,
 1042–43, 1045; POW camps,
 407, **445**; Pulaski Hotel, **1042**;
 Sherman's march to, 235, 741,
 1022–26
Savannah, USS, 545, **547**
Savannah River, 551, **563**, 1026,
 1029, **1036, 1039–40**
Sawmills, government, **920**
Sayler's Creek, battle at, 1200,
 1212–13, 1216, 1218
Scalawags, 1259
Schofield, John M., 471–74, 476,
 478, 479, **524,** 525, 526, 527,
 530; in Atlanta Campaign,
 680, 682, 686, 687, 688
Scholten, J. A., 857
Scott, Winfield, 302, **893**, 899–
 900; Anaconda Plan of, 899
Scottsboro, Ala., **683**
Scouts and guides, army, **96–97,**
 511
Scurvy, 24, 402, 404, 406
Sea King, the, 148, 162. *See also*
 Shenandoah, CSS
Sea of Okhotsk, 148
Secession Hall (South Carolina),
 218
Secessionism, 1062, 1153, 1156,
 1238; in West and Southwest,
 818–820, 826, 870
Secessionville, S.C., 168, **171**, 172
2nd Confederate Engineers,

1065

II Corps (Northern Virginia):
under Early, 627, 746, 757;
under Ewell, 613, 621; under
Gordon, 1201

II Corps (Potomac): under
Hancock, 615–16, 619, 626,
634, 664–67; under
Humphreys, 1211, **1271**

2nd Dragoons, 307

2nd Kentucky Cavalry, 306

Second Manassas. *See* Bull Run,
Second Battle of (1862)

2nd Massachusetts, 742; Atlanta
camp of, **734**

2nd Massachnsetts Cavalry, camp
of, **311**

2nd Michigan, **48**

2nd U.S. Cavalry, 640

2nd Vermont, **1003**

Secretary of War, U.S., office of,
897–99, 904–5

Secret service men, **98**

Secret societies, Southern, 1260,
1296

Seddon, James A., 19–20, 401

Sedgwick, John, **93, 642;** at
Brandy Station HQ, **617;**
death of, 618, 642; in Wilder-
ness Campaign, 615, 616, 618,
619, 632

Sedgwick Hospital, **255**

Selfridge, Thomas O., **809**

Selma, CSS, 963, 965, 967–68

Seminole, USS, 965

Semmes, Raphael ("Old Bees-
wax"), **136–37,** 138, **139,** 140–
42, 146, 150, 151, 157, **165,**
389; escape to England, 142;
Northerners' hatred of, 138;
promoted, 142; victory over
USS *Hatteras,* 140

Sentry duty, **300, 497, 564.** *See
also* Picket duty

Seven Days' Battles, 305, 871

Seven Pines (Fair Oaks), Battle
of, field hospitals at, **238**

7th Kansas, 823

7th Michigan Cavalry, 316, 358

7th New York Cavalry, **320**

7th Rhode Island, 644

7th Wisconsin, 429–31

XVII Corps (Sherman's army),
1024–25

17th Illinois, **59**

17th Indiana Cavalry, 331

17th Ohio, **1030**

17th South Carolina, 211

17th Virginia, 1138

Seward, William H., 144, 1254

Seymour, Truman, 170, **183**

"Shad–belly" bridges, **906**

Shannon, Alexander M., **339**

Shantytowns, at Vicksburg, **35**

Sharps, Christian, 908

Sharps carbines and rifles, 308,
908, **933,** 939

Sharpshooters' weapons, **941**

Sharpshooting drills, **493, 502**

Shaw, Robert Gould, 170, **184**

Shawnee, USS, **1311**

Shelby, Joseph O., 312, 1218

Shenandoah, CSS, 135, 144, 148–
49, **163,** 164, 361, 1218, 1236

Shenandoah River, **744**

Shenandoah Valley, 1058;
Confederate surrender in,
1212; Imboden's raids, 343;
invasion of 1864–65, 743–55;
Winchester battle (1863), **747.**
See also Valley Campaign of
1862; Valley Campaign of
1864–65

Sheridan, Philip Henry, 338, 339,
466, 620, 627, 1062, 1068,
1071, **1212,** 1219; at
Appomattox, 1200, 1202,
1204; arrival in Virginia, 311,
327; Belle Grove HQ of, **782;**
with his generals, **327–28, 336,
345;** scorched earth policy of,
752–53, 755; in the
Shenandoah, 312, 336, 751–
53, 755, **817,** 768, 770–71, 773,
775, 776, 779–80, **785;**
Sheridan's ride, 312, 780; after
the war, **1306, 1309**

Sherman, Thomas W., 167, 168,
170, 545, 894–95, 909

Sherman, William Tecumseh,
246, 305, 332, 336, 348, 470–
71, **505,** 523, 680, **681,** 786,
792, **1023,** 1062, 1251; in
Atlanta, 732, **734–35;** Chatta-

nooga HQ of, **483;** in Colum-
bia, S.C., 1031, 1047; death of,
1267; foraging policy of, 235,
1026, 1029, 1032; in Grand
Review, **1276;** Johnston and,
1267; march through Georgia
(Atlanta Campaign), 177, 235,
313, 407, 681–93, 696, 698,
702–5, 716, 720, 726, 892, 963;
March to the Sea, 471, 692,
739, 741, 1022–26, 1032, 1034;
march through the Carolinas,
330, 1022, 1027–36, 1039,
1045–57, 1071; at Missionary
Ridge, 462, 465–66, 467, 505–
8; philosophy of "total war,"
1022, 1027, 1031; in Savan-
nah, 1026, 1027–28; with his
staff, **1279;** truce agreement
with Johnston, 1213–15, 1216–
17, 1223, 1245, 1249; in
Vicksburg Campaign, 16, 17,
18, 21, 28, 31, 41; after the
war, 1267, **1279, 1306;** in the
West, 469–70

Sherman's army, 1024, **1028–30;**
in Grand Review of 1865,
1246, 1268, **1276–78;** his
"bummers," 1029, 1032, 1034.
See also XIV Corps; XV Corps;
XVII Corps; XX Corps
(Sherman's army)

Shields, Jefferson, **1324**

Shiloh, Battle of, 822, 902

Ship, Scott, **753**

Shipping, **474, 489, 491, 511,
638;** junctions with railroads,
909–10, 928, 1075; postwar
U.S., 1264, **1302–4.** *See also*
Blockade runners; Commerce
raiders; Ironclads; Steamboats;
and see names of ships

Ships' engines, **148, 367–68**

Shirley, James, 45; his "White
House" home in Vicksburg, **45**

Shockoe Valley, Richmond, **1159**

Shoup, Francis A., **707**

Shreveport, La., 786–87, 791, 870

Shunk, B., 290

Shy, William M., 481

Shy's Hill, 479–80

Sibley, Henry Hastings, 825

Sibley, Henry Hopkins, **828**, 829–31, 832

Sick call, 234–35

Sigel, Franz, 743, 744, **751**, 753, 754, 756

Signal, USS, 793, **816**

Signal corpsmen, **42**, **53**, **98–100**, **912**

Signal stations, **98**, 189–90; of cavalry, **314**; at Miner's Hill, **87**; Petersburg siege towers, **1098**, **1111–13**; at Savannah, **1040**

Silver Cloud, USS, **334**

Silver Spring, Md., 761

Simon's Bay, South Africa, 146

Sinclair, Arthur, **142**

Sinclair, E. W., 198, 393

Sinclair, George T., 143

Sioux Indians, 823–25, 846; War, 825, 848, **849–52**

Sisters of Charity, 246

Sisters of Mercy, 246

Sisters of St. Joseph, 246

Sisters of the Holy Cross, 246

6th California, 834

VI Corps (Potomac), 626–27, 748, 760, 781; under Sedgwick, 612–15, 617, **623**, **632**, 642; under Smith, 1006; under Wright, 1134

6th Iowa Cavalry, **852**

6th Minnesota Volunteers, 825

6th New York National Guard, **288–89**

6th Vermont, **1005**

6th Virginia Cavalry, 346

XVI Corps (Union), 692, 720, 728

16th Vermont, **1002**

Slaughterhouse, government, 922

Slavery and slaves, 1065, 1259; Alexandria slave pens, **126**; industrial labor, 1151; and military construction, 1065; slave family, **1018**; slave quarters, **129**, **283**. *See also* Blacks; Contraband blacks

Slave trade, 1151–52

Sleighing party, officers', **113**

Slocum, Henry W., 1024–25,

1053, 1054–55, **1277**

Slough, John, 830

Smith, Andrew J., 471, 478, 479, **792**; in Red River Campaign, 786, 787, 789, 792, 794

Smith, Edmund Kirby, Trans-Mississippi command, 787, 789–91, **798**, 804, 831, 832, **869**, 870–71, 881, 1218, **1231**, 1236

Smith, George A., **528**

Smith, Martin Luther, 17

Smith, S. L., **147**

Smith, William ("Extra Billy"), **1156**

Smith, William F. ("Baldy"), 1000, **1006**, 1007–8, 1011, 1014; at Cold Harbor, 626, **675**; HQ of, **1005**; at Petersburg, 1058, **1064**; in the West, 47

Smith, William Morris, 911, 1286

Smithfield, N.C., 1036

Smoothbores, 906–7. *See also* Dahlgren smoothbores

Smyrna, Ga., 686

Snake Creek Gap, Ga., 682, 683, 684

Snow, Ansel L., **265**

Soldiers, statistics on, 886; Union army, 893–94, 1249–50

Soldiers' Home (Camp Nelson), **270**

Soldiers' Orphans Home (Gettysburg), **1320**

Soldiers' Rest kitchen (Alexandria, Va.), **263**

Southampton, England, 137

South Anna River, 304

South Atlantic Blockading Squadron, 540, 543, 545–61; attacks on Charleston, 168–70, 171–72, 198–200, 209, 553, 556; commanding officers, 170, 541, **543**, 552, 555–56, **576–77**; fleet maintenance, **565–66**; at Fort Pulaski, 545–46, **547–50**, 551; postwar, 1303; recruiting of blacks, 362

South Carolina, black majority, 1259; Sherman in, 1027–28, 1029–32, 1045–52; state

house, **1047–48**; total war in, 1022, 1027, 1031. *See also* Charleston; Fort Sumter

South Carolina regiments: Charleston Light Artillery, **210**; 1st Artillery, 172; 15th, 522; 17th, 211; 25th, **187**, **1066**; Washington Light Infantry of Charleston, **187**, **1066**

South Carolina RR, 1029, 1031; facilities, **1049–50**

South Dakota, 848

Southern Home Journal, 1167

Southern Illustrated News, 1167

Southern Literary Messenger, 1167

Southern Punch, 1167

Southside RR, 892, 1059–60, 1065, 1068–69, 1070, 1135

Spain, 153, 159

Spanish–American War, 898, 1032, 1222

Spencer repeating rifles and carbines, 308, 331, 908, **934**, 940

Spies, **98**, **131**, **1307**; Southern women, **410**. *See also* Scouts; Secret service men

"Splinter–proofs," **610**

"Spontaneous Southern Rights Convention" (1861), 1156

Spotsylvania, Va., **638–40**, 641, 661; Battle of, 613, 617–22, 634, **635**, **638**, 640–46, 650, 1058–59

Spotsylvania Court House, **638**, 640

Spotsylvania Hotel, **639**

Sprague, William, 562

Springfield, Ill.: Lincoln home, **1251**; POW camp near, 399

Springfield, Mo., 818

Springfield rifles, 308, 907

Spring Hill, Tenn., 472, 473

Squirrel Level Road, 1070

Stahel, Julius, **757**

Stanley, David S., **526**, 1228

Stanton, Edwin M., 240, 242, 243, **892**, 897–99, 902, 904, 1026, 1249; in Grand Review, **1276**

Staph infections, 237

Starr carbine, **937**

"Starvation parties," 1168
States' rights, 1259
Station Creek (near Port Royal), **565**
Staunton, Va., 743, 755
Steamboats, **485–88, 1069**
Steedman, James B., 476–77, 480
Steele, Frederick, 18, 19, **786–87, 802,** 803–4, 831, **854,** 858, 860
Stephens, Alexander H., 1156, 1173, **1262, 1317**
Stevens, Walter H., **1179**
Stevensburg, Va., 348, 613
Stevens house (near Centreville, field hospital), **236**
Stevenson, Ala., Federals at, **456–58;** Redoubt Harker, **456**
Stewart, Alexander P., 478, 479, 688, 690, 1038, **1055**
Stokes, William J., 878
Stone Bridge (on Warrenton Road across Bull Run), ruins of, **128, 284**
Stoneman, George, 302, 313, **325, 708,** 709, 1170, 1214
Stoneman's Station, Va., supply depot, **929**
Stones River, Battle of, **455**
Stonewall, CSS, **159–61,** 162
Stonewall Brigade, 1905 reunion, **1324**
Stono River, 166, 168, 177, **210**
Stony Creek Depot, 1060
Stout, Samuel, **239**
Strahl, Otho F., 476, **528,** 529
Strasburg, Va., **746,** 752, 775
Strategy, Union, 899, 902–4, 909. *See also* Anaconda Plan
Strategy Board, 539–40, 545
Strawberry Plains, Tenn., railroad bridge, **354, 515**
Streight, Abel D., 308, 403
Stretcher, folding, **233**
Stretcher bearers, **233,** 236
Strong, James, **984**
Strother, David Hunter ("Porte Crayon"), **756**
Stuart, James Ewell Brown ("Jeb"), **321,** 323, 325, 329, **1087;** Buckland Mills battle, 311; in defense of Richmond (Peninsula Campaign), 304–

5, 311; exploits of, 301, 303–5, 308; at First Bull Run, 303; at Gettysburg (Brandy Station), 308, 309–10, 326; at Kelly's Ford, 309, 322; Pennsylvania raid of 1862, 307; "ride around McClellan," 304, 307; wounded, and death, 311, 620, 651, 652
Stuart, William H. (in death), **867**
Sturgis, Samuel D., 312, **335**
Sturgis, Mrs. Samuel D., **335**
Submersibles and semisubmersibles, 590. *See also* David, the; "Davids"
Sullivan, Jeremiah, **751**
Sullivan's Island, 166, 169, 172, 187; Fort Marshall, **181;** wreck of *Colt* at, **1022.** *See also* Fort Moultrie
Sully, Alfred, 825, **851,** 852
Sultana, SS, 406, 1245, **1260**
Sumner, Edwin V. ("Bull"), 828
Sumter, CSS, 136, **137,** 138, 139; officers of, **136**
Supply problems, South, 1060, 1062
Supply system, Union army, 19, 20–21, **456–57, 622–23, 646–49, 660, 668–69,** 891–98, 1060; Grant's "crackerline" in West, 462, **484–88;** shops and depots, **167, 895–905, 920–25, 927–31,** 1062. *See also* City Point; Ordnance yards; Railroads
Surgeon General, office of: in North, 232–33, 240–43, 251; in South, 231–32, 243, 272
Surgeons, 238–39, **243,** 245–46
Surgery, 237–38, **242–43;** anesthesia, 238, **241–42;** septic conditions, 237, 241. *See also* Amputations
Surgical fevers, 237–38
Surratt, Mary, 1245, 1249, **1254–57**
Sutherland's Station, Va., 1072
Sutlers, **168,** 315, **492, 931**
"Swamp Angel" battery, 171, **188, 225**

Sweatt, Blainwell, 921
Sweeney, Thomas, **692, 1301**
Switzerland, USS, **25**
Sydney, Australia, 1303; Williamstown dry dock at, **163**

T

Tacony, the, 145, 392
Talcott, T.M.R., 1206, **1216**
Taliaferro, William B., 184
Tallahassee, CSS, 146–47, **158**
Tallahassee, Fla., Confederate surrender at, 1217
Tartar emetic, banning of, 242
Taylor, Fletcher, **864**
Taylor, Richard, 787–88, 792, **798,** 801, 805, 831, 1217, **1229,** 1230
Taylor, Thomas H., **974**
Taylor, Walter, 1203
Taylor, Zachary, 158, 787, 798, 1229
Taylor Depot, Nashville, **923**
Tecumseh, USS, 964–67, 971, 981
Telegraph communications: in field, **602,** 911–**12,** 1066, **1070–78.** *See also* U.S. Military Telegraph Corps
Tennessee, 680; cavalry raids in, 311–12, **353–56,** 489; Eastern, 459, 513; 1863 struggle in, 455–70, **473–522;** 1864 struggle in, 470–81, 523, **524–38,** 1024, 1027; State House, **530–31;** Union supply lines to, **456–57,** 462, **484–88**
Tennessee, CSS, 962–70, 978, 981, **982–83,** 984, 996, **997**
Tennessee, USS, **1302**
Tennessee & Alabama RR, blockhouse, **355**
Tennessee regiments, 33rd, **1224**
Tennessee River, 312, 481, 681; Howe Turn Bridge, **463;** at Lookout Mountain, **124, 291–92, 480;** as supply line, 462, **484–88;** Union patrols, **489–90;** waterworks, **919**
Tennessee Valley, **291**
X Corps (Union), 1057
10th Virginia Cavalry, 679

"Tent manufactory," government, **924**

Terceira (Azores), 135–36

Terrill, James B., 625, **671**

Terrill, William R., 671

Terry, Alfred H., 1034, **1057**, 1062

Terry, Edward, **74**

Terry's Texas Rangers, 339

Tevis, C. Carroll, **800**

Texas, 828, 830–31, 832, 872–78; secession of, 819, 820, 822; Union invasion plan, 786

Texas Legion, 44

Texas regiments, 826–27, 828; 1st, **821**; 3rd Cavalry, **879**; 4th Cavalry (Arizona Brigade), **878**; 8th Cavalry, 339

Thayer, John M., **803**

III Corps (Northern Virginia), 614

III Corps (Potomac), 286, **620**

3rd Louisiana Cavalry, 28

3rd Maryland Cavalry, 800

3rd Pennsylvania Cavalry, camp of, **313, 319**

3rd Rhode Island Heavy Artillery, **560–62**

3rd Texas Cavalry, **879**

3rd Vermont, camp of, **1004**

13th Connecticut, Baton Rouge cemetery of, **132**

13th Iowa, 802

13th New York Cavalry, **303**; camp of, **313**

13th Vermont, camp of, **1004**

13th Virginia, 625

31st North Carolina, 1056

33rd New Jersey, **690**

33rd Tennessee, **348**

34th Indiana, 886

34th Massachusetts, **752**

36th Massachusetts, **633**

38th Massachusetts, 66

39th Illinois, **186**

Thomas, George H., 465, 471, 472, 476, 478, 530, 536, **711**; in Atlanta Campaign, 682, 688, 707, 711; Chattanooga HQ of, **481**; at Chickamauga, 457, 458, 460–61, **475**, 476, 477, 479; commands Army of the Cumberland, 462, 481, 680, 684, 711; his generals, **685**; at Missionary Ridge, 498, 499, 503, 505, 508; at Nashville, 477–81, 523, 530, 533, 534, 536, 1027; Ringgold (Ga.) HQ of, **684**; the "Rock of Chickamauga," 461, 475

Thomas, Lorenzo, **892**

Thompson, Lieutenant, **282**

Thompson, M. Jefferson ("Swamp Fox"), 308, **883**, 1217

Thompson's Creek, battle at, 22

Ticonderoga, USS, **153**

Tilden, Samuel J., 1263

Tillman, William, 55

Tillman's (Wm.) Saddle & Harness Manufactory, **55**

Todd, George, 820

Todd's Tavern, Va., 640

Tompkins, Charles H., **1253**

Torbert, Alfred T.A., **327, 328, 619**, 626, **779, 785**

Torpedo boats. *See* "Davids"

Torpedo mines, **225–26, 601**; at Mobile Bay, 962, 964, 966–67, 982, 984; water sweeping for, **1205**. *See also* Land mine "torpedoes"

"Total war," 1022, 1027, 1031

Totopotomoy Creek, 623, 625

Totten, Joseph G, 918

Townsend, Edward D., **1248**

Trade and commerce, 1151–52, 1264. *See also* Blockade; Blockade runners

Training of recruits, cavalry, **306**. *See also* Drill

Trans–Mississippi Department, 786, 787, 798, 831, 869–71, 881–85, 1218, 1230–31

Trapier, James M., 546, 548

Travelle. (Lee's horse), **1140, 1313**

Travers, T. B., **575**

Treasury Department (CSA), **1181, 1184**, 1216

Tredegar Iron Works, 1151, 1157, 1161, 1163, **1175**

Trench Cavalier (at Port Hudson), **79**

Trench warfare, 905, 909, 1060, **1101–11,** 1171

Trent's Reach, Va., 1063

Trimming shop, government, **898**

Trobriand, Philippe Regis Denis de Keredern de, **86**

Troth's farm, battle at, 22

Trout House hotel (Atlanta, Ga.), **722**

Tuberculosis, 235

Tucker, G.W., 1203–4

Tucker, William F., **693**

Tullahoma Campaign, 20, 455

Tunnard, Willie, 26

Turkey, 373

Turner, John W, 1210

Turner's Lane neurological hospital, Philadelphia, 245

Tuscaloosa, Ala., POW camp, 397

Tuscaloosa, CSS, 146, 157

Tuscarora, USS, **138**

Tuscumbia, USS, **39**

Turtle, James, 85

XII Corps (Potomac), sent West, commanded by Hooker, 462

12th New York Battery, **1099**

12th Vermont, **1003, 1013**

XX Corps (Cumberland), 456, 457, 472

XX Corps (Sherman's army), 712, 1024–25, 1027, **1053, 1278**

20th Maine, 1073

20th Mississippi Colored Regiment, **56**

XXI Corps (Cumberland), 458

21st Michigan, 1031

22nd New York State Militia, **282**

XXIII Corps (Union), 471–73, 478, 695

23rd Ohio, monument and mustering out, **1284**

23rd Virginia, 184

24th Massachusetts, 172

24th Wisconsin, 527

25th South Carolina, **187, 1066**

28th Ohio, 758

Tybee Island, 544, 547, 548, **551–52**, 553, **563**

Tyler, Texas, Camp Ford, 406, 441

Tyler, USS, **84**

Tyson Brothers, 270

U

Ulke, Julius, 1243

Umbrella Rock (Lookout Mountain), **121**

Unadilla, USS, **395, 542, 1205**

Underwood, John Cory, **414**

Uniforms, 924; Army Clothing Depot, **904**; sailors', 364

Union Blockade Board, 166, 539–40, 545

Union City, Tenn., Confederate capture of, **311**

Union Mills, Va., 1002

Union Pacific RR, 1306

United Confederate Veterans, 1266

U.S. Army: administrative system, 897–98; command system, 898–904; cooperation with Navy, Mobile Bay as example of, 972, 995. *See also* Supply system, Union army; *and see individual armies and corps*

U.S. Army Adjutant General's Department, 898

U.S. Army Corps of Engineers, 539, 898, 918

U.S. Army General Staff, 898

U.S. Army Inspector General's Department, 898

U.S. Army Judge Advocate General's Department, 898

U.S. Army Laboratory, **947**

U.S. Army Medical Department, 232, 241–42, 243, 247

U.S. Army Pay Department, 898

U.S. Army Signal Corps, 898, **911**. *See also* Signal corpsmen; Signal stations

U.S. Christian Commission, 246

U.S. Congress, 241, 903; post-war, 1259, 1263

U.S. Constitution, Fourteenth Amendment, 1259

U.S. Departments. *See* Navy Department (U.S.); Treasury Department (U.S.); War Department (U.S.)

U.S. Depot of Army Clothing and Equipage, **904**

U.S. Engineer Battalion, 1065

U.S. Government Stables, mess house, **308**

U.S. Marine Corps, hospitals, **54, 258**

U.S. Military Academy at West Point, 397, 903

U.S. Military Railroad Construction Corps, 893

U.S. Military Railroads, 892–93, 897, 910, 1060

U.S. Military Telegraph Corps, **101–3**. *See also* Telegraph communications in field

U.S. Navy, 167, 539, 540, 660, 1060; ammunition schooners, **947**; blacks in, 362, 365, **383, 385, 394, 545**; blockading squadrons of, 166–67, 540, 545–51 *(see also* North Atlantic Blockading Squadron; South Atlantic Blockading Squadron); cooperation with Army, Mobile Bay as example of, 972, 995; machine and repair shops, **566, 571, 590**; postwar activities, 1264, **1302–1304**; shipbuilding program, **1302**. *See also* Blockade; Ironclads; Naval operations; Navy Department (U.S.)

U.S. Sanitary Commission, 232–34, 240–41, 266, **268**; field offices and agents, **269–72**; HQ in Washington, **268**; soldiers' homes and lodges, **269–70**

U.S. Sharpshooters (Berdan's), 537, **1008**

U.S. Steam Fire Brigade, **262**

University of Maryland Medical School, 240

University of Tennessee, **518–19**

Upton, Emory, 618–19, **643**, 645

Utah, 307, 392

V

Valley Campaign of 1862, Lincoln and, 901

Valley Campaign of 1864–65, 312, 336, 343, 627, 743–55, 1071; Cedar Creek battle, 312, 753, 776, **777**, 778–80, **781**; federal ravaging policy, 744–45, 752–53, 755; Fisher's Hill battle, 752, 774, **775**, 776; New Market battle, 743, 753, 754, 755; Northern participants in, **749, 751–52, 754, 756–60, 767, 770, 772, 778–79**; Southern participants in, **748–50, 753–55, 757–58, 762–63, 769, 771–72, 774–76, 778, 783**; Winchester battle, 752–53, 762, 771–72, **773**, 774

Valley Pike, 768, 780

Val Verde, N.M. Territory, 828

Vance, Zebulon, 1036

Vanderhoff's Wharf (Charleston, S.C.), **230**

Van Derveer, Ferdinand, **526**

Vandever, William, **48**

Van Dorn, Earl, 17, **19**, 20, 21, 818, **853**, 854

Van Lew, Elizabeth, 1169, 1174

Vannerson, Julian, 1061, 1209

Vannerson & Jones, 624, 652

Van Vliet, Stewart, **96**

Vaughan, Alfred J., Jr., **706**

Vendors, **931**; camp (sutlers), **168, 315, 492, 931**

Vermont, USS, **377, 567–68**, 588

Vermont regiments: 1st, camp of, **1001**; 2nd, **1003**; 3rd, camp of, **1004**; 4th, **1001, 1009–11, 1013, 1021**; 6th, **1005**; 13th, camp of, **1004**; 16th, **1002**

Veterans: disabled, care for, **1308**; organizations, 1266–67; reunions, 1268, **1320, 1324**

Vicksburg, Miss., 16, **18**, **36–37**, 786; Catholic and Methodist churches, **51**; under Federal occupation, **50–60**; Federal refortification, **57–58**, **60**; Grant's HQ at, **53**; hospital ships at, **40**; national cemetery at, 1252; POW camp, and truce talks, **1226**; POW exchange point, 400; shantytown, **35**; Signal Corps

at, **42**, **53**; U.S. Marine Hospital at, **54**; war monument at, **84**; Warren County Courthouse, **18**, **38**, **50**, **55**; Washington Photographic Gallery, 35, **55**; waterfront, **83–85**

Vicksburg & Jackson RR depot, **34**

Vicksburg Campaign, 16–22, 24–27, 134, 166, 308, 333, 349, 906, 974; bombardments, 19, 26, **39**, **45**, 49; casualties, 17, 21, 22, 23, 26; Confederate defenders, **19**, **28**, **30**, **32–34**, **44**, **47**, **49**, **52**; diversionary expeditions on Yazoo, 18, 19, 28, 31; earthworks, **35**, **49**, **50**, **54**; Federal encampments, **20**, **43**, **56–57**; at Grand Gulf, 19, 28, 30; lines of supply and communications, 19, 20–21, **34**; at Champion's Hill, 21, 22, 32, 33, 59; Chickasaw Bluffs battle, 17, 21; city's inner defenses, 17, **35**, **38**; naval operations, 17–18, 22, 25, **26–27**, 29, **30**, **39–40**; siege, 22–23, 24–27, 39, **44–45**, 47, **49–50**; surrender, 26–27, 50, **51–60**, 81, 84; Union participants in, **17**, **22**, **24**, **31**, **40–43**, 46, 48

Victor, the. *See Rappahannock,* CSS

Vidaurri, Atanacio, **879**

Vienna, Va., cavalry camp at, **311**

Vindicator, USS, **26**

Vining's Station, Ga., 706

Virginia, at beginning of war, 1153–56; cavalry raids in, **311**, **340**, 341, 342, 1170–71; end of hostilities in, 1212, 1223; secession of, 1156; slavery, 1151–52; State House, **1152**, **1154**, **1182**, 1198. *See also individual battles and campaigns in Virginia*

Virginia, CSS *(formerly USS Merrimack)*, 146, 158, 550, 965, 983

Virginia & Tennessee RR, 744

Virginia Central RR, 625

Virginia Military Institute, 754, 756, 1167; cadets, 743, **753**, **1315**

Virginia regiments: 1st Cavalry, 303; 6th Cavalry, 346; 10th Cavalry, 679; 13th, 625; 17th, 1138; 23rd, 184; 43rd Cavalry, **341**; 54th, 699

Virginia State Penitentiary, **1163**

Virginia II, CSS, smokestack of, **1193–94**

Volley gun, **958–59**

Vulcan Iron Works (Charleston, S.C.), **224**

W

Wabash, USS, **382**, **384**, **543–44**, 545; guns of, **577–79**

Wachusett, USS, 144

Waddell, James I., 148–49, **162**, 164, 1218, **1236**

Wadsworth, James S., **636**

Wagner, George D., 474, 476

Wagon transport, **101**, **104**, **622–23**, 894, **914**, **929**, **1031**, **1069**, **1076**, **1141**; government yard, **923**; of guns, **945**, **958**; roadbuilding for, **663**

Walker, Henry H., **1262**

Walker, James, **119–20**, 121

Walker, John G., **801**

Walker, Lindsay, 1200

Walker, L. M., **884**

Walker, Mary Edwards, **240**

Walker, W. H. T., 458, 459

Wallace, Lew, 1184, **1195**, **1253**

Walton, James B., **504**, 505

War crimes, 1249, 1289

Ward, William H., 147

Ward, William T., **1053**

War Department (CSA), 1162

War Department (U.S.), 232–33, 246, 835, 892, **894**, 897–99, 902, 935, 937–38, 948, 1268

Warner, W., **735**

War of 1812, 34, 899

Warren, Gouverneur K., 1069, 1070, 1071, **1133**; commands V Corps in Wilderness, 615, 617–18, 620–21, 625, 626, 627, 628, 632, 643, 661–64

Warren County Courthouse (Vicksburg), **18**, 36, **38**, **50**, **55**

Warrenton, Va., Pleasonton and his staff at, **323**

Washington, Alexandria & Georgetown RR bridge, **909–10**

Washington, Augustine, 125

Washington, D.C., Early's threat to, 743, 747–49, 758–59, 760–62; government repair and supply shops, **895–904**; Government Stables, mess house, **308**; Grand Review of troops (1865), 1246, **1268–78**; hangings in, **1254–58**, **1289–91**; hospitals in, 248, **260–64**; Lincoln funeral parade, **1245**; "Minnesota Row," Douglas Hospital, **261**; Navy Department, **894**; Old Capitol Prison, 398, **407–8**; Old Penitentiary, **1254–58**; Pennsylvania Avenue, **1245**, **1269**; Sanitary Commission establishments, **268–69**; War Department, **894**; White House (Executive Mansion), **1245**

Washington, Ga., 1249

Washington, George, 125, 904

Washington Aqueduct, **91**

Washington Arsenal, **942**, **946**

Washington Artillery of New Orleans, **504**, **536**

Washington College (Lexington, Va.), 1267, **1315**

Washington Light Infantry of Charleston, **187**, **1066**

Washington Navy Yard, **161**; "David" at, **592**

Washington Photograph Gallery (Vicksburg), 35, **55**

Wassaw Sound, **572**

Wassuc, USS, **1311**

Water batteries, on James River, 1062, 1063–64, **1091–92**; at Mobile Bay, **971–73**

Waterloo, Battle of, 1172

Waud, Alfred R., **113**, **117**, **118–19**, 129

Wauhatchie, Battle of, 467, 495

Wauhatchie, SS, **487**

Wauhatchie Bridge, Union camp at, **682**

Waul, Thomas N., **44**

Weaponry. *See* Arms; Artillery; Cannon; Carbines; Rifles

Weaver, P. S., 252

Webb, Alexander S., **616, 1211**

Webb, William A., **415**, 551, **574**

Wedge, A. G., 874

Weehawken, USS, 176, 201, 203, 544, 551–52, 553, 572

Weitzel, Godfrey, 1072, **1128**, 1174, **1204**

Weldon, Va., 1059, 1216

Weldon RR, 1059, 1060, 1070–71, **1073, 1121**; battles for, 1058, 1067, 1069, 1073, 1121–22

Welford, Dr., 617

Welford's Ford, Hazel River, **280**

Welles, Gideon, 138, 145, 362, 539, 546, 555; and blockade, 149; in Grand Review, 1276

West, war in the, 818–32, 1024; cavalry, 305, **306**, 307, 310–13, 330–36, **351–56**; enlistment of volunteers, **833, 878**; guerrilla warfare, 818, 820–21, 823, 864–67; river ironclads, **28, 30**, 786, **789**, 807, **808–12**; surrender of Confederate forces, 1217–18; Union supply lines, **456–57**, 462, **484–88, 858–59**. *See also* Atlanta Campaign; Mississippi River; Mobile Bay; Port Hudson Campaign; Red River Campaign; Vicksburg Campaign; *and see individual states of the West*

Western & Atlantic RR, 470, 681, 682, 692, **696–97**; Atlanta Depot, 722, **723**; Chattanooga terminal, **491**

Western Penitentiary (Allegheny City, Pa.), **432**

Western Sanitary Commission, 233, 240, 245–46

West Gulf Blockading Squadron, 540, 963, 966

Westmoreland, USS, **85**

Westover Landing, Va., 318, 319

West Point. *See* U.S. Military Academy at West Point

Westport, Battle of, 882, 884–85

West Virginia, 1197; cavalry raids, 342, **344**, 346

Westward movement, 1265–66, **1306**

Weyanoke Point, Va., **1063**

Whaling industry, Confederate raids on, 134, 148–49, 163

Wharton, Gabriel C., **754**

Wharton, John A., **330, 805**

Wheaton, Frank, **760**

Wheeler, Joseph, 307, 310–11, 313, 330, 331, 333, 336, 467, 680, 692, 1026, **1032, 1215**

Wheeler, J. R., **147**

Wheelwright shops, government, **902, 931**

Whipple, William D., **685**

Whitaker, Walter C., 463, **478**

White Brotherhood, 1260

White Cloud, SS, 83

White House Landing, Va., **669**, 675; Army of the Potomac supply base (1864), 623, **668–69**, 675

Whitehurst, J. H., 158

White River, 312, **334**

Whiteside, Ga., 460

White Sulphur Springs, Va., **1312**

Whitworth rifle guns, **597, 1196**; ammunition, **946**

Wiard guns, **942**

Wickham, W. C., **776**

"Wigwag" flag communication, 911

Wilcox, Cadmus M., 1070, 1072, **1127, 1299**

Wilcox's Landing, Va., 1058, **1069–70**

Wilder, John T., **331**, 461

Wilderness, The, 613, **631**

Wilderness Campaign (1864), 613–21, 1059; battle sites, **625–26, 628–31, 635, 638, 640, 644, 652–54, 673–74**; casualties, 617, 622, 627; Cold Harbor, 625–27, 671, 673, **674**, 675, 679; Confederate participants, **624, 627, 636–37, 641–42, 651–52, 671–73, 676–79**; Northern participants, **614–20, 629, 632–36, 642–43, 645, 657–59, 675–79**; at Orange Turnpike and Plank Road, 613–16, **625, 630, 632**; river

crossings, **622–23, 661–68**; Spotsylvania battle, 613, 617–22, 634, **635, 638**, 640–46, 650; Union supply bases, 620, 622, 623, **646–50, 660, 668–69**; Union war council at Massaponax Church HQ, **657–59**

Wilderness Church, 614, 625, 628, **629, 630**

Wilderness Tavern, **628, 632**

Wild West, 1265–66

Wilkinson, John, 147

Willcox, Orlando B., 1069, **1122**

Williams, Alpheus S., **712**, 1024, 1027

Williams, Charles, 921

Williams, John J., **886**

Williams, John S., 467, **513**, 514

Williams, R. K., **633**

Williams, Seth, **893, 1280**

Williamsburg, Va., 1151

Williamstown dry dock, Sydney, Australia, **163**

Wilmington, N.C., 146, 147, 1028, 1036, 1059; blockade of, 972; POW exchange at, 409

Wilmington River, 551

Wilson, Edward L., 1319

Wilson, James H., 313, **327, 336**, 349, 473, 478, 479, 480, 481, **785**, 1214, 1266

Winchester, Oliver, 941

Winchester, Va., 312, **768, 770**; Battle of 1863, **747**; Battle of 1864, 752-53, 362, 771-72, **773**, 774; Federal winter camp at, **784**

Winder, John H., 396-97, 398, 403, 404, 407, 409, **1162**, 1168

Winnebago, USS, 965, 966, 980

Winnebago class of river monitors, **980**

Winnsboro, S.C., 1031

Winslow, Dr., **271**

Winslow, John A., 140, 142, **144, 146**

Wire gun, **948**

Wirz, Henry, 404, 409, 1249; execution of, **1289-91**

Wisconsin regiments: 7th, 429-31; 8th, **40**; 24th, 527

Wise, Henry A., 1058, 1156, **1216**, 1218
Wivern, HMS, **162**
Wolf Run Shoals, Va., **1003, 1013, 1017**
Wolverines, 677
Women, **247**, **267**; aid to POWs, 404; doctors, **240**; first woman to hold commission in U.S. Army, **240**; joining camp, **187**, **316**; Medal of Honor recipient, **240**; Northern relief organizations, 232, **253**, **266**; as nurses, **237**, 245-47, **264**, **270**, 273; Sanitary Commission work by, 233, 266; of the South, 246-47; as spies, **410**, **1307**
Women's Central Association of Relief, 232, **266**
Wood, James, **977**
Wood, John Taylor, 146-47, **158**
Wood, Thomas J., **470**, 478, 479, **526**
Woodbury, David B., **669**
Woodward, Joseph J., 241, 251
World War I, 905, 909
World War II, 895, 905
Wright, Lieutenant, **318**
Wright, Ambrose R., **1033**
Wright, Horatio G., **632**, 749, 754, 1071-72, **1134**
Wright, Marcus J., **718**
Wright, Robert, **1126**

Y

Yankee, USS, **660**
Yazoo Pass expedition, 18, **28**, **31**
Yazoo River, 16, 17, 18, 28, 29, 31
Yellow Tavern, Va., 27, 651
Young, Pierce M. B., **330**, **1046**
Younger, Cole, 821, 823
Young's Point, La., 19, 28

Z

Zacharias Brothers, 764
Zouave units, ambulance drill, **232**; Corcoran Legion (164th New York), **1086**; 114th Pennsylvania, **676**, **1081**